Reality through the Arts

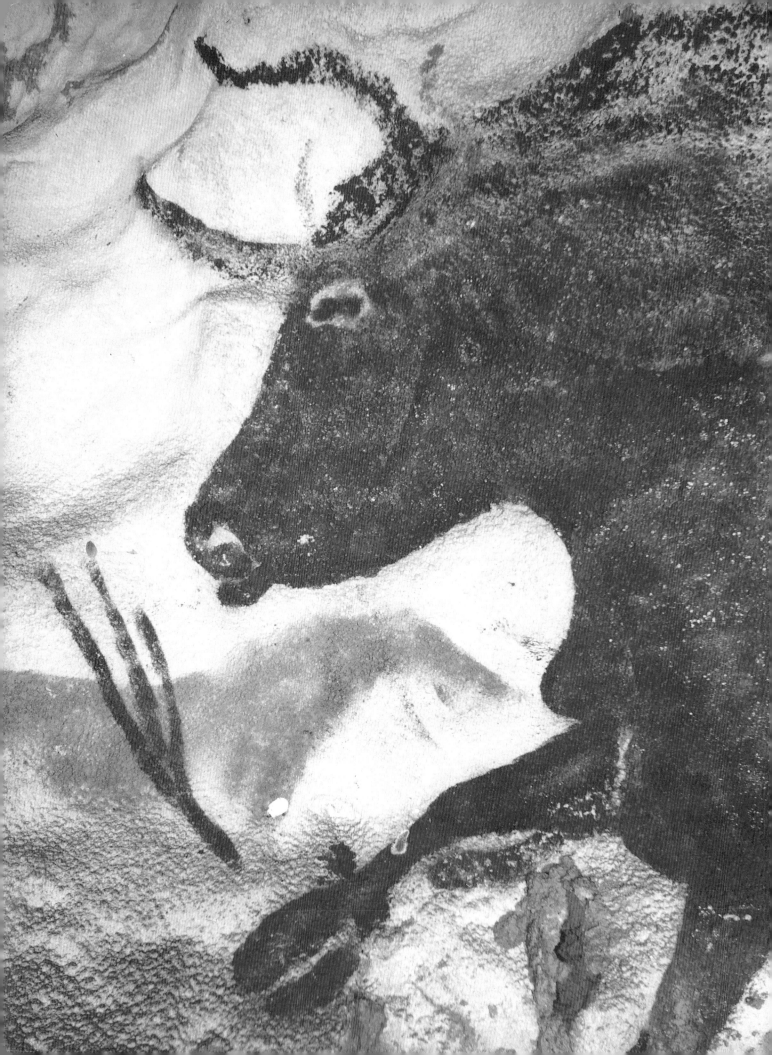

Reality through the Arts

DENNIS J . SPORRE

BALL STATE UNIVERSITY

PRENTICE HALL , ENGLEWOOD CLIFFS , N.J. 07632

© 1991 by Prentice Hall, Inc.
A Division of Simon & Schuster
Englewood Cliffs, New Jersey 07632

10 9 8 7 6 5 4 3 2 1

ISBN 0–13–764119–2

This book was designed and produced by
JOHN CALMANN AND KING LTD, LONDON

Designer Karen Stafford
Picture researcher Kathy Lockley
Artwork by Sarah-Jayne Stafford

Typeset by Wyvern Typesetting, Bristol
Printed in Hong Kong

Cover front detail and back: Johannes Vermeer, *The Kitchen Maid*, c. 1658. Oil on canvas, $17\frac{7}{8} \times 16\frac{1}{8}$ ins. (45.5 × 41 cm). Rijksmuseum, Amsterdam.

Frontispiece: Black bull, detail, c. 16,000–14,000 BC. Paint on limestone, total length of bull 13 ft (3.95 m). Lascaux, France.

The following pictures and details were used as the vignettes for the chapter openers:
page 11 detail of Stonehenge, fig. 7.1; *page 21* detail of ceiling ornament, fig. 1.7; *page 49* detail of Girl with Cat, fig. 2.16; *page 64* detail of Scene design for an opera, fig. 3.12; *page 79* The Swan Theatre, see fig. 12.50, BBC Hulton Picture Library; *page 95* artwork of camera by Sarah-Jayne Stafford; *page 106* detail of ballet shoes, photograph courtesy of Linda Rich; *page 119* the Acropolis, Athens; *page 147* artwork of Chaucer figure by Sarah-Jayne Stafford; *page 163* detail of Church of Nikolai Khamovnik, Moscow, fig. 9.6; *page 171* detail of Egyptian wall painting from the tomb of Sebek-hotpe (JCK archives); *page 190* Ijo Nigeria, ancestor screen (JCK archives); *page 207* Panathenaic Amphora 480–470 BC (JCK archives); *page 257* detail of *Rake's Progress* by Hogarth, fig. 13.16; *page 302* detail of Casa Batllo, Barcelona, fig. 14.17.

CONTENTS

Part One

THE MEDIA OF THE ARTS

Part Two

THE STYLES OF THE ARTS

PREFACE

The purpose of this book is to illustrate how the arts function as a means by which we can come to know reality—that is, the universe—to show how artists portray reality in artworks, and to describe the media artists use in that portrayal so that we can respond as fully as possible to the messages artworks bring to us. This text is an introduction to the humanities. It is aimed at individuals with little or no knowledge of the arts and is designed to give those individuals both a few touchstones concerning what to look and listen for in works of art and literature, and a basic familiarity with major styles. In addition, it attempts to provide the humanities instructor with a helpful textbook for courses which touch upon the arts in an inter- or multidisciplinary manner. To achieve these ends I have of necessity been selective and practical. My treatment of many definitions and concepts is somewhat superficial, and the reader should understand that. Many characteristics of the arts change in definition from one historical period to another. Furthermore, most artists do not paint, sculpt, or compose to neat, preordained parameters. Even widely used terms such as symphony have many subtle connotations and can be defined accurately only within specific historical contexts. Nonetheless, I attempt to define such terms in Part I, but only *in general*. Although some of my colleagues in the arts will reproach me for simplicity and superficiality, those who teach introductory, interdisciplinary courses in the humanities will, I hope, sympathize, if not applaud. I hope that students and teachers will attempt to expand upon the definitions provided in Part I with the help of the stylistically related discussions in Part II.

This book is not a completely self-contained humanities course. It cannot substitute for the classroom teacher, whose responsibility it is to shape and mold a course according to the needs of local curricula and to assist the student to focus on what is important for the thrust of that particular course. No textbook can be relied upon to answer all the student's questions and include all key points. A good text can only *suggest* the breadth of what is available.

Use of this text will encourage use of other source materials. The instructor should develop emphases or foci of his or her own choosing by adding, in lecture or other form, detailed expansion of particular areas raised in the general overview provided here. I have aimed to provide a convenient, one-volume outline with enough flexibility to serve a variety of purposes.

In discussing artworks I have for the most part kept to description and compositional analysis. By so doing I hope to assist the reader in polishing his or her skills of technical observation. By avoiding meanings and relationships I have left room for the classroom instructor to move discussions in whatever direction is deemed appropriate.

In trying to provide a respondent-oriented work dealing in part with the questions of what we can see and hear in works of art and what we can read in works of literature, I have chosen to relate them in a very cursory fashion by approaching each one in relation to the perceptual process. In so doing I have utilized and adapted Harry Broudy's rather mechanical formulation of aesthetic response. We can ask four questions about an art, an artwork, or a work of literature: (1) What is it? (2) How is it put together? (3) How does it stimulate the senses? (4) What does it mean? The first three of these questions are more cognitively directed and are well suited to study. They constitute a workable approach that provides a thread of consistency and a comfortable springboard for a beginner. However, like any categorical device, the approach is not foolproof. In some cases, the formula does not fit comfortably and I am guilty of bending corners. Moreover, some elements of some arts defy categorization, overlapping categories or seeming to fall equally into two. Some, by convention, imply a second category because of the first. In addition, there is always a danger in a work such as this that the necessary brevity can create its own form of inaccuracy. Definitions of terms are by no means universally agreed upon. Also, the choice of what to include and what to exclude must be arbitrary. This is especially true of the materials in Part II. In organizing each chapter in Part II, I have let the nature of the material suggest its own internal structure, using style to determine order. In all cases I have tried to keep the focus of the discussion on artworks. However, this section is *not* a history of the arts or culture; rather, it is a revelation or suggestion of how reality has been expressed by humankind in art—in its various media—across the centuries and around the world. To accomplish this aim I have included artworks from cultures outside the "Western

tradition." This raises some fundamental questions about the need to include such material, the usefulness of such material for prospective buyers of the text, and the balance of treatment between Western and non-Western material. I hope that whatever your point of view, you will understand that textbooks, by their very nature, are reactive, not pioneering. A textbook today can forge only toward ground which encompasses the needs of those who will use it. Nonetheless, however timid my attempt may be, I am convinced that at least some steps must be taken to show our students that human beings can see reality in various ways and yet still have significant, fundamental concerns that do not differ much from ours, and that parochialism does not stand up well in today's global world.

However, how does one organize multicultural materials into a multidisciplinary text? I have opted to keep the traditions separate. I have also opted to devote less space to non-Western subjects. I recognize that some will criticize my approach as tokenist. Others will argue that if I am truly committed to viewing the arts as global, then I should integrate rather than separate. Both criticisms have some validity. Nonetheless, one must start somewhere. Our surveys of humanities programs indicate that, although many instructors see the study of non-Western cultures as "the coming thing," most do not cover, and feel uncomfortable in their expertise concerning, non-Western cultures. My inclusion of a small amount of African and Eastern materials is a way of saying, "here is material which, if you do not wish to use it, will not make the rest of the book unusable. If you do wish to use non-Western materials, these, despite their organization and/or substance, constitute more than you might find elsewhere. Finally, if you are ambivalent, the presence of this material might be tempting enough to make you give it a try." Having returned from a visit to China only a few months before the massacre in Tiananmen Square, perhaps I feel this globality more than some, and certainly more than I used to. Whatever, intuitively, if not cognitively, the issue seems important.

Basic to this discussion is a belief that teachers of arts-survey courses should assist students to view the arts as reflections of the human condition. A work of art is a view of the universe, a search for reality, revealed in a particular medium and shared with others. Men and women similar to ourselves have struggled to understand the universe, as we do, and often, though separated by centuries or cultures, their concerns and questions, as reflected in their artworks, were alike. In the same vein, artworks from separate eras may appear similar even though the historical context is different. Sometimes the medium of expression required technological advancement, which delayed the revelation of a viewpoint more readily expressed in another medium. Sometimes disparate styles sprang from the same historical context. We need to be aware of similarities and differences in artworks and to try to understand why they occurred. We may even need to learn that we did not invent a certain style or form. Through such efforts we gain a more enriched relationship with our own existence.

Therefore, I trust that you who read this text will go beyond its facts and struggle with the potential meanings of the artworks included. Ask questions about what the artist may have been trying to accomplish and seek to understand how you relate to these creative expressions in terms of your perception of reality.

One further observation is implicit. Artworks affect us in the present tense. Hard-edged abstraction cannot invalidate our personal response to realism. Whatever the current vogue, the art of the past can stimulate meaningful contemporary responses to life and to the ideas of other humans who tried or try to deal with life and death and the cosmos. Nonetheless, discussing dance, music, painting, sculpture, drama, film, and architecture falls far short of the marvelous satisfaction to be gained by experiencing them. Black-and-white and even colour reproductions cannot stimulate the range of responses possible from the artwork itself. No reproduction can approximate the scale and mystery of a Gothic cathedral or capture the glittering translucence of a mosaic or a stained-glass window. No text can transmit the power of the live drama or the strains of a symphony. One can only hope that the pages that follow will open a door or two and perhaps stimulate the reader to experience the intense satisfaction of interacting with actual works of art, of whatever era or culture.

Finally, it should be obvious that a work such as this does not spring entirely from the general knowledge or primary source research of its author. Some of it does, because of my long-term and close affiliation with the various arts disciplines. Much is the result of notes accumulated here and there, of travel around the world, and of research specifically directed to this project. However, in the interest of readability and in recognition of the generalized purpose of this text, copious footnoting has been avoided. I hope that the method I have chosen for presentation and documentation of others' works meets the needs of both responsibility and practicality. The Bibliography gives a comprehensive list of works used.

D.J.S.

INTRODUCTION

This book is a story about us. It is a story about our perceptions of the world as we, humankind, have come to see it, both cognitively and intuitively, to respond to it, and to communicate our understandings of it to our fellow human beings. We have been doing this as part of our being human since the great Ice Age more than 35,000 years ago. We have not developed into our humanity since then. Our human characteristics of "being human" have been with us from the earliest times. Certainly we have learned, in a cognitive way, more about our world and how it functions. We have changed our patterns of existence and interdependence. But we have not changed our humanness. As archeological and anthropological evidence has been synthesized over the last 100 years, we have come to see that the fundamental characteristic of what makes us human—that is, our ability to intuit and to symbolize—has been with us from our beginnings. Our art tells us this in terms which are inescapable. So a story of humankind's ventures is our story.

Try as we may in these modern times to escape from the suggestions of our right cerebral hemisphere to the absolutes of the left brain—that is, the cognitive—we cannot escape the fact that we can and do know and communicate at an affective or intuitive level. The mistake of insisting only on cognitive knowing and development may already have robbed us of something of our capacity for being human.

THE HUMANITIES & THE ARTS

In our passion for categorizing we have sometimes tried to gather the more humanizing elements of our civilization into a vague general area called the humanities. There is no sharp boundary separating these aspects of life from the sciences, technology, and the social sciences. Still, the curiosity to know the secrets of the natural universe, or to know how something works, or even how people behave en masse, is motivated by a perceptibly different spirit than the one that drives a human being to try to comprehend humankind. In the traditions of formal scholarship—that is to say, in the way universities divide these things—the humanities are thought of as philosophy, literature, the fine arts, and (sometimes) history. But these very often simply constitute a convenient administrative unit . . . The humanities (if the term is to have a meaning beyond taxonomy) are marked by a point of view rather than by the names of certain disciplines. It is the point of view that wants to know what humanity is about, what kinds of creatures we are, and how we got to be this way. Are we civilized? What are our hopes and fears? What do we think about and dream about? What do we believe? How do we behave?

11

The answers to such questions lie in the millions of artworks that the human race has left strewn about the planet, from the caves of Lascaux and Altamira to the fleeting images of the latest film festival. The artworks are themselves expressions of the humanities, not—as they are so often presented—merely illustrations of literature or history.

Any definition of a work of art . . . is destined to be inadequate for some people. For me, a work of art is some sight, sound, or movement (or combination)—some sensible manifestation—intended as human expression. This is obviously not a value-laden definition aimed at placing a work of art on a pedestal. It accepts as an artwork whatever is intended as an artwork, whether it is a childish effort or a renowned masterpiece. As an expression each artwork carries within itself some evidence of that seeking that characterizes the human condition. Its banality or profundity, its innocence or sophistication, its light-heartedness or solemnity are descriptive, not restrictive qualities.

There are styles and fads in art forms, but unlike advances in technology and the sciences, a new form in the arts never really replaces an old one. Obviously not all styles and forms can survive indefinitely, but a Picasso cannot do to a Rembrandt what an Einstein did to a Newton, nor can the serialism of Schoenberg banish the tonality of Mozart as the evolutionary evidence of Darwin banished the eighteenth-century world of William Paley. The arts, even more than literature, survive by direct impact, and continue to swell the evergrowing reservoir of human manifestations. Times and customs change, the passions that shaped the artist's work disappear, his cherished beliefs become fables, but all of these are preserved in the form of his work. "All the assertions get disproved sooner or later," Bernard Shaw observed, "and so we find the world full of a magnificent debris of artistic fossils, with the matter-of-fact credibility gone clean out of them, but the form still splendid." No doubt one can often read much history or biography in the arts, and no doubt, too, a knowledge of history or of an artist's life can often enhance a work of art, but the response to an artwork is always in the present tense.

The arts are always a system of relationships, a careful, tenuous equilibrium between one thing and another—so much so that it has often occurred to me that almost any substantive question one can ask of a work of art must be answered initially with "That depends . . ." What should be its size? its complexity? its focal point? its relationship to nature? to society? to the artist? Multiply these questions to infinity, and ask them of any artwork, from an acknowledged masterpiece to a student work in progress. For an answer we must first discover the relationships, both within the work itself and outside itself. "It depends . . ."

Such a relativistic approach to the arts cannot result in giving every artwork a good or bad label, extolling one as a masterpiece and condemning another as a fraud. An enormous amount of nonsense is generated by such questions as "Is it really art?" or "Will it live?" A more proper question would always be, "What can we get out of it at this moment?" If the work engenders some response, there is little point in arguing whether it is art. Nor is it profitable to concern ourselves too much with the possible response of our grandchildren. History has provided us with no reliable pattern for the survival of art. Moreover, the number of variables involved in forming the taste of our posterity is nearly infinite. If we cannot know what kind of world they will be living in (if indeed the race survives) or what kind of pressures or passions will be driving them, surely we cannot pick their art for them. We cannot even be assured that the great masters, as we judge them, will continue to nourish them. It seems unlikely that Shakespeare, Rembrandt, or Beethoven might one day be passé, but we shall not be alive to defend them.

. . . We should be wiser, I believe, to think of the arts more as we think of people. We learn, most of us, at a very early age that an adequate adjustment to the world cannot be made from social responses that simply divide the "good people" from the "bad people." We have learned to be skeptical even of such categories as "the people I like" and "the people I don't like." If we do maintain such divisions, we find individuals constantly moving from one group to the other. Eventually we find human differences too subtle for easy classification, and the web of our relationships becomes too complex for analysis. And we try to move toward more and more sensitive discrimination, so that there are those we can learn from, those we can work with, those good for an evening of light talk, those we can depend on for a little affection, and so on—with perhaps those very few with whom we can sustain a deepening relationship for an entire lifetime. When we have learned this same sensitivity and adjustment to works of art—when we have gone beyond the easy categories of the textbooks and have learned to regard our art relationships as part of our own growth—then we shall have achieved a dimension in living that is as deep and as irreplaceable as friendship.[1]

THINGS COGNITIVE & AFFECTIVE

Language and communication come in many forms. Most familiar to us is the language of the written and spoken word and the signs and symbols of science and mathematics. In addition there exists the language of sound—that is, music—and the language of gesture, which we could call dance, although gesture or body language often occurs in circumstances extrinsic to dance. Nonverbal modes of communication comprise significant and meaningful avenues for our understanding of the world around us. In coming to grips with the variety of means of communication we have available to us, we often separate these not only into verbal and nonverbal categories but also into cognitive and affective realms. The term cognitive connotes generally those things which are factual and objective; affective connotes feelings, intuition, and emotions. Each of these areas—that is, the cognitive and the affective—comprises separate ways of coming to understand or to know, as well as ways of communicating, and appears to be directly related to activities of either the left or right cerebral hemispheres. Roger Sperry, among others, has shown that:

The left and right hemispheres of the brain are each found to have their own specialized form of intellect. The left is highly verbal and mathematical, and performs with analytic, symbolic, and computer-like sequential logic. The right, by contrast, is spatial, mute, and performs with a synthetic, spatioperceptual and mechanical kind of information processing not yet simulatable in computers.[2]

What Sperry's work tells us is that there is a scientific basis for our assumptions that we can know and communicate through affective experiences, which do not conform to verbal, mathematical, or sequential cognitive systems.

Finally, let us consider one further, related concept. That is the concept of aesthetic knowledge—the total experience surrounding our involvement with a work of art and/or its creation. Aesthetic knowledge stems from a unique synthesis of affective and cognitive, of emotive and intellectual skills that deal with the relationships between colors, images, sounds, forms, and movements. As we move through the material ahead of us in this textbook, we need to keep in mind that the facts and descriptions presented here comprise only the beginnings of an experience with our cultural heritage. We really must go beyond these facts and try to discern meaning. In the classroom that task will require discussion and some help on the part of the instructor. For those reading this book for pleasure, it will entail some additional reading.

LIVING WITH THE ARTS

The difficulty that many individuals have in approaching the arts and literature is caused mostly by their lack of familiarity. That unfamiliarity, perhaps, has been fostered by those individuals, both within the disciplines and outside them, who have tried to make the arts and literature elitist enterprises and the art gallery, museum, concert hall, theatre, and opera house sanctimonious institutions open only to the thoroughly knowledgeable and the truly sophisticated. Nothing could be further from the truth. As has been suggested by the title of this section, the arts, or things aesthetic, are elements of life with which we can and must deal and to which we must respond in our ordinary, everyday situations. We live with the arts because the principles of aesthetics permeate our existence. Specifically, the aesthetic experience is a way of knowing and communicating in and of itself, separate from other ways of knowing and communicating. It forms a significant part of our being human.

We also need to understand that the arts, aesthetics, and *design* play an important role in making the world around us a more interesting and habitable place. When domestic, physical objects are developed, essentially they are developed from a design which usually takes into consideration practical matters such as purpose and convention. The term *convention* is one that will be used repeatedly in this text, and it suits our purposes well to begin to discuss it here. A convention is a set of rules or mutually accepted circumstances. For example, that all of our electrical appliances have a standard male connector that we can be relatively assured fits every wall socket in every building in the United States of America is a convention. It is a practical convention to which those who have traveled abroad can testify. In England appliances are sold without connectors because the diversity of wall outlets in that small country is so great that it is impractical for manufacturers to sell appliances with a connector. A more appropriate example of a convention might be the keyboard and tuning of a piano. In any case, from these two examples we can imagine clearly the role that conventions play in practical and other circumstances.

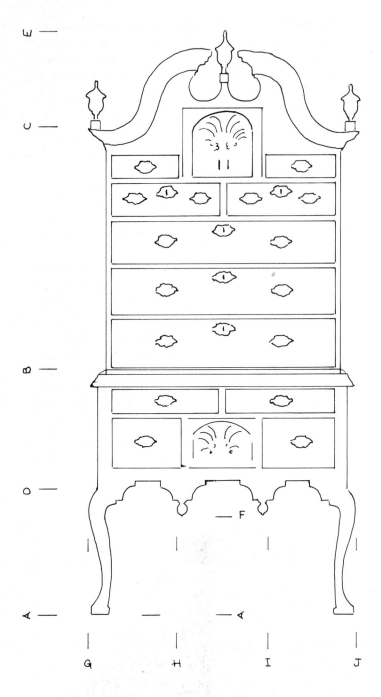

0.1 Scale drawing of an eighteenth-century highboy.

To apply the concepts of design and convention to items that have both practical and aesthetic components, examine Figure **0.1**, a scale drawing of an eighteenth-century highboy. The high chest was conceived to fill a practical purpose—to provide for storage of household objects in an easily accessible, yet hidden, place. However, while designing an object to accommodate that practical need, the cabinetmakers felt the additional need to provide an interesting and attractive object. Our experience of this piece of furniture can be enlightening and challenging if we use discrimination and imagination in our perception of its design.

First of all, the design is controlled by a convention that dictates a consistent height for tables and desks. So the lower portion of the chest, from point A to point B, designs space within a height that will harmonize with other furniture in the room. If we look carefully, we also can see that the parts of the chest are designed with a sophisticated and interesting series of proportional and progressive relationships. The distance from A to B is twice the distance from A to D and is equal to the distance from B to C. The distances from A to F and C to E bear no recognizable relationship to the previous dimensions but are, however, equal to each other and to the distances from G to H, H to I, and I to J. In addition, the size of the drawers in the upper chest decreases at an even and proportional rate from bottom to top. This discussion indicates some of the design factors in this piece of furniture and helps to illustrate the role that design plays in the world around us. The more we realize what there is to see and hear, aesthetically, the greater will be our potential for enhanced and exciting responses to that world.

A further example might be the design of the Volkswagen shown in Figure **0.2**. Here repetition of form reflects a concern for unity, one of the fundamental characteristics of art. The design of the early Volkswagen used strong repetition of the oval. We need only to look at the front and rear of the "Bug" to see variation on this theme as applied in the windows, motor-compartment hood, and bumpers. Later models of the Volkswagen differ from this version and reflect the intrusion of conventions, again, into the world of design. As safety standards called for larger bumpers, the oval design of the motor-compartment hood was flattened in order that a larger bumper could clear it. The rear window was enlarged and squared to accommodate the need for increased rear vision. The intrusion of these conventions changed the design of the Beetle by breaking down the strong unity of the original composition.

Finally, as Edwin J. Delattre states when he compares the purpose for studying technical subjects to the purpose for studying the humanities or the arts:

When a person studies the mechanics of internal combustion engines the intended result is that he should be better able to understand, design, build, or repair such engines, and sometimes he should be better able to find employment because of his skills, and thus better his life . . . When a person studies the humanities [the arts] the intended result is that he should be better able to understand, design, build, or repair a life—for living is a vocation we have in common despite our differences.

The humanities provide us with opportunities to become more capable in thought, judgment, communication, appreciation, and action.[3]

Delattre goes on to say that these provisions enable us to think more rigorously and to imagine more abundantly. "These activities free us to possibilities that are new, at least to us, and they unbind us from portions of our ignorance about living well . . . Without exposure to the cultural . . . traditions that are our heritage, we are excluded from a common world that crosses generations."[4]

The poet Archibald MacLeish is more succinct: "Without the Arts, how can the university teach the Truth."

The information in this text helps us understand the elements that comprise works of art, which we can respond to and which trigger that system of symbols belonging to the affective experience. The arts allow us to bridge cognitive and affective experiences, to bridge left- and right-brain activities. It is with this fundamental information that we begin our journey.

AESTHETIC PERCEPTION AND RESPONSE

The nature of the arts, artists, and their relationship to reality are complex issues. The question of how we go about approaching them, or how we study them, is nearly as difficult. A myriad of methods is available, and so it remains to choose one, for better or for worse, and carry on from there. So, a method of study must be chosen that can act as a springboard into the arts and literature, as a point of departure from the realm of the familiar into the unknown. Inasmuch as we live in a world of facts and figures, weights and measures, it seems logical to begin our study by dealing with some characteristics that lend themselves to the kind of study with which we are

0.2 Volkswagen Beetle, 1938. Courtesy of Volkswagen of America.

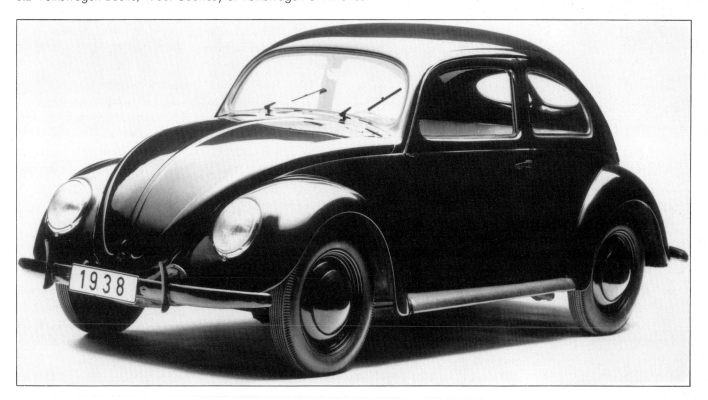

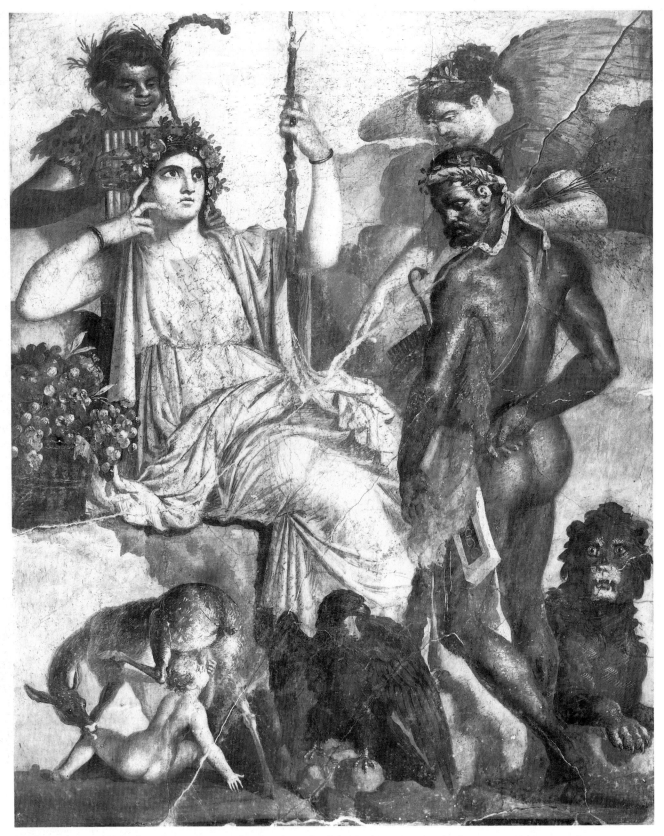

0.3 Hercules and Telephos, Roman copy of a Greek work of the 2nd century BC. Wall paintings from Herculaneum, height 5ft 7½ins (1.71 m) high. Museo Archeologico Nationale, Naples.

familiar. In other words, from a mostly cognitive point of view: what devices and media do artists use as they seek to reveal reality?

It will be extremely helpful in our examination in Part I to utilize a method that allows for consistency of observation as we pass from one art discipline to another. We will be asking three of the questions already mentioned: (1) What is it? (2) How is it put together? (3) How does it stimulate the senses? We will study these questions in the general context of each of the art disciplines. As we will see, these are also the basic questions we can ask of an individual artwork.

When we respond to the question *What is it?* we make a formal response. We recognize that we are perceiving the design of two-dimensional space in a picture (Fig. 0.3), three-dimensional space in a sculpture or the shelter of a piece of architecture, or perhaps the design of time in sound, or of time and space in dance. We also recognize the "form" of the item—for example, a still life, a human figure, a tragedy, a ballet, a concerto, a narrative film, a park or a residence. It should be noted, however, that the term "form" is a broad one: It can be used as just noted, as noted earlier, or in other ways. There are art forms, forms of arts, and forms in art.

When we respond to the question *How is it put together?* we respond to the technical elements of the design. We recognize and respond, for instance, to the fact that the picture has been done in oil, made by a printmaking technique, or created as a watercolor. We also recognize and respond to the elements that constitute the work, the item of composition—line, form or shape, mass, color, repetition, harmony, and the unity that results from all of these. What devices have been employed, and how does each part relate to the others to make a whole? A concerto is composed of melody, harmony, timbre, tone, and more; a tragedy utilizes language, *mise en scène*, exposition, complication, denouement; a ballet has formalized movement, *mise en scène*, line, idea content, and so on.

Moving to the third question, we examine *how the work stimulates the senses*—and why. In other words, how do the particular formal and technical arrangements (whether conscious or unconscious on the part of the artist) elicit a sense response from us? Here we deal with both physical and mental properties, and affective and cognitive response. Our response to sculpture, for example, can be physical. We can touch a piece of sculpture and sense its smoothness or its hardness (Fig. 0.4). Mentally, we experience sense responses that stem from what one, for want of a better term, calls the "universal language." When we respond to items composed of

upright triangles we grant them the qualities of solidity. When we perceive the colors green and blue we denote them as "cool;" reds and yellows are "warm" colors. Pictures that are predominantly horizontal or composed of broad curves are said to be "soft" or placid. Angular, diagonal, or short, broken lines are said to stimulate a sense of movement. Music which utilizes undulating melodic contours can be "smooth;" that which is highly consonant can be "warm" or "rich." These and other sense responses tend to be universal; most individuals respond in similar fashion to them.

We can then go on to ask the fourth of the questions mentioned earlier: *What does the work mean?* For example, if we deal with a painting, we know it is a painting; we know it is a seascape. We also know it has been done in oil with a particular palette. We know how the artist has utilized line and mass, and how he or she has affected balance. In addition, we respond to how all those items stimulate the senses. For example, the artist may have utilized predominantly harsh, broken lines that incite a feeling of movement or spontaneity. We know that the artist has used very intense, saturated colors that give the work a dynamic quality. However, for us *personally*, the seascape and the way it is put together may stimulate pleasantly romantic sensations. The causes of this response are strictly internal and subjective. Perhaps at

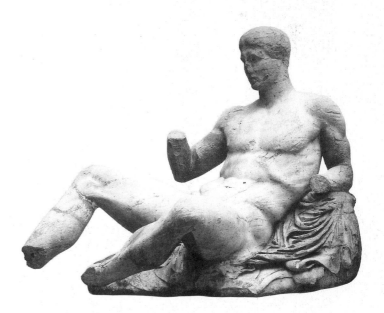

0.4 Dionysus (Herakles?) from the east pediment of the Parthenon, c. 438–432 BC. Marble, over life-size. The British Museum, London.

one time in our life we had a romantic encounter on a beach with someone for whom we cared very much.

However, we cannot dismiss the question *What does it mean?* as a reference to purely personal experience. Meaning in a work of art implies a certain level of communication from artist to respondent through the style of work, as we will examine in Part II. A work of art, including literature, is a way of looking at the universe and revealing reality. So, the ultimate response, meaning, and experience of an artwork goes beyond the merely personal to encompass an attempt to understand what the communicator may have had in mind. It is not sufficient, for example, merely to regard the disproportionate forms of a Mannerist painting as "strange." *Meaning* implies an understanding of the circumstances that effected that "strangeness." When we understand that, we may understand *why* the paintings of that period appear as they do. We may also sympathize with the agonies of individuals trying to cope with their universe. As a result, the "strangeness" of the artwork may come to mean something entirely different to us personally. Sometimes "meaning" in an artwork can be enhanced by understanding cultural or historical contexts, including biography. Sometimes artworks spring from purely aesthetic necessity. Sometimes it is difficult to know which case applies or if both cases apply.

PART ONE

The Media of the Arts

WHAT ARTISTS USE TO EXPRESS "REALITY "

ONE

PAINTING, PRINTMAKING, & PHOTOGRAPHY

WHAT IS IT?

Paintings, photographs, and prints are pictures, differing primarily in the technique of their execution. They constitute aesthetic communication through the design of two-dimensional space. Our initial level of response to all three is to subject matter. A picture might be a landscape, seascape, portrait, religious picture, nonobjective (nonrepresentational) or abstract picture, still life, or something else. So this level of our response is a rather simple and straightforward matter of observation, although subject matter can be a significant factor in the meaning of a work.

HOW IS IT PUT TOGETHER?

MEDIUM

Our technical level of response is more complex. First of all, our response to how a work is put together is to the medium by which the work was executed.

Paintings and Drawings

Paintings and drawings are executed through the use of oils, watercolors, tempera, acrylics, fresco, gouache, ink, pastels, and pencils, to name just a few of the more obvious. An artist may combine these media, and may use some others. Each medium has its own characteristics and to a great extent these dictate what the artist can or cannot achieve as an end result.

Oils are perhaps the most popular of the painting media, and have been since their development around the beginning of the fifteenth century. Their popularity stems principally from the great variety of opportunity they give the painter. Oils offer a tremendous range of color possibilities; they can be reworked; they present many options for textural manipulation; and, above all, perhaps, they are durable. If we compare two oils, van Gogh's *The Starry Night* (Fig. **1**.1) and Giovanni Vanni's *Holy Family with St. John* (Fig. **1**.2), the medium shows its importance to the final effect of the works. Vanni creates light and shade in the baroque tradition, and his chiaroscuro depends upon the capacity of the medium to blend

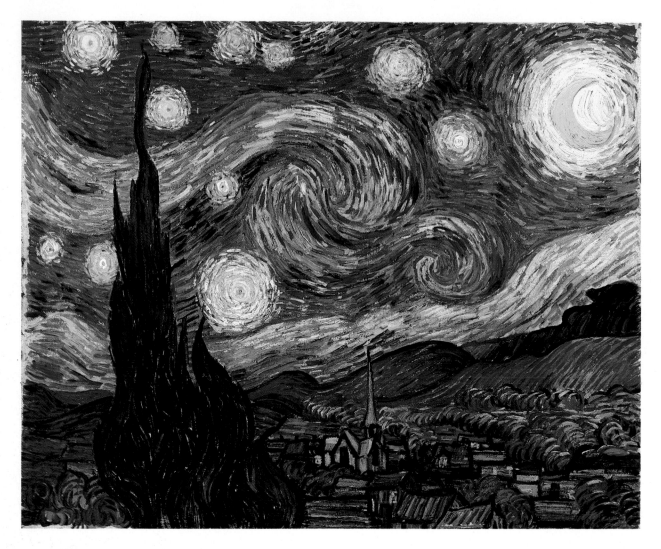

smoothly among color areas. Van Gogh, on the other hand, requires a medium that will stand up to form obvious brushstrokes. Vanni demands the paint to be flesh and cloth. Van Gogh demands the paint to be paint, and to call attention to itself.

Watercolor is a broad category that includes any color medium that uses water as a thinner. However, the term has traditionally referred to a transparent paint usually applied to paper. Since watercolors are transparent, an artist must be very careful to control them. If he or she overlaps one area of color with another, the overlap will show as a third area combining the previous hues. On the other hand, their transparency gives watercolors a delicacy that cannot be produced in any other medium.

Tempera is an opaque, watercolor medium whose use spans recorded history. It was employed by the Ancient Egyptians and is still used today by such familiar painters as Andrew Wyeth. Tempera refers to ground pigments and their color binders such as gum or glue, but is best

1.1 (*above*) Vincent van Gogh, *The Starry Night*, 1889. Oil on canvas, 29 x 36¼ ins (74 x 92 cm). The Museum of Modern Art, New York (acquired through the Lillie P. Bliss Bequest).

1.2 (*right*) Giovanni Battista Vanni, *Holy Family with St. John*. Oil on canvas, 70 x 58 ins (178 x 147 cm). Palmer Museum of Art, the Pennsylvania State University.

known in its egg tempera form. It is a fast-drying medium that virtually eliminates brushstroke and gives extremely sharp and precise detail. Colors in tempera paintings appear almost gemlike in their clarity and brilliance.

Acrylics, in contrast with tempera, are modern, synthetic products. Most acrylics are water-soluble (that is, they dissolve in water), and the binding agent for the pigment is an acrylic polymer. Acrylics are flexible media, offering the artist a wide range of possibilities both in color and technique. An acrylic paint can be either opaque

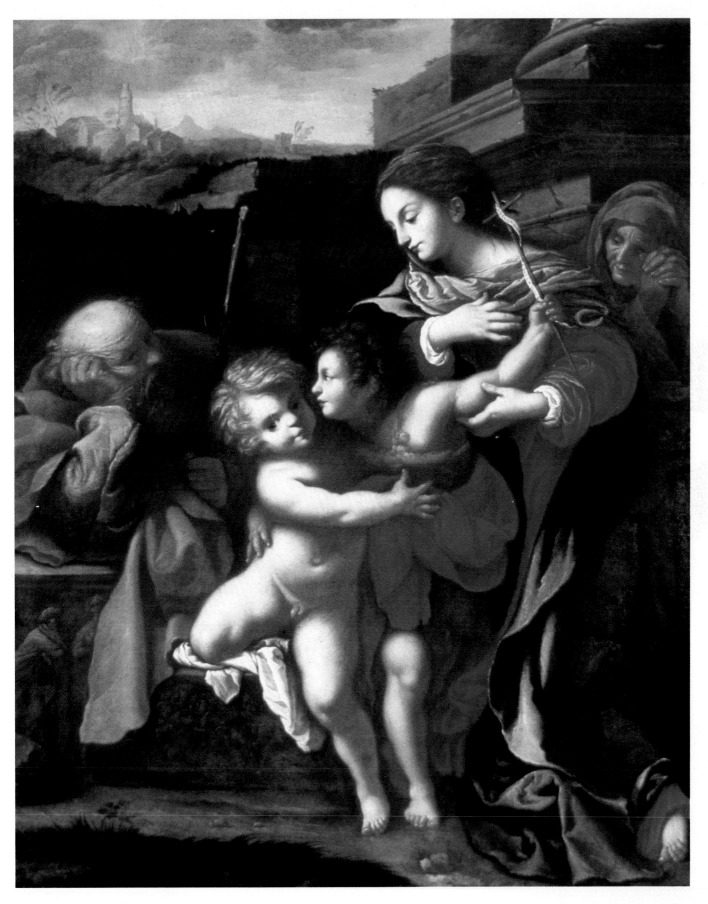

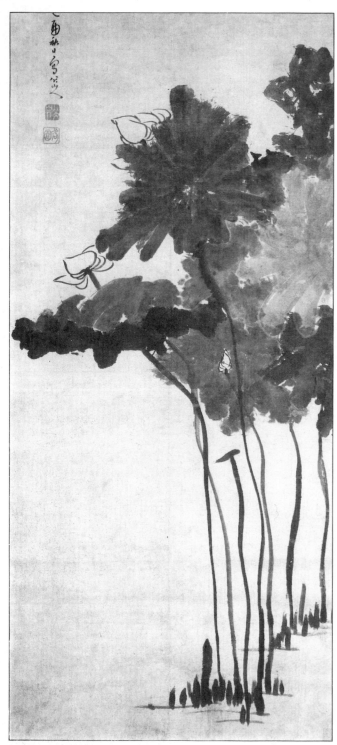

1.3 Chu Ta (Pata-shan-jen), *Lotus*, 1705. Brush and ink, 6½ x 28 ins (17 x 71 cm). Palmer Museum of Art, the Pennsylvania State University.

or transparent, depending upon dilution. It is fast-drying, thin, and resistant to cracking under temperature and humidity extremes. It is perhaps less permanent than some other media but adheres to a wider variety of surfaces. It will not darken or yellow with age, as does oil, and dries more rapidly than oil.

Fresco is a wall-painting technique in which pigments suspended in water are applied to fresh, wet plaster. Michelangelo's Sistine Chapel frescoes are, of course, the best-known examples of this technique. Since the end result becomes part *of* the plaster wall rather than being painted *on* it, fresco provides a long-lasting work. However, it is an extremely difficult process, and once the pigments are applied, no changes can be made without replastering the entire section of the wall.

Gouache is watercolor medium in which gum is added to ground opaque colors mixed with water. Transparent watercolors can be made into gouache by adding Chinese white to them. Chinese white is a special white, opaque, water-soluble paint. The final product, in contrast to watercolor, is opaque.

Ink as a painting medium has many of the same characteristics as transparent watercolor. It is difficult to control, yet its effects are nearly impossible to achieve in any other medium. Because it must be worked quickly and freely, it has a spontaneous and appealing quality (Fig. **1.3**).

Drawing media such as ink, when applied with a pen (as opposed to a brush), pastels (crayon or chalk), and pencils all create their effect through build-up of line. Each has its own characteristics, but all are relatively inflexible in their handling of color and color areas (Fig. **1.4**).

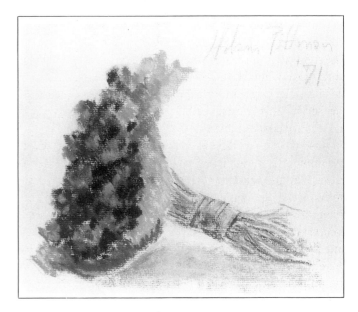

1.4 Hobson Pittman, *Violets No. 1*, 1971. Pastel, 9½ x 10¼ ins (24 x 26 cm). The Museum of Art, the Pennsylvania State University.

Prints

Prints fall generally into three main categories, based essentially on the nature of the printing surface. First is relief printing, such as woodcut, wood engraving, linoleum cut, and collograph. Second is intaglio, including etching, aquatint, drypoint, and again, collograph. Third is the planographic process, which includes lithography, serigraphy (silkscreen), and other forms of stencilling. In addition, other combinations and somewhat amorphous processes such as monoprinting are also used by printmakers. Because the printmaker's techniques are unfamiliar to most of us, we need to spend some time in further explanation.

To begin with, however, we need to ask, *What is a print?* A print is a hand-produced picture that has been transferred from a printing surface to a piece of paper. The artist personally prepares the printing surface and directs the printing process. Each step in the production of a print is accomplished by hand. In some cases a press is used, as we shall see, but it is always operated by hand. The uniqueness and value of a print lie in the fact that the block or surface from which the print is made is usually destroyed after the desired number of prints has been made. In contrast, a *reproduction* is not an original. It is a *copy* of an original painting or other artwork, reproduced usually by a photographic process. As a copy, the reproduction does not bear the handiwork of the artist.

We also need to note that on every print there is a number. On some prints the number may appear as a fraction—for example, "36/100." The denominator indicates how many prints were produced from the plate or block. This number is called the *issue number*, or *edition number*. The numerator indicates where in the series the individual print was produced. If only a single number appears, such as "500," it simply indicates the total number of prints in the series; this is also called the issue number. Printmakers are now eliminating the former kind of numbering because there is a misconception that the relationship of the numerator to the issue total has a bearing on a print's value. The numerator is an item of curiosity only; it has nothing to do with a print's value, monetarily or qualitatively. The issue number does have some value in comparing, for example, an issue of 25 with one of 500, and is usually reflected in the price of a print. However, the edition number is not the sole factor in determining the value of a print. The quality of the print and the reputation of the artist are more important considerations.

In *relief printing*, the image is transferred to the paper by cutting away nonimage areas and inking the surface that remains. Therefore, the image protrudes, in relief, from the block or plate and produces a picture that is reversed from the image carved by the artist. This reversal is a characteristic of all printmaking media. *Woodcuts* and *wood engravings* are two popular techniques. A woodcut, one of the oldest techniques, is cut into the plank of the grain; a wood engraving is cut into the butt of the grain (Fig. **1.5**). Figure **1.6** illustrates the linear essence of the woodcut and shows the precision and delicacy possible in this medium in the hands of a master.

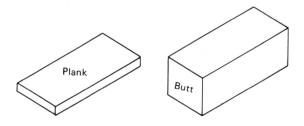

1.5 Wood plank and butt.

1.6 Albrecht Dürer, *Lamentation*, c. 1497–1500. Woodcut, 15½ x 11¼ ins (39 x 29 cm). The Museum of Art, the Pennsylvania State University (gift of the Friends of the Museum of Art).

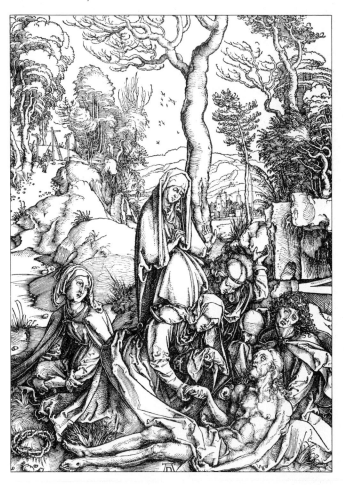

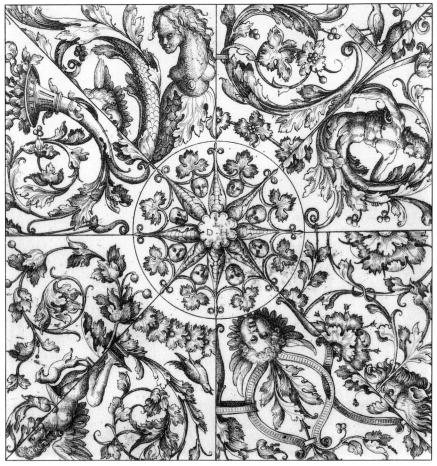

1.7 Daniel Hopfer, *Ceiling Ornament*. Etching, 10 x 8¾ ins (25 x 22 cm). The Museum of Art, the Pennsylvania State University.

The *collograph* is a new printmaking process in which assorted objects are glued to a board or plate. A collograph would represent relief printing when the raised surfaces are inked and printed. When the recessed areas are inked and printed, the collograph becomes an intaglio work.

The *intaglio* process is the opposite of relief printing. The ink is transferred to the paper not from raised areas but rather from grooves cut into a metal plate. *Line engraving*, *etching*, *drypoint*, and *aquatint* are some of the methods of intaglio.

Line engraving involves cutting grooves into the metal plate with special sharp tools. It requires great muscular control because the pressure must be continuous and constant if the grooves are to produce the desired image. The print resulting from the line-engraving process is very sharp and precise. This form of intaglio is the most difficult and demanding on the artist.

Etchings are less demanding. In this process the artist removes the surface of the plate by exposing it to an acid bath. First the plate is covered with a thin waxlike sub-stance called a *ground*. Then the artist scratches away the ground to produce the desired lines. The plate is then immersed in the acid, which burns away the exposed areas of the plate. The longer a plate is left in the acid, the deeper the resulting etches will be; the deeper the etch, the darker the final image. So, artists wishing to produce lines or areas of differing darkness must cover those lines that they do not desire to be more deeply cut before further immersions in the acid. They can accomplish this task easily. The desired number of repetitions of the process yields a plate that will produce a print with the desired differences in light and dark lines. All the details of Figure **1.7** consist of individual lines, either single or in combination. The lighter lines required less time in the acid than the darker ones. Because of the precision and clarity of the lines, it would be difficult to determine, without knowing in advance, whether this print is an etching or an engraving. Drypoint, on the other hand, produces lines with less sharp edges.

Drypoint is a technique in which the surface of the metal plate is scratched with a needle. Unlike line engraving, which gives a clean, sharp line, the drypoint technique leaves a ridge on either side of the groove. The resulting line is somewhat fuzzy.

Once the plate is prepared, whether by line engraving, etching, aquatint, drypoint, or a combination of methods, the artist is ready for the printing process. The plate is placed in a press and a special dampened paper is laid over it. Padding is placed on the paper and then a roller is passed over it, forcing the plate and the paper together with great pressure. The ink, which has been carefully applied to the plate and left only in the grooves, is transferred as the paper is forced into the grooves by the roller of the press. Even if no ink had been applied to the plate, the paper would still receive an image. This *embossing* effect is the mark of an intaglio process; the three-dimensional *platemark* is very obvious.

The intaglio methods noted thus far consist of various means of cutting lines into a metal plate. On occasion an artist may wish to create large areas of subdued tonality. Such shadowlike areas cannot be produced effectively with lines. Therefore, the artist dusts the plate with a resin substance, heats it, which fixes the resin, and puts it into the acid bath. The result is a plate whose surface is rough in texture, like sandpaper, and a print whose tonal areas reflect that texture. This is called aquatint.

In a *planographic process*, the artist prints from a plane surface (neither relief nor intaglio). *Lithography* (the term's literal meaning is "stone writing") is based on the principle that water and grease do not mix. To create a lithograph, artists begin with a stone, usually limestone, and grind one side until it is absolutely smooth. They then draw an image on the stone with a greasy substance. The darkness of the final image can be varied by the amount of grease used: The more grease applied, the darker the image will be. After the image has been drawn the artist treats the stone with gum arabic and nitric acid and then rinses it with water. This bath fixes the greasy areas to the surface of the stone. When the artist rinses the stone and fans it dry, the surface is clean! However, the water, gum, and acid have impressed the grease on the stone, and when the stone is wetted it absorbs water (limestone being porous) only in those areas that were not previously greased. Finally, a grease-based ink is applied to the stone. It, in turn, will not adhere to the water-soaked areas. As a result the stone, with ink adhering only to the areas on which the artist has drawn, can be placed in a press and the image transferred to the waiting paper. In Figures **1.8** and **1.9** we can see the characteristic most attributable to the medium

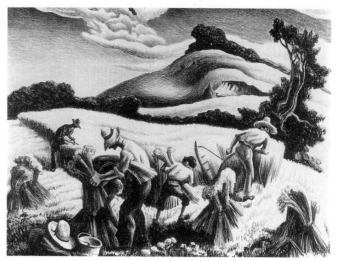

1.8 Thomas Hart Benton, *Cradling Wheat*, 1938. Lithograph, 9½ x 12 ins (24 x 30 cm). Palmer Museum of Art, the Pennsylvania State University (gift of Carolyn Wose Hull).

1.9 Charles Sheeler, *Delmonico Building*, 1925. Lithograph, 10 x 7⅛ ins (25 x 18 cm). Palmer Museum of Art, the Pennsylvania State University.

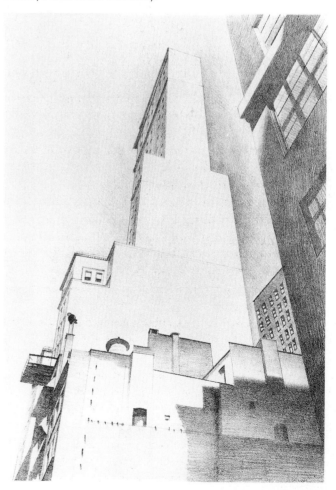

of lithography—a crayon-drawing appearance. Since the lithographer usually draws with a crayonlike material on the stone, the final print has exactly that quality.

The *serigraphic* process (serigraphy) or silkscreening is the most common of the stencilling processes. Silkscreens are made from a wooden frame covered with a finely meshed silk fabric. The non-image areas are blocked out with a glue mixture painted directly on the silk fabric or blocked out by a cut-paper stencil. The stencil is placed in the frame and ink is applied. By means of a rubber instrument called a squeegee, the ink is forced through the openings of the stencil, through the screen, and onto the paper below. This technique allows the printmaker to achieve large, flat, uniform areas. We can see this smooth uniformity of areas in Figure **1.10**. Here the artist has, through successive applications of ink, built up a complex composition with highly lifelike detail.

Various prints reflect recognizable differences in tech-

nique. Again, it is not always possible to discern the technique used in executing a print, and some prints reflect a combination of techniques. However, in seeking the method of execution, we add another layer of potential response to a work.

Photography

In some cases photography is not really an art at all; it is merely a matter of personal record executed with equipment of varying degrees of expense and sophistication. Certainly, photography as a matter of pictorial record, or even as photojournalism, may lack the qualities we believe are requisite to art. A photograph of a baseball player sliding into second base or of Aunt Mable cooking hamburgers at the family reunion may trigger expressive responses for us, but it is doubtful that the photographers had aesthetic communication or particular design in mind

1.10 Nancy McIntyre, *Barbershop Mirror*, 1976. Silkscreen, 26½ x 19 ins (67 x 48 cm). Palmer Museum of Art, the Pennsylvania State University.

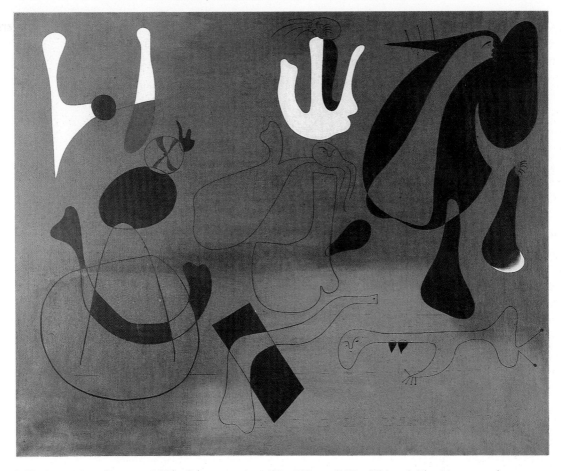

1.11 Joan Miró, *Painting*, 1933. Oil on canvas, 68½ x 77¼ ins (174 x 196 cm). The Museum of Modern Art, New York (gift of the Advisory Committee, by exchange).

when they snapped the shutter. On the other hand, a carefully composed and sensitively designed and executed photograph can contain every attribute of human expression possible in any art form.

Ansel Adams saw the photographer as an interpretative artist; he likened the photographic negative to the musical score, and the print to a performance. In other words, despite all the choices the artist may make in committing an image to film, they are only the beginning of the artistic process. The photographer still has the choice of *size*, *texture* and *value contrast or tonality*. A photo of the grain of a piece of wood, for example, has an enormous range of aesthetic possibilities depending upon how the artist employs and combines these three elements.

Consequently, the question "Is it art?" may have a cogent application to photography. However, the quality of our aesthetic repayment from the photographic experience is higher if we view photography in the same way as we do the other arts — as a visualization of reality manifested through a technique and resulting in an aesthetic response or communication.

COMPOSITION

Our discussions of how any artwork is put together eventually result in a discussion of how it is composed. The elements and principles of composition are basic to all the arts, and we shall return to them time and time again as we proceed.

Elements

The basic building block of a visual design is *line*. To most of us a line is a thin mark such as this: ——————. We find that denotation in art as well. In Figure **1.11** we find amorphous shapes. Some of these shapes are like cartoon figures — that is, they are identifiable from the background because of their outline. In these instances line identifies form and illustrates the first sentence of this paragraph. However, the other shapes in Figure **1.11** also exemplify line. These shapes appear black or white against the background. If we put our finger on the edge of these shapes, we have identified a second aspect of line — the boundary between areas of color and between shapes or forms.

29

There is one further aspect of line, which is implied rather than physical. The three rectangles in Figure **1.12** create a horizontal "line" that extends across the design. There is no physical line between the tops of the forms, but their spatial arrangement creates one by implication. A similar use of line occurs in Figure **1.1**, where we can see a definite linear movement from the upper left border through a series of swirls to the right border. That "line" is quite clear although it is composed not of a form edge or outline but of a carefully developed relationship of numerous color areas. This treatment of line is also seen in Figure **1.13**, although here it is much more subtle and sophisticated. By dripping paint onto his canvas (a task not as easily executed, simplistic, or accidental as it might appear) the artist was able to subordinate form, in the sense of recognizable and distinct areas, and thereby focal areas, to a dynamic network of complex lines. The effect of this technique of execution has a very strong relationship to the actual force and speed with which the pigment was applied.

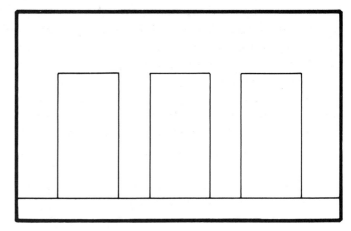

1.12 Outline and implied line.

Line is used by an artist to control our vision, to create unity and emotional value, and ultimately to develop meaning. In pursuing those ends, and by employing the three aspects of line noted earlier, the artist finds that line has one of two characteristics: It is curved or it is straight.

1.13 Jackson Pollock, *One* (Number 31, 1950), 1950. Oil and enamel paint on canvas, 8 ft 10 ins x 17 ft 5⅝ ins (2.69 x 5.32 m). The Museum of Modern Art, New York (the Sidney and Harriet Janis Collection Fund, by exchange).

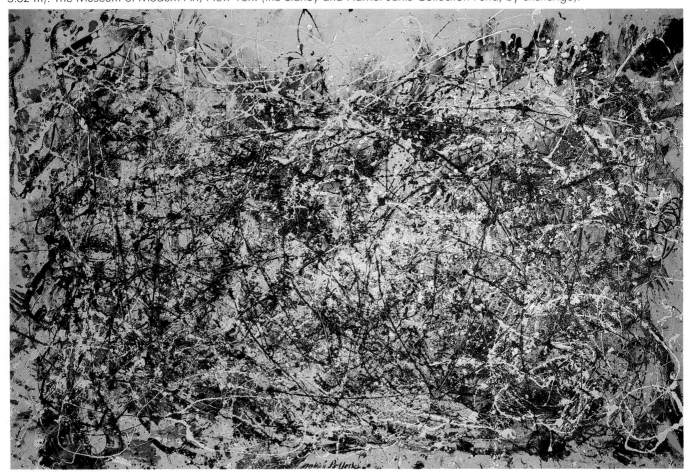

Whether it is expressed as an outline, as an area edge, or by implication, and whether it is simple or in combination, a line is some derivative of the characteristics of straightness or curvedness. It is interesting to speculate, as some do, on whether line can also be thick or thin. Certainly that quality is helpful in describing some works of art. Those who deny line that quality, however, have a point difficult to refute when they ask, If line can be thick or thin, at what point does it cease to be a line and become a form?

As we will discover, and will have to reiterate, definitions can be problematic. We, of course, are attempting to deal with the perception of artworks by noting what we can look for and what we call it. But we must remember that while this approach is important, all the terms it employs are highly related and serve only to make it more convenient for us to talk about an artwork. More important than complete agreement on definitions is the ability to apply the concepts they represent to the artwork. How has the artist used line? Does it make his composition active or passive? Are her forms sharp or fuzzy? Is the photograph in focus or not?

Form and *line* are closely related both in definition and in effect. Form is the shape of an object within the composition, and shape often is used as a synonym for form. Literally, form is that space described by line. A building is a form. So is a tree. We perceive them as buildings or trees, and we also perceive their individual details because of the line by which they are composed; form cannot be separated from line in two-dimensional design.

Color is a complex phenomenon, and no less than three theories exist as to its nature. It is not important for our purposes to understand these theories or how they differ. But knowing they exist helps us understand why some sources use different terms to describe the same color characteristics and other sources use the same terms to describe different characteristics. Although the treatment that follows may not be entirely satisfactory to those who learned color theory from one or another of these sources, I think it is a fair way to introduce color to those whose knowledge of color terminology is for response and communication rather than for creation of an artwork.

To begin, color characteristics differ depending upon whether we are discussing color in light or color in pigment. For example, in light the primary hues (those hues that cannot be achieved by mixing other hues) are red, green, and blue; in pigment they are red, yellow, and blue. If we mix equal proportions of yellow and blue pigments we will have green. Since green can be achieved by mixing, it cannot be a primary—in pigment. However, no matter how hard we try, we cannot mix any hues that will achieve green light. Inasmuch as our response to artworks most often deals with colored pigment, the discussion that follows concerns color in pigment. We will not discuss color in light.

Hue is the spectrum notation of color; a hue is a specific pure color with a measurable wavelength. The visible range of the color spectrum extends from violet on one end to red on the other. The color spectrum consists of the three primaries—blue, yellow, and red—and three additional hues that are direct derivatives of them—green, orange, and violet. These six hues are the basic hues of the spectrum, and each has a specific, measurable wavelength (Fig. **1.14**). In all there are (depending upon which theory one follows) from ten to twenty-four perceivably different hues, including these six. These perceptible hues are the composite hues of the color spectrum.

For the sake of clarity and illustration, let us assume that there are twelve basic hues. Arranged in a series, they would look like Figure **1.15**. However, since combina-

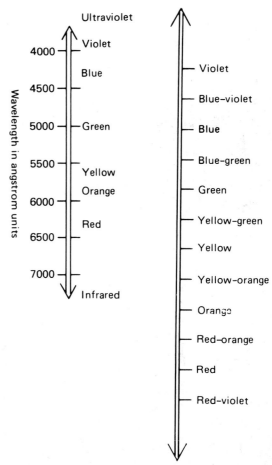

1.14 (*left*) Basic color spectrum.
1.15 (*right*) Color spectrum, including composite hues.

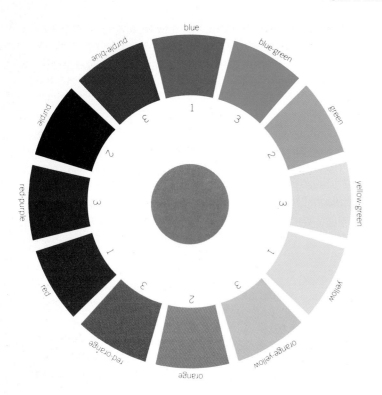

1.16 Color wheel.

The application of the effects of value on color is treated in different ways by different sources. Providing an overview is difficult. However, it appears most helpful if we approach the subject less from a theoretical point of view and more from a practical one—that is, what can painters do to change color in order to create a painting that gives the effect they desire? As we indicated, they may mix primaries to create secondary and tertiary hues. They thereby change hue. Every hue has its own value—that is, in its "pure" state each hue falls somewhere on the value scale in Figure **1.18**. An artist may change the value of a hue by *raising* or *lowering* it.

In practical terms the application of this concept causes different sources to travel different roads. How does one change a hue to a different value on the value scale? Many authorities propose that value is changed by adding white or black. White raises value; black lowers it. However, the actual mixing of paints to achieve different values is not quite that simple. For example, if we take primary red,

tions of these hues are possible beyond the straight-line configuration of the spectrum, it is helpful to visualize color by turning the color spectrum into a color wheel (Fig. **1.16**). With this visualization we now can discuss what an artist can do to and with color. First, an artist can take the primary hues of the spectrum, mix them two at a time in varying proportions, and create the other hues of the spectrum. For example, red and yellow in equal proportions make orange, a *secondary* hue. Varying the proportions—adding more red or more yellow—makes yellow-orange or red-orange, which are *tertiary* hues. Yellow and blue make green, and also blue-green and yellow-green; red and blue give us violet, blue-violet, and red-violet. Hues directly opposite each other on the color wheel are *complementary*. When they are mixed together in equal proportions, they produce gray (see the discussion of intensity, p. 33). First, therefore, an artist can vary hue.

In discussing photography, we noted in passing the concept of *value contrast*—the relationship of blacks to whites and grays. The range of possibilities from black to white forms the *value scale*, which has black at one end, white at the other, and medium gray in the middle. The perceivable tones between black and white are designated light or dark (Fig. **1.17**).

	White				W	
	High Light				HL	Yellow
	Light	Yellow-green			L	Yellow-orange
	Medium Light	Green			ML	Orange
	Medium (grey)	Blue-green			M	Red-orange
	High dark	Blue			MD	Red
	Dark	Blue-violet			D	Red-violet
	Low dark	Violet			LD	
	Black				B	

1.17 (*left*) Value scale.
1.18 (*right*) Color-value equivalents.

whose value is medium dark, and add various amounts of pure white, the changes that occur are perceivably different from the changes that occur when medium gray, medium-light gray, light gray, and high-light gray are added to the same pure red. Identical ranges of color do not result from the two processes. Let's take it from another direction. Suppose we wish to create a gray-pink color for our painting. We take primary red and add white. The result is pink. To subdue the pink, we add just a bit of black. What we have just done seems impossible, because we have both raised and lowered the value of our original red—at the same time. Of course, it is not impossible at all. We have merely raised our red to a lighter value by adding light gray (black and white).

There is a broad range of color possibilities between high-light gray and pure white, or between a pure hue and white, which does not fall on the traditional value scale. That range of possibilities is described by the term *saturation*. A saturated hue is a pure hue. An unsaturated hue is a hue to which some quantity of white alone has been added. Unsaturated hues, such as pink, are known as *tints*. What is not entirely clear is whether saturation is part of or separate from value—that is, whether the two terms should be considered as separate properties of color change or whether value includes saturation. More on this in a moment.

We can easily see that some colors are brighter than others. As we noted, the perceivable difference in brightness between primary yellow and primary blue is due to their difference in value. However, it is possible to have a *bright* yellow and a *dull* yellow. The difference in brightness between the two may be a matter of value, as we just observed—a pure yellow versus a grayed yellow. It may also be a matter of surface *brilliance*, or reflectance, a factor of considerable importance to all visual artists. A highly reflective surface creates a brighter color, and therefore a different response from the observer, than does a surface of lesser reflection, although all other color factors may be the same. This is the difference between high-gloss, semigloss, and flat paints, for example. Probably surface reflectance is more a property of texture than of color. However, the term brilliance is often used to describe not only surface gloss but also characteristics synonymous with value. Some sources also use brilliance as a synonym for saturation, while still others use saturation as a synonym for an additional color-change possibility, *intensity*.

Intensity is the degree of purity of a hue. It also is sometimes called *chroma*. Returning to the color wheel (Fig. **1.16**), we note that movement around the wheel creates a change in hue. Movement across the wheel creates a change in intensity. If we add green to red we alter its intensity. When, as in this case, hues are directly opposite each other on the color wheel such mixing has the practical effect of *graying* the original hue. Therefore, since graying a hue is a *value* change, one occasionally finds intensity and value used interchangeably. Some sources use the terms independently but state that changing a color's value automatically changes its intensity. It is well to ponder the implications of these concepts. There is a difference between graying a hue by using its complement and graying a hue by adding black (or gray derived from black and white). A gray derived from complementaries, because it has color, is far livelier than a gray derived from black and white, which are not colors.

All this discussion and divergence may be academic, but it illustrates the problem of attempting to describe complex phenomena.

The point to be made here is not that definitions are illogical, hopeless, or incomprehensible, but rather that one can use proper descriptive terminology as an aid to understanding what is happening in a work of art. If one is aware of divergences in theory and usage regarding a given term, responses can be phrased in such a way or in such a context as to make one's own observations even clearer. Some individuals will never admit to the viability of someone else's usage if it in any way differs from their own. But divergences are not necessarily matters of correct or incorrect. Often they are simply attempts to describe the indescribable so as to promote a clearer interchange of understanding and experience. The difficulties I have noted regarding color terminology essentially stem from differences in theory and the application of theory to practice. Attempts to create color wheels, three-dimensional color models, and all-inclusive terminology are our attempts to explain a marvelously complex natural phenomenon—color perception—that is still not comprehended in its entirety.

The composite, or overall, use of color by the artist is termed *palette*. An artist's palette can be broad, restricted, or somewhere in between, depending upon whether the artist has utilized the full range of the color spectrum and/or whether he or she explores the full range of *tonalities*—brights and dulls, lights and darks.

As to *mass* (space), only three-dimensional objects have mass—that is, take up space and have density. However, two-dimensional objects give the illusion of mass, *relative* only to the other objects in the picture.

Then there is the *texture* of a picture—that is, its apparent roughness or smoothness. Texture ranges from

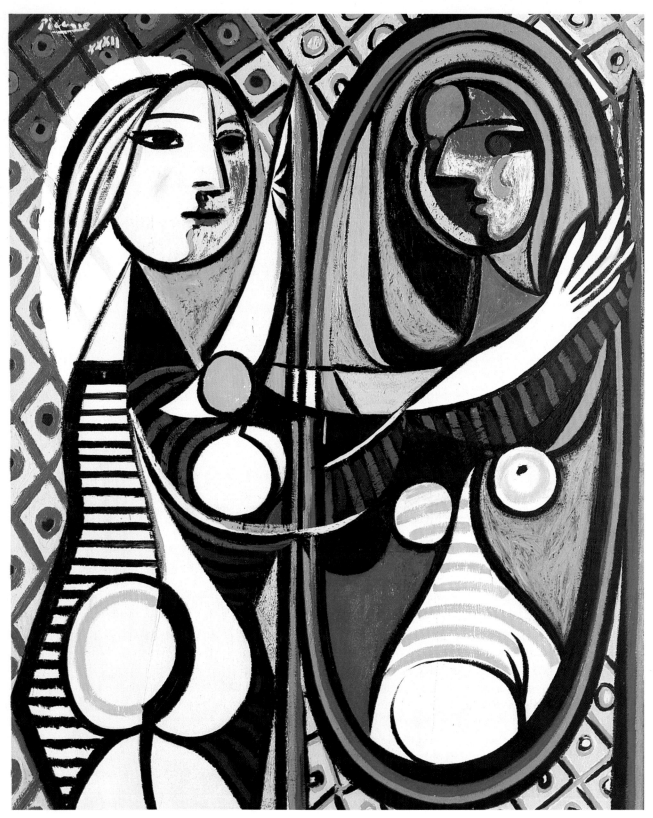

1.20 Pablo Picasso, *Girl before a Mirror*, Boisgeloup, March 1932. Oil on canvas, 64 x 51¼ ins (162.3 x 130.2 cm). The Museum of Modern Art, New York (gift of Mrs. Simon Guggenheim).

the smoothness of a glossy photo to the three-dimensionality of *impasto*, a painting technique wherein pigment is applied thickly with a palette knife to raise areas from the canvas. The texture of a picture may be anywhere within these two extremes. Texture may be illusory in that the surface of a picture may be absolutely flat but the image gives the impression of three-dimensionality. So the term can be applied to the pictorial arts either literally or figuratively.

Principles

Probably the essence of any design is *repetition*: how the basic elements in the picture are repeated or alternated. In discussing repetition let's consider three terms: rhythm, harmony, and variation.

Rhythm is the ordered recurrence of elements in a composition. Recurrence may be regular or irregular. If the relationships among elements are equal, the rhythm is regular (Fig. **1.12**). If not, the rhythm is irregular. However, one must examine the composition as a whole to discern if patterns of relationships exist and whether or not the patterns are regular, as they are in Figure **1.19**.

Harmony is the logic of the repetition. Harmonious relationships are those whose components appear to join naturally and comfortably. If the artist employs forms, colors, or other elements that appear incongruous, illogical, or "out of sync" with each other, then we would use a musical term and say the resulting picture is dissonant; its constituents simply do not go together in the way our cultural conditioning would describe as natural. However, we need to understand here, as we note later with music, that ideas and ideals relative to harmonious relationships in color or other elements often reflect cultural conditioning or arbitrary understandings.

Variation is the relationship of repeated items to each other; it is similar to theme and variation in music. How does an artist take a basic element in the composition and use it again with slight or major changes? The artist of Figure **1.20** has taken two geometric forms, the diamond and the oval, and created a complex painting via repetition. The diamond with a circle at its center is repeated over and over to form the background. Variation occurs in the color given to these shapes. Similarly, the oval of the mirror is repeated with variations in the composition of the girl. The circular motif also is repeated throughout the painting, with variations in color and size—similar to those in the design of the Volkswagen noted in Figure **0.2**.

The concept of *balance* is very important. It is not difficult to look at a composition and almost intuitively respond that it does or does not appear balanced. Most individuals have this "second sense." However, *how* artists achieve balance in their pictures is the object of our concern.

The most mechanical method of achieving balance is *symmetry*, or, specifically, bilateral symmetry, the balancing of like forms, mass, and colors on opposite sides of the vertical axis of the picture (Figs. **1.21** and **1.22**). Symmetry is so precise that we can measure it. Pictures employing absolute symmetry tend to be stable, stolid, and without much sense of motion. They are also, probably for that very reason, quite rare. Many works approach symmetry, but nearly all retreat from placing mirror images on opposite sides of the centerline.

1.19 Repetition of patterns.

1.21 Closed composition (composition kept within the frame).

1.22 Open composition (composition allowed to escape the frame).

Asymmetrical balance is achieved by careful placement of unlike items. It is sometimes referred to as psychological balance (Fig. **1.23**). It might seem that asymmetrical balance is a matter of opinion. However, intrinsic response to what is balanced or unbalanced is relatively uniform among individuals, regardless of their aesthetic training. Every painting illustrated in this chapter is asymmetrical. Comparative discussion as to *how* balance has been achieved would be a useful exercise, especially if colors were to be considered. Often color is used to balance line and form. Since some hues, such as yellow, have a great attraction for the eye, they can balance tremendous mass and activity on one side of a painting by being placed on the other side.

With a few exceptions, we can say that artists strive for a sense of self-contained completeness in their artworks. That is to say that an important characteristic in a work of art is the means by which *unity* is achieved. All of the elements of composition work together to provide us with a picture that "hangs together" to work toward meaning. Often compositional elements are juxtaposed in unusual or uncustomary fashion to achieve a particular effect. Nonetheless that effect usually comprises a conscious attempt at maintaining or completing a unified statement —that is, the total picture. Every element we have discussed in this section may be utilized in such a manner that it works with all the other elements to give us a picture that is unified. Our discussion of how an artist has employed compositional devices is not complete until we discern how the composition works as a totality.

1.24 (*right*) St. Mark from the Gospel Book of St. Médard of Soissons, France, early 9th century. Paint on vellum, 14⅜ x 10¼ ins (37 x 26 cm). Bibliothèque Nationale, Paris.

1.23 St. Mark and St. Luke from the Gospel Book of Godescale, 781–3. Vellum, 12¼ x 8¼ ins (31 x 21 cm). Bibliothèque Nationale, Paris.

37

...g. For example, painting in the ...is predominantly kept within the frame. ...illustrates a concern for the self-containment of the artwork and for precise structuring. On the other hand, baroque design tends to force the eye to escape the frame. Here the device has philosophical intent, suggesting the world or universe outside or the individual's place in an overwhelming cosmos. So, unity can be achieved by keeping the composition closed, but it is not necessarily lacking when the opposite state exists.

When we look at a picture for the first time, our eye moves around it, pausing briefly at those areas that seem to be of greatest visual appeal. These are *focal areas*. A painting may have a single focal area to which our eye is drawn immediately, and from which it will stray only with conscious effort. Or it may have an infinite number of focal points. We describe a picture of the latter type as "busy"—that is, the eye bounces at will from one point to another on the picture, without any attraction at all.

Focal areas are achieved in a number of ways—through confluence of line, by encirclement (Fig. 1.24), or by color, to name just a few. To draw attention to a particular point in the picture the artist may make all lines lead to that point. He or she may place the focal object or area in the center of a ring of objects, or give the object a color that demands our attention more than the other colors in the picture. Again, for example, bright yellows attract our eye more readily than dark blues. The artist uses focal areas, of whatever number or variety, as a control over what we see and when we see it when we glance at a picture for the first time.

OTHER FACTORS

Perspective

Perspective is a tool by which the artist indicates the spatial relationships of objects in a picture. It is based on the perceptual phenomenon which causes objects further away from us to appear smaller. If we examine a painting that has some degree of verisimilitude, we can identify, objects the positioning does not appear rational. So their composition strikes us as being rather primitive or mystical.

Two types of perspective may be used. The first, *linear* perspective, is characterized by the phenomenon of standing on railroad tracks and watching the two rails apparently come together at the horizon. It uses *line* to achieve the sense of distance. In Figure **1.25** the road recedes from foreground to background and becomes narrower as it does so. We perceive that recession, which denotes distance, through the artist's use of line.

The second, *aerial* perspective, indicates distance through the use of light and atmosphere. For example, mountains in the background of a picture are made to appear distant by being painted in less detail; they are "hazy." In the upper left of Figure **1.2** a castle appears at a great distance. We know it is distant because it is smaller and, more important, because it is indistinct.

Subject Matter

We can regard treatment of subject matter as ranging from verisimilitude, or representationalism, to nonobjectivity (Fig. **1.26**). We will use this continuum again in later chapters, substituting the term *theatricality* for nonobjectivity. Between the two ends of this continuum are many of the "-isms" we all are familiar with in the art world: realism, impressionism, expressionism, cubism, fauvism, and so forth. Each suggests a particular method of treatment of subject matter.

Chiaroscuro

Chiaroscuro (sometimes called *modeling*), whose meaning in Italian is "light and shade," is the device used by artists to make their forms appear *plastic*—that is, three-dimensional. The problem of making two-dimensional objects appear three-dimensional depends on the artist's ability to render highlight and shadow effectively. Without them all forms are two-dimensional in appearance.

Use of chiaroscuro gives a picture much of its character. For example, the dynamic and dramatic treatment of light

1.25 Jean-Baptiste-Camille Corot, *A View Near Volterra*, 1838. Oil on canvas, 27⅜ x 37½ ins (70 x 95 cm). The National Gallery of Art, Washington, DC (Chester Dale Collection).

1.26 Subject-matter continuum.

and shade in Figure **1.27** gives this painting a quality quite different from what would have resulted had the artist chosen to give full, flat, front light to the face. The highlights, falling as they do, create not only a dramatic effect but also a compositional triangle extending from shoulder to cheek, down to the hand, and then across the sleeve and back to the shoulder. Consider the substantial change in character had highlight and shadow been executed in a different manner. Finally, the treatment of chiaroscuro in a highly verisimilar fashion in Figure **1.28** helps give that painting its strangely real yet dreamlike appearance.

In contrast, works that do not employ chiaroscuro have a two-dimensional quality.

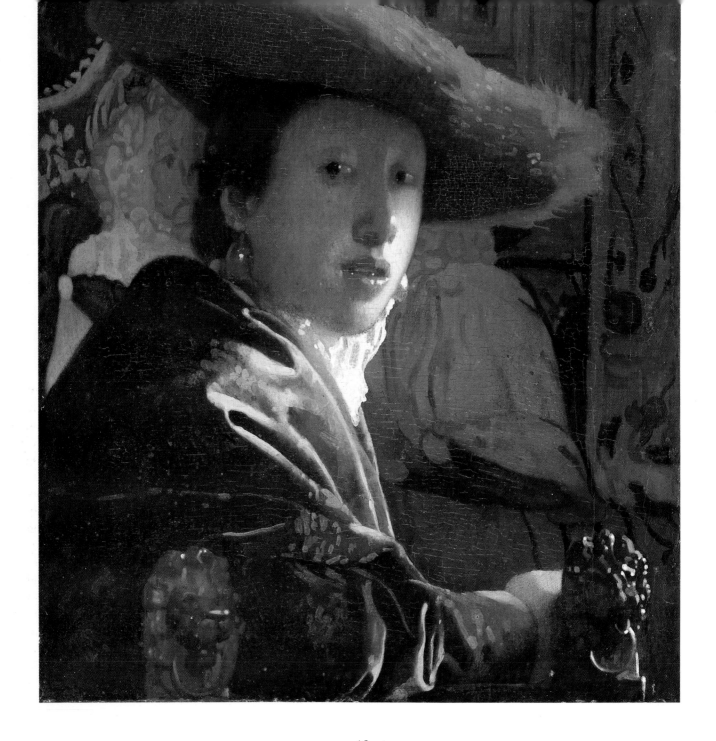

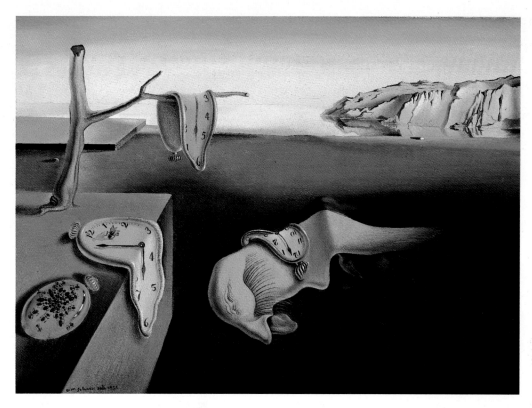

1.28 Salvadore Dali, *The Persistence of Memory*, 1931. Oil on canvas, 9½ x 13 ins (24 x 33 cm). The Museum of Modern Art, New York (given anonymously).

HOW DOES IT STIMULATE THE SENSES?

Our discussion of the ways in which pictures stimulate our senses must be in terms of non-tactile images. We do not touch pictures, and so we cannot feel their roughness or their smoothness, their coolness or their warmth. We cannot hear pictures and we cannot smell them. So, when we conclude that a picture affects our senses in a particular way, we are responding in terms of visual stimuli that are transposed into mental images of our senses of touch, taste, sound, and so forth.

1.27 Jan Vermeer, *The Girl with a Red Hat*, c. 1665. Oil on wood, 9⅛ x 7⅛ ins (23 x 18 cm). The National Gallery of Art, Washington, DC (Andrew W. Mellon Collection, 1937).

COLOR

The colors of an artist's palette are referred to as warm or cool depending upon which end of the color spectrum they fall. Reds, oranges, and yellows are said to be warm colors. Those are the colors of the sun and therefore call to mind our primary source of heat. So they carry strong implications of warmth. Colors falling on the opposite end of the spectrum—blues and greens—are cool colors because they imply shade, or lack of light and warmth. Here we have, as we will notice frequently, a stimulation that is mental but has a physical basis. Tonality and color contrast also affect our senses. The stark value contrasts of Figure **1.29** contribute significantly to the harsh and dynamic qualities of the work. The barren colorlessness of this monochromatic black, white, and gray work completes its horrifying comment on the tragic bombing of the Spanish city of Guernica. In the opposite vein, the soft, yet dramatic, tonal contrasts of Figure **1.27** and the strong warmth and soft texture of the red hat bring us a completely different set of stimuli.

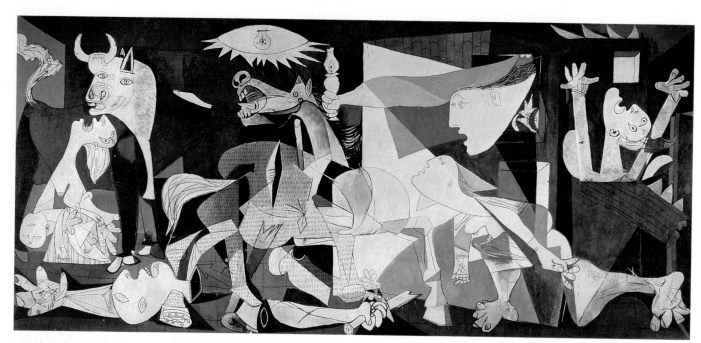

1.29 Pablo Picasso, *Guernica*, 1937. Oil on canvas, 11 ft 5½ ins x 25 ft 5¾ins (3.49 x 7.76 m). Copyright ARS NY SPADEM, 1988.

CHIAROSCURO

Many of the sense-affecting stimuli work in concert and cannot be separated from each other. We already have noted some of the effects of chiaroscuro, but one more will serve well. One of the most interesting effects to observe in a picture is the treatment of flesh. Some flesh is treated harshly and appears like stone. Other flesh appears soft and true to life. Our response to whatever treatment has been given is very tactile—we want to touch, or we believe we know what we would feel if we touched. Chiaroscuro is essential if an artist is to achieve those effects. Harsh shadows and strong contrasts create one set of responses; diffused shadows and subdued contrasts create another. Figure **1.30** presents us with softly modeled flesh whose warmth and softness come from color and chiaroscuro. Highlight and shadow function to create softness, and predominantly red hues warm the composition; our sensual response is heightened dramatically.

1.30 Sir Peter Paul Rubens, *Rape of the Daughters of Leucippus*, c. 1616–17. Canvas, 87½ x 82¼ ins (222 x 209 cm). Alte Pinakothek, Munich.

DYNAMICS

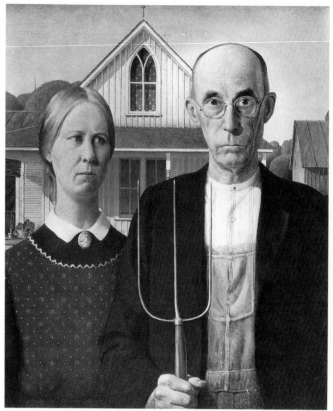

1.32 Grant Wood, *American Gothic*, 1930. Oil on beaver board, 30 x 25 ins (76 x 63 cm). Friends of American Art Collection. Photograph © 1990. The Art Institute of Chicago. All rights reserved.

Pictures, although they are static (they do not move), can effectively stimulate a sense of movement and activity. They can also create a sense of stable solidity. The artist stimulates these sensations by using certain conventional devices. Composition that is principally vertical can express, for example, a sense of dignity and grandeur (Figs. 1.31 and 1.32). A picture that is horizontal can elicit a sense of stability and placidity. The triangle, which

1.31 Giorgio de Chirico, *Nostalgia of the Infinite*, c. 1913–14, dated on the painting 1911. Oil on canvas, 53¼ x 25½ ins (135 x 65 cm). The Museum of Modern Art, New York (purchase).

1.33 Upright-triangular composition.

is a most interesting form in engineering because of its structural qualities, is also interesting in art because of its psychological qualities. If we place a triangle so that its base forms the bottom of a picture, we give the respondent a definite sense of solidarity and immovability (Fig. **1.33**). If that triangle were a pyramid sitting on a level plane, a great deal of effort would be required to tip it over. However, if we invert the triangle so that it balances on its apex, a sensation of instability and action results (Figs. **1.34** and **1.35**). We can feel clearly the sensations stimulated by these rather simple geometric forms. However, we should not conclude from this discussion that geometric forms used as compositional

1.34 Inverted-triangular composition.

1.35 Giotto, *The Lamentation*, 1305–6. Fresco. 7 ft 7 ins x 6 ft 7½ ins (2.31 x 2.02 m). Arena Chapel, Padua.

1.36 Curved line.

1.37 Broken line.

devices are either explicit or limited in communication to the sensations noted. Nonverbal communication in the arts is not that simple. Nonetheless, the basic compositional devices of works of art do influence our response, and we need to examine their impact on our perceptions.

TROMPE L'OEIL

Trompe l'oeil, or "trick of the eye," gives the artist a varied set of stimuli by which to affect our sensory response. Occasionally this device forms the core of a painting; at other times it is used to enhance a work's appeal. For example, in executing linear perspective, an artist knows that all objects drawn with parallel sides recede to a vanishing point. Some artists make subtle changes in the placement of the vanishing point of various objects in the same work, with the effect that the picture, while appearing verisimilar, gives the impression of rotating forward at the top. Its kinesthetic appeal is thereby much more dynamic.

LINE

The use of line also affects sense response. Figure **1.36** illustrates how this use of curved line can elicit a sense of ease and relaxation. On the other hand, the broken line in Figure **1.37** creates a much more dynamic and violent sensation. We can also feel that the upright triangle in Figure **1.33**, although solid and stable, is more dynamic than a horizontal composition because it uses strong diagonal line, which tends to stimulate a sense of movement.

Precision of linear execution also can create sharply defined forms or soft, fuzzy images. Figure **1.38** finds in straight lines and right angles the basic principles of life itself. Vertical lines signify vitality and life; horizontal lines signify tranquility and death. The intersection of vertical and horizontal line represents life's tensions.

1.38 Piet Mondrian, *Composition in White, Black and Red*, 1936. Oil on canvas, 40¼ x 41 ins (102 x 104 cm). The Museum of Modern Art, New York (gift of the Advisory Committee).

1.39 Juxtaposition.

for our attention. In comparison with the power and sweep of the baroque, Boucher appears gentle and shallow. The intricate formal design of the baroque, in which sophisticated ornateness created smooth articulation of parts, is lost here in intricate and delicate details each of which takes on a separate focus of its own and leads the eye first in one direction and then another, nearly without control.

JUXTAPOSITION

We can also receive sense stimuli from the results of an artist's juxtaposing. Juxtaposing curved and straight lines results in linear disonance or consonance. Figure **1.39** illustrates the juxtaposing of inharmonious forms, which creates stability. Careful use of this device can stimulate some very interesting and specific sense responses.

The metaphysical fantasies of Giorgio de Chirico (1888–1978) have surrealist associations. Works such as *Nostalgia* (Fig. **1.31**) contain no rational explanation for their juxtaposition of strange objects. They have a dreamlike quality, associating objects that are not normally grouped together. Such works are not rational and show a world humankind does not control. In them "there is only what I see with my eyes open, and, even better, closed."

FOCUS

The work of François Boucher (1703–70) in the rococo tradition gives us a taste of the decorative, mundane, and slightly erotic painting popular in the early and mid-eighteenth century. As a protégé of Madame de Pompadour, mistress of King Louis XV, Boucher enjoyed great popularity. His work has a highly decorative surface detail and portrays pastoral and mythological settings such as shown in Figure **1.40**. Boucher's figures almost always appear amid exquisitely detailed drapery. His rendering technique is nearly flawless, and his displays of painterly virtuosity provide fussily pretty works whose main subjects compete with their decorative backgrounds

SUBJECT MATTER

The method of treatment of subject matter, which, of course, involves any or all of the characteristics we have discussed, is a powerful device for effecting both sensory responses and more intense, subjective responses. The relative use of verisimilitude or nonobjectivity seems to be the most noticeable stimulant of individual response. It would seem logical for individuals to respond objectively and intellectually to nonobjective pictures, since the subject matter should be neutral, with no inherent expressive stimuli. However, no other aspect of a picture seems to create so extreme a *subjective* response (especially a negative one) as nonobjectivity. When asked whether they feel more comfortable with the treatment of subject matter in Figure **1.2** or that in Figure **1.13**, most individuals choose the former, even though the latter is a product of our age, our society, our world. Why is this so? Does the contemporary work tell us something about ourselves that we do not wish to hear?

So, our responses may depend on how directly or explicitly the subject matter is communicated.

The Spanish painter and printmaker Francisco de Goya (1746–1828) used his paintings to attack abuses of government both Spanish and French. His highly imaginative and nightmarish works reveal subjective emotionalism in humanity and nature, often at their malevolent worst. Figure **1.41** also tells a story of an actual event. On May 3, 1808 the citizens of Madrid rebelled against the invading army of Napoleon. As a result, individuals were arbitrarily arrested and summarily executed. It is impossible to escape the focal attraction of the man in white,

1.40 François Boucher, *Venus Consoling Love*, 1751. Oil on canvas, 42⅛ x 33⅜ ins (107 x 85 cm). The National Gallery of Art, Washington, DC (Chester Dale Collection).

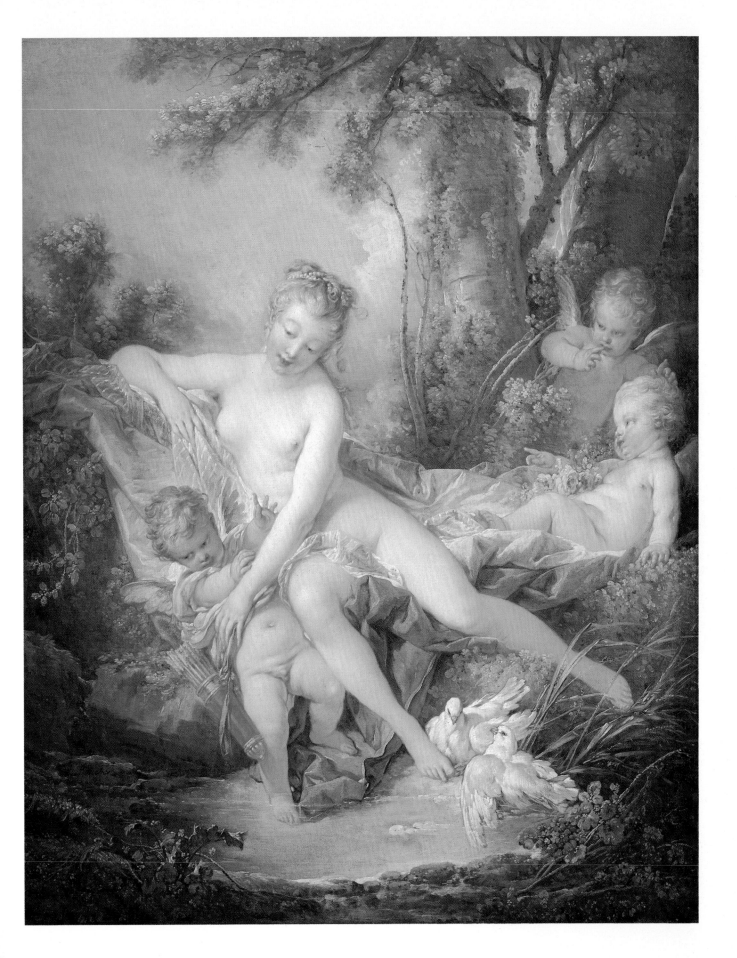

about to die. Goya's strong value contrasts force the eye to the victim; only the lantern behind the soldiers keeps the composition in balance. However, Goya leads us beyond the death of individuals, because these figures are not individuals—they are not realistically depicted.

Does the more explicit appeal cause a more profound response? Or does the stimulation provided by the unfamiliar cause us to think more deeply and respond more fully, since our imagination is left free to wander? The answers to these questions are worth considering as we perceive artworks, many of whose keys to response are not immediately obvious.

1.41 Francisco Goya, *Execution of the Citizens of Madrid, 3 May 1808*, 1814. Oil on canvas, 8 ft 6 ins x 11 ft 4 ins (2.59 x 3.45 m). Prado, Madrid.

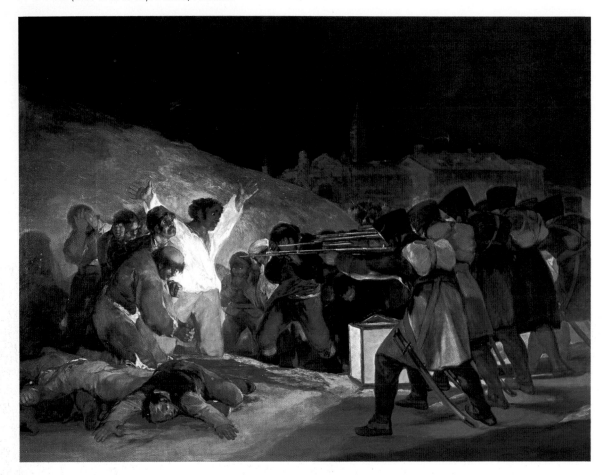

TWO

SCULPTURE

WHAT IS IT?

Sculpture is aesthetic communication through the design of three-dimensional space. It may take the form of whatever it seeks to represent, from pure, or nonobjective form, to lifelike depiction of the human being or any other entity. Sometimes sculpture, because of its three dimensionality, comes very close to reality in its depiction. Duane Hanson and John DeAndrea, for example, use plastics to render the human form so realistically that the viewer must approach the artwork and examine it closely to determine that it is not a real human. Every art form employs some degree of abstraction, and so it is with sculpture.

HOW IS IT PUT TOGETHER?

DIMENSIONALITY

Sculpture may be *full round*, *relief*, or *linear*. Full round works are freestanding and fully three-dimensional (Fig. 2.1). A work that can be viewed from only one side—that is, one that projects from a background—is said to be in

2.1 Roman copy of a Greek statue. The British Museum, London.

2.2 East frieze, Halicarnassus. The British Museum, London.

relief (Fig. **2.2**). A work utilizing linear materials is called linear (Fig. **2.17**). A sculptor's choice of full round, relief, or linearity as a mode of expression dictates to a large extent what he or she can and cannot do, both aesthetically and practically.

Full Round

All sculpture is three dimensional, but we can refine that characteristic further by noting the quality of three dimensionality which adheres to a given work. Sculptural works that explore full three dimensionality and are meant to be viewed from any angle are termed full round (Fig. **2.3**). Some subjects and styles pose certain constraints in this regard, however. Painters, printmakers, and photographers have virtually unlimited choice of subject matter and compositional arrangements. Full round sculptures dealing with such subjects as clouds, oceans, and panoramic landscapes are problematic for the sculptor. Since sculpture occupies real space, the use of perspective, for example, to increase spatial relationships poses certain obvious problems. In addition, since full round sculpture is freestanding and three-dimensional, sculptors must concern themselves with the practicalities of engineering and gravity. They cannot, for example, create a work with great mass at the top unless they can find a way (within the bounds of acceptable composition) to keep the statue from falling over. After we have viewed

2.3 Auguste Rodin, *The Burghers of Calais*, 1866. Bronze, height 82½ ins (209 cm). Hirshhorn Museum and Sculpture Garden, Smithsonian Institution, gift of Joseph H. Hirshhorn, 1966.

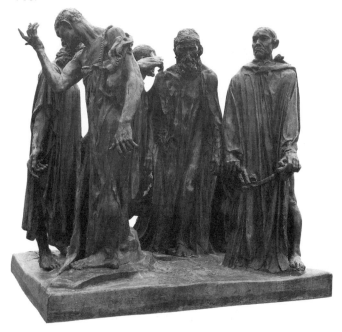

numerous full round works, we begin to note the small animals, branches, tree stumps, rocks, and other devices that have been employed to give practical stability to a work.

Relief

On the other hand, the sculptor who creates a work in relief does not have quite so many restrictions. Since the work is attached to a background, he or she has freer choice of subjects and need not worry about their positions or supports. Clouds, seas, and perspective landscapes are within the relief sculptor's reach, since the work needs to be viewed only from one side. Relief sculpture, then, is three dimensional. However, because it protrudes from a background, it maintains a two-dimensional quality, as compared to full round sculpture.

Linear

The third category of sculpture, linear sculpture, emphasizes construction with linear items such as wire or neon tubing. Artworks using linear materials and occupying three-dimensional space will occasionally puzzle us as we consider or try to decide whether they are really linear or full round. Here again, absolute definition is less important than the process of analysis and aesthetic experience and response.

METHODS OF EXECUTION

In general, we may say that sculpture is executed using additive, subtractive, substitute, or manipulative techniques, or any combination of these. A fifth category, that of found sculpture, may or may not be considered a "method" of execution, as we shall see later.

Subtraction

Carved works are said to be subtractive. That is, the sculptor begins with a large block, usually wood or stone, and cuts away (subtracts) the unwanted material. In previous eras, and to some extent today, sculptors had to work with whatever materials were at hand. Wood carvings emanated from forested regions, soapstone carvings from the Eskimos, and great works of marble from the regions surrounding the quarries of the Mediterranean. Anything that can yield to the carver's tools can be formed into a work of sculpture. However, stone, with its promise of immortality, has proven to be the most popular material.

Three types of rock hold potential for the carver. *Igneous* rocks, of which granite is an example, are very hard and potentially long-lasting. However, they are difficult to carve and are therefore not popular. *Sedimentary* rocks such as limestone are relatively long-lasting, easy to carve, and polishable. Beautifully smooth and lustrous surfaces are possible with sedimentary rocks. *Metamorphic*

rocks, including marble, seem to be the sculptor's ideal. They are long-lasting, are "a pleasure to carve," and exist in a broad range of colors. Whatever the artist's choice, one requirement must be met: The material to be carved, whether wood, stone, or a bar of soap, must be free of flaws.

A sculptor who sets about to carve a work does not begin simply by imagining a *Sampson Slaying a Philistine* (Fig. **2.4**) and then attacking the stone. The first step would be to create a model, usually smaller than the intended sculpture. The model is made of clay, plaster, or wax and is completed in precise detail—a miniature of the final product.

2.4 Giambologna, *Sampson Slaying a Philistine*, c. 1562. Courtesy of the Victoria and Albert Museum, London.

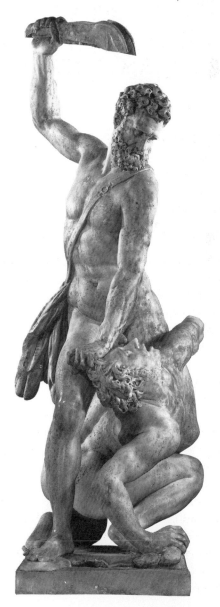

Once the likeness of the model has been enlarged and transferred, the artist begins to rough out the actual image ("knocking away the waste material," as Michelangelo put it). In this stage of the sculpting process, the artist carves to within two or three inches of what is to be the finished area, using specific tools designed for the purpose. Then, using a different set of carving tools, the material is carefully taken down to the precise detail. Finishing work and polishing follow.

Addition

In contrast with carving from a large block of material, the sculptor using an additive process starts with raw material and adds element to element until the work is finished. The term *built sculpture* is often used to describe works executed in an additive technique. The materials employed in this process can be plastics, metals such as aluminium or steel, terra cottas (clay), epoxy resins, or wood. Many times materials are combined (Fig. **2.5**). It is not uncommon for sculptors to combine methods as well. For example, built sections of metal or plastic may be combined with carved sections of stone.

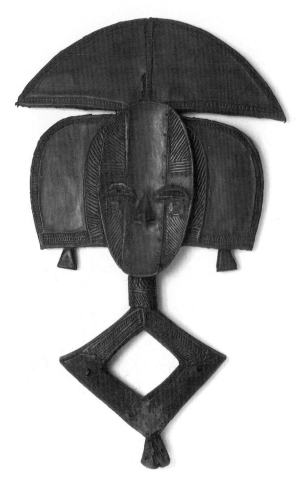

2.5 (*above*) Bakota ancestor figure from Gabon, late 19th century. Wood and copper sheeting, height 26¾ ins (68 cm). The British Museum, London.

2.6 Henry Moore, *Two Large Forms*, 1969. The Serpentine, Hyde Park, London.

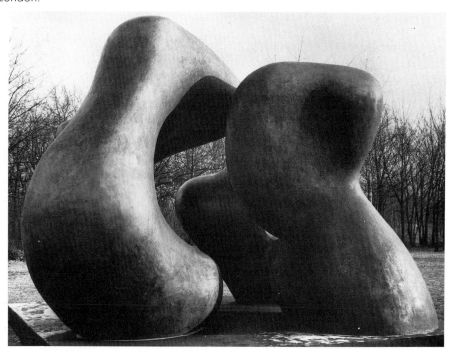

Substitution

Any material that can be transformed from a plastic, molten, or fluid state into a solid state can be molded or *cast* into a work of sculpture. Of course, the material must hold together permanently in its solid state. The creation of a piece of cast sculpture always involves the use of a mold. First, the artist creates an identically sized model of the intended sculpture. This is called a *positive*. The positive is then covered with a material, such as plaster of Paris, that when hardened and removed will retain the surface configurations of the positive. This form is called a *negative* and becomes the mold for the actual sculpture. The molten or fluid material is poured into the negative and allowed to solidify. When the mold is removed, the work of sculpture emerges. Surface polishing, if desired, brings the work to its final form (Figs. **2.6**, **2.7** and **2.8**).

2.7 (*right*) Giovanni Bologna, *Mercury*, c. 1567. Bronze, height 69 ins (175 cm). Museo Nationale del Bargello, Florence.

2.8 So-called statuette of Charlemagne, c. 860–70. Bronze cast and gilt, height 9½ ins (24 cm). The Louvre, Paris.

Very often sculpture is cast so that it is hollow. This method, of course, is less expensive, since it requires less material. It also results in a work that is less prone to crack, since it is less susceptible to expansion and contraction resulting from changes in temperature. Finally, hollow sculpture is, naturally, lighter and thus more easily shipped and handled.

Manipulation

In this technique, materials such as clay are shaped by skilled use of the hands. A term of similar meaning is *modeling*. The difference between this technique and addition is clear when we watch an artist take a single lump of clay and skillfully transform it, as it turns on a potter's wheel, into a final shape (Fig. **12.1**).

Found

This category of sculpture is exactly what its name implies. Very often natural objects, whether shaped by human hands or not, are discovered that for some reason have taken on characteristics that stimulate aesthetic response. They become *objets d'art* not because an artist put them together (although an artist may combine found objects to create a work), but because an artist chose to take them from their original surroundings and hold them up to the rest of us as vehicles for aesthetic communication. In other words, an "artist" decided that such an object said something aesthetically. As a result, he or she chose to present it in that vein.

Some may have concern about such a category, however, because it removes *techne* or skill from the artistic process. As a result, objects such as driftwood and interesting rocks can assume perhaps an unwarranted

place as art products or objects. However, if a "found" object is altered in some way to produce an artwork, then the process would probably fall under one of our previously noted methods, and the product could be termed an artwork in the fullest sense of the word.

Ephemeral

Ephemeral art has many different expressions and includes the works of the conceptualists, who insist that "art is an activity of change, of disorientation and shift, of violent discontinuity and mutability." Designed to be transitory, ephemeral art makes its statement and then, eventually, ceases to exist. Undoubtedly the largest work of sculpture ever designed was based on that concept. Christo's *Running Fence* (Fig. **2.9**) was an event and a process, as well as a sculptural work. In a sense, Christo's works are conceptual in that they call attention to the experience of art in opposition to its actual form. At the end of a two-week viewing period, *Running Fence* was removed entirely and ceased to be.

2.9 Christo, *Running Fence Sonoma and Marin Counties, California*, 1972–6. Woven nylon fabric and steel cables, height 18 ft (5.49 m), length 24½ miles (39.2 km) © Christo, 1976. Photograph Wolfgan Volz.

2.10 *The Fates*, from the east pediment of the Parthenon, c. 438–432 B.C. Marble, over life-size. The British Museum, London.

COMPOSITION

Composition in sculpture comprises the same elements and principles as composition in the pictorial arts—mass, line, form, balance, repetition, color, proportion, and unity. Sculptors' uses of these elements are significantly different, however, since they work in three dimensions.

Elements

Unlike a picture, a sculpture has literal *mass*. It takes up three-dimensional *space*, and its materials have *density*. Mass in pictures is *relative* mass: The mass of forms in a picture has application principally in relation to other forms within the same picture. In sculpture, however, mass is literal and consists of actual volume and density. So, the mass of a sculpture that is 20 ft (6 m) high, 8 ft (2.5 m) wide, and 10 ft (3 m) deep, but made of balsa wood, would seem less than a sculpture 10 ft (3 m) high, 4 ft (1.25 m) wide, and 3 ft (1 m) deep, made of lead. Space and density must both be considered. What if the material of a statue is disguised to look and feel like a different material? We will discuss this later in the chapter, when we look at how a sculpture affects our senses.

As we stated in the last chapter, *line* and *form* are highly related. We can separate them (with some difficulty) when we discuss pictures, since in two dimensions an artist uses line to define form. In painting, line is a construction tool. Without using line, artists cannot reveal their forms, and when we analyze a painting, line is perhaps more important to us than the actual form it reveals. However, in sculpture the case is nearly reversed. It is the form that draws our interest, and when we discuss line in sculpture, we do so in terms of how it is revealed in form.

The east pediment of the Parthenon contains marvelous sculptural examples (Fig. **2.10**). What strikes us first is the compositional accommodation to the confines of the pediment. Originally, it formed part of the architectural decoration high on the Parthenon, and probably, through its diagonal curvilinearity, was intended to off-set the straight lines and strong verticals and horizontals of the temple. It depicts the mythological story of the birth of Athena from her father's head. Also from the east pediment is the figure of Dionysus (Fig. **0.4**). Together they illustrate Greek idealization of their suprahuman deities. To begin with, treatment of cloth is highly sophisticated. The drape and flow of fabric carefully reinforce the overall but reasonably simple line of the work, representing considerable technical achievement. However, this depiction is far from mere decoration—in Figure **2.10** the cloth is used to reveal the perfected human female form beneath it in a way which once again demonstrates the classical purpose—not naturalism but the ideal. The aim here is to

raise these forms above the human or the specific to a symbolic level. Even in repose they show subtle and controlled grace and movement. The dynamic counterthrust of tensions and releases is obvious, but it is always restrained, never explosive or emotional.

When we view a sculpture its elements direct our eye from one point to another, just as focal points do, via line and color, in a picture. In some works the eye is directed through the piece and then off into space. Such sculptures have an *open* form. In Figures **2.4** and **2.7** the eye is directed outward from the work in the same fashion as composition that escapes the frame in painting. If, on the other hand, the eye is directed continually back into the form, we say the form is *closed*. If we allow our eye to follow the linear detail of Figure **2.11**, we find that we are continually led back into the work. This is similar to composition kept within the frame in painting and to

closed forms in music, which we will discuss in Chapter 3. Often it is difficult to fit a work precisely into one or the other of these categories.

Obviously, not all sculptures are completely solid; they may have openings. We call any such holes in a sculpture *negative space*, and we can discuss this characteristic in terms of its role in the overall composition. In some works negative space is inconsequential; in others it is quite significant. It is up to us to decide which, and how it contributes to the overall piece. In Figure **2.6** negative space plays a significant role. It could be argued that negative space is as instrumental to the overall concept of the work as is the metal form. On the other hand, in Figure **2.1** negative space is clearly incidental.

2.11 Aristide Maillol, *The Mediterranean*, 1902–5. Bronze, height 41 ins (104 cm). The Museum of Modern Art, New York (gift of Stephen C. Clark).

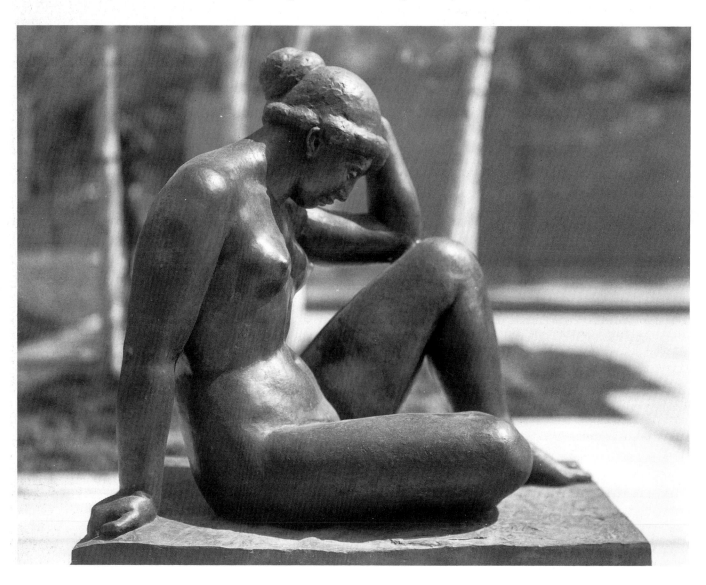

Perhaps *color* does not seem particularly important to us as we think of sculpture. We tend to see ancient sculpture as white and modern sculpture as natural wood or rusty iron. Color is as important to the sculptor as it is to the painter. In some cases the material itself may be chosen because of its color; in others, such as terra cottas, the sculpture may be painted. The lifelike sculptures of Duane Hanson depend on color for their effect. They are so lifelike that one could easily confuse them with real persons. Finally, still other materials may be chosen or treated so that nature will provide the final color through oxidation or weathering.

Texture, the roughness or smoothness of a surface, is a tangible characteristic of sculpture. Sculpture is unique in that we can perceive its texture through our sense of touch. Even when we cannot touch a work of sculpture, we can perceive and respond to texture, which can be both physical and suggested. Sculptors go to great lengths to achieve the texture they desire for their works. In fact, much of a sculptor's technical mastery manifests itself in that final ability to impart a surface to the work. We will examine texture more fully in our discussion of sense responses.

Principles

Proportion is the relationship of shapes. Just as we have a seemingly innate sense of balance, so we have a feeling of proportion. That feeling tells us that each form in the sculpture is in proper relationship to the others. However, as any student of art history will tell us, proportion—or the ideal of relationships—has varied from one civilization or culture to another. For example, such a seemingly obviously proportioned entity as the human body has varied greatly in its proportions as sculptors over the centuries have depicted it. Study the differences in proportion in the human body among Maillol's *The Mediterranean* (Fig. **2.11**), the Chartres' Saints (Fig. **2.12**), an ancient Greek Kouros figure (Fig. **2.13**), and Giacometti's *Man Pointing* (Fig. **2.14**). Each depicts the human form, but each utilizes differing proportions. This difference in proportion helps transmit the message the artist wishes to communicate about his or her subject matter.

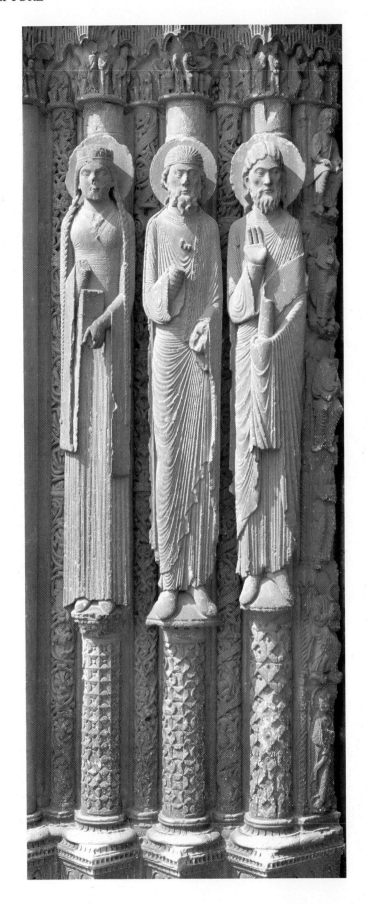

2.12 Jamb statues, west portal, Chartres Cathedral, begun 1145.

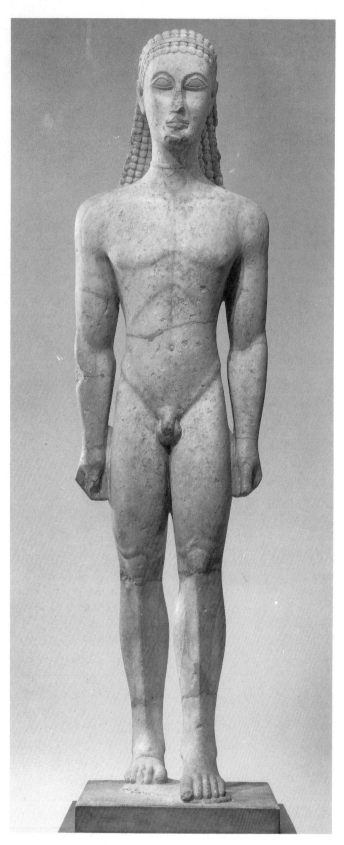

2.13 Kouros figure. The Metropolitan Museum of Art, New York (Fletcher Fund, 1932).

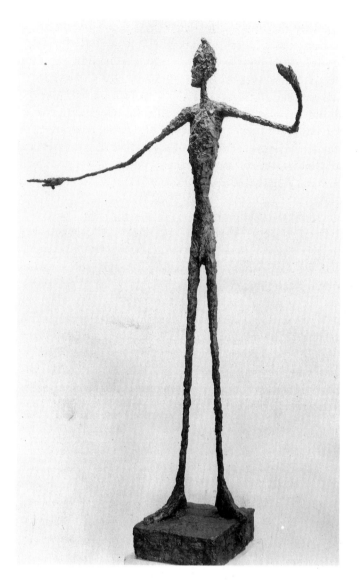

2.14 Alberto Giacometti, *Man Pointing*, 1947. Bronze, 70½ ins (179 cm), at base 12 x 13¼ ins (30 x 34 cm). The Museum of Modern Art, New York (gift of Mrs. John D. Rockefeller 3rd).

Rhythm, harmony, and variation constitute *repetition* in sculpture, as they did in the pictorial arts. However, in sculpture we must look more carefully and closely to determine how the artist has employed these elements. If we reduce a sculpture to its components of line and form, we begin to see how (as in music) rhythmic patterns—regular and irregular—occur. In Figure 2.2, for example, a regular rhythmic pattern is established in space as the eye moves from figure to figure and from leg to leg of the figures. We also can see whether the components are consonant or dissonant. For instance, again in Figure 2.2 a sense of dynamics—that is, action or movement—is

created by the dissonance that results from juxtaposing the strong triangles of the stances and groupings with the *biomorphic* lines of the human body. On the other hand, unity of the curves in Figure **2.15** provides us with a consonant series of relationships. Finally, we can see how line and form are used in theme and variation. We noted the repetition of triangles in Figure **2.2**. In contrast, the sculptor of Figure **2.16** varies his motif, the oval, as the eye moves from the child's face to the upper arm, the hand, and finally the cat's face.

2.15 (*right*) Tree Spirit, 1st century AD. Central Indian bracket figure. The British Museum, London.

2.16 (*below*) William Zorach, *Child with Cat*, 1926. Bronze, 17½ x 10 x 7½ ins (44 x 25 x 19 cm). Palmer Museum of Art, the Pennsylvania State University.

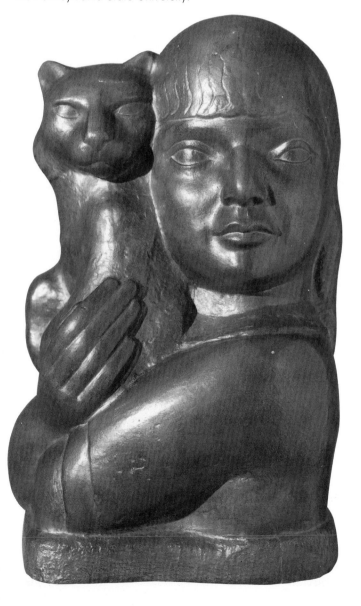

OTHER FACTORS

Articulation

Important, also, in viewing sculpture is noting the manner by which we move from one element to the next. That manner of movement is called articulation, and it applies to sculpture, painting, photography, and all the other arts. As an example, let us step outside the arts to consider human speech. Sentences, phrases, and individual words are nothing more than sound syllables (vowels) articulated (that is, joined together) by consonants. We understand what someone says to us because that individual articulates as he or she speaks. Let us put the five vowel sounds side by side: Eh–E E–Ah–O–OO. As yet we do not have a sentence. Articulate those vowels with consonants, and we have meaning: "Say, she must go too." The nature of an artwork depends on how the artist has repeated, varied, harmonized, and related its parts and how he or she has articulated the movement from one part to another—that is, how he or she indicates where one stops and the other begins.

Focal Area (Emphasis)

Sculptors, like painters or any other visual artists, must concern themselves with drawing the respondent's eye to those areas of their work that are central to what they wish to communicate. They also must provide the means by which the eye can move around the work. However, their task is much more complicated, because they deal in three dimensions and they have little control over the direction from which the viewer will first perceive the piece; the entire 360-degree view contributes to the total message communicated by the work.

The devices of convergence of line, encirclement, and color work for sculptors as they do for painters. The encircling line of the tree and body parts in Figure **2.15** causes us, however we proceed to scan the work, to focus ultimately on the torso of this sensuous fertility figure. One further device is available—movement. Sculptors have the option of placing moving objects in their work. Such an object immediately becomes a focal point of the sculpture. A mobile (Fig. **2.17**) presents many ephemeral patterns of focus as it turns at the whim of the breezes.

HOW DOES IT STIMULATE THE SENSES?

TEXTURE

Our discussion of the ways in which sculpture stimulates our senses can be presented in physical as well as mental terms. We can touch sculpture and feel its roughness or its smoothness, its coolness or perhaps its warmth. Even if we are prohibited by museum regulations from touching a sculpture, we can see the surface texture and translate the image into an imaginary tactile sensation. That is a much more direct form of sense response than the translation from sight to mind that occurs in viewing a picture. Unfortunately, museums often are forced to prohibit us from touching their sculptures. Such prohibitions are practical. Repeated touching of anything, whether it be stone, metal, or plastic, wears the surface. Even the oils from our fingers may deteriorate the surface. Certainly touching causes problems for the museum in keeping sculptures clean. Nevertheless, any work of sculpture cries out to be touched. Probably this is the first and most compelling response that any of us has to a sculpture. When we can touch, our sense responses are repaid many times over.

2.17 Alexander Calder, *Spring Blossoms*, 1965. Painted metal and heavy wire, extends 52 x 102 ins (135 x 259 cm). The Museum of Art, the Pennsylvania State University (gift of the class of 1965).

COLOR

As we indicated earlier, we do not usually think of color as significant in our response to a sculpture, at least not as significant as in our response to a picture. However, color in sculpture stimulates our response by utilizing the same universal symbols as it does in paintings, photographs, and prints. Reds, oranges, and yellows stimulate sensations of warmth; blues and greens, sensations of coolness. In sculpture, color can result from the conscious choice of the artist, either in the selection of material or in the selection of the pigment with which the material is painted. Or, as we indicated earlier, color may result from the artist's choice to let nature color the work through wind, water, sun, and so forth.

This weathering effect, of course, creates very interesting patterns, but in addition it gives the sculpture the attribute not only of space but also of time, because the work obviously will change as nature works her wonders. A copper sculpture early in its existence will be a different work, a different set of stimuli, from what it will be five, ten, or twenty years hence. This is not entirely accidental; the artist chooses copper knowing what weathering will do to it. He or she obviously cannot predict the exact nature of the weathering or the exact hues of the sculpture at any given time in the future, but such predictability is irrelevant.

In this regard it is interesting to note how our response to a work of art may be shaped by the effects of age on it. There is a great deal of charm and character in ancient objects. When you see a spotlessly clean, "restored" historic monument, it seems too new and quite sterile. Even if that was how the building originally looked, grime

2.18 Gero Crucifix, c. 975–1000. Wood, height 6 ft 2 ins (1.87 m). Cologne Cathedral. Courtesy of Heaton-Sessions, Stone Ridge, New York.

is more appealing. It looks old—and historic. So it might be, when we view a weathered wooden icon from the Middle Ages (Fig. 2.18). Our response can be enhanced or diminished by the weathering of centuries—even though the artist may not have intended the work to appeal through the effects of nature on it.

DYNAMICS

An artist's use of line, form, and juxtaposition impart to a sculpture varying characteristics of motion or activity in the same sense that it does to a painting (see Figs. 2.2 and 2.6). The activity of a sculpture, however, tends to be heightened because of its three-dimensionality. In addition, we experience a certain sense of dynamics as we walk around it. Although we are moving and not the sculpture, we perceive and respond to what seems to be movement in the work itself.

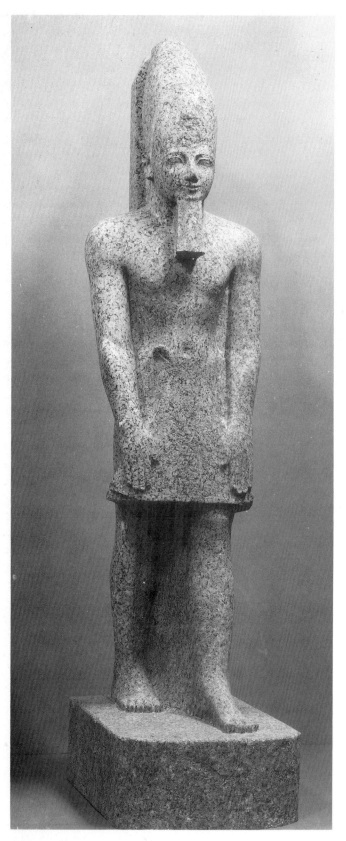

2.19 Egyptian statuary. The Metropolitan Museum of Art, New York (gift of Edward S. Harkness, 1914).

LINE AND FORM

Line and form can, of course, work apart from dynamics. Figures **2.5** and **2.15** are both symbols of fertility. However, even though both exhibit full development of the breast, the latter is the more sensuous because each area of the body is treated with greater softness of line. (Of course, *what* one finds to be sensuous may be a result more of convention than of treatment. Certainly, convention leads to treatment. Our modern conception of glamour, illustrated in the tall, leggy, and slender fashion model, contrasts sharply with that of the High Renaissance or baroque, in which corpulence was considered sexually appealing.)

MASS

Since sculpture has mass—that is, takes up space and has density—our senses respond to the weight or the size of a work. Egyptian sculpture, which is solid, stable, and oversized (Fig. **2.19**), has mass and proportion as well as line and form that make it appear heavier than a non-Egyptian work of basically the same size and material, such as Figure **2.7**. Moreover, the very same treatment of texture, verisimilitude, and subject elicits a completely different sense response if one work is 3 ft (1 m) and another 130 ft (39.6 m) tall.

Sculptures such as Trajan's Column are made to tell the story. Erected in the Emperor's Forum, it rose 128 ft (39 m) above the pavement on an 18 ft (5.5 m) base. Atop its 97 ft (29.6 m) column was a 13 ft (4 m) statue of Trajan. Inside the column is a circular staircase. From bottom to top a spiral band of relief sculpture (Fig. **2.20**) reveals the story of Trajan's defence of Rome and the Empire. He appears ninety times in the upward spiral of the narration, each appearance marking the start of a new episode. Its mass is overpowering.

Early in the chapter we mentioned the possibility of an artist's *disguising the material* from which the work is made. Marble polished to appear like skin or wood polished to look like fabric can change the appearance of mass of a sculpture and significantly affect our response to it.

We also must consider the purpose of disguising material. For example, does the detailing of the sculpture reflect a formal concern for design, or does it reflect a concern for the greatest verisimilitude? Examine the cloth represented in Figures **2.1** and **2.15**. In both cases the sculptor has disguised the material by making stone appear to be cloth. In Figure **2.1** the cloth is detailed to

reflect reality. It drapes as real cloth would drape, and as a result its effect in the composition depends upon the subtlety of line characteristic of draped cloth. However, in Figure 2.15 the sculptor has depicted cloth in such a way that its effect in the design is not dependent upon how cloth drapes, but rather upon the decorative function of line as the sculptor wishes to use it. Real cloth cannot drape as the sculptor has depicted it. Nor, probably, did the sculptor care. The main concern here was for decoration, for using line (that looks like cloth) to emphasize the rhythm of the work.

2.20 Apollódorus of Damascus, Column of Trajan, Rome, 106–13. Marble, height of base 18 ft (5.5 m), height of column 97 ft (29.6 m).

We might also consider whether or not a sculpture appears conscious of its own weight. For example, a work that has been carved from a huge block of stone, sitting squarely on the ground, and has a natural, undisguised texture and very little definition in terms of line would give us a strong impression of being *conscious of its own weight*. In contrast, a large sculpture of a human form positioned with all the weight on one foot and possessing a skinlike texture would appear totally *unconscious of its own weight*.

Mass, mass consciousness, and the disguising of materials leads us to another term: *glyptic*. Glyptic sculpture emphasizes the material from which the work is created and usually retains the fundamental geometric qualities of that material.

LIGHTING AND ENVIRONMENT

One final factor that significantly influences our sense response to a sculpture, a factor that we very often do not consider and that is outside the control of the artist unless he or she personally supervises every exhibition in which the work is displayed, is that of *lighting and environment*. As we will see in Chapter 4, light plays a seminal role in our perception of and thereby our response to three-dimensional objects. The direction and number of sources of light striking a three-dimensional work can change the entire composition of that work. Whether the work is displayed outdoors or indoors, the method of lighting affects the overall presentation. Diffuse room lighting allows us to see all aspects of a sculpture without external influence. However, if the work is placed in a darkened room and illuminated from particular directions by spotlights, it becomes much more dramatic and our response is affected accordingly.

Where and how a work is exhibited also contribute to our response. The response given to a sculpture placed in a carefully designed environment that screens our vision from distracting or competing visual stimuli will be different if the sculpture is exhibited among other works amid the bustle of a public park.

THREE

MUSIC & OPERA

Music often has been described as the purest of the art forms because it is free from the physical restrictions of space that adhere to the other arts. However, the freedom enjoyed by the composer becomes a constraint for the respondent, because music is an art in time that places significant responsibility in the hands (or the ears) of the listener. That consideration is especially critical for the respondent trying to learn and apply musical terminology, because he or she has only a fleeting moment to capture many of the characteristics of music. A painting or a sculpture stands still for us; it does not change or disappear, despite the length of time it takes us to find or apply some new characteristic. Such is not the case with music.

We live in a society that is very aural in its perceptions, but these perceptions usually do not require any kind of active listening. An excellent example is the Muzak that we hear in many stores, restaurants, and office buildings, which is intended solely as a soothing background designed *not* to attract attention. We hear music constantly on the radio, the television, and in the movies, but nearly always in a peripheral role. Since we are not expected to pay attention to it, we do not. Therefore, we simply do not undertake the kind of practice we need to be attentive to music and to perceive it in detail. However, like any skill, the ability to hear perceptively is enhanced through repetition and training. Individuals who have had

limited experience in responding to music have some difficulty in the "live" concert hall hearing what there is to hear in a piece of music that passes in just a few seconds. Likewise, their ability to *remember* what they have heard is impaired if they have not practiced that skill. To deduce the structure of a musical work, listeners must remember at the end what they heard at the beginning. These abilities require skills that most individuals in our society have not acquired.

WHAT IS IT?

Music is aesthetic communication through the design of time in motion using sound and silence. Musical design at the formal level of response is that shape we find in the finished work. So, at this level of response, music is a sonata, symphony, concerto, suite, concert overture, opera, oratorio, cantata, mass, or requiem, or motet, to name only a few of the most familiar types.

SONATA

A sonata is a group of movements loosely related and played in succession. Unlike the movements of a suite, these are not all in the same key but are in related tonalities.

The first movement of a sonata generally has a special form, which has taken on particular importance in musical composition —hence its name, sonata form. In discussing sonatas, we must be careful not to confuse *sonata* with *sonata form*, a particular structure we will discuss later.

SYMPHONY

The symphony is a large musical composition for orchestra which reached its full maturity in the late eighteenth century. Typically the symphony has four separate sections, called "movements." The tempos of the four movements are usually fast, slow, moderate, and fast. In addition, the first movement usually is in sonata form, sometimes with a slow introduction. The second movement generally consists of binary or sonata form; the third movement comprises a minuet and trio, in ternary form; the fourth movement explores sonata, rondo, or a combination of those forms. The symphony as a musical type has been shaped by, and to a large extent cannot be separated from, the development of the instruments for and the theories and styles of the historical periods in which it was composed. "Symphony" as a musical form may also apply to works composed for string quartet and chamber orchestra, for example. A symphony such as Beethoven's Symphony No. 9, which utilizes chorus as well as orchestra is unique. Some symphonies have only three movements, some have more than four movements, and some do not adhere to the characteristics just noted in relation to their movements.

CONCERTO

This term usually refers to a composition for solo instrument with accompaniment. It originated during the baroque era as the *concerto grosso*, which uses a solo group called the *concertino* and a full ensemble called the *ripieno*. By the end of the age the *solo concerto* emerged. The solo concerto usually has three movements, which alternate in a fast–slow–fast relationship.

SUITE

If we think of the term suite as it is frequently used outside of music, we have an insight into its musical implications. A grouping of items of furniture in the design of a living room is called a living-room *suite*. The ensemble of trousers, vest, and jacket designed in the same fabric and style and worn together is called a *suit*. The musical suite is a grouping of clichéd rhythms and meters of particular dances, usually unrelated except by

key and contrast. Suites were written primarily for keyboard instruments, specifically the harpsichord, but also for a solo instrument accompanied by harpsichord, or a group of stringed or wind instruments.

CONCERT OVERTURE

An overture is customarily a single-movement introduction to, for example, an opera. However, in concert it has been popular to perform many of these introductions apart from the work they introduce. As this practice became more popular, composers began to write concert overtures—overtures with no larger work intended to follow.

OPERA

Because of its special combination of music, theatre, and architecture, we will discuss opera in detail later (see p. 74).

ORATORIO

An oratorio is a large choral work for soloists, chorus, and orchestra which was developed in the baroque period. It is usually presented in concert form—that is, there is no physical action, staging, setting, costumes, or properties. The soloists in the oratorio may take the role of characters, and the work may have a plot, although perhaps the most familiar example, Handel's *Messiah*, does neither.

CANTATA

The cantata is a composition for chorus and/or solo voice(s) accompanied by an instrumental ensemble. Developed in the baroque period, it comprises several movements and uses either sacred or secular texts.

MASS

The mass as a choral type concerns itself directly with the Roman Catholic service, the Mass. As such it includes six musical parts: *Kyrie, Gloria, Credo, Sanctus, Benedictus,* and *Agnus Dei*. The Mass is the heart of the Church rite and is based on the Last Supper of Christ. Two kinds of texts accompanied the Mass, the *Ordinary*, appropriate throughout the year, and the *Proper*, which had texts appropriate to particular feast days. Masses may or may not be written for inclusion in the church service. The concert mass has been an important part of musical composition since the Middle Ages. Many masses have taken a special form—for example, the *requiem mass*, or mass for the dead.

MOTET

A motet is a choral composition of *polyphonic* texture. Motets, like symphonies, oratorios, cantatas, masses, and so on, are associated with specific historical periods. Early motets of the thirteenth century often utilized three voices and combined sacred and secular texts. By the fifteenth and sixteenth centuries the motet was a contrapuntal work for four or five voices, usually with a sacred text. In that form it is differentiated from the *madrigal*, which utilized a secular text.

HOW IS IT PUT TOGETHER?

As we examine the nature of how music is put together, we can find ourselves adrift in a sea of unusual technical vocabulary, most of it Italian. Understanding the vocabulary and being able to identify its application in a musical work help us to comprehend the communication which uses the musical language, and thereby to understand the creative communicative intent of the composer and the musicians who bring the composition to life. The ways in which musical artists shape the characteristics that follow bring us experiences which can challenge our intellects and excite our emotions. As in all communication, meaning depends upon each of the parties involved; communicators and respondents must assume responsibility for facility in the language utilized. Effort is required to communicate effectively and significantly and to understand that communication. The rewards, the unlocking of the depths of our own being, are well worth the effort.

Music is composed through the designing of sound and silence. The latter is reasonably understandable, but what of the former? What is sound? Sound is vibration that stimulates the auditory nerves. It includes sirens, speech, crying babies, jet engines, falling trees, and so forth. We might call such sources noise. However, even noise may have a part in a musical composition. Cannons and even floor polishers have found their way into serious musical works. So we must be careful about what we include or exclude from sound in music. On the other hand, musical design does depend primarily upon sound of a specific character —sound that can be controlled and shaped, sound that can be consistent in its qualities. One aspect of sound that is not limited to musical instruments but is fundamental to the designing of sound in music is tone.

TONE

Tone has four characteristics: pitch, duration, timbre, and intensity.

Pitch

Pitch is a physical phenomenon measurable in vibrations per second. So, when we describe differences in pitch we are describing recognizable and measurable differences in sound waves. A pitch has a steady, constant frequency. A faster frequency produces a higher pitch, a slower frequency, a lower pitch. If a sounding body—a vibrating string, for example—is shortened, it vibrates more rapidly. Musical instruments designed to produce high pitches, such as the piccolo, therefore tend to be small. Instruments designed to produce low pitches tend to be large—for instance, bass viols and tubas.

In Chapter 1 we discussed color. Color comprises a range of light waves within a visible spectrum. Sound also comprises a spectrum, one whose audible pitches range from 16 to 38,000 vibrations per second. We can perceive 11,000 different pitches! Obviously that is more than is practical for musical composition. Therefore, *by convention* the sound spectrum is divided into roughly ninety equally spaced frequencies comprising seven and a half *octaves*. The piano keyboard, consisting of eighty-eight keys (seven octaves plus two additional notes) representing the same number of equally spaced pitches, serves as an illustration (Fig. **3.1**). The thirteen pitches represented by the adjacent keys of the piano from C to C constitute an octave. The distance in frequency from C to C♯ is the same as that from C♯ to D, and so forth. The higher C vibrates at exactly twice the frequency of the lower C. Such is the case with every note and the note one octave below it. The A one octave above the lower one shown would vibrate at twice that rate. Again by convention, each musical note is usually tuned to a specific pitch, in vibrations per second. Normally, A is tuned to 440 vibrations per second, for example, and its octaves to 110, 220, 880, 1,760, and so forth.

3.1 Part of the piano keyboard and its pitches.

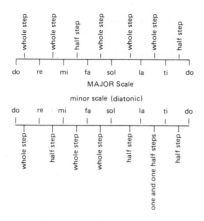

3.2 The major and minor scales.

The thirteen equally spaced pitches in an octave are called a *chromatic scale*. However, the scales that sound most familiar to us are the major and minor scales, which consist of an octave of eight pitches. The distance between any two pitches is an *interval*. Intervals between two adjacent pitches are *half steps*. Intervals of two half steps are *whole steps*. The major scale—*do re mi fa sol la ti do* (recall the song, "Doe, a deer . . ." from *The Sound of Music*)—has a specific arrangement of whole and half steps (Fig. **3.2**). Lowering the third and sixth notes of the major scale gives us the diatonic (the most common) minor scale.

To reiterate, a scale, which is an arrangement of pitches played in ascending or descending order, is a conventional organization of the frequencies of the sound spectrum. Not all music conforms to this convention. Music of Western civilization prior to approximately AD 1600 does not, nor does Eastern music, which makes great use of quarter tones. In addition, some contemporary Western music departs from the conventions of tonality of the major or minor scale.

Duration

A second characteristic of tone is duration, the length of time in which vibration is maintained without interruption. Duration in musical composition is relative and is designed within a set of conventions called musical notation (Fig. **3.3**). This system consists of a series of

3.3 Musical notation.

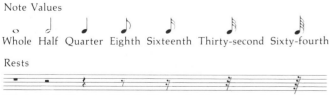

Note Values

Whole Half Quarter Eighth Sixteenth Thirty-second Sixty-fourth

Rests

Whole Half Quarter Eighth Sixteenth Thirty-second Sixty-fourth

symbols (notes) by which the composer indicates the relative duration of each pitch. The system is progressive—that is, each note is either double or half the duration of an adjacent note. Musical notation also includes a series of symbols that denote the duration of *silences* in a composition. These symbols are called *rests*, and have the same durational values as the symbols for duration of tone.

Timbre

Timbre is the characteristic of tone that allows us to distinguish a pitch played on a violin, for example, from the same pitch played on a piano. Timbre is also referred to as "voice print" and tone "color." In addition to identifying characteristic differences among sound-producing sources, timbre characterizes differences in quality of tones produced by the same source. Here the analogy of tone "color" is particularly appropriate. A tone that is produced with an excess of air—for example, by the human voice—is described as "white." The table below lists some of the various sources that produce musical tone and account for its variety of timbres.

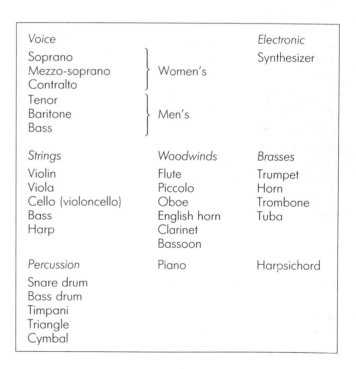

The piano could be considered either a stringed or a percussion instrument since it produces its sound by vibrating strings *struck* by hammers. The harpsichord's strings are set in motion by plucking.

Electronically produced music, extant since the development of the RCA synthesizer at the Columbia-

67

3.4 Karlheinz Stockhausen at his electronic control panel.

Princeton Electronics Music Center, has become a standard source in assisting contemporary composers. Originally electronic music fell into two categories: (1) the electronic altering of acoustically produced sounds, which came to be labeled as *musique concrète* (see Glossary) and (2) electronically generated sounds. However, advances in technology have blurred those differences over the years.

Intensity

A final characteristic of tone is intensity. Any tone of any pitch, duration, or timbre can be loud, soft, or anywhere in between. Intensity is the *decibel* level of the tone, and depends upon the physical phenomenon of *amplitude* of vibration. When greater force is employed in the production of a tone, the resulting sound waves are wider and cause greater stimulation of the auditory nerves. The *size* of the sound wave, not its number of vibrations per second, is changed.

Composers indicate intensity, or *dynamic level*, with a series of specific notations:

pp	pianissimo	very soft
p	piano	soft
mp	mezzo piano	moderately soft
mf	mezzo forte	moderately loud
f	forte	loud
ff	fortissimo	very loud

The notations of intensity that apply to an individual tone, such as *p*, *mp*, and *f*, also may apply to a section of music. *Dynamics* is the term used to refer to intensity levels throughout a composition. Changes in dynamics may be abrupt, gradual, wide, or small. A series of symbols also governs this aspect of music:

	Crescendo	becoming louder
	Decrescendo	becoming softer
> ∧ *sfz*	Sforzando	"with force;" a strong accent immediately followed by *p*

As we listen to and compare musical compositions we can consider the use and breadth of dynamics in the same sense that we consider the use and breadth of palette in painting.

MELODY

Melody is a succession of sounds with rhythmic and tonal organization. We can visualize melody as linear and essentially horizontal. Thus, any organization of musical tones occurring *one after another* constitutes a melody. Two other terms, *tune* and *theme*, relate to melody as parts to a whole. For example, the *tune* in Figure 3.5 is a melody—that is, a succession of tones. However, a

3.5 "The Star Spangled Banner" (excerpt).

Oh— say can you see by the dawn's ear-ly light

melody is not always a tune. For most people the term tune implies singability, and there are many melodies that cannot be considered singable. A *theme* is also a melody. However, in musical composition it specifically means a central musical idea, which may be restated and varied throughout a piece. Thus a melody is not necessarily a theme.

Related to theme and melody is the *motif*, or *motive*, a short melodic or rhythmic idea around which a composer may design a composition. For example, in Mozart's Symphony No. 40 the allegro movement is developed around a rhythmic motif of three notes:

In listening for how a composer develops melody, theme, and motive we can use two terms to describe what we hear: *conjunct* and *disjunct*. Conjunct melodies comprise notes close together, stepwise, on the musical scale. For example, the interval between the opening notes of the soprano line of J. S. Bach's chorale "Jesu Joy of Man's Desiring" from his Cantata 147 (Fig. **3.6**) is never more than a whole step. Such melodic development is highly conjunct. Disjunct melodies contain intervals of a third or more. However, there is no formula for determining disjunct or conjunct characteristics; there is no line at which a melody ceases to be disjunct and becomes conjunct. These are relative and comparative terms that assist us in description. For example, we would say that the opening melody of "The Star Spangled Banner" (Fig. **3.5**) is more disjunct than the opening melody of "Jesu Joy of Man's Desiring"—or that the latter is more conjunct than the former.

3.6 "Jesu Joy of Man's Desiring" (excerpt).

Je - su joy of man's de - sir - ing

HARMONY

When two or more tones are sounded at the same time, we have harmony. Harmony is essentially a vertical arrangement, in contrast with the horizontal arrangement of melody.

However, as we shall see, harmony also has a horizontal property—movement forward in time. In listening for harmony we are interested in how simultaneous tones *sound together*.

Two tones played simultaneously are an interval; three or more form a *chord*. When we hear an interval or a chord our first response is to its *consonance* or *dissonance*. Consonant harmonies sound stable in their arrangement. Dissonant harmonies are tense and unstable. Consonance and dissonance, however, are not absolute properties. Essentially they are conventional and, to a large extent, cultural. What is dissonant to our ears may not be so to someone else's. What is important in musical response is determining *how* the composer utilizes these two properties. Most of our music is primarily consonant. However, dissonance can be used for contrast, to draw attention to itself, or as a normal part of *harmonic progression*.

As its name implies, harmonic progression involves the movement forward in time of harmonies. In discussing pitch we noted the convention of the major and minor scales—that is, the arrangement of the chromatic scale into a system of *tonality*. When we play or sing a major or minor scale we note a particular phenomenon: Our movement from *do* to *re* to *mi* to *fa* to *sol* to *la* is smooth and seems natural. But when we reach the seventh note of the scale, *ti*, something strange happens. It seems as though we *must* continue back to *do*, the *tonic* of the scale. Try it! Sing a major scale and stop at *ti*. You feel uncomfortable. Your mind tells you that you must *resolve* that discomfort by returning to *do*. That same sense of tonality—that sense of the tonic—applies to harmony. Within any scale a series of chords may be developed on the basis of the individual tones of the scale. Each of the chords has a subtle relationship to each of the other chords and to the tonic—that is, the *do* of the scale. That relationship creates a sense of progression that leads back to the chord based on the tonic.

As I indicated, scales and harmonies are conventions. However, not all conventions are arbitrary. Harmonic progression, which is based on tonality, has a physical root. Physicists call it *sympathetic vibration*. If we take two tightly stretched strings, each of the same length, on a sounding board, we can easily set the second string in motion by plucking the first. Because both strings are the same length, their sound waves are identical and the waves from the plucked string will stir the second, setting it in motion. A little experimentation shows that by dividing the second string into various lengths we can develop a systematic chart of sympathetic vibration. Length A vibrates more easily than B, which vibrates more easily than C, and so on. The relationships we would establish in such an experiment basically govern harmonic progression. Chords based on the notes—that is, the lengths of string—most easily vibrated sympathetically are closer

to, and lead to, the tonic. For example, other than the same length of string or its double (the octave), the length of string, or note, most easily vibrated sympathetically is the fifth note (*sol*) of the scale; next is the fourth note, and then the second. If we played chords based on these tones in an order from difficult to easy sympathetic vibration, our progression would move us comfortably to a resolution on the tonic chord. So, harmonic progression is both conventional and physical.

The harmonic movement toward, and either resolving or not resolving to, the tonic is called *cadence*. Three different cadences are shown in Figure **3.7**. The use of cadence is one way of articulating sections of a composition or of surprising us by upsetting our expectations. A composer using a full cadence uses a harmonic progression that resolves just as our ear tells us it should. We have a sense of ending, of completeness. However, when a half cadence or a deceptive cadence is used, the expected progression is upset and the musical development moves in an unexpected direction.

3.7 Full, half, and deceptive cadences.

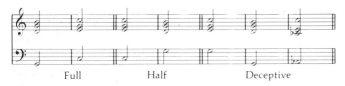

Full Half Deceptive

As we listen to music of various historical periods we may note that in some compositions tonal centers are blurred because composers frequently *modulate*—that is, change from one key (see Glossary) to another. In the twentieth century many composers, some of them using purely mathematical formulas to utilize equally all tones of the chromatic scale, have removed tonality as an arranging factor and have developed *atonal* music, or music without tonality. A convention of harmonic progression is disturbed when tonality is removed. However, we still have harmonic progression, *and* we still have harmony—dissonant or consonant.

TONALITY

Utilization of pitch and tonality has taken composers in various directions over the centuries. Conventional tonality, employing the major and minor scales and keys previously mentioned, forms the basis for most pre-twentieth-century music, as well as traditionally oriented music of the twentieth century. In addition, we find *serial-*

ism and *twelve-tone technique*, which, since World War II, have reflected a desire to exert more control and to apply a predetermined hierarchy of values to all elements of a composition. In the early twentieth century, traditional tonality was abandoned by some composers and a new *atonal* harmonic expression occurred. Exemplified in Schoenberg's "pantonality" (as he called it), atonal compositions seek the freedom to use any combination of tones without the necessity of having to resolve chordal progressions. Schoenberg referred to this as "the emancipation of dissonance."

TEXTURE

The aspect of musical relationships known as texture is treated differently by different sources. The term itself has various spatial connotations, and using a spatial term to describe a nonspatial phenomenon creates part of the divergence of treatment. Texture in painting and sculpture denotes surface quality—that is, roughness or smoothness. Texture in weaving denotes the interrelationship of the warp and the woof—that is, the horizontal and vertical threads of fibers. The organization in Figure **3.8** would be described as open or loose texture; that in Figure **3.9**, closed or tight. However, there is really no single musical arrangement that corresponds to either of these spatial concepts. The characteristic called *sonority* by some comes the closest. Sonority describes the relationship of tones played at the same time. A chord with large intervals between its members would have a more open, or thinner, sonority (or texture) than a chord with small intervals between its tones; that chord would have a tight, thick, or close sonority or texture. Sonority is a term that does not have universal application; some sources do not mention it at all.

3.8 (*left*) Open (loose) texture.

3.9 (*right*) Closed (tight) texture.

In a musical context *texture* (again, some sources do not use this term and treat the following characteristics as part of harmony) usually has two, and sometimes three, characteristics: *homophony* and *polyphony* (or *counterpoint*), and sometimes *monophony*. Monophony consists solely of one melodic line. There may be 500 voices singing a melody, but if it is the same melody it is monophonic. In homophonic music one melodic line dominates and the other voices play a subordinate or supporting role. Polyphony is the development of two or more independent melodic lines. Most music is not exclusively monophonic, homophonic, or polyphonic. Much music alternates, especially between homophonic and polyphonic textures.

RHYTHM

In all of the arts, rhythm comprises recurring pulses and accents which create identifiable patterns. Without rhythm we have only an aimless rising and falling of tones. Earlier we noted that each tone and silence has duration. Composing music means placing each tone into a time or rhythmical relationship with every other tone. As with the dots and dashes of the Morse code we can "play" the rhythm of a musical composition without reference to its pitches. Each symbol (or note) of the musical-notation system denotes a duration relative to each other symbol in the system.

BEAT

The individual stresses we hear are called *beats*. Beats may be grouped into rhythmic patterns by placing accents every few beats. Rhythm and beat combine to form *meter*.

METER

Normal musical practice is to group clusters of beats into units called *measures*. When these groupings are regular and reasonably equal they comprise *simple* meters. When the number of beats in a measure equals three or two it constitutes *triple* or *duple* meter. In the musical score, measures are indicated by *bar lines*, which are simple vertical dividing lines telling the performer that a measure has just ended or begun. We, as listeners, can distinguish between duple and triple meters because of their different *accent* patterns. In triple meter we hear an accent every third beat—ONE two three, ONE two three—and in duple meter the accent is every other beat—ONE two,

ONE two. If there are four beats in a measure (sometimes called quadruple meter), the second accent is weaker than the first—ONE two THREE four, ONE two THREE four.

Not all rhythm in music is regular, and not all meter is simple or consistent. Often it is difficult to hear precisely what is happening because the composer changes metrical patterns (in some cases almost every measure) throughout the piece. Changes in meter are communicated to the performers by *time signatures* noted in the score—for example, $\frac{2}{4}$ (*two* beats to the measure; *quarter note* equals one beat), $\frac{3}{2}$ (*three* beats to the measure; *half note* equals one beat); $\frac{7}{8}$ (*seven* beats to the measure; *eighth note* equals one beat), and so on. However, we, as audience members, can hear those changes only by perceiving the changes in accent patterns which accompany changes in meter. Such changes create variety in the rhythmical structure and add interest, and sometimes *chaos*, to it. Often, even when the meter is consistent, a composer will disturb our expectations by accenting normally unaccented beats. In such cases the rhythm is said to be *syncopated*.

TEMPO

The development of meter (rhythm and beat) has an *internal* order of relationships. As we indicated, each beat is assigned a duration relative to other durations, and beats are clustered to form measures and thereby metrical arrangements. However, none of these conventions indicates the amount of *actual* time assigned to each beat. Determining the length of a beat determines the rate of speed, or the *tempo*, of the composition. A composer may notate tempo in two ways. The first is by a *metronome marking*, such as ♩ = 60. This means that the piece is to be played at the rate of sixty quarter notes (♩) per minute. Such notation is precise. The other method is less precise and involves more descriptive terminology in Italian.

Largo (broad) Grave (grave, solemn)	Very slow
Lento (slow) Adagio (leisurely)	Slow
Andante (at a walking pace) Adantino (somewhat faster than adante) Moderato (moderate)	Moderate
Allegretto (briskly) Allegro (cheerful, faster than allegretto)	Fast
Vivace (vivacious) Presto (very quick) Prestissimo (as fast as possible)	Very fast

The tempo may be quickened or slowed, and the composer indicates this by the words, *accelerando* (accelerate) and *ritardando* (retard, slow down). A performer who takes liberties with the tempo is said to use *rubato*.

STRUCTURE

Musical structure, the organization of musical elements and relationships into successive events or sections, is concerned principally with two characteristics, variety and unity. *Variety* creates interest by avoiding monotony, and composers can use variety in every musical characteristic we have discussed in order to hold our attention or pique our interest. However, since music has design, composers must also concern themselves with *coherence*. Notes and rhythms that proceed without purpose or stop arbitrarily make little sense to the listener. Therefore, just as the painter, sculptor, or any other artist must try to develop design that has focus and meaning, the musician must attempt to create a coherent composition of sounds and silences—that is, a composition that has *unity*. The principal means by which an artist creates unity is repetition. As we noted in the *Introduction*, the Volkswagen (Fig. **0.2**) achieved unity through strong geometric repetition which varied only in size. Music achieves unity through repetition in a similar fashion. However, since in music we are dealing with time as opposed to space, repetition in music usually involves recognizable themes.

Structure can thus be seen as organization through repetition to create unity. Structure may be divided into two categories: *closed form* and *open form*. These terms are somewhat similar to the same ones as used in sculpture and to composition kept within or allowed to escape the frame in painting. Closed form directs the "musical eye" back into the composition by restating at the end of the thematic section that which formed the beginning of the piece. Open form allows the "eye" to escape the composition by utilizing repetition of thematic material only as a departure point for further development, and by ending without repetition of the opening section. A few of the more common examples of closed and open forms follow.

Closed Forms

Binary form, as the name implies, consists of two parts: the opening section of the composition and a second part which often acts as an answer to the first: AB. Each section is then repeated.

Ternary form is three-part development in which the opening section is repeated after the development of a different second section: ABA.

Ritornello, which developed in the baroque period, and *rondo*, which developed in the classical period, employ a continuous development which returns to modified versions of the opening theme after separate treatments of additional themes. Ritornello alternates orchestral or *ripieno* passages with solo passages. Rondo alternates a main theme in the tonic key with subordinate themes in contrasting keys.

Sonata form, or *sonata-allegro form*, takes its name from the conventional treatment of the first movement of the sonata. It is also the form of development of the first movement of many symphonies. The pattern of development is ABA or AABA. The first A section is a statement of two or three main and subordinate themes, known as the *exposition*. To cement the perception of section A, the composer may repeat it: AA. The B section, the *development*, takes the original themes and develops them with several fragmentations and modulations. The movement then returns to the A section; this final section is called the *recapitulation*. Usually, the recapitulation section is not an exact repetition of the opening section; in fact, it may be difficult to hear in some pieces. In Mozart's Symphony No. 40 the opening movement (allegro) is in sonata-allegro form. However, the recapitulation section is identified only by a very brief restatement of the first theme, as it was heard in the exposition, not a repetition of the opening section. Then, after a lengthy *bridge*, the second theme from the exposition appears. Mozart closes the movement with a brief *coda*, or closing section, in the original key, based on the first phrase of the first theme.

Open Forms

The fugue is a polyphonic development of one, two, or sometimes three short themes. Fugal form, which takes its name from the Latin *fuga* ("flight"), has a traditional, though not a necessary, scheme of development consisting of seven elements, only some of which may be found in any given fugue. However, two characteristics are common to all fugues: (1) counterpoint and (2) a clear dominant-tonic relationship—that is, imitation of the theme at the fifth above or below the tonic. Each voice in a fugue (as many as five or more) develops the basic subject independent from the other voices, and passes through as many of the seven elements as the composer deems necessary. Unification is achieved not by return to an

opening section, as in closed form, but by the varying recurrences of the subject throughout.

The canon is a contrapuntal form based on note-for-note imitation of one line by another. The lines are separated by a brief time interval—for example (the use of letters here does *not* indicate sectional development):

Voice 1: a b c d e f g
Voice 2: a b c d e f g
Voice 3: a b c d e f g

The interval of separation is not always the same among the voices. The canon is different from the *round*, an example of which, "Row, row, row your boat," we all sang as children. A round is also an exact melodic repeat; however, the canon develops new material indefinitely, while the round repeats the same phrases over and over. The interval of separation in the round stays constant—a phrase apart.

Variation form is a compositional structure in which an initial theme is modified through melodic, rhythmic, and harmonic treatments, each more elaborate than the last. Each section usually ends with a strong cadence, and the piece ends, literally, when the composer decides he or she has done enough.

HOW DOES IT STIMULATE THE SENSES?

It should be obvious by now that when we respond to any work of art we can examine it in a cause-and-effect manner to see how the artist has used any or all of the elements of technical and formal development to stimulate a particular sensation or expressive response in us. In music one might think that all our sense responses must stem from what we hear. If our only exposure to music were the record or tape recording, that would be true. However, there is more to music than sitting in an easy chair and listening to the record player. Much of the excitement of music comes from its live performance. So much of our response can be triggered by what we see as well as by what we hear. We can observe the emotional performance of the musician. What we see does have an effect on our response. If we see no involvement by the performer, we may hear very little as well. This is not always the case, but many critics have noted the

phenomenon. We miss much of the response to a work of music if we deprive ourselves of the opportunity of seeing the performance and experiencing the *event* by limiting our exposure to music to tape recordings or records.

How do the composer and the performer work on our senses through their music? The most obvious device for effecting response is the combination of rhythm and meter. We have all at one time or another heard music that caused us involuntarily to tap our toes, drum our fingers, or bounce in our seats in a purely physical response to the strongly accented beat of the music. This involuntary motor response to a "beat" is perhaps the most primitive of our sensual involvements. If the rhythm is regular and the beat strong, our body may respond as a unit. However, if the rhythm is irregular or the beat divided or syncopated, we may find one part of our body doing one thing and another part doing something else. Dynamics also have much to do with our sense response to music: The way that a composer manipulates volume and intensity in a piece can lull us to sleep or cause us to sit bolt upright in astonishment. A familiar example of manipulated dynamics is the second movement of Haydn's Symphony No. 94, in which the composer relaxes his audience with very soft passages and then inserts a sudden fortissimo. The result (and the "name" of the symphony ever since) was *surprise!*

From time to time throughout this chapter we have referred to certain historical conventions that permeate the world of music. Some of these have a potential effect on our sense response. Certain notational patterns, such as *appoggiaturas* (see Glossary), are a kind of musical shorthand, or perhaps mime, that conveys certain kinds of emotion to the listener. They, of course, have little meaning for us *unless we take the time and effort to study* music history. Some of Mozart's string quartets indulge in exactly this kind of communication. This is another illustration of how expanded knowledge can increase the depth and value of the aesthetic experience.

The timbre of a musical composition also works on our senses. A composer's use of timbre is analogous to a painter's use of palette. Only a study of an individual work will tell us how broad or narrow the composer's use of timbre is. However, the size of the musical ensemble has a nearly automatic control of our response. A large symphony orchestra can overwhelm us with diverse timbres and volumes; a string quartet cannot. Our expectations and our focus may change as we perceive the performance of one or the other. Because, for example, we know our perceptual experience with a string quartet will not involve the broad possibilities of an orchestra, we tune

ourselves to seek the qualities that challenge the composer and performer within the particular medium. The difference between listening to an orchestra and listening to a quartet is similar to the difference between viewing a museum painting of huge dimension and viewing the exquisite technique of a miniature.

Texture, rhythm, meter, and timbre, in combination, have much to do with sensual response to a musical work. The combinations of these elements that a composer uses to stimulate us in many different ways are infinite. The isolation of the woodwinds, the irregular rhythms, and the melodic development of Debussy's *Prèlude à l'après-midi d'un faune* combine to call up in us images of Pan frolicking through the woodlands and cavorting with the nymphs on a sunny afternoon. Of course, much of what we see has been stimulated by the title of the composition. Our perception is heightened further if we are familiar with the poem by Mallarmé on which the symphonic poem is based. Titles and especially text in musical compositions may be the strongest devices a composer has for communicating directly with us. Images are triggered by words, and a text or title can stimulate our imaginations and senses to wander freely and fully through the musical development. Johannes Brahms called a movement in his *Ein Deutsches Requiem* "All Mortal Flesh is as the Grass;" we certainly receive a philosophical and religious communication from that title. Moreover, when the chorus ceases to sing and the orchestra plays alone, the instrumental melodies stimulate images of fields of grass blowing in the wind. Our senses are stimulated significantly.

Harmony and tonality are both of considerable importance in stimulating our senses. Just as paintings and sculpture stimulate sensations of rest and comfort or action and discomfort, so harmonies create a feeling of repose and stability if they are consonant and a sensation of restlessness and instability if they are dissonant. Harmonic progression that leads to a full cadential resolution leaves us feeling fulfilled; unresolved cadences are puzzling and perhaps irritating. Major or minor tonalities have significantly differing effects: Major sounds positive; minor, sad or mysterious. The former seems close to home, and the latter, exotic. Atonal music sets us adrift to find the unifying thread of the composition.

Melody, rhythm, and tempo are very similar to the use of line in painting, and the term *melodic contour* could be seen as a musical analogue to this element of painting. When the tones of a melody are conjunct and undulate slowly and smoothly, they trace a pattern having the same sensual effect as their linear visual counterpart —that is,

soft, comfortable, and placid.

When melodic contours are disjunct and tempos rapid, the pattern and response change:

In conclusion, it remains for us as we respond to music to analyze how each of the elements available to the composer has in fact become a part of the channel of communication, and how the composer, consciously or unconsciously, has put together a work that elicits sensory responses from us.

OPERA

We have identified opera as one of the formal divisions of music. One might ask, Why devote the time to study this particular kind of music when we do not spend an equal amount of time studying the symphony and the other types of music we have identified? Part of the answer to this question stems from the history of the opera and from its position as a major art form. However, one could say the same of the oratorio or the symphony. Another part of the answer is that opera is more than just one of the formal divisions of music. Some would argue that opera is *drama* set to music, or even a separate discipline that is not drama or music but a third and equal art form. However, a traditional description of opera is that it is not drama set to music but rather a combination of music and drama in which music is not an equal or incidental partner but is the predominant element. It also is clear that the supportive elements of opera production, such as scenery, costumes, and staging, make it (while still a form of music) something apart from its musical brethren.

Traditions of opera are strong, deep, and also, as some would argue, part of the problem that opera has had in gaining popular support in the twentieth century. There have been recent attempts to make opera more like contemporary drama, with greater focus on plot, character development, and so on. Plays such as *Of Mice and Men* have been made into operas to make the form less exaggerated and implausible. In addition, some individuals find great distress in the traditional inability of opera singers to act and the frequent portrayal of supposedly sexually appealing heroines by obese singers. How much

of this is tradition, and how much is irrelevant, and how we as audience members ought to regard it is often a source of irritation for the neophyte and the opera buff alike.

Many devotees of opera regard it as the purest integration of all the arts. It contains music, drama, poetry, and, in the *mise en scène*, visual art. Certainly one could even include architecture, because an opera house is a particular architectural entity, with its own specific requirements for stage space and machinery, orchestra pit, and audience seating space. Because of opera's integration of art forms, much of what we respond to in opera at the formal, technical, and sensual levels is discussed in other chapters of this text. But since opera tends to be the art form most removed from popular awareness, let us examine a few additional characteristics.

Opera is a live art form. Recordings and television presentations make it available to a mass audience but are not substitutes for sitting in the large auditorium that comprises an opera house and witnessing a musical and dramatic spectacle unfold on a stage perhaps 50 ft (15 m) wide and 70 ft (21 m) deep, filled with scenery rising 20 or 30 ft (6 or 9 m) in the air, and peopled by a chorus of perhaps 100 people, all fully costumed and singing over a full orchestra (Figs. **3.10**, **3.11** and **3.12**). The scope and the spectacle of such an event is *opera*, or at least comprises the circumstances of the bulk of operatic repertoire, which emanates from the romantic tradition. Some operas of earlier and contemporary styles are much more intimate. Nonetheless, listening to the music of opera on the radio or from a record, or watching the miniscule productions brought to us through the medium of television falls short of the experience the live performance affords.

3.10 Giacomo Puccini, *Manon Lescaut*. Opera Company of Philadelphia. Photo by Trudy Cohen.

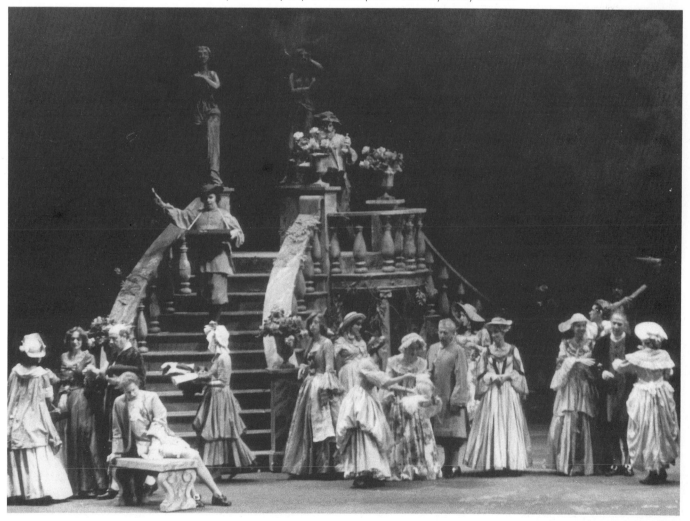

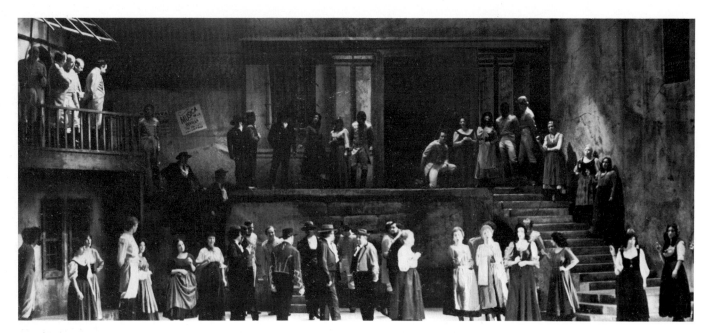

3.11 Georges Bizet, *Carmen*. Opera Company of Philadelphia. Composite photo by Trudy Cohen.

3.12 Giuseppi Galli de Bibiena, Scene design for an opera, 1719. Contemporary engraving. The Metropolitan Museum of Art, New York (the Elisha Whittelsey Fund, 1951).

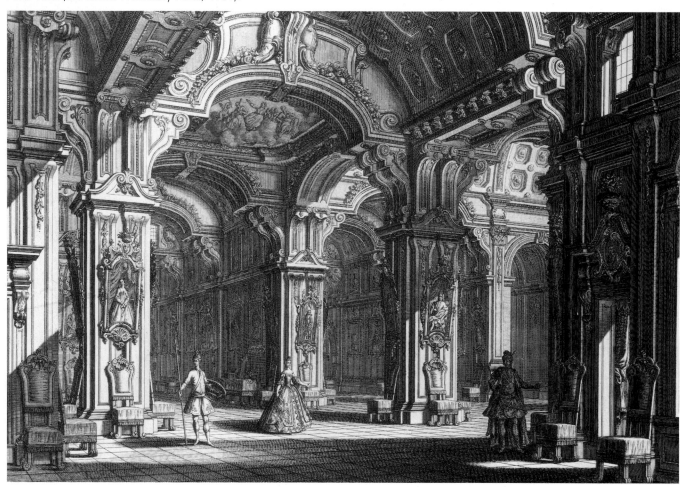

Opera can be divided more or less accurately into four varieties. *Opera* (without a qualifying adjective) is the serious or *tragic opera* that we perhaps think of immediately. This type also has been called *grand opera*, which implies to some an early operatic form consisting usually of five acts. *Opera seria* ("serious opera"), another name for tragic or grand opera, is generally highly stylized and treats heroic subjects, such as gods and heroes of ancient times.

Opéra comique, the second variety of opera, is any opera, *regardless of subject matter*, that has *spoken dialogue*.

The third type, *opera buffa*, is *comic* opera (do not confuse it with opéra comique), which usually does *not* have spoken dialogue. Opera buffa usually uses satire to treat a serious topic with humor—for example Mozart's *Marriage of Figaro*.

The fourth variety, which we will mention again in the next chapter, is *operetta*. Operetta also has spoken dialogue, but it has come to refer to a light style of opera characterized by popular themes, a romantic mood, and often a humorous tone. It is frequently considered more theatrical than musical, and its story line is usually frivolous and sentimental.

Opera does have some unique characteristics. The text of an opera, which is called the *libretto*, is probably the single most important barrier to the appreciation of opera by American audiences. Since the large majority of operas in the contemporary repertoire are not of American origin, the American respondent usually has to overcome the language barrier to understand the dialogue and thereby the plot. It is not a desire for snobbery or exclusivity that causes the lack of English-translation performances; rather, opera loses much of its musical character in translation. We spoke of tone color, or timbre, earlier in this chapter. There are timbre characteristics implicit in the Russian, German, and Italian languages that are lost when they are translated into English. In addition, inasmuch as opera is in a sense the Olympic Games of the vocal-music world—that is, the demands made on the human voice by the composers of opera call for the highest degree of skill and training of any vocal medium—tone placement, and the vowels and consonants requisite to that placement, becomes very important to the singer. It is one thing for a tenor to sing the vowel "eh" on high B-flat in the original Italian. If the translated word to be sung on the same note employs an "oo" vowel, the technical demand is changed considerably. So, the translation of opera from its original tongue into English is a far more difficult and complex problem

than simply providing an accurate translation for a portion of the audience that does not know the text—as important as that may seem. Translation must concern itself with tone quality, color, and the execution of tones in the *tessitura* of the human voice.

Experienced opera goers may study the score before attending a performance. However, every concert program contains a plot synopsis (even when the production is in English), so that even the neophyte can follow what is happening. Opera plots, unlike mysteries, have few surprise endings, and knowing the plot ahead of time does not diminish the experience of responding to the opera.

The first element in opera itself is the overture. This orchestral introduction may have two characteristics. First, it may set the mood or tone of the opera. Here the composer works directly with our sense responses, putting us in the proper frame of mind for what is to follow. In his overture to *I Pagliacci*, for example, Ruggiero Leoncavallo creates a tonal story that tells us what we are about to experience. Using only the orchestra, he tells us we will see comedy, tragedy, action, and romance. If we listen to this overture, we will easily identify these elements, and in doing so understand how relatively unimportant the work's being in English is to comprehension. Add to the "musical language" the language of body and mime, and we can understand even complex ideas and character relationships—*without* words. In addition to this type of introduction, an overture may provide melodic introductions—passages introducing the *arias* and *recitatives* that will follow.

The plot is unfolded musically through *recitative*, or sung dialogue. The composer uses recitative to move the plot along from one section to another; recitative has little emotional content to speak of, and the words are more important than the music. There are two kinds of recitative. The first is *recitativo secco*, for which the singer has very little musical accompaniment, or none at all. If there is accompaniment it is usually in the form of light chording under the voice. The second type is *recitativo stromento*, in which the singer is given full musical accompaniment.

The real emotion and poetry of an opera lie in its *arias*. Musically and poetically, an aria is the reflection of high dramatic feeling. The great opera songs with which we are likely to be familiar are arias.

In every opera there are duets, trios, quartets, and other small ensemble pieces. There also are chorus sections in which everyone gets into the act. In addition, ballet or dance interludes are not uncommon. These may have nothing to do with the development of the plot, but are

put in to add more life and interest to the dramatic production, and in some cases to provide a *segue* from one scene into another.

Bel canto, as its name implies, is a style of singing emphasizing the beauty of sound. Its most successful composer, Gioacchino Rossini, had a great sense of melody and sought to develop the *art song* to its highest level. In bel canto singing the melody is the focus.

Richard Wagner gave opera and theatre a prototype that continues to influence theatrical production—*organic unity*. Every element of his productions was integral and was shaped so as to help create a work of total unity. Wagner was also famous for the use of *leitmotif*, a common element in contemporary film. A leitmotif is a musical theme associated with a particular person or idea. Each time that person appears or is thought of, or each time the idea surfaces, the leitmotif is played.

Late in the nineteenth century, the *verismo* movement flourished. From the same root as the word verisimilitude, with which we have dealt previously, verismo opera treated themes, characters, and events from life in a down-to-earth fashion. The composer Pietro Mascagni is reported to have said, "In my operas do not look for melody or beauty . . . look only for blood!" Certainly in the works of Mascagni, Leoncavallo, and Puccini there is plenty of blood—as well as fine drama.

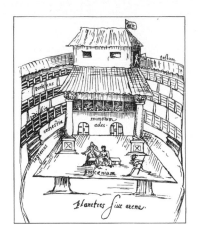

FOUR

THEATRE

Like the other performing arts, theatre is an interpretive discipline. Between the playwright and the audience stand the director and the designers, all artists in their own right but each functioning to communicate the playwright's artwork to the audience. At the same time, each of these artists, and the actors as well, seek to add their own artistic communication to the process. Sometimes the play becomes subordinate to what is expressed by the interpreters.

WHAT IS IT?

Theatre is aesthetic communication through the design of time, sound, and two- and three-dimensional space, using the live performer. Our formal response to a theatrical production depends upon the basic nature, or *genre* (see Glossary), of the play from which the production evolves. Genres in theatre are tragedy, drama, melodrama, comedy, farce, musical comedy, and others. Some are products of specific periods of history and illustrate trends in dramatic literature or theory that no longer exist. Others are still developing, and as yet lack definite form. The genres we will examine are relatively fixed in their definition and development; they are the major genres of

theatre history, including the twentieth century. Our response to genre is a bit different from our formal response or identification in music, for example, because we seldom find generic identification in the theatre program. Some plays are well-known examples of a specific genre, and in these cases, as with a symphony, we can see how the production develops the conventions of that form. Other plays, however, are not well known or may be open to interpretation (or may be arbitrarily interpreted by the director). As a result, we can draw our conclusions only *after* the performance has finished.

TRAGEDY

By convention, tragedy requires an unhappy ending and an ennobling of the victim. It also requires events of significance and dignity that transcend everyday life. In the past these criteria have been met through the use of poetry and the portrayal of personages of high stature, such as kings. Tragedies are as old as recorded history. Our experience with this genre dates to the classic Greek theatre of the fifth century BC. Aristotle, in his *Poetics*, describes in great detail the characteristics of tragedy, and much of his categorization shapes the basis for our discussion even today. There is some debate, however, surrounding the definition of tragedy and the claim that its

heroes must be larger than life. Can a play with an unhappy or tragic ending have a hero who is a common person and still be a tragedy? Another characteristic that seems to be standard for a tragic hero is what many have called the "tragic flaw." Very simply, the tragic flaw is that characteristic of the hero, usually excessive pride, by which he or she creates his or her downfall.

It should be obvious from this brief discussion that tragedy, like so many other genres, is a complex *theoretical* entity. Just as the characteristics of the symphony changed from one historical context or style to another, so too have the characteristics of tragedy changed. What we find in the tragedies of Periclean Athens is different from what we find in Elizabethan England or in seventeenth-century France, for example.

DRAMA

The term drama is often used as a synonym for theatre. Such usage is not entirely accurate. As a genre, drama refers to plays that have serious intent but do not fall within the definition of tragedy. In a drama we do not necessarily have an unhappy ending, but the subject matter is treated in a serious fashion. The events tend to be of lesser *magnitude* than in tragedy. The heroes are of everyday stuff.

MELODRAMA

Melodrama is a genre characterized by sensationalism and sentimentality. The personages and their characters tend to be stereotyped; problems and solutions tend to be all good or all evil. Black is black and white is white; there are no grays either in people or in issues. Plots tend to be overly romantic, and the action exaggerated. The plot usually unfolds as a series of trials, instigated by a villain, which the hero must overcome. In the end, however, "good" prevails and "evil" is punished. Melodrama involves characters in serious situations which arouse suspense, pathos, terror, and, occasionally, hatred. Elaborate scenic devices form a major part of its appeal. Melodrama reached its height as a dramatic genre in the nineteenth century, but can still be found today. In a typical melodrama such as *Uncle Tom's Cabin* we see sensation scenes such as Eliza carrying her baby across the ice on a raging river in the middle of a snowstorm. Much of what we see in modern movies and on television is melodrama. The term melodrama means a combination of music and drama. In the nineteenth century, music accompanied the performance.

COMEDY

We tend to think of plays that make us laugh as comedies. Such a description is not entirely accurate. Many dramas, and even tragedies, have comic moments or scenes. However, comedy *is* typified by humorous treatment of subject matter, whether or not the subject matter is frivolous. Comedies can have serious themes, and, as is occasionally the case, a playwright can cause us to laugh at what is essentially not a funny matter. Sometimes a playwright leads us to believe we are seeing a comic situation. We may laugh throughout the play. Only after leaving the theatre might we have cause to question the nature of what we have experienced.

Comedies, like tragedies, come in various types and from various historical periods. Some comedies, which may be called "high comedy" or comedy of manners, direct themselves to the intellect. Other types appeal more to the emotions. "Low comedy," as it is often called, may be seen as a separate genre called farce, which we will turn to shortly. Comedy, like tragedy, dates from earliest history, and Aristotle also examined its characteristics in the *Poetics*. He wrote that tragedy shows people as better than they are and comedy shows them as worse.

FARCE

The principal difference between comedy and farce lies in the latter's exaggeration of situations and in the actions of the actors. Some writers suggest that farce is to comedy what melodrama is to tragedy. Typically a farce relies for its effect on broad, slapstick humor filled with "sight gags" and action. A comedy rests mainly on its dialogue. If we look to the medium of film, we find in The Three Stooges examples of farce familiar to all of us.

MUSICAL COMEDY

Musical comedy is sometimes called operetta and has also been called the United States' unique contribution to the world of theatre. Whether or not this is true, the musical comedy is a popular theatrical genre in the United States. It is characterized by the interspersing of dialogue and vocal solos, choruses, and dances; the ratio of dialogue to music varies greatly from one musical comedy to another. The genre has apparently changed over a period of years, beginning in the 1950s. It may be more accurate to refer to recent musical comedies as *musicals*, because the themes and subjects of many of them are serious and even tragic, as in *West Side Story*, *A Little Night Music*, and *Les Miserables*.

Since in the theatre we witness a quickly passing parade of complex messages, we need to respond to many things in many ways. Asking ourselves questions about how a play may reflect the characteristics of the genres we have just discussed will help us discern some of the basic intent of the artists who are communicating with us.

HOW IS IT PUT TOGETHER?

Obviously, we can read plays and analyze them. This, however, is not adequate for understanding a theatrical production. Theatre is not literature; it is an art of time and space that transpires with live actors in the confines of some form of theatrical environment. The word *theatre* comes from the Greek *theatron*, which means "a place for seeing." The explicit nature of verbal language is present, but nonverbal language constitutes the essence of theatre. Studying a script is even less a means of responding to theatre than merely studying a score is in responding to music. So, we must examine the entire scope of a theatrical production if we are to understand our response to it.

CHARACTER, MESSAGE, & SPECTACLE PLAYS

To one degree or another every play has elements of character, message, and spectacle. I think it can be helpful to us in responding to a play to try to determine which of these three is the principal focus of the play. Obviously, some plays will appear to fall into more than one category and some into none.

Character Plays

Character plays focus on the development of the characters of the personages. For the sake of accuracy, the *dramatis personae*, or "cast of characters," are called *personages*. The term *character* is used in its psychological sense to mean the composite factors that motivate the actions of the personages. In a character play we focus on why individuals do what they do, how they change, and how they interact with the other individuals as the play unfolds. Tennessee Williams's *The Glass Menagerie* is an illustration of a character play.

Message Plays

A message play focuses on a theme, a specific idea communicated by the playwright to the audience. Its intent is basically instructive. The most obvious form of message play is the propaganda play, of which Clifford Odets's *Waiting for Lefty* is an excellent American example.

Spectacle Plays

Spectacle plays focus neither on character nor on message. There may be elements of both, but characters are superficially drawn and stereotyped and the themes are trite or shallow. Instead, the spectacle play focuses on "action." Most contemporary Americans are surprised to learn that the novel *Ben Hur* was also produced as a stage play, and that the great chariot race for which the movie version is famous was actually done on the stage with two chariots, eight horses, and a complex arrangement of treadmills and revolving background scenery. In this case, character development and message are clearly subordinate to spectacle.

LANGUAGE

An important response to what is in a production is to the language. It is the author's most direct communicative link with us, and it immediately tells us part of what we can expect from the play. Language can comprise *diction*, or what the playwright writes, and/or music, or how the actors say what the playwright writes. A continuum extending from verisimilitude to theatricality is helpful to consider. Dialogue that sounds to us like everyday speech is high in verisimilitude. Poetry, on the other hand, is high in theatricality. We also must listen for the relationship of the language to the overall presentation of the play. Some might call this characteristic *symbolism*. In any case, *how* does the play's language reveal character, theme, or magnitude? In other words, does the author wish us to read between the lines of dialogue? Do the words imply more than what first meets the ear? Does the language cue ideas beyond the text or subject matter of the play, or does it reflect or reveal only the character or personage who utters it? When we consider language we may also wish to consider the manner or style in which the actor utters the language. Poetry may be spoken to deemphasize its poetic qualities; street speech may be declaimed using abnormal durations and inflections, thereby changing its emphasis. What the playwright has written, *how* he or she has written it, and *how* the actors speak that language communicate explicitly and symbolically to us.

STRUCTURE

Dissecting the structure of a play is a delicate operation. Even "theatre people" do not agree on the terminology and procedures involved in putting a play together and making it work. Our task is complicated by the disinclination of most playwrights to adhere to neat formulas when they write. They do whatever they believe is necessary to accomplish their aims. Nevertheless, we can and should understand some basic concepts about play structure. The rudiments of play structure are *exposition*, *complication*, and *denouement*.

Exposition

In the exposition of a play the playwright gives us essential background information. He or she is setting the stage for what we will see as the play progresses. How much time or space (if any) is allotted to the exposition depends entirely on the playwright and the play. Some playwrights lay the exposition as quickly and succinctly as possible; others continue nearly to the final curtain to "fill us in" about what happened prior to the point at which the play began.

Complication

If we regard the situation of a play when the curtain opens as the status quo, or stasis, then usually something—an event or decision—happens to upset that status quo and thereby cause the play to move forward. If and when that happens, we have moved into the complication section of the play. In this section we might say "the plot thickens." The outlaws ride into town, and all is thrown into turmoil. Here the playwright twists the events of the plot and subplots.

Denouement

If an author wishes to resolve all these complications (some do not), then at some *point* we will reach a *climax*, after which the complications will be resolved. That resolution is called the denouement. In many plays the denouement is achieved through a logical sequence of events emanating from the characters of the personages. In early Greek tragedies, however, the complications were so complex that the only means by which the author could undo them was divine intervention. Whenever some device other than logical character development is used to bring about the denouement, we call that device a *deus ex machina*, or "god from a machine"—referring to the method of entrance used by the gods in the theatre of Ancient Greece. Whether the denouement is logical or contrived, a structural pattern that builds to a peak and then resolves to a conclusion is called *pyramidal*.

The Protagonist

Inside the structural pattern of a play some kind of action must take place. We must ask ourselves: How does this play work? How do we get from the beginning to the end? Most of the time, we take that journey via the actions and decisions of the *protagonist*, or central personage. Deciding the protagonist of a play is not always easy, even for directors. However, it is important to understand whom the play is about if we are to understand it. In Terence Rattigan's *Cause Célèbre* we could have three different responses depending upon whom the director decided was the protagonist. The problem is this: There are two central feminine roles. A good case could be made for either as the central personage of the play. Or they both could be equal. What we understand the play to be about depends on whom the director chooses to focus.

DYNAMICS

Every production has its own dynamic patterns, which we can chart (for example, as in Figure **4.1**). The structural pattern of a play, about which we just spoke, is made clear to us by the dynamic patterns the director establishes. These patterns also help to hold the interest of the audience. Scientific studies indicate that attention or interest is not a constant factor; human beings are able to concentrate on specific items only for very brief periods. Therefore, to hold audience attention over the two-hour span of a production, it is essential to employ devices whereby from time to time interest or attention is allowed to peak and then relax. However, the peaks must be carefully controlled. A production should build to a high point of dramatic interest. Usually this point is the climax and occurs late in the play. However, each scene or act has its own peak of development—again, to maintain interest. So, the rise from the beginning of the play to the high point of dramatic interest is not a steady rise, but a series of peaks and valleys. Each successive peak is closer to the ultimate one. The director controls where and how high these peaks occur by controlling the dynamics of the actors—volume and intensity, both bodily and vocal. These are the same two qualities that make up dynamics in music.

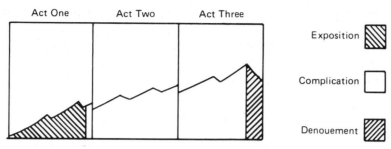

4.1 Hypothetical dynamic and structural development of a three-act play.

The importance of dynamics can be illustrated by situations in which dynamics are uncontrolled. I once saw a college production of Arthur Miller's *All My Sons*, a dramatic play about morality. The climax of the play occurs near the end, when the central personage discovers that his decision to allow defective aircraft engines to be sold to the Air Force caused the death of his own son. The difficulty for the director and actors is that there are scenes of conflict and emotion preceding the climax. In this production the dynamic level went too high too soon. Not only did this cause the climax to be anticlimactic, but since the dynamic level stayed at that early peak, it also caused the production to be monotonous.

THE ACTOR

Although it is not always easy to tell which functions in a production are the playwright's, which the director's, and which the actor's, the responsibility for one function is perfectly clear: the main channel of communication between the playwright and the audience is the actors. It is through their movements and speech that the audience perceives the play.

Our purpose in this discussion is not to study acting. However, we can look for two elements in an actor's portrayal of a role that will enhance our response. The first is *speech*. Language, as we noted a moment ago, is the playwright's words. Speech is the manner in which the actor delivers those words. Speech, like language, can range from high verisimilitude to high theatricality, and it is possible to utter language that is highly verisimilar and speech that is highly theatrical. If speech adheres to normal conversational rhythms, durations, and inflections, we respond in one way. If it utilizes extended vowel emphasis, long, sliding inflections, and dramatic pauses, we respond quite differently—even though the playwright's words are identical in both cases.

The second element of an actor's portrayal that aids our understanding is the physical reinforcement he or she gives to the character's basic motivation. Most actors try to identify a single basic motivation for their character. That motivation is called a *spine*, or superobjective. Everything that pertains to the decisions the personage makes is kept consistent for the audience because those decisions and actions stem from this basic drive. Actors will translate that drive into something physical that they can *do* throughout the play. For example, Blanche, a central personage in Tennessee Williams's *A Streetcar Named Desire*, is driven by the desire to arrange or rearrange whatever she comes in contact with. More specifically, she must *clean* what she encounters, because of the way she regards herself and the world around her. Ideally, the actress playing Blanche will discover that element of Blanche's personality as she reads the play and develops the role. To make that spine clear to us in the audience, the actress will translate it into physical action. Therefore, we will *see* Blanche constantly smoothing her hair, rearranging and straightening her dress, cleaning the furniture, brushing imaginary dust from other personages' shoulders, and so forth. Nearly every physical move she makes will relate somehow to the act of cleaning. Of course, these movements will all be subtle. Nevertheless, if we are attentive we can find them, and thereby understand the nature of the character we are perceiving.

MISE EN SCÈNE

There is another channel of communication between the playwright and the audience—the environment within which the actors work. We may call the elements of this environment the *technical* elements of a production, or we may use the French term *mise en scène*. This term implies not just scenery, lighting, properties, and costumes but also the interrelationship of audience and stage space.

Part of our response to a production is shaped by the design of the space in which the play is produced. The earliest and most natural arrangement is the theatre-in-

4.2 Ground plan of an arena theatre.

4.3 Ground plan of a thrust theatre.

4.4 Ground plan of a proscenium theatre.

the-round, or *arena* theatre (Fig. **4.2**), in which the audience surrounds the playing area on all sides. Whether the playing area is circular, square, or rectangular is irrelevant. Some argue that the closeness of the audience to the stage space in an arena theatre provides the most intimate kind of theatrical experience. A second possibility is the *thrust*, or three-quarter, theatre (Fig. **4.3**), in which the audience surrounds the playing area on three sides. The most familiar illustration of this theatre is what we understand to be the theatre of the Elizabethan or Shakespearean period. The third actor–audience relationship, and the one most widely used in the twentieth century, is the *proscenium* theatre, in which the audience sits on only one side and views the action through a "picture-frame" opening (Fig. **4.4**).

There are also experimental arrangements of audience and stage space. On some occasions acting areas are placed in the middle of the audience, creating little "island stages." In certain circumstances these small stages create quite an interesting set of responses and relationships between actors and audience.

Common experience indicates that the physical relationship of the acting area to the audience has a causal effect on the depth of audience involvement. Experience has also indicated that a certain amount of separation is necessary for certain kinds of emotional responses. We call this mental and physical separation *aesthetic distance*.

The proper aesthetic distance allows us to become involved in what we know is fictitious and even unbelievable.

Mise en scène also implies visual reinforcement involving scenery, lighting, costumes, and properties, each of which has specific goals in the production. The *mise en scène* may or may not have independent communication with the audience; this is one of the options of the director and designers. Before the nineteenth century there was no coordination of the various elements of a theatre production. This, of course, had all kinds of curious, and in some cases catastrophic, consequences. However, for the last century most theatre productions have adhered to what is called the organic theory of play production. That is, everything, visual and oral, is designed with a single purpose. Each production has a specific goal in terms of audience response, and all of the elements in the production attempt to achieve this end.

Scene Design

Simply stated, the purpose of scene design in the theatre is to create an environment conducive to the production's ends. The scene designer uses the same tools of composition—line, form, mass, color, repetition, and unity—as the painter. In addition, since a stage design occupies three-dimensional space and must allow for the movement of the actors in, on, through, and around the elements of scenery, the scene designer becomes a sculptor as well. Figures **4.5**, **4.6**, **4.7**, and **4.8** illustrate how emphasis on given elements of design highlight different characteristics in the production. C. Ricketts's design for *The Eumenides* (Fig. **4.5**) stresses formality, asymmetri-

4.5 Scene design for Aeschylus's *The Eumenides*, c. 1922. Designer: C. Ricketts. Courtesy of the Victoria and Albert Museum, London.

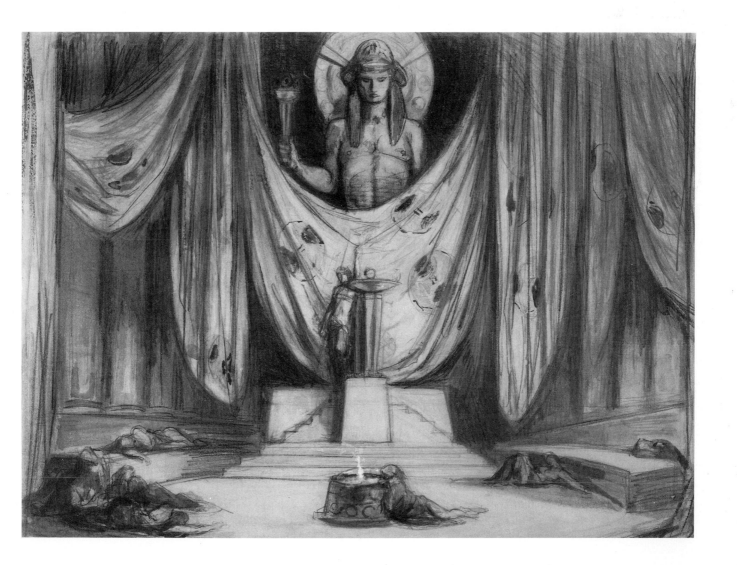

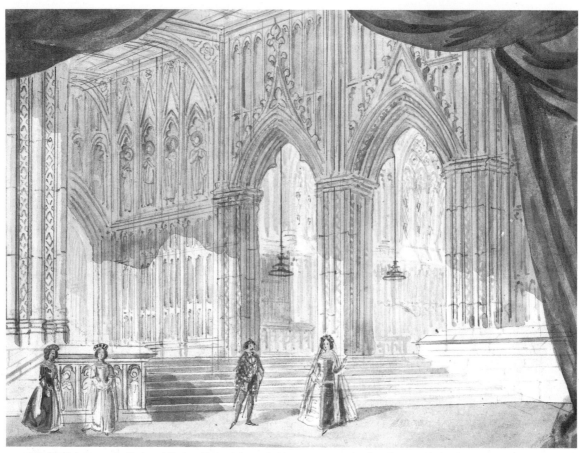

4.6 Shakespeare's *Richard II*, Act Two, scene 2: Entrance into St. Stephen's Chapel. Producer: Charles Kean, London, 1857. Courtesy of the Victoria and Albert Museum, London.

cality, and symbolism. Thomas Grieve's *Richard II* (Fig. **4.6**) is formal, but light and spacious. His regular rhythms and repetition of arches create a completely different feeling from the one elicited by Ricketts's design. William Telbin's *Hamlet* (Fig. **4.7**), with its strong central triangle and monumental scale, creates an overwhelming weight that, while utilizing diagonal activity in the sides of the triangles, cannot match the action of Robert Burroughs's zigzagging diagonals juxtaposed among verticals in his design for *Peer Gynt* (Fig. **4.8**). Unlike the painter or sculptor, however, the scene designer is limited by the stage space, the concepts of the director (as opposed to his or her own), the amount of time and budget available for the execution of the design, and elements of practicality: Can the design withstand the wear and tear of the actors? A scene designer also is limited by the talent and abilities of the staff available to execute the design. A complex setting requiring sophisticated painting and delicate carpentry may be impossible to do if the only staff available are unskilled. These are the constraints, and also the challenges, of scene design.

Lighting Design

Lighting designers are perhaps the most crucial of all the theatre artists in modern productions, because without their art nothing done by the actors, the costume designer, the property master, the director, or the scene designer would be seen by the audience. On the other hand, lighting designers work in an ephemeral medium. They must sculpt with light and create shadows that fall where they desire them to fall; they must "paint" over the colors provided by the other designers. In doing so they use lighting instruments with imperfect optical qualities. Lighting designers do their work in their minds, unlike

4.7 Scene design (probably an alternate design) for Charles Fechter's revival of Shakespeare's *Hamlet*, Lyceum Theatre, London, 1864. Designer: William Telbin. Courtesy of the Victoria and Albert Museum, London.

4.8 Scene design for Ibsen's *Peer Gynt*, the University of Arizona Theatre. Director: Peter R. Marroney. Scene designer: Robert C. Burroughs.

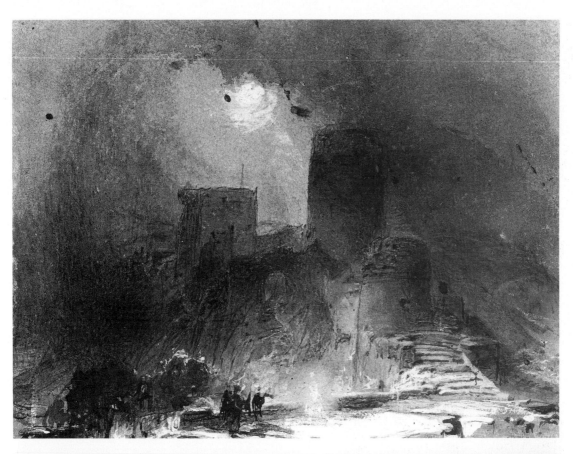

4.9 Costume designs for Shakespeare's *Twelfth Night*, the Old Globe Theatre, San Diego, California. Director: Craig Noel. Costume designer: Peggy J. Kellner.

scene designers, who can paint a design and then calculate it in feet and inches. Lighting designers must imagine what their light will do to an actor, to a costume, to a set. They must enhance the color of a costume, accent the physique of an actor, and reinforce the plasticity of a setting. They also try to reinforce the dramatic structure and dynamics of the play. They work within the framework of light and shade. Without shadows and highlights, the human face and body become imperceptible. A human face without shadows cannot be seen clearly more than a few feet away. In a theatre such small movements as the raising of an eyebrow must be seen clearly as much as 100 feet away. It is the lighting designer who, through proper use of light and shade, makes this possible.

Costume Design

One is tempted to think of the costumes of the theatre merely as clothing that has to be researched to reflect a particular historical period and constructed to fit a particular actor. But costuming goes beyond that. Costume designers work with the entire body of the actor. They design hair styles and clothing and sometimes makeup to suit a specific purpose or occasion, a character, a locale, and so forth (Figs. **4.9** and **4.10**). A costume outlines the actor's figure for the audience to see.

The function of stage costuming is threefold. First, it *accents*—that is, it shows the audience which personages are the most important in a scene, and it shows the relationship between personages. Second, it *reflects*—a par-

ticular era, time of day, climate, season, location, or occasion. The designs in Figure **4.9** reflect a historical period. We recognize different historical periods primarily through silhouette, or outline. Costume designers may merely suggest full detail or may actually provide it, as has been done in Figure **4.9**. We see here the designer's concern not only for period but also for character in her choice of details, color, texture, jewelry, and also hair style. Notice the length to which the designer goes to indicate detail, providing not only front but also back views of the costume, and also a head study showing the hair without a covering. Third, stage costuming *reveals* —the style of the performance, the characters of the personages, and the personages' social position, profession, cleanliness, age, physique, and health. In Figure **4.10** the concern of the designer is clearly less with historical period than with production style and character. This costume design reveals the high emotional content of the particular scene, and we see at first glance the deteriorated

4.10 Costume designs for Shakespeare's *King Lear*, the Old Globe Theatre, San Diego, California. Director: Edward Payson Call. Costume designer: Peggy J. Kellner.

KING LEAR
Act IV scene VI

health and condition of King Lear. The contrast provided by the king in such a state heightens the effect of the scene, and details such as the bare feet, the winter furs, and the storm-ravaged cape are precise indicators of the pathos we are expected to find and respond to in it. Costume designers work, as do scene and lighting designers, with the same general elements as painters and sculptors: the elements of composition. A stage costume is an actor's skin: It allows her to move as she must, and occasionally it restricts her from moving as she should not.

Properties

Properties fall into two general groups: *set props* and *hand props*. Set properties are part of the scene design: furniture, pictures, rugs, fireplace accessories, and so on. Along with the larger elements of the set, they identify the mood of the play and the character of those who inhabit the world they portray. Hand properties used by the actors in stage business also help to portray characters of the personages: cigarettes, cigars, ashtrays, papers, pencils, glasses, and so forth. The use of properties can be significant to our understanding of a play. For example, if at the opening curtain all properties appear to be neat and in order, we receive a particular message. If as the play develops the actors disrupt the properties so that at the end of the play the entire scene is in disarray, that simple transition can help illustrate what may have happened in the play.

VERISIMILITUDE

In describing the relationship of the *mise en scène* to the play, we have noted the designers' use of compositional elements. The use of these elements relative to "life" can be placed on a continuum, one end of which is theatricality and the other, verisimilitude. Items high in verisimilitude we recognize as being like those items with which we deal in everyday life: language, movements, furniture, trees, rocks, and so forth. As we progress on our continuum from verisimilitude to theatricality the elements of the production express less and less relationship to everyday life. They become distorted, exaggerated, and perhaps even nonobjective. Items far removed from verisimilitude, then, are high in theatricality. Poetry, as we noted, is high in theatricality; everyday speech is high in verisimilitude. The position of the various elements of a production on this continuum suggests the style of the play, in the same sense that brushstroke, line, and palette indicate style in painting.

Figures **4.11–4.16** illustrate the range between verisimilitude and theatricality. Figure **4.11** is a proscenium setting high in verisimilitude—including a full ceiling over the setting. Figure **4.12** is an arena setting high in verisimilitude; it reflects the basically lifelike over-all style of the presentation. However, the requirement of the arena configuration that there be *no walls* can cause problems in some productions. Note that some theatricality—specifically, the empty picture frame—is present in the decoration of this set. This is not an inconsistency

4.11 A proscenium setting for Jean Kerr's *Mary, Mary*, the University of Arizona Theatre. Director: H. Wynn Pearce. Scene and lighting designer: Dennis J. Sporre.

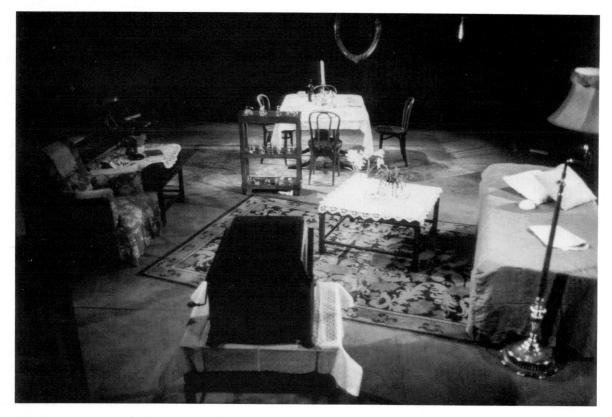

4.12 An arena setting for Tennessee Williams's *The Glass Menagerie*, State University of New York at Plattsburgh. Director: H. Charles Kline. Scene and lighting designer: Dennis J. Sporre.

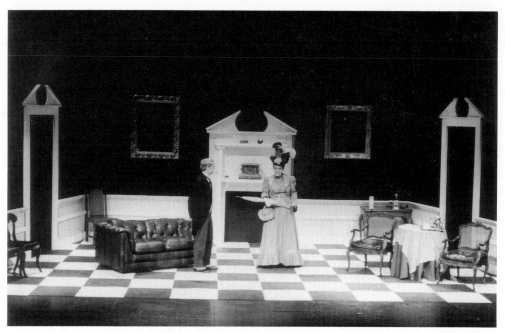

4.13 A proscenium setting for Oscar Wilde's *The Importance of Being Earnest*, the University of Arizona Theatre. Director: William Lang. Costume designer: Helen Workman Currie. Scene and lighting designer: Dennis J. Sporre.

4.14 Scene design for Jerry Devine and Bruce Montgomery's *The Amorous Flea* (musical), the University of Iowa Theatre. Director: David Knauf. Scene and lighting designer: Dennis J. Sporre.

since the play develops as a "flashback" in the mind of its main personage. In Figure **4.13** the designer has attempted to heighten the theatrical nature of the production by using set props high in verisimilitude and a setting that is representational but pushed toward theatricality by the use of open space where one might expect solid walls in this proscenium production. The setting in Figure **4.14** moves further toward theatricality and indicates clearly through exaggerated detail and two-dimensionality the whimsical and "fun" nature of the production. The

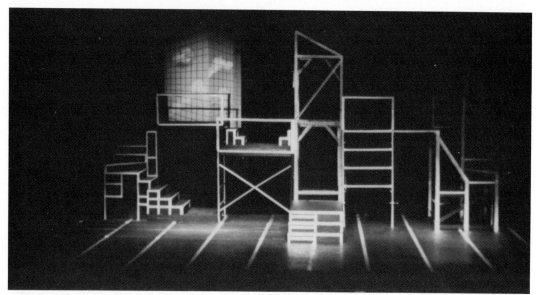

4.15 A proscenium setting for Stephen Sondheim's *Company* (musical), the University of Arizona Theatre. Director: Peter R. Marroney. Scene and lighting designer: Dennis J. Sporre.

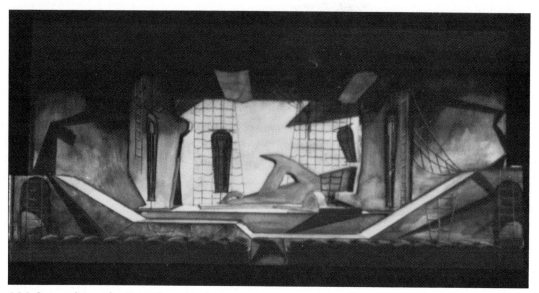

4.16 Scene design for Euripides's *The Bacchae*, University of Illinois at Chicago Circle. Director: William Raffeld. Scene and lighting designer: Dennis J. Sporre.

design in Figure **4.15** creates a purely formal and theatrical environment. No locale is specifically depicted, but the use of representational detail (various areas of the set served as "locations" and had realistic furniture) keeps the setting tied to the overall approach of the actors. Finally, in Figure **4.16**, neither time nor place is indicated or remotely suggested. Here the emphasis is on reinforcement of the high action of the production. The steep ramps throughout the set make it impossible for the actors to walk from one level to the next; the setting *forces* them to *run*.

In this series of illustrations I have used my own designs, not out of vanity but to make a further point. In most arts the artist's *style* is unique—a recognizable mark on his or her artwork. Some artists change their style, but they do so by their own choice. Interpretive artists such as costume, scene, and lighting designers, and to a degree conductors as well, must submerge their personal style to that of the work with which they are involved. The playwright or the director sets the style, and the scene designer adapts to it and makes *his* or *her design* reflect that style.

How does it Stimulate the Senses?

The specific treatment given to each of the elements we have just discussed stimulates our senses in a particular manner. We respond to the play's structure and how it works; we respond to dynamics. We are stimulated by the theatricality or verisimilitude of the language of the playwright and the movements and speech of the actors. We find our response shaped by the relationship of the stage space to the audience, and by the sets, lights, properties, and costumes. All of these elements bombard us simultaneously with complex visual and aural stimuli. How we respond, and how much we are able to respond, determine our ultimate reaction to a production.

Perhaps the theatre is unique in its ability to stimulate our senses, because only in the theatre is there a direct appeal to our emotions through the live portrayal of other individuals involved directly in the human condition. Being in the presence of live actors gives us much more of life in the two hours in which we share their company than we could experience outside the confines of the theatre in that same time span. That phenomenon is an experience difficult to equal. The term we use to describe our reaction to and involvement with what we experience in a theatrical production is *empathy*. Empathy causes us to cry when individuals whom we know are only actors become involved in tragic or emotional situations. Empathy makes us wince when an actor slaps the face of another actor, or when two football players collide at full speed. Empathy is our mental and physical involvement in situations in which we are not direct participants.

Now let us examine a few of the more obvious ways a production can appeal to our senses. In plays that deal in *conventions* the language may act as virtually the entire stimulant of our senses. Through the language the playwright sets the time, the place, the atmosphere, and even the small details of decoration. We become our own scene, lighting, and even costume designer, imagining what the playwright tells us ought to be there. In the opening scene of Shakespeare's *Hamlet* we find Bernardo and Francisco, two guards. The hour is midnight; it is bitter cold; they are on guard; we are in Denmark; a ghost appears, in "warlike form." How do we know all of this? In a modern production we might *see* it all through the work of the costume and set designers. But this need not be the case, because the playwright gives us all of this information *in the dialogue*. Shakespeare wrote for a theatre that had no lighting instruments save for the sun. His theatre (such as we know of it) probably used no scenery. The costumes were the street clothes of the day. The theatrical environment was the same whether the company was playing *Hamlet, Richard III,* or *The Tempest.* So what needed to be seen needed to be imagined. The language provided the stimuli for the audience.

We also respond to what we see. We examined dynamics earlier. A sword fight performed with flashing action, swift movements, and great intensity sets us on the edge of our chair. We are helpless to respond otherwise. Although we know the action is staged and the incident fictitious, we are caught in the excitement of the moment. We also can be gripped and manipulated by events of a quite different dynamic quality. In many plays we witness "character assassination" as one life after another is laid bare before us. The intense but subtle movements of the actors—both bodily and vocal—can pull us here and push us there emotionally and perhaps cause us to leave the theatre feeling as if a rock were resting in our stomach. Part of our response is caused by subject matter, part by language, but much of it is the result of careful manipulation of dynamics.

Mood is an important factor in the communication that occurs in the theatre. Before the curtain is up our senses are tickled by stimuli designed to put us in the mood for what follows. The houselights in the theatre may be very low, or we may see a *cool* or *warm* light on the front curtain. *Music* fills the theatre. We may recognize the raucous tones of a 1930s jazz piece or the melancholy of a ballad. Whatever the stimuli, they are all carefully designed to *cause* us to begin to react the way the director wishes us to react. Once the curtain is up, the assault on our senses continues. The palette utilized by the scene, lighting, and costume designers helps communicate the mood of the play and other messages about it. The rhythm and variation in the *mise en scène* capture our interest and reinforce the rhythmic structure of the play. In Figure **4.8** the use of line and form as well as color provides a formal and infinite atmosphere reflecting the epic grandeur of Ibsen's *Peer Gynt.*

The degree of plasticity or three-dimensionality created by the lighting designer's illumination of the actors and the set causes us to respond in many ways. If the lighting designer has placed the primary lighting instruments directly in front of the stage, plasticity will be diminished and the actors will appear washed out or two-dimensional. We respond quite differently to that visual stimulant than to the maximum plasticity and shadow resulting from lighting coming nearly from the side.

We also react to the *mass* of a setting. Scenery that towers over the actors and appears massive in weight is different in effect from scenery that seems miniscule in comparison with the human form. The settings in Figures **4.5**, **4.6**, **4.7**, and **4.13** are different from one another in scale, and each places the actors in a different relationship with their surroundings. In Figure **4.13** the personages are at the center of their environment; in Figure **4.7** they are clearly subservient to it.

Finally, focus and line act on our senses. Careful composition can create movement, outlines, and shadows that are crisp and sharp. Or it can create images that are soft, fuzzy, or blurred. Each of these devices is a stimulant; each has the potential to elicit a relatively predictable response. Perhaps in no other art are such devices so available and full of potential for the artist. We, as respondents, benefit through nearly total involvement in the life situation that comes to us over the footlights.

FIVE

FILM*

It is only within the last two decades that film has become accepted as a legitimate form of art and that serious and responsible critics and scholars have begun to examine the component parts of films and how they interact with the general form of the film to create both form and style. Of the forms of art considered in this volume, the film is the most familiar and the most easily accessible; it is usually accepted almost without conscious thought, at least in terms of the story line or the star image presented or the basic entertainment value of the product. Yet all these elements are carefully crafted out of editing techniques, camera usage, juxtaposition of image, and structural rhythms—among others. It is these details of cinematic construction that can enhance the viewing of a film and can raise the film from mere entertainment into the realm of serious art. Bernard Shaw once observed that "details are important; they make comments." The perception of the details of the film is not as easy as it might seem, since at the same time serious students are searching them out the entertainment elements of the film are drawing their attention away from the search. Because of these entertainment elements and the inundation of our society with film, the serious perception of the art of the film is not an easy one, but time and a conscious effort can reward the student with insights that are not those of the casual film viewer.

WHAT IS IT?

Film is aesthetic communication through the design of time and of three-dimensional space compressed into a two-dimensional image. Of all the arts discussed in this volume, film is the only one that also is an invention. Once the principles of photography had evolved and the mechanics of recording and projecting cinematic images were understood, society was ready for the production of pictures that could move, be presented in color, and eventually talk.

If you examine a strip of film, you will notice that it is only a series of pictures arranged in order the length of the strip. Each of these pictures, or *frames*, is about 4/5 in (22 mm) wide and 3/5 in (16 mm) high. If you study the frames in relation to one another, you will see that even though each frame may seem to show exactly the same scene, the position of the objects in the separate frames is slightly different. When this film, which contains sixteen frames per foot (30 cm) of film, is run on a projecting device and passed before a light source at the rate of

*The text for this chapter was prepared by M. Ellis Grove. I have edited and expanded where necessary to conform to the rest of the text.

twenty-four frames per second (sixteen to eighteen frames per second for silent films), the frames printed on it are enlarged through the use of a magnifying lens, are projected on a screen, and appear to show movement. However, the motion picture, as film is popularly called, does not really move but only seems to. This is due to an optical phenomenon called *persistence of vision*, which according to legend was discovered by the astronomer Ptolemy sometime around the second century AD. The theory behind persistence of vision is that the eyes take a fraction of a second to record an impression of an image and send it to the brain. Once the impression is received, the eye retains it on the retina for about one-tenth of a second after the actual image has disappeared. The film projector has built into it a device that pulls the film between the light source and a lens in a stop-and-go fashion, the film pausing long enough at each frame to let the eye take in the picture. Then a shutter on the projector closes, the retina retains the image, and the projection mechanism pulls the film ahead to the next frame. Holes, or *perforations*, along the right-hand side of the filmstrip enable the teeth on the gear of the driving mechanism to grasp the film and not only move it along frame by frame but also hold it steady in the gate or slot between the light source and the magnifying lens. It is this stop-and-go motion that gives the impression of continuous movement; if the film did not pause at each frame, the eye would receive only a blurred image.

The motion picture was originally invented as a device for recording and depicting motion. But once this goal was realized, it was quickly discovered that this machine could also record and present stories—in particular, stories that made use of the unique qualities of the medium of film.

Our formal response to film recognizes three basic techniques of presentation. These are narrative film, documentary film, and absolute film.

NARRATIVE FILM

The narrative film is one that tells a story; in many ways it uses the technique of theatre. The narrative film follows the rules of literary construction in that it begins with expository material, adds levels of complications, builds to a climax, and ends with a resolution of all the plot elements. As in theatre, the personages in the story are portrayed by professional actors under the guidance of a director; the action of the plot takes place within a *mise en scène* that is designed and constructed primarily for the action of the story but that also allows the camera to move freely in photographing the action. Many narrative films are genre films, constructed out of familiar literary styles—the western, the detective story, and the horror story, among others. In these films the story elements are so familiar to the audience that it usually knows the outcome of the plot before it begins. The final showdown between the "good guy" and the "bad guy," the destruction of a city by an unstoppable monster, and the identification of the murderer by the detective are all familiar plot elements that have become clichés or stereotypes within the genre; their use fulfills audience expectations. Film versions of popular novels and stories written especially for the screen are also part of the narrative-film form, but since film is a major part of the mass-entertainment industry the narrative presented is usually material that will attract a large audience and thus assure a profit.

DOCUMENTARY FILM

Documentary film is an attempt to record actuality using primarily either a sociological or a journalistic approach. It is normally not reenacted by professional actors and often is shot as the event is occurring, at the time and place of its occurrence. The film may use a narrative structure, and some of the events may be ordered or compressed for dramatic reasons, but its presentation gives the illusion of reality. The footage shown on the evening television news, programming concerned with current events or problems, and full coverage either by television or film companies of a worldwide event, such as the Olympics, are all kinds of documentary film. All convey a sense of reality as well as a recording of time and place.

ABSOLUTE FILM

Absolute film is to narrative film as absolute music is to program music (see Glossary). It is simply film that exists for its own sake, for its record of movement or form. It does not use narrative techniques—although documentary techniques can be used in some instances. Created neither in the camera nor on location, absolute film is built carefully, piece by piece, on the editing table or through special effects and multiple-printing techniques. It tells no story but exists solely as movement or form. Absolute film is rarely longer than twelve minutes (one reel) in length, and it usually is not created for commercial intent but is meant only as an artistic experience. Narrative or documentary films may contain sections that can be labeled absolute, and these sections can be studied either in or out of the context of the whole film.

HOW IS IT PUT TOGETHER?

MAGNITUDE & CONVENTION

In addition to considering whether a film is narrative, documentary, or absolute, the student of film must also realize both the magnitude of the film and the film's use of certain conventions. In considering the magnitude of a film, one must be aware of the means by which the film is to be communicated. In other words, was the film made for a television showing or for projection in a large film theatre? Due to the size of the television receiver, large panoramas or full-scale action sequences are not entirely effective on the TV—they become too condensed. TV films, to be truly effective, should be built around the close-up and around concentrated action and movement, since the TV audience is closer to the image than are the viewers in a large theatre. Scenes of multiple images with complex patterns of movement or scenes of great violence will become confusing because of the intimacy of television, and will seem more explicit than they really are. On the other hand, when close shots of intimate details are enlarged through projection in a theatre they may appear ridiculous. The nuance of a slightly raised eyebrow that is so effective in the living room will appear either silly or overly dramatic when magnified on a 60 ft (18 m) screen. Today's filmmakers, when creating a film, must be aware of how it will appear if translated to the home screen or enlarged in a theatre; their work ought to be designed to accommodate the size of either medium.

The film, as with theatre, has certain conventions or customs that the viewer accepts without hesitation. When an exciting chase scene takes place, no one asks where the orchestra is that is playing the music that enhances the sequence; they merely accept the background music as part of the totality of the film. A film photographed in black and white is accepted as a recording of reality, even though the viewers know that the real world has color while this particular reel world does not. When a performer sings and dances in the rain in the middle of a city street, no member of the audience worries if the orchestra is getting wet or wonders if the performer will be arrested for creating a public spectacle. The conventions of the musical film are equally acceptable to an audience conditioned to accept them.

This consideration of conventions is especially important to the acceptance of the silent film as a form of art. The silent film should not be thought of as a sound film without sound but as a separate entity with its own special conventions. These conventions revolve around the methods used to indicate sound and dialogue without actually using them. The exaggerated pantomime and acting styles, the use of titles, character stereotyping, and visual metaphors are all conventions that were accepted during the silent era but appear ludicrous today, because of changes in style and taste and improvements in the devices used for recording and projecting film. The action in the silent film was recorded and presented at a speed of sixteen to eighteen frames per second; when that action is presented today on a projector that operates at twenty-four frames per second, the movement becomes too fast and appears to be jerky and disconnected. However, once you learn to accept these antiquated conventions, you may find that the silent film is an equally effective form of cinematic art.

EDITING

Film is rarely recorded in the order of its final presentation; it is filmed in bits and pieces and put together, after all the photography is finished, as one puts together a jigsaw puzzle or builds a house. The force or strength of the final product depends upon the editing process used, the manner in which the camera and the lighting are handled, and the movement of the actors before the camera. Naturally, the success of a film depends equally on the strength of the story presented and the ability of the writers, actors, directors, and technicians who have worked on the film. However, this level of success is based on the personal taste of the audience and the depth of perception of the individual, and therefore does not lie within the boundaries of this discussion.

Perhaps the greatest difference between film and the other arts discussed within this volume is the use of *plasticity*, the quality of film that enables it to be cut, spliced, and ordered according to the needs of the film and the desires of the filmmaker. If twenty people were presented with all the footage shot of a presidential inauguration and asked to make a film commemorating the event, you would probably see twenty completely different films; each filmmaker would order the event according to his or her own views and artistic ideas. The filmmaker must be able to synthesize a product out of many diverse elements. This concept of plasticity is, then, one of the major advantages of the use of the machine in consort with an art form.

It is the editing process, then, that creates or builds the

film, and within that process are many ways of meaningfully joining shots and scenes to make a whole. Let's examine some of these basic techniques. The *cut* is simply the joining together of shots during the editing process. A *jump cut* is a cut that breaks the continuity of time by jumping forward from one part of the action to another part that obviously is separated from the first by an interval of time, location, or camera position. It is often used for shock effect or to call attention to a detail, as in commercial advertising on television. The *form cut* cuts from an image in a shot to a different object that has a similar shape or contour; it is used primarily to make a smoother transition from one shot to another. For example, in D. W. Griffith's silent film *Intolerance*, attackers are using a battering ram to smash in the gates of Babylon. The camera shows the circular frontal area of the ram as it is advanced towards the gate. The scene cuts to a view of a circular shield, which in the framing of the shot is placed in exactly the same position as the front view of the ram.

Montage can be considered the most aesthetic use of the cut in film. It is handled in two basic ways: first, as an indication of compression or elongation of time, and, second, as a rapid succession of images to illustrate an association of ideas. A series of stills from Leger's *Ballet mécanique* (Fig. **5.1**) illustrates how images are juxtaposed to create comparisons. For example, a couple goes out to spend an evening on the town, dining and dancing. The film then presents a rapid series of cuts of the pair—in a restaurant, then dancing, then driving to another spot, then drinking, and then more dancing. In this way the audience sees the couple's activities in an abridged manner. Elongation of time can be achieved in the same way. The second use of montage allows the filmmaker to depict complex ideas or draw a metaphor visually. Sergei Eisenstein, the Russian film director, presented a shot in one of his early films of a Russian army officer walking out of the room, his back to the camera and his hands crossed behind him. Eisenstein cuts immediately to a peacock strutting away from the camera and spreading its tail. These two images are juxtaposed, and the audience is allowed to make the association that the officer is as proud as a peacock.

CAMERA VIEWPOINT

Camera position and viewpoint are as important to the structure of film as is the editing process. How the camera is placed and moved can be of great value to filmmakers as an aid in explaining and elaborating upon their cinematic ideas. In the earliest days of the silent film the camera was

5.1 *Ballet mécanique*, 1924. A film by Fernand Léger.

merely set up in one basic position; the actors moved before it as if they were performing before an audience on a stage in a theatre. However, watching an action from one position became dull, and the early filmmakers were forced to move the camera in order to add variety.

The Shot

The *shot* is what is recorded by the camera over a particular period of time and is the basic unit of filmmaking. Several varieties are used. The *master shot* is a single shot of an entire piece of action, taken to facilitate the assembly of the component shots of which the scene will finally be composed. The *establishing shot* is a long shot introduced at the beginning of a scene to establish the interrelationship of details, a time, or a place, which will be elaborated upon in subsequent shots. The *long shot* is a shot taken with the camera a considerable distance from the subject. The *medium shot* is taken nearer to the subject. The *close-up* is a shot taken with the camera quite near the subject. A *two-shot* is a close-up of two persons with the camera as near as possible while keeping both subjects within the frame. A *bridging shot* is a shot inserted in the editing of a scene to cover a brief break in the continuity of the scene.

Objectivity

An equally important variable of camera viewpoint is whether the scene is shot from an objective or subjective viewpoint. The *objective viewpoint* is that of an omnipotent viewer, roughly analogous to the technique of third-person narrative in literature. In this way filmmakers allow their audience to watch the action through the eyes of a universal spectator. However, filmmakers who wish to involve their audience more deeply in a scene may use the *subjective viewpoint*: The scene is presented as if the audience were actually participating in it, and the action is viewed from the filmmaker's perspective. This is analogous to the first-person narrative technique, and is usually found in the films of the more talented directors.

CUTTING WITHIN THE FRAME

Cutting within the frame is a method used to avoid the editing process. It can be created by actor movement, camera movement, or a combination of the two. It allows the scene to progress more smoothly and is used most often on television. In a scene in John Ford's *Stagecoach*, the coach and its passengers have just passed through hostile Indian territory without being attacked; the driver and his passengers all express relief. Ford cuts to a long shot of the coach moving across the desert and *pans*, or follows, it as it moves from right to left on the screen. This movement of the camera suddenly reveals in the foreground, and in close-up, the face of a hostile Indian watching the passage of the coach. In other words, the filmmaker has moved from a long shot to a close-up without needing the editing process. He has also established a spatial relationship. The movement of the camera and the film is smooth and does not need a cut to complete the sequence. In a scene from *Jaws* (Fig. **5.2**) the camera moves from the distant objects to the face in the foreground, finally including them both in the frame; the pan across the scene in so doing is accomplished without editing of the film.

DISSOLVES

During the printing of the film negative transitional devices can be worked into a scene. They are usually used to indicate the end of the scene and the beginning of another. The camera can cut or jump to the next scene, but the transition can be smoother if the scene fades out into black and the next scene fades in. This is called a *dissolve*. A *lap dissolve* occurs when the fade-out and the fade-in are done simultaneously and the scene momentarily overlaps. A *wipe* is a form of optical transition in which a line moves across the screen, eliminating one shot and revealing the next, much in the way a windshield wiper moves across the windshield of a car. In silent film the transition could also be created by closing or opening the aperture of the lens; this process is called an *iris-out* or an *iris-in*.

MOVEMENT

Camera movement also plays a part in film construction. The movement of the camera as well as its position can add variety or impact to a shot or a scene. Even the manner in which the lens is focused can add to the meaning of the scene. If the lens clearly shows both near and distant objects at the same time, the camera is using *depth of focus*. In Figure **5.2** foreground and background are equally in focus. In this way actors can move in the scene without necessitating a change of camera position. Many TV shows photographed before an audience usually use this kind of focus. If the main object of interest is photographed clearly while the remainder of the scene is blurred or out of focus, the camera is using *rack* or *differential focus*. With this technique the filmmaker can focus the audience's attention on one element within a shot.

5.2 *Jaws*, 1975. Universal Pictures. Director: Steven Spielberg. Copyright © by Universal Pictures, a Division of Universal City Studios, Inc. All Rights Reserved.

5.3 *The Birth of a Nation*, 1915. Director: D.W. Griffith.

There are many kinds of physical (as opposed to apparent) camera movement that can have a bearing upon a scene. The *track* is a shot taken as the camera is moving in the same direction, at the same speed, and in the same place as the object being photographed. A *pan* is taken by rotating the camera horizontally while keeping it fixed vertically. The pan is usually used in enclosed areas, particularly TV studios. The *tilt* is a shot taken while moving the camera vertically or diagonally; it is used to add variety to a sequence. A *dolly shot* is taken by moving the camera toward or away from the subject. Modern sophisticated lenses can accomplish the same movement by changing the focal length. This negates the need for camera movement and is known as a *zoom shot*.

Of course, the camera cannot photograph a scene without light, either natural or artificial. Most television productions photographed before a live audience require a flat, general illumination pattern. For close-ups, stronger and more definitely focused lights are required to highlight the features, eliminate shadows, and add a feeling of depth to the shot. Cast shadows or atmospheric lighting (in art, *chiaroscuro*) is often used to create a mood, particularly in films made without the use of color (Fig. 5.3). Lighting at a particular angle can heighten the feeling of texture, just as an extremely close shot can. These techniques add more visual variety to a sequence.

If natural or outdoor lighting is used and the camera is hand-held, an unsteadiness in movement is found in the resulting film; this technique and effect is called *cinéma verité*. This kind of camera work, along with natural lighting, is found more often in documentary films or in sequences photographed for newsreels or television news programming. It is one of the conventions of current-events reporting and adds to the sense of reality necessary for this kind of film recording.

These techniques and many others are all used by filmmakers to ease some of the technical problems in making a film. They can be used to make the film smoother or more static, depending upon the needs of the story line, or to add an element of commentary to the film. One school of cinematic thought believes that camera technique is best when it is not noticeable; another, more recent way of thinking believes that the obviousness of all the technical aspects of film adds meaning to the concept of cinema. In any case, camera technique is present in every kind of film made and is used to add variety and commentary, meaning and method, to the shot, the scene, and the film.

HOW DOES IT STIMULATE THE SENSES?

The basic aim of film, as with any art, is to involve the audience in its product, either emotionally or intellectually. Of course, there is nothing like a good plot with well-written dialogue delivered by trained actors to create audience interest. But there are other ways in which filmmakers may enhance their final product, techniques that manipulate the audience toward a deeper involvement or a heightened intellectual response. Figure 5.4 illustrates how angles and shadows within a frame help create a feeling of excitement and variety. An in-depth study of the films of Fellini, Hitchcock, or Bergman may indicate how directors can use some of the technical aspects of film to underline emotions or strengthen a mood or an idea.

5.4 Still from an unidentified silent film.

It is in the area of technical detail that perception is most important for students of film. They should begin to cultivate the habit of noticing even the tiniest details in a scene, for often these details may add a commentary that the average member of an audience may miss. For example, in Hitchcock's *Psycho*, when the caretaker of the motel (Tony Perkins) wishes to spy upon the guests in cabin 1, he pushes aside a picture that hides a peephole. The picture is a reproduction of *The Rape of the Sabine Women*. Hitchcock's irony is obvious. Thus, perception becomes the method through which viewers of film may find its deeper meanings as well as its basic styles.

CROSSCUTTING

There are many techniques that filmmakers can use to heighten the feeling they desire their film to convey. The most familiar and most easily identified is that of crosscutting. This is an alternation between two separate actions that are related by theme, mood, or plot but are usually occurring within the same period of time. Its most common function is to create suspense. Consider this familiar cliché. Pioneers going west in a wagon train are besieged by Indians. The settlers have been able to hold them off, but ammunition is running low. The hero has been able to find a cavalry troop, and they are riding to the rescue. The film alternates between views of the pioneers fighting for their lives and shots of the soldiers galloping to the rescue. The film continues to cut back and forth, the pace of cutting increasing until the sequence builds to a climax— the cavalry arriving in time to save the wagon train. The famous chase scene in *The French Connection*, the final sequences in *Wait Until Dark*, and the sequences of the girl entering the fruit cellar in *Psycho* are built for suspense through techniques of crosscutting.

In fact, the crosscut is so effective in creating rhythm and tension in film that we can find it everywhere. This device gives the film its unique ability to create for the audience a perfectly believable representation of multiple actions occuring within the exact same timeframe.

A more subtle case of crosscutting, *parallel development* occurs in *The Godfather, Part I*. At the close of that film Michael Corleone is acting as godfather for his sister's son; at the same time his men are destroying all his enemies. The film alternates between views of Michael at the religious service and sequences showing violent death. This parallel construction is used to draw an ironic comparison; actions are juxtaposed. By developing the two separate actions, the filmmaker allowed the audience to draw their own inferences and added meaning.

TENSION BUILD-UP AND RELEASE

If the plot of a film is believable, the actors competent, and the director and film editor talented and knowledgeable, a feeling of tension will be built up. If this tension becomes too great, the audience will seek some sort of release, and an odd-sounding laugh, a sudden noise, or a loud comment from a member of the audience may cause the rest of the viewers to laugh, thus breaking the tension and in a sense destroying the atmosphere so carefully created. Wise filmmakers therefore build into their film a *tension release* that deliberately draws laughter from the audience, but at a place in the film where they wish them to laugh. This tension release can be a comical way of moving, a gurgle as a car sinks into a swamp, or merely a comic line. It does not have to be too obvious, but it should be present in some manner. After a suspenseful sequence the audience needs to be relaxed; once the tension release does its job, the audience can be drawn into another suspenseful or exciting situation.

Sometimes, to shock the audience or maintain their attention, a filmmaker may break a deliberately created pattern or a convention of film. In *Jaws*, for example, each time the shark is about to appear, a four-note musical *motif* is played. The audience thereby grows to believe that it will hear this warning before each appearance, and so it relaxes. However, toward the end of the film the shark suddenly appears without benefit of the motif, shocking the audience. From that point until the end of the film it can no longer relax, and its full attention is directed to it.

DIRECT ADDRESS

Another method used to draw attention is that of *direct address*. It is a convention in most films that the actors rarely look at or talk directly to the audience. However, in *Tom Jones*, while Tom and his landlady are arguing over money, Tom suddenly turns directly to the audience and says, "You saw her take the money." The audience's attention is focused on the screen more strongly than ever after that. This technique has been effectively adapted by television for use in commercial messages. For example, a congenial man looks at the camera (and you) with evident interest and asks if you are feeling tired, rundown, and sluggish. He assumes you are and proceeds to suggest a remedy. In a sense, the aside of nineteenth-century melodrama and the soliloquy of Shakespeare were also ways of directly addressing an audience and drawing them into the performance.

5.5 *Your Darn Tootin'*, 1928. A Hal Roach Production for Pathé Films. Director: Edgar Kennedy.

Of course, silent films could not use this type of direct address to the audience; they had only the device of titles. However, some of the silent comedians felt that they should have direct contact with their audience, and so they developed a *camera look* as a form of direct address. After an especially destructive moment in his films, Buster Keaton would look directly at the camera, his face immobile, and stare at the audience. When Charlie Chaplin achieved an adroit escape from catastrophe he might turn toward the camera and wink. Stan Laurel would look at the camera and gesture helplessly (Fig. 5.5), as if to say, "How did all this happen?" Oliver Hardy, after falling into an open manhole, would register disgust directly to the camera and the audience. These were all ways of commenting to the audience and letting them know that the comedians knew they were there. Some sound comedies adapted this technique. In the "road" pictures of Bob Hope and Bing Crosby both stars, as well as camels, bears, fish, and anyone else who happened to be around, would comment on the film or the action directly to the audience. However, this style may have been equally based on the audience's familiarity with radio programs, in which the performer usually spoke directly to the home audience.

STRUCTURAL RHYTHM

Much of the effectiveness of a film relies on its success as a form as well as a style. By that I mean that filmmakers create rhythms and patterns that are based on the way they choose to tell their stories or that indicate deeper meanings and relationships. The *structural rhythm* of a film is the manner in which the various shots are joined together and juxtaposed with other cinematic images, both visual and aural.

Symbolic images in film range from the very obvious to the extremely subtle, but they are all useful to filmmakers in directing the attention of the audience to the ideas inherent in the philosophical approach underlying the film. This use of symbolic elements can be found in such clichés as the hero dressed in white and the villain dressed in black, in the more subtle use of water images in Fellini's *La Dolce Vita*, or even in the presence of an X whenever someone is about to be killed in *Scarface*.

Sometimes, symbolic references can be enhanced by form cutting—for example, cutting directly from the hero's gun to the villain's gun. Or the filmmaker may choose to repeat a familiar image in varying forms, using it as a composer would use a motif in music. Hitchcock's

shower sequence in *Psycho* is built around circular images: the shower head, the circular drain in the tub, the mouth open and screaming, and the iris of the unseeing eye. In *Fort Apache* John Ford uses clouds of dust as a curtain to cover major events; the dust is also used to indicate the ultimate fate of the cavalry troop. Grass, cloud shapes, windblown trees, and patches of color have all been used symbolically and as motifs. Once such elements are perceived, serious students of film will find the deeper meanings of a film more evident and their appreciation heightened.

Another part of structural rhythm is the repetition of certain visual patterns throughout a film. A circular image positioned against a rectangular one, a movement from right to left, an action repeated regularly throughout a sequence—all can become observable patterns or even thematic statements. The silent film made extreme use of thematic repetition. In *Intolerance*, D.W. Griffith develops four similar stories simultaneously and continually cross-cuts between them. This particular use of form enabled him to develop the idea of the similarity of intolerance throughout the ages. In their silent films Laurel and Hardy often built up a pattern of "you do this to me and I'll do that to you;" they called it "tit for tat." Their audience would be lulled into expecting this pattern, but at that point the film would present a variation on the familiar theme (a process quite similar to the use of *theme and variation* in musical composition). The unexpected breaking of the pattern would surprise the audience into laughter.

Parallel development, discussed earlier, can also be used to create form and pattern throughout a film. For example, Edwin S. Porter's *The Kleptomaniac* alternates between two stories: a wealthy woman caught shoplifting a piece of jewelry, and a poor woman who steals a loaf of bread. Each sequence alternately shows crime, arrest, and punishment; the wealthy woman's husband bribes the judge to let her off, while the poor woman is sent to jail. Porter's final shot shows the statue of justice holding her scales, one weighted down with a bag of gold. Her blindfold is raised over one eye, which is looking at the money. In this case, as in others, the form is the film.

When sound films became practicable, filmmakers found many ways of using the audio track, in addition to just recording dialogue. This track could be used as symbolism, as a motif that reinforced the emotional quality of a scene, or for stronger emphasis or structural rhythm.

Some filmmakers believe that a more realistic feeling can be created if the film is cut rather than dissolved. They feel that cutting abruptly from scene to scene gives the film a staccato rhythm that in turn augments the reality they hope to achieve. A dissolve, they think, creates a slower pace and tends to make the film *legato* and thus more romantic. If the abrupt cutting style is done to the beat of the sound track, a pulsating rhythm is created for the film sequence; this in turn is communicated to the audience and adds a sense of urgency to the scene. In Fred Zinnemann's *High Noon* the sheriff is waiting for the noon train to arrive. The sequence is presented in *montage*, showing the townspeople, as well as the sheriff, waiting. The shot is changed every eight beats of the musical track. As the time approaches noon, the shot is changed every four beats. Tension mounts. The feeling of rhythm is enhanced by shots of a clock's pendulum swinging to the beat of the sound track. Tension continues to build. The train's whistle sounds. There is a series of rapid cuts of faces turning and looking, but there is only silence on the sound track, which serves as a tension release. This last moment of the sequence is also used as transition between the music and silence. In other films the track may shift from music to natural sounds and back to the music again. Or a pattern may be created of natural sound, silence, and a musical track. All depends on the mood and attitude the filmmaker is trying to create. In Hitchcock's films music is often used as a tension release or an afterthought, as Hitchcock usually relies on the force of his visual elements to create structural rhythm.

Earlier in this chapter I mentioned the use of motif in *Jaws*. Many films make use of an audio motif to introduce visual elements or convey meaning symbolically. Walt Disney, particularly in his pre-1940 cartoons, often uses his sound track in this manner. For example, Donald Duck is trying to catch a pesky fly, but the fly always manages to elude him. In desperation Donald sprays the fly with an insecticide. The fly coughs and falls to the ground. But on the sound track we hear an airplane motor coughing and sputtering and finally diving to the ground and crashing. In juxtaposing these different visual and audio elements, Disney is using his track symbolically.

John Ford often underlines sentimental moments in his films by accompanying the dialogue of a sequence with traditional melodies; as the sequence comes to a close the music swells and then fades away to match the fading out of the scene. In *The Grapes of Wrath*, when Tom Joad says goodbye to his mother, "Red River Valley" is played on a concertina; as Tom walks over the hill the music becomes louder, and when he disappears from view it fades out. Throughout this film, this familiar folk song serves as a thematic reference to the Joad's home in Oklahoma and also boosts the audience's feelings of nostalgia. In *She*

Wore a Yellow Ribbon the title of the film is underlined by the song of the same name, but through the use of different tempos and timbres the mood of the song is changed each time it is used. As the cavalry troop rides out of the fort the song is played in a strong $\frac{4}{4}$ meter with a heavy emphasis on the brass; the sequence is also cut to the beat of the track. In the graveyard sequences the same tune is played by strings and reeds in $\frac{3}{4}$ time and in a much slower tempo, which makes the song melancholy and sentimental. In the climactic fight sequence in *The Quiet Man* John Ford cuts to the beat of a sprightly Irish jig, which enriches the comic elements of the scene and plays down the violence.

Our discussion in these last few paragraphs touches only the surface of the techniques and uses of sound in film; of course, there are other ways of using sound and the other elements discussed thus far. But part of the challenge of the film as an art form is the discovery by the viewer of the varying uses to which film technique can be put, and this in turn enhances further perceptions.

Film is basically a visual art; the pictures tell the story. How these pictures are recorded, arranged, and enhanced can raise the mechanical, commercial movie form into a work of art. Full response to that art demands an informed and knowledgeable audience. Perception, or visual literacy, is the key.

SIX

DANCE

Dance is one of the most natural and universal of human activities. In virtually every culture, regardless of location or level of development, we find some form of dance. Dance appears to have sprung from humans' religious needs. For example, scholars are relatively sure that the theatre of Ancient Greece developed out of that society's religious, tribal dance rituals. So, there can be no doubt that dance is part of human communication at its most fundamental level. We can see this expression even in little children, who, before they begin to paint, sing, or imitate, begin to dance.

Most of us at one time or another have participated in some form of dancing. Doubtless, we hardly believe that participation approximates art. However, we do have some understanding of what the term *dance* means.

WHAT IS IT?

Dance is aesthetic communication through the design of time, sound, and two- and three-dimensional space focusing on the human form. In general it follows one of three traditions: ballet, modern dance, and folk dance. Other forms or traditions of dance exist. These include jazz dance, tap, and musical comedy. Their properties or qualities as concert dance are often debated. The reader is encouraged to explore these in detail elsewhere. We will note jazz dance in passing later in the chapter and will focus our brief discussion on ballet, modern dance, and folk dance.

BALLET

Ballet comprises what can be called "classical" or formal dance; it is rich in tradition and rests heavily upon a set of prescribed movements and actions, as we shall see. In general, ballet is a highly theatrical dance presentation consisting of solo dancers, duets, and choruses, or the *corps de ballets*. According to Anatole Chujoy in the *Dance Encyclopedia*, the basic principle in ballet is "the reduction of human gesture to bare essentials, heightened and developed into meaningful patterns." George Balanchine saw the single steps of a ballet as analogous to a single frame in a motion picture. Ballet, then, became a fluid succession of images, all existing within specialized codes of movement. As with all dance and all the arts, ballet expresses basic human experiences and desires.

MODERN DANCE

Modern dance is a label given to a broad variety of highly individualized dance works limited to the twentieth century, essentially American in derivation, and antiballetic in philosophy. It began as a revolt against the stylized and tradition-bound elements of ballet. The basic principle of modern dance could probably be stated as an emphasis on natural and spontaneous or uninhibited movement, in strong contrast with the conventionalized and specified movement of ballet. The earliest modern dancers found stylized ballet movement incompatible with their need to communicate in twentieth-century terms. As Martha Graham characterized it, "There are no general rules. Each work of art creates its own code." Nonetheless, in its attempts to be nonballetic, certain conventions and characteristics have accrued to modern dance. While there are narrative elements in many modern dances, there may be less emphasis on them than in traditional ballet. There also are differences in the use of the body, the use of the dance floor, and the interaction with the *mise en scène*.

FOLK DANCE

Folk dance, somewhat like folk music, is a body of group dances performed to traditional music. It is similar to folk music in that we do not know the artist who developed it; there is no choreographer of record for folk dances. They began as a necessary or informative part of certain cultures, and their characteristics are stylistically identifiable with a given culture. They developed over a period of years, without benefit of authorship, passing from one generation to another. They have their prescribed movements, their prescribed rhythms, and their prescribed music and costume. At one time or another they may have become formalized—that is, committed to some form of record. But they are part of a heritage, and usually not the creative result of an artist or a group of interpretative artists, as is the case with the other forms of dance. Likewise, they exist more to involve participants than to entertain an audience.

Folk dancing establishes an individual sense of participation in society, the tribe, or a mass movement. "The group becomes one in conscious strength and purpose, and each individual experiences a heightened power as part of it . . . [a] feeling of oneness with one's fellows which is established by collective dancing."[1]

HOW IS IT PUT TOGETHER?

Dance is an art of time and space that utilizes many of the elements of the other arts. In the *mise en scène* and in the line and form of the human body it involves many of the compositional elements of pictures, sculpture, and theatre. Dance also relies heavily on the elements of music—whether or not music accompanies the dance presentation. However, the essential ingredient of dance is the human body and its varieties of expression. So, it is with the human body that we will begin our examination of how a dance work is put together.

FORMALIZED MOVEMENT

The most obvious repository of formalized movement in dance is ballet. All movement in ballet is based upon five basic leg, foot, and arm positions. In the *first position* (Fig. 6.1) the dancer stands with weight equally distributed between the feet, heels together, and toes open and out to

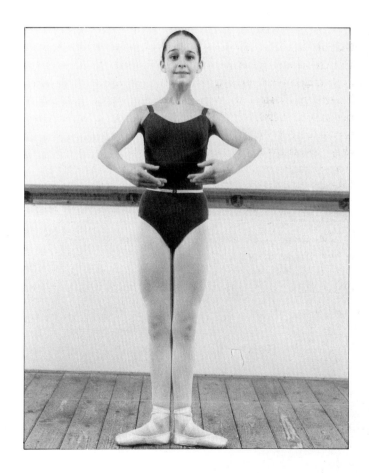

6.1 First position.

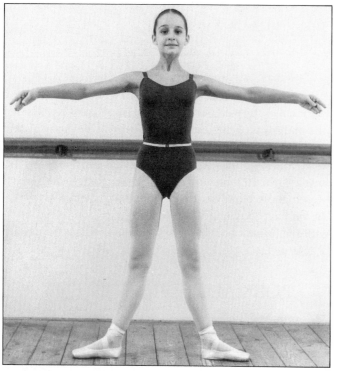

the side. In ballet all movements evolve from this basic *open* position; the feet are never parallel to each other and both pointing straight forward. The *second position* (Fig. **6.2**) is achieved by opening the first position the length of one's foot, again with the weight placed evenly on both feet. In the *third position* (Fig. **6.3**) the heel of the front foot touches the instep of the back foot; the legs and feet must be well turned out. In the *fourth position* (Fig. **6.4**) the heel of the front foot is opposite the toe of the back foot. The feet are parallel and separated by the length of the dancer's foot; again, the weight is placed evenly on both feet. The *fifth position* (Fig. **6.5**) is the most frequently used of the basic ballet positions. The feet are close together with the front heel touching the toe of the back foot. The legs and the feet must be well turned out to achieve this position correctly, and the weight is placed

6.2 (*above*) Second position.

6.3 (*left*) Third position.

6.4 (*right*) Fourth position.

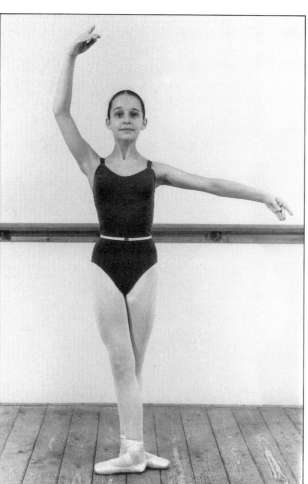

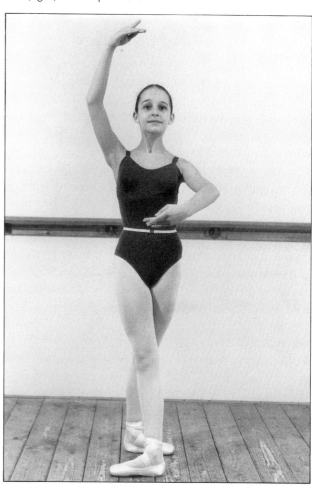

evenly on both feet. As is clear from Figures **6.1–6.5**, each position changes the attitude of the arms as well as that of the legs and feet. From these five basic positions a series of fundamental movements and poses is developed; these are the core of every movement of the human body in formal ballet.

Some of the fundamental ballet poses and movements can be recognized throughout a dance work, including modern dance; a few lend themselves to photographic illustration. Figure **6.6** shows a *demi-plié* in first position. This half-bend of the knees can be executed in any position. The *grand plié* shown in Figure **6.7**, also in first position, carries the bend to its maximum degree. The *arabesque* is a pose executed on one foot with arms and foot extended. It can appear in a variety of positions; it is

6.5 (*below*) Fifth position.

6.6 (*above right*) *Demi-plié* in first position.

6.7 (*below right*) *Grand plié* in first position.

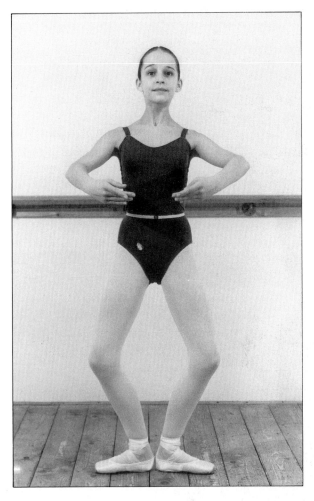

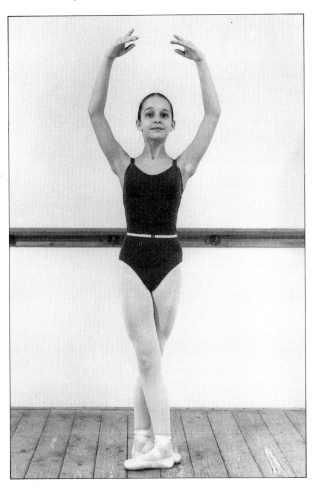

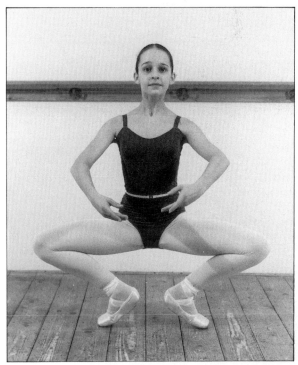

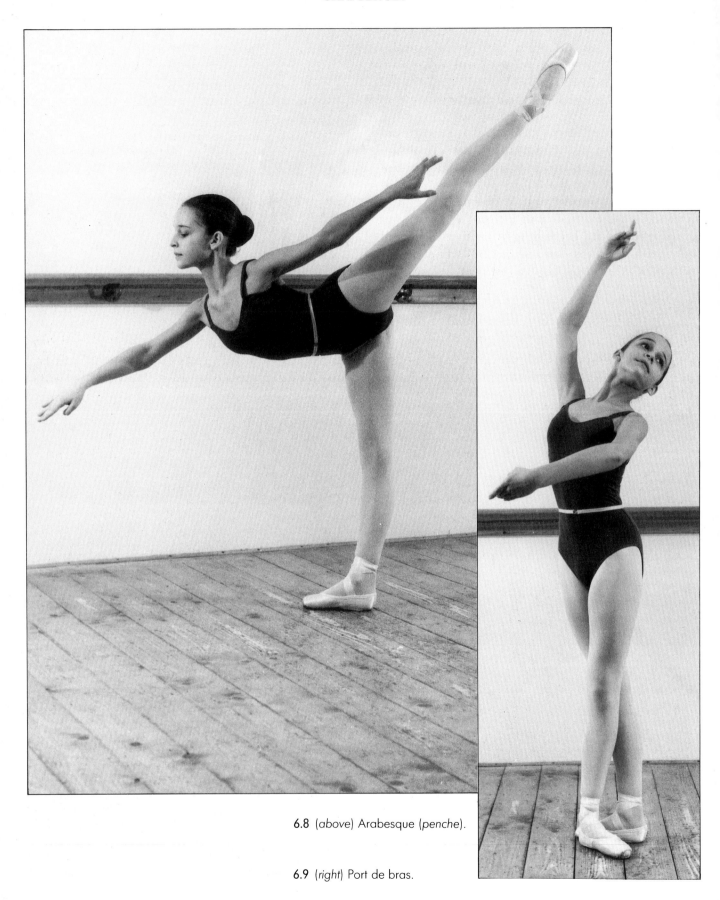

6.8 (*above*) Arabesque (*penche*).

6.9 (*right*) Port de bras.

shown in Figure **6.8** in the *penche*, or leaning position. The *port de bras* (Fig. **6.9**) is simply the technique of moving the arms correctly. As might be imagined, many variations can be made upon the five basic positions. For example, the *grande seconde* (Fig. **6.10**) is a variation upon second position in which the leg is elevated to full height. The leg also is elevated in the *demi-hauteur*, or "half height" (Fig. **6.11**). Full height requires extension of the leg at a 90-degree angle to the ground; half height requires a 45-degree extension. Movements carry the same potential for variety. For example, in the *ronds de jambe à terre* (Fig. **6.12**) the leg from the knee to and including the foot is rotated in a semicircle. Other basic movements (defined in the Glossary) include the *assemblé*, *changement de pied*, *jeté*, *pirouette*, and *relevé*. As we develop expertise in perceiving dance it will become obvious to us in watching formal ballet (and to a lesser degree, modern dance) that we see a limited number of movements and poses, turns and leaps, done over and over again. In this sense these bodily compositions form a kind of theme and variation, and they are interesting in that right alone.

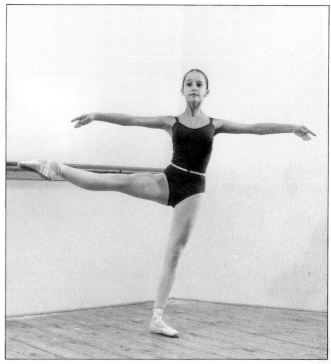

6.10 *Grande seconde.*

6.11 *Demi-hauteur.*

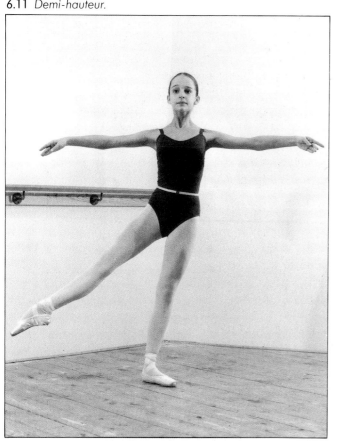

6.12 *Ronds de jambe à terre.*

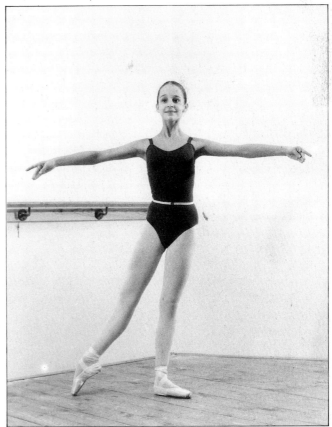

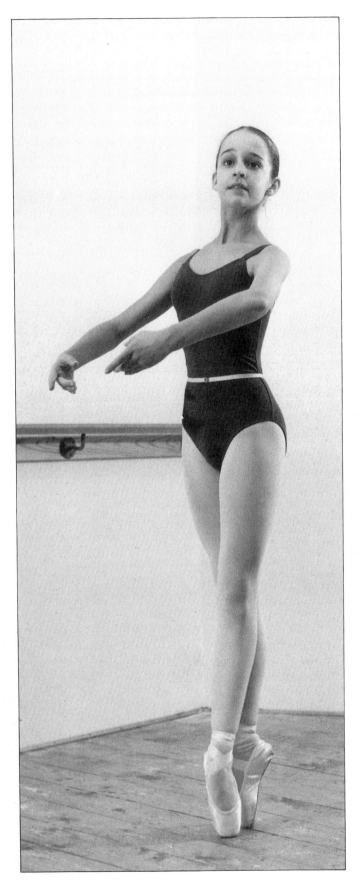

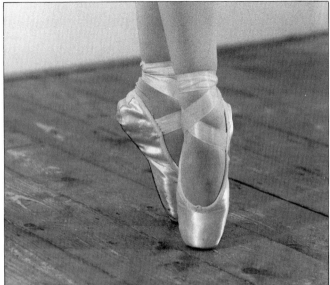

6.13 On point. (above) *Detail.*

In addition, it is possible for us to find a great deal of excitement in the bodily movements of formal ballet if for no other reason than the physical skills required for their execution. The standards of quality that are applied to a ballet dancer are based on the ability of the dancer to execute these movements properly. Just as in gymnastics or figure skating, the strength and grace of the individual in large part determine his or her qualitative achievement. It goes without saying, however, that ballet is far more than just a series of gymnastic exercises.

Perhaps the most familiar element of ballet is the female dancer's toe work or dancing *on point* (Fig. **6.13**). A special kind of footgear is required for toe work (see p. 106). Dancing on point is a fundamental part of the female dancer's development. It usually takes a minimum of two years of thorough training and development before a dancer can begin to do toe work. Certain kinds of turns are not possible without toeshoes and the technique for using them—for example, spinning on point or being spun by a partner.

We have focused on ballet in this discussion of formalized movement because it is the most familiar of the traditional, formalized dance forms. Ballet, however, is not alone in adhering to formalized patterns of movement. It is, in part, formalized movement that allows us to distinguish among folk and other dances, such as the *pavane*, the *galliard*, the *waltz*, and the *mambo*. All have formal or conventional patterns of movement. Perhaps only modern dance resists formal movement, and even then not completely.

LINE, FORM, & REPETITION

The compositional elements of line, form, and repetition apply to the use of the human body in exactly the same sense that they apply to those elements in painting and sculpture—the latter especially. The body of the dancer can be analyzed as a sculptural, three-dimensional form that reflects the use of line, even though the dancer is continually in motion. The body as a sculptural form moves from one pose to another, and if we were to take a stop-action movie of a dance, we could analyze, frame by frame or second by second, the compositional qualities of the human body. The human form in every illustration in this chapter, including those that show groupings of dancers, can be analyzed as a composition of line and shape. Dance, therefore, can be seen at two levels: first, as a type of pictorial communication employing symbols that occur only for a moment, and, second, as the design of transition with movement between those moments.

Because the dancer moves through time, the concept of repetition becomes an important consideration in analyzing how a dance work is put together. The relationship of the movements to each other as the dance progresses shows us a repetitional pattern that is very similar to theme and variation in music. So, *choreographers* concern themselves with the use of the individual dancer's body as well as combinations of dancers' bodies in duets, trios, or the entire corps de ballet (Figs. **6.14** and **6.15**).

6.14 *Nameless Hour*, Jazz Dance Theatre at Penn State, the Pennsylvania State University. Choreographer: Jean Sabatine. Photo by Roger Greenawalt.

6.15 *Family Tree,* Jazz Dance Theatre at Penn State, the Pennsylvania State University. Choreographer: Jean Sabatine. Photo by Roger Greenawalt.

RHYTHM

As we watch a dance we can see that the steps are related and coherent. Dance phrases are held together by their rhythm, in the same sense as in musical rhythm. Sequences of long and short motions occur which are highlighted by accents. In a visual sense dance rhythms occur in spatial arrangements, up and down, back and forth, curved and linear, large and small. We also can perceive rhythmic relationships in the ebb and flow of dancers' energy levels. Energy, of course, calls to mind dynamics in the sense that we discussed the term in music and theatre.

MIME AND PANTOMIME

Within any dance form, modern dance included, there may be elements of bodily movement that we call *mime* and *pantomime*. Bodily movement is *mimetic* whenever it suggests the kinds of movements we associate with people or animals. It is also mimetic if it employs any of the forms of conventional sign language, such as the Delsarte system. Of course, if there are narrative elements in the dance and the dancer actually portrays a character in the theatrical sense, there also may be pantomimetic action. Pantomime is the "acting out" of dramatic action without words. In the romantic style of ballet from the nineteenth century, for example, pantomime helps to carry forward the story line. We sense the emotions, the feelings, and the character relationships in the dancers' steps, gestures, movements, and facial expressions. Only when the movement of the dance is purely an emotional expression of the dancer can we say that it is free of mime.

IDEA CONTENT

Our consideration of the presence or absence of mime leads us to a consideration of how dance communicates its idea content. There are three general possibilities. First, the dance may contain *narrative* elements—that is, it may tell a story. Second, the dance may communicate through *abstract* ideas. There is a specific theme to be communicated in this case, but no story line. The ideas are abstract and general and relate to some aspect of human emotion or the human condition. Modern dance, especially, tends to deal with human psychology and behavior. Social themes occur frequently, as do impressions or expressions from plays, poems, and novels. Religious themes as well as folk themes can be found in the wide treatments and explorations of subject ideas in modern dance. The third possibility is the absence of narrative or abstract com-munication. The work may be a *divertissement*, or diversion. Romantic ballet usually has strong narrative elements. However, some ballets are divertissements. Modern ballet—that is, twentieth-century ballet—has dealt increasingly with abstract ideas. Modern dance often concerns itself with abstract ideas; it may have narrative elements as well.

A final variable of idea content in dance is the presence or absence of *ethnic influence*. It is interesting to note how elements of dance reflect sociocultural background. Jazz dance, for example, may stimulate us to consider the black heritage in the United States. Jazz dance has emerged strongly in the twentieth century, and many would include it as a form equal to ballet, modern, and folk. Jazz dance has its own history, which is linked closely with the Black experience in the United States, show business, and jazz as a musical idiom.

MUSIC

We associate music with dance as a matter of course. Most of the time music serves as a basis for the bodily movement of the work we are perceiving, although it is not necessary for dance to be accompanied by music. However, it is impossible to have dance without one element of music—rhythm, as we noted previously. Every action of the dancer's body has some relationship in time to every other movement, and those relationships establish rhythmic patterns that are musical regardless of the presence or absence of auditory stimuli.

When we hear music accompanying a dance we can respond to the relationship of the dance to the musical score. The most obvious relationship we will see and hear is the one between the gestures and footfalls of the dancer and the beat of the music. In some cases the two are in strict accord; the *beat-for-beat* relationship is one to one. In other cases there may be virtually no perceivable beat-for-beat relationship between the dancer's movements and the accent or rhythmic patterns of the musical score.

Another relationship is that of the *dynamics* of the dance to those of the music. Of prime importance in this relationship is the intensity, or *force*, of the dance movement. Moments of great intensity in a dance can manifest themselves in rapid movement and forceful leaps. Or they may be reflected in other qualities. We must discern how the actual performance employs dynamics.

We can use the same kind of analysis in dance as we did in theatre in plotting dynamic levels and overall structure. For maximum interest there must be variety of intensity. So, if we chart the relationship of the peaks and valleys of

dynamic levels, we are likely to conclude that the dynamic structure of a dance is quite similar to the dynamic structure of a play in that it tends to be pyramidal: It builds to a high point and then relaxes to a conclusion. This kind of analysis applies whether or not narrative elements are present.

MISE EN SCÈNE

Because dance is essentially a visual and theatrical experience, part of our response must be to those theatrical elements of dance that are manifested in the environment of the presentation. In other words, we can respond to the *mise en scène* of the dance (Fig. **6.15**). We can note the elements of verisimilitude in the *mise en scène* and how those elements reflect or otherwise relate to the aural and visual elements of the dance. A principal consideration here is the interrelationship of the dance with properties, settings, and the floor of the theatrical environment. The dance may use *properties* in significant or insignificant ways. As for *settings*, some dances employ massive stage designs. Others have no setting at all; they are performed in a neutral environment. Again, part of our response is to the relationship of the elements of the setting to the rest of the dance.

A principal difference between formal ballet and modern dance lies in the use of the *dance floor*. In formal ballet the floor acts principally as an agent from which the dancer springs and to which the dancer returns. But in modern dance the floor assumes an integral role in the dance, and we are likely to see the dancers sitting on the floor, rolling on it—in short, *interacting with* the floor. So, consideration of the use of the floor in dance concerns not only whether or not it is employed as an integral part of a dance, but also how the use of the floor relates to the idea content of the dance.

In discussing the relationship of *costume* to dance, we would do well to return to the section on costume design in Chapter 4 to note the purposes of costume, because those purposes apply to dance in the same manner that they apply to a theatre production. In some dances costume will be traditional, conventional, and neutral. There would be little representation of story line or character in the tights and *tutu* of the female dancer shown in Figure **6.16**. However, in many dances we are likely to see costumes high in verisimilitude. Costumes may help portray character, locality, and other aspects of the dance (Figs. **6.14** and **6.15**).

6.16 Traditional tights and tutu.

In addition, it is especially important that the costume should allow the dancer to do whatever it is that the choreographer expects him or her to do. In fact, costume may become an integral part of the dance itself. An extreme example of this is Martha Graham's *Lamentation*, in which a single dancer is costumed in what could be best described as a tube of fabric—no arms, no legs, just a large envelope of cloth. Every movement of the dancer stretches that cloth so that the line and form of the dancer is not the line and form of a human body but rather the line and form of a human body enveloped in a moving fabric.

The final element of the dance costume to be considered, and one of great significance, is footgear. Dancers' footgear ranges from the simple, soft, and supple ballet slipper to the very specialized toeshoe of formal ballet, with street shoes, character Oxfords, and a variety of representational or symbolic footwear in between. In addition, modern dance often is done in bare feet. Of course, the fundamental requirements of footgear are comfort and enough flexibility to allow the dancer to do whatever he or she must do. Footgear, whether it be toeshoe, ballet slipper, character Oxford, or bare feet, must be appropriate to the surface of the stage floor. Great care must be taken to ensure that the dance floor is not too hard, too soft, too rough, too slippery, or too sticky. The floor is so important that many touring companies take their own floor with them to insure that they will be able to execute their movements properly.

LIGHTING

Inasmuch as the entire perception of a dance relies on perception of the human body as a three-dimensional form, the work of the lighting designer is of critical importance in the art of dance. How we perceive the human form in space depends on how that body is lit. Certainly our emotional and sense response is highly shaped by the nature of the lighting that plays on the dancer and the dance floor.

Lighting designers can work with the human body in dance as though the body were pure sculptural form. When narrative qualities are present, lighting tends to be much like theatre lighting, with emphasis, first, on visibility of faces. However, careful selection of instrumentation, for harsh or soft light, angles, for degrees of plasticity, and color, for mood, turns the human body into meaningful, three-dimensional form in motion. How we see these bodily forms in motion depends entirely on the lighting designer.

HOW DOES IT STIMULATE THE SENSES?

The complex properties of the dance make possible perhaps the most diverse and intense communicative stimuli of any of the arts. We noted earlier that opera is a synthesis of all of the arts. The dance, as well, integrates elements of all of the arts, and it does so in such a way as to communicate in a highly effective symbolic and nonverbal manner.

We noted previously that it is possible to respond at different levels to an artwork. To some extent we can respond even at a level of total ignorance. In many ways artworks are like onions. If they lack quality we can call them rotten. But more important, and more seriously, an artwork, like an onion, has a series of skins. As we peel away one that is obvious to us, we reveal another and another and another, until we have gotten to the core of the thing. There will be levels of understanding, levels of meaning, levels of potential response for the uninitiated as well as the thoroughly sophisticated viewer. The more sophisticated a *balletomane* one becomes, the fuller one's understanding and response.

LINE AND FORM

Like every other artwork that exists in space, the dance appeals to our senses through the compositional qualities of line and form. These qualities exist not only in the human body but in the visual elements of the *mise en scène*. Essentially, horizontal line stimulates a sense of calm and repose. Vertical lines suggest grandeur and elegance. Diagonal lines stimulate a feeling of action and movement (Fig. 6.16), and curved lines, grace. As we respond to a dance work we respond to how the human body expresses line and form, not only when it is standing still but also when it moves through space. If we are alert and perceptive we will recognize not only how lines and forms are created but also how they are repeated from dancer to dancer and from dancer to *mise en scène*.

Often, the kind of line created by the body or body characteristics of a dancer is the key to understanding the work of the choreographer. George Balanchine, for example, insisted that his dancers be almost skin and bone; you would not see a corpulent or overly developed physique in his company. So, bodies themselves appeal to our senses, and choreographers capitalize on that appeal in their dance conceptions.

DYNAMICS

We noted in Chapter 3 that the beat of music is a fundamental appeal to our senses. Beat is the aspect of music that sets our toes tapping and our fingers drumming. Probably our basic response to a dance is to the dynamics expressed by the dancers and in the music. A dancer's use of vigorous and forceful action, high leaps, graceful turns, or extended pirouettes, appeals directly to us, as does the tempo of the dance. Variety in dynamics—the louds and softs and the highs and lows of bodily intensity as well as musical sound—is the dancer's and choreographer's means of providing interest, just as it is the actor's, the director's, and the painter's.

SIGN LANGUAGE

The dancer, like the actor, can stimulate us directly because he or she is another human being and can employ many symbols of communication (Fig. **6.15**). Most human communication requires us to learn a set of symbols, and, therefore, we can respond to the dance at this level only when we have mastered the language. There are systems of sign language, such as the Delsarte, in which the positions of the arms, the hands, and the head have meanings. Likewise, in our response to the hula dance, experts tell us, we ought not to concentrate on the vigorous hip movements of the dancer but rather on the hand movements, each of which communicates an idea. But until we learn what each of these movements means, we cannot respond in any significant way. However, there is a set of universal body symbols to which all of us respond (so psychologists tell us), regardless of our level of familiarity or understanding. For example, the gesture of acceptance in which the arms are held outward with the palms up has the same universal meaning. The universal symbol of rejection is the hands held in front of the body with the palms out as if to push away. When dancers employ universal symbols we respond to their appeal to our senses just as we would to the nonverbals or body language in everyday conversation.

COLOR

Although the dancer uses facial and bodily expressions to communicate some aspect of the human condition, we do not receive as direct a message from them as we do from the words of the actor. So, to enhance the dancer's communication the costume, lighting, and set designers must strongly reinforce the mood of the dance through the *mise en scène* they create. The principal means of expression of mood is color. In dance, lighting designers are free to work in much more obvious ways with color because they do not have to create patterns of light and shadow as high in verisimilitude as those of their counterparts in the theatre. As a result, they do not have to worry if the face of a dancer is red or blue or green, an attribute that would be disastrous in a play. So, we are apt to see much stronger, more colorful, and more suggestive lighting in dance than in theatre. Colors will be more saturated, intensity will be much higher, and the qualities of the human body, as form, will be explored much more strongly by light from various directions. The same is true of costumes and settings. Because dancers obviously do not portray a role in a highly verisimilar way, their costume can be very communicative in an abstract way. On the other hand, scene designers must be careful to utilize color in such a way that the dancer receives the focus in the stage environment. In any but the smallest of stage spaces it is very easy for the human body to be overpowered by the elements of the *mise en scène* since it occupies much more space. So, scene designers, in contrast with lighting designers, must be careful to provide a background against which the dancer will stand out in contrast unless a synthesis of the dancer with the environment is intended, as in the case, for example, of some works by choreographer Merce Cunningham. Nevertheless, scene designers use color as forcefully as they can to help reinforce the overall mood of the dance.

The examples of how dance affects our senses that we have just noted are rudimentary ones. Perhaps more than any other art, dance causes us to ascend beyond our three cognitive questions—What is it? How is it put together? How does it affect the senses?—and dwell in that fourth level of meaningful response—What does it mean?

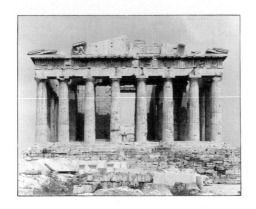

SEVEN

ARCHITECTURE

In approaching architecture as an art, it is virtually impossible for us to separate aesthetic properties from practical or functional properties. In other words, architects first have a particular function to achieve in their building. That function is their principal concern. The aesthetics of the building are important, but they must be tailored to overall practical considerations. For example, when architects set about to design a 110-story skyscraper, they are locked into an aesthetic form that will be vertical rather than horizontal in emphasis. They may attempt to counter verticality with strong horizontal elements, but the physical fact that the building will be taller than it is wide is the basis from which the architects must work. Their structural design must take into account all the practical needs implicit in the building's use. Nonetheless, considerable room for aesthetics remains. Treatment of space, texture, line, and proportion can give us buildings of unique style and character or buildings of unimaginative sameness.

Architecture is often described as the art of *sheltering*. To consider it as such we must use the term *sheltering* very broadly. Obviously there are types of architecture within which people do not dwell and under which they cannot escape the rain. Architecture encompasses more than buildings. So, we can consider architecture as the art of sheltering people both physically and spiritually from the raw elements of the unaltered world.

WHAT IS IT?

As we noted, architecture can be considered the art of sheltering. In another large sense, it is the design of three-dimensional space to create practical enclosure. Its basic forms are residences, churches, and commercial buildings. Each of these forms can take innumerable shapes, from single-family residences to the ornate palaces of kings to high-rise condominiums and apartments. We also could expand our categorization of architectural forms to include bridges, walls, monuments, and so forth.

HOW IS IT PUT TOGETHER?

In examining how a work of architecture is put together we will limit ourselves to ten fundamental elements: structure, building materials, line, repetition, balance, scale, proportion, context, space, and climate.

119

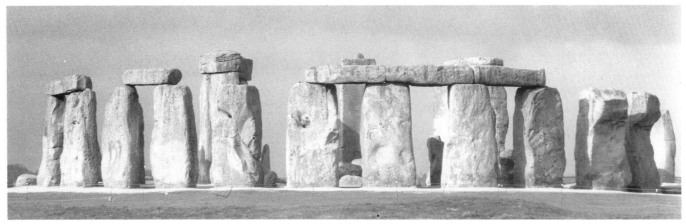

7.1 Stonehenge, Salisbury Plain, England, c. 1800–1400 B.C. British Information Services Photo.

STRUCTURE

There are many systems of construction or systems of structural support. We will deal with only a few of the more prominent. *Post-and-lintel*, *arch*, and *cantilever* systems can be viewed, essentially, as historical systems. Contemporary architecture, however, can better be described by two additional terms, which to some extent overlap the others. These "contemporary" systems are *bearing-wall* and *skeleton frame*.

Post-and-Lintel

Post-and-lintel structures consist of horizontal beams (lintels) laid across the open spaces between vertical supports (posts). In this architectural system the traditional material is stone. Post-and-lintel structures are similar to *post-and-beam* structures, in which series of vertical posts are joined by horizontal members, traditionally of wood. The wooden members of post-and-beam structures are held together by nails, pegs, or lap joints.

7.2 The Parthenon, Acropolis, Athens, 448–432 B.C. AC & R Photo.

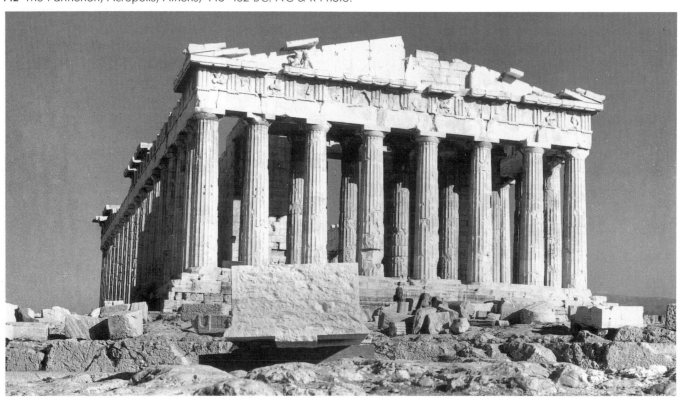

Because of the lack of tensile strength in its fundamental material, stone, post-and-lintel structures are limited in their ability to define space. *Tensile strength* is the ability of a material to withstand bending. If we lay a slab of stone across an open space and support it at each end, we can span only a narrow space before it cracks in the middle and falls to the ground. On the other hand, stone has great *compressive strength*—the ability to withstand compression or crushing.

A primitive example of a post-and-lintel structure is Stonehenge, that ancient and mysterious religious configuration of giant stones in Great Britain (Fig. **7.1**). The Ancient Greeks refined this system to high elegance; the most familiar of their post-and-lintel creations is the Parthenon (Fig. **7.2**).

The Greek refinement of post-and-lintel structure is a *prototype* for buildings throughout the world and across the centuries. One of the more interesting aspects of the style is its treatment of columns and *capitals*. Figure **7.3** shows the three basic Greek orders —Ionic, Doric, and Corinthian. These are not the only styles of post-and-lintel structure. Column capitals can be as varied as the imagination of the architect who designed them. Their primary purpose is to act as a transition for the eye as it moves from post to lintel. Columns also may express a variety of detail. A final element, present in some columns, is *fluting*—vertical ridges cut into the column.

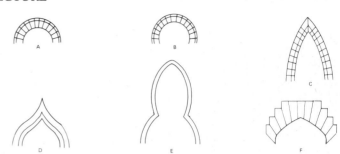

7.4 The arch: (A) Round (Roman) arch, (B) Horseshoe (Moorish) arch, (C) Lancet (pointed, gothic) arch, (D) Ogee arch, (E) Trefoil, arch, (F) Tudor arch.

Arch

A second type of architectural structure is the arch. As we indicated earlier, post-and-lintel structure is limited in the amount of unencumbered space it can achieve. The arch, on the other hand, can define large spaces, since its stresses are transferred outward from its center (the *keystone*) to its legs. So it does not depend on the tensile strength of its material.

There are many different styles of arches, some of which are illustrated in Figure **7.4**. The characteristics of different arches may have structural as well as decorative functions. As an example, examine St. Alban's Cathedral (Fig. **7.5**), built in the English Norman style. This style of building, with its accent on rounded arches, was loosely based on the classical architecture of Roman times.

7.3 Greek columns and capitals (*left*) Doric, (*center*) Ionic, (*right*) Corinthian.

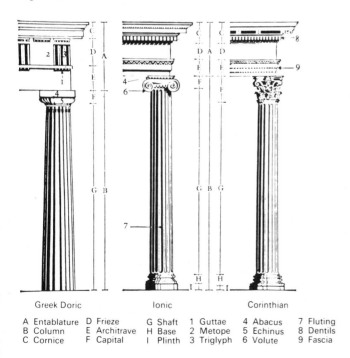

Greek Doric		Ionic		Corinthian	

A Entablature	D Frieze	G Shaft	1 Guttae	4 Abacus	7 Fluting
B Column	E Architrave	H Base	2 Metope	5 Echinus	8 Dentils
C Cornice	F Capital	I Plinth	3 Triglyph	6 Volute	9 Fascia

7.5 St. Alban's Cathedral, the nave, facing east.

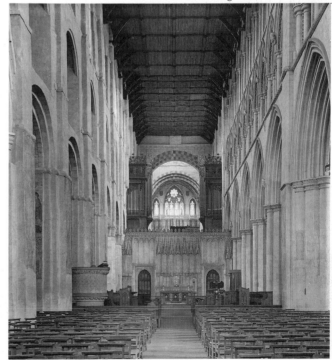

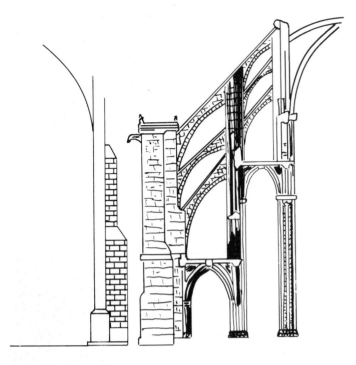

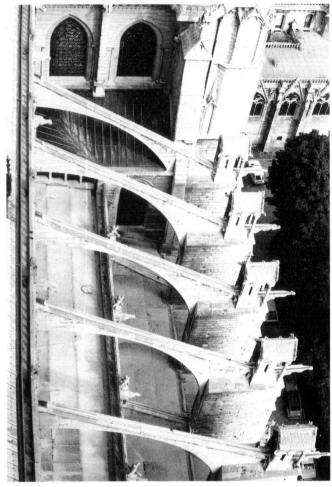

7.6 Buttress.

7.7 (*above right*) Flying buttresses. (*right*) The flying buttresses on the side of Notre Dame, Paris.

7.8 (*below*) Arcade.

The transfer of stress from the center of an arch outward to its legs dictates the need for a strong support to keep the legs from caving outward. Such a reinforcement is called a *buttress* (Fig. **7.6**). The designers of Gothic cathedrals sought to achieve a sense of lightness. Since stone was their basic building material, they recognized that some system had to be developed that would overcome the bulk of a stone buttress. Therefore, they developed a system of buttresses that accomplished

structural ends but were light in appearance. These are called *flying buttresses* (Fig. 7.7).

Several arches placed side by side form an *arcade* (Fig. 7.8). Arches placed back to back to enclose space form a *tunnel vault* (Fig. 7.9). When two tunnel vaults intercept at right angles, as they do in the floor plan of the traditional Christian cathedral, they form a *groin vault* (Fig. 7.10). The protruding masonry indicating diagonal juncture of arches in a tunnel vault or the juncture of a groin vault is *rib vaulting* (Fig. **7.11**).

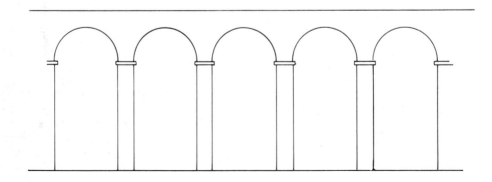

7.9 (*left*) Tunnnel vault.

7.10 (*right*) Groin vault.

7.11 (*far right*) Ribbed vault. (*below*) The choir in Canterbury Cathedral, England, showing ribbed vaulting.

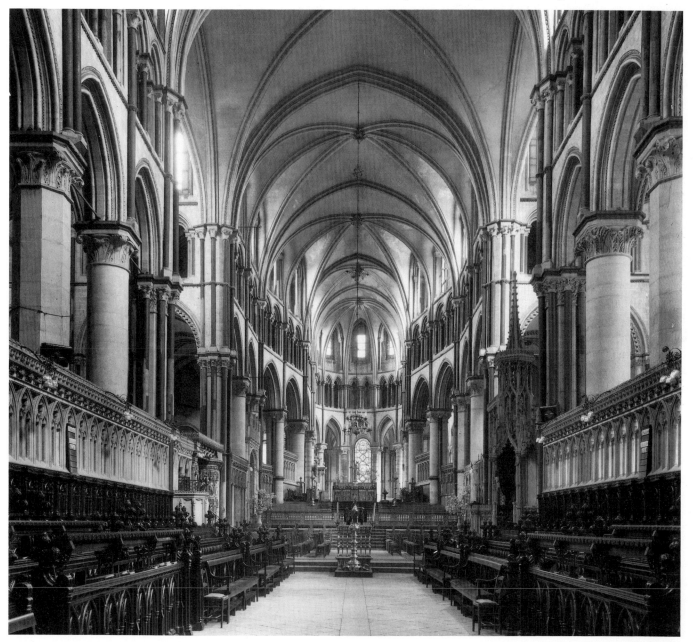

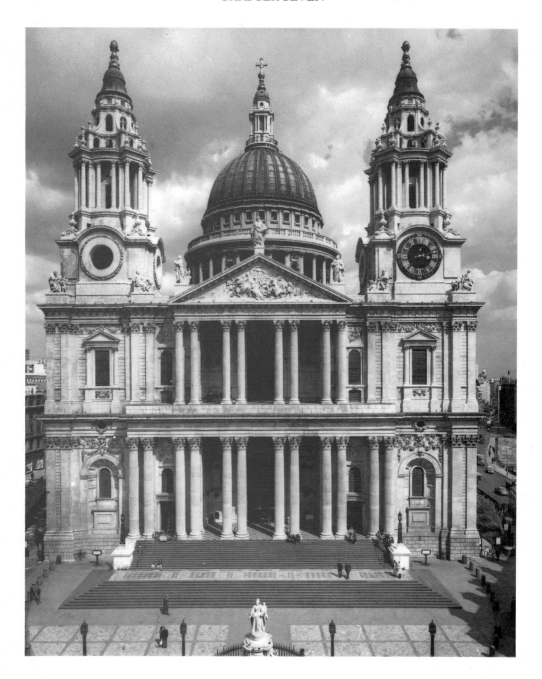

7.12 Dome, St. Paul's Cathedral, London, 1675–1710.

When arches are joined at the top with their legs forming a circle, the result is a *dome* (Fig. **7.12**). The dome, through its intersecting arches, allows for more expansive, freer space within the structure. However, if the structures supporting the dome form a circle, the result is a circular building such as the Pantheon in Rome (Fig. **7.13**). To permit squared space beneath a dome, the architect can transfer weight and stress through the use of *pendentives* (Fig. **7.14**).

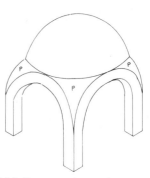

7.14 Dome with pendentives (P).

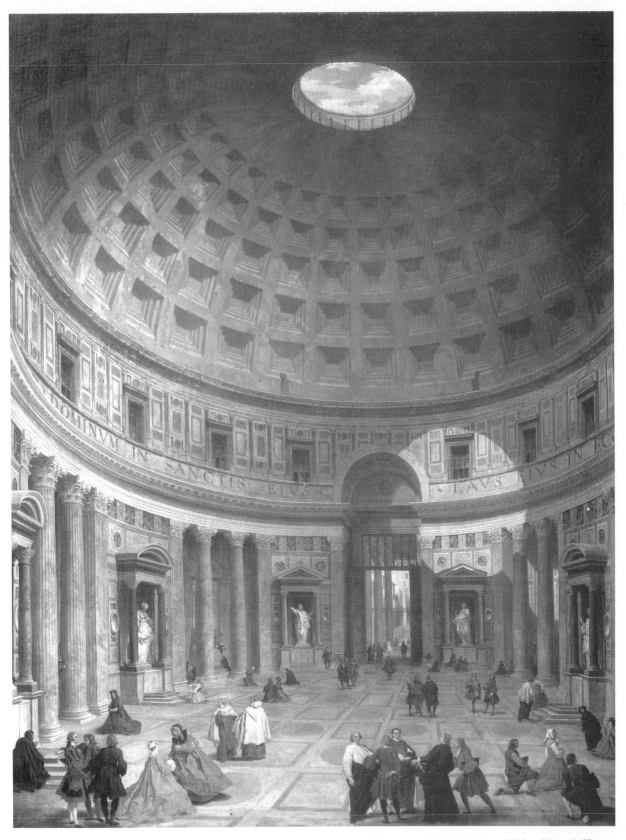

7.13 Giovanni Paolo. Pannini, *The Interior of the Pantheon, c.* 1740. Oil on canvas, 50 x 39 ins (128 x 99 cm). The National Gallery of Art, Washington, DC (Samuel H. Kress Collection).

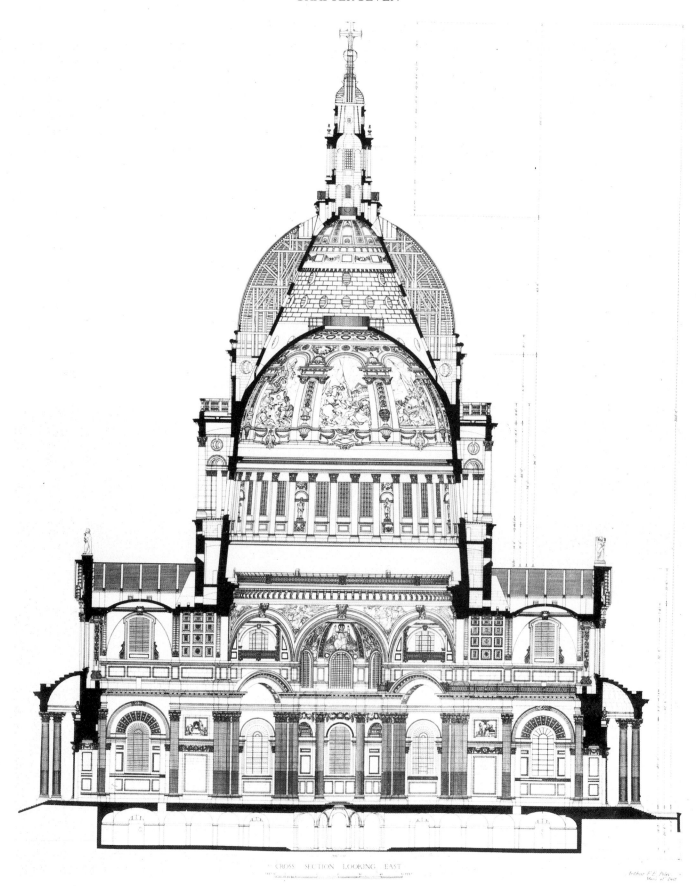

CROSS SECTION LOOKING EAST

The problems architects face in utilizing one form or another for structural support are illustrated by the story of St. Paul's Cathedral, London. Its dome measures 112 ft (34 m) in diameter and stands 365 ft (110 m) tall at the top of the cross. The lantern and cross alone weigh 700 tons (711 tonnes), while the dome and its superstructure weigh in at 64,000 tons (65,000 tonnes). In designing this cathedral Wren was faced with seemingly endless problems of supporting such a tremendous load. His solution was ingenious—the dome comprises nothing more than a timber shell covered in lead, the actual weight of the dome was only a fraction of what it would have been. This allowed Wren to create a wonderful silhouette on the outside and to have the high ceiling in the interior (Fig. 7.15). It was a solution never used before.

Cantilever

A cantilever is an overhanging beam or floor supported only at one end (Fig. 7.16). Although not a twentieth-century innovation—many nineteenth-century barns in the central and eastern parts of the United States employed it—the most dramatic uses of cantilevers have emerged with the introduction of modern materials such as steel beams and prestressed concrete (Fig. 7.17).

7.16 Cantilever.

7.15 (left) Christopher Wren, St. Paul's Cathedral, London, 1675–1710. Cross-section of dome.

7.17 Eduardo Torroja, Grandstand, Zarzuela Race Track, Madrid, 1935.

7.18 Aqueduct, Pont du Gard, near Nîmes, France, 1st century BC.

Bearing-Wall

In this system, the wall supports itself, the floors, and the roof. Log cabins are examples of bearing-wall construction; so are solid masonry buildings, in which the walls are the structure. In variations of bearing-wall construction, such as Figure 7.36, the wall material is continuous—that is, not jointed or pieced together. This variation is called *monolithic* construction.

Skeleton Frame

Here a framework supports the building; the walls are attached to the frame, thus forming an exterior skin. When skeleton framing utilizes wood, as in house construction, the technique is called *balloon construction*. When metal forms the frame, as in skyscrapers, the technique is known as *steel-cage construction*.

BUILDING MATERIALS

Historic and contemporary architectural practices and traditions often centre on specific materials, and to understand architecture further, we need to note a few.

Stone

The use of stone as a material turns us back to post-and-lintel systems and Figures 7.1 and 7.2. When stone is used together with mortar, for example, in arch construction, that combination is called *masonry* construction. The most obvious example of masonry, however, is the brick wall, and masonry construction is based on that principle. Stones, bricks, or blocks are joined together with mortar, one on top of the other, to provide basic, structural, weight-bearing walls of a building, a bridge, and so forth (Fig. 7.18). There is a limit to what can be accomplished with masonry because of the pressures that play on the joints between blocks and mortar and the foundation on which they rest. However, when one considers that office buildings such as Chicago's Monadnock Building (Fig. 7.19) are skyscrapers and that their walls are built solely of masonry—that is, there are no hidden steel reinforcements in the walls—it becomes obvious that much is possible with this elemental combination of stone and mortar.

7.19 Monadnock Building, Chicago, 1889–91. Daniel Hudson Burnham and John Wellborn Root.

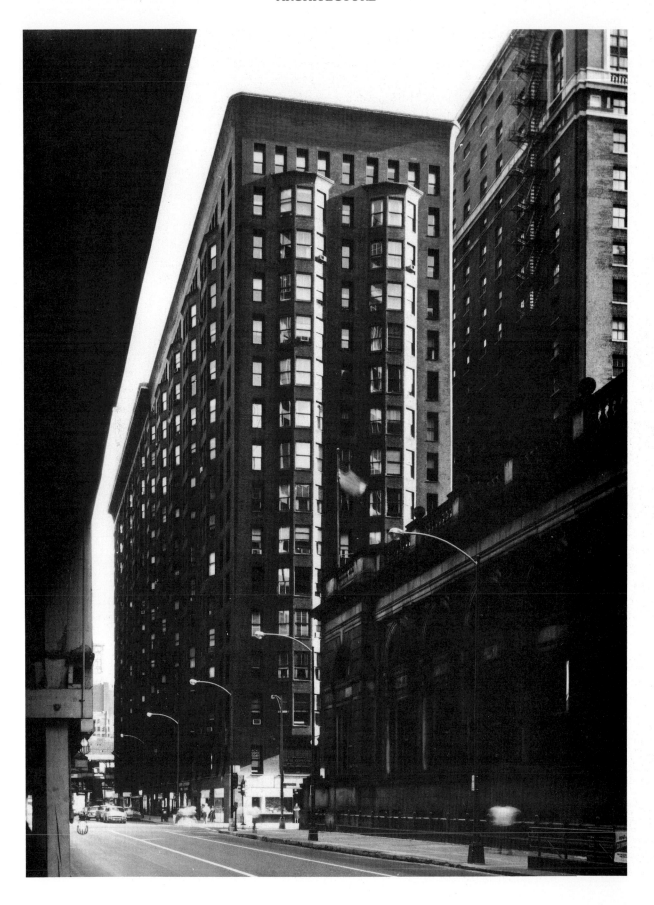

7.20 Richard Buckminster Fuller, Geodesic dome, Climatron, St. Louis, Missouri, 1959.

Concrete

The use of concrete is central to much contemporary architectural practice, but it was also significant as far back in the past as Ancient Rome. The Pantheon (Fig. **7.13**) comprises a masterful structure of concrete with a massive concrete dome, 142 ft (43 m) in diameter, resting on concrete walls 20 ft (6 m) thick. In contemporary architecture, we find *precast* concrete, which is concrete cast in place using wooden forms around a steel framework. We also find *ferroconcrete* or *reinforced concrete*, which utilizes metal reinforcing embedded in the concrete. Such a technique combines the tensile strength of the metal with the compressive strength of the concrete. *Prestressed* and *post-tensioned* concrete use metal rods and wires under stress or tension to cause structural forces to flow in predetermined directions. Both comprise extremely versatile building materials.

Wood

Whether in balloon framing for houses or in laminated beaming for modern churches, wood has played a pivotal role, especially in the United States, where its supply seems endless.

Steel

The use of steel has nearly endless variation and gives almost limitless possibilities for construction. Its introduction into the nineteenth-century industrial age forever changed style and scale in architecture. *Steel cage* construction and cantilever construction were noted earlier. *Suspension* construction in bridges, superdomes, aerial walkways, and so on has carried architects to the safe limits of space spansion and, sometimes, beyond

those limits. The *geodesic dome* (Fig. 7.20) is a unique use of materials invented by an American architect, R. Buckminster Fuller. Consisting of a network of metal rods and hexagonal plates, the dome is a light, inexpensive, yet strong and easily assembled building. Although it has no apparent size limit (Mr. Fuller claims he could roof New York City, given the funds), its potential for variation and aesthetic expressiveness seems somewhat limited.

LINE, REPETITION, & BALANCE

Line and repetition perform the same compositional functions in architecture as in painting and sculpture. In his Marin County Courthouse (Fig. 7.21), Frank Lloyd Wright takes a single motif, the arc, varies only its size, and repeats it almost endlessly. The result, rather than being monotonous, is dynamic and fascinating.

7.21 Frank Lloyd Wright, Marin County Courthouse, California, 1957–63.

Let's look at three other buildings. The main gate of Hampton Court Palace (Fig. 7.22), built in the English Tudor style around 1515 by Thomas Wolsey, at first appears haphazard to us because we seem to see virtually no repetition. Actually, this section of the palace is quite symmetrical, working its way left and right of the central gatehouse in mirror images. However, the myriad of chimneys, the imposition of the main palace, which is not centred on the main gate, and our own vantage point cause an apparent clutter of line and form that prompts our initial reaction. Line and its resultant form give Hampton Court Palace the appearance of a substantial castle.

Although it seems impossible, Figure 7.23 is the same Hampton Court Palace. Figure 7.22 reflects the style and taste of England during the reign of Henry VIII (who appropriated the palace from its original owner, Cardinal

Wolsey). Later monarchs found the cumbersome and primitive appearance unsuited to their tastes, and Christopher Wren was commissioned to plan a "new" palace. So, in 1689, in the reign of William and Mary, renovation of the palace proper began. The result was a new and classically oriented façade in the style of the English baroque.

As we can see in Figure 7.23, Wren has designed a sophisticated and overlapping system of repetition and balance. Note first that the façade is symmetrical. The outward wing at the far left of the photograph is duplicated at the right (but not shown in the photo). In the center of the building are four attached columns surrounding three windows. The middle window forms the exact center of the design, with mirror-image repetition on each side. Now note that above the main windows is a series of relief sculptures, pediments (triangular casings), and circular windows. Now return to the main row of

7.22 Hampton Court Palace, England. Tudor entry, c. 1515.

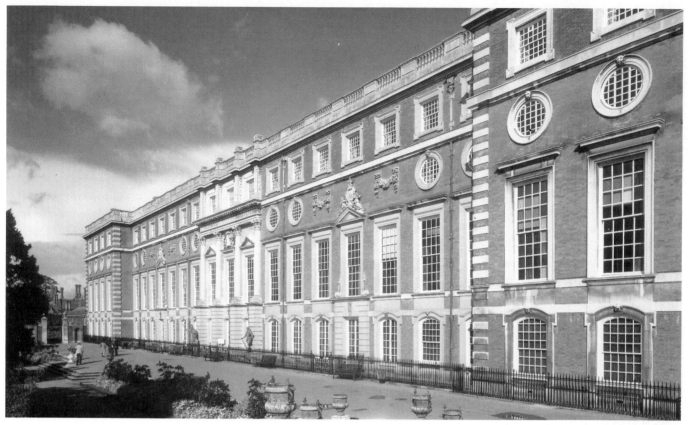

7.23 Hampton Court Palace, England. Wren façade, 1689.

windows at the left border of the photo and count toward the center. The outer wing contains three windows; then seven windows, then the central three; then seven; and finally the three of the unseen outer wing. Patterns of threes and sevens are very popular in architecture and carry religious and mythological symbolism. Wren has established a pattern of three in the outer wing, repeated it at the center, and then repeated it within each of the seven-window groups to create yet three additional patterns of three! How is it possible to create three patterns of three with only seven windows? First, locate the center window of the seven. It has a pediment and a relief sculpture above it. On each side of this window are three windows (a total of six) without pediments. So, we have *two* groupings of three windows each. Above each of the outside four windows is a circular window. The window on each side of the center window does not have a circular window above it. Rather, it has a relief sculpture, the presence of which joins these two windows with the center window to give us our third grouping of three. Line, repetition, and balance in this façade form a marvelous perceptual exercise and experience.

The overall effect of this facade, representing the English Baroque style, joins line, repetition, and balance to create an intricate and ornate experience. The facade is completely symmetrical in balance; every detail on one side of the centerline has a mirror image as its opposite. The center of the design is clearly marked by the collonaded portico. All of this comprises a clever composition expressing theme and variation based on themes of threes and sevens.

The entire facade has three major sections: Two wings and the large central wall. The central wall is broken into three sections comprising the main portico and the space on either side of it. The full facade achieves a freedom from plainness by Wren's breaking the plane into three extruding sections, that is, the two wings and the central portico. The vertical plane of the facade is broken into three sections by strong horizontal bands. The juxtaposition of curvilinear and rectilinear items within the design, again, creates variety of line and form through repetition.

The theme of seven is apparent in the sections right and left of the central portico, but also occurs when the

extruding sections are combined. Each wing contains four windows; the central portico contains three; the total is seven, twice. The typically Baroque quality of this intricate use of line, repetition, and balance lies in the fact that the design depends for its total unity and effect on the subtle interrelationship of these many different parts, no one of which suggests anything remotely like the whole.

Buckingham Palace, London (Fig. 7.24), and the Palace of Versailles (Fig. 7.25) illustrate different treatments of line and repetition. Buckingham Palace uses straight line exclusively, with repetition of rectilinear and triangular form. Like Hampton Court Palace, it exhibits *fenestration* groupings of threes and sevens, and the building itself is symmetrically balanced and divided by three pedimented, porticolike protrusions. Notice how the predominantly horizontal line of the building is broken by the three major pediments and given interest and contrast across its full length by the window pediments and the verticality of the attached columns.

Contrast Buckingham Palace with the Palace of Versailles, in which repetition occurs in groupings of threes and fives. Contrast is provided by juxtaposition and repetition of curvilinear line in the arched windows and baroque statuary. Notice how the horizontal line of the building, despite three porticoes, remains virtually undisturbed, in contrast with Buckingham Palace.

7.24 Buckingham Palace, London, c. 1825.

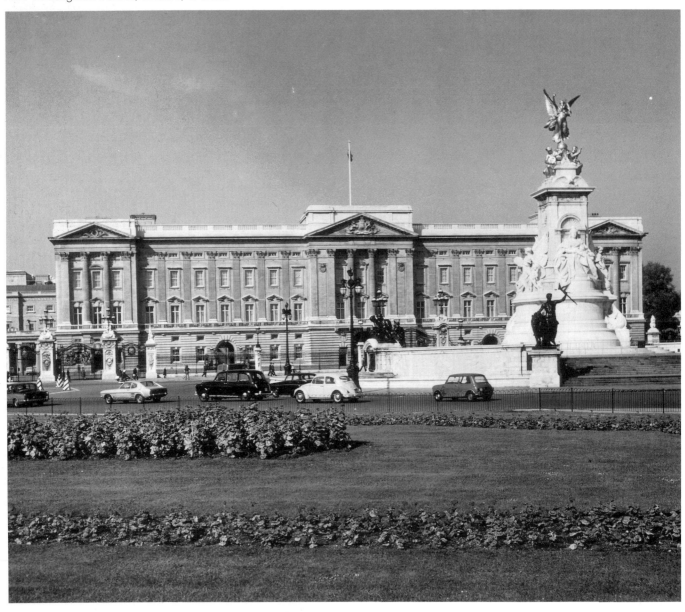

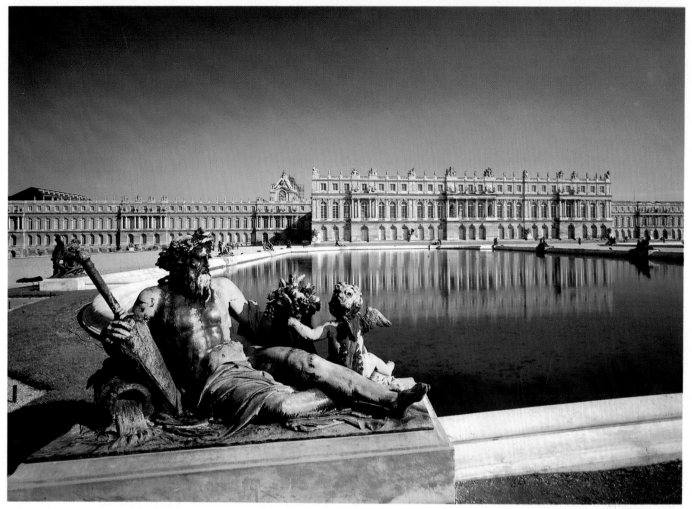

7.25 Palace of Versailles, France, 1669–85. Architects: Louis LeVau and Jules Hardouin-Mansart. Pan American World Airways Photo.

SCALE AND PROPORTION

The mass, or *scale*, and proportion of a building and its component elements are very important compositional qualities. Scale refers to the building's size and the relationship of the building and its decorative elements to the human form.

Proportion, or the relationship of individual elements in a composition to each other, also plays a role in the overall analysis and appearance of a design. Let's step outside architecture for a familiar example. The Concorde supersonic airliner appears to be a rather large plane when we view it on the movie screen or on television. Yet if we were to see the plane in actuality, we would be surprised to find that it is not particularly large—in comparison with a DC10, a Boeing 747, or even a Boeing 707. The proportion of the Concorde's window area to its overall size is misleading when we see the plane out of context

with the human body. The Concorde's windows are very small, much smaller than in other airliners. So when we see the Concorde in a newsreel we immediately equate the window size with which we are familiar with the windows in the Concorde. We assume that the relationship or *proportion* of window size to overall fuselage is conventional, and that assumption gives us a larger-than-actual image of the size of the plane. In terms of architecture, proportion and scale are tools by which the architect can create relationships that may be straightforward or deceptive. We must decide how these elements are used and to what effect. In addition, proportion in many buildings is mathematical: The relationships of one part to another often is based on ratios of three to two, one to two, one to three, and so on, as were the parts of the highboy (Fig. 0.1) discussed in the Introduction to Part I. Discovering such relationships in the buildings we see is one of the fascinating ways in which we can respond to architecture.

135

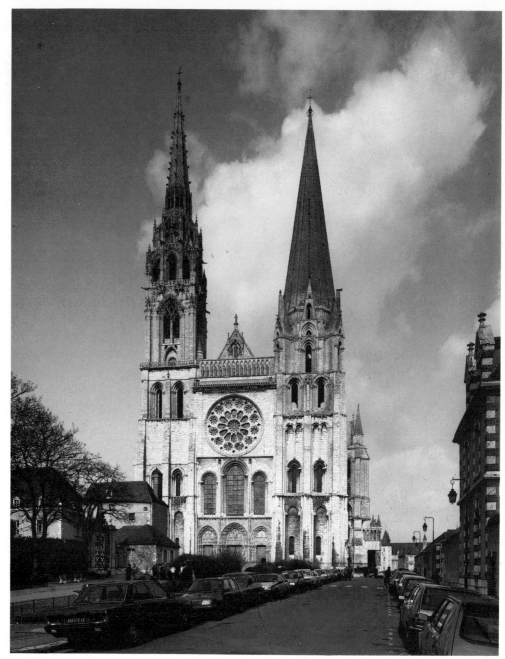

7.26 Exterior, Chartres Cathedral, France, 1145–1220. Photo: Giraudon/Art Resources, NY.

CONTEXT

An architectural design must take into account its context, or environment. In many cases context is essential to the statement made by the design. For example, Chartres Cathedral (Fig. **7.26**) sits at the center of and on the highest point in the village of Chartres. Its placement at that particular location had a purpose for the medieval artisans and clerics responsible for its design. The centrality of the cathedral to the community was an essential statement of the centrality of the church to the life of the medieval community. Context also has a psychological bearing on scale. A skyscraper in the midst of sky-scrapers has great mass but does not appear as massive in scale when overshadowed by another, taller skyscraper. A cathedral, when compared with a skyscraper, is relatively small in scale. However, when standing at the center of a community of small houses, it appears quite the opposite.

Two additional aspects of context concern the design of line, form, and texture relative to the physical environment of the building. On one hand, the environment can be shaped according to the compositional qualities of the building. Perhaps the best illustration of that principle is Louis XIV's palace at Versailles, whose formal symmetry is reflected in the design of thousands of acres around it.

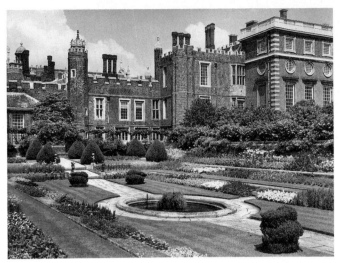

7.27 View of formal landscaping, Hampton Court Palace, England.

7.28 Frank Lloyd Wright, Kaufmann House, ''Falling Water'', Bear Run, Pennsylvania, 1936–37.

On a more modest scale, the formal gardens of Hampton Court (Fig. **7.27**) reflect the line and form of the palace.

On the other hand, a building may be designed so as to reflect the natural characteristics of its environment. Such an idea has been advanced by many architects and can be seen especially in residences in which large expanses of glass allow us to feel a part of the outside while we are inside. The interior decoration of such houses often takes as its theme the colors, textures, lines, and forms of the environment surrounding the home. Natural fibers, earth tones, delicate wooden furniture, pictures that reflect the surroundings, large open spaces—together they form the core of the design, selection, and placement of nearly every item in the home, from walls to furniture to silverware.

Frank Lloyd Wright was a great exponent of this style of work. His buildings seem to grow out of, and never violate, their environments. Perhaps his most inventive design is the Kaufmann House, ''Falling Water,'' at Bear Run, Pennsylvania (Fig. **7.28**). Cantilevered over a waterfall, its dramatic imagery is most exciting. The inspiration

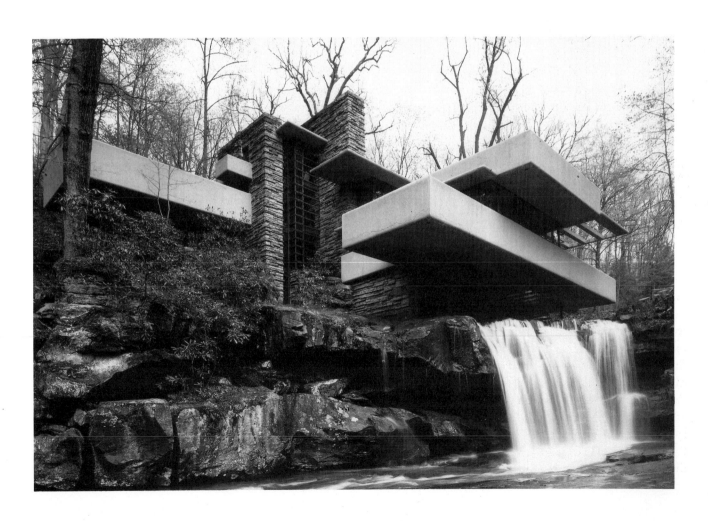

was probably the French Renaissance chateau of Chenonceaux, which is built on a bridge across the River Cher. However, "Falling Water" is no mere house built on a bridge. It seems to erupt out of the natural rock, and its beige concrete terraces blend harmoniously with the colors of the natural surrounding stone. Wright has successfully blended two seemingly dissimilar styles—the house is at one with its content, and yet is built in the rectilinear lines of the international style, to which Wright was opposed. He has taken that spare sterility of boxes and made them harmonize with the natural surroundings.

SPACE

It seems almost absurdly logical to state that architecture must concern space—for what else, by definition, is architecture? However, the world is overwhelmed with examples of architectural design that have not met that need. Design of space essentially means the design and flow of contiguous *spaces* relative to function. Take, for example, a sports arena. Of primary concern is the space necessary for the sports intended to occupy the building. Will it play host to basketball, hockey, track, football, or baseball? Each of these sports places a design restriction on the architect, and there may be curious results when functions not intended by the design are forced into its parameters. When the Brooklyn Dodgers moved to Los Angeles, they played for a time in the Los Angeles Coliseum, a facility designed for the Olympic Games and track and field and reasonably suited for the addition of football. However, the imposition of baseball created ridiculous effects; the left-field fence was only slightly over 200 ft (60 m) from home plate!

In addition to the requirements of the game, a sports arena must also accommodate the requirements of the spectators. Pillars that obstruct the spectator's view do not create good will and the purchase of tickets. Likewise, attempting to put more seats in a confined space than ought to be there can create great discomfort. Determining where to draw the line between more seats and fan comfort is not easy. The Montreal Forum, in which anyone over the height of 5 feet 2 inches is forced to sit with the knees under the chin, has not proven to be deleterious to ticket sales for the Montreal Canadiens hockey team. However, such a design of space might be disastrous for a franchise in a less hockey-oriented city.

Finally, the design of space must concern the relationship of various needs peripheral to the primary functions of the building. Again, in a sports arena the sport and its access to the spectator are primary. However, the relationship of access to spaces such as rest rooms and concession stands must also be considered. I once had season basketball tickets in an arena seating 14,000 people in which access to the *two* concession stands required standing in a line that, because of spatial design, intersected the line to the rest rooms! If the effect was not chaotic, it certainly was confusing, especially at half time of an exciting game.

Eeroe Saarinen's Trans-World Airline Terminal takes the dramatic shape of flight in curved lines and carefully designed spaces, which accommodate large masses of people and channel them to and from waiting aircraft. (Such shapes could be executed only by modern construction techniques and materials such as reinforced concrete.) Flight has also been suggested by Le Corbusier's dynamic church Notre-Dame-du-Haut (Fig. **7.29**). However, this pilgrimage church appears more like a work of sculpture than a building. Here function cannot be surmised from form. Rather, the juxtaposed rectilinear windows and curvilinear walls and the overwhelming roof nestled lightly on thin pillars above the walls all appear as a "pure creation of the spirit."

CLIMATE

Climate has always been a factor in architectural design in zones of severe temperature, either hot or cold. As the world's energy supplies diminish, this factor will grow in importance. In the temperate climate of much of the United States, solar systems and designs that make use of the moderating influence of the earth are common. These are passive systems—that is, their design accommodates natural phenomena rather than adding technological devices such as solar collectors. For example, in the colder sections of the United States a building can be made energy-efficient by being designed with no glass, or minimal glass, on its north-facing side. Windows facing south can be covered or uncovered to catch existing sunlight, which even in midwinter provides considerable warmth. Also, since temperatures at the shallow depth of 3 ft (1 m) below the earth's surface rarely exceed or go below 50° F (10° C) regardless of season, the earth presents a gold mine of potential for design. Houses built into the sides of hills or recessed below the earth's surface require much less heating or cooling than those standing fully exposed—regardless of climate extremes. Even in zones of uniform and moderate temperature, climate is a design factor. The "California lifestyle," as it often is known, is responsible for design that accommodates easy access to the out-of-doors, and large, open spaces with free-flowing traffic patterns.

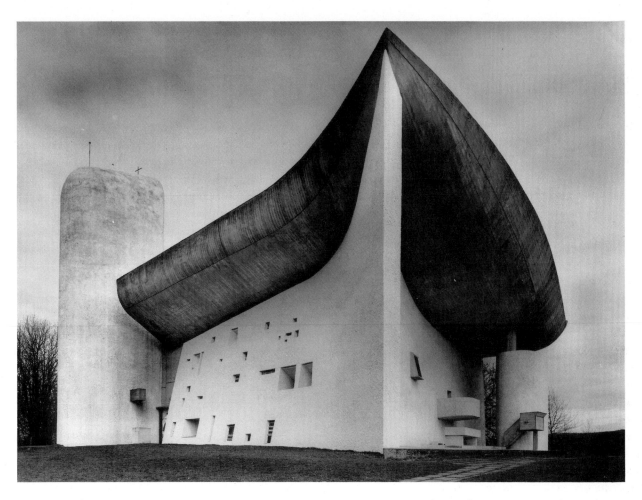

7.29 Le Corbusier, Notre-Dame-du-Haut, Rouchamp, France, 1950–54. From the southeast.

HOW DOES IT STIMULATE THE SENSES?

As should be clear at this point, our sensual response to a form of aesthetic design is a composite experience. To be sure, the individual characteristics we have discussed previously are the stimuli for our response. However, response is a product of the moment and happens because stimuli working in concert affect us in a particular manner. So, since in other chapters we have already considered how particular design considerations might affect us, I wish to make this chapter's analysis a bit more like our actual experience—that is a spontaneous response to the artwork. My remarks will be brief; much more could be said of each example. However, in the following progression of comparisons, I wish not to be impeded by excessive detail concerning each work.

GOTHIC CATHEDRALS

The Gothic cathedral has been described as the perfect synthesis of intellect, spirituality, and engineering. The upward, striving line of the Gothic arch makes a simple yet powerful statement of medieval people's striving to understand their earthly relation to the spiritual unknown. Even today the simplicity and grace of that design have an effect on most who view a Gothic cathedral.

The four-square power of Notre Dame, Paris (Fig. **7.30**), reflects the strength and solidity of an urban cathedral in Europe's largest city of the age. Its careful composition is highly mathematical—each level is equal to the one below it, and its tripartite division is clearly symbolic of the trinity. Arcs (whose radii are equal to the width of the building) drawn from the lower corners, meet at the top of the circular window at the second level. Careful design moves the eye inward and slowly upward. The exterior structure clearly reveals the interior space.

Chartres Cathedral (Figs. **7.31** and **7.32**) stands in remarkable contrast. Chartres is a country cathedral raised above the center of a small city. Just as its sculptures illustrate a progression of style, so does its architectural design. Our first encounter leads us to wonder why its cramped entry portal is so small in comparison with the rest of the building. The reason is that Chartres represents a cumulative building effort over many years, as fire destroyed one part of the church after another. The main entry portal and the windows above it date back to its Romanesque beginnings. The porch of the south transept (the portal holding the statues of the warrior saints) is much larger and more in harmony with the rest of the

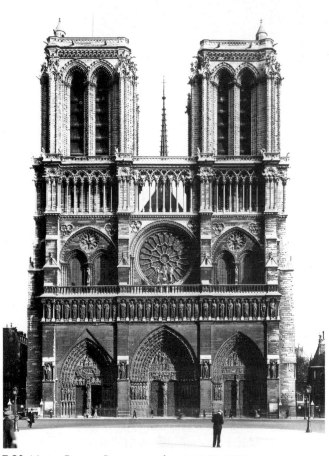

7.30 Notre Dame, Paris, west front, 1163–1250.

7.31 Chartres Cathedral, south transept porch, c. 1205–50.

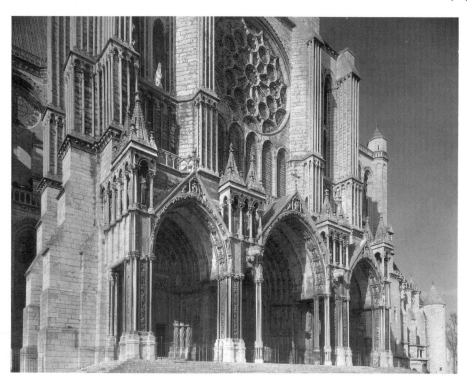

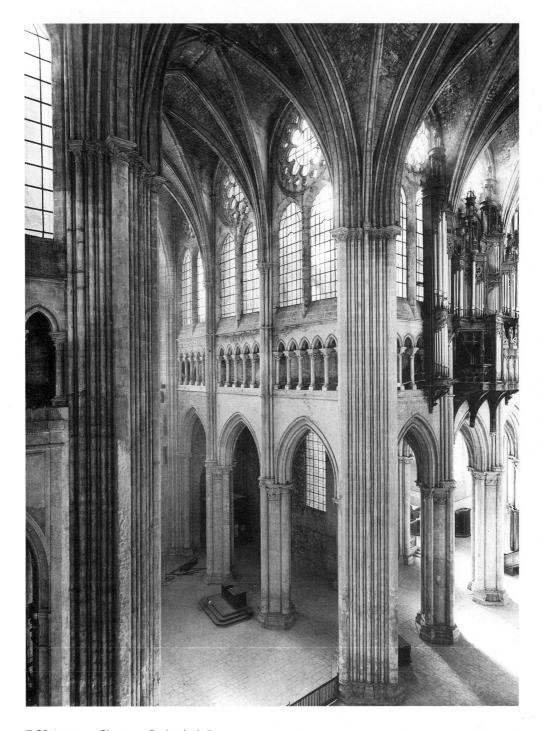

7.32 Interior, Chartres Cathedral, France.

building. Finally, as our eyes rise upward, we wonder at the incongruity of the two unmatched spires. Fire was again responsible. The early spire on the right illustrates faith in a simple upward movement that rises, unencumbered, to disappear at the tip into the ultimate mystery—space. The later spire, designed in psychological balance with the other, is more ornate and complex. The eye travels upward with increasing difficulty, its progress halted and held earthbound by decoration and detail. Only after some pause does the eye reach the tip of the spire, the point of which symbolizes the individual's escape from the earthly known to the unknown.

The Cathedral at Amiens (Fig. **7.33**) is similar in basic composition to Notre Dame, but rather than creating a sense of four-square power, it gives a feeling of delicacy. Amiens Cathedral illustrates a late development of Gothic style similar to the left spire of Chartres Cathedral. In scale and proportion, however, Amiens is more like Notre Dame. The differences between Amiens and Notre Dame provide an important lesson in the ways design can be used to elicit a response. Amiens is more delicate than Notre Dame, and this feeling is encouraged by the greater detail that focuses our attention on space as opposed to flat stone. Both churches are divided into three very obvious horizontal and vertical sections of roughly the same proportion. Notre Dame appears to rest heavily on its lowest section, whose proportions are diminished by

the horizontal band of sculptures above the portals. Amiens, on the other hand, carries its portals upward to the full height of the lower section. In fact, the central portal, much larger than the central portal of Notre Dame, reinforces the line of the side portals to form a pyramid whose apex penetrates into the section above. The roughly similar size of the portals of Notre Dame reinforces its horizontal sense, thereby giving it stability. Similarly each use of line, form, and proportion in Amiens reinforces lightness and action, as compared with stability and strength in Notre Dame. This discussion does not imply that one design is better than the other. Each is different and displays a different approach. Nevertheless, both cathedrals are unquestionably Gothic, and we can easily identify the qualities that make them so.

Together with the grandeur of simple vertical line in Gothic cathedrals is an ethereal lightness that defies the material from which they were constructed. The medieval architect has created in stone not the heavy yet elegant composition of the early Greeks, which focused upon treatment of stone, but rather a treatment of stone that focuses on space—the ultimate mystery. Inside the cathedrals the design of stained glass kept high above the worshippers' heads so controls the light entering that the overwhelming effect is, again, one of mystery. Line, form, scale, color, structure, balance, proportion, context, and space all combine to form unified compositions that have stood for hundreds of years as prototypes and symbols of the Christian experience.

A totally different appeal to the emotions emerges from the ornate German baroque style Kaiseraal Residenz (Fig. **7.34**), wherein ornateness and opulence form the object of line and form.

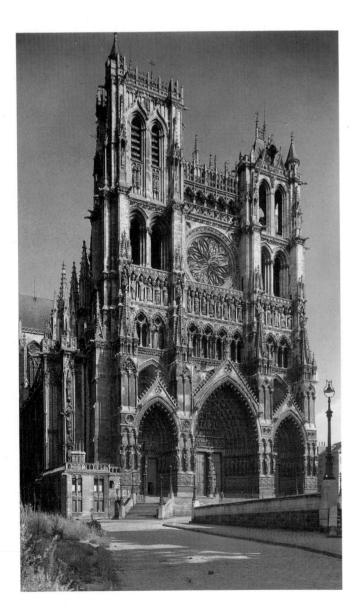

7.33 (*left*) Amiens Cathedral, west front, c. 1220–59.

7.34 (*above*) Balthasar Neumann, Kaisersaal, Residenz, Würzburg, Germany, 1719–44.

7.35 (*below*) Hall of Mirrors, Palace of Versailles, France, 1680. Architects: Jules Hardouin-Mansart and Charles LeBrun.

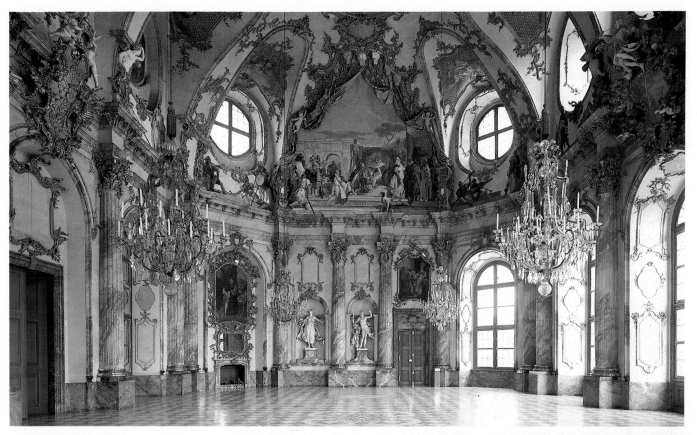

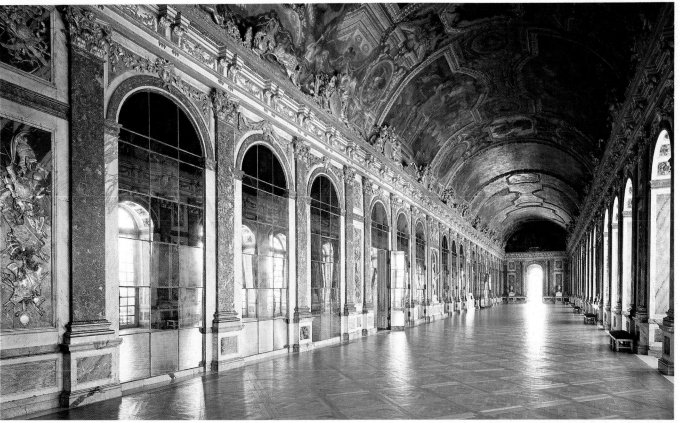

HOLY FAMILY CHURCH

The Christian experience is also the denominator of the design of the Holy Family Church (Fig. **7.36**). However, despite the clarity of line and the upward striving power of its composition, this church has a modern sophistication, perhaps speaking more of our own conception of space, which to us is less unknowable and more conquerable, than did the churches of our medieval predecessors. The juxtaposing of rectilinear and curvilinear lines creates an active and dynamic response, one that prompts in us abruptness rather than mystery. The composition is cool, and its material calls attention to itself—to its starkness and to its lack of decoration. The Church of the Holy Family achieves its balance psychologically, by intent rather than by accident, as was the case with Chartres Cathedral.

Each part of the church is distinct and is not quite subordinate to the totality of the design. This building perhaps represents a philosophy intermediate between the philosophy underlying the Chartres Cathedral, whose entire design can be reduced to a single motif—the Gothic arch—and the philosophy such as the baroque, as seen in the Hall of Mirrors of the Palace of Versailles (Fig. **7.35**). No single part of the design of this hall epitomizes the whole, yet each part is subordinate to the whole. Our response to the hall is shaped by its ornate complexity, which calls for detachment and investigation and intends to overwhelm us with its opulence. Here, as in most art, the expression and the stimuli reflect the patron. Chartres Cathedral reflects the medieval church, the Church of the Holy Family, the contemporary church, and Versailles, King Louis XIV. Versailles is complex, highly active, and yet warm. The richness of its textures, the warmth of its colors, and its curvilinear softness create a certain kind of comfort despite its scale and formality.

UNITED STATES CAPITOL BUILDING

In this neoclassic house of government (Fig. **7.37**), formality creates a foursquare, solid response. The symmetry of its design, the weight of its material, and its coldness give us a sense of impersonal power, which is heightened by the crushing weight of the dome. Rather than the upward-striving spiritual release of the Gothic arch, or even the powerful elegance of the Greek post-and-lintel, the Capitol Building, based on a Roman prototype, elicits a sense of struggle. This is achieved through upward columnar thrust (heightened by the context provided by Capitol Hill) and downward thrust (of the dome) focused toward the interior of the building.

7.36 Holy Family Church, Parma, Ohio, 1965. Architects: Conrad and Fleishman.

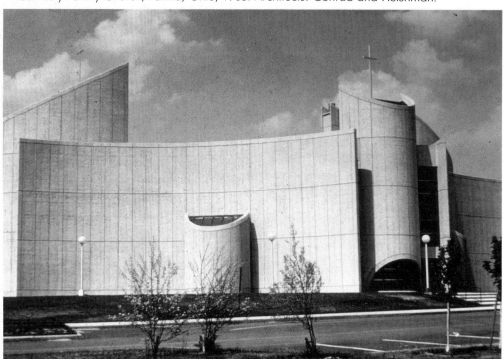

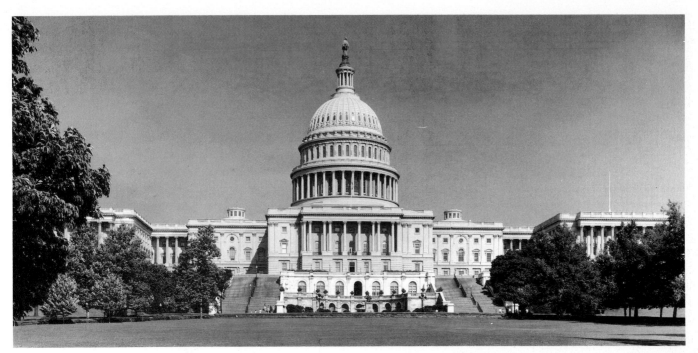

7.37 United States Capitol Building, 1792–1856. Washington Area Convention and Visitors Association Photo.

GUGGENHEIM MUSEUM

The architect Louis Sullivan (who employed Frank Lloyd Wright as an engineering student to work with him on the concept of a Tall Building, which led to the principle of the skyscraper) is credited with the concept that form follows function. To a degree we have seen that concept in the previous examples, even though, with the exception of the Church of the Holy Family, they all precede Sullivan in time. A worthy question concerning the Guggenheim Museum (Fig. **7.38**) might be how well Wright

7.38 Frank Lloyd Wright, Guggenheim Museum, New York City, 1942–59.

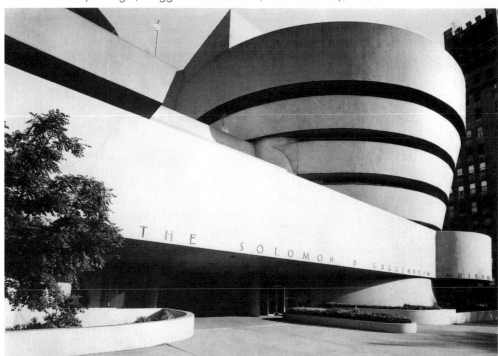

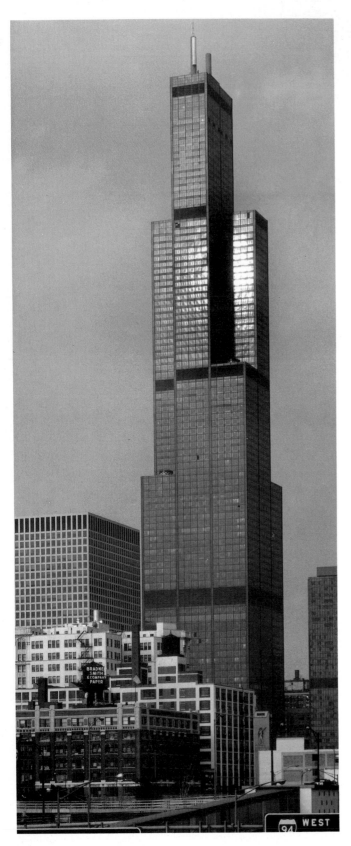

7.39 Skidmore, Owings, and Merrill, Sears Tower, Chicago, 1971.

followed Sullivan's philosophy. There is a story that Wright hated New York City because of unpleasant experiences he had had with the city fathers during previous projects. As a result, the Guggenheim, done late in his life, became his final gesture of derision to the city. This center of contemporary culture and art, with its single, circular ramp from street level to roof, was built (so the story goes) from the plans for a parking garage! Be that as it may, the line and form of this building create a simple, smoothly flowing, leisurely, upward movement juxtaposed against a stark and dynamic rectilinear form. The building's line and color and the feeling they produce are contemporary statements appropriate to the contemporary art the museum houses. The modern design of the Guggenheim is quite in contrast with the classical proportions of the Metropolitan Museum of Art, just down the street, which houses great works of ancient and modern art. The interior design is outwardly expressed in the ramp, and one can speculate that the slowly curving, unbroken line of the ramp is highly appropriate to the leisurely pace that one should follow when going through a museum.

ZARZUELA RACE TRACK

Leisurely progress through the Guggenheim is opposite to the sensation stimulated by the cantilevered roof of the grandstand at Zarzuela Race Track in Spain (Fig. 7.17). Speed, power, and flight are its preeminent concerns. The sense of dynamic instability inherent in the structural form—cantilever—and this particular application of that form, mirror the dynamic instability and forward power of the race horse at full speed. However, despite the form and the strong diagonals of this design, it is not out of control; the architect has unified the design through repetition of the track-level arcade in the arched line of the cantilevered roof. The design is dynamic and yet humanized in the softness of its curves and the control of its scale.

SEARS TOWER

Nothing symbolizes the technological achievement of modern humans more than the skyscraper. Also, nothing symbolizes the subordination of humans to their technology more than the scale of this monumental building (Fig. 7.39). Designed of rectangular components placed side by side, the Sears Tower is a glass and steel monolith overwhelming in its scale and proportions and cold in its materials. As a point of departure, its appeal to our senses raises the question of what comes next, the conquest of space or a return to respect for its natural mysteries?

LITERATURE

WHAT IS IT?

Literature is language whose purpose is to communicate. In the same sense that all artworks communicate through a particular medium someone's perception of reality or truth, so literature communicates using the forms we shall examine momentarily. There is a difference between literature that some call utilitarian and literature that may be called creative. Creative literature has a different approach than utilitarian literature. The approach determines the category in the same sense that a picture composed of line, form, and color is termed "art," whereas another picture, composed of those same characteristics but whose purpose is merely to provide a visual copy, is termed "illustration."

As with any work of art, creative literature has many layers which make it a symbolic rather than a literal presentation. Nonetheless, there is a difference between literature and the other arts. Perhaps the difference is academic, but I believe it is important if we are to understand how art and literature work to create responses in us. Literature operates in an explicit fashion. (Poetry, in which the visual format of the poem contributes to its meaning, is, of course, an exception.) That is, literature operates through a system of language in which the words themselves are the triggers for our symbolic understandings. The traditional arts, which we have previously examined, trigger our responses through nonverbal, that is to say, nonexplicit means. Even in the theatre, artistic communication goes far beyond the explicit language of the playwright. That is why the Greeks called it "theatre," from their word *theatron*, "a place of *seeing*". However, in its written form, which we call drama, the play script is a part of literature. When it is performed, with the addition of actors and *mise en scène*, it becomes theatre. So, what are the formal divisions of literature? They are fiction, poetry, biography, essay, and drama.

FICTION

Fiction is a work created from the author's imagination rather than from fact. Normally it takes one of two approaches to its subject matter: *realistic*—that is, the appearance of observable, true-to-life details; or *nonrealistic*—that is, fantasy. Other literary forms such as narrative poetry and drama can also be fiction, and fictional elements can be introduced into forms such as biography and epic poetry. Fiction traditionally is divided into *novels* and *short stories*.

Novels

The novel is a prose narrative of considerable length which has a plot that unfolds from the actions, speech, and thoughts of the characters. Normally the novel treats events within the range of ordinary experience and draws upon original subject matter rather than traditional or mythic subjects. Novels typically have numerous characters and employ normal, daily speech. The subject matter of novels can be divided into two general categories, *sociological-panoramic*, covering a wide-ranging story of many years and various settings, and *dramatic-intimate*, which is restricted in time and setting.

Often, novels are formally classified by their subject matter. A few of these categories are:

picaresque the adventures of a rogue
manners problems of personal relations
sentimental the development of emotionality, especially a sentimental appreciation of simplicity
Gothic the trials of a pure, sensitive, and noble heroine who undergoes terrifying experiences, emerging undamaged—usually this type of novel is stilted, melodramatic, and exploitive of the darker side of emotional psychology
historical intertwines historical events and fictional characters
realistic focuses on familiar situations and ordinary people
lyrical a short work with a metaphoric structure and a limited number of characters.

Short Stories

As the name implies, short stories are short prose fictional works focusing on unity of characterization, theme, and effect.

POETRY

Poetry is a type of work designed to convey a vivid and imaginative sense of experience. Poetry uses condensed language selected for its sound, suggestive power, and meaning, and employs specific technical devices such as meter, rhyme, and metaphor. Poetry can be divided into three major types: *narrative*, *dramatic*, and *lyric*.

Narrative

Narrative poetry tells a story. *Epic* poetry is narrative poetry of substantial length and elevated style. It uses strong symbolism, and has a central figure of heroic proportions. A *ballad* is a sung or recited narrative. A *metrical romance* is a long narrative, romantic tale in verse.

Dramatic

Dramatic poetry utilizes dramatic form or dramatic technique. Its major form is the dramatic monologue.

Lyric

Lyric poetry was originally intended to be sung and accompanied by a lyre. It is a brief, subjective work employing strong imagination, melody, and feeling to create a single, unified, and intense impression of the personal emotion of the poet.

BIOGRAPHY

Over the centuries, biography has taken many forms and witnessed many techniques and intentions, including literary narratives, catalogues of achievement, and psychological portraits. Biography is a written account of a person's life. Accounts of the lives of the saints and other religious figures are called *hagiographies*.

ESSAYS

Traditionally, the essay is a short literary composition on a single subject, usually presenting the personal views of the author. The word comes from the French, meaning "to try" and the vulgar Latin, meaning "to weigh." Essays include many subforms and a variety of styles, but they uniformly present a personal point of view with a conscious attempt to achieve grace of expression. Essays characteristically are marked by clarity, grace, good humor, wit, urbanity, and tolerance.

An essay is a work of nonfiction reflecting the author's attitudes toward a specific subject. In so doing, it may reveal the author's personality or speculations. For the most part, essays are brief, but occasionally much longer works, such as John Locke's treatise, *Essay Concerning Human Understanding*, 1690, have appeared. Traditionally, essays fall into two categories: *informal*, or *formal*.

Informal

Informal essays tend to be brief and very personal. They are conversational in tone and loose in structure. This type of essay can be further divided into categories called *familiar* or *personal* and *character*. The personal essay presents an aspect of the author's personality as he or she reacts to an event. Character essays describe persons, isolating their dominant traits, for example.

Formal

Formal essays are longer and more tightly structured than informal essays. Formal essays tend to focus on impersonal subjects and place less emphasis on the personality of the author.

DRAMA

Drama is the written script, or play, upon which a theatre performance may be based. We examined this genre in Chapter 4.

HOW IS IT PUT TOGETHER?

FICTION

Point of View

Fiction is a story told by someone at a particular time and place to a particular audience. So it has a definite perspective, and, therefore, certain limitations of objectivity. It raises questions about the right way of seeing things. For the story to achieve credibility as fiction, the author must appear to distance himself or herself from the representative truth of the story and the reader. The "point of view" is a device to objectify the circumstances. Four types of narrative point of view are *first person; epistolary*—that is, told through the use of letters written by the characters; *omnicient narration* or "third person;" and *stream of consciousness* or "interior monologue," wherein a flow of thoughts, feelings, and memories come from a specific character's psyche. These arbitrary definitions regarding point of view may vary, or be combined by authors to suit their own purposes. Point of view, as we have discussed it here, means merely that one of the means by which fiction is put together is usable by an author in several ways, at several levels, to communicate meaning.

Appearance and Reality

Fiction claims to be true to actuality, but it is built on invented sequences of events. It refers back on itself, layering the fictional and the factual.

Tone

Tone may also be called the atmosphere of the story. In essence, it is the author's attitude toward the story's literal facts. Reading is much like listening to conversation. That is, the words carry meaning, but the way in which they are said—their tone—shapes meaning much more effectively. In addition, the atmosphere of the story sometimes includes the setting or the physical environment. In many stories, atmosphere is psychological as well as physical, and when all of these characteristics of tone are taken together, they provide subtle and powerful suggestions leading to our fuller understanding of the work.

Character

What gives literature its appeal is people, but not just people alone. Our interest is drawn because we see a human character involved in some kind of conflict—that is, a struggle with some important human problem. Authors write to that potential interest and usually strive to focus our attention, and to achieve unity, by drawing a central character with whose actions, decisions, growth, and development we can identify, and in whom we can find an indication of some broader aspect of the human condition. As we noted in Chapter 4, the term character goes beyond the mere identification of a "person." Character means the psychological spine of the individual, the driving force which makes that individual respond the way he or she does when faced with a given set of circumstances. Character is what we are interested in: Given a set of troubling or challenging circumstances, what does the character of the individual lead him or her to do?

In developing character, an author has numerous choices, depending, again, on his or her purposes. Character may be fully three-dimensional and highly individualistic—that is, as complex as the restrictions of the medium allow. Novels, because of their length and the fact that the reader can go back to double-check a fact or description, allow much more complex character development or individuality than do plays, whose important points must be found by the audience the moment they are presented. Also, a change of narrative viewpoint, appropriate to the novel but not a play (unless a narrator is used, as in *Our Town*), can give the reader aspects of character in a more efficient manner than can revelation through action or dialogue. On the other hand, the author's purpose may be served by presenting character not as a fully developed individual but as a type. Whatever the author's choice, the nature of character development tells us much about the meaning we are to find in the work.

Plot

Plot is the structure of the work. It is more than the story line or the facts of the piece. In literature, as in the theatre, we find our interest dependent upon action. We are here to witness character in action. Plot is the structure of that action. It creates unity in the work and thereby helps us to find meaning. Plot is the skeleton which determines the ultimate shape of the piece, once the elements of flesh have been added to it. The action of a literary work is designed to dramatize a fully realized theme, situation, or character.

Plot may be the major or subordinate focus in a work, and it can be open or closed. Closed plots rely on the Aristotelian model of pyramidal action with exposition, complication, and resolution or denouement. An open plot has little or no resolution. We merely leave the characters at a convenient point and imagine them continuing on as their characters will dictate.

Theme

Most good stories have an overriding idea or theme by which the other elements are shaped. Quality in works of art may rest on the artist's ability to utilize the tools of his or her medium and on whether the artist has something worthwhile to say. Some critics argue that the quality of a theme is less important than what the author does with it. Yet, the conclusion is inescapable: The best artworks are those in which the author has taken a meaningful theme and developed it exceptionally. So the theme or idea of a work is what the author has to say. The other devices of the piece will help us to understand the ultimate idea. Theme may mean a definite intellectual concept, or it may indicate a highly complex situation such as occurs in "A Rose for Emily," which is reprinted in this chapter. Clues to understanding the idea can come as early as our exposure to the title. Beyond that, the theme is usually revealed in small pieces as we move from beginning to conclusion.

Symbolism

Every work of literature is symbolic to one degree or another. It stands for something greater than its literal reality. Words are symbols, as is language. So any story is symbolic inasmuch as it symbolizes human experience. Often the symbols that occur in a story are cultural in derivation. That is why we often have difficulty understanding the levels of meaning in works from other cultures. We also find it difficult to grasp the symbols in works from our own Western tradition. The more we

know about our culture and its various points of view through history, the more we are able to grasp the symbolism, and thereby the meaning, of the great thinkers, writers, and artists whose insights into the human condition can help us cope with the significant questions of our time and our personal condition.

Sometimes symbols are treated as if they are private or esoteric. In other words, sometimes writers will purposely try to hide some levels of meaning from all but the thoroughly initiated or truly sophisticated. Sometimes authors will try to create new symbol systems. Whatever the case, symbolism gives the story its richness and much of its appeal. When we realize that a character, for example, is a symbol, regardless of how much of an individual he or she may be, the story takes on new meaning for us. We often discover that every character in the story symbolizes us—that is, some aspect of *our* complex and often contradictory characters. Symbols can be hidden, profound, or simple. When we discover them and unlock their revelations, we have made a significant stride toward understanding meaning.

POETRY

Language

Rhythm can be broken into four types: quantitative, accentual, syllabic, and accentual-syllabic. Quantitative rhythm has a regular succession of long and short syllables. Accentual rhythm creates rhythm through stress—that is, accented syllables. Syllabic rhythm has a fixed number of syllables in a line that set the rhythm. Accentual-syllabic rhythm combines accents with a relatively fixed number of syllables to create rhythm.

Imagery comprises a verbal representation of a sensory experience. It can be literal or figurative. In the former, there is no change or extension in meaning; for example, "green eyes" are simply eyes that are a green color. In the latter, there is a change in literal meaning; for example, green eyes might become "green orbs."

Figures, like images, take words beyond their literal meaning. Much of poetic meaning comes in comparing objects in ways that go beyond the literal. For example, in Robert Frost's "Stopping by Woods on a Snowy Evening," snowflakes are described as *downy*, which endows them with the figurative quality of soft, fluffy feathers on a young bird. In the same sense, Frost uses "sweep" and "easy" to describe the wind.

Metaphors are figures of speech by which new implications are given to words. For example, the expression "the

twilight of life" takes the word *twilight* and applies it to the concept of life to create an entirely new image and meaning.

Symbols also are often associated with figures of speech, but not all figures are symbols, and not all symbols are figures. Symbolism is critical to poetry, which uses compressed language to express, and carry us into, its meanings. In poetry "the whole poem helps to determine the meaning of its parts, and in turn, each part helps to determine the meaning of the whole poem."[1]

Structure

Form or structure in poetry derives from fitting together lines of similar structure and length tied to other lines by end rhyme. For example, the sonnet has fourteen lines of iambic pentameters rhymed 1–3, 2–4, 5–7, 6–8, 9–11, 10–12, 13–14.

Stanzas, which are any recurring groupings of two or more lines in terms of length, meter, and rhyme, are part of structure. A stanza usually presents a unit of poetic experience, and if the poem has more than one stanza, the pattern is usually repeated.

Sound Structures

Rhyme is the most common sound structure. Rhyme is, of course, the coupling of words that sound alike. Its function in poetry is to tie the sense together with the sound. Rhyme can be masculine, feminine, or triple. Masculine rhyme is based on single-syllable vowels such as "hate" and "mate." Feminine rhyme is based on sounds between accented and unaccented syllables, for example, "hating" and "mating." Triple rhyme comprises a correspondence among three syllables such as "despondent" and "respondent."

Alliteration is a second type of sound structure in which an initial sound is repeated for effect; for example, *fancy free*.

Assonance is a similarity among vowels but not consonants.

Meter

Meter comprises the type and number of rhythmic units in a line. Rhythmic units are called *feet*. Four common kinds of feet are *iambic, trochaic, anapestic,* and *dactyllic*. Iambic meter alternates one unstressed and one stressed syllable; trochaic meter alternates one stressed and one unstressed syllable; anapestic meter alternates two unstressed and one stressed syllable; and dactyllic meter alternates one stressed and two unstressed syllables.

Line, also called verse, determines the basic rhythmic pattern of the poem. Lines are named by the number of feet they contain. One foot is monometer; two, dimeter; three, trimeter; four, tetrameter; five, pentameter; six, hexameter; seven, heptameter; and eight, octameter.

BIOGRAPHY

Facts

Facts are the verifiable details around which a biography is shaped. However, facts, other than matters such as birth, death, marriage, and other date-related occurrences, often have a way of becoming elusive. "Facts" often turn out to be observations filtered through the personality of the observer. Incontrovertible facts may comprise a chronological or skeletal framework for a biography, but often they do not create much interest. Often they do not provide much of a skeleton either. Many individuals about whose lives we would like to learn more have few facts recorded about them. On the other hand, the lives of other important individuals have been chronicled in such great detail that too many facts exist. Artistry entails selection and composition, and in the latter case, interest may require leaving many facts out of the narrative. Of course, another issue related to facts and biography is the question of what the author should do with the facts. If the facts are injurious, should they be used? In what context should they be used? Whatever the situation, facts alone do not comprise a sufficient quality for an artistic or interesting biography.

Anecdotes

Anecdotes are stories or observations about moments in a biography. Anecdotes take the basic facts and expand them for illustrative purposes, thereby creating interest. Anecdotes may be true or untrue. Their purpose, often, is to create a memorable generalization. They may also generate debate or controversy.

Quotations form part of anecdotal experience. Their purpose is to create interest by changing the presentational format to that of dialogue. In one sense, dialogue brings us closer to subjects of the biography by helping to create the impression that we are part of the scene, as opposed to being third parties listening to someone else describe a situation.

HOW DOES IT APPEAL TO THE SENSES?

The following seven selections serve as illustrations of literature. Literature appeals to our senses by the way in which the writer uses the tools of the medium. We have applied the formal and technical elements of the arts enough times now that to do so again would be to restate the obvious. Read the following examples and decide for yourself how your response is manipulated by the author's use of the devices we have discussed. Discuss each example with a friend to see if your reactions were similar or different. Where differences arise, try to determine why.

FICTION

"A Rose for Emily"
William Faulkner
1897–1962

1

When Miss Emily Grierson died, our whole town went to her funeral; the men through a sort of respectful affection for a fallen monument, the women mostly out of curiosity to see the inside of her house, which no one save an old manservant—a combined gardener and cook—had seen in at least ten years.

It was a big, squarish frame house that had once been white, decorated with cupolas and spires and scrolled balconies in the heavily lightsome style of the seventies, set on what had once been our most select street. But garages and cotton gins had encroached and obliterated even the august names of that neighborhood; only Miss Emily's house was left, lifting its stubborn and coquettish decay above the cotton wagons and the gasoline pumps—an eyesore among eyesores. And now Miss Emily had gone to join the representatives of those august names where they lay in the cedar-bemused cemetery among the ranked and anonymous graves of Union and Confederate soldiers who fell at the battle of Jefferson.

Alive, Miss Emily had been a tradition, a duty, and a care; a sort of hereditary obligation upon the town, dating from that day in 1894 when Colonel Sartoris, the mayor—he who fathered the edict that no Negro woman should appear on the streets without an apron—remitted her taxes, the dispensation dating from the death of her father on into perpetuity. Not that Miss Emily would have accepted charity. Colonal Sartoris invented an involved tale to the effect that Miss Emily's father had loaned money to the town, which the town, as a matter of business, preferred this way of repaying. Only a man of Colonel Sartoris' generation and thought could have invented it, and only a woman could have believed it.

When the next generation, with its more modern ideas, became mayors and aldermen, this arrangement created some little dissatisfaction. On the first of the year they mailed her a tax notice. February came, and there was no reply. They wrote her a formal letter, asking her to call at the sheriff's office at her convenience. A week later the mayor wrote her himself, offering to call or send his car for her and received in reply a note on paper of an archaic shape, in a thin flowing calligraphy in faded ink, to the effect that she no longer went out at all. The tax notice was also enclosed, without comment.

They called a special meeting of the Board of Aldermen. A deputation waited upon her, knocked at the door through which no visitor had passed since she ceased giving china-painting lessons eight or ten years earlier. They were admitted by the old Negro into a dim hall from which a stairway mounted into still more shadow. It smelled of dust and disuse—a close, dank smell. The Negro led them into the parlor. It was furnished in heavy, leather-covered furniture. When the Negro opened the blinds of one window, they could see that the leather was cracked; and when they sat down, a faint dust rose sluggishly about their thighs, spinning with slow motes in the single sun-ray. On a tarnished gilt easel before the fireplace stood a crayon portrait of Miss Emily's father.

They rose when she entered—a small, fat woman in black, with a thin gold chain descending to her waist and vanishing into her belt, leaning on an ebony cane with a tarnished gold head. Her skeleton was small and spare; perhaps that was why what would have been merely plumpness in another was obesity in her. She looked bloated, like a body long submerged in motionless water, and of that pallid hue. Her eyes, lost in the fatty ridges of her face, looked like two small pieces of coal pressed into a lump of dough as they moved from one face to another while the visitors stated their errand.

She did not ask them to sit. She just stood in the door and listened quietly until the spokesman came to a stumbling halt. Then they could hear the invisible watch ticking at the end of the gold chain.

Her voice was dry and cold. "I have no taxes in Jefferson. Colonel Sartoris explained it to me. Perhaps one of you can gain access to the city records and satisfy yourselves."

"But we have. We are the city authorities, Miss Emily. Didn't you get a notice from the sheriff, signed by him?"

"I received a paper, yes," Miss Emily said. "Perhaps he considers himself the sheriff . . . I have no taxes in Jefferson."

"But there is nothing on the books to show that, you see. We must go by the—"

"See Colonel Sartoris. I have no taxes in Jefferson."

"But, Miss Emily—"

"See Colonel Sartoris." (Colonel Sartoris had been dead almost ten years.) "I have no taxes in Jefferson. Tobe!" The Negro appeared. "Show these gentlemen out."

2

So she vanquished them, horse and foot, just as she had vanquished their fathers thirty years before about the smell. That was two years after her father's death and a short time after her sweetheart—the one we believed would marry her—had deserted her. After her father's death she went out very little; after her sweetheart went away, people hardly saw her at all. A few of the ladies had the temerity to call, but were not received, and the only sign of life about the place was the Negro man—a young man then—going in and out with a market basket.

"Just as if a man—any man—could keep a kitchen properly," the ladies said; so they were not surprised when the smell developed. It was another link between the gross, teeming world and the high and mighty Griersons.

A neighbor, a woman, complained to the mayor, Judge Stevens, eighty years old.

"But what will you have me do about it, madam?" he said.

"Why, send her word to stop it," the woman said. "Isn't there a law?"

"I'm sure that won't be necessary," Judge Stevens said. "It's probably just a snake or a rat that nigger of hers killed in the yard. I'll speak to him about it."

The next day he received two more complaints, one from a man who came in diffident deprecation. "We really must do something about it, Judge. I'd be the last one in the world to bother Miss Emily, but we've got to do something." That night the Board of Aldermen met—three graybeards and one younger man, a member of the rising generation.

"It's simple enough," he said. "Send her word to have her place cleaned up. Give her a certain time to do it in, and if she don't . . ."

"Dammit, sir," Judge Stevens said, "will you accuse a lady to her face of smelling bad?"

So the next night, after midnight, four men crossed Miss Emily's lawn and slunk about the house like burglars, sniffing along the base of the brickwork and at the cellar openings while one of them performed a regular sowing motion with his hand out of a sack slung from his shoulder. They broke open the cellar door and sprinkled lime there, and in all the outbuildings. As they recrossed the lawn, a window that had been dark was lighted and Miss Emily sat in it, the light behind her, and her upright torso motionless as that of an idol. They crept quietly across the lawn and into the shadow of the locusts that lined the street. After a week or two the smell went away.

That was when people had begun to feel really sorry for her. People in our town, remembering how old lady Wyatt, her greataunt, had gone completely crazy at last, believed that the Griersons held themselves a little too high for what they really were. None of the young men were quite good enough for Miss Emily and such. We had long thought of them as a tableau. Miss Emily a slender figure in white in the background, her father a spraddled silhouette in the foreground, his back to her and clutching a horsewhip, the two of them framed by the backflung front door. So when she got to be thirty and was still single, we were not pleased exactly, but vindicated; even with insanity in the family she wouldn't have turned down all of her chances if they had really materialized.

When her father died, it got about that the house was all that was left to her; and in a way, people were glad. At last they could pity Miss Emily. Being left alone, and a pauper, she had become humanized. Now she too would know the old thrill and the old despair of a penny more or less.

The day after his death all the ladies prepared to call at the house and offer condolence and aid, as is our custom. Miss Emily met them at the door, dressed as usual and with no trace of grief on her face. She told them that her father was not dead. She did that for three days, with the ministers calling on her, and the doctors, trying to persuade her to let them dispose of the body. Just as they were about to resort to law and force, she broke down, and they buried her father quickly.

We did not say she was crazy then. We believed she had to do that. We remembered all the young men her father had driven away, and we knew that with nothing left, she would have to cling to that which had robbed her, as people will.

3

She was sick for a long time. When we saw her again, her hair was cut short, making her look like a girl, with a vague resemblance to those angels in colored church windows—sort of tragic and serene.

The town had just let the contracts for paving the sidewalks, and in the summer after her father's death they began the work. The construction company came with niggers and mules and machinery, and a foreman named Homer Barron, a Yankee—a big, dark, ready man, with a big voice and eyes lighter than his face. The little boys would follow in groups to hear him cuss the niggers, and the niggers singing in time to the rise and fall of picks. Pretty soon he knew everybody in town. Whenever you heard a lot of laughing anywhere about the square, Homer Barron would be in the center of the group. Presently we began to see him and Miss Emily on Sunday afternoons driving in the yellow-wheeled buggy and the matched team of bays from the livery stable.

At first we were glad that Miss Emily would have an interest, because the ladies all said, "Of course a Grierson would not think seriously of a Northerner, a day laborer." But there were still others, older people, who said that even grief could not cause a real lady to forget noblesse oblige—without calling it noblesse oblige. They just said, "Poor Emily. Her kinsfolk should come to her." She had some kin in Alabama; but years ago her father had fallen out with them over the estate of old lady Wyatt, the crazy woman, and there was no communication between the two families. They had not even been represented at the funeral.

And as soon as the old people said, "Poor Emily," the whispering began. "Do you suppose it's really so?" they said to one

another. "Of course it is. What else could . . ." This behind their hands; rustling of craned silk and satin behind jalousies closed upon the sun of Sunday afternoon as the thin, swift clop-clop-clop of the matched team passed: "Poor Emily."

She carried her head high enough—even when we believed that she was fallen. It was as if she demanded more than ever the recognition of her dignity as the last Grierson; as if it had wanted that touch of earthiness to reaffirm her imperviousness. Like when she bought the rat poison, the arsenic. That was over a year after they had begun to say, "Poor Emily," and while the two female cousins were visiting her.

"I want some poison," she said to the druggist. She was over thirty then, still a slight woman, though thinner than usual, with cold, haughty black eyes in a face the flesh of which was strained across the temples and about the eyesockets as you imagine a lighthouse-keeper's face ought to look. "I want some poison," she said.

"Yes, Miss Emily. What kind? For rats and such? I'd recom—"

"I want the best you have. I don't care what kind."

The druggist named several. "They'll kill anything up to an elephant. But what you want is—"

"Arsenic," Miss Emily said. "Is that a good one?"

"Is . . . arsenic? Yes, ma'am. But what you want—"

"I want arsenic."

The druggist looked down at her. She looked back at him, erect, her face like a strained flag. "Why, of course," the druggist said. "If that's what you want. But the law requires you to tell what you are going to use it for."

Miss Emily just stared at him, her head tilted back in order to look him eye for eye, until he looked away and went and got the arsenic and wrapped it up. The Negro delivery boy brought her the package; the druggist didn't come back. When she opened the package at home there was written on the box, under the skull and bones: "For rats."

4

So the next day we all said, "She will kill herself"; and we said it would be the best thing. When she had first begun to be seen with Homer Barron, we had said, "She will marry him." Then we said, "She will persuade him yet," because Homer himself had remarked—he liked men, and it was known that he drank with the younger men in the Elks' Club—that he was not a marrying man. Later we said, "Poor Emily" behind the jalousies as they passed on Sunday afternoon in the glittering buggy. Miss Emily with her head high and Homer Barron with his hat cocked and a cigar in his teeth, reins and whip in a yellow glove.

Then some of the ladies began to say that it was a disgrace to the town, and a bad example to the young people. The men did not want to interfere, but at last the ladies forced the Baptist minister—Miss Emily's people were Episcopal—to call upon her. He would never divulge what happened during that inter-view, but he refused to go back again. The next Sunday they again drove about the streets, and the following day the minister's wife wrote to Miss Emily's relations in Alabama.

So she had blood-kin under her roof again and we sat back to watch developments. At first nothing happened. Then we were sure that they were to be married. We learned that Miss Emily had been to the jeweler's and ordered a man's toilet set in silver, with the letters H.B. on each piece. Two days later we learned that she had bought a complete outfit of men's clothing, including a nightshirt, and we said, "They are married." We were really glad. We were glad because the two female cousins were even more Grierson that Miss Emily had ever been.

So we were not surprised when Homer Barron—the streets had been finished some time since—was gone. We were a little disappointed that there was not a public blowing-off, but we believed that he had gone on to prepare for Miss Emily's coming, or to give her a chance to get rid of the cousins. (By that time it was a cabal, and we were all Miss Emily's allies to help circumvent the cousins.) Sure enough, after another week they departed. And, as we had expected all along, within three days Homer Barron was back in town. A neighbor saw the Negro man admit him at the kitchen door at dusk one evening.

And that was the last we saw of Homer Barron. And of Miss Emily for some time. The Negro man went in and out with the market basket, but the front door remained closed. Now and then we would see her at a window for a moment, as the men did that night when they sprinkled the lime, but for almost six months she did not appear on the streets. Then we knew that this was to be expected too; as if that quality of her father had thwarted her woman's life so many times had been too virulent and too furious to die.

When we next saw Miss Emily, she had grown fat and her hair was turning gray. During the next few years it grew grayer and grayer until it attained an even pepper-and-salt iron-gray, when it ceased turning. Up to the day of her death at seventy-four it was still that vigorous iron-gray, like the hair of an active man.

From that time on her front door remained closed, save for a period of six or seven years, when she was about forty, during which she gave lessons in china-painting. She fitted up a studio in one of the downstairs rooms; where the daughters and granddaughters of Colonel Sartoris' contemporaries were sent to her with the same regularity and in the same spirit that they were sent to church on Sundays with a twenty-five cent piece for the collection plate. Meanwhile her taxes had been remitted.

The newer generation became the backbone and the spirit of the town, and the painting pupils grew up and fell away and did not send their children to her with boxes of color and tedious brushes and pictures cut from the ladies' magazines. The front door closed upon the last one and remained closed for good. When the town got free postal delivery, Miss Emily alone refused to let them fasten the metal numbers above her door and attach a mailbox to it. She would not listen to them.

Daily, monthly, yearly we watched the Negro grow grayer and more stooped, going in and out with the market basket. Each December we sent her a tax notice, which would be returned by the post office a week later, unclaimed. Now and then we would see her in one of the downstairs windows—she had evidently shut up the top floor of the house—like the carven torso of an idol in a niche, looking or not looking at us, we could never tell which. Thus she passed from generation to generation—dear, inescapable, impervious, tranquil, and perverse.

And so she died. Fell ill in the house filled with dust and shadows, with only a doddering Negro man to wait on her. We did not even know she was sick; we had long since given up trying to get any information from the Negro. He talked to no one, probably not even to her, for his voice had grown harsh and rusty, as if from disuse.

She died in one of the downstairs rooms, in a heavy walnut bed with a curtain, her gray head propped on a pillow yellow and moldy with age and lack of sunlight.

5

The Negro met the first of the ladies at the front door and let them in, with their hushed, sibilant voices and their quick, curious glances, and then he disappeared. He walked right through the house and out the back and was not seen again.

The two female cousins came at once. They held the funeral on the second day, with the town coming to look at Miss Emily beneath a mass of bought flowers, with the crayon face of her father musing profoundly above the bier and the ladies sibilant and macabre; and the very old men—some in their brushed Confederate uniforms—on the porch and the lawn, talking of Miss Emily as if she had been a contemporary of theirs, believing that they had danced with her and courted her perhaps, confusing time with its mathematical progression, as the old do, to whom all the past is not a diminishing road but, instead, a huge meadow which no winter ever quite touches, divided from them now by the narrow bottleneck of the most recent decade of years.

Already we knew that there was one room in that region above the stairs which no one had seen in forty years, and which would have to be forced. They waited until Miss Emily was decently in the ground before they opened it.

The violence of breaking down the door seemed to fill this room with pervading dust. A thin, acrid pall as of the tomb seemed to lie everywhere upon this room decked and furnished as for a bridal: upon the valance curtains of faded rose color, upon the rose-shaded lights, upon the dressing table, upon the delicate array of crystal and the man's toilet things backed with tarnished silver, silver so tarnished that the monogram was obscured. Among them lay a collar and tie, as if they had just been removed, which, lifted, left upon the surface a pale crescent in the dust. Upon a chair hung the suit, carefully folded; beneath it the two mute shoes and the discarded socks.

The man himself lay in the bed.

For a long while we just stood there, looking down at the profound and fleshless grin. The body had apparently once lain in the attitude of an embrace, but now the long sleep that outlasts love, that conquers even the grimace of love, had cuckolded him. What was left of him, rotted beneath what was left of the nightshirt, had become inextricable from the bed in which he lay; and upon him and upon the pillow beside him lay that even coating of the patient and biding dust.

Then we noticed that in the second pillow was the indentation of a head. One of us lifted something from it, and leaning forward, that faint and invisible dust dry and acrid in the nostrils, we saw a long strand of iron-gray hair.[2]

POETRY

The Seven Ages of Man
William Shakespeare
1564–1616

All the world's a stage,
And all the men and women merely
 players.
They have their exits and their entrances,
And one man in his time plays many parts,
His acts being seven ages. At first the
 infant,
Mewling[1] and puking in the nurse's arms.
Then the whining schoolboy, with his
 satchel
And shining morning face, creeping like
 snail
Unwillingly to school. And then the lover,
Sighing like furnace, with a woeful
 ballad[2]
Made to his mistress' eyebrow. Then a soldier,
Full of strange oaths and bearded like the
 pard,[3]
Jealous in honor,[4] sudden and quick in quarrel,
Seeking the bubble reputation[5]
Even in the cannon's mouth. And then the
 justice,
In fair round belly with good capon lined,[6]
With eyes severe and beard of formal cut,
Full of wise saws[7] and modern instances;[8]
And so he plays his part. The sixth age
 shifts
Into the lean and slippered Pantaloon,[9]
With spectacles on nose and pouch on side;
His youthful hose, well saved, a world too
 wide
For his shrunk shank, and his big manly
 voice,
Turning again toward childish treble, pipes
And whistles in his sound. Last scene of all,
That ends this strange eventful history,
Is second childishness and mere oblivion,
Sans[10] teeth, sans eyes, sans taste, sans everything.
 —*As You Like It*, Act Two, scene 7, 139–66.

[1]Whimpering. [2]Poem. [3]Leopard. [4]Sensitive about honor. [5]As quickly burst as a bubble. [6]Magistrate bribed with a chicken. [7]Sayings. [8]Commonplace illustrations. [9]The foolish old man of Italian comedy. [10]Without.

The Canterbury Tales
Geoffrey Chaucer
c. 1340–1400

THE COOK'S PROLOGUE

The cook from London, while the reeve yet spoke,
Patted his back with pleasure at the joke.
"Ha, ha!" laughed he, "by Christ's great suffering,
This miller had a mighty sharp ending
Upon his argument of harbourage!
For well says Solomon, in his language,
'Bring thou not every man into thine house;'
For harbouring by night is dangerous.
Well ought a man to know the man that he
Has brought into his own security.
I pray God give me sorrow and much care
If ever, since I have been Hodge of Ware,
Heard I of miller better brought to mark.
A wicked jest was played him in the dark.
But God forbid that we should leave off here;
And therefore, if you'll lend me now an ear,
From what I know, who am but a poor man,
I will relate, as well as ever I can,
A little trick was played in our city."
 Our host replied: "I grant it readily.
Now tell on, Roger; see that it be good;
For many a pasty have you robbed of blood,
And many a Jack of Dover have you sold
That has been heated twice and twice grown cold.
From many a pilgrim have you had Christ's curse,
For of your parsley they yet fare the worse,
Which they have eaten with your stubble goose;
For in your shop full many a fly is loose.
Now tell on, gentle Roger, by your name.
But yet, I pray, don't mind if I make game,
A man may tell the truth when it's in play."
 "You say the truth," quoth Roger, "by my fay!
But 'true jest, bad jest' as the Fleming saith.
 And therefore, Harry Bailey, on your faith,
Be you not angry ere we finish here,
If my tale should concern an inn-keeper.
Nevertheless, I'll tell not that one yet.
But ere we part your jokes will I upset."
 And thereon did he laugh, in great good cheer,
And told his tale, as you shall straightway hear.

Thus ends the prologue of the cook's tale

THE COOK'S TALE

There lived a 'prentice, once, in our city,
And of the craft of victuallers was he;
Happy he was as goldfinch in the glade,
Brown as a berry, short, and thickly made,
With black hair that he combed right prettily.
He could dance well, and that so jollily,
That he was nicknamed Perkin Reveller.
He was as full of love, I may aver,
As is a beehive full of honey sweet;
Well for the wench that with him chanced to meet
At every bridal would he sing and hop,
Loving the tavern better than the shop.

 When there was any festival in Cheap,
Out of the shop and thither would he leap,
And, till the whole procession he had seen,
And danced his fill, he'd not return again.
He gathered many fellows of his sort
To dance and sing and make all kinds of sport.
And they would have appointments for to meet
And play at dice in such, or such, a street.
For in the whole town was no apprentice
Who better knew the way to throw the dice
Than Perkin; and therefore he was right free
With money, when in chosen company.
His master found this out in business there;
For often-times he found the till was bare.
For certainly a revelling bond-boy
Who loves dice, wine, dancing, and girls of joy—
His master, in his shop, shall feel the effect,
Though no part have he in this said respect;
For theft and riot always comrades are,
And each alike he played on gay guitar.
Revels and truth, in one of low degree,
Do battle always, as all men may see.

 This 'prentice shared his master's fair abode
Till he was nigh out of his 'prenticehood,
Though he was checked and scolded early and late
And sometimes led, for drinking, to Newgate;
But at the last his master did take thought,
Upon a day, when he his ledger sought,
On an old proverb wherein is found this word:
"Better take rotten apple from the hoard
Than let it lie to spoil the good ones there."
So with a drunken servant should it fare;
It is less ill to let him go, apace,
Than ruin all the others in the place.
Therefore he freed and cast him loose to go
His own road unto future care and woe;
And thus this jolly 'prentice had his leave.
Now let him riot all night long, or thieve.

But since there's never thief without a buck
To help him waste his money and to suck
All he can steal or borrow by the way,
Anon he sent his bed and his array
To one he knew, a fellow of his sort,
Who loved the dice and revels and all sport,
And had a wife that kept, for countenance,
A shop, and whored to gain her sustenance.

Of this cook's tale Chaucer made no more.[3]

"Stopping by Woods on a Snowy Evening"
Robert Frost
1874–1963

Whose woods these are I think I know.
His house is in the village though;
He will not see me stopping here
To watch his woods fill up with snow.

My little horse must think it queer
To stop without a farmhouse near
Between the woods and frozen lake
The darkest evening of the year.

He gives his harness bells a shake
To ask if there is some mistake.
The only other sound's the sweep
Of easy wind and downy flake.

The woods are lovely, dark and deep.
But I have promises to keep,
And miles to go before I sleep.
And miles to go before I sleep.[4]

"Musée Des Beaux Arts"
W. H. Auden
1907–73

About suffering they were never wrong,
The Old Masters; how well they
 understood
Its human position; how it takes place
While someone else is eating or opening
 a window or just walking dully along;
How, when the aged are reverently,
 passionately waiting
For the miraculous birth, there always must
 be
Children who did not specially want it to
 happen, skating
On a pond at the edge of the wood:
They never forgot
That even the dreadful martyrdom must
 run its course
Anyhow in a corner, some untidy spot
Where the dogs go on with their doggy life
 and the torturer's horse
Scratches its innocent behind on a tree.
In Brueghel's *Icarus*, for instance:
 how – everything turns away
Quite leisurely from the disaster; the
 ploughman may
Have heard the splash, the forsaken cry;
But for him it was not an important failure;
 the sun shone
As it had to on the white legs disappearing
 into the green
Water; and the expensive delicate ship that
 must have seen
Something amazing, a boy falling out of the
 sky,
Had somewhere to get to and sailed calmly
 on.[5]

BIOGRAPHY

God Brought Me Safe
John Wesley
1703–91

[Oct. 1743.]

Thur. 20.—After preaching to a small, attentive congregation, I rode to Wednesbury. At twelve I preached in a ground near the middle of the town to a far larger congregation than was expected, on "Jesus Christ, the same yesterday, and to-day, and for ever." I believe every one present felt the power of God; and no creature offered to molest us, either going or coming; but the Lord fought for us, and we held our peace.

I was writing at Francis Ward's in the afternoon when the cry arose that the mob had beset the house. We prayed that God would disperse them, and it was so. One went this way, and another that; so that, in half an hour, not a man was left. I told our brethren, "Now is the time for us to go;" but they pressed me exceedingly to stay; so, that I might not offend them, I sat down, though I foresaw what would follow. Before five the mob surrounded the house again in greater numbers than ever. The cry of one and all was, "Bring out the minister; we will have the minister." I desired one to take their captain by the hand and bring him into the house. After a few sentences interchanged between us the lion became a lamb. I desired him to go and bring one or two more of the most angry of his companions. He brought in two, who were ready to swallow the ground with rage; but in two minutes they were as calm as he. I then bade them make way, that I might go out among the people. As soon as I was in the midst of them I called for a chair, and, standing up, asked, "What do any of you want with me?" Some said, "We want you to go with us to the Justice." I replied, "That I will, with all my heart." I then spoke a few words, which God applied; so that they cried out with might and main, "The gentleman is an honest gentleman, and we will spill our blood in his defence." I asked, "Shall, we go to the Justice to-night, or in the morning?" Most of them cried, "To-night, to-night;" on which I went before, and two or three hundred followed, the rest returning whence they came.

The night came on before we had walked a mile, together with heavy rain. However, on we went to Bentley Hall, two miles from Wednesbury. One or two ran before to tell Mr. Lane they had brought Mr. Wesley before his Worship. Mr. Lane replied, "What have I to do with Mr. Wesley? Go and carry him back again." By this time the main body came up, and began knocking at the door. A servant told them Mr. Lane was in bed. His son followed, and asked what was the matter. One replied, "Why an't please you, they sing psalms all day; nay, and make folks rise at five in the morning. And what would your Worship advise us to do?" "To go home," said Mr. Lane, "and be quiet."

Here they were at a full stop, til one advised to go to Justice

Persehouse at Walsall. All agreed to this; so we hastened on, and about seven came to his house. But Mr. P. likewise sent word that he was in bed. Now they were at a stand again; but at last they all thought it the wisest course to make the best of their way home. About fifty of them undertook to convoy me. But we had not gone a hundred yards when the mob of Walsall came, pouring in like a flood, and bore down all before them. The Darlaston mob made what defense they could; but they were weary, as well as outnumbered; so that in a short time, many being knocked down, the rest ran away, and left me in their hands.

To attempt speaking was vain, for the noise on every side was like the roaring of the sea. So they dragged me along till we came to the town, where, seeing the door of a large house open, I attempted to go in; but a man, catching me by the hair, pulled me back into the middle of the mob. They made no more stop till they had carried me through the main street, from one end of the town to the other. I continued speaking all the time to those within hearing, feeling no pain or weariness. At the west end of the town, seeing a door half open, I made toward it, and would have gone in, but a gentleman in the shop would not suffer me, saying they would pull the house down to the ground. However, I stood at the door and asked, "Are you willing to hear me speak?" Many cried out, "No, no! knock his brains out; down with him; kill him at once." Others said, "Nay, but we will hear him first." I began asking, "What evil have I done? Which of you all have I wronged in word or deed?" and continued speaking for above a quarter of an hour, till my voice suddenly failed. Then the floods began to lift up their voice again, many crying out, "Bring him away! Bring him away!"

In the meantime my strength and my voice returned, and I broke out aloud into prayer. And now the man who had just before headed the mob turned and said, "Sir, I will spend my life for you: follow me, and not one soul here shall touch a hair of your head." Two or three of his fellows confirmed his words, and got close to me immediately. At the same time, the gentleman in the shop cried out, "For shame, for shame! Let him go." An honest butcher, who was a little farther off, said it was a shame they should do thus; and pulled back four or five, one after another, who were running on the most fiercely. The people then, as if it had been by common consent, fell to the right and left; while those three or four men took me between them, and carried me through them all. But on the bridge the mob rallied again: we therefore went on one side over the mill-dam, and thence through the meadows, till, a little before ten, God brought me safe to Wednesbury, having lost only one flap of my waistcoat and a little skin from one of my hands.[6]

The Benefits of Luxury, in Making a People More Wise and Happy
Oliver Goldsmith
1730?–74

From such a picture of nature in primeval simplicity, tell me, my much respected friend, are you in love with fatigue and solitude? Do you sigh for the severe frugality of the wandering Tartar, or regret being born amidst the luxury and dissimulation of the polite? Rather tell me, has not every kind of life vices peculiarly its own? Is it not a truth, that refined countries have more vices, but those not so terrible; barbarous nations few, and they of the most hideous complexion? Perfidy and fraud are the vices of civilized nations, credulity and violence those of the inhabitants of the desert. Does the luxury of the one produce half the evils of the inhumanity of the other? Certainly those philosophers who declaim against luxury have but little understood its benefits; they seem insensible, that to luxury we owe not only the greatest part of our knowledge, but even of our virtues.

It may sound fine in the mouth of a declaimer, when he talks of subduing our appetites, of teaching every sense to be content with a bare sufficiency, and of supplying only the wants of nature; but is there not more satisfaction in indulging those appetites, if with innocence and safety, than in restraining them? Am not I better pleased in enjoyment than in the sullen satisfaction of thinking that I can live without enjoyment? The more various our artificial necessities, the wider is our circle of pleasure; for all pleasure consists in obviating necessities as they rise; luxury, therefore as it increases our wants, increases our capacity for happiness.

Examine the history of any country remarkable for opulence and wisdom, you will find they would never have been wise had they not been first luxurious; you will find poets, philosophers, and even patriots, marching in luxury's train. The reason is obvious: we then only are curious after knowledge, when we find it connected with sensual happiness. The senses ever point out the way, and reflection comments upon the discovery. Inform a native of the desert of Kobi, of the exact measure of the parallax of the moon, he finds no satisfaction at all in the information; he wonders how any could take such pains, and lay out such treasures, in order to solve so useless a difficulty: but connect it with his happiness, by showing that it improves navigation, that by such an investigation he may have a warmer coat, a better gun, or a finer knife, and he is instantly in raptures at so great an improvement. In short, we only desire to know what we desire to possess; and whatever we may talk against it, luxury adds the spur to curiosity, and gives us a desire to becoming more wise.

But not our knowledge only, but our virtues are improved by luxury. Observe the brown savage of Thibet, to whom the fruits of the spreading pomegranate supply food, and its branches are habitation. Such a character has few vices, I grant, but those he has are of the most hideous nature; rapine and cruelty are scarcely crimes in his eye; neither pity nor tenderness, which ennoble every virtue, have any place in his heart; he hates his enemies, and kills those he subdues. On the other hand, the polite Chinese and civilized European seem even to love their enemies. I have just now seen an instance where the English have succoured those enemies, whom their own countrymen actually refused to relieve.

The greater the luxuries of every country, the more closely, politically speaking, is that country united. Luxury is the child of society alone; the luxurious man stands in need of a thousand different artists to furnish out his happiness; it is more likely, therefore, that he should be a good citizen who is connected by motives of self-interest with so many, than the abstemious man who is united to none.

In whatsoever light, therefore, we consider luxury, whether as employing a number of hands naturally too feeble for more laborious employment; as finding a variety of occupation for others who might be totally idle; or as furnishing out new inlets to happiness, without encroaching on mutual property; in whatever light we regard it, we shall have reason to stand up in its defence, and the sentiment of Confucius still remains unshaken: *that we should enjoy as many of the luxuries of life as are consistent with our own safety, and the prosperity of others; and that he who finds out a new pleasure is one of the most useful members of society.*[7]

PART TWO

The
Styles
of the
Arts

HOW ARTISTS
PORTRAY " REALITY "

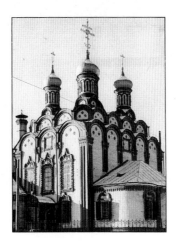

NINE

WHAT IS STYLE?

A work of art or an art form is a way of looking at the universe that is manifested in a particular medium and shared with others. That summation indicates briefly what the aesthetic experience is about. The manner in which artists express themselves constitutes their style. *Style,* then, is the composite use of the devices and characteristics applicable to their medium of expression. Style is tantamount to the personality of an artwork.

However, applying its connotations to a body of artworks calls for breadth and depth of knowledge. Style is that body of characteristics that identifies an artwork with an individual, a historical period, a "school" of artists, or a nation. Applying the term means assimilating materials and, inductively, drawing conclusions.

Therefore, determining the style of any artwork requires analysis of how the artist has utilized the characteristics applicable to his or her medium. If the usage is similar to others', we might conclude that they exemplify the same style. For example, Bach and Handel typify the *baroque* style in music; Haydn and Mozart, the *classical.* Listening to works by these composers quickly leads to the conclusion that the ornate melodic developments of

Bach are like those of Handel, and quite different from the precise concern for structure and clearly articulated motifs of Mozart and Haydn. The precision and symmetry of the Parthenon compared with the ornate opulence of the Palace of Versailles suggest that in line and form the architects of these buildings treated their medium differently. Yet the design of the Parthenon is very much a visual companion, stylistically, of Mozart and Haydn; Versailles reflects an approach to design similar to that of Bach and Handel.

We can take our examination one step further and play a game of stylistic analysis with four paintings. The first three of these paintings were done by three different artists; the fourth, by one of those three. By stylistic analysis we will determine the painter of the fourth painting.

The first painting (Fig. **9.1**) is Corot's *A View Near Volterra.* We can see that Corot has used curvilinear line primarily, and that line (which creates the edges of the forms or shapes in the painting) is somewhat softened. That is, many of the forms—the rocks, trees, clouds, and so on—do not have crisp, clear edges. Color areas tend to blend with each other, giving the painting a softened,

9.1 Jean-Baptiste-Camille Corot, *A View Near Volterra*, 1838. Oil on canvas, 27⅜ x 37½ ins (70 x 95 cm). The National Gallery of Art, Washington, DC (Chester Dale Collection).

somewhat fuzzy or out-of-focus appearance. That comfortable effect is heightened by Corot's use of *palette*. Palette, as we noted, encompasses the total use of color and contrast, and since our illustrations are black and white we can deal with only one aspect of palette, and that is *value contrast*. As with his use of line, Corot maintains a subtle value contrast—that is, a subtle relationship of blacks to whites. His movement from light to dark is gradual, and he avoids stark contrasts. He employs a full range of black, grays, and whites, but does so without calling attention to their positioning. His *brushstroke* is somewhat apparent. That is, if we look carefully we can see brush marks, individual strokes where paint has been applied. Even though the objects in the painting are life-like, Corot has not made any pretensions about the fact that his picture has been painted. We can tell that the foliage was executed by stippling—that is, by dabbing the brush to the canvas as one would dot an ''i'' with a pencil. Likewise, we can see throughout the painting marks made by the brush. The overall effect of the painting is one of realism, but we can see in every area the spontaneity with which it was executed.

The second painting (Fig. **9.2**) is Picasso's *Guernica*. We hardly need be an expert to tell that this painting is by a different painter—or certainly in a different style than the previous one. Picasso has joined curved lines and straight lines, placing them in such relationships that they create a great sense of movement and discomfort. The edges of color areas and forms are sharp and distinct; nothing here is soft or fuzzy. Likewise, the value contrasts are stark and extreme. Areas of the highest value—that is, white—are forced against areas of the lowest value—black. In fact, the range of tonalities is far less broad than in the previous work. The mid or medium (gray) tones are there, but they play a very minor role in the effect of the palette. Our examination of palette does not suffer here, because the work is executed only in blacks, whites, and grays. The starkness of the work is also reinforced by brushstroke, which is noteworthy in its near *absence*. Tonal areas are flat, and few traces of brush exist.

The third painting (Fig. **9.3**) is van Gogh's *The Starry Night*. Use of line is highly active although uniformly curvilinear. Forms and color areas have both hard and soft edges, and van Gogh, as does Picasso, uses outlining to

9.2 Pablo Picasso, *Guernica*, 1937. Oil on canvas, 11 ft 5 ins x 25 ft 5¾ ins (3.4 x 7.76 m). Copyright ARS NY SPADEM, 1988.

9.3 Vincent van Gogh, *The Starry Night*, 1889. Oil on canvas, 29 x 36¼ ins (74 x 92 cm). The Museum of Modern Art, New York (acquired through the Lillie P. Bliss Bequest).

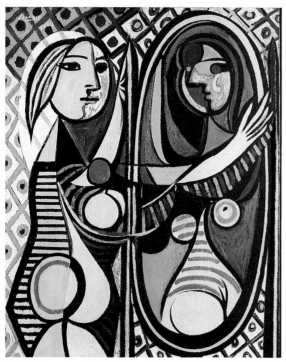

9.4 Exercise painting. See page 34 for identification.

This is not like Corot, a bit like van Gogh, and most like Picasso. Finally, brushstroke is generally unobtrusive. Tonal areas mostly are flat. This is definitely not a van Gogh and probably not a Corot. Three votes out of three go to Picasso, and the style is so distinctive that you probably had no difficulty deciding, even without my analysis. However, could you have been so certain if asked whether Picasso painted Figure **1.11**? A work by another "cubist" painter would pose even greater difficulty. So some differences in style are obvious; some are unclear. Distinguishing the work of one artist from another who designs in a similar fashion becomes even more difficult. However, the analytical process we just completed is indicative of how we can approach artworks in order to determine *how* they exemplify a given style, or what style they reflect.

We recognize differences in style sometimes without thinking much about it. Our experience or formal training need not be extensive to recognize that the buildings in Figures **9.5** and **9.7** reflect different cultural circumstances, even though they each can be found in the same nation. The Russian Orthodox Church in Figure **9.5** is distinguishable by its characteristic domes and by the icons which decorate its walls (Fig. **9.6**). In the same

strengthen his images and reduce their reality. The overall effect of line is a sweeping and undulating movement, highly dynamic and yet far removed from the starkness of the Picasso. On the other hand, van Gogh's curvilinearity and softened edges are quite different in effect from the relaxed quality of the Corot. Van Gogh's value contrasts are very broad, but moderate. He ranges from darks through medium grays to white, all virtually equal in importance. Even when movement from one area to another is across a hard edge to a highly contrasting value, the result is moderate: not soft, not stark. It is, however, brushstroke that gives the painting its unique personality. We can see thousands of individual brush marks where the artist applied paint to canvas. The nervous, almost frenetic use of brushstroke makes the painting come alive.

Now that we have examined three paintings in different styles and by different artists, can you determine which of the three painted Figure **9.4**? First, examine the use of line. Form and color edges are hard. Outlining is used. Curved and straight lines are *juxtaposed*. The effect is active and stark. By comparison, use of line is not like Corot, a bit like van Gogh, and very much like Picasso. Next, examine palette. Darks, grays, and whites are used broadly. However, the principal utilization is of strong contrast—the darkest darks against the whitest whites.

9.5 (*right*) The Church of Nikolai Khamovnik, 1679–82. Moscow, USSR.

9.6 (*below*) Detail, front portal, The Church of Nikolai Khamovnik, 1679–82. Moscow, USSR.

9.7 Tomb of the Shirvanshah, 15th century. Baku, Azerbaijan, USSR.

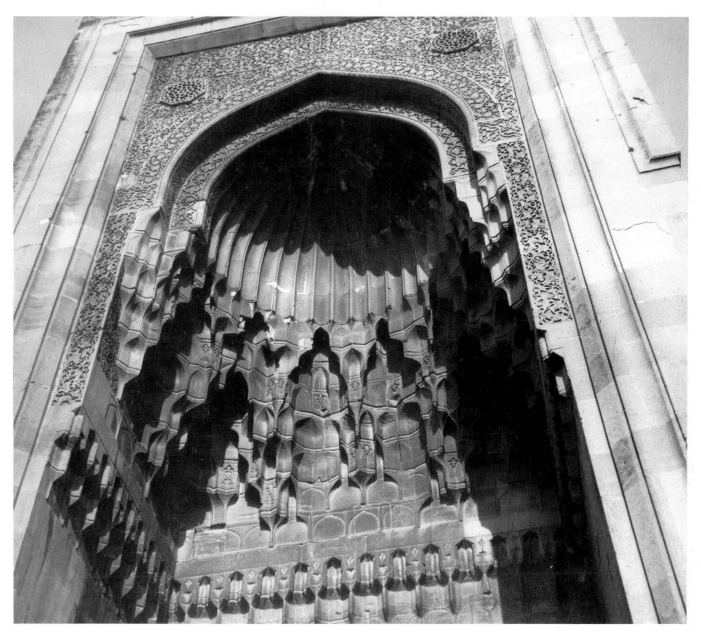

9.8 Detail, entrance portal, tomb of the Shirvanshah, 15th century. Baku, Azerbaijan, USSR.

sense, the tomb in Figure **9.7** is typically Moslem, identifiable by its arch. The decorative embellishment (Fig. **9.8**), in contrast to the icons of the Orthodox Church, reflect the prohibition of the Islamic faith of depicting human form in architectural decoration.

Finally, how does a style get its name? Why is some art called classical, some pop, some baroque, and some impressionist? Some styles were named hundreds of years after they occurred, with the definition accruing from extended, common usage or an historical viewpoint. The Athenian Greeks, whose works we know as classical, were centuries removed from the naming of the style they

shared. Some labels were coined by artists themselves. Many stylistic labels are attributed to individual critics who, having experienced the emerging works of several artists and noting a common or different approach, invented a term (sometimes a derogatory one) to describe that approach. Because of the influence of the critic or the catchiness of the term, the name was adopted by others, and commonly used. Thus, a style was born.

We must be careful, however, when we use the labels by which we commonly refer to artworks. Occasionally such labels imply stylistic characteristics; occasionally they identify broad attitudes or tendencies which are not

169

really stylistic. Often debate exists as to which is which. For example, romanticism has stylistic characteristics in some art disciplines, but the term connotes a broad philosophy toward life in general. Often a style label is really a composite of several styles whose characteristics may be dissimilar, but whose objectives are the same. Terminology is convenient but not always agreed upon in fine detail. Occasionally experts disagree as to whether certain artworks fall within the descriptive parameters of one style or another, even while agreeing on the definition of the style itself.

In addition, we can ask how the same label might identify stylistic characteristics of two or more unrelated art disciplines, such as painting and music. Is there an aural equivalent to visual characteristics, or vice versa? These are difficult questions, and potential answers can be troublesome as well as debatable. More often than not, similarity of objectives and data, as opposed to directly transferable technical characteristics, result in the same stylistic label being used for works in quite different disciplines. Nevertheless, some transference is possible, especially in a perceptual sense. For example, undulating line in painting is similar in its sense-stimuli to undulating melodic contours in music. However, the implications of such similarities have many hidden difficulties, and we must be careful in our usage, regardless of how attractive similarities in vocabulary may seem.

Styles do not start and stop on specific dates, nor do they recognize national boundaries. Some styles reflect deeply held convictions or creative insights; some styles are imitations of previous styles. Some styles are profound; others are superficial. Some styles are intensely individual. However, merely dissecting artistic or stylistic characteristics can be a dull experience. What makes the experience come alive is the actual experience of artworks themselves, describing to ourselves and to others such things about our reactions as can be described, and attempting to find the deepest level of meaning possible. Within every artwork there is the reflection of another human being attempting to express some view of the human condition. We can try to place that viewpoint in the context of the time or the specific biography that produced it and speculate upon why its style is as it is. We can attempt to compare those contexts with our own. We may never know the precise stimuli that caused a particular artistic reflection, but our attempts at understanding make our responses more informed and exciting, and our understanding of our own existence more profound.

TEN

ANCIENT APPROACHES

PALEOLITHIC EUROPE

OUR EARLIEST ART

Humankind's first known sculpture apparently predates drawings and occurs during the period from approximately 30,000 to 15,000 B.C. The head and body of a man carved from mammoth ivory were found in a burial site at Brno, Czechoslovakia (Fig. **10.1**). Although many body parts are missing, we can see that the head, in contrast to the body, shows a remarkable degree of verisimilitude. The hair is closely cropped, the brow is low and the eyes are deeply set.

Western European art probably began approximately 25,000 to 30,000 years before the Christian era, and at its earliest, consisted of simple lines scratched in damp clay. The people making these line scratchings lived in caves and seem, eventually, to have elaborated their simple line "drawings" into the outlines of animals. This development

10.1 Man from Brno, c. 27,000–20,000 B.C. Ivory, height 8 ins (20 cm). Moravian Museum, Brno, Czechoslovakia.

171

from what appears to be idle doodling into sophisticated art seems to have come in three phases. The first comprises black outline drawings of animals with a single colored filler. Next came the addition of a second color within the outline, so as to create a sense of light and shade, or modeling. As we shall see, these depictions often incorporated projecting portions of the cave walls to add a sense of three-dimensionality. In many cases it appears as though the artist picked an actual rock protrusion or configuration specifically for his or her animal drawing. The third step in the development of Ice Age art brought forth exciting multicolored paintings which show an impressive naturalistic style. In this category are the well-known paintings of Altamira (Fig. **10.2**). Here the artists have captured detail, essence, mass, and a remarkable sense of power and movement in the subject matter, using only basic earth colors and charcoal.

Early in the twentieth century Henri Breuil traced the development of Paleolithic art over a period of 20,000 years. According to Breuil, art began with simple animal outlines and progressed to the multicolored animals just noted, changing stylistically from naturalistic depiction toward greater abstraction until, in the Mesolithic period, an animal was represented by only a few characteristic strokes.

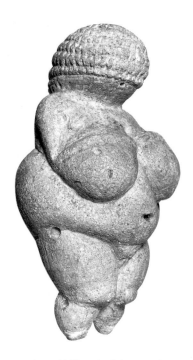

10.3 The Woman from Willendorf, Lower Austria, c. 30,000–25,000 BC. Limestone, height 4⅓ ins (11 cm) Naturhistorisches Museum, Vienna.

10.2 Bison, c. 14,000–10,000 BC. Paint, length 8 ft 3 ins (2.51 m) long, Altamira, Spain.

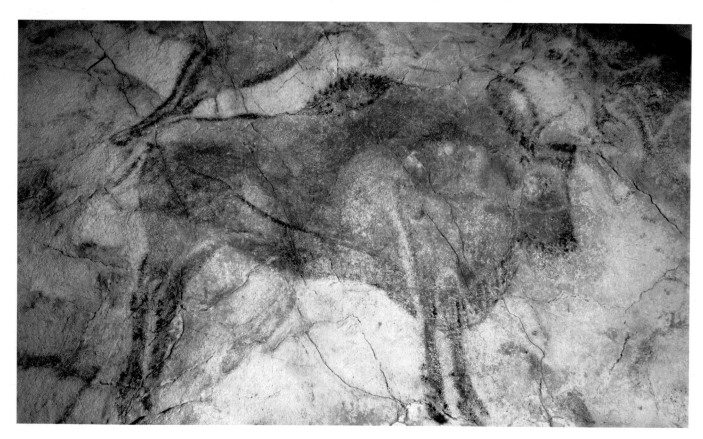

Paleolithic artists seem to have shied away from the difficulties of suggesting three-dimensionality, keeping their subjects in profile (as, much later, the Egyptians were to do). Only an occasional turning of head or antlers tests the artist's skill at dimensional portrayal.

VENUS FIGURES

Venus figures have been found on burial sites in a band stretching approximately 1,100 miles (1,833 km) from western France to the central Russian Plain. Many scholars believe that these figures are the first works in the representational style. The figures share certain stylistic features and are remarkably similar in overall design. They may be symbolic fertility figures or they may be no more than objects for exchange or recognition. Whatever the case, each figure has the same tapering legs, wide hips, and tapering shoulders and head, forming a diamond-shaped silhouette.

The Woman from Willendorf

The Woman from Willendorf (Fig. **10.3**) is the best-known example of the Venus figures. Like the others, she is a unique and naturalistic portrayal, within the stylistic

framework. The emphasis is on swollen thighs and breasts and prominent genitals. The image is without doubt a fertility symbol, and some have gone so far as to suggest that these works reveal an obsession of their makers. Carved from limestone, the figure was originally colored red, the color of blood, perhaps symbolizing life itself. Corpses were painted red by many primitive peoples.

Although faceless, these figures usually have hair, often wear bracelets, beads, aprons or a waist band, and often show markings that may represent tattoos. Although the culture was dominated by the male hunting ethos, women alone are represented by the extant statuary, which emphasizes their sexuality. The mystery and apparent miracle of birth and the uniquely female role therein must clearly have influenced the carvers' perception of reality. The Venus figurines seem to blend women's practical and symbolic roles in an image which undoubtedly had a mystical significance for these people.

THE CAVE OF LASCAUX

The cave of Lascaux lies slightly over a mile from the little French town of Montignac, in the valley of the Vézère river. It was discovered by a group of children who, investigating a tree uprooted by a storm, scrambled down a fissure into a world undisturbed for thousands of years.

10.4 Main hall, or "Hall of Bulls", Lascaux.

Here, underground, we find ourselves in the undeniable presence of our early ancestors. The hundreds of paintings here add to those found elsewhere in France, Spain, and other parts of Europe. The significance of the Lascaux works lies in the quantity and the quality of an intact group.

An overwhelming sense of the power and sweep of Lascaux emerges from the main hall or "Hall of Bulls" (Fig. **10.4**). The thundering herd moves below a sky of rolling contours formed in the stone ceiling of the cave, sweeping our eyes forward as we travel into the cave itself. At the entrance of the hall an 8-ft (2.5 m) unicorn begins a monumental montage of bulls, horses, and deer, whose shapes intermingle one with another and whose colors radiate warmth and power. With heights ranging to 12 ft (3.5 m), these magnificent creatures overwhelm us and remind us that the artists were fully capable technicians who captured the essences beyond the photographic surface of their world. Although the paintings in the main hall were created over a long period of time and by a succession of artists, the cumulative effect of this 30- by 100-ft (9 x 30 m) domed gallery strikes us as that of a single work, carefully composed for maximum dramatic and communicative impact. We must remember, however, that our experience of the work, illuminated by electric floodlighting, may be very different from that of people who could only ever see small areas at a time, lit by flickering stone lamps of oil or animal fat.

MESOPOTAMIA

The mythological Tower of Babel rose to connect heaven and earth. In much the same way the arts of the Mesopotamians symbolized humankind's relationship to its kings and, through them, its gods. Here, for the first time, agriculture, metal technology, literacy, the specialization of labor and a hierarchically organized urban community were combined. Kingdoms rose and fell as one power plundered its enemies, obliterated their cities, and was, in turn itself plundered and obliterated, until, spilling out of the Crescent north into Asia Minor and south as far as Egypt, the vast empires of Mesopotamia clashed with and influenced our more immediate cultural forebears—the Greeks.

EARLY SUMERIAN ART

Bridging prehistory and history, the cities of the Fertile Crescent, the land between the Tigris and the Euphrates, were the prototypes for our civilization.

The majority of surviving artworks from Mesopotamia prior to 3000 BC consist of painted pottery and stamp seals. The decoration of pottery served to satisfy the creative urge of providing the functional with an aesthetic appeal. Decoration was abstract. Stamp seals, whether round or rectangular, went beyond tool status and clearly came to be regarded as surfaces ideally suited to exercise the artist's creative ingenuity. Later, for reasons unknown to us, the cylindrical seal came into being. A carved wooden roller was applied to wet clay to produce a ribbon-like design of indefinite length. The creative possibilities for individuality in design in the cylinder seal, a stamp of sorts, were far greater than those of the stamp seal. What must have fascinated the Sumerians is the intricate design capable of infinite repetition. Scenes of sacrifice, hunting, and battle all appear in the examples of cylinder seal art which have survived. Throughout the early periods of Sumerian art there seems to be a conflict, or at

10.5 Mesopotamian cylinder seal and impression, showing snake-necked lions, c. 3300 BC. Green jasper, height 1¾ ins (4 cm). The Louvre, Paris.

least an alternation, between symbolism and naturalism in the depictions in cylinder art.

Figure **10.5** combines two aspects of fertility: the lioness and the intertwined snake. This fertility-based design and the cycle it presents exemplifies the cyclical Sumerian religious philosophy, and it appears again and again in Sumerian art.

Low relief art of the early Sumerians provides further insights into everyday life. In works such as Figure **10.6** we find a preoccupation with ritual and the gods. This alabaster vase, which stands 3 feet tall, celebrates the cult of E-anna, goddess of fertility and love. The vase is divided into four bands, commemorating the marriage of the goddess, which was reenacted to insure fertility. The bottom band has alternate stalks of barley and date palms; above it, rams and ewes. In the third band we see naked worshippers carrying baskets of fruit and other offerings. At the top the goddess herself stands before her shrine, two coiled bundles of reeds, to receive a worshipper or priest, also nude, whose tribute basket brims with fruit.

The composition exhibits an alternating flow of movement from left to right in the rams and ewes, and right to left in the worshippers. Conventions of figure portrayal are similar to but not as rigid as those in Egyptian art. Here bodies are depicted in profile, as are heads. However, the representation of the torso seems more naturalistic. On the other hand, anatomical proportions, especially in the torso, display varying degrees of adherence to reality. Yet the muscular little men seem to show the strain of the weight of their burden far more realistically than the always upright, relaxed figures of Egyptian art. Finally, the faces are clearly not portrayals of individuals.

10.6 Vase with ritual scene in relief, from the E-anna precinct, Uruk (Warka), Iraq, c. 3500–3100 BC. Alabaster, height 36 ins (91 cm). Iraq Museum, Baghdad.

THE ARCHAIC PERIOD

In the years from 3000 to 2340 BC persons and events become less anonymous. Here we find kings portrayed in devotional acts rather than as warlords. We also grasp a sense of the cylindrical mass of Sumerian sculpture, so different from the heavy, block-like style of the Egyptian. The famous statues from Tell Asmar and the Temple of Abu illustrate this (Fig. **10.7**).

10.7 Statues of worshippers and deities from the Square Temple at Tell Asmar, Iraq, c. 2750 BC. Gypsum, height of tallest figure 30 ins (76 cm). Iraq Museum, Baghdad, and The Oriental Institute, University of Chicago.

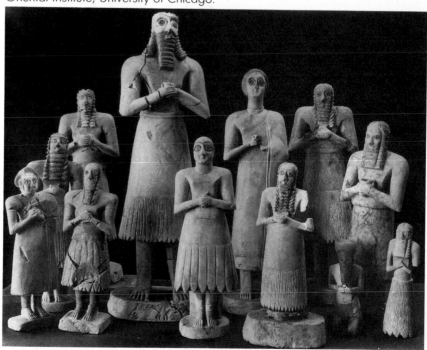

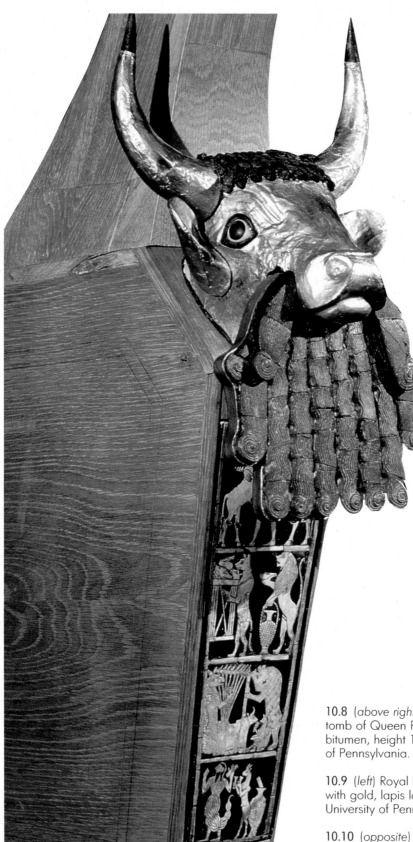

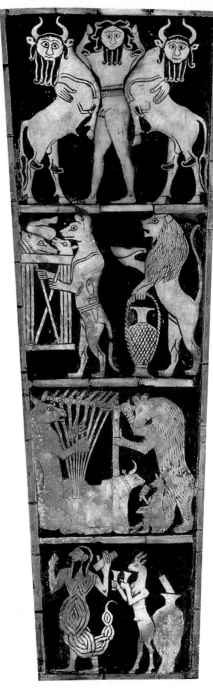

10.8 (*above right*) Soundbox panel of the royal harp from the tomb of Queen Puabi at Ur, Iraq, 2650–2550 BC. Shell inlay set in bitumen, height 13 ins (33 cm). The University Museum, University of Pennsylvania.

10.9 (*left*) Royal harp from the tomb of Queen Puabi at Ur. Wood with gold, lapis lazuli and shell inlay. The University Museum, University of Pennsylvania.

10.10 (*opposite*) He-goat from Ur, *c.* 2600 BC. Wood with gold and lapis lazuli overlay, height 20 ins (51 cm). The University Museum, University of Pennsylvania.

If crudity marks the depiction of the human figure in the votive statues, grace and delicacy mark two other works from this period (Figs. **10.8** and **10.9**). These works illustrate the golden splendor of the Sumerian court. Inlaid in gold, the bearded bull symbolizes the royal personage of Ancient Mesopotamia. Also laden with the symbolism of masculine fertility is the equally dazzling golden goat from the royal graves at Ur (Fig. **10.10**). Here we see what was basic to the Sumerians—that is, the divine revelation and incorporation of animal power, wisdom, and perfection. The goat clearly manifests on Earth the character of the god Tammuz. He is crisp and elegant in portrayal and undoubtedly superhuman.

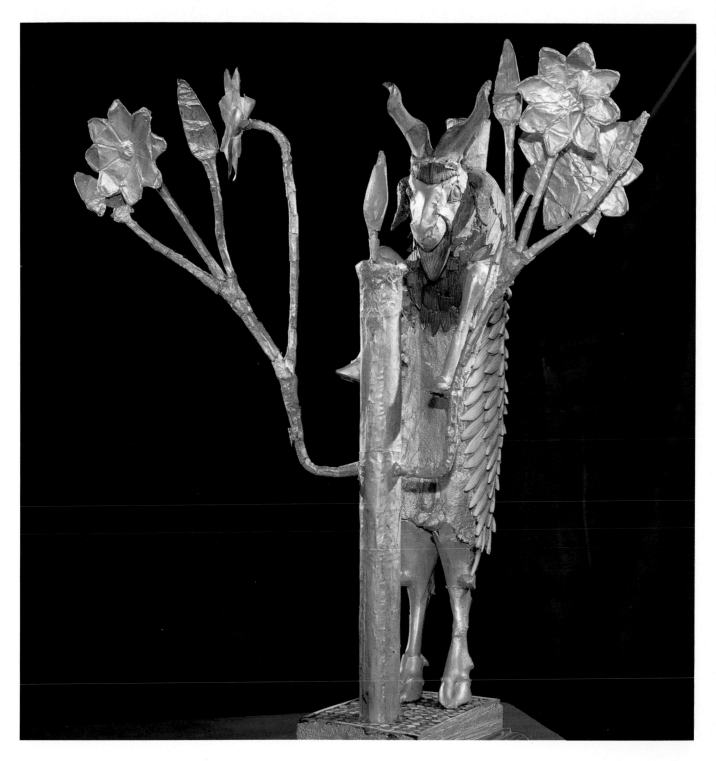

The Tell Asmar Statues

The most striking features of these figures (Fig. 10.7) are the enormous, staring eyes, with their dramatic composition, in a blend of shell, lapis lazuli, and black limestone. Representing Abu, god of vegetation (the large figure), a goddess assumed to be his spouse, and a crowd of worshippers, the statues occupied places around the inner walls of an early temple, as though they were at prayer, awaiting the divine presence.

Certain geometric and expressive qualities are clearly exhibited by these statues. Each form is based on the cone or cylinder—in typical Sumerian style, in contrast to the cubic mass of Egyptian statues. The arms and legs are stylized and pipe-like, rather than realistic depictions of the subtle curves of human limbs. Abu and the mother goddess can be distinguished from the rest by their size and by the large diameter of their eyes.

The meaning in these statues clearly bears out what we know of Mesopotamian religious thought: The gods were believed to be present in their images. The statues of the worshippers were substitutes for the real worshippers, although no attempt appears to have been made to make them look like any particular individual. Every detail is simplified, focusing attention on the remarkable eyes.

Sargon II at Dur Sharrukin

Under Sargon II, who came to power in 722 BC, the high priests of the country regained many of the privileges they had lost under previous kings, and the Assyrian Empire reached the peak of its power. Early in his reign he founded the new city of Dur Sharrukin (on the site of the modern city of Khorsabad), about 9 miles (15 km) northeast of Nineveh. His vast royal citadel, occupying an area of some quarter of a million square feet, was built as an image not only of his empire but of the cosmos itself. A reconstruction of the citadel shown in Figure 10.11 synthesizes the style of architecture and the priorities of Assyrian civilization at this time. It is quite clear that in Sargon's new city secular architecture took precedence over temple architecture. The rulers of Assyria seem to have been far more preoccupied with building fortifications and pretentious palaces than with erecting religious shrines. Dur Sharrukin represents a city built, occupied and abandoned within a single generation.

10.11 Reconstruction of Sargon II's citadel at Khorsabad.

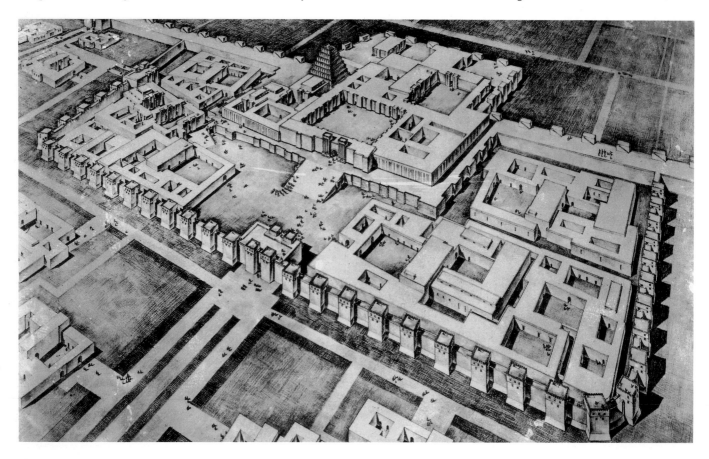

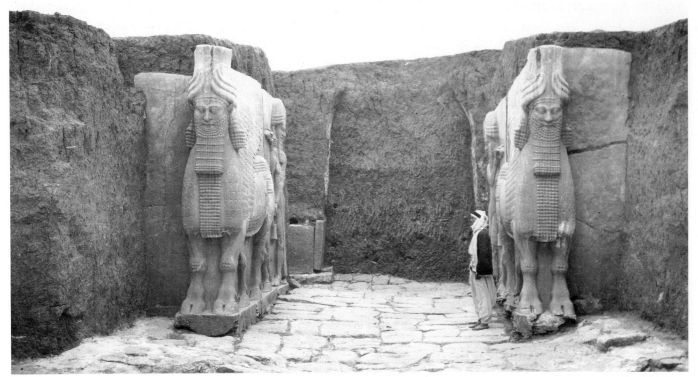

10.12 Gate of Sargon II's citadel at Khorsabad (during excavation), with pair of winged and human-headed bulls. Limestone.

The citadel, representing the ordered world, rises like the hierarchy of Assyrian gods, from the lowest levels of the city through a transitional level, to the king's palace, which stands on its own elevated terrace. Two gates connect the walled citadel to the outside world. The first was undecorated; the second was adorned with and guarded by winged bulls and genii (Fig. **10.12**).

Remarkably, excavations at the site have shown building methods to be fairly inadequate. Buildings are arranged haphazardly and within the inner walls, five minor palaces were crowded with obvious difficulty into the available space.

The main palace comprises an arrangement of ceremonial apartments around a central courtyard. Entrances to the throne room were guarded by winged bulls and other figures. The walls of the room itself stood approximately 40 ft (12 m) high and were decorated with floor-to-ceiling murals. Three small temples adjoined the palace and beside these rose a ziggurat with successive stages painted in different colors, connected by a spiral staircase. Construction was of mud brick, laid without mortar while still damp and pliable, and of dressed and undressed stone. Some roof structures utilized brick barrel vaulting, although the majority appear to have had flat ceilings with painted beams.

Corresponding to the vast scale and attitude of the buildings are the great guardian figures of which Figure **10.12** is representative. Undoubtedly symbolizing the supernatural powers of the king, these colossal hybrids are majestically powerful in stature and scale. Carved partly in relief and partly in the round, they are rationalized to be seen from front or side: the sculptor has provided the figure with a fifth leg, with the result that the viewer can always see four legs. Each of these monoliths was carved from a single block of stone upwards of 15 ft (4.5 m) square.

Subject matter in murals and relief sculpture consisted primarily of tributes to the victorious campaigns of the king. Since warfare tended to be a seasonal activity, the intervening time was, apparently, spent in hunting; and so we find alternating scenes of the slaughter of men and beasts, as well as some cult ceremonies. These represent narratives, and while probably more symbolic than actual, the historicizing of these events appears to have yielded a greater naturalism in style than we have seen previously.

As we examine reliefs such as Figure **10.13** we recognize a composition of pictorial space more like that of the medieval period. Here is an artist's attempt to portray deep space—that is, to remove the image from the surface plane of the work and to suggest perspective. Of course,

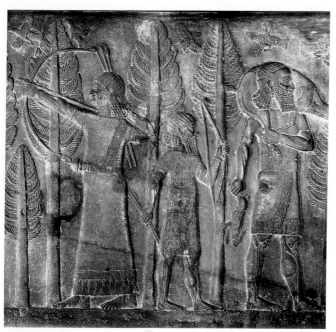

10.13 Mural relief from the palace of Sargon II at Khorsabad. Basalt, length 5 ft 10 ins (1.7 m). The British Museum, London.

the understanding of vanishing points and horizon lines, which was to revolutionize visual art in the Renaissance, is absent. Nonetheless, the attempt to portray distance through diminution stands out clearly. A hurried roughness haunts the works, and the stylization of the figures counteracts spatial naturalism.

JERUSALEM

THE TEMPLE OF SOLOMON

The Temple of Jerusalem was the symbol of Israel's faith as early as its third King, Solomon, son of David (*c.* 1000 BC). Described in the Old Testament in I Kings, 5–9, the Temple of Solomon was primarily the house of the Lord God, as opposed to a place for common people to come to worship.

The temple itself, as reconstructed in Figure **10.14**, stood on a platform with a dominating entrance of huge wooden doors flanked by two bronze pillars about 18 ft (5.5 m) tall. The doors were decorated with carved palms, flowers, and cherubim (guardian winged beasts sometimes shown with human or animal faces). The entrance hall, or vestibule, measured approximately 15 ft

by 30 ft (4.5 x 9 m). Inside the temple proper was a Holy Place or *Hekal*, about 45 ft (13.5 m) high, 60 ft (18 m) long, and 30 ft (9 m) wide. The cedarwood paneled walls were fenestrated at the top by small rectangular windows, allowing a modicum of light to enter. The walls themselves were made from cedars of Lebanon and exhibited rich carvings of floral motifs. In the room itself were various sacred furnishings: ten large lampstands, an inlaid table for priestly offerings, and a cedarwood altar covered with gold.

From a staircase behind the altar one entered the Holy of Holies, the most sacred part of the Temple. This comprised a windowless cubicle 30 feet square and contained the Ark of the Covenant, the symbol of God's presence, which the Jews had carried with them since their sojourn in the wilderness. The Ark was flanked by two large cherubim.

10.14 Reconstruction drawing of Solomon's Temple. The significance of the two bronze pillars is uncertain, but some scholars suggest that they may have represented the twin pillars of fire and smoke that guided the Israelites during their wanderings in the desert after the Exodus from Egypt.

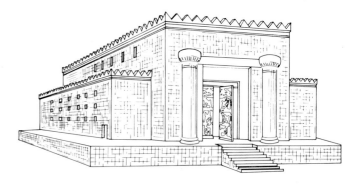

THE BIBLE

The Bible, meaning "books," is a collection of works held sacred by Jews and Christians. The Old Testament comprises, with a few exceptions, the same contents (that is, the Law, Prophets, and Writings) as do the Jewish scriptures. The Old Testament presents a sweeping history, detailed laws, ethics, poetry, psalms, and wisdom literature. The New Testament is the story of the life and teachings of Jesus and the establishment of the Christian Church.

The Psalter is the hymnal of ancient Israel. Most of the Psalms were probably composed to accompany worship in the temple. They can be divided into various categories such as hymns, enthronement hymns, songs of Zion, laments, songs of trust, thanksgiving, sacred history, royal

psalms, wisdom psalms, and liturgies. Here we include Psalm 22 (a psalm of David), and Psalms 130 and 133 (Songs of Ascent).[1]

PSALM 22

My God, my God, why has thou forsaken me?
Why art thou so far from helping me,
from the words of my groaning?
2 O my God, I cry by day, but thou dost not
 answer;
3 Yet thou art holy, enthroned on the praises of
 Israel.
4 In thee our fathers trusted;
 they trusted, and thou didst deliver them.
5 To thee they cried, and were saved;
 in thee they trusted, and were not disappointed.

6 But I am a worm, and no man;
 scorned by men, and despised by the people.
7 All who see me mock at me,
 they make mouths at me, they wag their heads;
8 He committed his cause to the LORD; let
 him deliver him,
 let him rescue him, for he delights in him!

9 Yet thou art he who took me from the womb;
 thou didst keep me safe upon my mother's
 breasts.
10 Upon thee was I cast from my birth,
 and since my mother bore me thou hast been my
 God.
11 Be not far from me,
 for trouble is near
 and there is none to help.

12 Many bulls encompass me
 strong bulls of Bashan surround me;

13 they open wide their mouths at me,
 like a ravening and roaring lion.

14 I am poured out like water,
 and all my bones are out of joint;
 my heart is like wax,
 it is melted within my breast;

15 my strength is dried up like a potsherd,
 and my tongue cleaves to my jaws;
 thou dost lay me in the dust of death.

16 Yea, dogs are round about me;
 a company of evildoers encircle me;
 they have pierced my hands and feet—
17 I can count all my bones—
 they stare and gloat over me;
18 They divide my garments among them,
 and for my raiment they cast lots.

19 But thou, O LORD, be not far off!
 O thou my help, hasten to my aid!
20 Deliver my soul from the sword,
 my life from the power of the dog!
21 Save me from the mouth of the lion,
 my afflicted soul from the horns of the wild
 oxen!

22 I will tell of thy name to my brethren;
 in the midst of the congregation I will praise
 thee:
23 You who fear the LORD, praise him!
 all you sons of Jacob, glorify him,
 and stand in awe of him, all you sons of Israel!
24 For he has not despised or abhorred
 the affliction of the afflicted;
 and he has not hid his face from him,
 but has heard, when he cried to him.

25 From thee comes my praise in the great
 congregation;
 my vows I will pay before those who fear him.
26 The afflicted shall eat and be satisfied;
 those who seek him shall praise the LORD!
 May your hearts live for ever!

27 All the ends of the earth shall remember
 and turn to the LORD;
 and all the families of the nations shall
 worship before him.
28 For dominion belongs to the LORD,
 and he rules over the nations.

29 Yea, to him shall all the proud of the earth
 bow down;
 before him shall bow all who go down to the
 dust,
 and he who cannot keep himself alive.
30 Posterity shall serve him;
 men shall tell of the Lord to the coming
 generation,
31 And proclaim his deliverance to a people yet
 unborn,
 that he has wrought it.

PSALM 130

Out of the depths I cry to thee, O LORD!
 Lord, hear my voice!
2 Let thy ears be attentive
 to the voice of my supplications!

3 If thou, O LORD, shouldst mark iniquities,
 Lord, who could stand?
4 But there is forgiveness with thee,
 that thou mayest be feared.

5 I wait for the LORD, my soul waits,
 and in his word I hope;
6 My soul waits for the LORD
 more than watchmen for the morning,
 more than watchmen for the morning.

7 O Israel, hope in the LORD!
 For with the LORD there is steadfast love,
 and with him is plenteous redemption.
8 And he will redeem Israel
 from all his iniquities.

PSALM 133

Behold, how good and pleasant it is
 when brothers dwell in unity!
2 It is like the precious oil upon the head,
 running down upon the beard,
 upon the beard of Aaron,
 running down on the collar of his robes!
3 It is like the dew of Hermon,
 which falls on the mountains of Zion!
 For there the LORD has commanded the blessing,
 life for evermore.

ANCIENT EGYPT

Protected by deserts and confined to a narrow river valley, Ancient Egypt experienced a relatively isolated cultural history, virtually unbroken for thousands of years. It was a unified civilization, rural in nature, under the control of an absolute monarch and uniquely dependent upon the regular annual flooding of a single river, the Nile. Death—or, rather, everlasting life in the hereafter—was the focus of much of the art of the Egyptians. Appearing mostly in the service of the cult of a god or to glorify the power and wealth of a pharoah, art and architecture centered on the provision of an eternal dwelling-place for the dead.

PAINTING

Painting for the most part was a decorative medium which provided a surface finish to a work of sculpture. Sculptures in relief and in the round were painted. Flat surfaces were also painted, although such painting appears to be a substitute for relief sculpture. In the period of the Middle Kingdom (*c.* 2130–*c.* 1700 BC) painting largely replaced relief sculpture and the scenes presented vividly portrayed a genuine human interest and original insight. The same may be said of painting in the New Kingdom (*c.* 1575–1100 BC). Here we often find humor in portrayals of daily life and, again, a high level of technical craftsmanship. Nonetheless, it may be that the only time painting was regarded as a true art was in the New Kingdom during the reign of Akhenaton. Painting appears to have died out as even a subsidiary art after the New Kingdom.

OLD KINGDOM

Sculpture was the major art form of the Egyptians. It not only provided the "other self" for the deceased in his or her tomb, to provide an immortalizing function, but also stood in temples. By the time of the Old Kingdom sculptors had overcome many of the technical difficulties that plagued their predecessors of the pre-dynastic period. It may also be the case that religious tenets confounded sculptors during those archaic times. Many primitive peoples throughout history have regarded the naturalistic portrayal of the human figure as inviting danger. Making a likeness of an individual may be thought to capture the soul. Concerning technical problems, pre-dynastic sculpture left detailing rough and simple. Convention rather than naturalism prevailed. It seems certain that sculptors relied on memory to portray the human form rather than working from live models. Since pre-dynastic sculpture is also pre-written history, we really cannot do more than speculate as to how much convention reflected technical mastery, or philosophy, or both. As we examine classic Greek sculpture, we are certain that the idealized form of its sculpture was philosophical because the technical skill was obviously there. In pre-dynastic Egypt the reverse appears more logical.

10.15 Prince Rahotep and his wife Nofret from Medum, c. 2580 BC. Painted limestone, height 47½ ins (120 cm). The Egyptian Museum, Cairo.

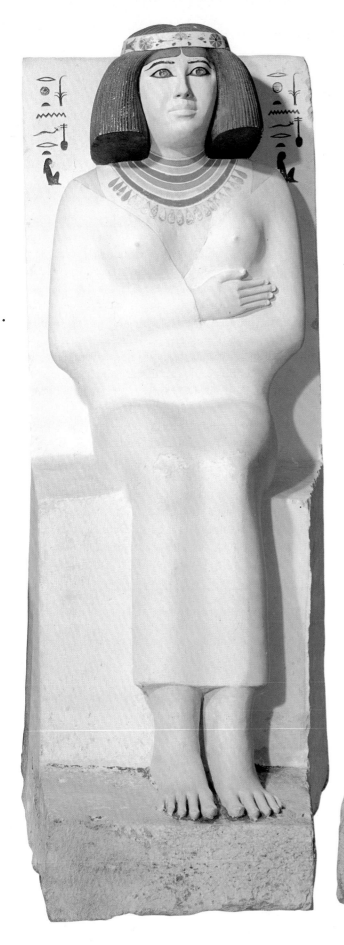
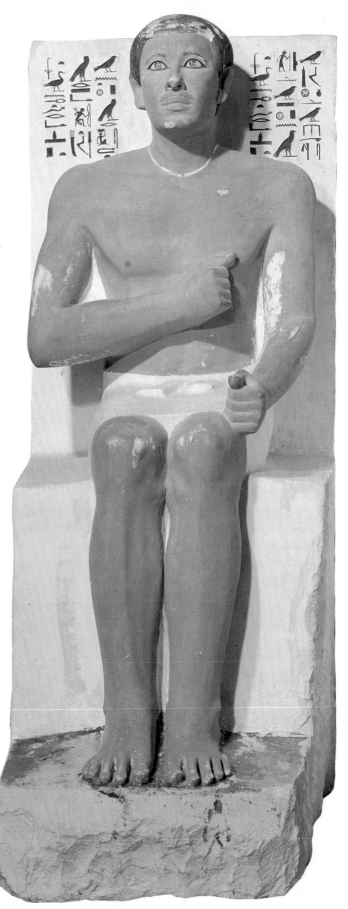

Old Kingdom sculpture shows technical mastery and is well crafted. Life-size sculpture which captured the human form in exquisite natural detail came to the fore. At the same time conventional portrayal of certain ideals of pharaonic demeanor also prevailed. The divine characteristics of the pharaoh dictated a dignified and majestic portrayal. Although such rigidity of treatment lessened as time went on, the softening and human-centered qualities such softening connotes never completely divested the pharaonic statue of its divine repose.

The dual sculpture of Prince Rahotep and his wife Nofret (Fig. **10.15**) comes from the tomb of Prince Rahotep, one of Snofru's sons. The stylized posture is the trademark of Egyptian art, with its intellectual or conceptual, as opposed to naturalistic or visual, nature. The striking colors of the statues exemplify the Egyptian tendency to use painting to provide a decorative surface for sculpture, but the work is in no way commonplace. The eyes of both figures are dull—and light-colored quartz. The eyelids are painted black. Both figures wear the costume of the time. In a somewhat conventionalized treatment, the skin tones of the woman are several shades lighter than those of the man. A woman's skin traditionally exhibited a creamy yellow hue, whereas a man's ranged from light to dark brown. In Dynasty IV the kings rose from peasant stock, an ancestry which is apparent in the sturdy, broad-shouldered, well-muscled physique of the king. At the same time his facial characteristics, particularly the eyes and expression, exhibit alertness, wisdom, strength, and capacity. The portrayal of Nofret expresses similar individuality. Probably for the first time in Egyptian art we find in this work the full development of the naturalistic, three-dimensional female body. She is wearing the typical gown of the period, cut to reveal well-formed and voluptuous breasts. Here, as is the case with all the details of the upper portion of both statues, the artist has been meticulous in observation and depiction.

Egyptian admiration for the human body reveals itself clearly in both statues. Precise modeling and attention to detail are seen in the smallest items. In the statue of Nofret the gown at once covers and reveals the graceful contours of the body beneath. Comparison of facial features reveals in Nofret an individual of less distinct character than her husband. She has a sensual and pampered face. Her hair is obviously a wig shaped in the style of the day. Beneath the constricting head band we can see Nofret's own hair, of much finer character, parted in the middle and swept back beneath the wig. A precise and delicate treatment of the hand held open against the body reveals both the artist's skill and perception and also the care and attention Nofret has given to herself. The hand is, indeed, delicate and feminine. Small dimples decorate the fingers and the nails exhibit extraordinary care. The unpainted nails are correctly observed as being lighter than normal skin tone.

Dynasty IV gave us the most remarkable edifices of Egyptian civilization—the pyramid area of Giza. In addition to the three most obvious pyramids, the area comprises burial places for almost all of the important individuals of Dynasties IV and V. Each pyramid complex has four buildings. The largest pyramid, that of Cheops

10.16 The Great Pyramid of Cheops, 2680–2565 BC.

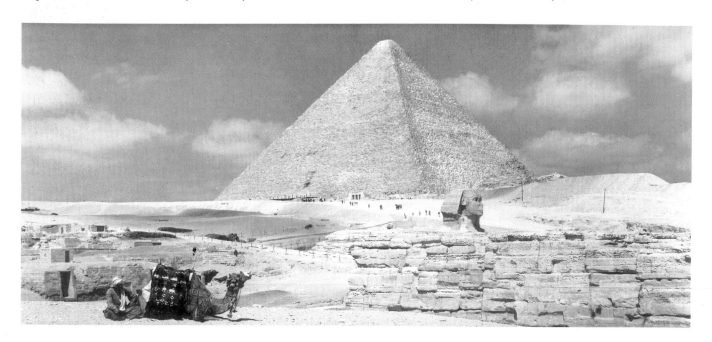

(Fig. **10.16**) measures approximately 750 ft (228 m) square (440 cubits) and rises at an angle of approximately 51° to a height of 481 ft (146 m). The burial chamber of the pharaoh lay hidden in the middle of the pyramid (Fig. **10.17**). Construction consisted of irregularly placed, rough-hewn stone blocks covered by a carefully dressed limestone facing approximately 17 ft (5 m) thick. The famous Sphinx (Fig. **10.18**) is a colossal figure carved from natural rock, lying at the head of the causeway leading from the funerary temple adjoining the pyramid of Cheops' son Chephren, whose pyramid originally measured 707 ft (215 m) square, and rose at an angle of 52° to a height of 471 ft (143 m).

10.18 The Sphinx, c. 2650 BC.

10.17 Longitudinal section, direction south–north, of the Great Pyramid of Cheops.

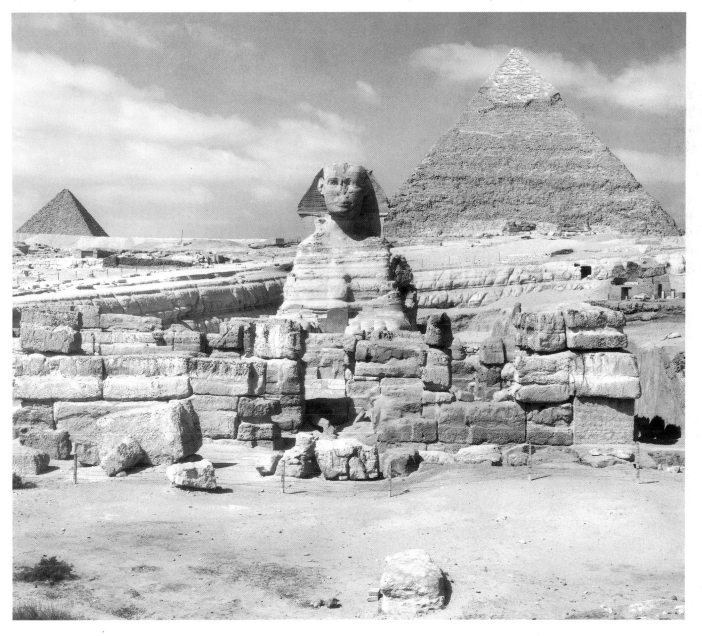

NEW KINGDOM

Leaving the pyramids behind, we move to Dynasty XVIII and a building of great luxury and splendor—the Temple at Luxor (Fig. **10.20**). It approaches more nearly our conception of architecture as a useful place for mankind to spend the present rather than eternity. Built by Amenhotep III the temple is dedicated to Amun, Mut, and Chons. Amenhotep III was a great builder and his taste for splendid buildings drew sustenance from a number of architects, who appear to have been the best Egypt had produced since the time of Sesotris. Notable among these was Athribis, whose likeness at age eighty is preserved in a magnificent statue which shows that he had retained his intellectual and physical abilities and that he expected to reach the age of 110, which the Egyptians considered to be the natural human life span.

Amenhotep III removed all traces of the Middle Kingdom at Luxor, erecting in their place the magnificent temple. The pylon, obelisk, and first courtyard were added by Rameses II. In the time of Dynasty XVIII we would have entered the temple through a vestibule comprising giant pillars with palmiform capitals (Fig. **10.19**). From the vestibule we would have progressed to a huge courtyard surrounded by bunched columns, followed by the hypostyle room, and the Holy of Holies. The temple served two purposes. First, it was the place of worship for the Theban Triad of Amun, Mut, and Chons. Second, during the great feast of the middle of the flood, the barques of Amun, Mut, and Chons were anchored there for several days. We cannot escape the loveliness of the columns. The balance between the open spaces and the mass of the columns creates a beautiful play of light and shade. We can get a feel for the proportions of the great Temple of Luxor when we realize that the seven pairs of central pillars in the Hall of Pillars stand nearly 52 ft (15.8 m) tall. Surviving the centuries, the temple grew by the addition of a forecourt by Rameses II. The inner sanctuary served as a sanctuary for Alexander the Great, and in the early Christian period it was used as a Christian church.

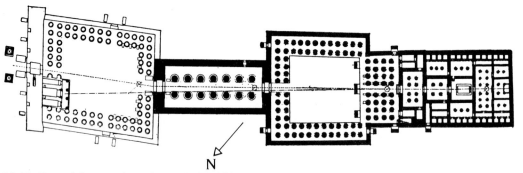

10.19 Plan of the temple at Luxor, 1417–1397 BC.
10.20 The temple at Luxor.

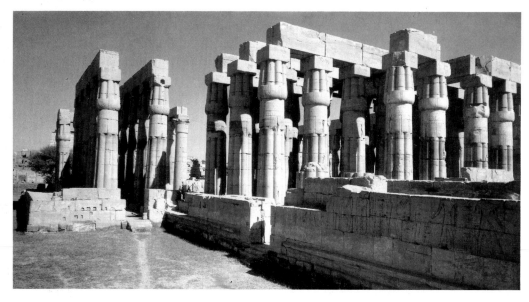

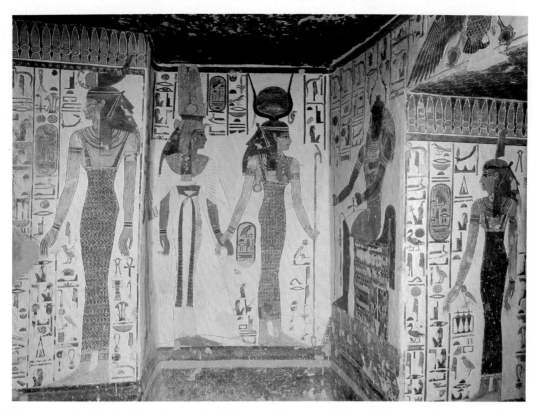

10.22 Queen Nefertari guided by Isis, from the tomb of Queen Nefertari at Thebes, Egypt, 1290–1224 B.C.

Theban Rock Tombs

The functions of tomb paintings and low relief carvings were to furnish the dead with an "eternal castle" with durable effects and to establish the status, attained on earth, which they would have in the hereafter. The painted tombs of Thebes provide most of our knowledge of Egyptian painting of this period. Representations of gods are found for the first time here. Ceiling decorations are common and elaborate. The paintings portray the vivacity and humor of daily life. Theban tombs portray workmen and peasants differently from the tombs of the Old Kingdom, particularly in the shape of the heads and in the garments worn.

The Tomb of Nefertari

Queen Nefertari-mi-en-Mat, of Dynasty XIX was one of the four principal wives of King Rameses II, and her tomb lies in the Valley of Queens in western Thebes (now the west bank at Luxor) (Fig. 10.21). Nefertari was Rameses's favorite. Her tomb rests under the precipitous cliff walls at the end of the gloomy valley of Biban el Harin. Exemplifying a style of painting done in low relief, the paintings adorning the walls of Nefertari's tomb exhibit great ele-

gance, charm, and vivacious color. The tomb is entered through the First Room, shown in Figure 10.21. Off this room and to the south lies the Main Room or offering chamber. Connected to these chambers is the major part of the tomb, in which the Hall of Pillars or Sarcophogus Chamber provides the central focus. Off and surrounding the Hall of Pillars lie three side rooms.

The northeast wall of the First Room houses a vibrant painting showing, on the extreme left, the goddess Selkis with a scorpion on her head (Fig. 10.22). On the extreme right appears the goddess Maat. On her head rests her hieroglyph, the feather. The rear wall of the recess depicts Queen Nefertari led by Isis toward the beetle-headed Khepri, a form assumed by the sun god which implies his

10.21 The ground plan of the tomb of Queen Nefertari-mi-en-Mat, 1290–1224 B.C.

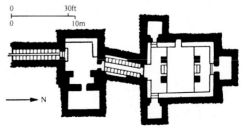

everlasting resurrection (Fig. **10.22**). Over the door to the main room, on the extreme right of the illustration, we see the vulture goddess Nekhbet of El-Kab. Her claws hold the shen-sign, which symbolizes eternity and sovereignty. The goddess Isis wears on her crown the horns of a cow, surrounded by the sun-disc from which hangs a cobra. In her left hand she carries the divine scepter. Queen Nefertari is dressed according to the fashion of the time, and over the vulture hood she wears the tall feathered crown of the Divine Consort.

The painting itself is rich and warm, elegant, and highly stylized. The limited palette uses four hues, which never change in value throughout the work. Yet, the overall effect of this wall decoration is one of great variety. The composition maintains the conventionalized style established since Dynasty I, which treats the human form in flat profile. Eyes, hands, head, and feet show no attempt at verisimilitude. Quite the contrary, the fingers become extenuated designs, elongating the arms to balance the elegant and sweeping lines of legs and feet. The matching figures of Selkis and Maat, extreme left and right, exhibit arms of unequal length and proportion. Although the basic style remains consistent, we can observe a significant change in body proportions from those of the Old and Middle Kingdom.

Akhenaton and Monotheism: The Tell el Amarna Period

The reign of Akhenaton marked a break in the continuity of artistic style in Egypt. The stiff poses disappear and a more natural form of representation replaces them. The pharaoh, moreover, is depicted in intimate scenes of domestic life rather than in the formal ritual or military acts which were traditional and expected. He is no longer seen associating with the traditional gods of Egypt. Rather, he and his queen are depicted worshipping the disc of the sun, whose rays end in hands that either bless the royal pair or hold to their nostrils the *ankh*, the symbol of life.

What accounts for this revolution is not certain, but evidence suggests that the priesthood of Heliopolis, the ancient seat of the sun cult, had reestablished the primacy of their god. Amenhotep IV, as Akhenaton was called before changing his name to reflect his god, possessed a "strange genius" for religious experience and its expression. Depictions of him show that he apparently suffered from physical deformity. The realistic trends of the period and Akhenaton's desire for truth seem to have resulted in his graphic representation as a man with a misshapen

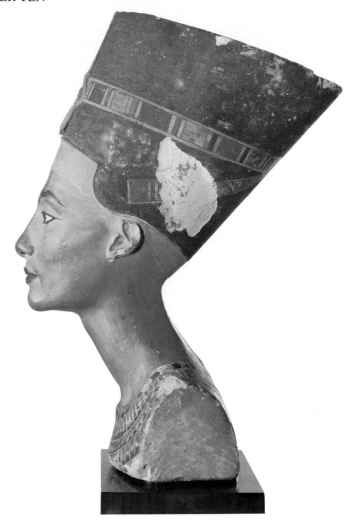

10.23 Nofretete (Nefertiti), c. 1360 BC. Painted limestone, height 19 ins (48 cm). The Egyptian Museum, Berlin.

body, an elongated head and drooping jaw. Yet, the eyes are deep and penetrative. The effect is one of a brooding genius.

In the fifth or sixth year of his reign, the king moved his court to a sandy desert ground on the east side of the Nile to the newly constructed city of Tell el Amarna. It was a new city for a new king intent on establishing a new order based on a new religion. Because the movement failed and the city was abandoned, we are left with an encapsulated artistic synthesis, including the city itself. Tell el Amarna lay away from cultivated land, and once abandoned was never built over.

The town itself is dominated by the large estates of the wealthy, who chose the best sites and laid them out in the style of the Egyptian country house, with large gardens and numerous outbuildings, enclosed within a wall. In between these large estates lay the smaller dwellings of the

less wealthy. There was even a slum area outside the northern suburb. Nearby was the grand North Palace.

In many ways Amarna reflects the regular features of New Kingdom domestic architecture, but seems much less sumptuous. Its lines and style are relatively simple. Structures are open, in contrast to the dark and secret character of the Temple of Luxor, for example. At Amarna numerous unroofed areas lead to the altar of the god, Aton, left open to provide access to the rays of his sun.

Sculpture at Amarna departed from tradition. It became more a form of secular art, with less emphasis, apparently, on sculpture for tombs and temples. Perhaps as a result of the king's religious fervor, the Amarna sculptor seems to have sought to represent the uniqueness and individuality of humankind through the human face. In one sense Amarna sculpture is highly naturalistic, and yet, in another, departs from the merely natural into the realm of the spiritual. The bust of Queen Nofretete illustrates these characteristics (Fig. **10.23**). Of course, we have no way of knowing how Queen Nofretete actually looked, but the figure is so anatomically correct that it could be a naturalistic representation. Nonetheless, the line and proportions of the neck and head are almost certainly elongated, to increase her spiritual appearance. This technique is not unlike the Mannerist style of the sixteenth century.

Isolated by geographical and religious circumstance, Tell el Amarna brings us a complete and vivid encapsulation of artistic interrelationships centered on a philosophical and religious concept. Although his religious reforms failed, Akhenaton's experiment in monotheism has, nonetheless, left us with a clear portrait of an integrated scheme of life and culture.

Tutankhamun

One of the most popular artifacts from the succeeding period must be the exquisite sculpture from the tomb of Tutankhamun, son of Akhenaton (Fig. **10.24**). The tomb was discovered in the Valley of Kings near Thebes. The funerary mask is of solid beaten gold inlaid with semi-precious stones and colored glass. Designed to cover the face of the king's mummy, the mask is highly naturalistic in style, and apparently a true likeness of the young king. The mask wears the royal *nemes* headdress with two lappets hanging down at the sides. A ribbon holds the king's queue at the back. The hood formed by the headdress exhibits two symbolic creatures, the uraeus serpent and the vulture goddess Nekhbet of El-Kab, divinities who protected Lower and Upper Egypt.

10.24 Funerary mask of King Tutankhamun, c. 1340 BC. Gold inlaid with enamel and semiprecious stones, height 21¼ ins (54 cm). The Egyptian Museum, Cairo.

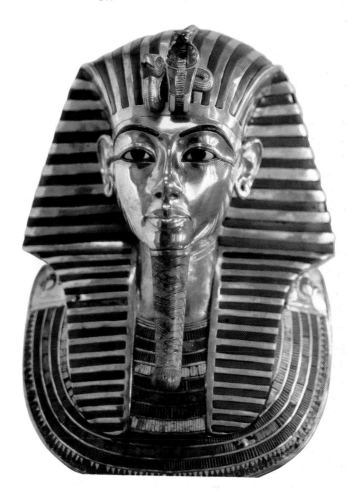

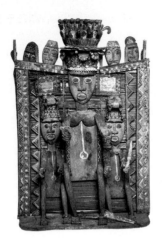

ELEVEN

AFRICAN, EAST ASIAN & BYZANTINE TRADITIONS

AFRICA

For thousands of years African artists and craftsmen have created objects of sophisticated vision and masterful technique. The modern banalities of so-called primitive "airport art," sold to tourists, belie the rich cultural history of the African continent, which witnessed trade with the Middle East and Asia as early as AD 600, as documented by Chinese T'ang Dynasty coins found on the maritime coast of East Africa. Climate, materials, and the very nature of tribal culture doomed much of African art to extinction; only a small fraction remains. Nonetheless, what has survived traces a rich vision which varies from culture to culture and whose style runs from abstract to naturalistic. Its purposes range from magic to the utilitarian, adding layer upon layer to its potential meaning, and portraying levels and visions of reality that we may be ill-equipped to understand, inasmuch as our culture views reality differently. Nonetheless, if we know how to look we can find profound human statements, meaning, and great satisfaction in these works.

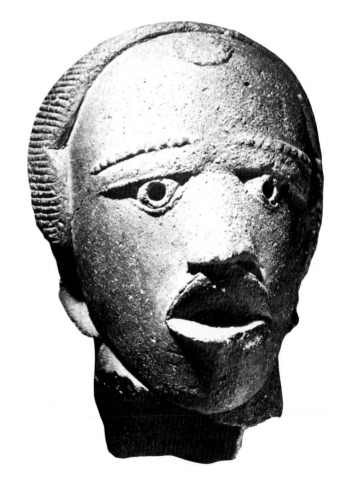

11.1 Head from Jemaa, c. 400 BC. Terracotta, height 10 ins (25 cm). The National Museum, Lagos.

190

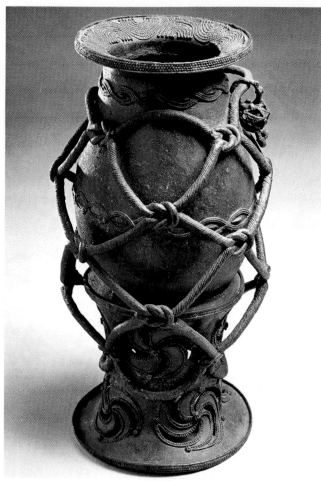

11.2 Roped pot on a stand, from Igbo-Ukwu, 9th–10th century. Leaded bronze, height 12½ ins (32 cm). The National Museum, Lagos.

Igbo-Ukwu Roped Pot on a Stand

The level of skill achieved by the ninth and tenth centuries AD can be seen in a ritual water pot from the village of Igbo-Ukwu in eastern Nigeria (Fig. 11.2). Cast using the *cire-perdu* or lost-wax process, this leaded bronze artifact is amazing in its virtuosity. The graceful design of its recurved lines and flaring base by themselves are exquisite, but the addition of the delicate and detailed rope overlay reflects sophistication of both technique and vision.

Head of a Queen

A link between the Nok culture and that of Ife, also in Nigeria, may have existed to draw these two cultures together in their art across the centuries. Ife was an important cultural and religious center in the southwest. The accomplishments of its artists, in their mastery of the terracotta medium, their rendering skills, and the depth of their vision, suggest to some scholars a long developmental period, culminating in twelfth- to thirteenth-century works such as Figure 11.3. There can be little question that this represents a mature artistic style. We cannot escape the temperament of this young woman: The anatomical detail is remarkable and even today the textures are so exquisite that the figure seems ready to come

Head from Jemaa

During the first millennium BC on the Jos plateau of northern Nigeria the Noks, a nonliterate culture of farmers, entered the Iron Age and developed an accomplished artistic style. Working in terracotta, and apparently nearly as sophisticated in its firing as were the makers of the Qin Dynasty terracotta warriors of China, these artists produced boldly designed sculptures (Fig. 11.1). Some works represent animals in naturalistic form and others portray life-sized human heads. Although stylized, with flattened noses and segmented lower eyelids, for example, each work reveals individualized character. Facial expressions and hairstyles differ and "it is this unusual combination of human individuality and artistic stylization which gives them their peculiar power."[1] Probably these heads are portraits of ancestors of the ruling class. The technique and medium of execution seem to have been chosen to insure permanence and for magical rather than artistic reasons. The Nok style appears seminal to several West African styles.

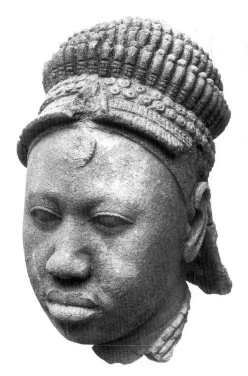

11.3 Head of a queen, 12th–13th century. Terracotta, height 10 ins (25 cm). Museum of Ife Antiquities, Ife.

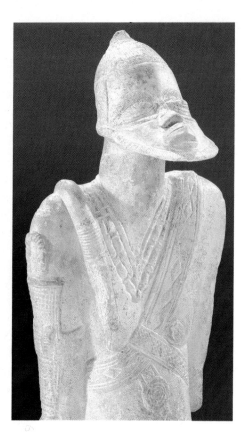

11.4 Bearded male figure from Djenne, Mali, 14th century. Terracotta, height 15 ins (38 cm). Detroit Institute of Arts (Eleanor Clay Ford Fund for African Art).

to life. The full mouth and expressive eyes suggest extreme sensitivity. The high brow and minutely detailed headdress complete this naturalistic portrait, which captures more than photographic reality as it brings to its surface detail the innermost essences of the individual.

Bearded Figure from Djenne

The styles of African art range widely from the naturalistic to the highly expressive and abstract. Up the Niger River at Djenne, in Mali, we find an expression of the latter in a small, fourteenth-century terracotta figure of a bearded male (Fig. 11.4). The most striking aspect is its thrusting chin, which flies in the face of anatomical realism. The lower and upper jaws protrude grotesquely from a plate-like appendage, probably a stylized beard, where the jaw would normally be. The eyes are lightly incised on the conical surface of the head. The proportions of the torso pinch inward, as if compressed by the undetached arms. The details of what could be armor show exquisite workmanship, and the sophisticated rendering of the entire form suggests an intentional style whose purpose again is to reflect inner essence.

Pectoral Mask from Ife

Superb craftsmanship also dominates an early-sixteenth-century ivory mask of the Benin School. The origins of this style are ascribed by local tradition to either a master from Ife or the Portuguese. Whatever the root, the result is an exquisite portrayal made for the Oba, or King of Benin (Fig. 11.5), reigning when the Portuguese arrived in Africa. Again, we find expressive qualities reflected in the elongated head and stylized features, yet the carver's mastery of the medium leaves no doubt about his or her sophistication of vision or technique. The details of the mask reflect precision and delicacy, and the heads of Portuguese men with beards, woven skillfully into the headdress, hold some symbolic, if unclear, meaning. The intensity of the eyes and mouth conveys a profound strength of expression.

11.5 Pectoral or waist mask, early 16th century. Ivory, height 9¼ ins (25 cm). The British Museum, London.

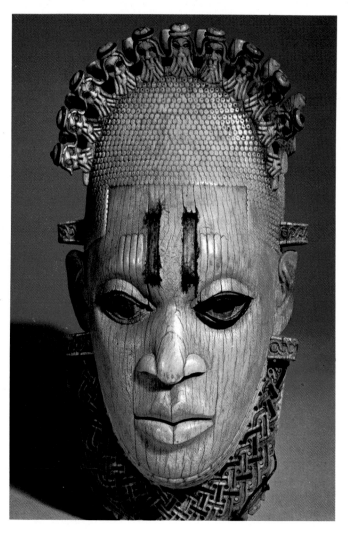

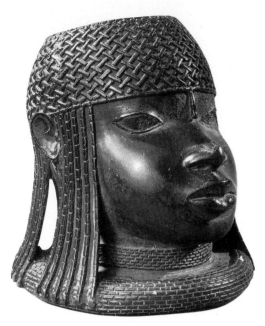

11.6 Benin Head, Nigeria, 16th century. Bronze casting, height 9¼ ins (23 cm). The Metropolitan Museum of Art, New York (the Michael C. Rockefeller Memorial Collection of Primitive Art).

Benin Head

In the sixteenth century, bronze-casting in Benin reached great levels of technical accomplishment. In Figure 11.6 a freestanding likeness of the head of a royal personage shows realistic detail and an apparent understanding of compositional principles. The rendering of facial detail is anatomically correct and individual enough to suggest that the head represents a particular individual. At the same time, facial features seem simplified, suggesting idealization to reveal the subject's character. In addition, the elaborate details of the headgear and neck ornamentation (which doubles as a base), juxtaposed with the simplicity of the facial treatment, make the face the focus of attention. Focus is created subtly through contrast coupled with radial balance—that is, the detailed rectilinear elements of the cap, side flaps, and neck ornamentation surround the face and, because the details are unvaried, force us to focus on the facial features.

EAST ASIA

CHINA

The social heritage of China plays a fundamental role in all East Asian culture. It focuses on concepts of family which subordinate the individual and result in particular political and ethical systems.

From the earliest times China witnessed the crowding of populations into walled villages and this packing-in influenced social and family relationships. The importance of the family was reinforced by the religious practice of ancestor worship. The family also formed the basic political unit. A system of mutual responsibility called *Pao-chia* made individuals in the same household responsible for each other's actions. Within the family, a hierarchical system existed; each individual's position was dictated by birth and marriage. The greatest virtue was filial piety. Marriages were arranged, more as a union of families than of individuals, and women, in general, were subordinate to men. The norms for social conduct, such as loyalty, honesty, and benevolence, were inculcated into the family system. Later, the precepts of Confucianism, an ethical system, fulfilled the role played by law and religion in the West. The Chinese social model was authoritarian and class-conscious.

From approximately 1400 to 1100 BC verifiable Chinese history was beginning, with the emergence of the Shang dynasty. In the third or Zhou (Chou) dynasty, from approximately 1100 to 256 BC, accurate documentation of Chinese history begins. The earliest Chinese books date to the early first millennium BC. They weave a pattern of ethics, philosophy, and mythology. From this strong sense of history came an ideal of political unity and a belief in the uniqueness of the "Central Country," or *Chung-kuo*.

China entered its great period of philosophy and classicism, the Eastern Zhou period, around 770 BC. The next 500 years saw a period of remarkable accomplishments, with China drawing abreast of other cultures in technology. At the same time classical philosophy emerged, focusing on humankind as a social and political animal. It was distinctly humanistic in tone, in contrast to the divine philosophies of India and parts of the Mediterranean world. Philosophers further strengthened the historical focus of China by using the past as a model for the present. Amid this drift came the establishment of a classic canon of Chinese literature—that is, a specific set of books associated with the Confucian tradition and called *The Five Classics*.

Confucianism

Confucius (551–479 BC) was the greatest of all teachers and philosophers in China. His work, *The Analects*, comprises a series of answers prefaced by "The Master said."

His thought tends to be on a more pragmatic plane than that of Plato or Socrates. His primary interest seems to lie in politics. He proposed a return to the ancient way, with persons playing their proper, assigned roles subject to authority. Nonetheless, his ingenuity came in his perception that the problem of government was fundamentally an ethical one. He believed that a ruler's virtue, rather than power, led to contentment in the people and his aim was to convince China's rulers of ethical principles. He thereby became the country's first moralist and the founder of a great ethical tradition.

Taoism

In contrast to Confucianism, Taoism (or *The Way*) taught the independence of the individual. It was a philosophy of protest by the common individual against despotic rulers and by the sensitive intellectual against the rigidity of the Confucian moralists. If Confucianism was pragmatic, Taoism was mystical.

Against this background, by the late second century AD, the great local families had grown too rich and powerful to be curbed by any central authority, and a united government became impossible. By the early third century China had been broken into three separate kingdoms and was unable to resist the invasions by Turks, Mongols, and Tibetans. With foreign pressures came other foreign influences, especially Buddhism, and an unprecedented upturn in religious fervor occurred.

Buddhism

Buddhism was a system of philosophy and ethics founded in India by Buddha (563–483 BC). The "four noble truths" of Buddha are: existence is suffering; the origin of suffering is desire; suffering ceases when desire ceases; the way to reach the end of desire is by following the "noble eightfold path", which comprises right belief, right resolve (to renounce carnal pleasure, harm no living creature, and so on), right speech, right conduct, right occupation or living, right effort, right contemplation or right mindedness, and right ecstasy. The final goal is to escape from existence into blissful nonexistence—nirvana. Individuals are made up of elements that existed before them, that separate at death, and that may be recombined in a somewhat similar fashion. It is from this chain of being that humans seek to escape by religious living.

In the seventh century AD China turned outward to conquest and supremacy over East and Central Asia. This was the golden age of Buddhist pilgrimages to India, and Persian and Arab influences could be seen everywhere.

China became a balanced society, but by the middle of the eighth century class conflict erupted again, and foreign influences became highly suspect. Buddhists were persecuted, and Muslims were massacred outright. Confucianism became the central focal point of Chinese tradition. China was again vulnerable to invasion.

JAPAN

Chinese chronicles mention Japan for the first time in the first century AD. By that time Japan was using metals and had a major rice-growing economy. The first development of any political center, however, did not occur until the fourth century, and the country was controlled by a strongly entrenched aristocracy, the Yamato, whose dominance continued throughout the fifth and sixth centuries. At this time Japan saw strong influence from Korean culture.

The Yamato created a state centered on the Chinese model. Buddhism was introduced and adopted by the court sometime in the sixth century, although Shinto, Japan's ancient animistic religion, appears to have maintained itself. A constitution modeled on Confucian ethics, land reform which transformed the aristocracy into a bureaucracy paid by the state, the introduction of legal and penal codes, and the development of historical chronicles occurred over the next 200 years. An official break with China in 894 testified to the progress of Japanese culture. Japanese aesthetics had matured as well.

By the fifteenth century Japanese culture and society had reached one of its highest points. Homogeneity among local economies, technological advances, and a burgeoning sea trade each contributed their part.

The Amidaist sects of Buddhism spread throughout the lower classes while the Zen movement, with its rigid morality, meditation techniques, and body mastery, took hold among the warriors. Zen monasteries, encouraged by the shogunate, developed a hierarchical system known as the "Five Mountains." War epics replaced poetry as the favored literary form.

As in the Western world, a new middle class or bourgeoisie made a significant impact on Japanese culture. Zen gardens proliferated and the "tea ceremony" was invented. Architectural masterpieces emerged and the Noh theatre was founded. Nevertheless, Japan, politically, could not maintain a level course of centralized government and despite its prosperity and cultural accomplishment, it was a sorely divided state when the Portuguese arrived in 1543 to bring Christianity and firearms to the islands.

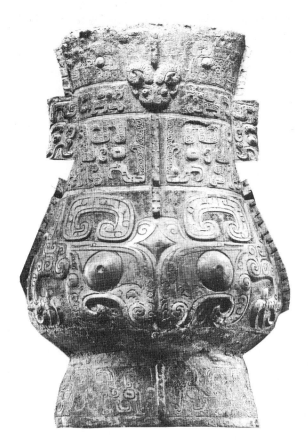

11.7 Ritual wine vessel or *hu* c. 1300–1100 BC. Bronze, 16 ins (40.6 cm) high, 11 ins (27.9 cm) wide. Nelson Gallery, Atkins Museum, Kansas City.

Shang Bronzes

Shang bronzes from approximately 1400 BC in China comprise two types: weapons and ceremonial vessels. Both are frequently covered with elaborate designs, either incised or in high relief. The craftmanship of the design is exquisite and surpasses the quality of virtually every era, including the Western Renaissance. Each line has perfectly perpendicular sides and a flat bottom, meeting at a precise 90-degree angle, in contrast, for example, with incising which forms a groove. The approach to design seen in animal representation illustrates a vision unlike Western culture's and similar to later East Asian and Pacific Northwest Indian design, in which the animal appears as if it had been skinned and laid out with the pelt divided on either side of the nose. A rigid bilateral balance occurs. The grace and symmetry of the bronze ritual vessel of the shape known as *hu* (Fig. 11.7) exhibits subtle patterns carefully balanced and delicately crafted. The graceful curves of the vessel are broken by deftly placed ridges and gaps, and while the designs are delicate, the overall impression exhibits solidity and stability.

11.8 Elephant feline head, Chinese, Shang Dynasty c. 1200 BC. Jade, length 1⅝ ins (4 cm). The Cleveland Museum of Art, Anonymous Gift, 52.573.

Stone Sculpture

Another innovation of the Shang culture is stone sculpture in high relief or in the round. Most numerous are small-scale images in jade. They represent a broad vocabulary, from fish, owls, and tigers, for example, as single units to combinations and metamorphoses such as the elephant head of Figure 11.8. This design expresses a simplicity of form with incised, subtle detail. We can easily see the metamorphic intention of the piece as we note the feline head with large, sharp teeth, elephant's trunk, and bovine horns.

Qin Dynasty Terracotta Warriors

Although the Qin dynasty lasted less than fifty years, during the third century BC, the emperor spent that entire time preparing his palace and mausoleum. Over the years minor pilfering and excavation have occurred, since the location of the underground vaults was well known. In March 1974, however, during the digging of a well near the vaults, some life-size and lifelike pottery figures were unearthed. The vaults containing the terracotta warriors, horses and bronze chariots had been located. In one vault (measuring 760 ft by 238 ft [231 × 72 m]) alone, 6,000 terracotta warriors and horses were found. A total of three vaults contain over 8,000 figures (Fig. 11.9).

11.9 Terracotta warriors, Qin Dynasty, China, 3rd century BC. Life-size. Courtesy Peoples Republic of China.

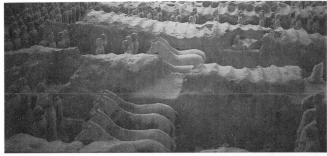

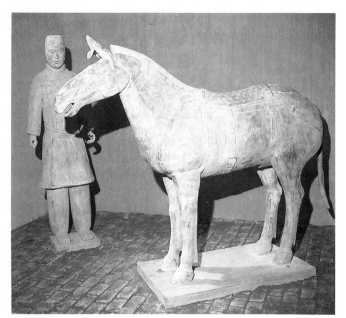

11.10 A clay rider with saddled horse, Qin Dynasty, China, 3rd century B.C. Life-size. Courtesy, Peoples Republic of China.

The warriors have different expressions. Some are dignified; others, vigorous; some are cheerful; others, debonair. Some appear lost in brooding, while still others look witty and handsome. Each figure displays an almost knowable character, as if some living form had been miraculously frozen in time. The realistic style and the consummate skill of the artists who created these figures are breathtaking. Detailing is so precise that in addition to

temperament, we can determine the rank and provenance of these warriors. Common soldiers, for example, appear in short battle tunics or laceless armoured suits; their heads are covered by small round caps, and they wear square-toed sandals on their feet.

The horses appear well bred, and all look muscular and vigorous. Their proportions are exquisite (Fig. 11.10) and even their expressions reflect the strong insight, understanding, and skill of the artists. The eyes stare ahead intensely and the necks stretch in magnificent curvature, reflecting energy and power.

The quality of these works indicates clearly that Chinese technical mastery had reached a high level. To create such masterpieces, the artists needed to master scientific manufacturing processes and to know how to control firing temperatures. The hardness of the figures and their almost flaw-free condition testify to the superior clay-making technology of the Qin dynasty.

Han Dynasty Painting

Three styles of painting existed in the Han period of the first century AD. The first was a rather formal and stiff style, very geometric and hieratic, which stressed silhouette. The second contrasted greatly, depicting lively action and deep space. The third was in between these two, being more painterly and exhibiting movement and lively depictions of, for example, mythical beings, dragons, and rabbits. In Figure 11.11 we can see in a painted

11.11 Lintel and Pediment of Tomb, Han Dynasty, 50 BC–50AD. Earthenware, hollow tiles painted in ink and colors on a whitewashed ground, 29 x 80½ ins (73.8 x 204.7 cm). Denman Waldo Ross Collection. Courtesy, Museum of Fine Arts, Boston.

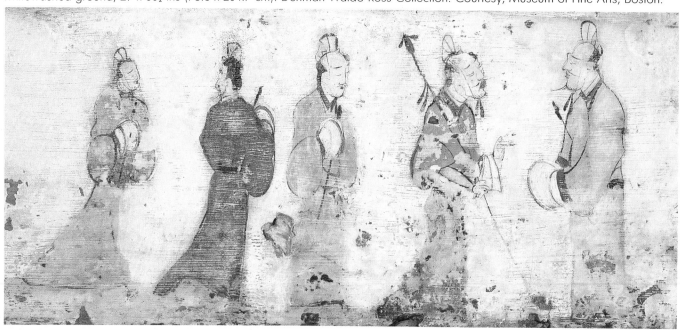

tile masterfully rendered figures whose brushstroke suggests liveliness and movement. The figures appear in three-quarter poses, which gives the painting a sense of depth and action. The active line, with its diagonal sweeps, adds to the sense of action. The poses of the personages suggest character—that is, the psychology of the figure portrayed. Although the use of pose and direction reflects a sophisticated approach and technique, the figures remain on the same baseline, with no sense of placement in deeper space.

Bodhisattva Kuan-yin

Buddhist influence in sculpture and the demand for religious images in the sixth century made the period one of significant sculptural output. It was probably the one great age of Chinese sculpture. Chinese sculpture showed deeply religious spiritualism, and, in contrast to the realism of the past, exhibited a stiff, austere abstraction while limiting realism to the details of clothing (Fig. **11.12**). In this depiction of the Bodhisattva Kuan-yin, carved in stone, we find the Bodhisattva in its later, feminine, state as the "Goddess of Mercy" (Japanese, Kannon). The flow of line from all points in the image uses gentle curves to direct the eye upward to the serene visage of the face. Repetition of the deep curve unifies the composition, giving it grace, harmony, and softness. In this feminine form the Bodhisattva or "Enlightened Existence," although having attained the enlightenment of a Buddha, stays in this world to help others achieve salvation before passing onto nirvana herself, and becomes a gentle and compassionate protectress. Later, when Chinese interests turned in a more humanistic direction, sculpture reflected a more intimate and human depiction. Images became rounder and more lifelike, approximating Chinese concepts of human beauty. Throughout this period both religious and secular sculpture occurred side by side. Monumental sculpture for the tombs of emperors and other great men seemed especially popular.

The Monastery of the Buddha's Halo

Very little has survived of early Chinese architecture, because it was mostly constructed of wood. We can capture a sense of its style, however, by examining a reconstruction drawing of the main hall of the ninth-century Fo-kuang-ssu (Monastery of the Buddha's Halo) on Mount Wu-t'ai (Fig. **11.13**). This is China's oldest wooden building and is located in northern Shansi. We can see here the indicators that have come to represent Asian style in the curved roof lines with their deep overhangs and ornate decoration.

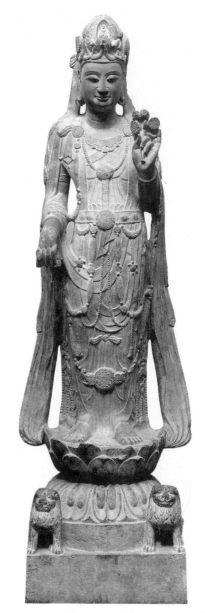

11.12 *Kuan-yin, The Bodhisattva of Compassion*, China, Northern Chou-sui dynasty, about 580. From the Ku Shihfo Ssu monastery, Sion, Shensi Province, Limestone 6⅜ ins (2.49 cm).

11.13 Front elevation and cross section of the main hall of the Fo-kuang-ssu Mount Wu-t'ai.

197

11.14 Liurong Temple, Guangzhou, China, c. 989.

Liurong Temple

Also typical and common is the Liurong Temple or "Six Banyon Pagoda" of Guangzhou (Fig. **11.14**). Built in its final form in approximately 989, the pagoda rises 188 ft (57 m) in nine storys from the outside. From the inside it contains seventeen storys. The pagoda is richly painted in red, green, gold, and white, so colorfully that it was at one time called the Flowery Pagoda. The current name comes from the famous writer and calligrapher Su Dong-po, who visited it in 1100 and was attracted to the six banyan trees surrounding it. Again, we can see in the upward curving line of the eaves and the colorful glazed roof tiles the characteristics of Chinese architecture which become typical from this time onward.

The Kondo of Muro-ji

At approximately the same time, Buddhism also made a significant impact on Japan during the Jogan or Early Heian period, between 794 and 897. The Mikkyo, also called Esoteric Buddhism, emphasized secrecy and mystery, and its precepts can be found in the kondo of Muro-ji (Fig. **11.15**), which stands in the remote area of Nara. The secluded location removes the temple from "distractions and corruptions." The design follows an asymmetrical plan, with a close relationship to the natural site. The shingled roof sets the kondo of Muro-ji apart from the tiled-roof structures of Chinese influence and argues for a native Japanese style in temple architecture. As with most buildings of this period, the kondo is relatively intimate in scale.

11.15 Kondo of Muro-ji. Nara prefecture, Japan. Early Heian period, ninth century.

Sung Dynasty Painting

In China's Sung dynasty of the eleventh to thirteenth centuries, we find extant paintings of impressive quality, and it is from this time on that the Chinese have seen painting as their greatest art. The basic canons were established then and reached a zenith that has probably never been surpassed. Buddhist influence remained strong in painting, although secular art saw greater prominence than before. In secular painting the emphasis was placed on landscapes, as opposed to human events and images. Figure **11.16** reflects a soft and atmospheric style. It is part of a larger scroll entitled *Twelve Views from a Thatched Cottage* by Hsia Kuei (c. 1180–1230). In it we see a mountain range and a lake with boats on the water. Each of the sections of the scroll carry an inscription, for example, "Distant Mountains and Wild Geese." Taken as a whole, the scroll reveals time as well as space as it moves from daylight to dusk. Subtle technique merges soft washes with firm brushstrokes, and images move from sharp focus to indistinct suggestion. Certainly the detail-

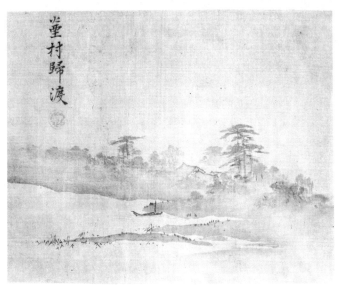

11.16 Hsia Kuei, *Twelve Views from a Thatched Cottage* (detail), c. 1200–1230. Hand scroll, ink on silk, 11 ins (28 cm) high. Nelson Gallery, Atkins Museum, Kansas City.

ing gives the subject a degree of realism, but we are taken beyond realism to a "sense" of nature. The images are impressions rather than verisimilar depictions. Details are highly selective and the artist's concentration focuses on essences. In the eleventh century, color took little importance, and most Chinese painting was monochromatic. Landscapes, for the Chinese, represent nature as a whole.

11.17 Unkei, *Nio*, 1203. Wood, height 26 ft 6 ins (8 m). Todaiji Temple, Nara.

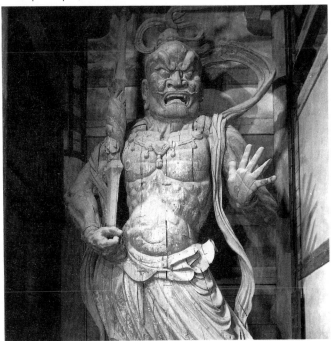

Each small detail symbolizes the larger universe. In this painting an overriding sense of mysticism emerges and probably reflects the Taoist belief system.

Japanese Buddhism and Sculpture

In the thirteenth century in Japan, sculpture reached a new maturity, turning to simple works that stressed strength and virility. A series of civil wars had led to the military dictatorship of the Shoguns and their Samurai (warriors) and to a wider based feudal regime. This was reflected in the works of sculptors, such as Unkei, whose demonic and colossal wooden Buddhist deities (Fig. 11.17) guard the entrance to the Todaiji temple at Nara. We are drawn by both the statue's power, expressed in the fierce facial expression and forbidding hand, and by it's simplicity, through the clean lines of the swirling fabrics.

Kumano Mandala

In the period just prior to the Ashikaga shogunate in Japan—that is, in the late thirteenth century—painting expanded its subject matter from individual portraiture to landscape (Fig. 11.18). The Kumano Mandala draws into close proximity three Shinto shrines which are geographically many miles apart. Above the shrines appear circular *mandorlas* or *mandaras* (Chinese: *mandala*) with Buddhist deities inside. The presence of the Buddhist deities in

11.18 Kumano Mandala, Japanese, Kamakura Period, c. 1300. Color on silk. The Cleveland Museum of Art, John L. Severance Fund, 53.16.

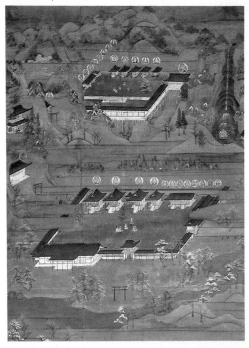

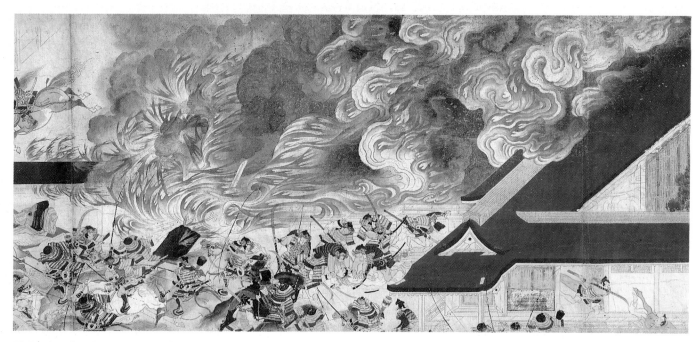

11.19 Scroll with depictions of the Night Attack on the Sanjo Palace from the Heiji Monogatori Emaki, Japan, Kamakura period, second half of the 13th century. Handscroll, ink and colors on paper, 16¼ ins x 23 ft (41.3 cm x 6.99 m). Fenolloso-Wel Collection. Courtesy, Museum of Fine Arts, Boston.

portrayals of Shinto shrines attests to the dominance of Buddhism at the time. The mandala itself comprises a ceremonial incantation or magic formula represented in a schematic, cosmological drawing. Around and between the depiction of the shrines there is delicately rendered landscape. The presentational style creates both a short-hand of essences and also a beautiful design device of delicate and active line, which holds the entire work together and leads the eye from section to section.

Heiji Monogatori Scroll

In contrast to the contemplative esotericism of the Kumano Mandala, the Japanese Heiji Monogatori scroll (Fig. 11.19) depicts a dramatically active fire scene replete with crowds and emotion. As the Sanjo Palace burns, figures and flames explode from the right border to the left. In a stylized fashion, the artist creates a masterful scene which is so tightly controlled compositionally that it could be a study for any painter of any age. The forceful diagonals and the powerful, horizontal, dark thrust of the palace roof meet to form an arrow shooting across the paper. In a design as intricate and powerful as any baroque painting, this work builds detailed individual pieces, stimulating in their own right, into a large and complicated unity of contrasting colors, values, and tex-tures. Straight and curved lines are juxtaposed to create further conflict and dramatic tension.

Mongol Period Drama

The Mongol period in China (1325–55) witnessed the development of a new artistic form: drama. Written in the vernacular, as opposed to the classical form, Chinese drama sought to reach a broader and less highly educated audience than literature had in the past. This reaching out to those who had not been classically educated reflected a general trend in Chinese society at the time.

Over 1,000 play titles have survived the centuries, and the popular form seems to have been a four-act structure. Themes treat "conflicts of human passion with the social bonds of filial piety, fidelity or loyalty." The style appears to have been operatic or semioperatic, with accompani-ment by orchestra, including singing and dancing. Scenery and properties were minimal if not nonexistent, with the drama resting on a series of specific and elaborate conventions, including stylized hand, arm, leg, and foot movements. Female roles, at least in later times, were played by men, and the accompanying falsetto singing, dancing, and delicate gestures gained great admiration among Chinese audiences. Performances were vigorous, romantic, comic, and high in technical virtuosity.

Noh Drama

At the same time in the fourteenth century, the Japanese Noh drama emerged. It represented the most significant and original literary and performing art development of

200

the Ashikaga period. A highly conventionalized art form, Noh drama grew out of two sources: simple dramas based on symbolic dances performed to music at the imperial court and similar mimetic performances popular with the common people. Its final form is credited to a Shinto priest named Kan'ami (1333–84) and his son Seami (1363–1443). They also founded one of the hereditary lines of Noh performers, the Kanze, which still perform today.

Noh drama is performed on a simple, almost bare stage and, like classical Greek tragedy, uses only two actors. Also, as in Greek classical drama, actors wear elaborate masks and costumes, and a chorus functions as the narrator. Actors chant the highly poetic dialogue to orchestral accompaniment. All the actions suggest rather than depict, which gives the drama its sense of stylization and conventionality. Noh drama's subjects range from Shinto gods to Buddhist secular history and usually center on the more popular Buddhist sects. The tone of Noh plays tends to be serious, with a focus on the spirit of some historical person who wishes salvation but is tied to this earth by worldly desires. The plays tend to be short, and an evening's performance encompasses several plays interspersed with comic burlesque called *Kyogen* (Crazy Words).

BYZANTIUM

Astride the main land route from Europe to Asia and its riches, Byzantium possessed tremendous potential as a major metropolis. In addition, the city was a defensible deep-water port, which controlled the passage between the Mediterranean and the Black Sea. Blessed with fertile agricultural surroundings, it formed the ideal "New Rome." For this was the objective of the Emperor Constantine when he dedicated his new capital in 330 and changed its name to Constantinople. The city prospered, and became the center of Christian Orthodoxy and mother to a unique and intense style in the visual arts and architecture. When Rome fell to the Goths in 476 it had long since handed the torch of civilization to Constantinople. Here it was that the arts and learning of the classical world were preserved and nurtured, along with an Eastern orientation, while Western Europe underwent the turmoil and destruction of barbarian invasion.

BYZANTINE ART

A fundamental characteristic of Byzantine visual art is the concept that in art exists the potential to interpret as well as to represent perceived phenomena. Byzantine art, like its literature, was conservative and mainly anonymous and impersonal. Much of Byzantine art remains undated, and questions concerning derivation of styles, if not the styles themselves, lie unresolved. The physical expansion of artistic form from the constrained style of the late Roman and Roman Christian churches to the vast wall surfaces of new Byzantine churches posed problems of style which took time to resolve. The development of narrative Christian art with its relatively new approach dates back to the mid-fifth century. Early attempts at iconography can be traced to the third and fourth centuries.

The content and purpose of Byzantine art was always religious, although the style of representation underwent numerous changes. Classical standards subsided with a decline in enlightened patronage and skilled craftsmanship. The period of Justinian marks an apparently deliberate break with the past. What we describe as the distinctly Byzantine style, with its characteristic abstraction and focus on feeling rather than form, began to take shape in the fifth and sixth centuries, although the classical Hellenistic tradition seems to have survived as an undercurrent. High realism in some works has led to occasional confusion among scholars over dating, where the style of a work appears to predate the work itself. Throughout the seventh century classicism and decorative abstraction intermingled in Byzantine art.

Certainly by the eleventh century Byzantine style had adopted a hierarchical formula in wall painting and mosaics, coupled with a reduced emphasis on narrative. The Church represented the kingdom of God, and as one moved up the hierarchy, one encountered figures changing in form from human to divine. Placement in the composition depended upon religious, not spatial, relationships. Depiction is not illusionistic, but flat and antique. Here again, the Byzantine style is penetrated from time to time by several renaissance movements, mostly in the minor arts. By the eleventh century a strictly two-dimensional style appears which is elegant and decorative. Stylization and dramatic intensity characterize twelfth-century art, a style further intensified in the thirteenth century with turbulent movement, architectural backdrops, and elongated figures. The fourteenth century produced small-scale, crowded works of narrative content. Use of space is confused and perspective is irrational. Figures are distorted, with small heads and feet. A more intense spiritualism is obvious.

Stretching as it did over 1,000 years, and influenced by turbulent history, Byzantine art represents a complex repertoire of styles.

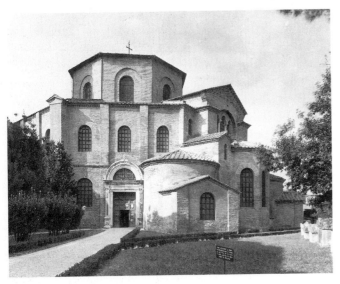

11.20 San Vitale, Ravenna, Italy, 526–47.

San Vitale in Ravenna

San Vitale in Ravenna (Figs. **11.20** and **11.21**) is the major Justinian monument in the West, and was probably built as a testament to Orthodoxy in the declining kingdom of the Ostrogoths.

11.21 San Vitale, interior.

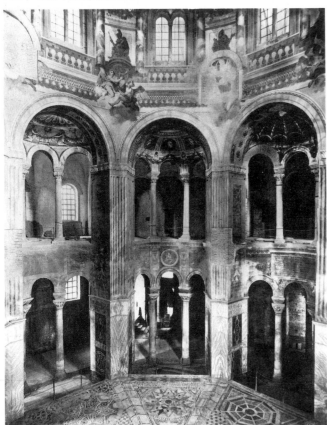

The prismatic geometry and warm brick texture of the exterior envelop an exhilarating, expanding well of strongly verticalized interior space. The key to the design is in the ingenious reciprocal manner in which volumenic parts are interlocked. For example, the eastern apse and its flanking spaces are composed of cylinders, prisms, and blocks which pile up dramatically against the outer octagonal shell, carrying the eye continuously across a concatenated play of surfaces. Each unit, delimited by the shadow lines of a sketchy terracotta cornice, can be read as an entity but is simultaneously joined and subordinated to the whole effect.[2]

The structure consists of two concentric octagons (Fig. **11.22**). The hemispherical dome rises 100 ft (30.5 m) above the inner octagon, and floods the interior with light. Eight large piers alternate with columned niches to define precisely the central space and to create an intricate, multifoliate design. An inexplicable feature is the placement of the narthex at an odd angle. Two possible explanations encompass both the practical and the spiritual. One suggests that the narthex paralleled a then-existing street; the other, that it was designed in order to make worshippers reorient themselves on entering the complex arrangement of spaces, and thereby experience a transition from the outside world to the spiritual one.

11.22 Plan and transverse section of San Vitale.

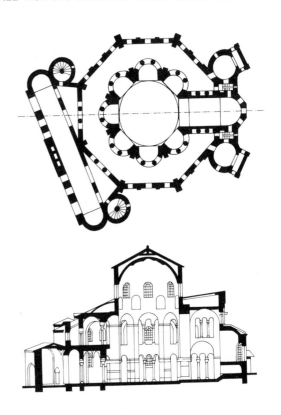

On the second level of the ambulatory was a special gallery reserved for women—a standard feature of Byzantine churches. The design is one of intricate complexity, as the visitor experiences an ever-changing panoply of arches within arches, and flat and curved spaces. The aisles and gallery spaces contrast strikingly with the calm area under the dome. The clerestory light reflects off the mosaic tiles with a greater richness than in any Western churches. In fact, new construction techniques in the vaulting allow for windows on every level and open the sanctuary to much more light than previously possible, or than was found in the West until the end of the Romanesque style and the advent of the Gothic.

The sanctuary itself is alive with mosaics of the imperial court and sacred events. Figure **11.23** provides a vivid picture of the emperor. Particularly fascinating here is the stylistic contrast of two mosaics in the same church. *Abraham's Hospitality and the Sacrifice of Isaac* (Fig. **11.24**)

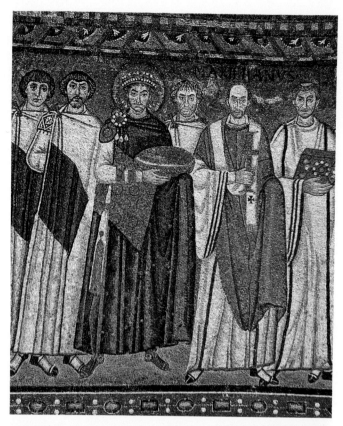

11.23 (*right*) Emperor Justinian and his court, c. 547. Wall mosaic, San Vitale, Ravenna.

11.24 (*below*) Abraham's Hospitality and the Sacrifice of Isaac. Wall mosaic, San Vitale, Ravenna.

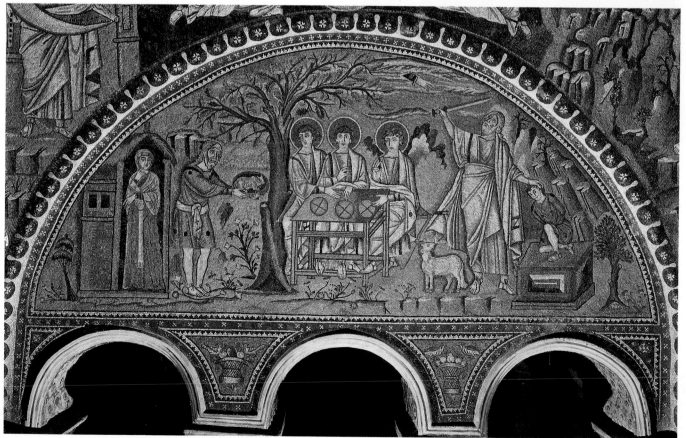

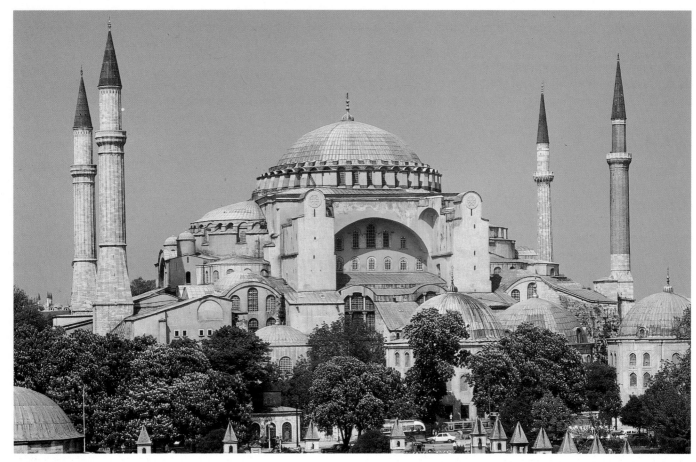

11.25 Anthemius of Tralles and Isidorus of Miletus, Hagia Sophia, 532–7.

demonstrates a relaxed naturalism whereas the mosaic depicting Justinian and his court demonstrates the orientalized style, more typically Byzantine, with the figures posed rigidly and frontally rather than naturalistically. The mosaics clearly link the church to the Byzantine court, reflecting, again, the connection of Emperor to the Faith, of Christianity to the State, and, indeed, the concept of the "Divine Emperor." Justinian and Theodora are portrayed as analogous to Christ and the Virgin. The emperor has a golden halo with a red border, is robed in regal purple, and presents a golden bowl to Christ, pictured in the semidome above.

If San Vitale praises the emperor and Orthodoxy in the West, Hagia Sophia in Istanbul (Constantinople) represents a crowning memorial in the East (Figs. **11.25 – 11.28**). Characteristic of Justinian Byzantine style, called *arcuate domicile*, Hagia Sophia uses well-rehearsed vaulting techniques of Roman economy plus Hellenistic design and geometry. The result is a richly colored building in a style of orientalized antiquity. Basic to the conception is the elevated central pavilion with its domical image of heaven and large, open, and functional spaces. The magnificent Hagia Sophia provides us with a rare experience of Byzantine artistry. We know a little of its architect, Anthemius, who was a natural scientist and

11.26 Plan of Hagia Sophia.

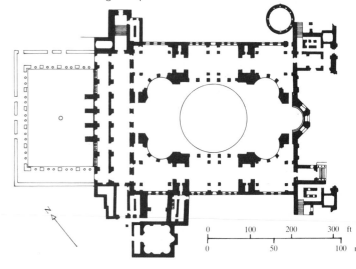

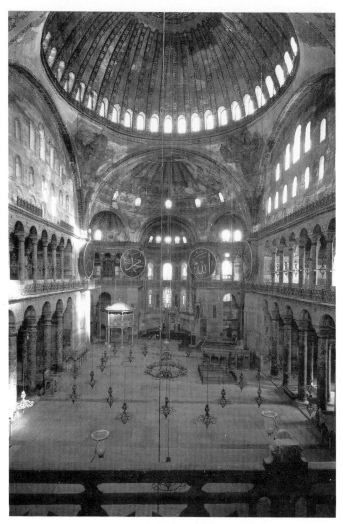

11.27 Hagia Sophia, interior.

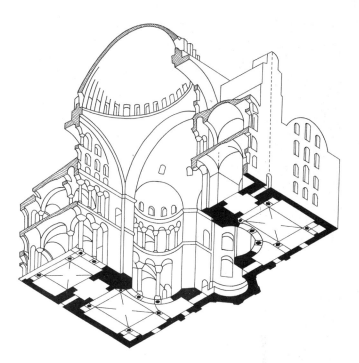

11.28 Axonometric section (worm's eye view) of Hagia Sophia.

geometer from Tralles in Asia Minor. The church was built to replace an earlier basilica. This monument, which for a long time was the largest church in the world, was completed in only five years and ten months. The speed of the work, together with Byzantine masonry techniques, in which courses of brick alternate with courses of mortar as thick or thicker than the bricks, caused great weight to be placed on insufficiently dry mortar. As a result arches buckled and buttresses had to be erected almost at once. Because of the rapid construction and the effects of two earthquakes, the eastern arch and part of the dome itself fell in 557. The flatness of a dome that large remains unique. Also remarkable is the delicate proportioning of the vaults which support such great weight. The building is intensely spiritual and yet capable of holding large numbers of worshippers; it creates a transcendental environment, where thoughts and emotions are at once wafted to a spiritual rather than a mundane sphere. "It

seemed as if the vault of heaven were suspended above one," wrote Procopius.

Justinian's reign thus inaugurated the style called Byzantine, blending all traces of previous styles, Eastern or Western, together in a new style. Forms and relationships were imbued with a spiritual essence built on classical models but shaped in its own unique way. The wide range of works from the reign of Justinian synthesizes the relationships between God, the state, philosophy, and art. The emperor was the absolute monarch and also defender of the faith, governing by and for the will of God. Reality thus became spiritualized and was reflected in works of art which depicted earthly habitation in a hieratic style.

HIERATIC STYLE

By the middle centuries a style known as "hieratic"—holy or sacred—presented a formalized, almost rigid depiction intended not so much to represent people as to inspire reverence and meditation. One formula of the hieratic style ordained that an individual should measure nine heads (seven heads would be our modern measurement). The hairline was a nose's length above the forehead. "If the man is naked, four nose's lengths are needed for half his width." By the thirteenth century mosaics display a return to more naturalistic depictions, but with a clear sense of spiritualism; for example, the Ravenna mosaic shown in Figure **11.23**. Illustrations of this style also

occur in other media; for example, the ivory, Figure **11.29**. It exhibits the frontal pose, formality, solemnity, and slight elongation of form which typify the Byzantine hieratic style.

BYZANTINE IVORIES

Ivory, traditionally a luxury material, was always popular in Byzantium. A number of carved works of different styles provide evidence of the varying influences and degrees of technical ability in the Eastern Empire. Many of the ivories are consular diptychs and others are imperial diptychs, although not all ivories were in diptych form.

Later ivories of the tenth century show delicate elegance and a highly finished style. The Harbaville Triptych has been described as the most beautiful of all the Byzantine ivories (Fig. **11.29**). It represents the hieratic style in sculpture, here producing a sense of detachment from the world and evoking a deep spirituality.

The Harbaville Triptych

Called a triptych because of its three sections (*tri-*), it was probably intended as a portable altar or shrine. Each of the two wings folded shut across the center panel. In the top center we see Christ enthroned and flanked by John the Baptist and the Virgin Mary, an arrangement called a *Deesis*. They plead for mercy on behalf of all humanity. Five of the apostles appear below. An ornament, repeated with the addition of rosettes at the bottom border and three heads in the top border, divides the two registers of the central panel. On either side of Christ's head appear medallions depicting angels holding the symbols of the sun and the moon. The figures reflect a hieratic formality and solemnity, and yet the depiction here exhibits a softness which counters the hard formality of other hieratic works. Perhaps this may result from a stronger classical influence at the time.

11.29 *The Harbaville Triptych*, interior, late 10th century. Ivory, height 9½ ins (24 cm); central panel width 5⅜ ins (14 cm). The Louvre, Paris.

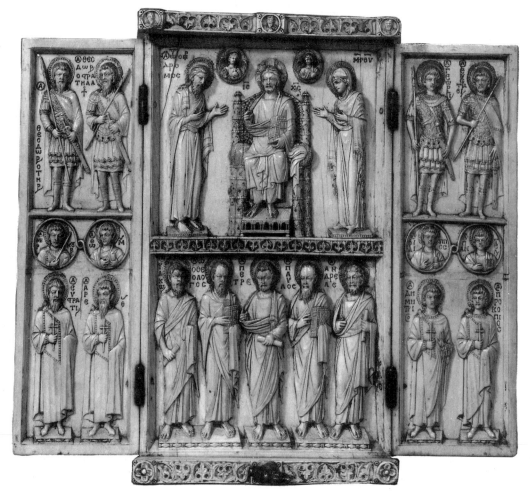

TWELVE

EARLY EUROPEAN REFLECTIONS
CLASSICAL GREECE TO THE RENAISSANCE

CLASSICAL GREECE

Under the ruler Pericles, classical Greek culture reached its miraculous zenith. In the brief span of time between approximately 600 and 200 BC Greek influence and civilization spread throughout the Mediterranean world until, under Alexander the Great, it stretched—for the span of a single lifetime—from Spain to the Indus. All this was achieved by a people whose culture, at its height, took as its measure the human intellect. In society as in the arts, rationality, clarity, and beauty of form were the aim, although as the style we call Hellenistic developed in the fourth century BC, artists increasingly sought to imbue their works with the expression of feeling.

CLASSICAL STYLE

Fifth-century Athenian painting of the classical style reflected some characteristics of earlier work, including the principally geometric nature of the design. This indicated a concern for form and order in the organization of space and time. What separated the classical style in vase painting (our only extant evidence of Greek two-dimensional art of this period) from earlier styles was a new sense of *idealized reality in figure depiction*.

Such realism reflected a technical advance as well as a change in attitude. Many of the problems of foreshortening (the perceivable diminution of size as the object recedes in space) had been solved, and, as a result, figures had a new sense of depth. Depth and reality were also heightened in some cases by the use of light and shadow. Some records imply that mural painters of this period were highly skillful in representation, but we have no surviving examples to study. The restrictions inherent in vase painting do not allow us to assess the true level of skill and development of the two-dimensional art of this period. Vase painting does demonstrate, however, the artists' concern for formal design—that is, logical, evident, and perfectly balanced organization of space.

The fifth century also saw many of the most talented artists turn to sculpture, mural painting, and architecture. The idealism and dignity of the classical style is nonetheless aptly portrayed by such artists as the Achilles Painter,

whose work is seen in Figure 12.1. Here a quiet grandeur infuses the elegant and stately figures. The portrayal of feet in the frontal position is a significant development, reflecting the new skill in depicting space.

12.1 Achilles Painter, white ground lekythos from Eretria, showing woman and her maid, 440 BC. 15 ins (38 cm). Courtesy, Francis Bartlett Fund, The Museum of Fine Arts, Boston.

By the end of the fifth century the convention we have seen in Egyptian and Mesopotamian art of putting all the figures along the baseline on the front plane of the design gave way to suggestions of depth, as some figures are occasionally placed higher than others. By the end of the fourth century the problems of depth and foreshortening were fully overcome.

We generally relate style to treatment of form rather than content or subject matter, but often form and content cannot be separated. When classicism was modified by a more individualized and naturalistic treatment of form, its subject matter broadened to include the mundane, as opposed to the heroic.

12.2 *Doryphos (Lance Bearer)*, Roman copy after an original of c. 450–440 BC, by Polyklitus. Marble, height 6 ft 6 ins (1.98 m). Museo Archeologico Nazionale, Naples.

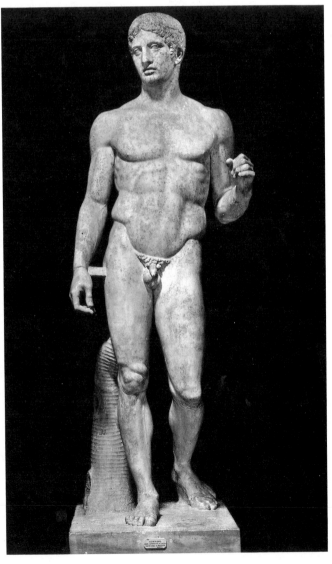

Appeal to the intellect was the cornerstone of classical style in all the arts. In painting, as well as in other disciplines, four characteristics reflected that appeal. First and foremost is an *emphasis on form*, on the formal organization of the whole into logical and structured parts. A second characteristic is *idealization*, an underlying purpose to portray things as better than they are, as according to Aristotle in his *Poetics*, or to raise them above the level of common humanity. For example, the human figure is treated as a type rather than as an individual. A third characteristic is *the use of convention*. A fourth characteristic is *simplicity*. Simplicity does not mean lack of sophistication. Rather, it means freedom from unnecessary ornamentation and complexity.

The age of Greek classical style in sculpture probably began with the sculptors Myron and Polyklitus in the middle of the fifth century BC. Both contributed to the development of cast sculpture. Polyklitus is reported to have achieved in Figure **12.2** the ideal proportions of the male athlete. It is important to note, again, in our pursuit of the elements of Greek classical style, that the *Lance Bearer* represents *the* male athlete, and not *a* male athlete. In this work the body's weight is thrown onto one leg in the *contrapposto* stance. The resulting sense of relaxation and controlled dynamics in the realistically treated human body and the subtle play of curves made possible by this simple but important change in posture are also characteristic of Greek classical style.

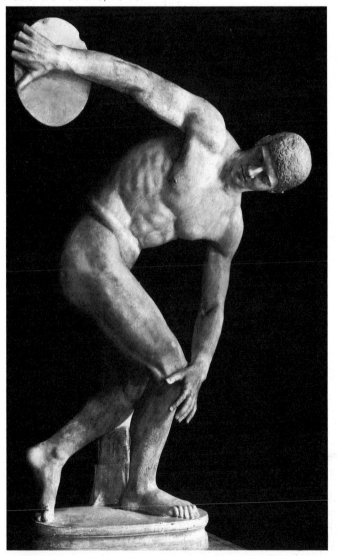

12.3 *Diskobolus (Discus Thrower)*, Roman copy after a bronze original of c. 450 BC, by Myron. Marble, life size. Museo Nazionale Romano, Rome.

Myron—Discus Thrower

Myron's best-known work displays both concern for restraint, for subtle control of movement coupled with balance, and concern for flesh and the idealized human form. Figure **12.3** is a much later marble copy; Myron worked in bronzes and so was freed from many of the constraints of marble. A work of statuary, as opposed to relief sculpture, must stand on its own, and supporting the weight of a marble statue on the small area of one ankle poses significant structural problems. Metal, having greater tensile strength, provides a solution to many of these problems.

Greek statuary may be portraiture, but the features are idealized. Man may be the measure of all things, but in art he is raised above human reality to the state of perfection found only in the gods.

This representation of an athlete in an Olympic event brought a new sense of dynamics to Greek sculpture. It captures a dramatic moment, freezing the figure in the split second before the explosive release of the discus, and Myron achieves, thereby, a conflict of opposing forces. His composition draws its tension not only from the expectation of the impending explosive force, but also in the dramatic intersection of two opposing arcs: One in the downward thrust of the arms and shoulders; the other, in the forward thrusting of the thighs, torso, and head.

Typical of Greek freestanding statues, the *Discus Thrower* is designed to be seen from one direction only. As such it comprises a sort of freestanding, three-dimensional "super-relief." The beginnings of classical style represented by this celebration of the powerful nude male figure or *kouros* type are an outgrowth of what is called the *severe style*, a transitional style between archaic and

classical. From this style, in which Myron was trained, come suggestions of moral idealism, dignity, and self-control, qualities inherent in classicism. However, the *Discus Thrower* steps forward in a chain of increasing vitality of figure movement.

For Myron, the geometrical composition remains the focus of the work. Form takes precedence over feeling.

CLASSICAL THEATRE

The theatre of Periclean Athens was a theatre of convention, and the term convention, as it applies here, takes on another dimension. Every era and every style have their conventions, those underlying, accepted expectations and/or rules which influence the artist subtly or otherwise. In some styles conventions are fundamental; in others the conventions are unconventional. Theatre of convention implies a style of production lacking in illusion or stage realism. So in contrast to sculpture and painting, which pursued the noble and the ideal with fair dependence upon a verisimilar but idealized treatment of subject matter, the Greek classical theatre pursued the same ends through a slightly different means.

Theatre of convention is to a large extent freer to explore the ideal than theatre of illusion, in which scenic details are realistically portrayed, because dependence upon stage mechanics does not hamper the playwright. An audience will accept a description in poetic dialogue, but by convention does not demand to see it. Imagination is the key to theatre of convention. The Greek dramatist found that with freedom from the restraints imposed by dependence on illusion or depiction, he was much better able to pursue the lofty moral themes fundamental to his perception of the universe. Although we have some extant plays from the era indicating what and how the playwright wrote, we are at a loss to know specifically how that work became theatre—that is, a production. Nevertheless, we can try to build a picture of production from descriptions in the plays themselves, other literary evidence, and from a few extant archeological examples.

Theatre productions in Ancient Greece were part of religious festivals held three times a year: the City Dionysia, Rustic Dionysia, and Lenaea. The first of these was a festival of tragic plays and the last, of comic. The City Dionysia was held in the Theatre of Dionysus in Athens. The contests were begun in 534 BC, before the classical era. Our knowledge of Greek theatre is enhanced somewhat by the fact that although we do not have most of the plays, we do know the titles and the authors who won these contests from the earliest to the last. From the records (inscriptions in stone) we know that three playwrights figured prominently and repeatedly as winners in the contests of the era.[1] They were Aeschylus, Sophocles, and Euripides. Our entire collection of complete tragedies is from these three playwrights—seven from Aeschylus, seven from Sophocles, and eighteen from Euripides.

A playwright entering the contests for tragedy or comedy was required to submit his plays to a panel of presiding officers, who selected three playwrights for actual production. The early plays of the classical style had only one actor plus a chorus, and at the time of play selection the playwright was assigned the chief actor plus a *choregus*, a patron who paid all the expenses for the production. The playwright was author, director, choreographer, and musical composer. He often also played the leading role.

Aeschylus

Aeschylus was the most famous poet of Ancient Greece. Clearly fitting the classic mold, he wrote magnificent tragedies of high poetic nature and lofty moral theme. In *Agamemnon*, the first play in the *Oresteia* trilogy, Aeschylus's chorus warns us that success and wealth are insufficient without goodness.

> Justice shines in sooty dwellings
> Loving the righteous way of life,
> But passes by with averted eyes
> The house whose lord has hands unclean.
> Be it built throughout of gold.
> Caring naught for the weight of praise
> Heaped upon wealth by the vain, but turning
> All alike to its proper end.[2]

Aeschylus probed questions that we still ask: How responsible are we for our own actions? How much are we controlled by the will of heaven? His characters were larger than life; they were types rather than individuals, in accordance with the idealism of the time. Yet his characters were also human, as evidenced by his portrayal of Clytemnestra in *Agamemnon*. Aeschylus's early plays consisted of the traditional single actor, plus a chorus of fifty, but he is credited with the addition of a second actor. By the time Aeschylus ended his career a third actor had been added and the chorus reduced to twelve.

In Aeschylus's plays we find a strong appeal to the intellect. Aristophanes, the master of Greek comedy, has Aeschylus, a character in *The Frogs*, defend his writing as an inspiration to patriotism, to make men proud of their

achievements. This is inspiration in an intellectual, not a rabble-rousing, sense. Aeschylus lived through the Persian invasion, witnessed the great Athenian victories, and fought at the battle of Marathon. His plays reflect this experience and spirit.

Sophocles

Overlapping with Aeschylus was Sophocles, who reached the peak of his personal career during the zenith of the Greek classical style with works like *Oedipus tyrannus*. Sophocles's plots and characterizations illustrate a trend toward increasing realism, similar to that in classical sculpture. The movement toward realism was not a movement into theatre of illusion and even Euripides's plays, the most realistic of the Greek tragedies, are not realistic in our sense of the word. However, Sophocles was a less formal poet than Aeschylus. His themes are more humane and his characters more subtle, although his exploration of the themes of human responsibility, dignity, and fate is of the same intensity and seriousness as we see in Aeschylus. His plots show increasing complexity, but with the formal restraints of the classical spirit. Sophocles lived and wrote beyond the death of Pericles in 429 BC and so he experienced the shame of Athenian defeat. Even so, his later plays show nothing of the "action" noted in sculpture. Classical Greek theatre was mostly discussion and narration. Themes often dealt with bloodshed, but, though the play led up to violence, blood was never shed on stage.

Euripides

Euripides was younger than Sophocles, although both men died in 406 BC. They did, however, compete with each other. They do not share the same style. Euripides's plays carry realism to the furthest extent we see in Greek tragedy. They deal with individual emotions rather than great events, and his language, though still basically poetic, is higher in verisimilitude and much less formal than that of his predecessors. Euripides also experimented with, and ignored, many of the conventions of his theatre. He explored the mechanics of scenography and questioned in his plays the religion of his day. His tragedies are more tragicomedies than pure tragedies. Some critics have described many of his plays as melodramas. He was also less dependent on the chorus.[3]

Plays such as *The Bacchae* reflect the changing Athenian spirit and dissatisfaction with contemporary events. Euripides was not particularly popular in his time, perhaps because of his less idealistic, less formal, and less conventional treatment of dramatic themes and characters. Was he perhaps too close to the reality of his age? His plays were received with enthusiasm in later years and are unquestionably the most popular of the Greek tragedies today.

Aristotle's Theory of Tragedy

We cannot pass from our discussion of classical and post-classical Greek theatre without noting Aristotle's analysis of tragedy. His concepts are still basic to dramatic theory and criticism despite the fact that they have often been misunderstood and misapplied over the last 2,400 years. 100 years after the fact and drawing principally on Sophocles as a model, Aristotle laid out in the *Poetics* six parts for tragedy, which are, in order of importance: first, plot, which includes exposition, discovery, reversal, point of attack, foreshadowing, complication, climax, crisis, and denouement; second, character; third, thought; fourth, diction; fifth, music; and sixth, spectacle.

Here we find yet more evidence of the classical focus on intellect, form, idealism, convention, and simplicity. *Plot* in tragedy is far more than the simple story line. For Aristotle, plot forms the basic structure of the play, as structure or form is the cornerstone of classical design. The parts of plot shape the play into a beginning (exposition), middle (complication), and end (denouement) by which the audience understands the progress of the drama. Discoveries, by which characters learn about themselves and others, foreshadowing, by which the playwright alerts the audience to future action, reversals, by which fortunes change, and crises, by which tension is created and characters grow, all form additional parts of plot. The point of attack and the climax are special forms of crises which comprise the beginning and end of the complication section of the play, respectively.

Aristotle uses *character* to mean the driving force of the individuals in the play—that is, the psychological makeup that determines the way the people in the play respond to a situation. *Thought* is the intellectual content of the play. *Diction* is the words of the script, as opposed to *music*, which consists of all the aural elements of the play, including the way in which the actors speak the words. Finally, *spectacle* includes all the visual elements of the production.

Tragedy, for Aristotle, is a form of drama in which the protagonist goes through a significant struggle which ends in disaster. However, the protagonist is a heroic character, who emerges with a moral victory in physical defeat. Tragedy, therefore, asserts the dignity of humankind as well

as the existence of larger moral forces. In the end, tragedy is a positive experience which evokes a *catharsis* or purging of pity and fear in the audience.

Aristophanes

Tragedies and satyr plays (Euripides's *Cyclops* is the only example we have of that genre) were not the only works produced in the theatre of the classical era in Athens. The Athenians were extremely fond of comedy, although no examples survive from the Periclean period. Aristophanes (*c.* 450–*c.*380 BC), of whose plays we have eleven, was the most gifted of the comic poets, and his comedies of the postclassical period, such as the *Acharnians*, are highly satirical, topical, sophisticated, and often obscene. Translated productions of his comedies are still staged, but the personal and political targets of his invective are unknown to us, and so these modern productions are mere shadows of what took the stage at the turn of the fourth century BC.

Theatre Design

The form of the Greek theatre owes much to the choral dances associated with the worship of Dionysus from which it originated. In 534 BC Thespis is reported to have introduced a single actor to these choric dances or dithyrambs. In 472, Aeschylus added a second actor, and in 458, Sophocles added a third. So throughout its history the Greek theatre comprised a large circular *orchestra*— acting and dancing area—with an altar at its center, and a semicircular *theatron*—auditorium or viewing place— usually cut into or occupying the slope of a hill. Since the actors played more than one role, they needed somewhere to change costume, and so a *skene*—scene building or retiring place—was added. The gradual development of the *skene* into a raised stage is somewhat obscure and problematical, but later, by Hellenistic times, it had become a rather elaborate, two-storied affair (Fig. **12.4**) with projecting wings at each end and a raised stage.

The earliest extant theatre is the theatre of Dionysus, on the south slope of the Acropolis, dating from the fifth century BC, where the plays of Aeschylus, Sophocles, Euripides, and Aristophanes were staged. Its current form dates back to a period of reconstruction work around 338–326 BC. The theatre at Epidaurus (Figs. **12.5** and **12.6**) is the best preserved, and was built by Polykleitus the Younger about 350 BC. Its sheer size demonstrates the monumental character the theatre had assumed by that time. The orchestra measures 80 ft (24 m) in diameter, with an altar to Dionysus in the center. The auditorium,

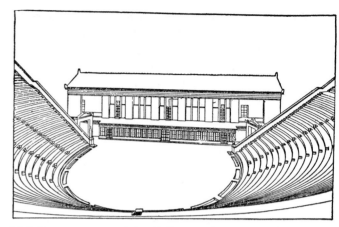

12.4 Reconstruction of the Hellenistic theatre at Ephesus, Turkey, c. 280 BC, rebuilt c. 150 BC.

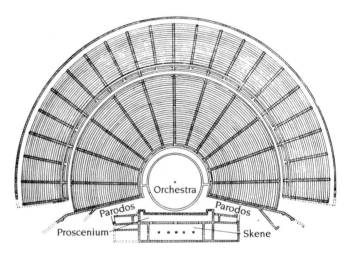

12.5 Plan of the theatre at Epidaurus.

12.6 Polykleitus the Younger, theatre at Epidaurus, c. 350 BC. Diameter 373 ft (114 m), orchestra 66 ft (20 m) across.

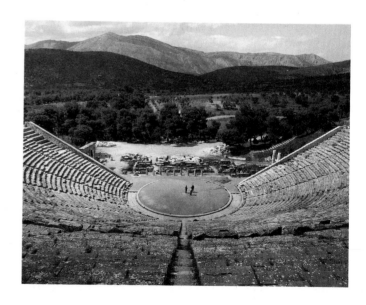

comprising slightly more than a semicircle, is divided by an ambulatory about two-thirds of the way up, and by radiating stairways. All the seats were of stone, and around the first or lowest row were seats for the dignitaries of Athens. These seats had backs and arms, and some were decorated with relief sculptures.

There was undoubtedly variation in the design of theatres in different locations, but, again, time has removed most examples from our grasp. The many theories of how Greek theatre productions worked, how scenery was or was not used, and whether or not and when a raised stage was present make fascinating reading, and the reader is encouraged to explore this area in detail elsewhere.

CLASSICAL ARCHITECTURE

Existing examples of Greek architecture, to which the arts of the Western world have returned over the past 2,300 years, offer a clear and consistent picture of basic classical style. Nothing brings that picture so clearly to mind as the term Greek temple. We all have an amazingly accurate concept of the structure and proportions of a Greek temple. H.W. Janson suggests that the crystallization of the characteristics of a Greek temple is so complete that when we think of one Greek temple, we basically think of all Greek temples. Even so obvious a structure as a Gothic

cathedral does not have this capacity, for despite the explicit symbol of the Gothic arch, its employment is so diverse that no one work typifies the many.

The classical Greek temple, as seen in Figure **12.7**, has a structure of horizontal blocks of stone laid across vertical columns. This is the *post-and-lintel* structure we have seen earlier (Chapter 7). It is not unique to Greece, but certainly the Greeks refined it to its highest aesthetic level. As we have seen, this type of structure creates some very basic problems. Stone is not high in tensile strength—the ability to withstand bending and twisting—although it is high in compressive strength—the ability to withstand crushing. Downward thrust works against tensile qualities in horizontal slabs (lintels) and works for compressive qualities in vertical columns (posts). As a result, columns can be relatively delicate, whereas lintels must be massive.

Only limited open space can be created using this structural system. Such a limitation was not of great concern to the Greeks because a Greek temple was to be seen and used from the outside. The Greek climate does not dictate that worshippers crowd inside a building. Exterior structure and aesthetics were of primary concern.

Greek temples were of three orders—*Ionic*, *Doric*, and *Corinthian* (Fig. 7.3). The first two of these are *classical*, the third, though of classical derivation, is of the later, *Hellenistic* style. The contrasts between these types make an important, if subtle, stylistic point. Simplicity was an

12.7 Iktinos and Kallikrates, the Parthenon, Acropolis, Athens, from the northwest, 447–438 BC.

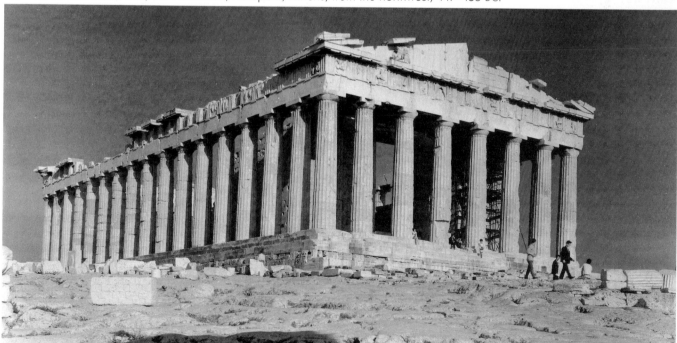

important characteristic of the Greek classical style, and the Ionic and Doric orders maintain clean and simple lines in their capitals. The Corinthian order has more ornate and complex capitals. When taken in the context of an entire building, this small detail does not appear to be of great consequence, but it is significant in understanding the rudiments underlying this style. Columns and capitals are convenient tags for identifying the order of a Greek temple. Differences are apparent in column bases and the configuration of the lintel, as well as in the columns and capitals.

The earlier of the two types, the Doric, has a massive appearance compared to the Ionic. The Ionic, with a round base, has a curved profile which raises the column above the baseline of the building. The flutings of the Ionic order, usually twenty-two per column, are deeper and separated by wider edges than are those of the Doric, giving it a more delicate appearance. The Ionic capital is surrounded by a crown of hanging leaves or a *kymation*. The architrave, or lintel, shows a three-part division, each section of which diminishes downward, creating a much lighter impression than the more massive architrave of the Doric.

The Parthenon

Perched on the top of the Acropolis at Athens, the Parthenon (Fig. **12.7**) stands as the greatest temple built by the Greeks and the prototype for all classical buildings thereafter. When the Persians sacked Athens in 480 BC they destroyed the then existing temple and its sculpture. When Pericles rebuilt the Acropolis in the late fifth century, Athens was at her zenith, and the Parthenon was her crowning glory.

In plan the Parthenon is a *peripteral* temple—that is, columns surround the interior room or cella, and the number of columns on the sides is two times the number across the front, plus one. Its interior, divided into two parts, housed the 40 ft (12 m) high ivory and gold statue of Athena Parthenos.

The Parthenon typifies every aspect of Greek classical style in architecture. It is *Doric* in character and *geometric* in configuration. Balance is achieved through symmetry, and the clean, simple line and plan hold the composition together perfectly. For the Greeks, deities were just slightly more than mortals, and this human-centred philosophy is reflected by the human scale of the temple.

The number of columns across the front and down the sides of the temple represents a specific convention. The internal harmony of the design rests in the regular repeti-

tion of virtually unvaried form. To the casual glance each column appears alike and seems to be equidistant from its neighbor, except at the corners, where the spacing is clearly lessened in subtle, aesthetic adjustment. Each element is carefully adjusted. A great deal has been written about the so-called "refinements" of the Parthenon, those elements which form intentional departures from strict geometric regularity. According to some, the slight outward curvature of horizontal elements compensates for the tendency of the eye to perceive a downward sagging if all elements are actually parallel. Each column has about a 7-ins (17 cm) gradual dilation, supposedly to compensate for the tendency of vertical parallel lines to appear to curve inward. The columns also tilt inward at the top so as to appear perpendicular. The *stylobate* is raised toward the center so as not to appear to sag under the immense weight of the stone columns and roof. Even the white marble color, which in other circumstances might appear stark, may have been chosen to harmonize with and reflect the intense Athenian sunlight, although parts of the temple and its statuary were brightly painted.

So here we have the perfect embodiment of classical characteristics: *convention, order, balance, idealization, simplicity, grace* and *restrained vitality*—of this earth but mingled with the divine.

LATE CLASSICAL STYLE

Sculpture of the fourth century BC illustrates clearly the change in attitudes reflected in late classical styles. Praxiteles is famous for *individualism* and delicacy of themes such as the *Cnidian Aphrodite* (Fig. **12.8**). There is a look-

12.8 *Cnidian Aphrodite*, probably Hellenistic copy of 4th century BC bronze original by Praxiteles. Marble, height 60½ ins (154 cm). The Metropolitan Museum of Art, New York (Fletcher Fund, 1952).

12.9 *Apoxyomenos (Scraper)*, Roman copy, probably after a bronze original of c. 330 BC by Lysippos. Marble, height 6 ft 9 ins (2.05 m). Vatican Museums, Rome.

ing inward in this work which is different from the formal detachment of earlier sculpture. Female nudity also appears for the first time. Originally, Aphrodite rested her weight on one foot. Her body sways to the left in the famous Praxitelean S-curve. Strain on the ankle of the sculpture was minimized by the arm's attachment to drapery and a vase.

The late fourth century found in the sculpture of Lysippos (a favorite of Alexander the Great) a dignified naturalness and a new concept of space. His *Scraper* (Fig. **12.9**) illustrates an attempt to put the figure into motion, in contrast to the posed figures at rest we have seen previously. The theme of the *Scraper* is mundane—an athlete scraping dirt and oil from his body. The proportions of the figure are even more naturalistic than those of Polyklitus, but the naturalism is still far from perfect. Style had moved dramatically from earliest classical reflections, but classical influence remained.

HELLENISTIC STYLE

As the age of Pericles gave way to the Hellenistic period, the dominant characteristics of classicism were gradually modified to a less formal, more naturalistic, and more emotional style.

Like other media and art forms, vase painting around the year 400 BC had a highly ornate style. Thick lines, dark patterns on garments, and a generous use of white and yellow characterized compositions of crowded figures represented mainly in three-quarter views. Illustrative of this change in style is the combat scene from an amphora painted by the Suessula Painter (Fig. **12.10**). Here we also see the illusion of spatial depth, as the figures leave the baseline of the frontal plane.

12.10 Attributed to the Suessula painter, amphora showing combat of Greeks and Amazons, 5th–6th century BC. height 14 ins (36 cm). The Metropolitan Museum of Art, New York (Fletcher Fund, 1944).

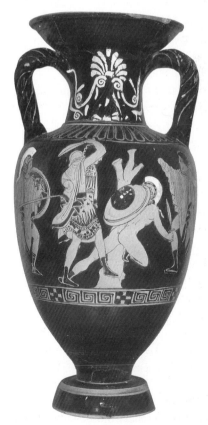

In the Hellenistic era, everyday scenes, sometimes comic and vulgar, were common in wall painting. These scenes are remarkable for the use of aerial and linear perspective to indicate three-dimensional space. Unfortunately for us, the few extant examples of classical and Hellenistic two-dimensional art furnish us with only a glimpse of these two important styles, so closely linked, but reflecting such different attitudes.

Hellenistic style in sculpture continued to dominate the Mediterranean world until the first century BC, and as time progressed, style changed to reflect an increasing interest in individual human differences. Rather than idealization, the Hellenistic sculptor often turned to pathos, banality, trivia, and flights of individual virtuosity in technical exploration. *The Dying Gaul* (Fig. **12.11**) is a powerful expression of emotion and of pathos as it depicts a noble warrior on the verge of death. This Roman copy of a statue from Pergamon places the figure on a stage, as if to act out a drama. Representing a Gallic casualty in the wars between Pergamon and barbarian invaders, the warrior is slowly bleeding to death from a chest wound. In the same sense, the *Nike of Samothrace* (Fig. **12.13**), or *Winged Victory*, displays a dramatic and dynamic technical virtuosity. Symbolizing a triumph of one of the successors to Alexander, she "brings strength, weight, and airy grace into an equipoise one would not expect to be achieved in the hard mass of sculptured marble." The sculptor has treated stone almost as if the work were a painting. We sense, as a result, the full reality of wind and sea.

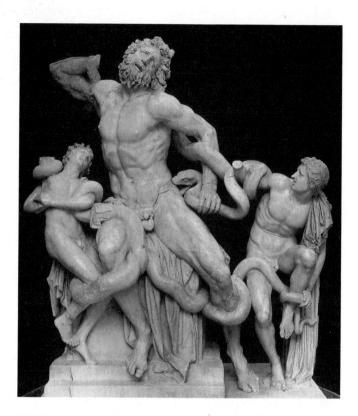

12.12 *Laocoön and his sons*, 1st century. Marble, height 5 ft (1.52 m). The Vatican Museums, Rome.

The common Hellenistic theme of suffering is taken up explosively in the *Laocoön* group (Fig. **12.12**). The Trojan priest Laocoön and his sons are depicted being strangled by sea serpents. Based on Greek myth, the subject is Laocoön's punishment for defying Poseidon, god of the sea, and warning the Trojans of the Greek strategy of the Trojan horse. Emotion and movement are freed from all restraint, and straining muscles and bulging veins are portrayed with stark realism.

The temple of the Olympian Zeus (Fig. **12.14**), illustrates Hellenistic modification of classical style in architecture, similar to that in painting, sculpture, and theatre. Scale and complexity are considerably different from the Parthenon, and the philosophy of emotionalism is clearly evident. Order, balance, moderation, and consonant harmony are still present, but in these huge ruins we can see the change in proportions from the Parthenon in the slender and ornate Corinthian columns. Temple architecture in this style was designed to produce an overpowering emotional experience. This temple, begun by the architect Cossutius for King Antiochus IV of Syria, is the first major Corinthian temple. Its elaborate detail pushed its completion date into the second century AD under the Roman emperor Hadrian. The remaining ruins

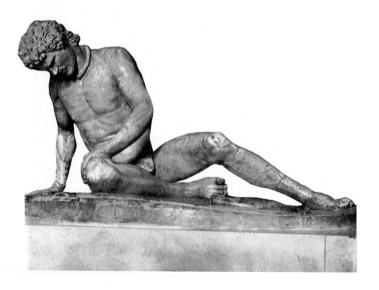

12.11 *The Dying Gaul*, Roman copy of a bronze original of c. 230–220 BC. Marble, life-size. Museo Capitolino, Rome.

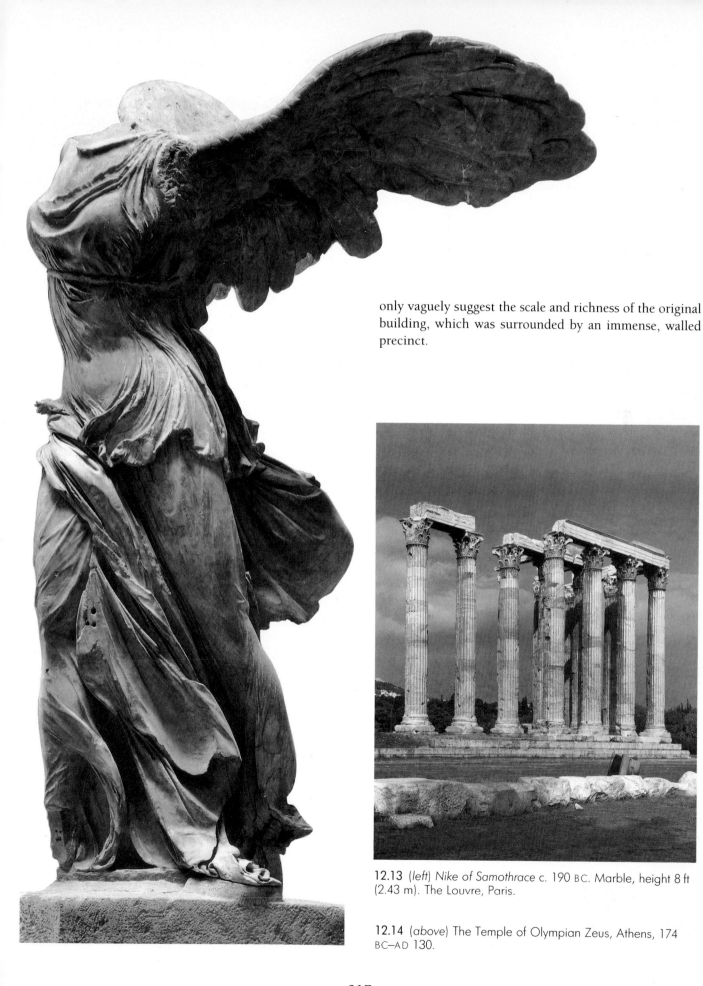

only vaguely suggest the scale and richness of the original building, which was surrounded by an immense, walled precinct.

12.13 (*left*) *Nike of Samothrace* c. 190 BC. Marble, height 8 ft (2.43 m). The Louvre, Paris.

12.14 (*above*) The Temple of Olympian Zeus, Athens, 174 BC–AD 130.

IMPERIAL ROMAN CLASSICISM

By AD 70 the Romans had destroyed the Temple of Jerusalem and colonized Britain, spreading their pragmatic and pluralistic version of Hellenistic Mediterranean civilization to peoples of the Iron Age in north and west Europe. Under Augustus, Roman culture turned again to Greek classicism and in that spirit glorified Rome, the Emperor and the Empire. Inventive and utilitarian, Roman culture left us roads, fortifications, viaducts, planned administration, and a sophisticated yet robust legal system.

ROMAN STYLE

We should beware of classifying all Roman art as an imitative and sterile reconstruction of Greek prototypes. Although some Roman statues fit that description, others display vigorous creativity that is uniquely Roman and uniquely expressive of Roman circumstances. All the same, scholars are divided not only on what various works of Roman sculpture reveal but also on what motivated them. The *Portrait of an Unknown Roman* (Fig. **12.15**)

12.15 *Portrait of an Unknown Roman*, 1st century BC. Marble, height 14⅜ ins (36 cm). The Metropolitan Museum of Art, New York (Rogers Fund, 1912 [12.233]).

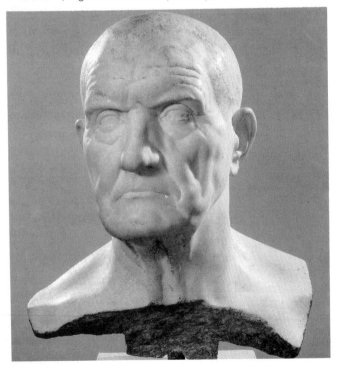

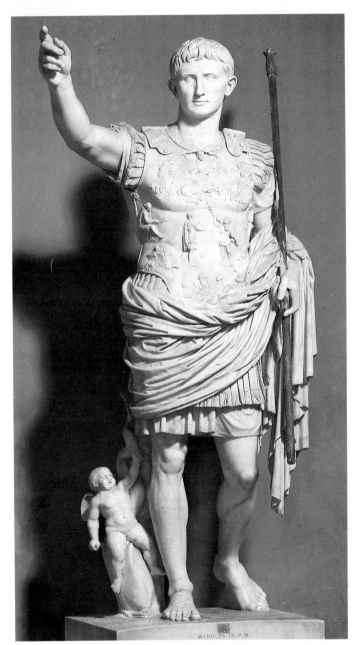

12.16 Augustus in armor, Villa of Livia, Prima Porta, c. 20 BC. Marble, 6 ft 8 ins (2.03 m). The Vatican Museums, Rome.

dates from a time when Hellenistic influence was becoming well established in Rome. It is tempting to attribute the highly naturalistic representation of this work to the same artistic viewpoint which governed Hellenistic style, and conclude that it is a copy of Hellenistic work. Such a conclusion, however, neglects an important Etruscan–Roman religious practice, undoubtedly of stronger influence. Portraits were an integral part of household and ancestor worship, and the image of a departed ancestor

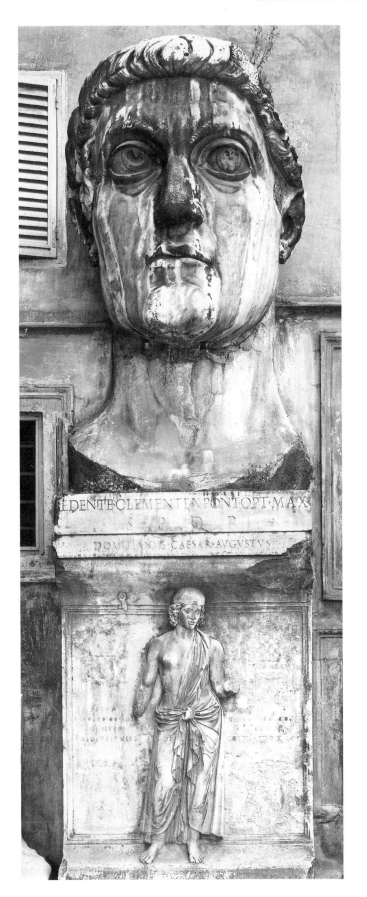

was maintained in a wax death mask. Wax is not a substance ideally suited for immortality, and there is a possibility that the naturalism of portraiture of this bust stems from the fact that it was made from a death mask. However, there may be more than mere portrait accuracy in this work, and some scholars point to an apparent selectivity of features and a reinforcement of an idea or ideal of ruggedness and character.

The straightforward *naturalism* of the Republican era changed during the Augustan period. Hellenistic influence had grown by the late first century BC. In certain quarters Greek classical influence dominated, but always with a Roman—that is, a more practical and individual—character. By the time of the Empire, classical influence had returned sculpture to the idealized characteristics of Periclean Athens.

Augustus boasted that when he took Rome over it was a city of sun-dried bricks, and that when he left it it had become a metropolis in marble. Greek classical form in sculpture was duplicated, recast, and translated into vital forms of the present. The Greek concept of the "perfect body" predominated. It was also a common practice to copy the idealized body of a well-known Greek statue and add to it a highly realistic portrait head of a contemporary Roman. Other figures were similarly Romanized. One statue portrayed a male figure draped in a toga, while another showed Augustus in armor (Fig. **12.16**). The aesthetics of sculptural depiction thus remained Greek with Roman clothing added. The pose, rhythm, and movement of the body originated in the past. The purpose of much sculpture at this time was the portrayal of the emperor. Emperors were raised to the status of gods, perhaps because a far-flung empire required assurances of stability and suprahuman characteristics in its leaders.

The reality that men are men and not gods was not long in returning to Roman consciousness, however, and third-century sculpture exhibited a stark and expressive reality. In the fourth century a new and powerful emperor had taken the throne, and his likeness (Fig. **12.17**), part of a gigantic sculpture (the head is over 8 ft [2.5 m] tall), shows an exaggerated, ill-proportioned intensity that we can compare with expressionist works of the early twentieth century. This work is not an actual likeness of Constantine. Instead, it is the artist's view of Constantine's perception of himself as emperor and of the office of emperor itself.

12.17 Head of Constantine the Great (part of an original colossal seated statue), 313. Marble, height 8 ft 6⅜ ins (2.61 m). Palazzo dei Conservatori, Rome.

219

Virgil—The Aeneid

At such time when literature became reasonably acceptable to the practical Romans, it was chiefly through the contributions of Greek slaves that it was nurtured. At first literary works were imitations of Greek works and written in Greek. Latin was initially seen as a peasant language with few words capable of expressing abstract notions. The credit for developing a Latin prose style and vocabulary for the expression of philosophical ideas probably belongs to Cicero.

During the reign of Augustus, the poets Horace and Virgil wrote verses glorifying the emperor, the origins of Rome, the simple honesty of rural Roman life, patriotism, and the glory of dying for one's country. Livy set about retelling Roman history in sweeping style. Virgil's *Aeneid* tells the story of Rome, in an epic account of the journey of Aeneas from the ruins of Troy to the shores of Italy, far surpassing any mere propagandistic brief. Here we include the main section of Book 1.

ARMS and the man I sing, who first made way
Predestined exile, from the Trojan shore
To Italy, the blest Lavinian strand.
Smitten of storms he was on land and sea
By violence of Heaven, to satisfy
Stern Juno's sleepless wrath; and much in war.
He suffered, seeking at the last to found
The city, and bring o'er his fathers' gods
To safe abode in Latium; whence arose
The Latin race, old Alba's reverend lords,
And from her hills wide-walled, imperial Rome.

O Muse, the causes tell! What sacrilege,
Or vengeful sorrow, moved the heavenly Queen
To thrust on dangers dark and endless toil
A man whose largest honor in men's eyes
Was serving Heaven? Can gods such anger feel?

In ages gone an ancient city stood—
Carthage, a Tyrian seat, which from afar
Made front on Italy and on the mouths
Of Tiber's stream; its wealth and revenues
Were vast, and ruthless was its quest of war.

'T is said that Juno, of all lands she loved,
Most cherished this—not Samos' self so dear.
Here were her arms, her chariot; even then
A throne of power o'er nations near and far,
If Fate opposed not, 't was her darling hope
To 'stablish here; but anxiously she heard
That of the Trojan blood there was a breed
Then rising, which upon the destined day

Should utterly o'erwhelm her Tyrian towers;
A people of wide sway and conquest proud
Should compass Libya's doom;—such was the web
The Fatal Sisters spun.

 Such was the fear
of Saturn's daughter, who remembered well
What long and unavailing strife she waged
For her loved Greeks at Troy. Nor did she fail
To meditate th' occasions of her rage,
And cherish deep within her bosom proud
Its griefs and wrongs: the choice by Paris made;
Her scorned and slighted beauty; a whole race
Rebellious to her godhead; and Jove's smile
That beamed on eagle-ravished Ganymede.
With all these thoughts infuriate, her power
Pursued with tempests o'er the boundless main
The Trojans, though by Grecian victor spared
And fierce Achilles; so she thrust them far
From Latium; and they drifted, Heaven-impelled
Year after year, o'er many an unknown sea—
O labor vast, to found the Roman line!

Below th' horizon the Sicilian isle
Just sank from view, as for the open sea
With heart of hope they sailed, and every ship
Clove with its brazen beak the salt, white waves.
But Juno of her everlasting wound
Knew no surcease, but from her heart of pain
Thus darkly mused: "Must I, defeated, fail
Of what I will, not turn the Teucrian King
From Italy away? Can Fate oppose?
Had Pallas power to lay waste in flame
The Argive fleet and sink its mariners,
Revenging but the sacrilege obscene
By Ajax wrought, Oileus' desperate son?
She, from the clouds, herself Jove's lightning threw,
Scattered the ships, and ploughed the sea with storms.
Her foe, from his pierced breast out-breathing fire,
In whirlwind on a deadly rock she flung.
But I, who move among the gods a queen,
Jove's sister and his spouse, with one weak tribe
Make war so long! Who now on Juno calls?
What suppliant gifts henceforth her altars crown?"

So, in her fevered heart complaining still,
Unto the storm-cloud land the goddess came,
A region with wild whirlwinds in its womb,
Æolia named, where royal Æolus
In a high-vaulted cavern keeps control
O'er warring winds and loud concourse of storms.
There closely pent in chains and bastions strong,
They, scornful, make the vacant mountain roar,
Chafing against their bonds. But from a throne

Of lofty crag, their king with sceptred hand
Allays their fury and their rage confines.
Did he not so, our ocean, earth, and sky
Were whirled before them through the vast inane
But over-ruling Jove, of this in fear,
Hid them in dungeon dark: then o'er them piled
Huge mountains, and ordained a lawful king
To hold them in firm sway, or know what time,
With Jove's consent, to loose them o'er the world.

To him proud Juno thus made lowly plea:
"Thou in whose hands the Father of all gods
And Sovereign of mankind confides the power
To calm the waters or with winds upturn,
Great Æolus! a race with me at war
Now sails the Tuscan main towards Italy,
Bringing their Ilium and its vanquished powers.
Uprouse thy gales! Strike that proud navy down!
Hurl far and wide, and strew the waves with dead!
Twice seven nymphs are mine, of rarest mould,
Of whom Deiopea, the most fair,
I give thee in true wedlock for thine own,
To mate thy noble worth; she at thy side
Shall pass long, happy years, and fruitful bring
Her beauteous offspring unto thee their sire."
Then Æolus: " 'T is thy sole task, O Queen,
To weigh thy wish and will. My fealty
Thy high behest obeys. This humble throne
Is of thy gift. Thy smiles for me obtain
Authority from Jove. Thy grace concedes
My station at your bright Olympian board,
And gives me lordship of the darkening storm."
Replying thus, he smote with spear reversed
The hollow mountain's wall; then rush the winds
Through that wide breach in long embattled line,
And sweep tumultuous from land to land:
With brooding pinions o'er the waters spread,
East wind and south, and boisterous Afric gale
Upturn the sea; vast billows shoreward roll;
The shout of mariners, the creak of cordage,
Follow the shock; low-hanging clouds conceal
From Trojan eyes all sight of heaven and day;
Night o'er the ocean broods; from sky to sky
The thunders roll, the ceaseless lightnings glare;
And all things mean swift death for mortal man.

Straightway Æneas, shuddering with amaze,
Groaned loud, upraised both holy hands to Heaven,
And thus did plead: "O thrice and four times blest,
Ye whom your sires and whom the walls of Troy
Looked on in your last hour! O bravest son
Greece ever bore, Tydides! O that I
Had fallen on Ilian fields, and given this life
Struck down by thy strong hand! where by the spear

Of great Achilles, fiery Hector fell,
And huge Sarpedon; where the Simois
In furious flood engulfed and whirled away
So many helms and shields and heroes slain!"
While thus he cried to Heaven, a shrieking blast
Smote full upon the sail. Up surged the waves
To strike the very stars; in fragments flew
The shattered oars; the helpless vessel veered
And gave her broadside to the roaring flood,
Where watery mountains rose and burst and fell.
Now high in air she hangs, then yawning gulfs
Lay bare the shoals and sands o'er which she drives.
Three ships a whirling south winds snatched and flung
On hidden rocks,—altars of sacrifice
Italians call them, which lie far from shore
A vast ridge in the sea; three ships beside
An east wind, blowing landward from the deep,
Drove on the shallows,—pitiable sight,—
And girdled them in walls of drifting sand.

That ship, which, with his friend Orontes, bore
The Lycian mariners, a great, plunging wave
Struck straight astern, before Æneas' eyes.
Forward the steersman rolled and o'er the side
Fell headlong, while three times the circling flood
Spun the light bark through swift engulfing seas.
Look, how the lonely swimmers breast the wave!
And on the waste of waters wide are seen
Weapons of war, spars, planks, and treasures rare,
Once Ilium's boast, all mingled with the storm.
Now o'er Achates and Ilioneus.
Now o'er the ship of Abas or Aletes,
Burst the tempestuous shock; their loosened seams
Yawn wide and yield the angry wave its will.

Meanwhile, how all his smitten ocean moaned,
And how the tempest's turbulent assault
Had vexed the stillness of his deepest cave,
Great Neptune knew; and with indignant mien
Uplifted o'er the sea his sovereign brow.
He saw the Teucrian navy scattered far
Along the waters; and Æneas' men
O'erwhelmed in mingling shock of wave and sky.
Saturnian Juno's vengeful stratagem
Her brother's royal glance failed not to see;
And loud to eastward and to westward calling,
He voiced this word: "What pride of birth of power
Is yours, ye winds, that, reckless of my will,
Audacious thus, ye ride through earth and heaven,
And stir these mountains waves? Such rebels!—
Nay, first I calm this tumult! But yourselves
By heavier chastisement shall expiate
Hereafter your bold trespass. Haste away
And bear your king this word! Not unto him

Dominion o'er the seas and trident dread,
But unto me, Fate gives. Let him possess
Wild mountain crags, thy favored haunt and home,
O Eurus! In his barbarous mansion there,
Let Æolus look proud, and play the king
In yon close-bounded prison-house of storms!"

He spoke, and swiftlier than his word subdued
The swelling of the floods, dispersed afar
Th' assembled clouds, and brought back light to heaven.
Cymothoë then and Triton, with huge toil,
Thrust down the vessels from the sharp-edged reef
While, with the trident, the great god's own hand
Assists the task; then, from the sand-strewn shore
Out-ebbing far, he calms the whole wide sea,
And glides light-wheeled along the crested foam.
As when, with not unwonted tumult, roars
In some vast city a rebellious mob,
And base-born passions in its bosom burn,
Till rocks and blazing torches fill the air
(Rage never lacks for arms)—if haply then
Some wise man comes, whose reverend looks attest
A life to duty given, swift silence falls;
All ears are turned attentive; and he sways
With clear and soothing speech the people's will.
So ceased the sea's uproar, when its grave Sire
Lookd o'er th' expanse, and, riding on in light,
Flung free rein to his winged obedient car.

Æneas' wave-worn crew now landward made,
And took the nearest passage, whither lay
The coast of Libya. A haven there
Walled in by bold sides of a rocky isle,
Offers a spacious and secure retreat,
Where every billow from the distant main
Breaks, and in many a rippling curve retires.
Huge crags and two confronted promontories
Frown heaven-high, beneath whose brows outspread
The silent, sheltered waters; on the heights
The bright and glimmering foliage seems to show
A woodland amphitheatre; and yet higher
Rises a straight-stemmed grove of dense, dark shade.
Fronting on these a grotto may be seen,
O'erhung by steep cliffs; from its inmost wall
Clear springs gush out; and shelving seats it has
Of unhewn stone, a place the wood-nymphs love.
In such a port, a weary ship rides free
Of weight of firm-fluked anchor or strong chain.
Hither Æneas, of his scattered fleet
Saving but seven, into harbor sailed;
With passionate longing for the touch of land,
Forth leap the Trojans to the welcome shore,
And fling their dripping limbs along the ground.[4]

The influence of Horace, Virgil, and Livy on Western culture is difficult to overestimate; "they are so much a part of us that we take their values for granted and their epigrams for truisms."[5] As far as the Emperor Augustus was concerned, they fully expressed the Roman tradition and Roman language. Horace, Virgil, and Livy created a literature which distracted the upper classes from Greek "free thought" and which the emperor could exploit to rally them to the Ancient Roman order as represented in his person.

Throughout the literature of the Augustan period runs a moralizing stoicism. The most remarkable product of stoicism in poetry was satire, which allowed writers to combine morality with popular appeal. Martial and Juvenal utilized poetry to attack vice, and were thereby able to describe it in graphic detail. Petronius produced satirical picaresque novels of verse and prose, whose details were as readable as Martial's and Juvenal's but void of their morality. Finally, Apuleius and Lucan followed in the same literary tradition. Apuleius's *Golden Ass* is among the earliest novels ever written. The author creates a fictional biography describing how he was tried and condemned for the murder of three wineskins. He was brought back to life by a sorceress, and in the process of trying to follow her in the form of a bird, he was changed instead into an ass. The only cure for his affliction appeared to be the procurement of rose leaves, and in his search for these, he fell into some bizarre and fantastic adventures.

ARCHITECTURAL CLASSICISM

Given the practicality of the Roman viewpoint, we should not be surprised to find that it is in architecture that an immediately distinctive Roman style is most evident. The clear crystallization of form we found in the post-and-lintel structure of the classical Greek temple is also apparent in the Roman arch. However, here the whole is suggested, and to a certain degree summarized, by the part, whereas the Greek composition finds the part subordinate to the whole.

Very little remains of the architecture of the Republican period, but what there is suggests a strong Hellenistic influence with Corinthian orders and fairly graceful lines. There were notable differences, however. Hellenistic temples were on an impressive scale. Roman temples were even smaller than the classical Greek ones, principally because Roman worship was mostly a private rather than public matter. Roman temple architecture also employed engaged columns—that is, columns partly embedded in

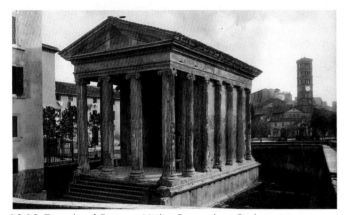

12.18 Temple of Fortuna Virilis, Rome, late 2nd century BC.

the wall. As a result, on three sides Roman temples lacked the open colonnade of the Greek temple. The Temple of Fortuna Virilis (Fig. **12.18**) is the oldest and best preserved example of its kind, dating from the second century BC. The influence of Greek style can be seen in the delicate Ionic columns and entablature, and yet Etruscan elements are present in the deep porch and engaged columns, necessitated by the wide *cella* (main enclosed space). The cella, containing only one room, is a departure from the Etruscan convention of three rooms. Roman temples needed more spacious interiors as they

12.19 Colosseum, Rome, c. 70–82.

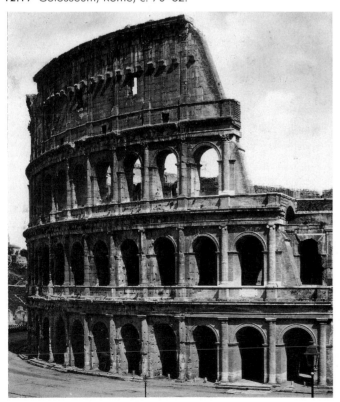

were used to display trophies from military campaigns, as well as to house the image of the deity.

In the Augustan age a refashioning of Roman architecture according to Greek style, as we saw in the case of sculpture, took place. This accounts for the dearth of surviving buildings from previous eras. Temples were built on Greek plans, but the proportions were significantly different.

The first through fourth centuries brought us what we typically identify as the Roman style, the most significant characteristic of which is the use of the arch as a structural system in arcades and tunnel and groin vaults. The Colosseum (Figs. **12.19** and **12.20**), the best known of Roman buildings and one of the most stylistically typical, could seat 50,000 spectators. Combining an arcaded exterior with vaulted corridors, it was a marvel of engineering. Its aesthetics are reminiscent of Greek classicism, but fully Roman in style. The circular sweep of each level is care-

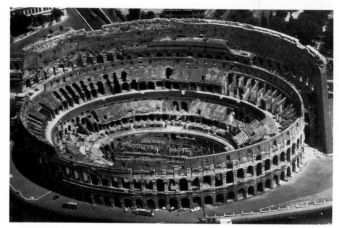

12.20 Colosseum, interior.

fully countered by the vertical line of engaged columns flanking each arch. Doric, Ionic, and Corinthian columns mark each level and progress upward from heavy to lighter orders.

Placed in the center of the city of Rome, the Colosseum was the site of gladitorial games, including the martyrdom of Christians by turning lions loose on them as a gruesome "spectator sport." Emperors competed with each other to produce the most lavish spectacles here. The Colosseum was a new type of building called an "amphitheatre," in which two "theatres," facing each other, are combined to form an arena surrounding an oval space. Originally a series of poles and ropes supported awnings to provide shade for the spectators. The space below the arena contained animal enclosures, barracks for

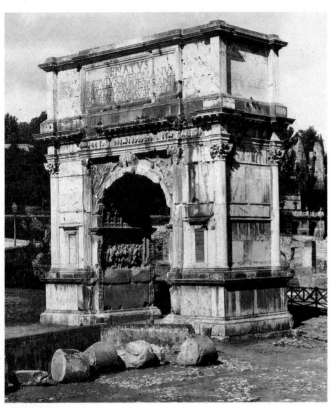

12.21 Arch of Titus, Forum Romanum, Rome, 81. Marble.

gladiators, and machines for raising and lowering scenery.

Roman triumphal arches were also impressive architectural monuments. In the second Arch of Titus (Fig. **12.21**), the Roman classical style survives in a memorial to Titus raised by his younger brother, Domitian. It memorializes the accomplishments which Titus shared with his father, Vespasian, in the conquest of Jerusalem. The sculptural reliefs on the arch show Titus alone as *Triumphator*. The reliefs represent allegories of political reverence rather than illustrations of an historical event. Accompanying Titus in these reliefs are figures such as the *Genius Senatus* and the *Genius Populi Romani*, embodiments of the spirit of the Senate and general populace. What is important to recognize in this work is the contrast of external appearance—that is, the richly and delicately ornamented façade, with the massive internal structure of the arch, a characteristic which will reappear in Renaissance architecture.

The Pantheon

The Pantheon (Figs. **7.13**, **12.22** and **12.23**) fuses Roman engineering, practicality, and style in a domed temple of unprecedented scale, dedicated, as its name suggests, to all the gods.

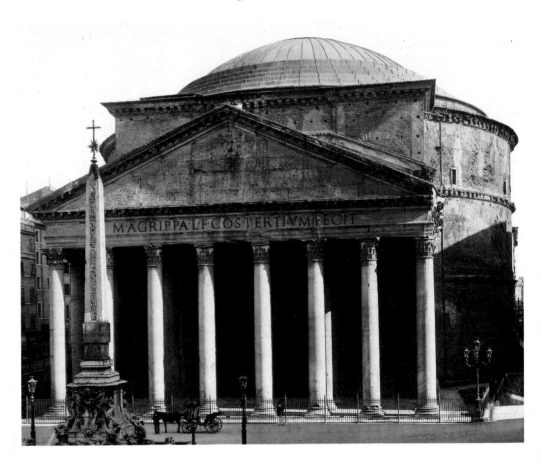

12.22 Pantheon, Rome, c. 118–28.

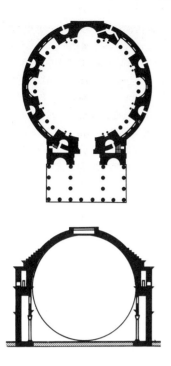

12.23 Plan and section of the Pantheon.

Around the circular interior, niches carved out of the massive walls are occupied by statues of the gods. Corinthian columns add grace and lightness to the lower level. Heavy horizontal moldings accentuate the feeling of open space made possible by the huge dome, which is 143 ft (43 m) in both diameter and height (from the floor to the *oculus* (eye), the round opening at the top of the dome). The circular walls supporting the dome are 20 ft (6 m) thick and 70 ft (21 m) high. Recessed square coffers on the underside of the dome give an added sense of lightness and reflect the framework into which concrete was poured. Originally the dome was gilded to suggest "the golden dome of heaven."

In both plan and section the Pantheon is a round temple. From the exterior we glimpse a *cella* comprising a simple, unadorned cylinder capped by a gently curving dome. The entrance is a Hellenistic porch with graceful Corinthian columns. Originally the porch was approached by a series of steps and attached to a rectangular forecourt, so we see only part of a more complex design. Inside, the scale and detail overwhelm us. Support piers for the dome alternate rectangular and rounded niches, each of which supports a vault designed to transfer the weight of the dome onto solid footings.

How could the Romans build such a colossal structure? Historians argued that the key lay with a novel form of concrete containing a specific kind of cement developed near Naples. The secret, however, may lie in the mysterious rings around the dome, as suggested by a recent study at Princeton University: "Probably they perform a function similar to the buttresses of a Gothic cathedral ... The extra weight of the rings ... helps stabilize the lower portion of the dome: Rather than functioning like a conventional dome, the Pantheon behaves like a circular array of arches, with the weight of the rings holding the end of each arch in place."[6]

MEDIEVAL EUROPE

At its broadest, the Middle Ages is the name we have come to use for the 1,000 years from the fall of Rome to the Renaissance in Italy. The so-called Dark Ages, when humankind seemed to withdraw into a barricaded world of mental and physical isolation, comprise the early part of this period. In monasteries and convents throughout Europe, literacy, learning and artistic creativity were nurtured. It was widely believed that the year 1000 would see the end of the world.

The later Middle Ages saw a spiritual and intellectual revival, perfectly expressed in the Gothic cathedral—the mystery of faith embodied in the mystery of space. The austere and fortresslike massiveness of the Romanesque style was transformed, as emphasis shifted from the wrath of God to the sweetness and mercy of the loving Saviour and the Virgin Mary. The growth of towns and cities accelerated the pace of life, turning the focus of wealth and power away from the feudal countryside, and the new universities replaced monasteries as centers of learning.

ROMANESQUE STYLE

As Charlemagne's empire and the ninth and tenth centuries passed, a new and radical style in architecture emerged. Unlike its stylistic counterparts in painting and sculpture, Romanesque architecture was a fairly identifiable style, despite its diversity. The Romanesque style took hold throughout Europe in a relatively short period of time. It took its name from the Roman-like arches of its doorways and windows. To Renaissance persons, who saw these examples throughout Europe, the characteristics were clearly pre-Gothic and post-Roman (but Romanlike) and, therefore, they called them *Romanesque*. In addition to arched doorways and windows, characteristic of this

style was a massive, static, and lightless quality in which we perceive a further reflection of the barricaded mentality and lifestyle generally associated with the Middle Ages.

The Romanesque style nonetheless exemplified the power and wealth of the Church Militant and Triumphant. If the style mirrored the social and intellectual system that produced it, it also reflected a new religious fervor and a turning of the Church toward its growing flock. Romanesque churches were larger than their predecessors and we can appreciate their scale in Figures **12.24** and **12.25**. St. Sernin is an example of southern French Romanesque, and it reflects a heavy elegance and complexity we have not seen previously. The plan of the church describes a Roman cross, and the side aisles are extended beyond the crossing to create an ambulatory or walking space so that pilgrims, who were mostly on their way to Spain, could walk around the altar without disturbing the service. One additional change is worth noting. The roof of this church is stone, whereas earlier buildings had wooden roofs. As we view the magnificent vaulted interior we wonder how or whether the architect reconciled the conflicting forces of engineering, material, and aesthetics. Given the properties of stone and the increased force of added height, did he try to push his skills to the edge of practicality in order to create an

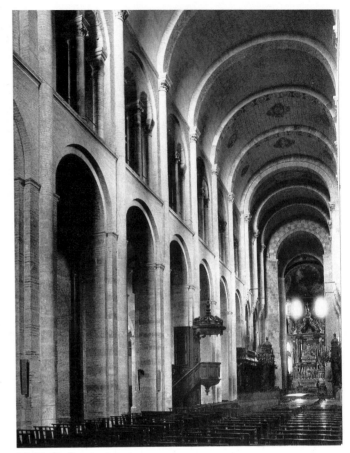

12.25 St. Sernin, interior.

12.24 St. Sernin, Toulouse, France, c. 1080–1120.

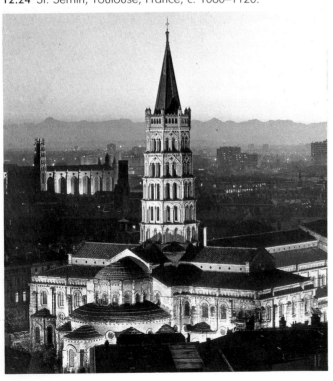

interior of breathtaking scale? Were his efforts reflective of the glory of God or the abilities of Man?

Returning to the exterior view, we can see how some of the stress of the high tunnel vaulting was diffused. In a complex series of vaults, transverse arches, and bays, the tremendous weight and outward thrust of the central vault was transferred to the ground, leaving a high and unencumbered central space. If we compare this structural system with that of post-and-lintel and consider the compressive and tensile properties of stone, we can easily see the superiority of the arch as a structural device for creating open space. Because of the stresses and weight in this style, only very small windows were possible. So, although the fortresslike` and lightless characteristics of Romanesque architecture reflect the historical context of the era, they also had a practical explanation.

In the case of sculpture Romanesque refers more to an era than to a style. Examples are so diverse that if most sculptural works were not decorations attached to Romanesque architecture, we probably could not group them under a stylistic label. However, we can draw some general conclusions about Romanesque sculpture. First, it

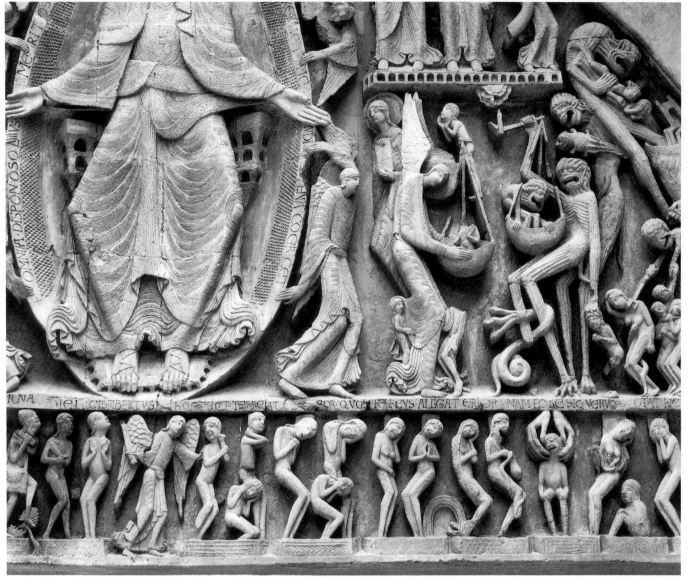

12.26 Gislebertus, Last Judgement tympanum c. 1130–35. Autun Cathedral, France.

is associated with Romanesque architecture. Second, it is heavy and solid. Third, it is stone. Fourth, it is monumental. These last two characteristics represent a distinct departure from previous sculptural style. Monumental stone sculpture had all but disappeared in the fifth century. Its reemergence across Europe in such a short time was remarkable. As we shall see, Church architecture was prolific during the Christian era, but the emergence of sculptural decoration indicated at least a beginning of an outward dissemination of knowledge from the cloistered world of the monastery to the general populace. Romanesque sculpture was applied to the exterior of the building, from where it could appeal to the lay worshipper. The relationship of this artistic development to the increase in religious zeal among the laity is not without significance. In such works as the Last Judgement tympanum (Fig. **12.26**), the illiterate masses could now read the message of the Church, an opportunity previously the prerogative only of the clergy. The message here is quite clear. In the center of the composition, framed by a Roman-style arch, is an awe-inspiring figure of Christ. Around him are a series of malproportioned figures in various degrees of torment. The inscription of the artist, Gislebertus, tells us that their purpose was "to let this horror appal those bound by earthly sin." Death was still central to medieval thought, and devils share the stage, attempting to tip the scales in their favor and gleefully pushing the damned into the flaming pit.

The Bronze Doors of Hildesheim Cathedral

Of the Ottonian rulers, Henry II was the greatest patron of the arts, and in the church the honour belongs to Bernward of Hildesheim, tutor of Otto III. During his years as Bishop (993–1022), Hildesheim became a center for manuscript painting and other arts. His patronage, however, was largely confined to the decoration of metal objects, and in particular the bronze doors of the Hildesheim Cathedral (Fig. 12.27) which employed the *cire-perdue* technique, a lost-wax process that had been used for the casting of the bronze doors at Aachen 200 years earlier.

The scenes portrayed on Bernward's doors display carefully arranged biblical stories. For example, The Temptation of Adam and Eve (third from the top, left) depicts the fall of humankind, and that panel is purposely aligned with the Crucifixion (third from the top, right), which illustrates the redemption of humankind. What is striking about all the scenes is the strong sense of bodily composition and physical movement. Every set of images, set against a plain background of open space, speaks forcefully in pantomime. The doors tell their story in medieval fashion, as a vivid drama of silent action, effectively communicating the message of the Christian faith to a largely illiterate public.

12.27 Doors of Hildesheim Cathedral, 1015. Bronze, height 16 ft 6 ins (5.03 m). Hildesheim, Germany.

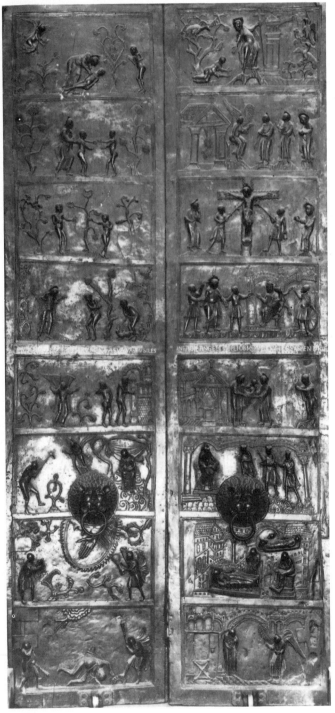

The Song of Roland

In the early Middle Ages, with the notable exception of the Carolingian court, the politically powerful cared little for culture, and for the most part could neither read nor write. Thanks to the efforts of the monastic community, and particularly the Benedictine monks, important books and manuscripts were carefully preserved and copied. St. Benedict (*c.* 480–*c.* 550) was one of the few great scholars of the Middle Ages. Literature flourished in Spain, where Muslim contact with Greek scholarship, established when they invaded Egypt, led to the setting up of schools in Cordoba. Aristotle, Plato, and Euclid were on the curriculum alongside the Koran. Toledo and Seville were also centers of learning. It was biblical literature, however, which became the central focus of the period.

However, there were also the poems of the troubadours, *Minnesänger*, and *trouvères* or court poets, who were popular throughout Europe. These professional storytellers produced fantastic legends and romances, such as the *Song of Roland*. In the *Song of Roland*, an unknown poet tells, with fine but simple dramatic skills, the story of a great battle between Charlemagne and the Saracens of Saragossa in the Pyrenees. Charlemagne is deceived by the Saracens, draws his main army back into France and leaves Roland with a rearguard to hold the pass. The Saracens are aided by recreant Christian knights, and after a furious struggle, Roland and his entire army are killed. Our extract describes the battle between Roland's army and the Saracens.

King Marsilion comes along a valley
with all his men, the great host he assmbled:
twenty divisions, formed and numbered by the King,
helmets ablaze with gems beset in gold,
and those bright shields, those hauberks sewn with brass.
Seven thousand clarions sound the pursuit,
and the great noise resounds across that country.
Said Roland then: "Oliver, Companion, Brother,
that traitor Ganelon has sworn our deaths:
it is treason, it cannot stay hidden,
the Emperor will take his terrible revenge.
We have this battle now, it will be bitter,
no man has ever seen the like of it.
I will fight here with Durendal, this sword,
and you, my companion, with Halteclere—
we've fought with them before, in many lands!
how many battles have we won with these two!
Let no one sing a bad song of our swords." AOI.[7]

When the French see the pagans so numerous,
the fields swarming with them on every side,
they call the names of Oliver, and Roland,
and the Twelve Peers: protect them, be their warranter.
The Archbishop told them how he saw things:
"Barons, my lords, do not think shameful thoughts,
do not, I beg you all in God's name, run.
Let no brave man sing shameful songs of us:
let us all die here fighting: that is far better.
We are promised: we shall soon find our deaths,
after today we won't be living here.
But here's one thing, and I am your witness:
Holy Paradise lies open to you,
you will take seats among the Innocents."
And with these words the Franks are filled with joy,
there is no man who does not shout Munjoie! AOI.

A Saracen was there of Saragossa,
half that city was in this pagan's keeping,
this Climborin, who fled before no man,
who took the word of Ganelon the Count,
kissed in friendship the mouth that spoke that word,
gave him a gift: his helmet and its carbuncle.
Now he will shame, says he, the Land of Fathers,
he will tear off the crown of the Emperor;
sits on the horse that he calls Barbamusche,
swifter than the sparrowhawk, than the swallow;
digs in his spurs, gives that war horse its head,
comes on to strike Engeler of Gascony,
whose shield and fine hauberk cannot save him;
gets the head of his spear into his body,
drives it in deep, gets all the iron through,
throws him back, dead, lance straight out, on the field.
And then he cries: "It's good to kill these swine!

At them, Pagans! At them and break their ranks!"
"God!" say the French, "the loss of that good man!" AOI.

Roland the Count calls out to Oliver:
"Lord, Companion, there is Engeler dead,
we never had a braver man on horse."
The Count replies: "God let me avenge him";
and digs with golden spurs into his horse,
grips—the steel running with blood—Halteclere,
comes on to strike with all his mighty power:
the blow comes flashing down; the pagan falls.
Devils take away the soul of Climborin.
And then he killed Alphaïen the duke,
cut off the head of Escababi,
struck from their horses seven great Arrabites:
they'll be no use for fighting any more!
And Roland said: "My companion is enraged!
Why, he compares with me! he earns his praise!
Fighting like that makes us dearer to Charles";
lifts up his voice and shouts: "Strike! you are warriors!"AOI.

And now again: a pagan, Valdabrun,
the man who raised Marsilion from the font,
lord of four hundred dromonds that sail the sea:
there is no sailor who does not call him lord;
the man who took Jerusalem by treason:
he violated the temple of Solomon,
he killed the Patriarch before the fonts;
took the sworn word of Ganelon the Count,
gave him his sword and a thousand gold coins.
He rides the horse that he calls Gramimund,
swifter by far than the falcon that flies;
digs hard into its flanks with his sharp spurs,
comes on to strike Sansun, our mighty duke:
smashes his shield, bursts the rings of his hauberk,
drives in the streamers of his bright gonfanon,
knocks him down, dead, lance straight out, from the saddle:
"Saracens, strike! Strike and we will beat them."
"God!" say the French, "the loss of that great man!" AOI.

Roland the Count, when he sees Sansun dead—
now, lords, you know the rage, the pain he felt;
digs in his spurs, runs at that man in fury,
grips Durendal, more precious than fine gold,
comes on, brave man, to strike with all his power,
on his helmet, beset with gems in gold,
cuts through the head, the hauberk, the strong body,
the good saddle beset with gems in gold,
into the back, profoundly, of the horse,
and kills them both, praise him or damn him who will.
Say the pagans: "A terrible blow for us!"
Roland replies: "I cannot love your men,
all the wrong and presumption are on your side." AOI.

An African, come there from Africa,
is Malquidant, the son of King Malcud,
his battle gear studded with beaten gold:
he shines to heaven, aflame among the others
rides the war horse that he calls Salt Perdut—
no beast on earth could ever run with him;
comes on to strike Anseïs, strikes on his shield
straight down, and cut away the red and blue,
burst into shreds the panels of his hauberk,
thrust into him the iron and the shaft.
The Count is dead, his days are at an end.
And the French say: "Lord, you fought well and died!"

Across the field rides Archbishop Turpin.
Tonsured singer of masses! Where is the priest
who drove his body to do such mighty deeds?
said to the pagan: "God send you every plague,
you killed a man it pains my heart to remember";
and sent his good war horse charging ahead,
struck on that pagan shield of Toledo;
and he casts him down, dead, on the green grass.

And now again: a pagan, Grandonie,
son of Capuel, the king of Cappadocia;
he is mounted on the horse he calls Marmorie,
swifter by far than the bird on the wing;
loosens the reins, digs in sharp with his spurs,
comes on to strike with his great strength Gerin,
shatters the dark red shield, drags it from his neck,
and driving bursts the meshes of his hauberk,
thrusts into him the blue length of his banner
and casts him down, dead, upon a high rock;
and goes on, kills Gerer, his dear companion,
and Berenger, and guion of Saint Antonie;
goes on still, strikes Austorie, a mighty duke
who held Valence and Envers on the Rhone;
knocks him down, dead, puts joy into the pagans.
The French cry out: "Our men are losing strength!"

Count Roland holds his sword running with blood;
he has heard them: men of France losing heart;
filled with such pain, he feels he will break apart;
said to the pagan: "God send you every plague,
the man you killed, I swear, will cost you dear";
his war horse, spurred, runs straining every nerve.
One must pay, they have come face to face.

Grandonie was a great and valiant man,
and very strong, a fighter; and in his path
he came on Roland, had never seen him before;
but knew him now, knew him now, knew him now,
that fury on his face, that lordly body,
that look, and that look, the tremendous sight of him;
does not know how to keep down his panic,

and wants to run, but that will not save him;
the blow comes down, Roland's strength is in it,
splits his helmet through the nosepiece in two,
cuts through the nose, through the mouth, through the teeth,
down through the trunk, the Algerian mail,
the silver bows of that golden saddle,
into the back, profoundly, of the horse;
and killed them both, they never rode again.
The men of Spain cry out their rage and grief.
And the French say: "Our defender has struck!"

The battle is fearful, there is no rest,
and the French strike with all their rage and strength,
cut through their fists and their sides and their spines,
cut through their garments into the living flesh,
the bright blood flows in streams on the green grass.
The pagans cry: "We can't stand up to this!
Land of Fathers, Mahummet's curse on you!
Your men are hard, we never saw such men!"
There is not one who does not cry: "Marsilion!
Come to us, King! Ride! We are in need! Help!"

The battle is fearful, and vast,
the men of France strike hard with burnished lances.
There you would have seen the great pain of warriors,
so many men dead and wounded and bleeding,
one lies face up, face down, on another.
The Saracens cannot endure it longer.
Willing and unwilling they quit the field.
The French pursue, with all their heart and strength. AOI.

Marsilion sees his people's martyrdom.
He commands them: sound his horns and trumpets;
and he rides now with the great host he has gathered.
At their head rides the Saracen Abisme:
no worse criminal rides in that company,
stained with the marks of his crimes and great treasons,
lacking the faith in God, Saint Mary's son.
And he is black, as black as melted pitch,
a man who loves murder and treason more
than all the gold of rich Galicia,
no living man ever saw him play or laugh;
a great fighter, a wild man, mad with pride,
and therefore dear to that criminal king;
holds high his dragon, where all his people gather.
The Archbishop will never love that man,
no sooner saw than wanted to strike him;
considered quietly, said to himself:
"That Saracen—a heretic, I'll wager.
Now let me die if I do not kill him—
I never loved cowards or cowards' ways." AOI.

Turpin the Archbishop begins the battle.
He rides the horse that he took from Grossaille,

who was a king this priest once killed in Denmark.
Now this war horse is quick and spirited,
his hooves high-arched, the quick legs long and flat,
short in the thigh, wide in the rump, long in the flanks,
and the backbone so high, a battle horse!
and that white tail, the yellow mane on him,
the little ears on him, the tawny head!
No beast on earth could ever run with him.
The Archbishop—that valiant man—spurs hard,
he will attack Abisme, he will not falter,
strikes on his shield, a miraculous blow:
a shield of stones, of amethysts, topazes,
esterminals, carbuncles all on fire—
a gift from a devil, in Val Metas,
sent on to him by the Amiral Galafre.
There Turpin strikes, he does not treat it gently—
after that blow, I'd not give one cent for it;
cut through his body, from one side to the other,
and casts him down dead in a barren place.
And the French say: "A fighter, that Archbishop!
Look at him there, saving souls with that crozier!"

Roland the Count calls out to Oliver:
"Lord, Companion, now you have to agree
the Archbishop is a good man on horse,
there's none better on earth or under heaven,
he knows his way with a lance and a spear."
The Count replies: "Right! Let us help him then."
And with these words the Franks began anew,
the blows strike hard, and the fighting is bitter;
there is a painful loss of Christian men.
To have seen them, Roland and Oliver,
these fighting men, striking down with their swords,
the Archbishop with them, striking with his lance!
One can recount the number these three killed:
it is written—in charters, in documents;
the Geste tells it: it was more than four thousand.
Through four assaults all went well with our men;
then comes the fifth, and that one crushes them.
They are all killed, all these warriors of France,
all but sixty, whom the Lord God has spared:
they will die too, but first sell themselves dear. AOI.

Count Roland sees the great loss of his men,
calls on his companion, on Oliver:
"Lord, Companion, in God's name, what would you do?
All these good men you see stretched on the ground
We can mourn for sweet France, fair land of France!
a desert now, stripped of such great vassals.
Oh King, and friend, if only you were here!
Oliver, Brother, how shall we manage it?
What shall we do to get word to the King?"
Said Oliver: "I don't see any way.
I would rather die now than hear us shamed." AOI.[8]

GOTHIC STYLE

In the twelfth to the fifteenth centuries traditional paintings in the form of frescoes and altar panels returned to prominence while manuscript illumination continued. Two-dimensional art continued to illustrate the gradual flow of one style into another without the emergence of a clearly dominant identity. Because this period is so closely identified with Gothic architecture, and because painting found its primary outlet within the Gothic cathedral, we need to ask what qualities reflect a Gothic style. The answer is not as readily apparent as it is in architecture and sculpture, but several characteristics can be identi-

12.28 *David Harping,* from the Oscott Psalter, c. 1270 AD. 7½ x 4¾ ins (20 x 11.1 cm). The British Library.

fied. One is the beginnings of *three-dimensionality* in figure representation. Another is a striving to give these figures *mobility* and *life* within three-dimensional space. *Space* is the essence of Gothic style. The Gothic painter and illuminator had not mastered perspective, and his compositions do not exhibit the spatial rationality of later works, but if we compare him with his predecessors of the earlier medieval eras, we discover that he has more or less broken free from the static, frozen, two-dimensionality of earlier styles. Gothic style also exhibits *spirituality, lyricism*, and a new *humanism* (mercy versus irrevocable judgement). Gothic style is less crowded and frantic—it was a changing style with many variations.

The Gothic style of two-dimensional art found magnificent expression in manuscript illumination. The Court Style of France and England produced some truly exquisite works. In *David Harping* (Fig. **12.28**) the curious proportions of the face and hands of David, and the awkward linear draping of fabric juxtaposed against the curvilinear forms of the harp and chair create a sense of unease and nervous tension. There is almost a carelessness about the layout of the background screen. The upward curving arcs at the top are intended to be symmetrical, but their departure from symmetry is reinforced by the lack of precision in the repetition of diamond shapes. A touch of realism appears in the curved harp string which David is plucking. Rudimentary use of highlight and shadow give basic three-dimensionality to cloth and skin, and while unbalanced in the interior space, the figure, nonetheless, does not appear to crowd the borders.

THE GOTHIC CATHEDRAL

Gothic style in architecture took many forms, but it is best exemplified in the Gothic cathedral. The cathedral, in its synthesis of intellect, spirituality, and engineering, perfectly expresses the medieval mind. Gothic style was widespread in Europe. Like the other arts it was not uniform in application, nor was it uniform in date. It developed initially as a very local style on the Ile de France in the late twelfth century, and spread outward to the rest of Europe. It had died as a style in some places before it was adopted in others. The "slipping, sliding, and overlapping" circumstances of artistic development were fully applicable to Gothic architecture.

The cathedral was, of course, a church building whose purpose was the service of God. However, civic pride as well as spirituality inspired cathedral building. Various local guilds contributed their services in financing or in the actual building of the churches, and guilds were often

memorialized in special chapels and stained-glass windows. The Gothic church occupied the central, often elevated, area of the town or city. Its physical centrality and context symbolized the dominance of the universal Church over all affairs of humankind, both spiritual and secular. Probably no other style has exercised such an influence across the centuries or played such a central role, even in twentieth-century Christian architecture. The Gothic church spins an intricate and fascinating story, only a few details of which we can highlight here.

The beginnings of Gothic architecture can be pinpointed between 1137 and 1144 in the rebuilding of the royal Abbey Church of St. Denis near Paris. There is ample evidence that Gothic was a physical extension of philosophy, rather than a practical response to the structural limitations of the Romanesque style—that is, Gothic theory preceded its application. The philosophy of the Abbot Suger, who was advisor to Louis VI and a driving force in the construction of St. Denis, held that harmony, the perfect relationship of parts, is the source of beauty, that Light Divine is a mystic revelation of God, and that space is symbolic of God's mystery. The composition of St. Denis and subsequent Gothic churches perfectly expressed that philosophy. As a result, Gothic architecture is more unified that Romanesque. Gothic cathedrals use refined, upward-striving line to symbolize, both in exterior spires and the pointed arch, humanity's upward striving to escape (at the tip) from earth into the mystery of space (the Kingdom of Heaven).

The pointed arch is the most easily identifiable characteristic of this style, and it represents not only a symbol of Gothic spirituality but also an engineering practicality. The pointed arch completely changes the thrust of downward force into more equal and controllable directions, whereas the round arch places tremendous pressure on its keystone, which then transfers thrust outward to the sides. The pointed arch controls thrust into a downward path through its legs. It also adds design flexibility. Dimensions of space encompassed by a round arch are limited to the radii of specific semicircles. Since the proportions of a pointed arch are flexible, dimensions may be adjusted to whatever practical and aesthetic parameters are desired. The Gothic arch also increased the sense of height in its vaults. Some sources suggest that this structure actually made increased heights possible. That implication is not quite correct. Some Romanesque churches had vaults as high as any Gothic churches, but the possibility for change in proportion of height to width did increase the apparent height of the Gothic church.

Engineering advances implicit in the new form made

possible larger clerestory windows (hence more light) and more slender ribbing (hence a greater emphasis on space as opposed to mass). Outside, practical and aesthetic flying buttresses carry the outward thrust of the vaults through a delicate balance of ribs, vaults, and buttresses gracefully and comfortably to the ground. Every detail is carefully integrated into a tracery of decoration emphasizing mysterious space.

The importance of stained-glass windows in Gothic cathedrals cannot be overemphasized. They carefully controlled light entering the sanctuary, reinforcing a marvelous sense of mystery. They also took the place of wall paintings in telling the story of the gospels and the saints, the walls of the Romanesque style having been replaced by space and light in the Gothic.

Salisbury Cathedral

With the exception of St. Paul's Cathedral in London, Salisbury (Fig. **12.29**) is the only English Cathedral whose entire interior structure was built to the design of a

12.29 Salisbury Cathedral from the Southwest, begun 1220.

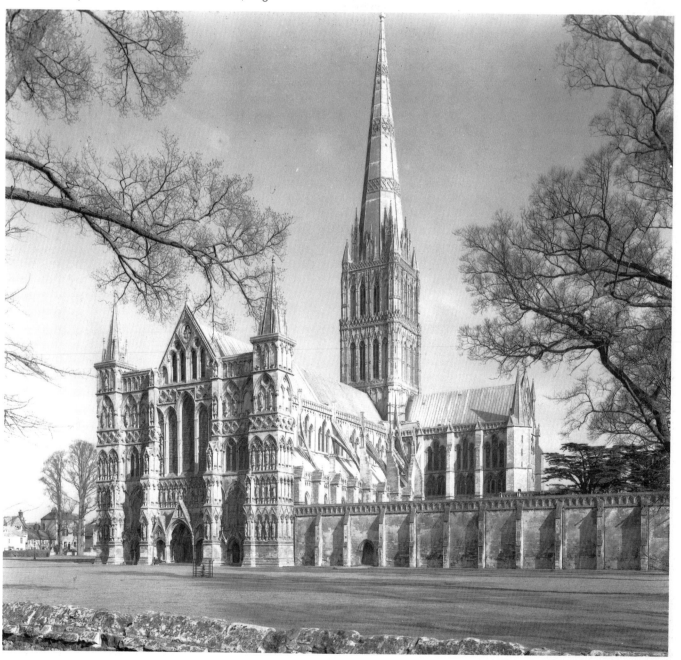

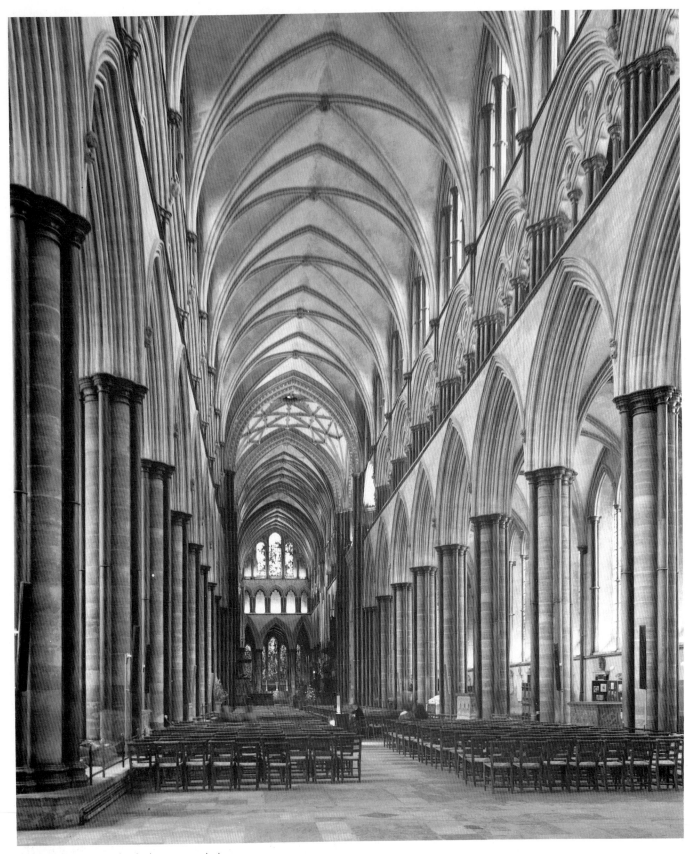

12.31 Salisbury Cathedral, nave and choir.

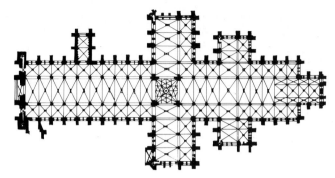

12.30 Plan of Salisbury Cathedral.

and damnation are replaced with conceptions of Christ as a benevolent teacher and of God as beautiful. This style has a new *order, symmetry,* and *clarity.* Its visual images carry with greater distinctness over a distance. The figures of Gothic sculpture are less entrapped in their material and stand away from their backgrounds (Fig. **12.32**).

12.32 Jamb statues, west portal, Chartres Cathedral, France. c. 1145–70.

single architect and completed without a break, in 1265. However, what is perhaps the most perfect part of the cathedral took another fifty-five years to complete. The famous spire, built between 1285 and 1310, added an additional 404 ft (123 m) to a very squat tower which rose only a few feet above the nave. The spire thus became the highest in England and the second highest in Europe. Unfortunately, the piers and foundations were not designed to carry the additional 6,400 tons, and the masons were forced to add a strong stone vault at the crossing of the nave below the tower, one of the few stylistic modifications in the building.

Compared to the soaring vertical cathedrals of France, Salisbury seems long, low, and sprawling. The west front functions more as a screen wall, wider than the nave, whose horizontal bands of decoration further emphasize the horizontal thrust of the building. The plan of the cathedral (Fig. **12.30**), with its double transept, retains the features of the Romanesque style. The same emphasis on the horizontal appears in the interior, where the nave wall looks more like a succession of arches and supports (Fig. **12.31**). Typical of Early English Gothic, the nave vaults curve steeply with the ribs extending down to the *triforium* level and thereby tucking the clerestory windows into the vaults. Also characteristic of the Early English style is the use of dark Purbeck marble for the colonnettes and capitals, establishing an almost Romanesque color contrast. The building is free of tracery and the lancet windows are grouped in threes and fives.

GOTHIC SCULPTURE

Gothic sculpture again reveals the changes in attitude of the period. It portrays *serenity, idealism,* and *simple naturalism.* Gothic sculpture, like painting, has a human quality, and takes a kindlier view of life. The vale of tears, death,

Schools of sculpture developed throughout France, and although individual stone carvers worked alone, their common links with a school gave their works a unified character. Rheims, for example, had an almost classical quality, while Paris was dogmatic and intellectual (perhaps a reflection of its role as a university city). As the period progressed, sculpture became more naturalistic. *Spiritualism* was sacrificed to everyday appeal, and sculpture reflected the increasing influence of secular interests, both middle class and aristocratic.

Compositional unity also changed from early to late Gothic. Early architectural sculpture was subordinate to the overall design of the building. Later work lost much of that integration as it gained in emotionalism (Fig. **12.33**).

12.33 Jamb statues, south transept portal, Chartres Cathedral, c. 1215–20.

The Sculptures of Chartres Cathedral

The sculptures of Chartres Cathedral, which bracket nearly a century, illustrate clearly the transition from early to late Gothic. The attenuated figures of Figure **12.32** display a relaxed serenity, idealism, and simple naturalism. Although an integral part of the portal columns, they also emerge from them, each in its own space. Detail is somewhat formalized and shallow, but we now see the human figure beneath the fabric—in contrast to the previous use of fabric as mere compositional decoration. Naturalistic qualities are even more pronounced in the figures of 100 years later (Fig. **12.33**). Here we can see the characteristics of the *High Gothic* style.

Proportion is more lifelike, and the figures have only the most tenuous connection to the building. Figures are carved in subtle S-curves rather than as rigid perpendicular columns. Fabric drapes are much more naturally depicted, with deeper and softer folds. In contrast to the idealized older saints, these figures have the features of specific individuals expressing qualities of spirituality and determination.

The content of Gothic sculpture is also noteworthy. Gothic sculpture, like most church art, was *didactic*, or designed to teach. Many of its lessons are fairly straightforward, and can be appreciated by anyone with a basic knowledge of the Bible. Christ appears as a ruler and judge of the universe above the main doorway of Chartres Cathedral, with a host of symbols of the apostles and others (Fig. **12.34**). Also decorating the portals are the prophets and kings of the Old Testament, whose purpose is to proclaim the harmony of secular and spiritual rule by making the kings of France the spiritual descendants of Biblical rulers—in much the same sense as we noted in the art of Justinian at Ravenna in Chapter 10.

Other lessons of Gothic cathedral sculpture are more complex and hidden. According to some scholars specific conventions, codes, and sacred mathematics are involved. These factors relate to positioning, grouping, numbers, symmetry, and recognition of subjects. For example, the numbers three, four, and seven (which we often see in compositions of post-Gothic periods) symbolize the Trinity, the Gospels, the sacraments, and the deadly sins. The positioning of the figures around Christ show their relative importance, with the position on the right being the most important. Amplifications of these codes and symbols are carried to highly complex levels. All of this is consistent with the *mysticism* of the period, which held to strong beliefs in *allegorical* and *hidden meanings* in Holy sources.

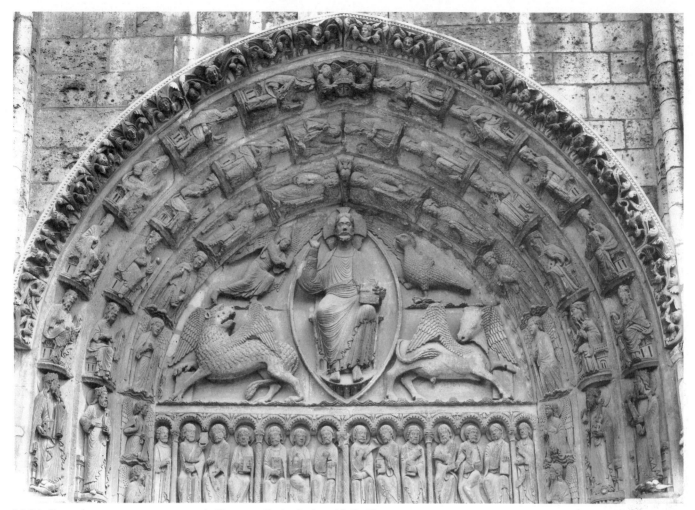

12.34 Central tympanum, west portal, Chartres Cathedral, c. 1145–70.

THE RENAISSANCE

The Renaissance was explicitly seen by its leading exponents as a rebirth of our understanding of ourselves as social and creative beings. "Out of the sick Gothic night our eyes are opened to the glorious touch of the sun," was how Rabelais expressed what most of his educated contemporaries felt. At the center of Renaissance concerns were the visual arts, whose new ways of looking at the world soon had their counterparts in the performing arts as well. For the first time, it seemed possible not merely to emulate the works of the classical world but to surpass them.

However, there was nervousness and unease in many leading minds in the decades following the close of the High Renaissance. The Reformation had challenged institutional Christian faith and its authority. The pro-posal of a heliocentric universe knocked humankind from its previously assured place at the center of all things. Harmony seemed once more to be an unattainable ideal as Europe was riven by wars and as philosophers cast doubt on the certainties of the Renaissance. The modern age was in the making.

FLEMISH PAINTING

In the north of Europe lies a small area known as the Low Countries. In the fifteenth century the Low Countries included Flanders, and amid a dominant atmosphere of late Gothic architecture and sculpture, Flemish painters and musicians forged new approaches, which departed significantly from the *International Gothic* style, formed a link with their contemporaries in northern Italy, and influenced European painters and musicians for the next century. Many scholars believe that early-fifteenth-

century Flemish arts remained totally a part of the late Gothic style, but clearly the painters of this locale had significant contact with Italy, the heart of the Early Renaissance in art. Clearly, also, the Italians of this new Renaissance spirit admired Flemish painting.

Flemish painting of this period was revolutionary. In Gothic art painters attempted to create realistic sensations of deep space. For all their ingenuity, they essentially retained a two-dimensional feeling and a lack of continuity or rationality in their perspective. Gothic work contains a certain childish or fairy-tale quality. Flemish painters, however, achieved pictorial reality and rational perspective, and the sense of completeness and continuity found in Flemish works marked a new and clearly different style. Line, form, and color were painstakingly controlled to compose subtle, varied, three-dimensional, clear, and logically unified statements.

Part of the drastic change in Flemish painting stemmed from a new development in painting media—oil paint. Oil's versatile characteristics gave the Flemish painter new opportunities to vary surface texture and brilliance, and to create far greater subtlety of form. Oils allowed blending of color areas, because oil could be worked wet on the canvas, whereas egg tempera, the previous painting medium, dried almost immediately upon application. Gradual transitions between color areas made possible by oil paints allowed fifteenth-century Flemish painters to enhance use of atmospheric perspective—that is, the increasingly hazy appearance of objects furthest from the viewer—and thereby to control this most effective indicator of deep space. Blending between color areas also enhanced *chiaroscuro*, by which all objects assume three-dimensionality—without highlight and shadow perceptible plasticity is lost. Early-fifteenth-century Flemish painters used sophisticated exploration of light and shade not only to heighten three-dimensionality of form but also to achieve rational unity in their compositions. Pictures which do not exhibit consistent light sources or which omit natural shadows on surrounding objects create very strange effects, even if their individual form depiction is high in verisimilitude. This new rational unity and realistic three-dimensionality separated fifteenth-century Flemish style from the Gothic style and tied it to the Renaissance.

Van Eyck—The Arnolfini Marriage

Jan van Eyck's *Arnolfini Marriage*, or *Giovanni Arnolfini and His Bride* (Fig. **12.35**), illustrates the qualities of Flemish painting, and also provides a marvelous range of aesthetic responses. Van Eyck used the full range of values from darkest darks to lightest lights and blended them with extreme subtlety to achieve a soft and realistic appearance. His colors are rich, varied, and predominantly warm in feeling. All forms achieve three-dimensionality through subtle color blending and softened shadow edges. Natural highlights and shadows emanate from obvious sources, such as the window, and tie the figures and objects together.

The painting depicts a young couple taking a marriage vow in the sanctity of the bridal chamber and the painting is thus both a portrait and a marriage certificate. The artist has signed the painting in legal script above the mirror "Johannes de Eyck fuit hic. 1434" (Jan van Eyck was here. 1434). In fact, we can see the artist and another witness reflected in the mirror.

RENAISSANCE PAINTING IN FLORENCE

It was in Italy, and more precisely in Florence, that the Renaissance, whatever connotations we attach to it, found its early spark and heart in about 1400. Florence was a wealthy port and commercial center and, like Athens, leapt into a golden age on a soaring spirit of victory as the city successfully resisted the attempts of the Duke of Milan to subjugate it. Under the patronage of the Medici family the outpouring of art made Florence the focal point of the early Italian Renaissance.

Two general trends in Florentine painting can be identified in this period. The first was lyrical and decorative. Its adherents were the painters Fra Angelico, Fra Lippo Lippi, Benozzo Gozzoli and Sandro Botticelli. This tradition is probably best expressed in the paintings of Botticelli. The linear quality of *Spring* (Fig. **12.36**) suggests an artist apparently unconcerned with deep space or subtle plasticity in light and shade. Rather, forms emerge through outline. Botticelli's use of line brings the form to life, as opposed to the medieval practice of denying the body. The composition moves gently from side to side through a lyrical combination of undulating, curved lines, with focal areas in each grouping. Mercury, the Three Graces, Venus, Flora, Spring, and Zephyrus—each part of this human, mythical (notice the non-Christian subject

12.35 Jan van Eyck, *The Arnolfini Marriage* (*Giovanni Arnolfini and His Bride*), 1434. Oil on panel, 33 x 22½ ins (84 x 57 cm). The National Gallery, London.

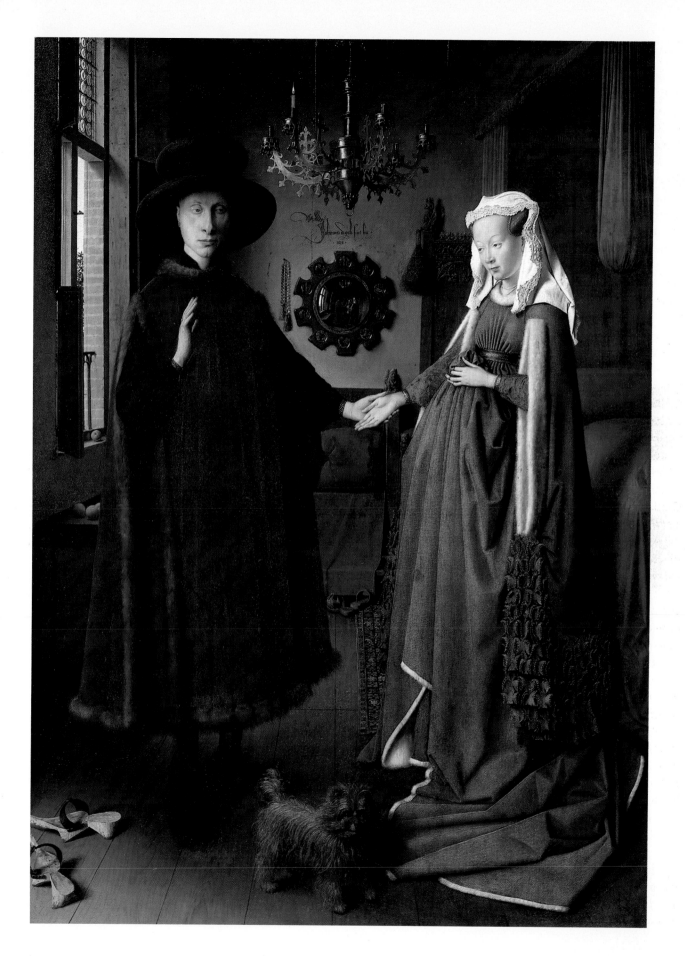

matter) composition carries its own emotions, from contemplation to sadness to happiness. Beyond the immediate qualities there is deeper symbolism and emotion relating not only to the mythological figures, but also to the Medici family, the patron rulers of Florence.

Botticelli's figures further exhibit anatomical simplicity quite unlike the detailed muscular concerns we will find elsewhere in Florentine Renaissance painting. Although figures are rendered three-dimensionally and shaded subtly, they appear almost like balloons, floating in space without anatomical definition.

The second tradition in Florentine and other Italian painting of this period is much more clearly Renaissance in approach. The works of Masaccio (1401–28) and others have a unifying monumentality, so they are, or seem to be, larger than lifesize. The use of deep space, plasticity, and *chiaroscuro* to create dramatic contrasts, gives figures solidity and unifies the composition. Atmospheric and linear perspective—that is, a new and significant scientific mechanization of single and multiple vanishing-point perspective (an invention that allowed the artist to plot foreshortened objects with photographic accuracy)—enhanced deep, spatial realism. Figures are warm, strong, detailed, and very human. At the same time composition carefully subordinated parts to the whole.

This tradition was initiated by Masaccio in the early 1420s, and in the space of two years Florence had progressed from the *International Gothic* style to this radically different approach.

Masaccio—The Tribute Money

The most famous of Masaccio's frescoes in the Brancacci family chapel in the Church of Santa Maria del Carmine is *The Tribute Money* (Fig. **12.37**). Its setting makes full use of the new discovery of linear perspective, as the rounded figures move freely in unencumbered deep space. It employs a technique called "continuous narration," unfolding a series of events across a single canvas—here the New Testament story from Matthew (17:24–27).

The figures in this fresco are remarkably accomplished. In the first place, they are "clothed nudes," dressed in fabric which falls like real cloth. Next, weight and volume are depicted in an entirely new way. Each figure stands in classical *contrapposto* stance; the sense of motion is not particularly remarkable, but the accurate rendering of the feet makes these the first painted figures to seem to stand on real ground. Comparing the figures with Botticelli, we see that whereas Botticelli reveals form and volume through line, Masaccio uses *chiaroscuro*. The key to

chiaroscuro is to establish a source for the light which strikes the figures and then to render the objects in the painting so that all highlights and shadows occur as if caused by that single light source.

In addition, the figures form a circular and three-dimensional grouping rather than a flat line across the surface of the work as in the Botticelli. Even the haloes of the apostles appear in the new perspective and overlap at odd angles. Compositionally, the single vanishing point, by which the linear perspective is controlled, sits at the head of Christ, a device for achieving focus which we will see again in Leonardo da Vinci's *Last Supper* (Fig. **12.42**). In addition, Masaccio has rediscovered *atmospheric perspective*, in which distance is indicated through diminution of light and blurring of outlines.

RENAISSANCE SCULPTURE IN FLORENCE

An attempt to capture the essence of European sculpture in the early Renaissance can, again, best be served by looking to fifteenth-century Florence, where sculpture also enjoyed the patronage of the Medicis. The early Renaissance sculptors developed the skills to create images of high verisimilitude. The goal, however, was not the same as that of the Greeks, with their idealized reality of human form. Rather, the Renaissance sculptor found his ideal in individualism. The ideal was the glorious individual—even if not quite perfect. Sculpture of this style presented an uncompromising and stark view of humankind—complex, balanced, and full of action. Relief sculpture, like painting, revealed a new means of representing deep space through systematic, scientific perspective. Freestanding statuary works, long out of favor, returned to dominance. Scientific inquiry and interest in anatomy were reflected in sculpture as well as painting. The nude, full of character and charged with energy, made its first reappearance since ancient times. The human form was built up layer by layer upon its skeletal and muscular framework. Even when clothed, fifteenth-century sculpture revealed the body under the outer sculpture, quite unlike the decorative shell which often clothed medieval works.

Notable and typical among fifteenth-century Italian sculptors were Ghiberti and Donatello. In Ghiberti's *Gates of Paradise*, we see the same concern for rich detail, humanity, and feats of perspective that we saw in Florentine painting. In these doors of the Baptistery in Florence, Ghiberti, trained as a goldsmith and painter, creates beautiful surfaces with delicate and careful detail. He also

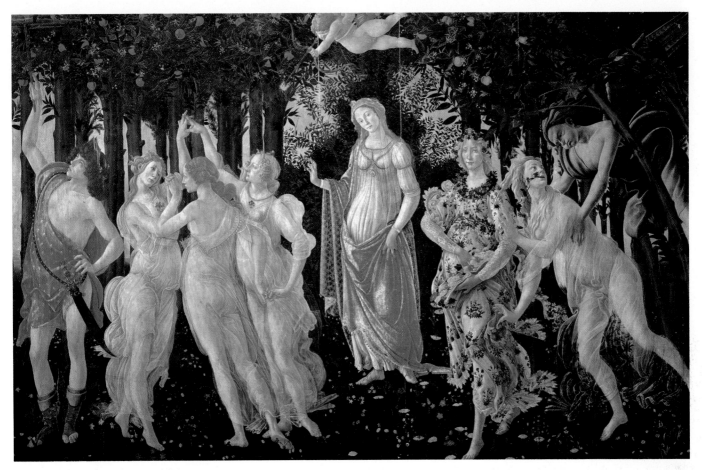

12.36 Sandro Boticelli, *La Primavera (Spring)*, c. 1478. Tempera on panel, 6 ft 8 ins x 10 ft 4 ins (2.03 x 3.15 .m). Galleria degli Uffizi, Florence.

12.37 Masaccio, *The Tribute Money*, c. 1427. Fresco, Santa Maria del Carmine, Florence.

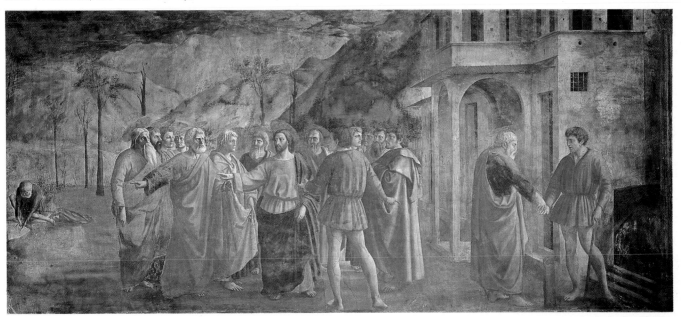

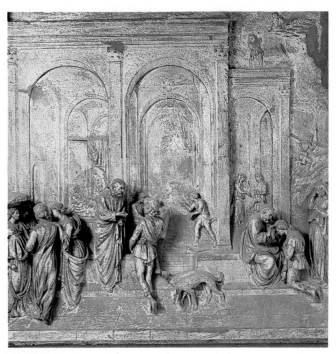

12.38 Lorenzo Ghiberti, *The Story of Jacob and Esau*, panel of the *Gates of Paradise*, c. 1435. Gilt bronze, 31¼ ins (79 cm) square. The Baptistery, Florence.

conveys a tremendous sense of space in each of the ten panels. In The Story of Jacob and Esau (Fig. **12.38**), for example, he uses receding arcades to create depth and perspective. Every detail is exact, and the bold relief of these scenes took Ghiberti twenty-one years to complete.

However, the greatest masterpieces of fifteenth-century Italian Renaissance sculpture came from the unsurpassed master of the age, Donatello (1386–1466). He had a passion for antiquity, and began his career as an assistant on the Florentine Baptistry doors of Ghiberti. His early statues were similar to medieval works in that they were architectural. However, even though his statues occupied niches, in his *St. George*, the niche is so shallow that the work actually emerges as free-standing, almost separated from the building. His magnificent *David* (Fig. **12.39**) was the first freestanding nude since classical times. However, unlike classical nudes, David is partially clothed. His armor and helmet, along with bony elbows and adolescent character, invest him with rich detail of a highly individualized nature. *David* exhibits a return to classical *contrapposto* stance, but its carefully executed form expresses a new humanity whose individual parts seem almost capable of movement. The work symbolizes Christ's triumph over Satan. The laurel crown on the helmet and laurel wreath on which the work stands allude to the Medici family, in whose palace the statue was displayed in 1469.

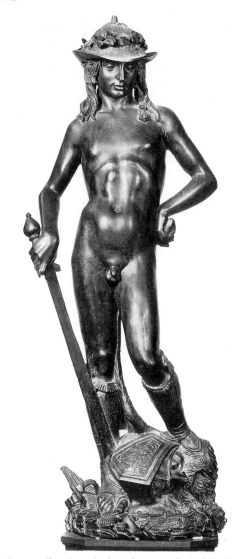

12.39 Donatello, *David*, dated variously 1430–40. Bronze, height, 5 ft 2¼ ins (1.58 m). Museo Nazionale del Bargello, Florence.

RENAISSANCE LITERATURE

Boccaccio

The work of Giovanni Boccaccio (1313–75) culminated in the writing of the *Decameron*, which tells the story of ten young people fleeing from the plague in Florence in 1348. *Decameron* means "Ten Days' Work," and consists of 100 stories told over a fourteen-day period.

Here we include the first tale from day one, a lively day spent in witty conversation. Days two and three are focused on tales of adventure. Day four presents unhappy love, and five treats the same subject in a somewhat lighter vein. Day six returns to the happiness of day one, and days seven, eight and nine comprise laughter, trick-

ery, and license. Day ten ties the previous themes together into a conclusion. In total, the *Decameron* extols the virtue of humankind, proposing that in order to be noble one must accept life as one finds it, without bitterness, and above all, accept the responsibility for and consequences of one's own actions. The *Decameron* is an early reflection of the Renaissance spirit.

Master Ciappelletto dupeth a holy friar with a false confession and dieth; and having been in his lifetime the worst of men, he is, after his death, reputed a saint and called Saint Ciappelletto.

"It is a seemly thing, dearest ladies, that whatsoever a man doth, he give it beginning from the holy and admirable name of Him who is the maker of all things. Wherefore, it behoving me, as the first, to give commencement to our story-telling, I purpose to begin with one of His marvels, to the end, that, this being heard, our hope in Him, as in a thing immutable, may be confirmed and His name be ever praised of us. It is a manifest that, like as things temporal are all transitory and mortal, even so both within and without are they full of annoy and anguish and travail and subject to infinite perils, against which it is indubitable that we, who live enmingled therein and who are indeed part and parcel thereof, might avail neither to endure nor to defend ourselves, except God's especial grace lent us strength and foresight; which latter, it is not to be believed, descendeth unto us and upon us by any merit of our own, but of the proper motion of His own benignity and the efficacy of the prayers of those who were mortals even as we are and having diligently ensued His commandments, what while they were on life, are now with Him become eternal and blessed and unto whom we,—belike not daring to address ourselves unto the proper presence of so august a judge,—proffer our petitions of the things which we deem needful unto ourselves, as unto advocates informed by experience of our frailty. And this more we discern in Him, full as He is of compassionate liberality towards us, that, whereas it chanceth whiles (the keeness of mortal eyes availing not in any wise to penetrate the secrets of the Divine intent), that we peradventure, beguiled by report, make such an one our advocate unto His majesty, who is outcast from His presence with an eternal banishment,—nevertheless He, from whom nothing is hidden, having regard rather to the purity of the suppliant's intent than to his ignorance or to the reprobate estate of him whose intercession he invoketh, givether ear unto those who pray unto the latter, as if he were in very deed blessed in His aspect. The which will manifestly appear from the story which I purpose to relate; I say manifestly, ensuing, not the judgment of God, but that of men.

It is told, then, that Musciatto Franzesi, being from a very rich and considerable merchant in France become a knight and it behoving him thereupon go into Tuscany with Messire Charles Sansterre, brother to the King of France, who had been required and bidden thither by Pope Boniface, found his affairs in one part and another sore embroiled (as those of merchants most times are), and was unable lightly or promptly to disentangle them; wherefore he bethought himself to commit them unto diverse persons and made shift for all, save only he abode in doubt whom he might leave sufficient to the recovery of the credits he had given to certain Burgundians. The cause of his doubt was that he knew the Burgundians to be litigious, quarrelsome fellows, ill-conditioned and disloyal, and could not call one to mind, in whom he might put any trust, curst enough to cope with their perversity. After long consideration of the matter, there came to his memory a certain Master Ciapperello da Prato, who came often to his house in Paris and whom, for that he was little of person and mighty nice in his dress, the French, knowing not what Cepparello meant and thinking it be the same with Cappello, to wit, in their vernacular, Chaplet, called him, not Capello, but Ciappelletto, and accordingly as Ciappelletto he was known every where, whilst few knew him for Master Ciapperello.

Now this said Ciappelletto was of this manner life, that, being a scrivener, he thought very great shame whenas any of his instruments was found (and indeed he drew few such) other than false; whilst of the latter he would have drawn as many as might be required of him and these with a better will by way of gift than any other for a great wage. False witness he bore with especial delight, required or not required, and the greatest regard being in those times paid to oaths in France, as he recked nothing of forswearing himself, he knavishly gained all the suits concerning which he was called upon to tell the truth upon his faith. He took inordinate pleasure and was mighty diligent in stirring up troubles and enmities and scandals between friends and kinsfolk and whomsoever else, and the greater the mischiefs he saw ensue thereof, the more he rejoiced. If bidden to manslaughter or whatsoever other naughty deed, he went about it with a will, without ever saying nay thereto; and many a time of his proper choice he had been known to wound men and do them to death with his own hand. He was a terrible blasphemer of God and the saints, and that for every trifle, being the most choleric man alive. To church he went never and all the sacraments thereof he flouted in abominable terms, as things of no account; whilst, on the other hand, he was still fain to haunt and use taverns and other lewd places. Of women he was as fond as dogs of the stick; but in the contrary he delighted more than any filthy fellow alive. He robbed and pillaged with as much conscience as a godly man would make oblation to God; he was a very glutton and a great wine bibber, insomuch that bytimes it wrought him shameful mischief, and to boot, he was a notorious gamester and a caster of cogged dice. But why should I enlarge in so many words? He was belike the worst man that ever was born. His wickedness had long been upheld by the power and interest of Messer Musciatto, who had many a time safeguarded him as well from private persons, to whom he often did a mischief, as from the law, against which he was a perpetual offender.

This Master Ciappelletto, then, coming to Musciatto's mind, the latter, who was very well acquainted with his way of life, bethought himself that he should be such an one as the perversity of the Burgundians required and accordingly, sending for him, he bespoke him thus: 'Master Ciapelletto, I am, as thou knowest, about altogether to withdraw hence, and having to do, amongst others, with certain Burgundians, men full of guile, I know none whom I may leave to recover my due from them more fitting than myself, more by token that thou dost nothing at this present; wherefore, an thou wilt undertake this, I will e'en procure thee the favor of the Court and give thee such part as shall be meet of that which thou shalt recover.'

Dan Ciappelletto, who was then out of employ and ill provided with the goods of the world, seeing him who had long been his stay and his refuge about to depart thence, lost no time in deliberation, but, as of necessity constrained, replied that he would well. They being come to an accord, Musciatto departed and Ciappelletto, having gotten his patron's procuration and letters commendatory from the king, betook himself into Burgundy, where well nigh none knew him, and there, contrary to his nature, began courteously and blandly to seek to get in his payments and do that wherefor he was come thither, as if reserving choler and violence for a last resort. Dealing thus and lodging in the house of two Florentines, brothers, who there lent at usance and who entertained him with great honor for the love of Messer Musciatto, it chanced that he fell sick, whereupon the two brothers promptly fetched physicians and servants to tend him and furnished him with all that behoved unto the recovery of his health.

But every succor was in vain, for that, by the physicians' report, the good man, who was now old and had lived disorderly, grew daily worse, as one who had a mortal sickness; wherefore the two brothers were sore concerned and one day, being pretty near the chamber where he lay sick, they began to take counsel together, saying one to the other, 'How shall we do with yonder fellow? We have a sorry bargain on our hands of his affair, for that to send him forth of our house, thus sick, were a sore reproach to us and a manifest sign of little wit on our part, if the folk, who have seen us first receive him and after let tend and medicine him with such solitude, should now see him suddenly put out of our house, sick unto death as he is, without it being possible for him to have done aught that should displease us. On the other hand, he hath been so wicked a man that he will never consent to confess or take any sacrament of the church; and he dying without confession, no church will receive his body; nay, he will be cast into a ditch, like a dog. Again, even if he do confess, his sins are so many and so horrible that the like will come of it, for that there is nor priest nor friar who can or will absolve him thereof; wherefore, being unshriven, he will still be cast into the ditches. Should it happen thus, the people of the city, as well on account of our trade, which appeareth to them most iniquitous and of which they missay all day, as of their itch to plunder us, seeing this, will rise up in riot and cry out, "These Lombard dogs, whom the church refuseth to receive, are to be suffered here no longer";—and they will run to our houses and despoil us not only of our good, but may be of our lives, to boot; wherefore in any case it will go ill with us, if yonder fellow die.'

Master Ciappelletto, who as we have said lay near the place where the two brothers were in discourse, being quick of hearing, as is most times the case with the sick, heard what they said of him and calling them to him, bespoke them thus: 'I will not have you unwise misdoubt of me nor fear to take any hurt by me. I have heard what you say of me and am well assured that it would happen even as you say, should matters pass as you expect; but it shall go otherwise. I have in my lifetime done God the Lord so many an affront that it will make neither more nor less, an I do Him yet another at the point of death; wherefore do you make shift to bring me the holiest and worthiest friar you may avail to have, if any such there be, and leave the rest to me, for that I will assuredly order your affairs and mine own on such wise that all shall go well and you shall have good cause to be satisfied.'

The two brothers, albeit they conceived no great hope of this, nevertheless betook themselves to a brotherhood of monks and demanded some holy and learned man to hear the confession of a Lombard who lay sick in their house. There was given them a venerable brother of holy and good life and a past master in Holy Writ, a very reverend man, for whom all the townsfolk had a very great and special regard, and they carried him to their house; where, coming to the chamber where Master Ciappelletto lay and seating himself by his side, he began first tenderly to comfort him and after asked him how long it was since he had confessed last; whereto Master Ciappelletto, who had never confessed in his life, answered, 'Father, it hath been my usance to confess every week once at the least and often more; it is true that, since I fell sick, to wit, these eighty days past, I have not confessed, such is the annoy that my sickness hath given me.' Quoth the friar, 'My son, thou hast done well and so must thou do henceforward. I see, since thou confessest so often, that I shall be at little pains either of hearing or questioning.' 'Sir,' answered Master Ciappelletto, 'say not so; I have never confessed so much nor so often, but I would still fain make a general confession of all my sins that I could call to mind from the day of my birth to that of my confession; wherefore I pray you, good my father, question me as punctually of everything, nay, everything, as if I had never confessed; and consider me not because I am sick, for that I had far liefer displease this my flesh than, in consulting its ease, do aught that might be the perdition of my soul, which my Savior redeemed with His precious blood.'

These words much pleased the holy man and seemed to him to argue a well-disposed mind; wherefore, after he had much commended Master Ciappelletto for that his usance, he asked him if he had ever sinned by way of lust with any woman. 'Father,' replied Master Ciappelletto, sighing, 'on this point I am ashamed to tell you the truth, fearing to sin by way of vainglory.' Quoth the friar, 'Speak in all security, for never did one sin by telling the truth, whether in confession or otherwise.' 'Then,'

said Master Ciappelletto, 'since you certify me of this, I will tell you; I am yet a virgin, even as I came forth of my mother's body.' 'O blessed be thou of God!' cried the monk. 'How well hast thou done! And doing thus, thou hast the more deserved, inasmuch as, an thou wouldst, thou hadst more leisure to do the contrary than we and whatsoever others are limited by any rule.'

After this he asked him if he had ever offended against God in the sin of gluttony; whereto Master Ciappelletto answered, sighing, 'Ay had he, and that many a time; for that, albeit, over and above the Lenten fasts that are yearly observed of the devout, he had been wont to fast on bread and water three days at the least in every week,—he had oftentimes (and especially whenas he had endured any fatigue, either praying or going a-pilgrimage) drunken the water with as much appetite and as keen a relish as great drinkers do wine. And many a time he had longed to have such homely salads of potherbs as women make when they go into the country; and whiles eating had given him more pleasure than himseemed it should do to one who fasteth for devotion, as did he. 'My son,' said the friar, 'these sins are natural and very slight and I would not therefore have thee burden thy conscience withal more than behoveth. It happeneth to every man, how devout soever he be, that, after long fasting, meat seemeth good to him, and after travail, drink.'

'Alack, father mine,' rejoined Ciappelletto, 'tell me not this to comfort me; you must know I know that things done for the service of God should be done sincerely and with an ungrudging mind; and whoso doth otherwise sinneth.' Quoth the friar, exceeding well pleased, 'I am content that thou shouldst thus apprehend it and thy pure and good conscience therein pleaseth me exceedingly. But, tell me, hast thou sinned by way of avarice, desiring more than befitted or withholding that which it behoved thee not to withhold?' 'Father mine,' replied Ciappelletto, 'I would not have you look to my being in the house of these userers; I have naught to do here; nay, I came hither to admonish and chasten them and turn them from this their abominable way of gain; and methinketh I should have made shift to do so, had not God thus visited me. But you must know that I was left a rich man by my father, of whose good, when he was dead, I bestowed the most part in alms, and after, to sustain my life and that I might be able to succor Christ's poor, I have done my little traffickings, and in these I have desired to gain; but still with God's poor have I shared that which I gained, converting my own half to my occasions and giving them the other, and in this so well hath my Creator prospered me that my affairs have still gone from good to better.'

'Well hast thou done,' said the friar, 'but hast thou often been angered?' 'Oh,' cried Master Ciappelletto, 'that I must tell you I have very often been! And who could keep himself therefrom, seeing men do unseemly things all day long, keeping not the commandments of God neither fearing His judgments? Many times a day I had liefer been dead than alive, seeing young men follow after vanities and hearing them curse and forswear themselves, haunting the taverns, visiting not the churches and ensuing rather the ways of the world than that of God.' 'My son,' said

the friar, 'this is a righteous anger, nor for my part might I enjoin thee any penance therefor. But hath anger at any time availed to move thee to do any manslaughter or to bespeak any one unseemly or do any other unright?' 'Alack, sir,' answered the sick man, 'you, who seem to me a man of God, how can you say such words? Had I ever had the least thought of doing any one of the things whereof you speak, think you I believe that God would so long have forborne me? These be the doings of outlaws and men of nought, whereof I never saw any but I said still, "Go, may God amend thee!"'

Then said the friar, 'Now tell me, my son (blessed be thou of God!), has thou never borne false witness against any or missaid of another or taken others' good, without leave of him to whom it pertained?' 'Ay, indeed, sir,' replied Master Ciappelletto; 'I have missaid of others; for that I had a neighbor aforetime, who, with the greatest unright in the world, did nought but beat his wife, insomuch that I once spoke ill of him to her kinsfolk, so great was the compassion that overcame me for the poor woman, whom he used as God alone can tell, whenassoever he had drunken overmuch.' Quoth the friar, 'Thou tellest me thou hast been a merchant. Hast thou never cheated any one, as merchants do whiles?' 'I' faith, yes, sir,' answered Master Ciappelletto; 'but I know not whom, except it were a certain man, who once brought me monie which he owed me for cloth I had sold him and which I threw into a chest, without counting. A good month after, I found that they were four farthings more than they should have been; wherefore, not seeing him again and having kept them by me a full year, that I might restore them to him, I gave them away in alms.' Quoth the friar, 'this was a small matter, and thou didst well to deal with it as thou didst.'

Then he questioned him of many other things, all of which he answered after the same fashion, and the holy father offering to proceed to absolution, Master Ciappelletto said, 'Sir, I have yet sundry sins that I have not told you.' The friar asked him what they were, and he answered, 'I mind me that one Saturday, afternone, I caused my servant sweep out the house and had not that reverence for the Lord's holy day which it behoved me have.' 'Oh,' said the friar, 'that is a light matter, my son.' 'Nay,' rejoined Master Ciappelletto, 'call it not a light matter, for that the Lord's Day is greatly to be honored, seeing that onsuch a day our Lord rose from the dead.' Then said the friar, 'Well, hast thou done aught else?' 'Ay, sir,' answered Master Ciappelletto; 'once, unthinking what I did, I spat in the church of God.' Thereupon the friar fell a-smiling and said, 'My son, that is no thing to be reckoned of; we who are of the clergy, we spit there all day long.' 'And you do very ill,' rejoined Master Ciappelletto; 'for that there is nought which it so straitly behoveth to keep clean as the holy temple wherein is rendered sacrifice to God.'

Brief, he told him great plenty of such like things and presently fell a-sighing and after weeping sore, as he knew full well to do, whenas he would. Quoth the holy friar, 'What aileth thee, my son?' 'Alas, sir,' replied Master Ciappelletto, 'I have only one sin left, whereof I never yet confessed me, such shame

have I to tell it; and every time I call it to mind, I weep, even as you see, and meseemeth very certain that God will never pardon it me.' 'Go to, son,' rejoined the friar; 'what is thou sayest? If all the sins that were ever wrought or are yet to be wrought of all mankind, what while the world endureth, were all in one man and he repented him thereof and were contrite therefor, as I see thee, such is the mercy and loving-kindness of God that, upon confession He would freely pardon them to him. Wherefore do thou tell it in all assurance.' Quoth Master Ciappelletto, still weeping sore, 'Alack, father mine, mine is too great a sin, and I can scarce believe that it will ever be forgiven me of God, except your prayers strive for me.' Then said the friar, 'Tell it me in all assurance, for I promise thee to pray God for thee.'

Master Ciappelletto, however, still wept and said nought; but, after he had thus held the friar a great while in suspense, he heaved a deep sigh and said, 'Father mine, since you promise me to pray God for me, I will e'en tell it you. Know, then, that, when I was little, I once cursed my mother.' So saying, he fell again to weeping sore. 'O my son,' quoth the friar, 'seemeth this to thee so heinous a sin? Why, men blaspheme God all day long and He freely pardoneth whoso repenteth him of having blasphemed Him; and deemest thou not He will pardon thee this? Weep not, but comfort thyself: for, certes, wert thou one of those who set Him on the cross, He would pardon thee, in favor of such contrition as I see in thee.' 'Alack, father mine, what say you?' replied Ciappelletto. 'My kind mother, who bore me nine months in her body, day and night, and carried me on her neck an hundred times and more, I did passing ill to curse her and it was an exceeding great sin; and except you pray God for me, it will not be forgiven me.'

The friar, then, seeing that Master Ciappelletto had no more to say, gave him absolution and bestowed on him his benison, holding him a very holy man and devoutly believing all that he had told him to be true. And who would not have believed it, hearing a man at the point of death speak thus? Then, after all this, he said to him, 'Master Ciappelletto, with God's help you will speedily be whole; but, should it come to pass that God call your blessed and well-disposed soul to himself, would it please you that your body be buried in our convent?' 'Ay, would it, sir,' replied Master Ciappelletto. 'Nay, I would fain not be buried otherwhere, since you have promised to pray God for me; more by token that I have ever had a special regard for your order. Wherefore I pray you that, whenas you return to your lodging, you cause bring me that most veritable body of Christ, which you consecrate a-mornings upon the altar, for that, with your leave, I purpose (all unworthy as I am) to take it and after, holy and extreme unction, to the intent that if I have lived as a sinner, I may at the least die like a Christian.' The good friar replied that it pleased him much and that he said well and promised to see it presently brought him; and so it was done.

Meanwhile, the two brothers, misdoubting them sore lest Master Ciappelletto should play them false, had posted themselves behind a wainscot, that divided the chamber where he lay from another, and listening, easily heard and apprehended that which he said to the friar and had whiles so great a mind to laugh, hearing the things which he confessed to having done, that they were like to burst and said, one to another, 'What manner of man is this, whom neither old age nor sickness nor fear of death, whereunto he seeth himself near, nor yet of God, before whose judgment-seat he looketh to be ere long, have availed to turn from his wickedness nor hinder him from choosing to die as he hath lived?' However, seeing that he had so spoken that he should be admitted to burial in a church, they recked nought of the rest.

Master Ciappelletto presently took the sacrament and growing rapidly worse, received extreme unction, and a little after evensong of the day he had made his fine confession, he died; whereupon the two brothers, having, of his proper monies, taken order for his honorable burial, sent to the convent to acquaint the friars therewith, bidding them come hither that night to hold vigil, according to usance, and fetch away the body in the morning, and meanwhile made ready all that was needful thereunto.

The holy friar, who had shriven him, hearing that he had departed this life, betook himself to the prior of the convent and letting ring to chapter, gave out to the brethren therein assembled that Master Ciappelletto had been a holy man, according to that which he had gathered from his confession, and persuaded them to receive his body with the utmost reverence and devotion, in the hope that God should show forth many miracles through him. To this the prior and brethren credulously consented and that same evening, coming all whereas Master Ciappelletto lay dead, they held high and solemn vigil over him and on the morrow, clad all in albs and copes, book in hand and crosses before them, they went, chanting the while, for his body and brought it with the utmost pomp and solemnity to their church, followed by well nigh all the people of the city, men and women.

As soon as they had set the body down in the church, the holy friar, who had confessed him, mounted the pulpit and fell a-preaching marvellous things of the dead man and of his life, his fasts, his virginity, his simplicity and innocence and sanctity, recounting, amongst other things, that which he had confessed to him as his greatest sin and how he had hardly availed to persuade him that God would forgive it him; thence passing on to reprove the folk who hearkened, 'And you, accursed that you are,' quoth he, 'for every waif of straw that stirreth between your feet, you blaspheme God and the Virgin and all the host of heaven.' Moreover, he told them many other things of his loyalty and purity of heart; brief, with his speech, whereto entire faith was yielded of the people of the city, he so established the dead man in the reverent consideration of all who were present that, no sooner was the service at an end, than they all with the utmost eagerness flocked to kiss his hands and feet and the clothes were torn off his back, he holding himself blessed who might avail to have never so little thereof; and needs must they leave him thus all that day, so he might be seen and visited of all.

The following night he was honorably buried in a marble tomb in one of the chapels of the church and on the morrow the

folk began incontinent to come and burn candles and offer up prayers and make vows to him and hang images of wax at his shrine, according to the promise made. Nay, on such wise waxed the fame of his sanctity and men's devotion to him that there was scarce any who, being in adversity, would vow himself to another saint than him; and they styled and yet style him Saint Ciappelletto and avouch that God through him hath wrought many miracles and yet worketh them every day for whose devoutly commendeth himself unto him.

Thus, then, lived and died Master Ciappelletto da Prato and became a saint, as you have heard; nor would I deny it to be possible that he is beatified in God's presence, for that, albeit his life was wicked and perverse, he may at his last extremity have shown such contrition that peradventure God had mercy on him and received him into His kingdom; but, for that this is hidden from us, I reason according to that which is apparent and say that he should rather be in the hands of the devil in perdition than in Paradise. And if so it be, we may know from this how great is God's loving-kindness towards us, which, having regard not to our error, but to the purity of our faith, whenas we thus make an enemy (deeming him a friend) of Him our intermediary, giveth ear unto us, even as if we had recourse unto one truly holy, as intercessor for His favor. Wherefore, to the end that by His grace we may be preserved safe and sound in this present adversity and in this so joyous company, let us, magnifying His name, in which we have begun our diversion, and holding Him in reverence, commend ourselves to Him in our necessities, well assured of being heard." And with this he was silent.[9]

ARCHITECTURE

Brunelleschi

Early Renaissance architecture was centered in Florence and departed from medieval architecture in three significant ways. First was its concern with the revival of classical models along very mechanical lines. Ruins of Roman buildings were measured carefully and their proportions became those of the Renaissance buildings. Rather than seeing Roman arches as limiting factors, Renaissance architects saw them as geometric devices by which a formally derived design could be composed. The second departure from the medieval was the application of decorative detail—that is, non-structural ornamentation—to the façade of the building. Third, and a manifestation of the second difference, was a radical change in the outer expression of structure. The outward form of a building was previously closely related to its actual structural systems—that is, the structural support of the building, for example, post-and-lintel, masonry, and the arch. In the Renaissance, these supporting elements were hidden from view and the external appearance was no longer sacrificed to structural concerns.

Early architecture of the period, such as the dome on the Cathedral of Florence (Fig. **12.41**) designed by Brunelleschi (1377–1446), was an imitation of a classical form appended to a medieval structure. In this curious design, added in the fifteenth century to a fourteenth-century building, the soaring dome rises 180 ft (55 m) into the air, and its height is apparent from both outside and within. If we compare it with the Pantheon (Figs. **12.22** and **12.23**), Brunelleschi's departure from traditional practice becomes clearer. The dome of the Pantheon is impressive only from the inside of the building, because its exterior supporting structure is so massive that it clutters the visual experience. That Brunelleschi's dome rises to a phenomenal height is apparent on the inside because the architect has hidden from view the supporting elements such as stone and timber girdles and lightweight ribbings. The result is an aesthetic statement, where visual appearance is foremost and structural considerations are subordinate.

The use of classical ornamentation can be seen in Brunelleschi's Pazzi Chapel (Fig. **12.40**). Small in scale,

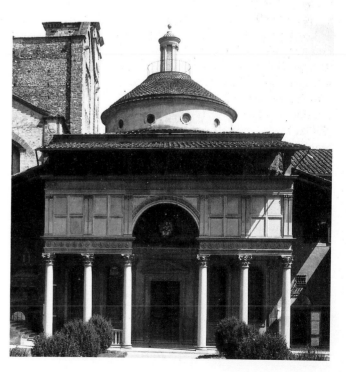

12.40 Filippo Brunelleschi, Pazzi Chapel, c. 1440–61. Santa Croce, Florence.

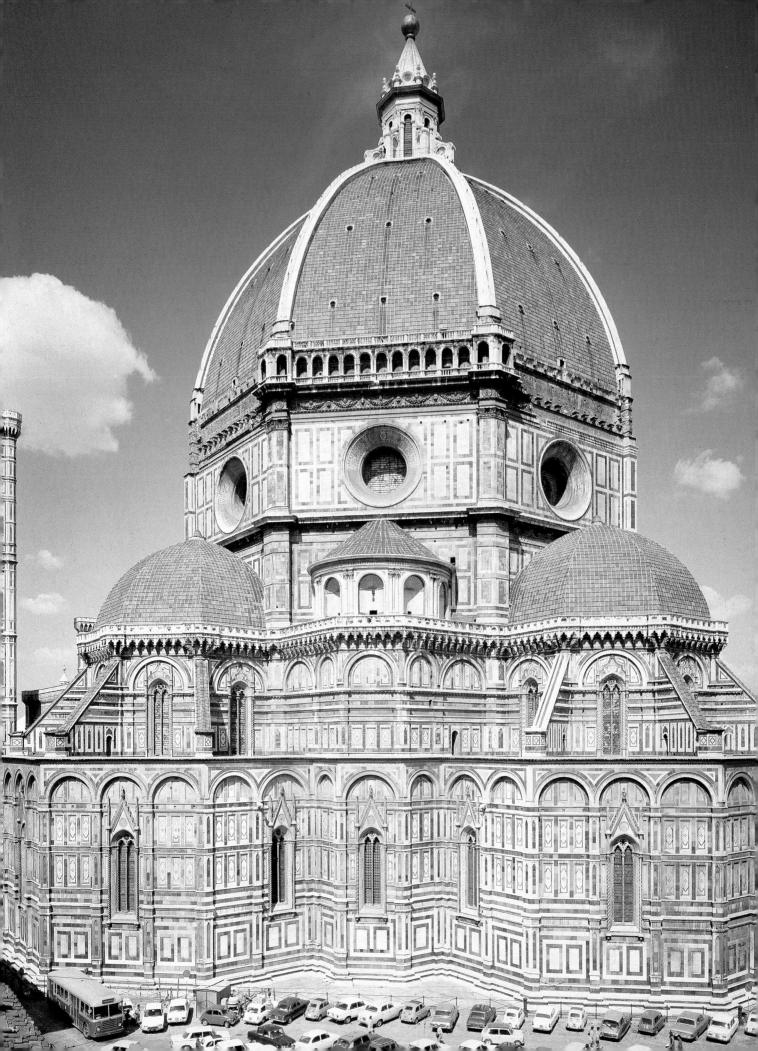

its walls serve as a plain background for a wealth of surface decoration. Concern for proportion and geometric design is very clear, but the overall composition is not a slave to pure arithmetical considerations. Rather, the Pazzi Chapel reflects Brunelleschi's sense of classical aesthetics. Brunelleschi's influence was profound in the first half of the fifteenth century, and he served as a model and inspiration for later Renaissance architects.

The second half of the fifteenth century was dominated by the Florentine scholar, writer, architect, and composer Leon Battista Alberti. His treatise *Concerning Architecture* was based on Vitruvius and provided a scholarly approach to architecture that influenced Western building for centuries. His scientific approach to sculpture and painting, as well as architecture, encompassed theories on Roman antiquity that typified the reduction of aesthetics to rules.

However, the problems of Renaissance architects were different from those of their predecessors. Faced with an expanding range of types of building, such as townhouses, hospitals, and business establishments, for which classical forms had to be adapted, the architect had to meet specific practical needs, which, apparently, the ancients did not. As a result, classical detail was applied to a wide range of forms and structures, many of which, like the Cathedral of Florence, were nonclassical in origin.

THE HIGH RENAISSANCE IN ROME

As important and revolutionary as the fifteenth century was, both in Flanders and Italy, the high point of the Renaissance came in the early sixteenth century, as papal authority was reestablished and artists were called to Rome. Its importance as the apex of Renaissance art has led scholars to call this period in the visual arts the High Renaissance. Painters of the High Renaissance included the titans and giants of Western visual art: Leonardo da Vinci, Michelangelo, Raphael, Giorgione, and Titian.

Implicit in humanistic exploration of the individual's earthly potential and fulfillment is a concept of particular importance to our overview of visual art in the High Renaissance style—the concept of genius. In Italy between 1495 and 1520 everything in visual art was subordinate to the overwhelming genius of two men, Leonardo da Vinci

12.41 Filippo Brunelleschi, dome of Florence Cathedral, 1420–36.

and Michelangelo Buonarroti. Their great genius and impact have led many to debate whether the High Renaissance of visual art was a culmination of earlier Renaissance style or a new departure.

By 1500 the courts of the Italian princes had become important sources of patronage and cultural activity. In pursuit of their world of beauty, the Italian nobility needed artists, writers, and musicians. The arts of the early Renaissance now seemed vulgar and naïve. A more aristocratic, elegant, dignified, and exalted art was demanded. This new style is lofty. The wealth of the popes and their desire to rebuild and transform Rome on a grand scale also contributed significantly to the shift in style and the emergence of Rome as the center of High Renaissance patronage. Music came of age as a major art, finding a great patron in Pope Leo X. There was a revival of Ancient Roman sculptural and architectural style. Important discoveries of ancient sculptures such as the *Apollo Belvedere* and the *Laocoön* were made. Because the artists of the High Renaissance had such a rich immediate inheritance of art and literature from the early Renaissance period, and felt they had developed even further, they considered themselves on an equal footing with the artists of the antique period. Their approach to the antique in arts and letters was therefore different from that of their early Renaissance predecessors.

High Renaissance painting sought a universal ideal achieved through impressive art, as opposed to overemphasis on tricks of perspective or on anatomy. Figures became types again, rather than naturalistic individuals—Godlike human beings in the Greek classical tradition. Artists and writers of the High Renaissance sought to capture the essence of classical art and literature without resorting to copying, which would have captured only the externals. They tried to emulate, and not to imitate. As a result, High Renaissance art idealizes all forms and delights in composition. Its impact is one of stability without being static, variety without confusion, and clear definition without dullness. High Renaissance artists carefully observed how the ancients borrowed motifs from nature, and they then set out to develop a system of mathematically defined proportion and compositional beauty emanating from a total harmonization of parts. Such faith in harmonious proportions reflected a belief among artists, writers, and composers that a harmonious universe and nature also possessed perfect order. In addition, High Renaissance style departed from previous styles in its meticulously arranged composition, based almost exclusively on geometric devices. Composition was closed—line, color, and form or shape kept the viewer's

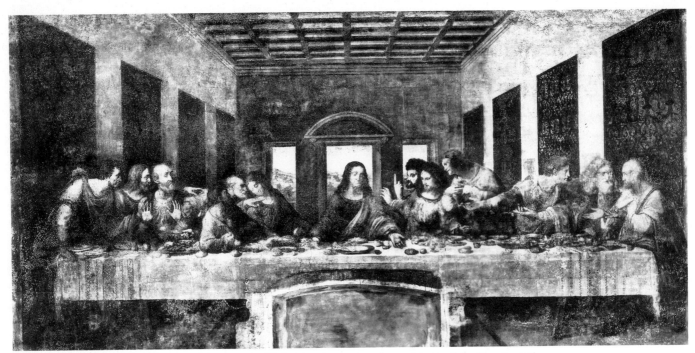

12.42 Leonardo da Vinci, *The Last Supper*, c. 1495–8. Mural painting. Santa Maria della Grazie, Milan.

eye continually redirected into the work, as opposed to leading the eye off the canvas. Organization centered upon a geometric shape, such as a central triangle or an oval.

Leonardo da Vinci

The work of Leonardo da Vinci (1452–1519) contains an ethereal quality which he achieved by blending light and shadow (called *sfumato*). His figures hover between reality and illusion as one form disappears into another, and only highlighted portions emerge. It is difficult to say which of Leonardo's paintings is the most popular or admired, but certainly *The Last Supper* (Fig. **12.42**) ranks among the greatest. It captures the drama of Christ's prophecy, "One of you shall betray me," at the moment that the apostles are responding with disbelief. Leonardo's choice of medium proved most unfortunate because his own mixtures of oil, varnish, and pigments, as opposed to fresco, were not suited to the damp wall. The painting began to flake and was reported to be perishing as early as 1517. Since then it has been clouded by retouching, defaced by a door cut through the wall at Christ's feet, and bombed during World War II. Miraculously, it survives. Recent attempts at restoration have created great controversy in the art world.

In *The Last Supper* human figures and not architecture are the focus. The figure of Christ dominates the center of the painting, forming a stable, yet active, central triangle. All line, actual and implied, leads outward from the face of Christ, pauses at various subordinate focal areas, is directed back into the work, and returns to the central figure. Various postures, hand positions, and groupings of the disciples direct the eye from point to point. Figures emerge from the gloomy architectural background in strongly accented relief; nothing anchors these objects to the floor of the room of which they are a part. Although this is not the greatest example of Leonardo's use of *sfumato*, the technique is there. This typically geometric composition is amazing in that so much drama can be expressed within such a mathematical format. Yet, despite the drama, the mood in this work and others is calm, belying the conflict and turbulence of Leonardo's own life, personality and times.

Michelangelo

Perhaps the most dominant figure of the High Renaissance, however, was Michelangelo Buonarroti (1475–1564), who was entirely different in character from Leonardo. Leonardo was a skeptic, while Michelangelo was a man of great faith. Leonardo was fascinated by science and natural objects; Michelangelo showed little interest in anything other than the human form.

Michelangelo's Sistine Chapel ceiling (Fig. **12.43**) is a shining example of the ambition and genius of this era

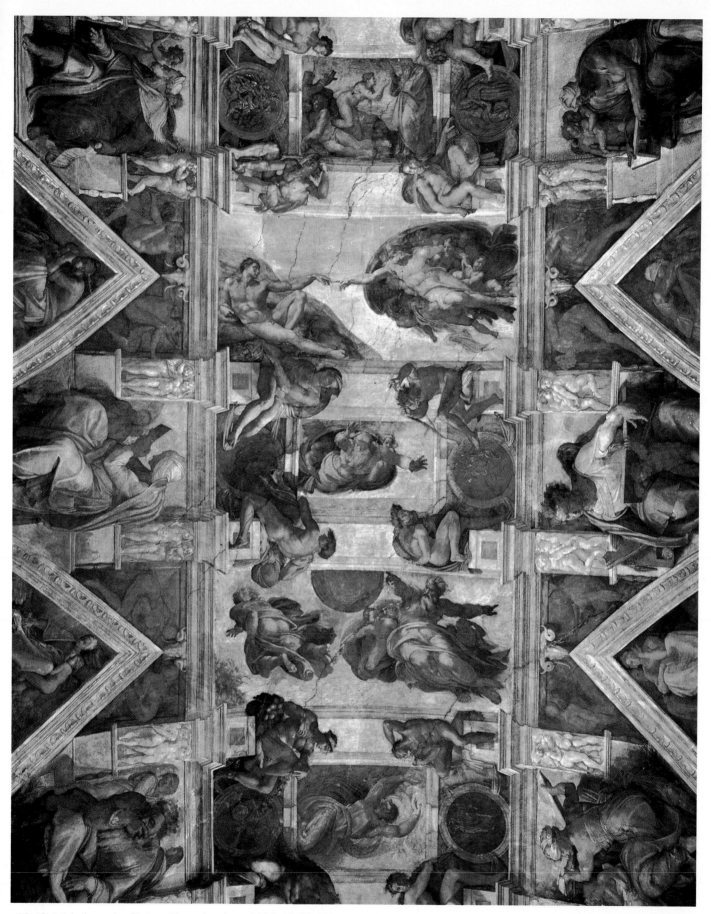

12.43 Michelangelo, Sistine Chapel ceiling, 1508–12, The Vatican, Rome.

and its philosophies. Some scholars see in this monumental work a blending of Christian tradition and a neo-Platonist view of the soul's progressive ascent through contemplation and desire. In each of the triangles along the sides of the chapel the ancestors of Christ await the Redeemer. Between them, amidst painted pillars, are the sages of antiquity. In the corners Michelangelo depicts various biblical stories, and across the center of the ceiling he unfolds the episodes of Genesis. The center of the ceiling captures, at the moment of fulfillment, the Creation of Adam (Fig. **12.44**) and does so in sculpturesque human form and beautifully modeled anatomical detail. God, in human form, stretches outward from his matrix of angels to a reclining, but dynamic, Adam, awaiting the divine infusion, the spark of the soul. The figures do not touch, and we are left with a supreme feeling of anticipation of what we imagine will be the power and electricity of God's physical contact with mortal man.

The Sistine Chapel ceiling creates a visual panoply of awesome proportions. It is not possible to get a comprehensive view of the entire ceiling, standing at any point in the Chapel. If we look upward and read the scenes back toward the altar, the prophets and sibyls appear on their sides. If we view one side as upright, then the other appears upside down. These opposing directions are held together by the structure of simulated architecture, whose transverse arches and diagonal bands separate vault compartments. Twenty nudes appear at intersections and harmonize the composition because they can be read either with the prophets and sibyls below them or with the Genesis scenes, at whose corners they appear. We thus see the basic High Renaissance principle of composition created by the interaction of the component elements.

Michelangelo believed, as did Plato, that the image from the artist's hand must spring from the idea in his mind. The idea is the reality, and it is revealed by the genius of the artist. The artist does not create the ideas, but finds them in the natural world, which reflects the absolute idea: beauty. So, to the neo-Platonist, *imitation of nature in art reveals hidden truths within nature*.

Michelangelo broke with earlier Renaissance artists in his insistence that measurement was subordinate to judgement. He believed that measurement and proportion should be kept "in the eyes," and so established a rationale for the release of genius to do what it would, free from any preestablished "rules." This enabled him to produce works such as *David* (Fig. **12.45**), a colossal figure and the earliest monumental sculpture of the High Renaissance. Towering some 18 ft (5.5 m) above the floor, this nude champion exudes a neo-Platonic pent-up energy as the body seems to act as an earthly prison of the soul. The upper body moves in opposition to the lower. The eye is led downward by the right arm and leg of the figure, and then upward along the left arm. The entire composition seeks to break free from its confinement through thrust and counterthrust.

12.44 Michelangelo, *The Creation of Adam*, Sistine Chapel ceiling (detail), 1508–12. Fresco.

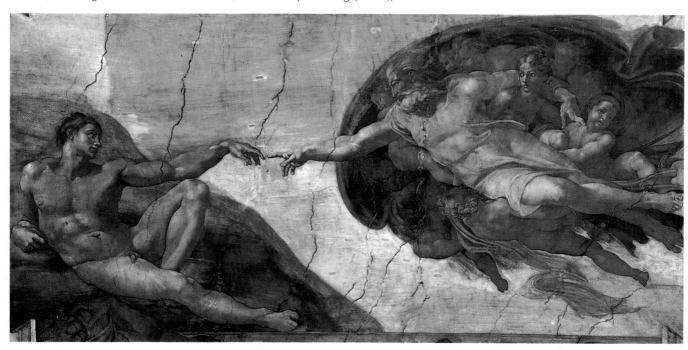

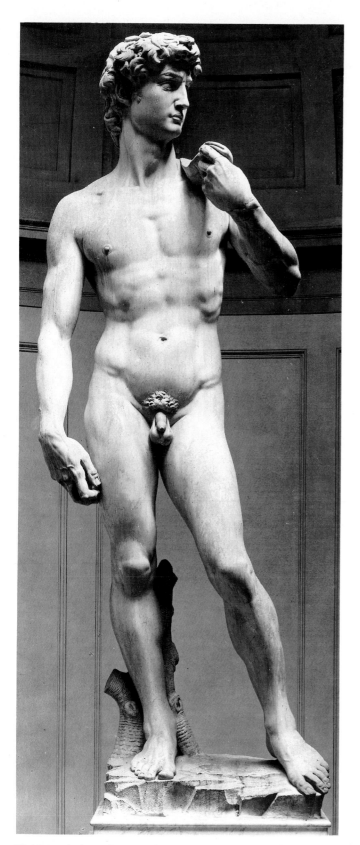

Inspired by the Hellenistic sculptures he had seen in Rome, Michelangelo set out in pursuit of an emotion-charged, heroic ideal. The heroic scale, musculature, emotion, superhuman beauty, and power of the earlier works became a part of his style. However, in contrast with the Hellenistic approach to realism, in which the "body 'acts' out the spirit's agony," 'David, at once calm and tense, shows the action-in-repose so characteristic of Michelangelo."[10]

Papal Splendor: The Vatican

Here for almost 2,000 years has been the center of a spiritual communion; in countries all over the world, Christians aspire to achieve a community of spirit with the successor to St. Peter. By comprehending this significance of the Vatican, one can also understand what it was that led Roman Catholicism to embellish the center of its spiritual power with the diversity of human knowledge, including the arts.[11]

The Renaissance—and particularly the High Renaissance, when the papacy called all great artists to Rome—contributed most of the splendor of Vatican art and architecture. The papacy as a force and the Vatican as the symbol of that force represent a synthesis of Renaissance ideas and reflections. Rome was the city of the arts in the fifteenth and sixteenth centuries. The artists of the age rediscovered classical antiquity and emulated what they found. Imitation was frowned upon, and the classical nature of Renaissance art lies in its expressiveness, which is indeed comparable to that of Greece and Rome. St. Peter's and the Vatican have earthly and heavenly qualities which reflect the reality of the Church on earth and the mystery of the spiritual church of Christ (Fig. **12.47**).

Plans for replacement of the original basilica of Old St. Peter's were made in the fifteenth century, but it was Pope Julius II (1503–13) who decided to put into effect the plans of Nicholas V (1447–55). Julius commissioned Bramante to construct the new basilica. Bramante's design

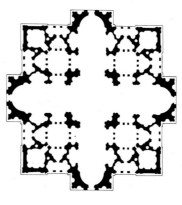

12.46 Bramante's design for St. Peter's, 1506.

12.45 Michelangelo, *David*, 1501–4. Marble, height 13 ft 5 ins (4.08 m) high. The Academy, Florence.

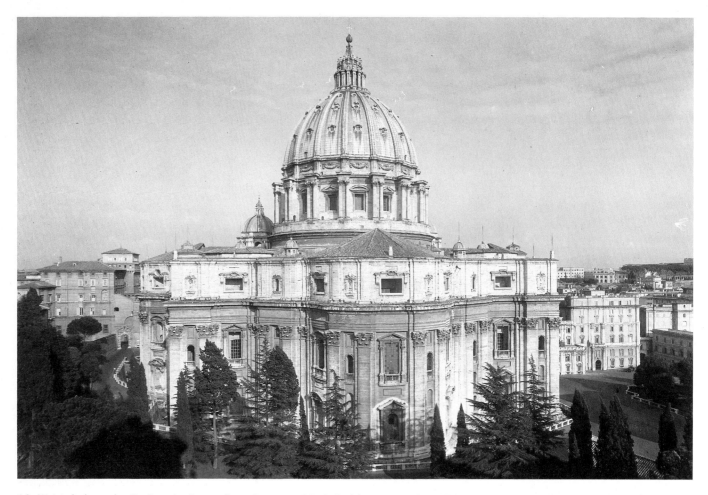

12.47 Michelangelo, St. Peter's, Rome, from the west, 1546–64 (dome completed by Giacomo della Porta, 1590).

called for a building in the form of a Greek cross (Fig. 12.46). The work was planned as "an harmonius arrangement of architectural forms" in an "image of bright amplitude and picturesque liveliness."

Bramante died in 1514 and was succeeded by two of his assistants and Raphael. Liturgical considerations required an elongated structure. Subsequent changes were made by additional architects, and these designs were severely criticized by Michelangelo. Following the death of the last of these architects, Pope Paul III (1534–49) convinced Michelangelo to become chief architect. Michelangelo set aside liturgical considerations and returned to Bramante's original conceptions, which he described as "clear and pure, full of light . . . whoever distances himself from Bramante, also distances himself from the truth" (Fig. 12.48). Michelangelo's project was completed in May of 1590 as the last stone was added to the dome and a High Mass was celebrated. Work on the thirty-six columns continued, however, and was completed by Della Porta and Fontana after Michelangelo's death. Full completion of

the basilica as it stands today was under the direction of yet more architects, including Maderna. Maderna was forced to yield to the wishes of the cardinals and change the original form of the Greek cross to a Latin cross (Fig.

12.48 Michelangelo's design for St. Peter's, 1547.

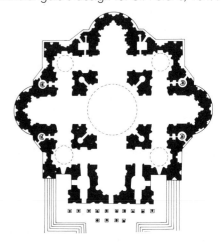

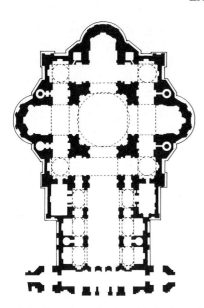

12.49 Plan of St. Peter's as built to Michelangelo's design with alterations by Carla Maderna, 1606–15.

12.49). As a result, the Renaissance design of Michelangelo and Bramante, with its central altar, was rejected. It was replaced by Maderna's design of a travertine façade of gigantic proportions and sober elegance. His extension of the basilica was influential in the development of baroque architecture. The project was completed in 1614.

THE LATE RENAISSANCE IN ENGLAND

Shakespeare and Marlowe

While late Renaissance Italy prepared the way for our modern theatre building and certain acting techniques, sixteenth-century England produced a new theatre of convention, and history's foremost playwright.

We must always be careful when we try to draw conclusions about why the arts developed as they did within a particular historical context. While Italy and France saw the arts prosper under varying forms of extravagant patronage, England saw a theatre of great literary consequence and conventional nature prosper under a monarch who loved the theatre only as long as it did not impose upon her financially. In other words, Elizabeth I encouraged the arts not by patronage of the kind provided by the Medicis, the Church, or Kings Francis I or Louis XIV, but, rather, by benign neglect.

England's drama in the mid- to late sixteenth century was national in character, influenced undoubtedly by the severance of Church and state under Henry VIII. Never-

theless, literary influences in England in the sixteenth century were strongly Italian, and the theatre reflected these influences.

The Elizabethans loved drama, and the theatres of London saw prince and commoner together among its audiences. They sought and found, usually in the same play, action, spectacle, comedy, character, and intellectual stimulation so deeply reflective of the human condition that Elizabethan plays have found universal appeal through the centuries since their first production.

Shakespeare (1564–1616) was the preeminent Elizabethan playwright, and his and English sensitivity to and appreciation of the Italian Renaissance can be seen in the Renaissance Italian settings of many of his plays. In true Renaissance expansiveness, Shakespeare took his audiences back into history, both British and classical, and far beyond, to the fantasy world of Caliban in *The Tempest*. We gain perspective on the Renaissance world's perception of their own or their fellows' condition when we compare the placid, composed reflections of Italian painting with Shakespeare's tragic portraits of Renaissance Italian intrigue.

Like most playwrights of his age, Shakespeare wrote for a specific professional company (of which he became a partial owner). The need for new plays to keep the company alive from season to season provided much of the impetus for his prolific writing, in the same sense that a required weekly cantata stimulated Bach and Scarlatti. A robust quality exists in Shakespeare's plays. His ideas have universal appeal because of his understanding of human motivation and character and his ability to probe deeply into emotion. He provided insights dramatically equivalent to Rembrandt's visual probings. Shakespeare's plays reflect life and love, action and nationalism; and they present those qualities in a magnificent poetry that explores the English language in unrivalled fashion. Shakespeare's use of tone, color, and complex or new word meanings give his plays a musical as well as dramatic quality, which appeals to every generation.

We know more about the theatres that Shakespeare played in than we do about his life, but that information is far from complete. Most authorities believe that the Elizabethan theatre took a unique form. The only previous theatres that approach it are the Spanish corrales, although the Elizabethan theatres may have some distant connections with the Dutch and the Italian. Our sources of information about the Elizabethan playhouse are: first, the great halls and inn yards, where plays were given before the theatres were built; second, the buildings used for bearbaiting and bullbaiting; third, four sketches rang-

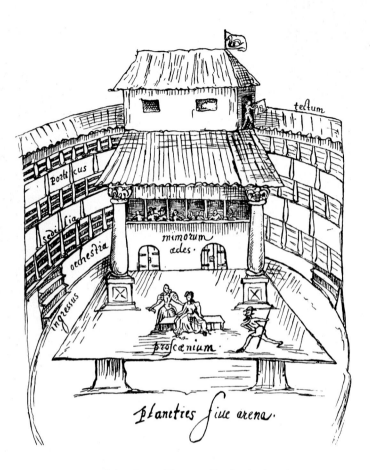

12.50 Interior of the Swan Theatre, Bankside, London (opened 1598). Contemporary pen drawing.

ing in date from about 1596 to 1640, one of which is shown in Figure 12.50; fourth, the wording of the contract for the building of the Fortune Theatre; and fifth, evidence from the stage directions of Elizabethan plays.

When we examine the Elizabethan play, we soon realize how flexible the stage must have been. *Antony and Cleopatra*, for example, has forty-three scenes.

Shakespeare was not the only significant playwright of the English Renaissance stage, however, and the plays of Christopher Marlowe (1564–93) and Ben Jonson (1573–1637) still captivate theatre audiences. Marlowe's love of sound permeates his works, and if his character development is weak, his heroic grandeur has the classical qualities of Aeschylus and Sophocles. His most famous play is *Doctor Faustus (The Tragical History of the Life and Death of Doctor Faustus)*, first published in 1604. The story resembles the plot of a morality play, narrating a man's temptation, fall, and damnation, in richly poetic language. His language was a breakthrough in drama of the time. His flexible use of blank verse and the brilliance of his imagery combine to stimulate emotion and rivet his audience's attention. The imagery of terror in the final scene is among the most powerful in all of drama. In addition, Marlowe's language and imagery unify the play: the patterns in Faust's references to Heaven provide a subtle implication of the force from which Faust cannot escape and yet which he must, at the beginning, deny. "He cannot escape from a world order and from responsibility; nor can he escape from a dream of unfettered domination. That is his tragedy."[12]

THIRTEEN

POST-RENAISSANCE STYLES

BAROQUE TO POST-IMPRESSIONISM

The baroque meant opulence, intricacy, ornateness, and appeal to the emotions, and outdid its predecessors in reflecting the grandiose expectations of its patrons. Diverse and widespread, baroque art took Renaissance clarity of form and recast it into intricate patterns of geometry and fluid movement. The idea of proving one's position to one's peers by overwhelming art infected the aristocracy, the bourgeoisie, and the Roman Catholic Church, whose strategy for coping with the Reformation and the spread of Protestantism included attracting worshippers back into the church with magnificent art, architecture, and music. Systematic rationalism sprang forth as an organizational concept for works of art and as a means of explaining the universe in more secular and scientific terms as well. The world became more and more secularized as power shifted from the Church to more worldly institutions, above all of whom reigned the absolute monarch.

BAROQUE STYLE

With the seventeenth century came an age of intellectual, spiritual, and physical action. Along with the new age

came a new style, the *baroque*, which reflected the characteristics and concerns of its age, and did so in forms that acknowledged the presence of middle-class patronage in addition to that of the Church and the nobility. Painting appealed to the emotions and to a desire for magnificence through opulent ornamentation, but it also adopted a systematized and rational composition in which ornamentation was unified through variation on a single theme. Realism replaced beauty as an objective for painting. Color and grandeur were emphasized, as was dramatic use of lights and darks which carry the viewer's eye off the page. In all baroque art a sophisticated organizational scheme subordinated a multitude of single parts to the whole and carefully merged one part into the next to create an exceedingly complex but highly unified design. Open composition was used to symbolize the notion of an expansive universe. The viewer's eye traveled off the canvas to a wider reality. The human figure, as an object or focus in painting, could be monumental in full Renaissance fashion, but could also now be a minuscule figure in a landscape, part of, but subordinate to, an overwhelming universe. Above all, baroque style was characterized by intensely active compositions that emphasized feeling

rather than form, emotion rather than the intellect.

Baroque painting was diverse in application, although fairly easily identifiable as a general style. It was used to glorify the Church and religious sentiment—both Catholic and Protestant. It portrayed the magnificence of secular wealth, both noble and common, and it spread throughout Europe, with examples in every corner.

The idea of absolutism dominated individual as well as collective psychology in the baroque age, each man governing his life like an absolute monarch. Balthasar Gracian advises the courtier: "Let all your actions be those of a king, or at least worthy of a king in due proportion to your estate." Every man was inwardly a king. The ego, or the superego, became an entity which recognized no limits beyond itself . . . The baroque artist exercised this sovereignty "in due proportion to his estate" as Balthasar Gracian would have any man do; that is, his art. The seventeenth century produced artists who, if not solitaries, were at least independent men . . . who considered their art, even if it depended upon commissions, as a personal activity, allowing no limits to be placed on their creative power.[1]

Individual paintings exhibit clear individuality. Virtuosity emerged as each artist sought to establish a style that was distinctly his own. Baroque style was nearly universal in the period between 1600 and 1725.

COUNTER-REFORMATION BAROQUE

Counter-Reformation baroque art was art in the baroque style which pursued the objectives and visions of the Roman Catholic Church after the Council of Trent.

13.1 Caravaggio, *The Calling of St. Matthew*, c. 1596–98. Oil on canvas, 11 ft 1 in x 11 ft 5 ins (3.38 x 3.48 m). Contarelli Chapel, Santo Luigi dei Francesi, Rome.

Caravaggio

In Rome—the center of early baroque—papal patronage and the Counter-Reformation spirit brought artists together to make Rome the "most beautiful city of the entire Christian world." Caravaggio (1569–1609) was probably the most significant of the Roman baroque painters, and in his works we can see his extraordinary style, in which verisimilitude is carried to new heights. In *The Calling of St. Matthew* (Fig. **13.1**) highlight and shadow create a dynamic portrayal of the moment when the future apostle is touched by divine grace. However, we find here a religious subject depicted in contemporary terms. Realistic imagery turns away from idealized and rhetorical form, and presents itself, rather, in a mundane form. The call from Christ streams, with dramatic *chiaroscuro*, across the two groups of figures via the powerful gesture of Christ to Matthew. Focus occurs through counterthrust of implied line. As Matthew looks down, the others' eyes lead us to Christ, whose gesture, and that of the figure in the center of the grouping, point to Matthew. This great painting expresses one of the central themes of Counter-Reformation belief: that faith and grace are open to all who have the courage and simplicity to transcend intellectual pride, and that the spiritual understanding is a personal, mysterious and overpowering emotional experience.

The splendor of the baroque was particularly noticeable in sculpture. Form and space were charged with energy, which carried beyond the limits of actual physical confines in the same sense as did Bologna's work. As with painting, sculpture appealed to the emotions through an inwardly directed vision that invited participation rather than neutral observation. Feeling was the focus. Baroque sculpture also treated space pictorially, almost like a painting, to describe action scenes rather than single sculptural forms. The best examples we can draw upon are those of the sculptor Gianlorenzo Bernini (1598–1680).

Bernini

David (Fig. **13.2**) exudes dynamic power, action, and emotion as he curls to unleash his stone at a Goliath standing somewhere outside the statue's frame. Our eyes sweep upward along a diagonally curved line and are propelled outward by the concentrated emotion of David's expression. A wealth of detail occupies the composition. Detail is part of the work, elegant in nature but ornamental in character. Repetition of the curvilinear theme carries throughout the work in deep, rich, and fully contoured form. Again the viewer participates emotionally, feels the

13.2 Bernini, *David*, 1623. Marble, height 67 ins (170 cm). Galleria Borghese, Rome.

drama, and responds to the sensuous contours of dramatically articulated muscles. Bernini's *David* flexes and contracts in action, rather than repressing pent-up energy as did Michelangelo's giant-slayer (Fig. **12.45**).

ARISTOCRATIC BAROQUE

Aristocratic baroque was art in the general baroque style which reflected the visions and purposes of the aristocracy. At this time, the power of the aristocracy had become increasingly threatened by the growing bourgeoisie or middle class.

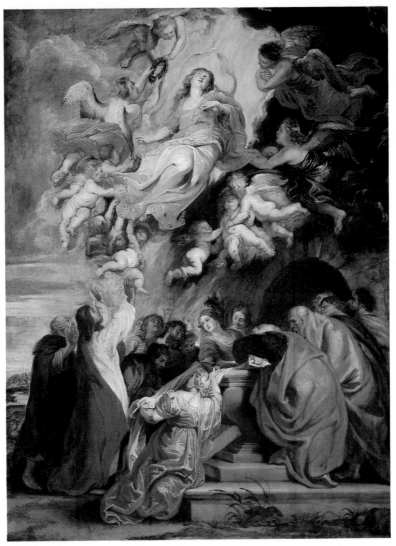

13.3 Peter Paul Rubens, *The Assumption of the Virgin*, c. 1626. Oil on wood, 49⅜ x 37⅛ ins (125 x 94 cm). The National Gallery of Art, Washington DC (Samuel H. Kress Collection).

Rubens

Peter Paul Rubens (1577–1640) painted in the baroque style with vast, overwhelming canvases and fleshy female nudes. His work also illustrates the use of art as religious propaganda. In *The Assumption of the Virgin* (Fig. **13.3**) he presents a swirling and complex composition full of lively action, color, and curvilinear repetition. Typical of Rubens are corpulent cupids and women whose flesh has a sense of softness and warmth we find in few other artists. Rubens's colors here are warm and predominantly limited to the red end of the spectrum. A diagonal sweep of green pulls through the figures in the upper left, but like all the low-value colors in this painting, it is subdued in brilliance. As a result the composition shows a strong contrast in light and dark and in lively and subdued tones. This work swirls comfortably through its uniformly

curvilinear line. Detail is richly naturalistic, but each finely rendered part is subordinate to the whole. Rubens leads the eye around the painting, upward, downward, inward, and outward, occasionally escaping the frame entirely. Nevertheless, he maintains a High Renaissance central triangle beneath the complexity, thus holding the broad base of the painting solidly in place and leading the eye upward to the lovely face of the Virgin at the apex. The overall feeling inspired by this painting is one of richness, glamor, decorativeness, and emotional optimism. Religious and artistic appeal is to worldly emotion and not to intellectualism or mystical asceticism.

Rubens produced works at a prolific rate, primarily because he ran what was virtually a painting factory, where he employed numerous artists and apprentices to

assist in his work. He priced his paintings on the basis of their size and on the basis of how much actual work he, personally, did on them. We should not be overly disturbed by this fact, especially when we consider the individual qualities and concepts expressed in his work. His unique baroque style emerges from every painting, and even an untutored observer can recognize a Rubens with relative ease. Clearly artistic value here lies in the conception, not merly in the handiwork.

BOURGEOIS BAROQUE

Bourgeois baroque was art in the baroque style which reflected the visions and objectives of the new and wealthy middle class, the bourgeoisie. The wealth of this class in some cases was greater than that of the aristocracy, and, as a result, a power struggle was at hand.

Rembrandt

Rembrandt van Rijn (1606–69), in contrast to Rubens, could be called a middle-class artist. Born in Leiden, he trained under local artists and then moved to Amsterdam. His early and rapid success gained him many commissions and students—more, in fact, than he could handle. Rembrandt became what can only be called the first capitalist artist. He believed that the quality of art was represented not only in itself but also in its value on the open market. He reportedly spent huge sums of money in buying his own works to increase their value.

Rembrandt's genius lay in depicting human emotions and characters. He suggests rather than depicts great detail, a characteristic we can find in *The Night Watch*, one of his greatest works (Fig. **13.4**). He concentrates here on atmosphere and shadow, implication and emotion. As in

13.4 Rembrandt van Rijn, *The Night Watch* (*The Company of Captain Frans Burnign Cocq*), 1642. Oil on canvas, 12 ft 2 ins x 14 ft 6 ins (3.7 x 4.44 m). Rijksmuseum, Amsterdam.

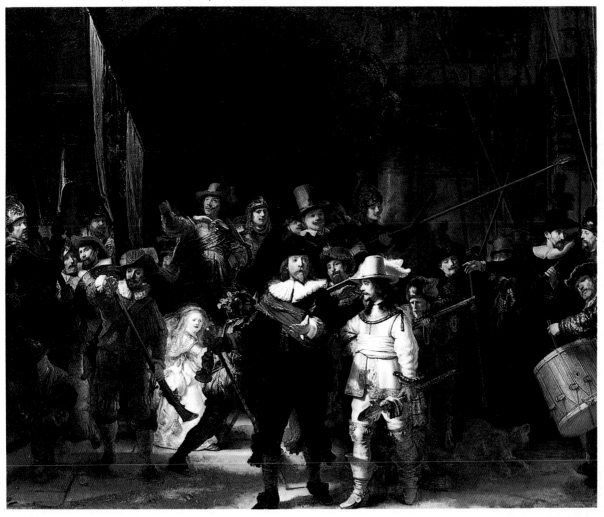

most baroque art, the viewer is invited to share in an emotion, to enter into an experience rather than to observe as an impartial witness.

The huge canvas now in the Rijksmuseum in Amsterdam is only a portion of the original, which was cut down in the eighteenth century to fit into a space in the Town Hall of Amsterdam and no longer shows the bridge over which the members of the watch were about to cross. Group portraits, especially of military units, were popular at the time. They usually showed the company in a social setting such as a gathering around a banquet table. Rembrandt chose to break with the norm and portrayed the company, led by Captain Cocq, as if on duty. The result was a scene of greater vigor and dramatic intensity true to the baroque spirit, but it displeased his patrons.

A recent cleaning has revealed the vivid color of the original; however, its dramatic highlights and shadows reflect no natural light whatsoever. Although the painting is now a good deal brighter than in its previous state, no analysis of light can solve the problem of how these figures are illuminated. Another problem lies in the very title of the work. It has been suggested that this is, in fact, a "Day Watch", so that the intense light at the center of the work is explained as morning sunlight. However, an examination of the highlights and shadows in the painting shows that Rembrandt has based his choice of light for dramatic purposes only. While the figures are rendered with a fair degree of verisimilitude, no such claim can be made for the light sources.

BAROQUE MUSIC

The adjectives generally used to describe baroque painting and sculpture—ornate, complex and emotionally appealing—are applicable in a non-visual sense to music. Reflective of the systematic rationalism of the era, baroque music stressed a refined systematizing of harmonic progression around tonal centers and led to tonal concepts of harmonic progression and major and minor keys that were basic to Western music for the next 300 years.

Baroque composers also began to write for specific instruments, in contrast to previous practices of writing music that might be either sung or played. They also brought to their music implicit forces of action and tension—for example, strong and immediate contrasts in tonal color or volume, and rhythmic strictness played against improvizatory freedom. The baroque era produced great geniuses in music and many new ideas, new instruments, and, most significantly, an entirely new form, opera.

Handel's Messiah

Another major development in the same vein was the *oratorio*. Broad in scale like an opera, it combined a sacred subject with a poetic text, and, like the cantata, was designed for concert performances, without scenery or costume. Many oratorios could be staged and have highly developed dramatic content with soloists portraying specific characters. Oratorio began in Italy in the early seventeenth century, but all other oratorio accomplishments pale in comparison with the works of its greatest master, George Frederick Handel (1685–1759). Although Handel was German by birth he lived in England and wrote his oratorios in English. His works continue to enjoy wide popularity, and each year his *Messiah* has thousands of performances around the world. Most of Handel's oratorios are highly dramatic in structure and contain exposition, conflict or complication and *denouement* or resolution sections. Many could be staged in full operatic tradition (except for two outstanding examples, *Israel in Egypt* and the *Messiah*). Woven carefully into the complex structure of Handel's oratorios was a strong reliance on the chorus. His choral sections (as well as his arias and recitatives) are carefully developed and often juxtapose complex polyphonic sections and homophonic sections. Each choral movement has its own internal structure, which, like the oratorio itself, rises to a climax and resolves to a conclusion. Most of the solo and choral sections of Handel's oratorios can stand on their own as performance pieces. They also fit magnificently together in a systematic development, losing their separate importance to the overall composition.

The most popular of all oratorios, Handel's *Messiah*, was written in 1741 in twenty-four days. The work is divided into three parts: the birth of Jesus; Jesus' death and resurrection; and the redemption of humanity. The music comprises an overture, choruses, recitatives, and arias, and is written for small orchestra, chorus, and soloists. The choruses provide some of the world's best-loved music, including the famous *Hallelujah Chorus*.

The chorus *For Unto Us a Child is Born* is the climax of the first part. First, the orchestra presents the opening theme and then the voices restate it (Fig. **13.5**).

13.5 Handel, *For Unto Us a Child is Born*, opening theme of chorus.

Later the texture will alternate between polyphonic (contrapuntal) and homophonic (chordal). The opening key is G major, which then modulates to D major and C major, returning to G major. The meter is quadruple, and the tempo lively; the chorus quickly moves into long melismatic passages—that is, single words sustained over many notes. These melismas are characteristic of Handel's works. The climax of the chorus comes with the words "and his name shall be called Wonderful! Counselor!" Over the course of the piece that text is repeated three times. A second theme appears before the climax and consists of a rising and falling melodic contour with a new phrase of text (Fig. **13.6**).

13.6 Handel, *For Unto Us a Child is Born*, second theme of chorus.

The structure of the piece works around an alternation of the first and second themes. The chorus ends with a repeat of the opening theme in the orchestra.

Bach—Fugue in G Minor (S.578)

Bach's organ compositions are famous for their drama, bold pedal solos and virtuoso techniques. The *Fugue in G Minor*, or "Little Fugue," is a characteristic example.

The *fugue* is a polyphonic development of one, two, or sometimes three short themes. Fugal form, which takes its name from the Latin *fuga* ("flight"), has a traditional scheme of seven elements, only some of which may be found in any given fugue. However, two characteristics are common to all fugues: first, counterpoint and, second, a clear *dominant-tonic* relationship—that is, imitation of the theme or subject at the fifth above or below the tonic. Each voice in a fugue develops the basic subject independently from the other voices, and passes through as many of the seven elements as the composer deems necessary. Unification is achieved not by return to an opening section, as in closed form, but by the varying recurrences of the subject throughout.

· The *Fugue in G Minor* is typical of Bach's fugues in that the texture begins as a monophonic phrase that is followed with polyphony. This fugue has four voices, and the subject is stated in the top voice and then answered by the alto voice (Fig. **13.7**).

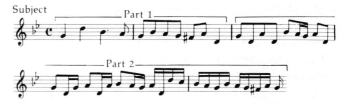

13.7 Bach, *Fugue in G Minor*, statement of subject.

The meter is duple and the texture monophonic, moving to polyphony or counterpoint. The exposition of the piece closes after the subject has been stated in each of the four voices. Immediately following the exposition Bach inserts a brief episode based on the first three notes of the subject. The work then modulates to the dominant key of D minor and returns to a restatement of the subject in this new key. Below the restatement of the subject and counter-subject, all of which is somewhat hidden in a complex texture, Bach sustains a bass pedal tone, called a *pedal point*, a characteristic element of the fugue.

Once he has restated the subject and counter-subject in the dominant key, he makes a brief statement on the subject in a third key, B-flat major, the relative major to G minor. In this episode Bach presents the subject and counter-subject once each. A third episode follows and remains in B flat, stating the subject and counter-subject once more. In a fourth episode, based on the first, the fugue not only restates the subject but changes its rhythmic pattern as well. The ending episode of the piece moves into a complex harmonic development in several keys and homophonic texture, climaxing in a rising chromatic scale and ending in a strong cadence. The final statement of the subject comes in the bass line.

COURT BAROQUE

Absolutism at Versailles

Probably no monarch better represents the absolutism of the baroque era than Louis XIV, and no artwork better represents the magnificence and grandeur of the baroque style than does the Palace of Versailles and its sculpture and grounds—a grand design of buildings and nature to reflect man's systematic rationalism. The great Versailles complex grew from the modest hunting lodge of Louis XIII into the grand palace of the Sun King over a number of years, involving several architects and amid curious political and religious circumstances.

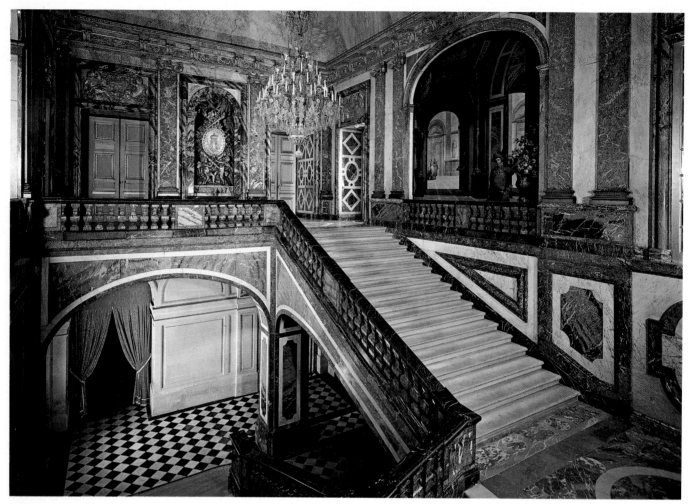

13.8 The Queen's Staircase, Palace of Versailles.

The Versailles château was rebuilt in 1631 by Philibert Le Roy. The façade was decorated by Louis Le Vau with bricks and stone, sculpture, wrought iron and gilt lead. In 1668 Louis XIV ordered Le Vau to enlarge the château by enclosing it in a stone envelope containing the king's and queen's apartments (Fig. **13.8**). The city side of the château retains the spirit of Louis XIII, but the park side reflects classical French influence (Fig. **13.9**). François d'Orbay and, later Jules Hardouin-Mansart expanded the château into a palace whose west façade extends over 2,000 ft (609 m). The palace became Louis XIV's permanent residence in 1682. French royalty was at the height of its power and Versailles was the symbol of the Divine Right of Kings—the absolute authority of the monarch.

As much care, elegance and precision was employed on the interior as on the exterior. With the aim of developing French commerce, Louis XIV had his court live in unparalleled luxury. He also decided to furnish his château permanently, something which was unheard of.

The result was a fantastically rich and beautiful set of furnishings. Royal manufactories produced mirrors, tapestries, and brocades. The highest quality was required, and these furnishings became highly sought after in Europe. Le Brun coordinated all the decoration and furnishing of the royal residences, and kept a meticulous eye on anything for the State Apartments, such as the creation of statues, the design of ceilings and the carving of silver pieces of furniture. The grounds are adorned throughout with fountains and statues. The Fountain of Apollo (Fig. **13.10**) emphasizes the symbolism of the gardens and sits astride the east–west axis of the grounds. This magnificent composition by Tuby was originally covered with gold. The sculpture was executed from a drawing by Le Brun and inspired by a painting by Albani. It continues the theme of allegorical glorification of *Le Roi Soleil* by representing the break of day, as the sun god rises in his chariot from the waters. Apollo was the perfect symbol for Louis XIV, whose absolutism shone in

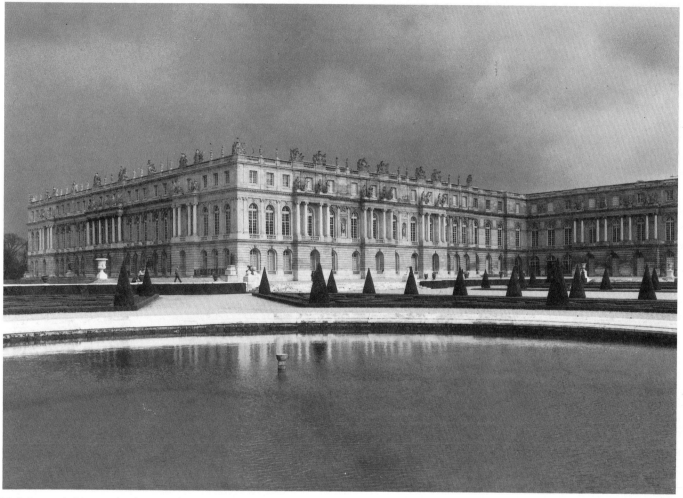

13.9 Louis de Vau and Jules Hardouin-Mansart, garden façade, Palace of Versailles, 1669–85.

glorious baroque splendor, systematically rational, yet emotional in spirit, opulent in tone, and complex in design.

13.10 The Fountain of Apollo, Palace of Versailles.

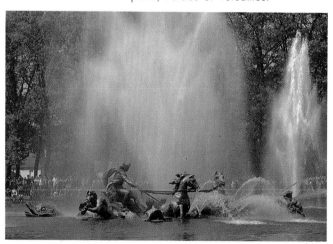

THE ENLIGHTENMENT

The eighteenth century was an age of change and revolution in some areas and prosperous stability in others. The idea of the absolute monarch was challenged—though with varying success. The middle class rose to demand its place in society, and the human condition—social philosophy in action—attempted to make a place for all classes in the scheme of things. Knowledge, for the *Philosophes*, was a transcendent and universal goal. The *Philosophes* were writers and scholars who undertook the challenge of making the great ideas and texts of human intellect accessible to the general public. In short, they were popularizers. The aristocracy found itself in decline, and the rococo style reflected their increasingly superficial and delicate condition. The pendulum then swung back from exquisite refinement and artifice to intellectual seriousness, at least for a while. The structural clarity of classi-

cism returned in painting, sculpture, and architecture, and above all in music, which found the culmination of a remarkable century in works of emotional depth and formal inventiveness. The cult of "sensibility" with which the century closed presaged the upheavals of *Sturm und Drang* and the Romantics.

ROCOCO

The change from grand baroque courtly life to that of the small salon and intimate townhouse was reflected in a new style of painting called rococo. This was a product of its time. Rococo art satirized the mores of the age, criticizing with humor the behavior of the times. Its intimate grace, charm, and delicate superficiality reflect the social ideals and manners of the age. Informality replaced formality in life and in painting. The logic and academic character of the baroque of Louis XIV was found lacking in feeling and sensitivity. Its overwhelming scale and grandeur were too ponderous. Deeply dramatic action

faded into lively effervescence and melodrama. Love, sentiment, pleasure, and sincerity became predominant themes. None of these characteristics conflicts significantly with the overall tone of the Enlightenment, whose major goal was the refinement of man. The arts of the period dignified the human spirit through social consciousness and bourgeois social morality, as well as through the graceful gamesmanship of love. Delicacy, informality, lack of grandeur, and lack of action did not always imply superficiality or limp sentimentality.

The transitional quandary of the aristocracy can be seen in the rococo paintings of Antoine Watteau (1683–1721). Although largely sentimental, much of Watteau's work refrains from gaiety or frivolousness. *Embarkation for Cythera* (Fig. **13.11**) illustrates idealized concepts of aristocratic social graces. Cythera is a mythological land of enchantment, the island of Venus, and Watteau portrays aristocrats as they await departure for that faraway place idling away their time in amorous pursuits. Fantasy qualities in the landscape are created by fuzzy

13.11 Antoine Watteau, *Embarkation for Cythera*, 1717. Oil on canvas, 51 x 76½ ins (129.5 x 194.3 cm). The Louvre, Paris.

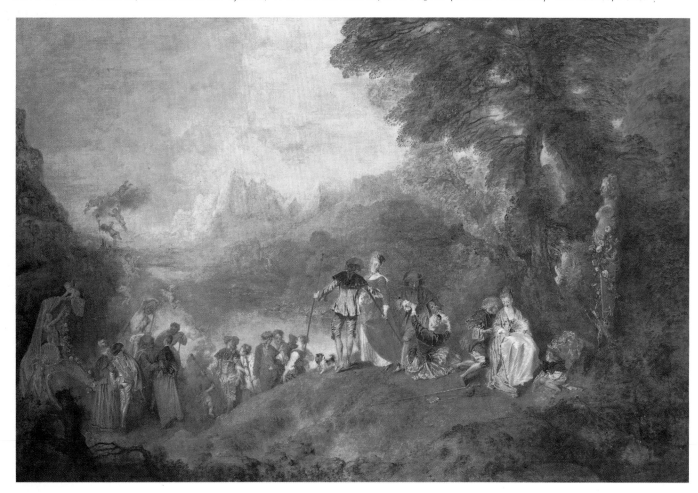

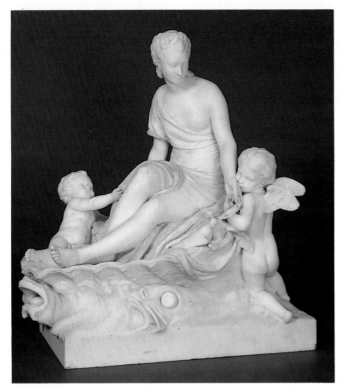

so on, recurring motifs in painting of this style. Venus appears frequently, often depicted in the thinly disguised form of a prominent lady of the day. Madame de Pompadour, who epitomized love, charm, grace, and delicacy for the French, appears often as a subject in sculpture as well as in painting. Rococo sculpture was not on the monumental scale of its predecessors. Rather, in the spirit of decoration that marked the era, sculpture often took the form of delicate and graceful porcelain and metal figurines. Falconet's *Madame de Pompadour as the Venus of the Doves* (Fig. **13.12**) fully captures the erotic sensuality, delicacy, lively intelligence, and charm of the rococo heritage. The unpretentious nudity indicates the complete comfort and naturalness the eighteenth century found in love and affairs of the flesh.

Rococo sculpture exhibits masterful technique. Its surface textures, detail, and line all display superb delicacy and control of the medium. If this style and the society it exemplifies is found wanting in profundity, it must be admired for its technical achievement.

Claude Michel, best known as Clodion, reinforces the delicate themes of the time in dynamic miniatures such as the *Satyr and Bacchante* (Fig. **13.13**). "His groups of

13.12 Étienne-Maurice Falconet, *Madame de Pompadour as the Venus of the Doves*, 1782. Marble, height 29½ ins (75 cm). The National Gallery of Art, Washington DC (Samuel H. Kress Collection).

color areas and hazy atmosphere. A soft, undulating line underscores the human figures, all posed in slightly affected attitudes. Watteau's fussy details and decorative treatment of clothing stand in contrast to the diffused quality of the background. Each grouping of couples engages in graceful conversation and love games typical of the age. Delicacy pervades the scene, over which an armless bust of Venus presides. Underlying this dreamlike fantasy there is a deep, poetic melancholy. These doll-like figurines, which are only symbols, engage in sophisticated and elegant pleasure, but the softness and affectation of the work counterbalance gaiety with languid sorrow.

Sculpture struggled in the eighteenth century. The Academy of Sculpture and the French Academy in Rome encouraged the copying of antique sculpture, and resisted changes in style. Sculpture continued in the baroque style and lacked originality. Rococo style did find expression in the work of Falconet (1716–91) and Clodion (1738–1814), with their myriad decorative cupids, nymphs, and

13.13 Clodion (Claude Michel), *Satyr and Bacchante*, c. 1775. Terracotta, height 23¼ ins (59 cm). The Metropolitan Museum of Art, New York (Bequest of Benjamin Altman, 1913 [14.40.687]).

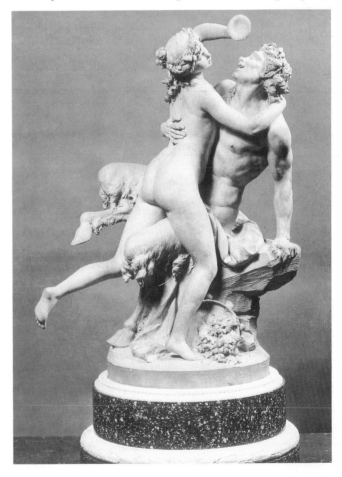

13.14 G.H. Krohne, The Music Room, 1742–51. Thuringer Museum, Eisenach, Germany.

accurately modeled figures in erotic abandon are made all the fresher and more alluring by his knowing use of pinkish terracotta as if it were actually pulsating flesh, rendering each incipient embrace 'forever warm and still to be enjoyed'."[2]

Rococo also exhibited itself in interior design. Its refinement and decorativeness applied nicely to furniture and décor. The difference between opulence and delicacy

13.15 Francois de Cuvilliés, The Pagondenburg, c. 1722. Schloss Nymphenburg, Munich, Germany.

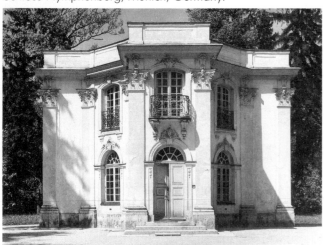

was apparent. Figure **13.14** shows a polygonal music room characteristic of German rococo. Broken wall surfaces made possible stucco decoration of floral branches in a pseudo-naturalistic effect. In Venice curved leg furniture, cornices, and guilded carvings were *à la mode*. French designer François de Cuvilliés (1695–1768) combined refinement, lightness, and reduced scale to produce a pleasant atmosphere of grace and propriety (Fig. **13.15**).

Jonathan Swift—A Modest Proposal

Jonathan Swift (1667–1745) was an Anglo-Irish satirist and churchman. His *Gulliver's Travels* mocked pomposity and woolly-headed idealism equally, while his other famous work in prose, *A Modest Proposal* (included here), took satire to the very edge of horror with its chillingly deadpan suggestion that the English should solve the "Irish Problem" by eating the babies of the poor. He represents enlightened rococo spirit in literature.

For Preventing the Children of Poor People in Ireland from Being a Burden to Their Parents or Country, and for Making Them Beneficial to the Public

It is a melancholy object to those who walk through this great town or travel in the country, when they see the streets, the roads and cabin doors, crowded with beggars of the female sex, followed by three, four, or six children, all in rags and importuning every passenger for an alms. These mothers, instead of being able to work for their honest livelihood, are forced to employ all their time in strolling to beg sustenance for their helpless infants, who, as they grow up, either turn thieves for want of work, or leave their dear native country to fight for the Pretender in Spain, or sell themselves to the Barbadoes.

I think it is agreed by all parties that this prodigious number of children in the arms, or on the backs, or at the heels of their mothers, and frequently of their fathers, is in the present deplorable state of the kingdom a very great additional grievance; and therefore whoever could find out a fair, cheap, and easy method of making these children sound, useful members of the commonwealth would deserve so well of the public as to have his statue set up for a preserver of the nation.

But my intention is very far from being confined to provide only for the children of professed beggars; it is of a much greater extent, and shall take in the whole number of infants at a certain age who are born of parents in effect as little able to support them as those who demand our charity in the streets.

As to my own part, having turned my thoughts for many years upon this important subject, and maturely weighed the several schemes of other projectors, I have always found them grossly

mistaken in their computation. It is true, a child just dropped from its dam may be supported by her milk for a solar year, with little other nourishment; at most not above the value of two shillings which the mother may certainly get, or the value in scraps, by her lawful occupation of begging; and it is exactly at one year old that I propose to provide for them in such a manner as instead of being a charge upon their parents or the parish, or wanting food and raiment for the rest of their lives, they shall on the contrary contribute to the feeding, and partly to the clothing, of many thousands.

There is likewise another great advantage in my scheme, that it will prevent those voluntary abortions, and that horrid practice of women murdering their bastard children, alas, too frequent among us, sacrificing the poor innocent babes, I doubt, more to avoid the expense than the shame, which would move tears and pity in the most savage and inhuman breast.

The number of souls in this kingdom being usually reckoned one million and a half, of these I calculate there may be about two hundred thousand couples whose wives are breeders; from which number I subtract thirty thousand couples who are able to maintain their own children, although I apprehend there cannot be so many under the present distresses of the kingdom; but this being granted, there will remain an hundred and seventy thousand breeders. I again subtract fifty thousand for those women who miscarry, or whose children die by accident or disease within the year. There only remain an hundred and twenty thousand children of poor parents annually born. The question therefore is, how this number shall be reared and provided for, which, as I have already said, under the present situation of affairs, is utterly impossible by all the methods hitherto proposed. For we can neither employ them in handicraft or agriculture; we neither build houses (I mean in the country) nor cultivate land. They can very seldom pick up a livelihood by stealing till they arrive at six years old, except where they are of towardly parts; although I confess they learn the rudiments much earlier, during which time they can however be looked upon only as probationers, as I have been informed by a principal gentleman in the county of Cavan, who protested to me that he never knew above one or two instances under the age of six, even in a part of the kingdom so renowned for the quickest proficiency in that art.

I am assured by our merchants that a boy or a girl before twelve years old is no salable commodity; and even when they come to this age they will not yield above three pounds, or three pounds and half a crown at most on the Exchange; which cannot turn to account either to the parents or the kingdom, the charge of nutriment and rags having been at least four times that value.

I shall now therefore humbly propose my own thoughts, which I hope will not be liable to the least objection.

I have been assured by a very knowing American of my acquaintance in London, that a young healthy child well nursed is at a year old a most delicious, nourishing, and wholesome food, whether stewed, roasted, baked, or boiled; and I make no doubt that it will equally serve in a fricassee or a ragout.

I do therefore humbly offer it to public consideration that of the hundred and twenty thousand children, already computed, twenty thousand may be reserved for breed, whereof only one fourth part to be males, which is more than we allow to sheep, black cattle, or swine; and my reason is that those children are seldom the fruits of marriage, a circumstance not much regarded by our savages, therefore one male will be sufficient to serve four females. That the remaining hundred thousand may at a year old be offered in sale to the persons of quality and fortune through the kingdom, always advising the mother to let them suck plentifully in the last month, so as to render them plump and fat for a good table. A child will make two dishes at an entertainment for friends; and when the family dines alone, the fore or hind quarter will make a reasonable, dish, and seasoned with a little pepper or salt will be very good boiled on the fourth day, especially in winter.

I have reckoned upon a medium that a child just born will weigh twelve pounds, and in a solar year if tolerably nursed increaseth to twenty-eight pounds.

I grant this food will be somewhat dear, and therefore very proper for landlords, who, as they have already devoured most of the parents, seem to have the best title to the children.

Infant's flesh will be in season throughout the year, but more plentiful in March, and a little before and after. For we are told by a grave author, an eminent French physician, that fish being a prolific diet, there are more children born in Roman Catholic countries about nine months after Lent than at any other season; therefore, reckoning a year after Lent, the markets will be more glutted than usual, because the number of popish infants is at least three to one in this kingdom; and therefore it will have one other collateral advantage, by lessening the number of Papists among us.

I have already computed the charge of nursing a beggar's child (in which list I reckon all cottagers, laborers, and four fifths of the farmers) to be about two shillings per annum, rags included; and I believe no gentleman would repine to give ten shillings for the carcass of a good fat child, which, as I have said, will make four dishes of excellent nutritive meat, when he hath only some particular friend or his own family to dine with him. Thus the squire will learn to be a good landlord, and grow popular among the tenants; the mother will have eight shillings net profit, and be fit for work till she produces another child.

Those who are more thrifty (as I must confess the times require) may flay the carcass; the skin of which artificially dressed will make admirable gloves for ladies, and summer boots for fine gentlemen.

As to our city of Dublin, shambles may be appointed for this purpose in the most convenient parts of it, and butchers we may be assured will not be wanting; although I rather recommend

buying the children alive, and dressing them hot from the knife as we do roasting pigs.

A very worthy person, a true lover of his country, and whose virtues I highly esteem, was lately pleased in discoursing on this matter to offer a refinement upon my scheme. He said that many gentlemen of this kingdom, having of late destroyed their deer, be conceived that the want of venison might be well supplied by the bodies of young lads and maidens, not exceeding fourteen years of age nor under twelve, so great a number of both sexes in every county being now ready to starve for want of work and service; and these to be disposed of by their parents, if alive, or otherwise by their nearest relations. But with due deference to so excellent a friend and so deserving a patriot, I cannot be altogether in his sentiments, for as to the males, my American acquaintance assured me from frequent experience that their flesh was generally tough and lean, like that of our schoolboys, by continual exercise, and their taste disagreeable; and to fatten them would not answer the charge. Then as to the females, it would, I think with humble submission, be a loss to the public, because they soon would become breeders themselves; and besides, it is not improbable that some scrupulous people might be apt to censure such a practice (although indeed very unjustly) as a little bordering upon cruelty; which I confess, hath always been with me the strongest objection against any project, how well soever intended.

But in order to justify my friend, he confessed that this expedient was put into his head by the famous Psalmanazar, a native of the island Formosa, who came from thence to London above twenty years ago, and in conversation told my friend that in his country when any young person happened to be put to death, the executioner sold the carcass to persons of quality as a prime dainty; and that in his time the body of a plump girl of fifteen, who was crucified for an attempt to poison the emperor, was sold to his Imperial Majesty's prime minister of state, and other great mandarins of the court, in joints from the gibbet, at four hundred crowns. Neither indeed can I deny that if the same use were made of several plump young girls in this town, who without one single groat to the fortunes cannot stir abroad without a chair, and appear at the playhouse and assemblies in foreign fineries which they never will pay for, the kingdom would not be the worse.

Some persons of a desponding spirit are in great concern about that vast number of poor people who are aged, diseased, or maimed, and I have been desired to employ my thoughts what course may be taken to ease the nation of so grievous an encumbrance. But I am not in the least pain upon that matter, because it is very well known that they are every day dying and rotting by cold and famine, and filth and vermin, as fast as can be reasonably expected. And as to the younger laborers, they are now in almost as hopeful a condition. They cannot get work and consequently pine away for want of nourishment to a degree that if at any time they are accidentally hired to common labor, they have not strength to perform it; and thus the country and themselves are happily delivered from the evils to come.

I have too long digressed, and therefore shall return to my subject. I think the advantages by the proposal which I have made are obvious and many, as well as of the highest importance.

For first, as I have already observed, it would greatly lessen the number of Papists, with whom we are yearly overrun, being the principal breeders of the nation as well as our most dangerous enemies; and who stay at home on purpose to deliver the kingdom to the Pretender, hoping to take their advantage by the absence of so many good Protestants, who have chosen rather to leave their country than stay at home and pay tithes against their conscience to an Episcopal curate.

Secondly, the poorer tenants will have something valuable of their own, which by law be made liable to distress, and help to pay their landlord's rent, their corn and cattle being already seized and money a thing unknown.

Thirdly, whereas the maintenance of an hundred thousand children, from two years old and upwards, cannot be computed at less than ten shillings a piece per annum, the nation's stock will be thereby increased fifty thousand pounds per annum, besides the profit of a new dish introduced to the tables of all gentlemen of fortune in the kingdom who have any refinement in taste. And the money will circulate among ourselves, the goods being entirely of our own growth and manufacture.

Fourthly, the constant breeders, besides the gain of eight shillings sterling per annum by the sale of their children, will be rid of the charge of maintaining them after the first year.

Fifthly, this food would likewise bring great custom to taverns, where the vintners will certainly be so prudent as to procure the best receipts for dressing it to perfection, and consequently have their houses frequented by all the fine gentlemen, who justly value themselves upon their knowledge in good eating; and a skillful cook, who understands how to oblige his guests, will contrive to make it as expensive as they please.

Sixthly, this would be a great inducement to marriage, which all wise nations have either encouraged by rewards or enforced by laws and penalties. It would increase the care and tenderness of mothers toward their children, when they were sure of a settlement for life to the poor babes, provided in some sort by the public, to their annual profit instead of expense. We should see an honest emulation among the married women, which of them could bring the fattest child to the market. Men would become as fond of their wives during the time of their pregnancy as they are now of their mares in foal, their cows in calf, or sows when they are ready to farrow; nor offer to beat or kick them (as is too frequent a practice) for fear of a miscarriage.

Many other advantages might be enumerated. For instance, the addition of some thousand carcasses in our exportation of barreled beef, the propagation of swine's flesh, and improvement in the art of making good bacon, so much wanted among us by the great destruction of pigs, too frequent at our tables, which are no way comparable in taste or magnificence to a well-grown, fat, yearling child, which roasted whole will make a considerable figure at a lord mayor's feast or any other public

entertainment. But this and many others I omit, being studious of brevity.

Supposing that one thousand families in this city would be constant customers for infants' flesh, besides others who might have it at merry meetings, particularly weddings and christenings, I compute that Dublin would take off annually about twenty thousand carcasses, and the rest of the kingdom (where probably they will be sold somewhat cheaper) the remaining eighty thousand.

I can think of no one objection that will possibly be raised against this proposal, unless it should be urged that the number of people will be thereby much lessened in the kingdom. This I freely own, and it was indeed one principal design in offering it to the world. I desire the reader will observe, that I calculate my remedy for this one individual kingdom of Ireland and for no other that ever was, is, or I think even can be upon earth. Therefore let no man talk to me of other expedients: of taxing our absentees at five shillings a pound: of using neither clothes nor household furniture except what is of our own growth and manufacture: of utterly rejecting the materials and instruments that promote foreign luxury: of curing the expensiveness of pride, vanity, idleness, and gaming in our women: of introducing a vein of parsimony, prudence, and temperance: of learning to love our country, in the want of which we differ even from Laplanders and the inhabitants of Topinamboo: of quitting our animosities and factions, nor acting any longer like the Jews, who were murdering one another at the very moment their city was taken: of being a little cautious not to sell our country and conscience for nothing: of teaching landlords to have at least one degree of mercy toward their tenants: lastly, of putting a spirit of honesty, industry, and skill into our shopkeepers; who, if a resolution could now be taken to buy only our native goods, would immediately unite to cheat and exact upon us in the price, the measure, and the goodness, nor could ever yet be brought to make one fair proposal of just dealing, though often and earnestly invited to it.

Therefore I repeat, let no man talk to me of these and the like expedients, till he hath at least some glimpse of hope that there will ever be some hearty and sincere attempt to put them in practice.

But as to myself, having been wearied out for many years with offering vain, idle, visionary thoughts, and at length utterly despairing of success, I fortunately fell upon this proposal, which, as it is wholly new, so it hath something solid and real, and no expense and little trouble, full in our own power, and whereby we can incur no danger in disobliging England. For this kind of commodity will not bear exportation, the flesh being of too tender a consistence to admit a long continuance, in salt, although perhaps I could name a country which would be glad to eat up our whole nation without it.

After all, I am not so violently bent upon my own opinion as to reject any offer proposed by wise men, which shall be found equally innocent, cheap, easy, and effectual. But before something of that kind shall be advanced in contradiction to my scheme, and offering a better, I desire the author or authors will be pleased maturely to consider two points. First, as things now stand, how they will be able to find food and raiment for an hundred thousand useless mouths and backs. And secondly, there being a round million of creatures in human figure throughout this kingdom, whose sole subsistence put into a common stock would leave them in debt two millions of pounds sterling, adding those who are beggars by profession to the bulk of farmers, cottagers, and laborers, and their wives and children who are beggars in effect; I desire those politicians who dislike my overture, and may perhaps be so bold to attempt an answer, that they will first ask the parents of these mortals whether they would not at this day think it a great happiness to have been sold for food at a year old in the manner I prescribe, and thereby have avoided such a perpetual scene of misfortunes as they have since gone through by the oppression of landlords, the impossibility of paying rent without money or trade, the want of common sustenance, with neither house nor clothes to cover them from the inclemencies of the weather, and the most inevitable prospect of entailing the like or greater miseries upon their breed forever.

I profess, in the sincerity of my heart, that I have not the least personal interest in endeavoring to promote this necessary work, having no other motive than the public good of my country, by advancing our trade, providing for infants, relieving the poor, and giving some pleasure to the rich. I have no children by which I can propose to get a single penny; the youngest being nine years old, and my wife past childbearing.[3]

THE HUMAN CONDITION

In strong contrast to the aristocratic frivolity of rococo style was the biting satire and social comment of enlightened individuals such as William Hogarth (1697–1764) in England in the 1730s. Hogarth portrayed dramatic scenes on moral subjects, and his *Rake's Progress* and *Harlot's Progress* series are an attempt to instil solid middle-class values. He attacked the foppery of the aristocracy, drunkenness, and social cruelty. In the *Harlot's Progress* series the harlot is a victim of circumstances. She arrives in London, is seduced by her employer, and ends up in Bridewell Prison. Hogarth portrays her final fate less as a punishment for her sins than as a comment on humankind's general cruelty. The same may be said of the *Rake's Progress*, which portrays the unfortunate downfall of a foolish young man from comfortable circumstances. This series moves through

several unusual and exciting incidents (Fig. **13.16**) to a final fate in Bedlam insane asylum. Hogarth's concern for and criticism of social conditions are expressed in his paintings and represent incitement to action characteristic of eighteenth-century humanitarianism. The fact that his paintings were made into engravings and widely sold as prints to the public illustrates the popularity of attacks on social institutions of the day.

LANDSCAPE AND PORTRAITURE

The popularity of portraiture and landscape also increased in the eighteenth century. One of the most influential English painters of the time was Thomas Gainsborough (1727–88), whose landscapes bridge the gap between the styles of baroque and romantic and whose portraits range from rococo to sensitive elegance.

Although the elegant attenuation of his lords and ladies is indebted to his study of Van Dyck, Gainsborough achieved in his full-length portraits a freshness and lyric grace all his own. Occasional objections to the lack of structure in his weightless figures are swept away by the beauty of his color and the delicacy of his touch, closer to the deft brushwork of Watteau than to Boucher's enameled surface . . . His landscapes . . . exhale a typically English freshness.[4]

In *The Market Cart* (Fig. **13.17**) we find a delicate use of wash reminiscent of Watteau. We are caught up in an exploration of tonalities and shapes which express a deep and almost mystical response to nature. Although a pastoral, the composition has energy from its diagonal character. The tree forms on the right border are twisted and gnarled. The foremost tree leads the viewer's eye up and to the left, to be caught by the downward circling line of the trees and clouds in the background and returned on

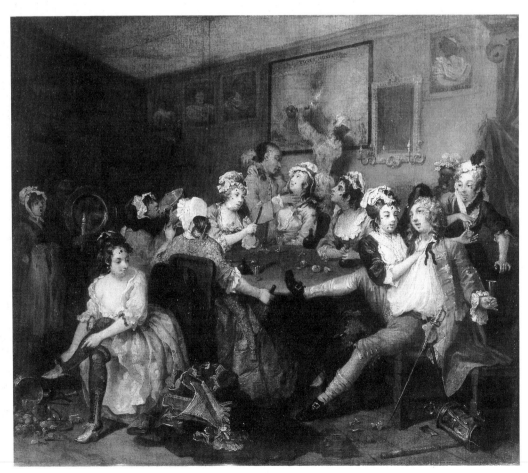

13.16 William Hogarth, *The Rake's Progress: The Orgy*, 1733–34. Oil on canvas, 24½ x 29½ ins (62 x 75 cm). By Courtesy of the Trustees of Sir John Soane's Museum, London.

13.17 Thomas Gainsborough, *The Market Cart*, 1786–7. Oil on canvas, 72½ x 60¼ ins (184 x 153 cm). The Tate Gallery, London.

the diagonal. Gainsborough does not wish us to become too interested in the humans in the picture; they are warmly rendered, but not as individuals, their forms remain indistinct. Rather, we see them as a subordinate to the forces of nature, which ebb and flow around and through them.

GENRE AND SOCIAL COMMENT

A new bourgeois flavor could be found in the mundane (genre) subjects of France's Jean-Baptiste Siméon Chardin (1699–1779). He was the finest still-life and genre painter of his time, and a rival to the Dutch masters of the previous century. His early works are almost exclusively still lifes, and *Menu de Gras* (Fig. **13.18**) illustrates how the everyday could be raised to exquisite levels. With gentle insight and sympathy, the artist invests cooking pot, ladle, pitcher, bottles, cork, a slab of meat, and other small items with significance. Richness of texture and color combined with sensitive composition and the use of

chiaroscuro make these humble items somehow noble. The eye moves slowly from point to point, carefully directed by shapes and angles, color and highlight. The work controls the speed of our viewing; each new focus demands that we pause and savor its richness. There is pure poetry in Chardin's brush. We are subtly urged to go beyond the surface impression of the objects themselves into a deeper reality.

Goldsmith

Contemporary literature also reflected the eighteenth-century focus on the commonplace which we see in the paintings of Chardin. Day-to-day occurrences are frequently used as symbols of a higher reality—for example, in the work of Oliver Goldsmith (1730–74), a prominent English eighteenth-century poet and playwright. He grew up in the village of Lissoy, where his father was vicar. The *Deserted Village*, written in 1770, describes the sights and personalities of his village.

13.18 Jean-Baptiste Simeon Chardin, *Menu de Gras*, 1731. Oil on canvas, 13 x 16⅛ ins (33 x 41 cm). The Louvre, Paris.

Sweet Auburn! Loveliest village of the plain
Where health and plenty cheered the laboring swain;
Where smiling spring its earliest visit paid,
And parting summer's lingering blooms delayed,
Dear lovely bowers of innocence and ease,
Seats of my youth, where every sport could please;
How often have I loitered o'er thy green,
Where humble happiness endeared each scene!

His portrait of the old village parson includes a lovely simile:

To them his heart, his love, his griefs were given,
But all his serious thoughts had rest in heaven.
As some tall cliff that lifts its awful form,
Swells from the vale, and midway leaves the storm,
External sunshine settles on its head.

Finally, we find great tenderness in his description of his unfulfilled dream of ending his life amid the scenes in which it had begun.

In all my wanderings round this world of care,
In all my griefs—and God has given my share—
I still had hopes, my latest hours to crown,
Amid these humble bowers to lay me down,
To husband out life's taper at the close,
And keep the flame from wasting by repose.

And as an hare whom hounds and horns pursue,
Pants to the place from which at first she flew,
I still had hopes my long vexations past,
Here to return—and die at home at last.[5]

Johnson

The mid-eighteenth century is often called the Age of Johnson. Samuel Johnson (1709–84) began his literary career as a sort of miscellaneous journalist, writing for a newspaper. His principal achievement was as an essayist and the 208 *Rambler* essays covered a huge variety of topics including "Folly of Anger: Misery of a Peevish Old Age" and "Advantages of Mediocrity: An Eastern Fable." His purpose in the essays was to promote the glory of God and the salvation of himself and others.

In 1758, Johnson began the *Idler Essays*, a weekly contribution to the *Universal Chronicle*. In these, one of

which are included here, we find the moralist and social reformer still present, together with an increasingly comic element.

The Idler
No. 22. Saturday, September 9, 1758

Many naturalists are of opinion, that the animals which we commonly consider as mute, have the power of imparting their thoughts to one another. That they can express general sensations is very certain; every being that can utter sounds, has a different voice for pleasure and for pain. The hound informs his fellows when he scents his game; the hen calls her chickens to their food by her cluck, and drives them from danger by her scream.

Birds have the greatest variety of notes; they have indeed a variety, which seems almost sufficient to make a speech adequate to the purposes of a life, which is regulated by instinct, and can admit little change or improvement. To the crisis of birds, curiosity or superstition has been always attentive, many have studied the language of the feathered tribes, and some have boasted that they understood it.

The most skillful or most confident interpreters of the silvan dialogues have been commonly found among the philosophers of the East, in a country where the calmness of the air, and the mildness of the seasons, allow the student to pass a great part of the year in groves and bowers. But what may be done in one place by peculiar opportunities, may be performed in another by peculiar diligence. A shepherd of Bohemia has, by long abode in the forests, enabled himself to understand the voice of birds, at least he relates with great confidence a story of which the credibility may be considered by the learned.

"As I was sitting (said he) within a hollow rock, and watching my sheep that fed in the valley, I heard two vultures interchangeably crying on the summit of the cliff. Both voices were earnest and deliberate. My curiosity prevailed over my care of the flock; I climbed slowly and silently from crag to crag, concealed among the shrub, till I found a cavity where I might sit and listen without suffering, or giving disturbance.

"I soon perceived, that my labour would be well repaid; for an old vulture was sitting on a naked prominence, with her young about her, whom she was instructing in the arts of a vulture's life, and preparing, by the last lecture, for their final dismission to the mountains and the skies.

" 'My children,' said the old vulture, 'you will the less want my instructions because you have had my practice before your eyes; you have seen me snatch from the farm the household fowl, you have seen me seize the leveret in the bush, and the kid in the pasture, you know how to fix your talons, and how to balance your flight when you are laden with your prey. But you remember the taste of more delicious food; I have often regaled you

with the flesh of man.' 'Tell us,' said the young vultures, 'where man may be found, and how he may be known; his flesh is surely the natural food of a vulture. Why have you never brought a man in your talons to the nest?' 'He is too bulky,' said the mother; 'when we find a man, we can only tear away his flesh and leave his bones upon the ground.' 'Since man is so big,' said the young ones, 'how do you kill him. You are afraid of the wolf and of the bear, by what power are vultures superior to man, is man more defenseless than a sheep?' 'We have not the strength of man,' returned the mother, 'and I am sometimes in doubt whether we have the subtilty; and the vultures would seldom feast upon his flesh, had not nature, that devoted him to our uses, infused into him a strange ferocity, which I have never observed in any other being that feeds upon the earth. Two herds of men will often meet and shake the earth with noise, and fill the air with fire. When you hear noise and see fire which flashes along the ground, hasten to the place with your swiftest wing, for men are surely destroying one another; you will then find the ground smoking with blood and covered with carcasses, of which many are dismembered and mangled for the convenience of the vulture.' 'But when men have killed their prey,' said the pupils, 'why do they not eat it? When the wolf has killed a sheep he suffers not the vulture to touch it till he has satisfied himself. Is not man another kind of wolf?' 'Man,' said the mother, 'is the only beast who kills that which he does not devour, and this quality makes him so much a benefactor to our species.' 'If men kill our prey and lay it in our way,' said the young one, 'what need shall we have of labouring for ourselves.' 'Because man will, sometimes,' replied the mother, 'remain for a long time quiet in his den. The old vultures will tell you when you are to watch his motions. When you see men in great numbers moving close together, like a flight of storks, you may conclude that they are hunting, and that you will soon revel in human blood.' 'But still,' said the young one, 'I would gladly know the reason of this mutual slaughter. I could never kill what I could not eat.' 'My child,' said the mother, 'this is a question which I cannot answer, tho' I am reckoned the most subtle bird of the mountain. When I was young I used frequently to visit the ayry of an old vulture who dwelt upon the Carpathian rocks; he had made many observations; he knew the places that afforded prey round his habitation, as far in every direction as the strongest wing can fly between the rising and setting of the summer sun; he had fed year after year on the entrails of men. His opinion was, that men had only the appearance of animal life, being really vegetables with a power of motion; and that as the boughs of an oak are dashed together by the storm, that swine may fatten upon the falling acorns, so men are by some unaccountable power driven one against another, till they lose their motion, that vultures may be fed. Others think they have observed something of contrivance and policy among these mischievous beings, and those that hover more closely round them, pretend, that there is, in every herd, one that gives directions to the rest, and seems to be more eminently delighted with a wide carnage. What it is that intitles

him to such pre-eminence we know not; he is seldom the biggest or the swiftest, but he shews by his eagerness and diligence that he is, more than any of the others, a friend to vultures.' ' "[6]

NEO-CLASSICISM

Discovery of the ruins of Pompeii, Winckelmann's interpretation of Greek classicism, Rousseau's Noble Savage, and Baumgarten's aesthetics sent the late eighteenth century whirling back to antiquity and in particular to nature. Rather than seeing the past as a single, continuous cultural stream broken by a medieval collapse of classical values, theoreticians of the eighteenth century saw history as a series of compartments—for example, Antiquity, Middle Ages, Renaissance, and so on. A principal proponent of neo-classicism in painting was Jacques-Louis David (1748–1825). His works illustrate the newly perceived grandeur of antiquity and its reflection in subject matter, composition, depiction, and historical accuracy. Although propagandist in tone (he sought to inspire patriotism and democracy), his neo-classical works show a Roman two-dimensionality and a strong, simple compositional unity. Accurate historical detail and antiquarian subject matter complete the works. In *The Oath of the Horatii* (Fig. **13.19**), David exploits his political ideas amidst Greek and Roman themes. He implies a devotion to ideals so strong that one should be prepared to die in their defense. David's belief in a rational and ordered existence is reinforced by his sparse and classically simple composition. We must recognize, however, that the neo-classicism of David and others is not confined to copying ancient works. Classical detail and principles are treated selectively and adapted.

David—The Oath of the Horatii

The painting was inspired by Corneille's play *Horace*, whose subject is the conflict between love and patriotism. In legend, the leaders of the Roman and Alban armies, on the verge of battle, decide to resolve their conflicts by means of an organized combat between three representatives from each side. The three Horatius brothers represented Rome; the Curatius sons represented the Albans. A sister of the Horatii was the fiancée of one of the Curatius brothers. David's painting depicts the Horatii as they swear on their swords to win or die for Rome, disregarding the anguish of their sister. The work captures a directness and an intensity of expression that were to play

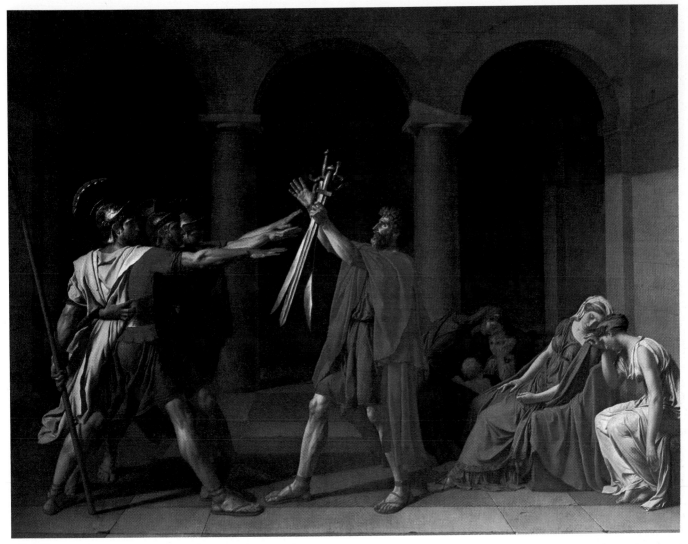

13.19 Jacques-Louis David, *The Oath of the Horatii*, 1784–5. Oil on canvas, c. 14 x 11 ft (4.27 x 3.35 m). The Louvre, Paris.

an important role in romanticism, but the starkness of outline, strong geometric composition (which juxtaposes straight line in the men and curved line in the women), and the smooth color areas and gradations hold it to the more formal, classical tradition.

The form is *academic neo-classicism*. The scene takes place in "a shallow picture box, defined by a severely simple architectural framework" and the people reflect historical reality. The musculature, even the arms and legs of the women, has a surface devoid of warmth or softness as does the drapery.

Curiously David's work was admired and purchased by King Louis XVI, against whom David's revolutionary cries were directed and whom he, as a member of the French Revolutionary Convention, would sentence to death. David's career flourished; neo-classicism in painting increased in popularity and continued beyond the Revolution to the era of Napoleon and into the nineteenth century.

ARCHITECTURAL NEO-CLASSICISM

In the mid-eighteenth century architecture's viewpoints changed entirely and embraced the complex philosophical concerns of the Enlightenment. Three important concepts emerged as a result of this change in viewpoint. First was the *archeological* concept, which viewed the present as continually enriched by persistent inquiry into the past (progress). Second was the *eclectic*, which allowed the

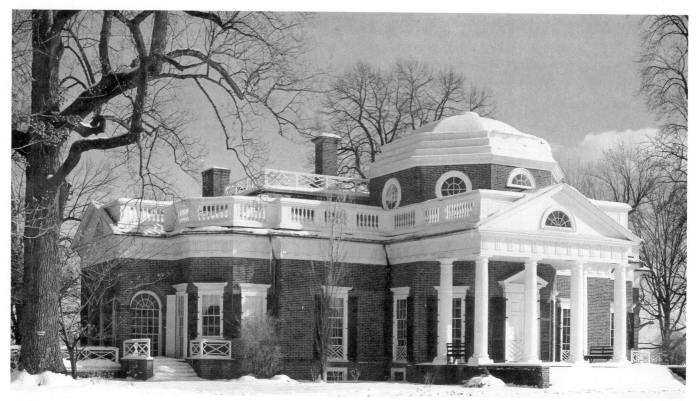

13.20 Thomas Jefferson, Monticello, Charlottesville, Virginia, 1770–84; (rebuilt 1796–1800).

artist to choose among styles, or, more importantly, to combine elements of various styles. The third was the *modernist* concept, which viewed the present as unique and, therefore, possible of expression in its own terms. These three concepts profoundly influenced eighteenth-century architecture, had important bearing on the other arts and fundamentally changed the basic premises of art from that time forward.

Neo-classicism as applied to architecture encompasses these three concepts and reflects a variety of treatment and terminology. Basic to it, of course, are the identifiable forms of Greece and Rome. Neo-classicism in architecture took considerable impetus from the *Essai sur l'architecture* (Paris, 1753) by the Abbé Laugier. Laugier's work was strictly rationalistic and expressed neo-classicism in a nutshell. He discarded the architectural language developed since the Renaissance. Rather, he urged the architect to seek truth in principles demonstrated in the architecture of the ancient world and to use those principles to design modern buildings that expressed the same logical limitations as the classical temple. Laugier's classicism descended directly from the Greeks, with only passing reference to the Romans.

In Italy, the architect Giambattista Piranesi (1720–78) was incensed by Laugier's arguments, which placed Greece above Rome, and he retaliated with an overwhelmingly detailed work that professed to prove (perhaps by sheer weight of evidence) the superiority of Rome over Greece. Both Piranesi (*Della Magnificenza ed Architettura dei Romani*) and Laugier were instigators of the neo-classical tradition. The revival of classicism in architecture was seen in many quarters as a revolt against the frivolity of the rococo with an art that was serious and moral.

In America neo-classicism had special meaning as the colonies struggled to rid themselves of the monarchical rule of England's George III. For revolutionary Americans classicism meant Greek and Greece meant democracy. The designs of colonial architects like Thomas Jefferson (Fig. **13.20**) reflect the complex interrelationships of this period. Jefferson was highly influenced by Palladio, who enjoyed popularity in a significant revival in English villa architecture between 1710 and 1750. Jefferson, in a uniquely eighteenth-century way, considered architecture objectively within the framework of contemporary thought. His philosophy of architecture, of which Monticello is illustrative, was founded on a belief that the architecture of antiquity embodied indisputable natural principles. He was strongly influenced by natural law, and considered Palladian reconstruction of the Roman temple a foundation on which a theory of architecture could be

built. Monticello contains a center with superimposed Doric and Ionic porticos (porches) with short, low wings attached to the center by continuing Doric entablatures. The simplicity and refinement of Jefferson's statement here goes beyond reconstruction of classical prototypes and appeals directly to the intellect.

MUSICAL CLASSICISM

In 1785 Michel Paul de Chabanon wrote, "Today there is but one music in all of Europe." The basis of this statement was music composed to appeal not only to the aristocracy but to the broad middle classes as well. Egalitarian tendencies and popularizing of ideals typical of the *Philosophes* had also influenced artists, turning them toward a larger audience. Pleasure became a legitimate artistic purpose. Eighteenth-century rationalism regarded excessive ornamentation and excessive complexity (both baroque characteristics) as contrary to meeting a wide audience on its own terms. Those sentiments, against the background of neo-classicism, prompted a move to order, simplicity, and careful attention to form. We call this style in music classical (the term was not applied until the nineteenth century) rather than neoclassical or classical revival because although the other arts returned (more or less) to Greek and Roman prototypes, music had no known classical antecedents to revive, despite a fairly detailed understanding of Greek music theory. Music thus turned to classical *ideals*, though not to classical *models*.

One very clear characteristic of classical style was a definitely articulated structure. Each piece was organized into short statements called phrases, which recurred regularly and clearly. The most frequently cited example of this practice is Mozart's *Symphony No. 40 in G minor*, whose opening movement is based on a three-note rhythmic pattern or motif, organized into two contrasting phrases. These phrases are then grouped into themes which comprise sections in the movement. Classical music also avoided the baroque style of polyphony, introducing instead its own, which relied upon a melodic line that could be shaped into clear and expressive contours and brought to a definite cadence (conclusion).

A third change from the baroque lay in rhythmic patterns. Baroque's numerous ornamented parts flowing together in complex design fostered essentially unchanging rhythmic patterns. Classical phrase structure and melodic linearity allowed far more opportunity for rhythmic variety and also for rhythmic contrasts among or between lines. For example, the featured upper melodic line could carry one rhythmic impulse while the chordal supporting lines could carry another. Usually the chordal voices had more regular rhythms than the independent voice. Classical style also changed harmonic relationships, including the invention of a true modulation.

Major musical forms such as the opera, oratorio, and concerto changed according to classical priorities. For example, Mozart's the *Marriage of Figaro* (1786), a comic opera on the theme of love and marriage, with a fast-paced plot, subplot, and dramatic conflicts, shows concern for simplicity and clarity. Haydn's oratorio, *The Creation*, reflects the Enlightenment's concepts of God and nature, reason and benevolence. *The Creation* also exhibits concern for simplicity and clear form. Operas and oratorios continued in popularity, but for the most part instrumental music became the dominant force. The concerto adapted smoothly from its baroque configurations into classical form and style. Chamber music also increased in popular appeal. Its small ensemble format was perfect for performance *en chambre*, in the small rooms of the eighteenth-century salon.

The most important forms in this period, however, were the symphony and the sonata. Sonatas were composed for virtually every instrument, and composers varied in their approach. Haydn, for example employed a sonata-rondo form (*rondo* was a classical variation of *ritornello*). The classical sonata, sometimes called sonata cycle, is a work of three or four movements, each of which consists of a specific structure. The most important structural configuration of the sonata is the typical configuration of the first movement. This structure is so important and specific that it is called sonata or sonata-allegro form.

The symphony, which used sonata-allegro form in its opening movement, also played an important part in the classical music tradition. By the last quarter of the eighteenth century the symphony, as well as other forms of instrumental ensemble music, had largely eliminated use of *basso continuo*, and, thereby, the harpsichord. Primary focus, then, fell on the violin section, and classical symphonic compositions reflect that new focus. By the turn of the nineteenth century other sections, such as the woodwind, were given more, independent material.

The timbre of an orchestra was fairly close to what we know today. The size, and therefore the overall volume of sound was not. The largest orchestra of the mid-eighteenth century, the Mannheim Orchestra, consisted of forty-five players, mostly strings, with six woodwinds, five brasses, and two timpani. Haydn's orchestra between 1760 and 1785 rarely exceeded twenty-five players, and the Vienna orchestras of the 1790s averaged thirty-five.

The most illustrative symphonic literature of the classical style came from the minds and pens of Haydn, Mozart, and Beethoven (in his early years).

Haydn

Austrian-born Franz Joseph Haydn (1732–1809) pioneered the development of the symphony from a short, simple work into a longer, more sophisticated one. Haydn's symphonies are diverse and numerous (some sources indicate that he wrote more than 104). Some are light and simple, others are serious and sophisticated. Many of his early symphonies use the pre-classical, three-movement form. His middle symphonies from the early 1770s exhibit imaginative emotion and a larger scale than the earlier works. Exposition sections explore broadly expressed themes, followed by contrasting ideas and restatement. The development sections are dramatic and employ sudden and unexpected changes of dynamics. The slow movements contain great warmth and emotion, Haydn frequently drew on Austrian folk songs and baroque dance music, and his modulations and changes of tonality contain great dramatic power. Among his late works the most famous is *Symphony No. 94 in G Major* (1792), commonly known as the "Surprise Symphony."

13.21 Haydn, *Symphony No. 94 in G Major*, first theme.

The development section opens with a variation on the first theme and then goes through a series of variations built around modulations and dynamic changes. The recapitulation section starts with a return to the first theme in the original key.

Mozart

Wolfgang Amadeus Mozart (1756–91), also an Austrian, had performed at the court of Empress Maria Theresa at the age of six. As was the case throughout the classical period, aristocratic patronage was essential for musicians to earn a living, although the middle classes provided a progressively larger portion of commissions, pupil fees, and concert attendance. Mozart's short career (he died at the age of thirty-five) was dogged by financial insecurity.

His early symphonies were simple and relatively short, like those of Haydn, while his later works were longer and more complex. His last three symphonies are generally regarded as his greatest masterpieces, and *Symphony No. 40 in G Minor* is often referred to as the typical classical symphony. This work and Nos. 39 and 41 have clear order and restraint and yet exhibit tremendous emotional urgency, which many scholars cite as the beginning of the romantic style.

13.22 Mozart, *Symphony No. 40 in G Minor*, first movement.

Mozart is also well known for his operas, and was especially skilled in opera buffa. *The Marriage of Figaro* is fast and humorous, with slapstick action in the manner of farce, but has great melodic beauty.

13.23 Mozart, *The Marriage of Figaro*, first theme of *Cinque . . . deici* duet.

Beethoven

Ludwig van Beethoven (1770–1827) is often considered apart from the classical period and treated as a singular transitional figure between classicism and romanticism. Beethoven wanted to expand the classical symphonic form in order for it to accommodate greater emotional character. The typical classical symphony moves through contrasting movements; Beethoven changed that to accommodate a single thematic development throughout, and thereby achieved a unified, emotional work.

Beethoven's works are significantly different from those of Haydn and Mozart. They are more dramatic and use changing dynamics for emotional effects. Silence is used as a device in pursuit of dramatic and structural ends.

His works are also longer. He lengthened the development section of sonata-allegro form and did the same to his codas, many of which take on characteristics of a second development section. He also changed traditional thematic relationships among movements especially in the *Symphony No. 6*, which has no break between the fourth and fifth movements.

Although classical style had a simpler character and used a more symmetrical structure than baroque, it did not sacrifice dynamic qualities in that pursuit. In the same

sense that the simple qualities of Greek architecture, for example, did not lose their sophistication and interest in a slavish pursuit of apparently mathematical form and symmetry, so classical music maintained its dynamic and sophisticated character in its pursuit of form and reason.

13.24 Beethoven, *Piano Sonata in C Minor*, third movement, first theme.

As classical style was shaped by its advocates it moved as comfortably toward romanticism as it had moved away from baroque.

THE AGE OF INDUSTRY

With its roots in the eighteenth century, the romantic movement entered the nineteenth with a force that matched the new engines of industrial progress. Again, in the arts, the pendulum had swung. Classical formality and restraint gave way to a relentless questioning and self-questioning, and in some cases an escapism, as the artist, a moral hero now liberated from patronage, was on his or her own, to rise or fall, to experiment, and to protest.

Caught between the institutionalized expectations of the Academy, the tastes of the public, and the artist's own vision of individual expression, each generation reacted more and more strongly against the style of its predecessor. The pace of change—social, technological, artistic—was quickening, and artists began to feel themselves increasingly marginalized within a materialistic society. The Impressionists and their successors tried to redefine their role and their art.

CLASSICISM

The neo-classical traditions of the eighteenth century continued into the nineteenth, particularly in France, and the pursuit of physical and intellectual perfection initiated by David was taken up by Jean-Auguste-Dominique Ingres (1780–1867). The work of Ingres, and perhaps David as well, illustrates the confusing relationships and conflicts that surrounded the neo-classical and romantic traditions in painting. Ingres's *Grande Odalisque*, or *Harem Girl* (Fig. 13.25), has been called both neo-classical and romantic,

13.25 Jean-Auguste-Dominique Ingres, *Grande Odalisque*, 1814. Oil on canvas, $36\frac{1}{4} \times 63\frac{1}{4}$ ins (92 x 161 cm). The Louvre, Paris.

and in many ways represents both. Ingres professed to despise romanticism, and yet his proportions and subject exude romantic individualism and escape to the far away and long ago. His sensuous textures appear emotional, not intellectual. At the same time, his line is simple, his palette is cool, and his spatial effects are geometric. The linear rhythms of his painting are very precise and calculated and, therefore, classically intellectual in appeal.

Neo-classical sculpture prevailed during the early years of the nineteenth century and consisted predominantly of a reproduction of classical works rather than a revising of them, as was the case in architecture. In France, neo-classicism served its commemorative and idealizing functions as the political tool of Napoleon, who was glorified in various Greek and Roman settings, sometimes garbed in a toga and sometimes in the nude, as if granting him the status of a Greek god. No style is free from outside influences, and nineteenth century neo-classical sculpture often reveals aspects of rococo, baroque, and romantic style.

13.26 Antonio Canova, *Pauline Borghese as Venus Victrix,* 1808. Marble, life-size. Galleria Borghese, Rome.

Antonio Canova (1757–1822) is recognized as the ablest of the neo-classical sculptors, and his works illustrate not only this style, but also influences of the rococo tradition. *Venus Victrix* (Fig. **13.26**), for which Pauline Borghese, Napoleon's sister, was the model, presents classical pose and proportions, similar in many ways to Ingres's *Grande Odalisque.* Line, costume, and hairstyle reflect the ancients, but sensuous texture, individualized expression, and realistic and fussy detail suggest other approaches. At the same time, this work is almost two-dimensional. Canova appears unconcerned with the work when see from any angle other than the front.

The nineteenth century was an age of increased individualism and subjective viewpoints. However, what is possible by way of experimentation for the painter, sculptor, musician, choreographer, and to some degree, the playwright, is not always possible for the architect. An architect's work involves a client who must be satisfied, and the results are public and permanent.

The use of Greek and Roman forms after 1750 has been called classical revival or neo-classicism. Basically this revival can be broken into two general periods—Roman

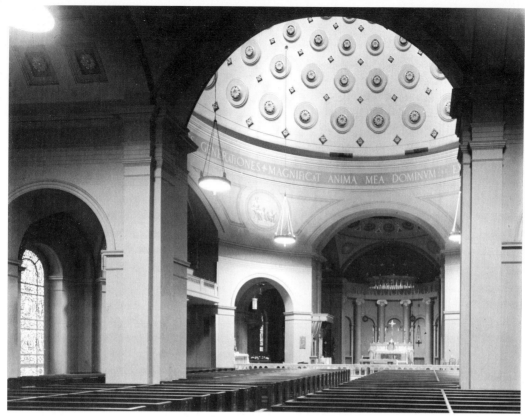

13.27 Benjamin H. Latrobe, interior, Basilica of the Assumption, Baltimore, Maryland, 1805–18.

prior to 1815 and Greek from then on. Often the plethora of terms describing this period can be confusing, including federal style, which, essentially is a specific substyle of the resurrection of ancient prototypes in the romantic era.

Benjamin H. Latrobe's Catholic cathedral in Baltimore (Fig. **13.27**) illustrates many of the principles at issue here. In this view the Ionic orders of Athens are visible in the alcove behind the altar, while a Roman dome, like that of the Pantheon, dominates the nave. These basically "classical" forms are significantly modified and added to with numerous individualized details. Traditional Roman semicircular arches flank the central opening above the altar, yet that arch and its complements are flattened and also broken by cantilevered balconies. Whimsical, starlike decoration marks the dome, and a misty panorama of painted scenes winds over and through the modified pendentives.

Classical revival found numerous examples in domestic architecture in the United States. The Belamy Mansion in Wilmington, North Carolina is one of the most exquisite examples of this style (Fig. **13.28**). Designed by Connecticut architect Rufus H. Bunnell, the house was built by skilled, free Blacks and completed in 1859. The stately house is situated on a major thoroughfare a few blocks from the downtown business district, central to the city now as it was a century ago. The beautifully proportioned main body of the house is offset by a massive portico, whose Corinthian columns uphold a monumental cornice and pediment. The entire structure is raised some 5 ft (1.5 m) off the ground on brick pillars, hiding a basement, and crowned by a rectangular cupola.

13.28 Rufus H. Bunnell, Belamy Mansion, Wilmington, North Carolina, 1859.

ROMANTICISM

If Ingres believed himself to be a neo-classicist and not a romantic, there were those who willingly championed the banner of romanticism. The romantic style was diverse. It had an emotional appeal and tended toward the picturesque, nature, the Gothic, and, often, the macabre. Romanticism sought to break the geometric compositional principles of classicism. Compositions moved toward fragmentation of images. The intent was to dramatize, to personalize, and to escape into imagination. Romantic painting reflected a striving for freedom from social and artistic rules, a subordination of formal content to expressive intent, and an intense introversion. As the writer Zola said of romantic naturalism, "A work of art is part of the universe as seen through a temperament." Closely associated with the critic and writer Baudelaire, romanticism dwelt upon the capacity of color and line to affect the viewer independently of subject matter.

Many romantic painters are worthy of note, but a detailed look at Géricault and Bonheur will suffice for our overview.

Géricault

Théodore Géricault (1791–1824), pillar of the beginnings of French romanticism, was a champion of the downtrodden and rejected. A prodigy who died young, he offers us a full conception of the romantic hero, both in his art and in his life. Although a direct descendant of David, Géricault departed from his master in his use of brushwork. David insisted that the brushwork should not show, whereas Géricault uses the visual impact of the strokes themselves brilliantly. He accepted the heroic Napoleonic view of this period in France's history, and his paintings frequently treat the struggle between humankind and nature. The influence of the grandeur and violence of Michelangelo, is particularly clear in the famous *Raft of the "Medusa"* (Fig. **13.29**). The painting is in the romantic style, tempered by classical and even High Renaissance influences. Géricault, like David, achieved firmly modeled flesh, realistic figures, and a precise play of light and shade. His treatment of the physical form is reminiscent of Michelangelo. In contrast to David's ordered, two-dimensional paintings, however, Géricault's work had complex

13.29 Théodore Géricault, *The Raft of the "Medusa"*, 1819. Oil on canvas, 16 ft x 23 ft 6 ins (4.91 x 7.16 m). The Louvre, Paris.

13.30 Rosa Bonheur, *Plowing in the Nivernais*, 1849. Oil on canvas, 5 ft 9 ins x 8 ft 8 ins (1.75 x 2.64 m). Musée Nationale du Château de Fontainebleau.

and fragmented compositional structures. He preferred to base the design on two triangles rather than a strong central triangle. In the *Medusa*, which tells a story of governmental incompetence resulting in tragedy, the left triangle's apex is the makeshift mast, signifying death and despair. The other triangle moves up to the right to the figure waving the fabric, signifying hope as a rescue ship appears in the distance. The dramatic composition is charged with unbridled emotion which extols the individual heroism of the survivors. As preparation for the work and seeking maximum fidelity to truth, Géricault interviewed the survivors, read newspaper accounts, and went so far as to paint corpses and the heads of guillotined criminals. His result captures the dramatic climax at the precise moment the rescue ship is sighted. The composition builds upward from the bodies of the dead and dying in the foreground to the dynamic group whose final energies are summoned to support the figure waving to the ship. The play of light and shade heightens the dramatic effect.

Bonheur

Rosa Bonheur (1822–99), certainly the most popular woman painter of her time, has been labeled both a realist and a romantic in style. Her subjects were mostly animals, and their raw energy. "Wading in pools of blood," as she put it, she studied animal anatomy even in slaughter houses and was particularly interested in animal psychology. Her work *Plowing in the Nivernais* (Fig. 13.30) expresses the tremendous power of the oxen on which European agriculture depended before the Industrial Revolution. The beasts appear almost monumental, and each detail is precisely executed. *Plowing in the Nivernais* clearly reveals Bonheur's reverence for the dignity of labor and humankind's harmony with nature.

Romantic sculpture

Romantic sculpture never developed into a uniform style. Those works not clearly of the traditions we have just mentioned show a generally eclectic spirit and a uniformly undistinguished character. There may be a reasonable explanation for such a phenomenon in that romantic idealism, whose strivings after nature and the far away and the long ago cannot be easily translated into sculptural expression. Certainly, nineteenth-century devotion to landscapes does not. Of course, the term romantic is often applied to almost anything of the nineteenth century, as is the case with the most remarkable sculptor of this era, Auguste Rodin (1840–1917).

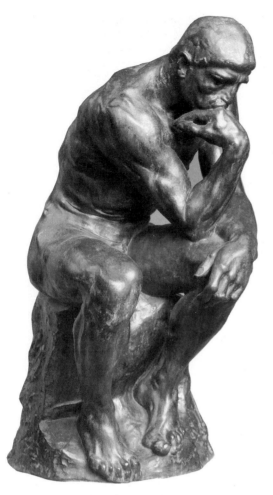

13.31 Auguste Rodin, *The Thinker*, first modelled c. 1880, executed c. 1910. Bronze, height 27½ ins (70 cm). The Metropolitan Museum of Art, New York (Gift of Thomas F. Ryan, 1910 [11.173.9]).

Rodin's textures, more than anything else, reflect impressionism; his surfaces appear to shimmer as light plays on their irregular features. The *Thinker* (Fig. **13.31**) provides a familiar example and shows the difficulty inherent in attempting to put into sculptural form what painters like Monet were trying to do with color and texture. Rodin's textures, however, are more than reflective surfaces—they give his works dynamic and dramatic qualities. Although he used a fair degree of verisimilitude, he nevertheless presented a subjective reality beyond the surface.

Romantic literature

The beginning of the main phase of romantic literature can probably be dated to around 1790. One characteristic was the tendency of writers to form groups or partner-ships, an example of which was the close relationship between Goethe and Schiller. Britain again produced major literary figures such as Wordsworth, Coleridge, Scott, Byron, Shelley, and Keats.

Wordsworth

William Wordsworth (1770–1850) charged the common-place and everyday with transcendental and often indefinable significance. He created a new world of beauty through his closeness to nature and in the harmony he felt existed between man and nature.

In 1795, he met Samuel Taylor Coleridge (1772–1834), an English poet, and his relationship with Coleridge opened his life and writing. Out of this relationship came the *Lyrical Ballads*, which Wordsworth published anonymously along with four poems by Coleridge. Among these ballads, *Tintern Abbey* exhibits Wordsworth's love of nature. That love is first seen as a sensuous animal passion, then as a moral influence, and finally as a mystical communion.

**Lines Composed a Few Miles
Above Tintern Abbey, on Revisiting
the Banks of the Wye
During a Tour. July 13, 1798**

Five years have past; five summers, with the length
Of five long winters! and again I hear
These waters, rolling from their mountain-springs
With a soft inland murmur.—Once again
Do I behold these steep and lofty cliffs,
That on a wild secluded scene impress
Thoughts of more deep seclusion; and connect
The landscape with the quiet of the sky.
The day is come when I again repose
Here, under this dark sycamore, and view
These plots of cottage-ground, these orchard-tufts,
Which at this season, with their unripe fruits,
Are clad in one green hue, and lose themselves
'Mid groves and copses. Once again I see
These hedge-rows, hardly hedge-rows, little lines
Of sportive wood run wild: these pastoral farms,
Green to the very door; and wreaths of smoke
Sent up, in silence, from among the trees!
With some uncertain notice, as might seem
Of vagrant dwellers in the houseless woods,
Or of some Hermit's cave, where by his fire
The Hermit sits alone.

These beauteous forms,
Through a long absence, have not been to me

As is a landscape to a blind man's eye:
But oft, in lonely rooms, and 'mid the din
Of towns and cities, I have owed to them
In hours of weariness, sensations sweet,
Felt in the blood, and felt along the heart;
And passing even into my purer mind,
With tranquil restoration:—feelings too
Of unremembered pleasure: such, perhaps,
As have no slight or trivial influence
On that best portion of a good man's life,
His little, nameless, unremembered, acts
Of kindness and of love. Nor less, I trust,
To them I may have owed another gift,
Of aspect more sublime; that blessed mood,
In which the burthen of the mystery,
In which the heavy and the weary weight
Of all this unintelligible world,
Is lightened:—that serene and blessed mood,
In which the affections gently lead us on,—
Until, the breath of this corporeal frame
And even the motion of our human blood
Almost suspended, we are laid asleep
In body, and become a living soul:
While with an eye made quiet by the power
Of harmony, and the deep power of joy,
We see into the life of things.

If this
Be but a vain belief, yet, oh! how oft—
In darkness and amid the many shapes
Of joyless daylight; when the fretful stir
Unprofitable, and the fever of the world,
Have hung upon the beatings of my heart—
How oft, in spirit, have I turned to thee,
O sylvan Wye! thou wanderer thro' the woods,
How often has my spirit turned to thee!
And now, with gleams of half-extinguished thought,
With many recognitions dim and faint,
And somewhat of a sad perplexity,
The picture of the mind revives again:
While here I stand, not only with the sense
Of present pleasure, but with pleasing thoughts
That in this moment there is life and food
For future years. And so I dare to hope,
Though changed, no doubt, from what I was when first
I came among these hills; when like a roe
I bounded o'er the mountains, by the sides
Of the deep rivers, and the lonely streams,
Wherever nature led: more like a man
Flying from something that he dreads, than one
Who sought the thing he loved. For nature then
(The coarser pleasures of my boyish days,
And their glad animal movements all gone by)
To me was all in all.—I cannot paint

What then I was. The sounding cataract
Haunted me like a passion: the tall rock,
The mountain, and the deep and gloomy wood,
Their colours and their forms, were then to me
An appetite; a feeling and a love,
That had no need of a remoter charm,
By thought supplied, nor any interest
Unborrowed from the eye.—That time is past,
And all its aching joys are now no more,
And all its dizzy raptures. Not for this
Faint I, nor mourn nor murmur; other gifts
Have followed; for such loss, I would believe,
Abundant recompense. For I have learned
To look on nature, not as in the hour
Of thoughtless youth; but hearing often-times
The still, sad music of humanity,
Nor harsh nor grating, though of ample power
To chasten and subdue. And I have felt
A presence that disturbs me with the joy
Of elevated thoughts; a sense sublime
Of something far more deeply interfused,
Whose dwelling is the light of setting suns,
And the round ocean and the living air,
And the blue sky, and in the mind of man;
A motion and a spirit, that impels
All thinking things, all objects of all thought,
And rolls through all things. Therefore am I still
A lover of the meadows and the woods,
And mountains; and of all that we behold
From this green earth; of all the mighty world
Of eye, and ear,—both what they half create,
And what perceive; well pleased to recognise
In nature and the language of the sense,
The anchor of my purest thoughts, the nurse,

The guide, the guardian of my heart, and soul
Of all my moral being.
Nor perchance,
If I were not thus taught, should I the more
Suffer my genial spirits to decay:
For thou art with me here upon the banks
Of this fair river; thou my dearest Friend,
My dear, dear Friend; and in thy voice I catch
The language of my former heart, and read
My former pleasures in the shooting lights
Of thy wild eyes. Oh! yet a little while
May I behold in thee what I was once,
My dear, dear Sister! and this prayer I make,
Knowing that Nature never did betray
The heart that loved her; 'tis her privilege,
Through all the years of this our life, to lead
From joy to joy: for she can so inform
The mind that is within us, so impress
With quietness and beauty, and so feed

With lofty thoughts, that neither evil tongues,
Rash judgments, nor the sneers of selfish men,
Nor greetings where no kindness is, nor all
The dreary intercourse of daily life,
Shall e'er prevail against us, or disturb
Our cheerful faith, that all which we behold
Is full of blessings. Therefore let the moon
Shine on thee in thy solitary walk;
And let the misty mountain-winds be free
To blow against thee; and, in after years,
When these wild ecstasies shall be matured
Into a sober pleasure; when thy mind
Shall be a mansion for all lovely forms,
Thy memory be as a dwelling-place
For all sweet sounds and harmonies; oh! then,
If solitude, or fear, or pain, or grief,
Should be thy portion, with what healing thoughts
Of tender joy wilt thou remember me,
And these my exhortations! Nor, perchance—
If I should be where I no more can hear
Thy voice, nor catch from thy wild eyes these gleams
Of past existence—wilt thou then forget
That on the banks of this delightful stream
We stood together; and that I, so long
A worshipper of Nature, hither came
Unwearied in that service: rather say
With warmer love—oh! with far deeper zeal
Of holier love. Nor wilt thou then forget,
That after many wanderings, many years
Of absence, these steep woods and lofty cliffs,
And this green pastoral landscape, were to me
More dear, both for themselves and for thy sake![7]

Romantic style in music

In pursuit of the expression of human emotion, romantic music made stylistic changes to classical music. The classical–romantic antithesis—the form versus feeling or the intellect versus emotional conflict—simply cannot be applied neatly to music of the eighteenth and nineteenth centuries. Subjectivity and emotion played a more important role in romanticism, and even if classicism sought sustenance in nature and antiquity, romanticism imbued nature with a strangeness that went beyond classical inspirations. Utopia, whether in the past or the future, and nature, whether malevolent or benevolent, were as obvious and influential in nineteenth-century music as in any other art discipline.

As in painting, spontaneity replaced control, but the primary emphasis of music in this era was on beautiful, lyrical, and expressive melody. Phrases became longer, more irregular, and more complex than in classical music. Melodic development nearly always had individual performance virtuosity as its object.

Rhythm varied from simple to complex. Much romantic rhythm was strictly traditional, but experiments produced new meters and patterns. Emotional conflict was often suggested by juxtaposing duple and triple meters, and rhythmic irregularity became increasingly common as the century progressed.

Harmony and tone color changed significantly. Harmony was seen as a means of expression, and any logic or restriction regarding key relationships was submerged by the need to achieve striking emotional effects. Form was clearly subordinate to feeling. Harmonic procedures became increasingly complex, and traditional outlines of major and minor keys were blurred in chromatic harmonies, complicated chords, and modulations to distant keys. In fact, key changes became so frequent in some composers' works that their compositions comprised virtually nothing but tonal whirls of continuous modulation. Chromaticism—the altering of normal whole- and half-tone relationships in a scale—gained increasing importance as composers sought to disrupt previously logical expectations. The result was a sense of uncertainty and of the bizarre. More and more dissonance occurred, changing in its role from that of a passing dissettlement leading to resolution to that of a principal focus. That is, dissonance was explored for its own sake, as a stimulant of emotional response, as opposed to its use merely as a device in traditional harmonic progression to resolution on the tonic. By the end of the romantic period, exploration (and exhaustion) of chromatics and dissonance led to a search for a wholly different tonal system.

Exploration of color as a response stimulant was as important to the romantic musician as it was to the painter. Interest in tonal color or timbre led to great diversity in vocal and instrumental performance. The technical and emotional limbs of every aspect of music were probed with enthusiasm, and music literature of this period abounds with solo works and a tremendous increase in the size and diversity of the orchestra.

Chopin

Frederic Chopin (1810–49) wrote almost exclusively for the piano. Each of his *études*, or technical studies, explored a single technical problem, usually around a single motive. More than simple exercises, these works explored the possibilities of the instrument and became

short tone poems in their own right. A second group of compositions included short intimate works such as preludes, nocturnes, and impromptus and dances such as waltzes, polonaises, and mazurkas. Polish folk dance tunes were particularly influential. A final class of compositions included larger works such as scherzos, ballades, and fantasies. Chopin's compositions were highly individualized, and many were without precedent. His style was completely opposed to classicism, almost totally without standard form and having little sense of balance of structure. His melodies were lyrical, and his moods varied from melancholy to exaltation.

Brahms

At the same time as these relatively innovative directions were being pursued by romantic composers, a traditional direction continued in the romantic symphony and concerto, personified by Johannes Brahms (1833–97). His direction, while employing the lyrical melodic tendencies of the period, retained classical form, and he produced symphonic works based solely on musical information. That is, these symphonic works are built upon musical ideas such as motifs, themes and phrases, and maintain their unity through structure as opposed to nonmusical ideas or texts. These works are known as abstract or absolute music. Their melodies, rhythms, and timbres reflect the characteristics noted at the beginning of the chapter, and include an increasingly dense texture and greatly expanded dynamic range. Although their form maintains tradition, their effect is emotional—the listener is bathed in an overwhelmingly sensual experience. Contrasts in dynamics and timbre are stressed, and, as in painting, form, although maintained, is subordinated to expressive intent.

An outstanding example of the romantic symphony is Brahms' *Symphony No. 3 in F Major* (1883). Composed in four movements, the work calls for pairs of flutes, oboes, clarinets, bassoon, a contrabassoon, four horns, two trumpets, three trombones, two timpani, and strings.

13.32 Brahms, *Symphony No. 3 in F Major*, opening theme.

Tchaikovsky

We can also identify a new nationalistic trend in music of the romantic period. The roots of such movements went deep into the past, but the political circumstances of the century prompted composers. Folk tunes and themes dominated this tendency, and localized experimentation with rhythms and harmonics created qualities which, while still within romantic parameters, are easily associated with national identities. This was true in Russia, Bohemia (Czechoslovakia), Spain, England, Scandinavia, and in Germany and Austria.

Of all the nationalistic composers of the romantic period, the Russian Peter Ilyich Tchaikovsky (1840–93) has enjoyed the greatest popularity. His *Violin Concerto in D Major* (1878) remains one of the best known nineteenth-century concertos for violin.

Romantic Opera

Early romantic opera in Italy featured the *bel canto* style, which emphasizes beauty of sound. Illustrative of this substyle of romanticism were the works of Rossini (1792–1868). Rossini's *Barber of Seville* takes melodic singing to tremendous heights and quality. His songs are light, ornamented, and very appealing, and his drama is exciting.

Great artists often stand apart from or astride general stylistic trends, exploring on their own a unique or dominant theme. Such is the case with the Italian composer Giuseppe Verdi (1813–1901). Verdi combined earthy emotions and clear expression within a nationalistic philosophy. He refined opera into a human drama consisting of simple, beautiful melody.

His long career experienced different phases. The early phase saw works such as *La Traviata* (1853). In these works Verdi focused upon logic and structure, using recurring themes to provide unity.

Out of this second phase came *Aida* (1871), a grand opera of spectacular proportion built upon a tightly woven dramatic structure. Finally, a third phase produced operas based on Shakespearean plays. *Otello* (1887) contrasts tragedy and opera buffa, and explores subtle balance among voices and orchestra, in concert with strong melodic development.

Wagner

Richard Wagner (1813–83) was perhaps the master of romantic opera. At the heart of Wagner's prolific artistry lay a philosophy which was to affect the world of the musical and legitimate stage from the mid-nineteenth century to the present day. His ideas were laid out principally in two books—*Art and Revolution* (1849) and *Opera and Drama* (1851). Wagner's philosophy centered on the

Gesamtkunstwerk, a comprehensive work of art in which music, poetry and scenery are all subservient to the central generating idea. For Wagner the total unity of all elements reigned supreme. Fully expressive of German romantic philosophy, which confers upon music supremacy over all other arts, Wagner's operas placed music in the predominant role. Dramatic meaning unfolded through the use of *leitmotif*, for which Wagner is famous, although he did not invent it. A *leitmotif* ties a musical theme to ideas, persons, or objects. Whenever those ideas, persons, or objects appear or occupy thought, the theme is played. Juxtaposing *leitmotifs* can suggest relationships between their subjects to the audience. These themes also provide the composer with building blocks, which can be used for development, recapitulation, and unification.

Wagner's operas are legendary. Each work deserves detailed attention. However, whatever we might say by way of description or analysis would be insignificant compared to the dramatic power these works exhibit in full production. Even a recording cannot approach the tremendous effect of these works in full production in an opera house.

Romantic ballet

Choreographers of romantic ballet sought magic and escape in fantasies and legends. Ballets about elves and nymphs enjoyed great popularity, as did ballets about madness, sleepwalking, and opium dreams. Fascinating subject matter came to the fore, for example, harem wives revolting against their oppressors with the help of the "Spirit of Womankind," in Filippo Taglioni's the *Revolt in the Harem* (possibly the first ballet about the emancipation of women). Not only did women come to prominence as ballerinas and in subject matter, but also as choreographers.

Giselle (1841) marked the height of romantic achievement. It contains many fine dancing roles for women and men and has been a favorite of ballet companies since its first production. Adolphe Adam, known for his piece *O Holy Night*, composed the score. The prima ballerina was Carlotta Grisi. The choreography was created by Jean Coralli, ballet master at the Paris Opéra, although, apparently, Jules Perrot, Carlotta's teacher, choreographed all of her dances and in them lies the essence of the ballet.

Romantic architecture

Romanticism also borrowed styles from other eras and produced a vast array of buildings reviving Gothic motifs and reflecting fantasy, a style which has come to be known as picturesque. Eastern influence and whimsy abounded in John Nash's Royal Pavilion in Brighton, England (Fig. **13.33**). Picturesque also describes the most famous example of romantic architecture, the Houses of Parliament (Fig. **13.34**). The Houses of Parliament

13.33 John Nash, Royal Pavilion, Brighton, England, remodeled 1815–23.

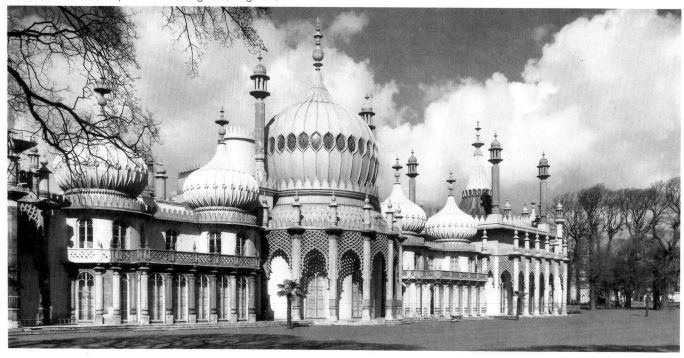

demonstrates a significant concept which can be described as a modern tendency in architectural design. The exterior walls function as a screen, and suggest nothing of structure, interior design or function. What we find inside has absolutely no spatial relationship to the outside. The strong contrast of forms and totally asymmetrical balance is also significant.

The nineteenth century was an age of industry, of experimentation and new materials. In architecture steel and glass came to the fore. At first it took courage for an architect actually to display structural honesty by allowing support materials to be seen as part of the design itself. England's Crystal Palace (Fig. **13.35**) exemplified the nineteenth-century fascination with new materials and

13.34 (*left*) Sir Charles Barry and Augustus Welby Northmore Pugin, Houses of Parliament, London, 1839–52.

13.35 Sir Joseph Paxton, Crystal Palace, London, 1851.

concepts. Built for the Great Exhibition of 1851, this mammoth structure was completed in the space of nine months. Space was defined by a three-dimensional grid of iron stanchions and girders, designed specifically for mass production and rapid assembly (in this case, disassembly as well—the entire structure was disassembled and rebuilt in 1852–4 at Sydenham). Like the Houses of Parliament, the Crystal Palace was the product of the growing dichotomy between the function of a building as reflected in the arrangement of the interior spaces, its surface decoration, and its structure.

REALISM

A new painting style arose in the mid-nineteenth century called realism. The term occurs in varying contexts in various sources. Some refer to *social realism*, which describes various styles that emphasize the contemporary scene, usually from a left-wing point of view and always with a strong thematic emphasis on the pressure of society on human beings. Others extend realism to include painters like Manet. For others, the term appears to apply only to Courbet. Whatever the case, the term *reality* in the

nineteenth century came to have special significance because the camera, a machine to record events, people, and locations, thrust itself into what previously had been considered the painter's realm.

Courbet

The central figure of realism was Gustave Courbet (1819–77), whose aim was to make an objective and unprejudiced record of the customs, ideas and appearances of contemporary French society. He depicted everyday life and was influenced by the innovations of Corot in terms of the play of light on surfaces (Fig. **13.36**). This painting was the first to display his philosophy to the full. Courbet painted two men as he had seen them, working beside a road. The painting is lifesize, and the treatment seems objective, and yet it makes a sharp comment on the tedium and laborious nature of the task. Also a social realist, Courbet was more intent on social message than on meditative reaction and was therefore less dramatic and nostalgic than others.

13.36 Gustave Courbet, *The Stone Breakers*, 1849. Oil on canvas, 5 ft 3 ins x 8 ft 6 ins (1.6 x 2.59 m). Formerly Gemalde galerie, Dresden (destroyed 1945).

13.37 Edouard Manet, *Le Déjeuner sur l'herbe (The Picnic)*, 1863. Oil on canvas, 7 ft x 8 ft 10 ins (2.13 x 2.69 m). The Louvre, Paris.

Manet

Edouard Manet (1832–83) followed in the realist tradition, although often he is regarded as an impressionist (an association he denied). He strove to paint "only what the eye can see." Yet his works go beyond a mere reflection of reality to encompass an artistic reality, telling us that a painting has an internal logic different from the logic of familiar reality. Manet liberated the canvas from competition with the camera. As indicated in the catalogue for an exhibition he produced when he was excluded from the International Exhibition in Paris in 1867, Manet believed that he presented in his art, not a faultless perception, but, rather a sincere perception. In his sincerity came a form of protest—his impressions. To a certain extent Manet was both a conformist and a protester; he came from a comfortable bourgeois background and yet maintained a conviction in socialism. His work leans heavily on the masters of the past, for example, Raphael and Watteau, and at the same time explores completely new ground. He sought acceptance in the salon circles while seeking to shock those same individuals. He sought to be a man of his own time and to reject the superficiality he found in Romantic themes. He gives the reality of the world around him a different and more straight-forward interpretation. He "merely tried to be himself and not someone else." As a result, he often is hailed as the "first modern painter". *Le Déjeuner sur l'herbe* (Fig. **13.37**) shocked the public when it first appeared, at the Salon des Refusés in 1863. Manet sought specifically to "speak in a new voice." The setting is pastoral, as we might find in Watteau, for example, but the people are real and identifiable: Manet's model, his brother, and the sculptor Leenhof. The apparent immorality of a naked frolic in a Paris park outraged the public and the critics. Had his figures been nymphs and satyrs or men and women in classical dress, all would have been well. The painting is both a modern version and a comment upon similar themes of the past. But the intrusion of reality into the sacred confines of the mythical proved more than the public could handle.

Manet's search for spontaneity, harmonious colors, subjects from everyday life, and faithfulness to observed lighting and atmospheric effects led to the development of a style by a small group of painters in the 1860s described in 1874 by a hostile critic as *impressionists*.

Tanner

The first important black painter, the American Henry O. Tanner (1859–1937), studied with the American realist painter Thomas Eakins (1844–1916). *The Banjo Lesson* (Fig. **13.38**) presents its images in a strictly realistic manner, without sentimentality. The painting's focus is achieved through the contrast of clarity in the central objects and less detail in the surrounding areas. In many respects this technique follows Corot's experiments with the perceptual experience—that is, the natural phenomenon wherein only those objects immediately in the center of our vision are in sharp focus; the rest remain slightly out of focus. Tanner's skill is in capturing the atmosphere of concentration and the warm relationship of teacher and pupil.

IMPRESSIONISM

The impressionists created a new way of seeing reality and sought to capture "the psychological perception of reality in color and motion." Undoubtedly Manet should be credited with the original concepts of the style. It emerged in competition with the newly invented technology of the camera, and the impressionists tried to beat photography at its own game by portraying the essentials of perception which the camera cannot capture. The style lasted only fifteen years in its purest form, but it profoundly influenced all art that followed. Working out of doors, the impressionists concentrated on the effects of natural light on objects and atmosphere. They discovered that color, for example, is not inherent in an object but in the perception of that object as modified by the quality of existing light. Their experiments resulted in a profoundly different vision of the world around them and way of rendering that vision. This "revolution of the color patch," as it has been called, taught that the painted canvas was, first of all "a material surface covered with pigments—that we must look *at* it, not *through* it." As we look at the paintings, we observe that the canvas is filled with small "color patches," and that our *impression* of the reality depicted comes as through the totality of those "flickering" patches. The result is a lively and vibrant image.

Impressionism was as collective a style as any we have seen thus far. In an age as individualistic as the nineteenth century this style reflected the common concerns of a relatively small group of artists who met together frequently and held joint exhibitions. As a result, this painting style had marked characteristics, which applied to all its exponents. Paintings of the style are impressions of landscapes, rivers, streets, cafés, theatres, and so on. *On*

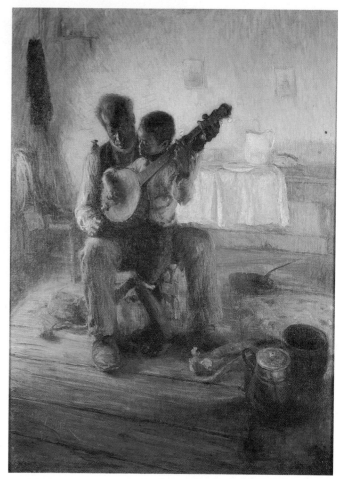

13.38 Henry O. Tanner, *The Banjo Lesson*, c. 1893. Oil on canvas, 48 x 35 ins (122 x 89 cm). Hampton University Museum, Hampton, Virginia.

the Seine at Bennecourt (Fig. **13.39**) by Claude Monet (1840–1926) illustrates the concerns of the impressionists. It portrays a pleasant picture of the times, an optimistic view, in contrast to the often pessimistic viewpoint of the romantics. It also suggests a fragmentary and fleeting image—a new tone in a new era. The tempo increases, and life's pace is more rapid. Monet, along with Degas, Renoir, and Mary Cassatt, among others, were central figures in the development of impressionism.

Renoir

Pierre Auguste Renoir (1841–1919) specialized in the human figure and sought out what was beautiful in the body. His paintings sparkle with the joy of life. In *Moulin de la Galette* (Fig. **13.40**) he depicts the bright gaiety of a Sunday crowd in a popular Parisian dance hall. The artist celebrates the liveliness and charm of these everyday folk as they talk, crowd the tables, flirt, and dance. Sunlight

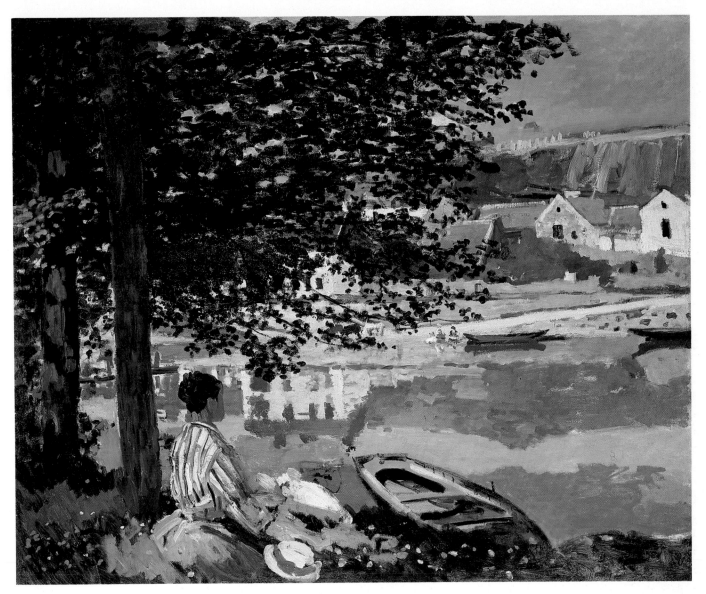

13.39 Claude Monet, *On the Seine at Bennecourt* (Au Bord de l'eau, Bennecourt), 1868. Oil on canvas, 31⅞ x 39½ ins (81.5 x 100.7 cm). Potter Palmer Collection. Photograph © 1990.

and shade dapple the scene and create a sort of floating sensation in light. There is a casualness here, a sense of life captured in a fleeting and spontaneous moment, and of a much wider scene extending beyond the canvas. This is not a formally composed scene like David's *Oath of the Horatii* (Fig. **13.19**). Rather, we are invited to become a part of the action. People are going about their everyday routine with no reaction to the painter's presence. As opposed to the classicist who seeks the universal and the typical, the *realism* of the Impressionist seeks "the incidental, the momentary and the passing."

Morisot

The original group of impressionists included a woman, Berthe Morisot (1841–95), on equal terms. Her works have a gentle introspection, often focusing on family members. Her view of contemporary life is edged with pathos and sentimentality. In *In the Dining Room* (Fig. **13.41**) she uses impressionist techniques to give a penetrating glimpse of psychological reality. The servant girl has a personality, and she stares back at the viewer with complete self-assurance. The painting captures a

295

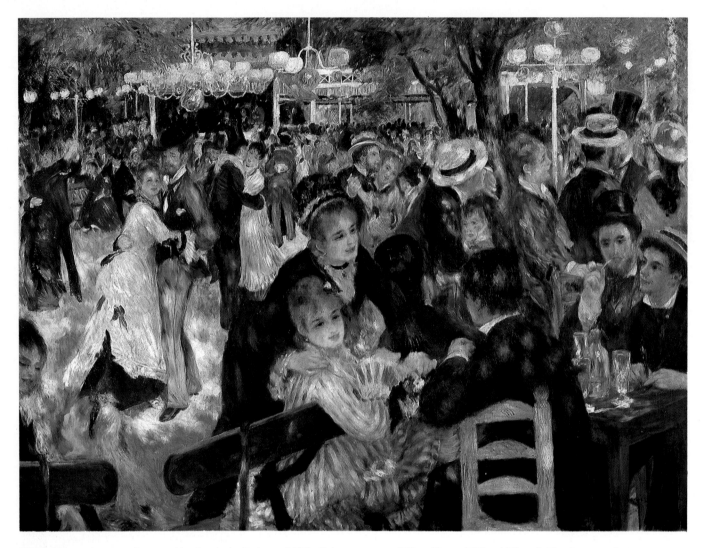

13.40 Pierre-Auguste Renoir, *Moulin de la Galette*, 1876. Oil on canvas, 51½ x 69 ins (131 x 175 cm). The Louvre, Paris.

moment of disorder: The cabinet door stands ajar with what appears to be a used table cloth merely flung over it. The little dog playfully demands attention. Morisot's brushstroke is delicate, and her scenes are full of insight.

Debussy

In music the antiromantic spirit produced a style analogous to that of the impressionist painters. Even among the romantics a free use of chromatics marked later nineteenth-century style. However, a parting of the ways occurred, the effects of which still permeate contemporary music. On the one hand free use of chromatics and key shifts stayed within the parameters of traditional major/ minor tonality. By the end of the century traditional tonality was rejected completely, and a new atonal harmonic expression occurred. Rejection of traditional tonality led to impressionism in music, a movement international in scope but limited in quantity and quality. There was some influence from the impressionist painters, but mostly impressionism in music turned to the symbolist poets for inspiration.

Even though impressionist music was international, it is difficult, principally for want of significance or quality, to go beyond its primary champion, Claude Debussy (1862–1918), to find its substance. However, Debussy did

13.41 Berthe Morisot, *In the Dining Room*, 1886. Oil on canvas, 24⅛ x 19¾ ins (61 x 50 cm). National Gallery of Art, Washington D C.

296

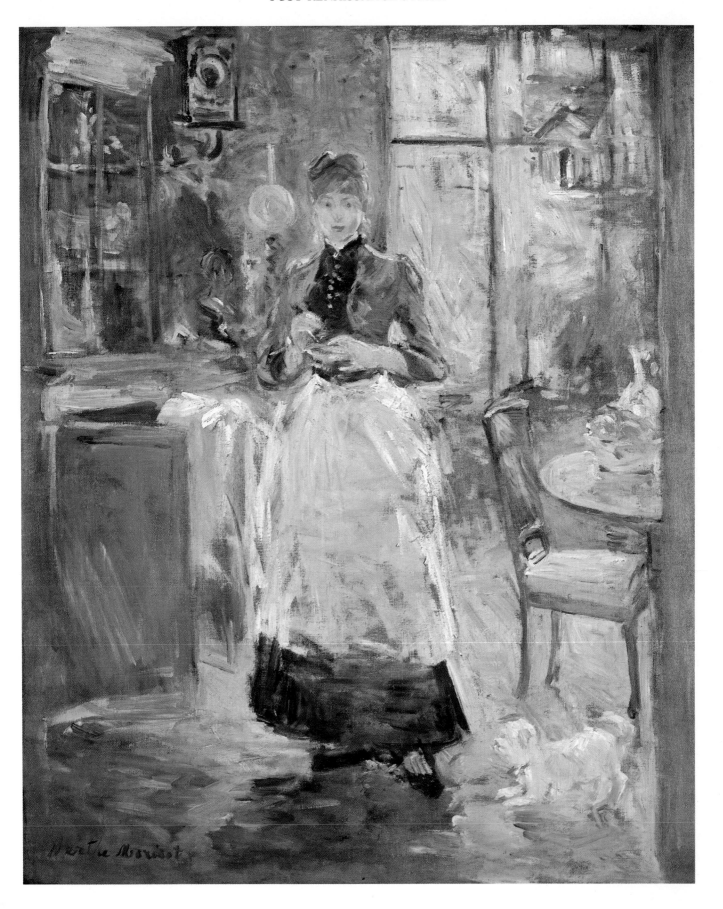

not like to be called an impressionist, which is not surprising because the label was coined by a severe critic of the painters and was intended to be derogatory. He maintained that he was "an old romantic who has thrown the worries of success out the window," and he sought no association with the painters. However, similar motifs and characteristics can be seen. His use of tone color has been described as "wedges of color" applied in the same manner that the painters employed individual brushstrokes. Oriental influence is also apparent, especially in Debussy's use of the Asian five-tone scale. He wished above all to return French music to fundamental sources in nature and move it away from the heaviness of the German tradition. He delighted in natural scenes, as did the impressionist painters, and sought to capture the effects of shimmering light.

In contrast to his predecessors, Debussy reduced melodic development to short motifs of limited range and removed chordal harmony from traditional progression, perhaps his greatest break with tradition. For Debussy, and impressionists in general, a chord was considered strictly on the merits of its expressive capabilities and apart from any context of tonal progression. As a result, gliding chords (repetition of a chord up and down the scale) have become a hallmark of musical impressionism. Dissonance and irregular rhythm and meter further distinguish Debussy's works. Here, again, form and content are subordinate to expressive intent. His works tend to suggest, rather than to state, and to leave the listener with ambiguity, with an impression. Freedom, flexibility, and nontraditional timbres mark his compositions, the most famous of which is *Prélude à l'après-midi d'un faune*, based on a poem by Mallarmé. The piece uses a large orchestra, with emphasis on the woodwinds, most notably in the haunting theme running throughout. Although freely ranging in an irregular $\frac{9}{8}$ meter and having virtually no tonal centers, *Prélude* has a basically traditional ABA structure.

13.42 Georges Seurat, *Sunday Afternoon on the Island of La Grande Jatte*, 1884–86. Oil on canvas, 6 ft 9½ ins x 10 ft ⅜ ins (2.07 x 3.06 m). Helen Birch Bartlett Memorial Collection, 1926.224. Photograph © 1990. Art Institute of Chicago. All rights reserved.

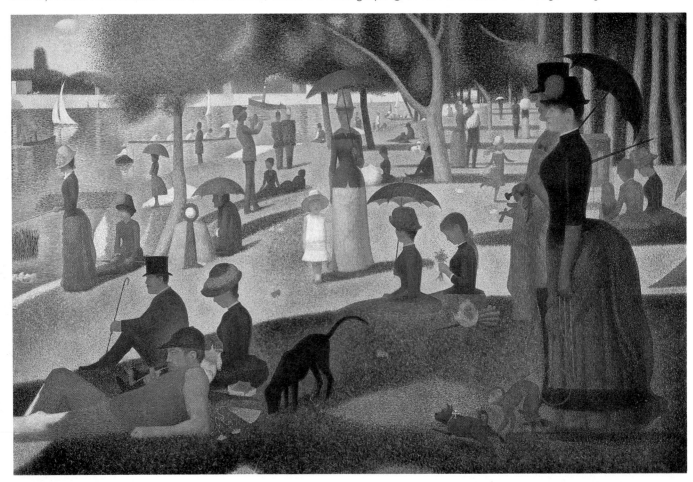

13.43 Paul Cézanne, *Mont Sainte-Victoire seen from Les Lauves*, 1902–4. Oil on canvas, 27½ x 35¼ ins (70 x 90 cm). The Philadelphia Museum of Art (George W. Elkins Collection).

POST-IMPRESSIONISM

In the last two decades of the nineteenth century impressionism evolved gently into a collection of rather disparate styles called, simply, post-impressionism. In subject matter post-impressionist paintings were similar to impressionist paintings—landscapes, familiar portraits, groups, and café and nightclub scenes. The post-impressionists, however, gave their subject matter a complex and profoundly personal significance. Georges Seurat (1859–91), often described as a *neo-impressionist* (he called his approach and technique *divisionism*), departed radically from existing painting technique with experiments in optics and color theory. His patient and systematic application of specks of paint is called pointillism, because paint is applied with the point of the brush, one small dot at a time. He applied paint in accordance with his theory of color perception, and *Sunday Afternoon on the Island of Grande Jatte* (Fig. **13.42**) illustrates his

concern for the accurate depiction of light and colorations of objects. The composition of this work shows attention to perspective, and yet it willfully avoids three-dimensionality. As was the case in much of post-impressionism, Japanese influence is apparent—color areas are fairly uniform, figures are flattened, and outlining is continuous. Throughout the work we find conscious systematizing. The painting is broken into proportions of three-eighths and halves, which Seurat believed represented true harmony. He also selected his colors by formula. Physical reality for Seurat was a pretext for the artist's search for a superior harmony, for an abstract perfection.

Post-impressionism in painting called for a return to form and structure, characteristics the post-impressionists believed were essential to art and were lacking in the works of the impressionists. Taking the evanescent light qualities of the impressionists, Gauguin, Seurat, Van Gogh, and Cézanne brought formal patterning to their canvases, used clean color areas, and casually applied

color in a systematic and almost scientific manner. The post-impressionists sought to return painting to traditional goals while, at the same time, retaining the clean palette of the impressionists.

Paul Cézanne (1839–1906), considered by many as the father of modern art, illustrates concern for formal design, and his *Mont Sainte-Victoire* (Fig. **13.43**) shows a nearly geometric configuration and balance. Foreground and background are tied together in a systematic manner so that both join in the foreground to create two-dimensional patterns. Shapes are simplified and outlining is used throughout. Cézanne employed geometric shapes—the cone, the sphere, and the cylinder—to reveal the permanent reality that lay beneath surface appearance.

A highly imaginative approach to post-impressionist goals came from Paul Gauguin (1848–1903). An artist without training, and a nomad who believed that all European society and its works were sick, Gauguin devoted his life to art and wandering, spending many years in rural Brittany and the end of his life in Tahiti and the Marquesas Islands. His work shows his insistence on form and his resistance to naturalistic effects. The *Vision after the Sermon* (Fig. **13.44**) has Gauguin's typically flat, outlined figures, simple forms, and the symbolism for which he and his followers were known—Symbolists or "Nabis" (from the Hebrew word for prophet). In the background of this painting Jacob wrestles with the Angel while, in the foreground, a priest, nuns, and women in

13.44 Paul Gauguin, *The Vision after the Sermon*, 1888. Oil on canvas, 28¾ x 36¼ ins (73 x 92 cm). The National Gallery of Scotland, Edinburgh.

Breton costume pray. The intense reds of this work are typical of Gauguin's symbolic and unnatural use of color, used here to portray the powerful sensations of a Breton folk festival.

A final approach to post-impressionism was that of Vincent van Gogh (1853–90), whose emotionalism in the pursuit of form was absolutely unique. Van Gogh's turbulent life included numerous short-lived careers, impossible love affairs, a tempestuous friendship with Gauguin, and, finally, serious mental illness. Biography here is essential because Van Gogh gives us one of the most personal and subjective artistic viewpoints in the history of Western art. Works such as the *Starry Night* (Fig. **1.1**) explode with frenetic energy manifested in van Gogh's brushwork. Flattened forms and outlining reflect Japanese influence. Tremendous power and controlled focal areas exist, and we can sense the dynamic, personal energy and mental turmoil present in van Gogh's art.

EXPERIMENTATION

A new age of experimentation also took nineteenth-century architects in a different direction—upward. Late in the period the skyscraper was designed in response to the need to create commercial space on limited property in burgeoning urban areas. Burnham and Root's Monadnock building in Chicago (Fig. **7.19**) was an early example. Although this prototypical "skyscraper" is all masonry—built completely of brick and requiring increasingly thick supportive walls toward its base—it was part of the trend to combine design, materials, and new concepts of architectural space. When all these elements were finally combined, the skyscraper emerged— almost exclusively in America. Architects were able to erect buildings of unprecedented height without increasing the thickness of lower walls by erecting structural frameworks (first of iron, later of steel) and by treating walls as independent partitions. Each story was supported on horizontal girders. The concept of the skyscraper could not be realized, however, until a man named Otis had invented a safe and reliable elevator.

13.45 Louis Henry Sullivan, Carson, Pirie and Scott Department Store, Chicago, 1899–1904.

A very influential figure in the development of the skyscraper and the philosophy of modern architecture was Louis Sullivan, the first truly modern architect. Working in the last decade of the nineteenth century in Chicago, then the most rapidly developing metropolis in the world, Sullivan designed buildings characterized by dignity, simplicity, and strength. Most importantly, he created a rubric for modern architecture by combining form and function into a theory in which the former flowed from the latter. As Sullivan said to an observer of the Carson, Pirie, and Scott building (Fig. **13.45**), "It is evident that we are looking at a department store. Its purpose is clearly set forth in its general aspect, and the form follows the function in a simple, straightforward way."[8]

FOURTEEN

EUROPEAN & AMERICAN PLURALISM IN THE TWENTIETH CENTURY

The one constant in the arts of this turbulent and phenomenal century has been a seemingly inexhaustible quest for originality and freshness. Among the awesome contradictions of an age that has witnessed the worst and the best that humanity is capable of, our vision of ourselves and where we are going is as troublesome for us as it was for our Paleolithic ancestors.

EXPRESSIONISM

Expressionism traditionally refers to a movement in Germany between 1905 and 1930, but its broad applications include a variety of specific approaches, essentially in Europe, that focused on a joint artist/respondent reaction to composition elements. Any element (line, form, color, and so on) could be emphasized to elicit a specific response in the viewer. The artist would consciously try to stimulate a response that had a specific relationship to his or her feelings about or commitment to the subject matter. Subject matter itself mattered little; what counted was the artist's attempt to evoke in the viewer a similar response to his or her own. In Max Beckmann's *Christ and the Woman Taken in Adultery* (Fig. **14.1**), the artist's

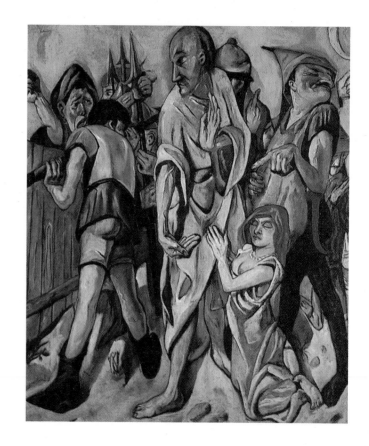

revulsion against physical cruelty and suffering is transmitted through distorted figures crushed into shallow space. Linear distortion, changes of scale and perspective, and a nearly Gothic spiritualism communicate Beckmann's reactions to the horrors of World War I. In this approach, meaning relies on very specific nonverbal communication.

The 1970s saw a continuation of expressionism in the lyrical work of artists such as William T. Williams (b. 1942). In *Batman* (Fig. **14.2**) we see a methodology which has been compared to jazz improvization. In the carefully defined two-part structure, continuing verticals subtly play across the dividing line to pull the work together. At the same time delicate traceries reinforce the basic structure and provide endless variations. The resulting texture is evocative, like cracking or peeling paint on a series of old boards, perhaps. True to its expressionist heritage, the work links the artist's memory with the experience of the viewer.

Expressionism brought to the theatre ideas which reflected disillusionment more than they did realism. But here we must tread carefully, because the theatre is both visual and oral. The painter's revolt against naturalism came to the theatre in visual form in scenic design. Settings which followed expressionism in painting occurred often. For the playwright, expressionism was merely an extension of realism and naturalism and allowed the playwright a more adequate means to express his own reaction to specific items in the universe around him. August Strindberg, for example, had turned inward to the subconscious in expressionistic plays such as the *Ghost Sonata*. In so doing, he created a presentational rather than representational style.

Expressionism also found its way to America. Elmer Rice's play *Adding Machine* (1923) depicts Mr. Zero, a cog in the great industrial machinery of twentieth-century life, who stumbles through a pointless existence. Finding himself replaced by an adding machine he goes berserk, kills his employer, and is executed. Then, adrift in the hereafter, he is too narrow-minded to understand the happiness offered to him there. He becomes an adding machine operator in Heaven and finally returns to earth to begin his tortured existence all over again.

German expressionism made its mark in film as well as in the visual and other performing arts, and in 1919 its most masterful example, Robert Wiene's *Cabinet of Dr.*

14.1 Max Beckmann, *Christ and the Woman Taken in Adultery*, 1917. Oil on canvas, 58¾ x 49⅞ ins (149 x 127 cm). The Saint Louis Art Museum (Bequest of Curt Valentin).

Caligari, shook the world. Macabre sets, surrealistic lighting effects, and distorted properties, all combined to portray a menacing post-war German world.

CUBISM

Between 1901 and 1912 an entirely new approach to pictorial space emerged to which the term cubism was applied. Cubist space violates all concepts of two- or three-dimensional perspective. In the past the space within a composition had been thought of as separate from the main object of the work. That is, if the subject were removed, the space would remain, unaffected. Pablo Picasso (1881–1973) and Georges Braque (1882–1963) changed that relationship to one in which the artist tried to paint "not objects, but the space they engender." The area around an object became an extension of the object itself. If the object were removed, the space around it would collapse. Cubist space is typically quite shallow and gives the impression of reaching forward toward the viewer, thereby intruding into space outside of the frame. Essentially the style developed as the result of independent experiments of Braque and Picasso with various ways of describing form. Newly evolving notions of time–space continuity were being proposed by Albert Einstein at this time. We cannot be sure whether the Theory of Relativity influenced Picasso and Braque, but it certainly helped to make their works more acceptable. The results of these experiments brought them to remarkably similar conclusions.

Picasso influenced the arts of the twentieth century more than any other individual. Born in Spain, in 1900 he moved to France, where he resided for most of his life. In Paris he was influenced by Toulouse-Lautrec and the late works of Cézanne, particularly in terms of their organization, analysis of forms, and assumption of different viewpoints. Very early on Picasso began to identify deeply with society's misfits and cast-offs. He was able to express that identification strongly in his art, which focused on form kept within the frame. Mass was "built up within [the frame] like a box within a box."[1]

Depression characterized his works from 1901 until around 1904 or 1905. This is known as his Blue Period, and was followed by his Rose Period (1904–6), "in which he was less concerned with the tragic aspects of poverty than with the nostalgic charm of itinerant circus performers and the school of make-believe." Picasso himself was amused by the critics' attempts to explain him and to follow the twists and turns of his development.

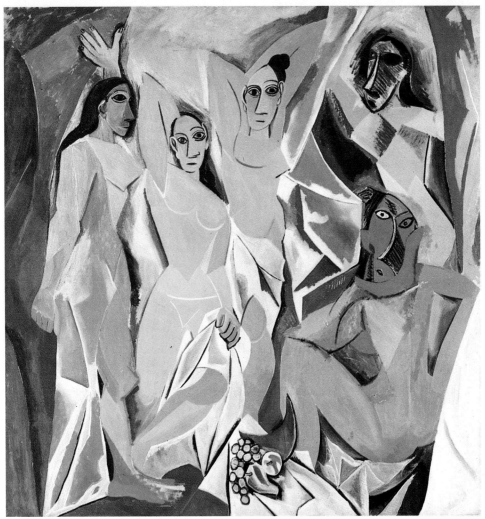

14.3 Pablo Picasso, *Les Demoiselles d'Avignon*, 1907. Oil on canvas, 8 ft x 7 ft 8 ins (2.44 x 2.34 m). The Museum of Modern Art, New York (acquired through the Lillie P. Bliss Bequest).

In 1907, the creative revelation of *Les Demoiselles d'Avignon* (Fig. **14.3**) was released upon the art world and cubism was born. Simplified forms and restricted color followed, as cubism uniformly reduced its palette range to allow emphasis to fall on spatial exploration alone. This landmark painting was a deliberate break with the traditions of Western illusionistic art, stemming from Picasso's discovery of primitive African art and sculpture, and its use of flat forms and exaggeration of certain features. Three of the heads in this painting are adaptations of African masks. He used primitive art as a "battering ram against the classical conception of beauty." Classical proportions, as well as the organic integrity and continuity of

the human body are denied. The *Demoiselles* is aggressive and harsh: Forms are simplified and angular, and colors are restricted to blues, pinks, and terracottas. Cubism uniformly reduced its palette range, thereby emphasizing the exploration of space. Subjects are broken into angular wedges which are given a sense of three-dimensionality. The *trompe l'oeil* leaves us unsure whether the forms protrude out or recess in. Picasso rejects the single viewpoint, so the "reality" of nature is no longer the mirror of what we see in the world, but has been interpreted by a new set of principles. Understanding depends on *knowing* rather than *seeing* in the literal sense.

FAUVISM

14.2 William T. Williams, *Batman*, 1979. Acrylic on canvas, 80 x 60 ins (203 x 152 cm). Collection of the artist.

Closely associated with the development of the expressionist movement were the *fauves* (wild beasts). The label

was applied by a critic in response to a sculpture (exhibited in 1905) which seemed to him "a Donatello in a cage of wild beasts." Violent distortion and outrageous coloring mark the subjective expression of the fauves. Their two-dimensional surfaces and flat color areas were new to European painting. The best-known artist of this short-lived movement was Henri Matisse (1869–1954). Matisse tried to paint pictures that would "unravel the tensions of modern existence." In his old age he made a series of very joyful designs for the Chapel of the Rosary at Venice, not as exercises in religious art but, rather, to express the joy and nearly religious feeling he had for life.

The Blue Nude (Fig. **14.4**) illustrates the wild coloring and distortion of Matisse and fauvism. The painting takes its name from the energetically applied blues, which occur throughout the figure as darkened accents. For Matisse color and line were indivisible, and the bold strokes of color in his work comprise coloristic and linear stimulants, as well as revelations of form. Matisse literally "drew with color." Underlying this work, and illustrative of the fauves' relationship to expressionism, is Matisse's desire, not to draw a nude as he saw it in life, but rather to express his feelings about the nude as an object of aesthetic interest. Expressionism was associated with a number of other trends, including the Bridge and Blue Rider groups and artists such as Kandinsky, Rouault, and Kokoschka.

HARLEM RENAISSANCE

From 1919 to 1925 Harlem, a small enclave in New York City, became the international capital of Black culture. "Harlem was in vogue" wrote the Black poet Langston Hughes (see pp. 315). Black painters, sculptors, musicians, poets, and novelists joined in a remarkable artistic outpouring. The period became an intensely controversial one, its artistic merits attacked by some critics of the time as isolationist and conventional; the qualities of the Harlem Renaissance still stir debate. Nonetheless, this period of intense creative activity by Black Americans "gave the artists an identifiable artistic context for their work, propelled them to the forefront of the New Negro Movement, and inspired their art for the remainder of their careers."[2]

The artistic works emanating from this period reached a national audience through exhibitions sponsored by the Harlem Foundation. The spirit of the movement, expressed through its artists, took several themes: glorification of the Black American's African heritage; the tradition of Black folklore; and general interest in the daily life of Black people. In every case Harlem Renaissance artists broke with previous Black artistic traditions. They celebrated Black history and culture and "defined a visual vocabulary for Black Americans."[3]

Black intellectuals such as W. E. B. Du Bois, Alain Locke,

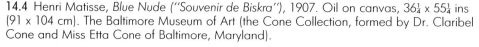

14.4 Henri Matisse, *Blue Nude ("Souvenir de Biskra")*, 1907. Oil on canvas, 36¼ x 55¼ ins (91 x 104 cm). The Baltimore Museum of Art (the Cone Collection, formed by Dr. Claribel Cone and Miss Etta Cone of Baltimore, Maryland).

14.5 Aaron Douglas, *Aalta*, 1936. Oil on canvas, 18 x 23 ins (45.7 x 58.4 cm). Afro-American Collection of Art, The Carl Van Vechten Gallery of Fine Arts, Fisk University.

and Charles Spurgeon spearheaded the movement. Among the notable artists were social documentarian and photographer James Van Der Zee (1886–1983), painter William Henry Johnson (1901–1970), painter Palmer Hayden (1890–1973), painter Aaron Douglas (1899–1979), and sculptor Meta Vaux Warrick Fuller (1877–1968).

Palmer Hayden (Peyton Cole Hedgeman) trained at the Cooper Union in New York in 1919 and later at the Boothbay Art Colony. In 1927 he travelled to Europe and studied at the École des Beaux Arts. His work was exhibited widely in New York and drew heavy criticism from those who believed that his depictions mocked Black people and sustained negative stereotypes. Later in life he created the John Henry series, twelve oil paintings portraying the life and death of the Black folk hero John Henry. Hayden focused on Black American legends and folk themes, expressing visually the wealth of material from the Black oral culture of the rural South and of Africa. Utilizing folk themes to illustrate industrial Ameri-

ca's dependence on the Black labor force, Hayden's works symbolize ethnic heroism.

Aaron Douglas, perhaps the foremost painter of the Harlem Renaissance earned a Bachelor of Fine Arts degree from the University of Nebraska and a Master's degree from Columbia University. His training encouraged him to explore the rich vocabulary of Black American myth and culture. His work is highly stylized, explores a palette of muted tones, and is well known through its appearance as illustrations and cover designs for many books by Black writers. His mural *Aspects of Negro Life*, at the New York Public Library's Cullen Branch, documents in four panels the emergence of a Black American identity. The first panel portrays the African cultural background in images of music, dance, and sculpture. The next two panels bring to life slavery and emancipation in the American South and the flight of Blacks to the cities of the North. The third panel returns to the theme of music. Among Douglas' wide variety of stylistic approaches, his realistic

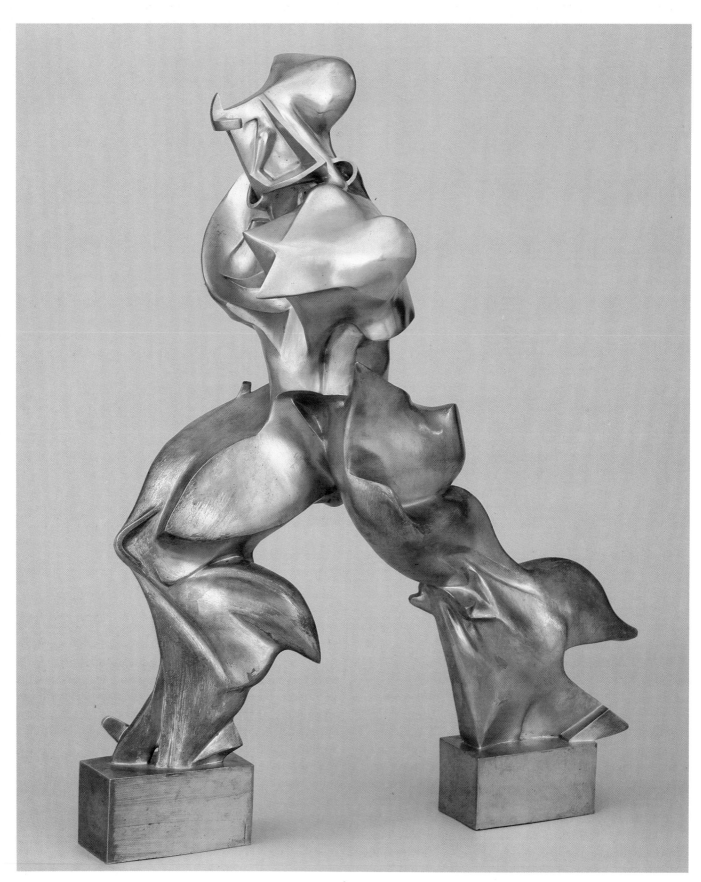

14.6 Umberto Boccioni, *Unique Forms of Continuity in Space*, 1913. Bronze (cast 1931), height 43⅞ ins (111 cm). The Museum of Modern Art, New York (acquired through the Lillie P. Bliss Bequest).

portrait of ALTA (Fig. **14.5**) provides a warm and relaxed composition, whose palette and expression express dignity, elegance, and stability.

Meta Vaux Warrick Fuller "was the first Black American artist to draw heavily on African themes and folklore for her subjects".[4] Years before the Harlem Renaissance, she began to express the pan-African ideals which later permeated the movement. After finishing graduate work at the Pennsylvania Museum and School for Industrial Arts, she studied in Paris at the École des Beaux Arts and the Academie Colarossi. One of her mentors was the sculptor Auguste Rodin, and his influence can be seen in her impressionistic surface treatment of romantic realist subjects. Fuller built her own studio in Framingham, Massachusetts, and focused on themes dealing with anti-slavery and protests against injustice to Black Americans. In one of the earliest works by a Black American focusing on the African heritage, her sculpture *Ethiopia Awakening* shows an Egyptian woman emerging from her embalming wrappings. "The work symbolically represents the emergence of Black cultural awareness from the 'wrappings' of ignorance and oppression, and the beginnings of the end of colonial rule in Africa."[5] Works such as *The Talking Skull* are based on African models and illustrate the confrontation of humans with death, a prevalent theme in her career.

William Henry Johnson studied at the National Academy of Design in New York, followed by a three-year fellowship in 1926 to study in Europe. Under the influence of the European Impressionists and realists, his style became much more personally expressive. His many works focus on the Black experience in America, with Harlem, where he spent his childhood, being the central theme. Just prior to World War II his style changed again, moving from fully rounded to flat figures.

FUTURISM

New concerns for space turned, logically, to three-dimensional space and the potential relationships it presented. Technological developments and new materials also encouraged the search for new forms characteristic of the age. Futurists in the visual arts searched for dynamic qualities representative of the times and believed that many of the new machines of the era had sculptural form. Some sculptures followed mechanistic lines and also included motion.

Boccioni's *Unique Forms of Continuity in Space* (Fig. **14.6**) takes the mythological subject of Mercury, messen-ger of the gods, and turns him into a futuristic machine. The overall form is recognizable and the connotations of the myth move the viewer's thoughts in a particular direction. Nonetheless, this is primarily an exercise in composition of forms. The intense sense of energy and movement is created by the variety of surfaces and curves which flow into one another, in a seemingly random yet highly controlled pattern. The overall impression is of a figure in motion, rather than of the figure itself.

ABSTRACTION

Paintings, sculptures, plays, and symphonies all are abstractions regardless of the degree of verisimilitude they contain. However, abstract or nonrepresentational art contains minimal reference to natural objects—that is, objects in the phenomenal or natural world. In many ways abstract art stands in contrast to impressionism and expressionism in that the observer can read little or nothing in the painting of the artist's feelings about any aspect of the universe. Abstract art seeks to explore the expressive qualities of formal design elements in their own right. These elements are assumed to stand apart from subject matter. The aesthetic theory underlying abstract art maintains that beauty can exist in form alone, and no other quality is needed. Numerous painters have explored these approaches, and several subgroups such as de Stijl, suprematists, constructivists, and the Bauhaus painters have pursued its goals. The works of Piet Mondrian and Kasimir Malevich illustrate many of the principles at issue in abstract painting.

Mondrian (1872–1944) believed that the fundamental principles of life consisted of straight lines and right angles. A vertical line signified active vitality and life, and a horizontal line signified tranquility, rest, and death. The crossing of the two in a right angle expressed the highest possible tension between these forces, positive and negative. *Composition in White, Black, and Red* (Fig. **1.38**) explores Mondrian's philosophy in a manner characteristic of all his linear compositions. The planes of the painting are close to the surface of the canvas, creating, in essence, the thinnest space possible, in contrast to the deep space of other styles. The palette is restricted to three hues. Even the edges of the canvas take on expressive possibilities as they provide additional points of interaction between lines. Mondrian believed that he could create "the equivalence of reality" and make the "absolute appear in the relativity of time and space" by keeping visual elements in a state of constant tension, a style called *Logical Abstract*.

14.7 Georgia O'Keeffe, *Dark Abstraction*, 1924. Oil on canvas, 24⅞ x 20⅞ ins (63.3 x 53 cm). St. Louis Art Museum (gift of Charles E. and Mary Merrill).

14.8 Isamu Noguchi, *Kouros* (in nine parts), 1944–45. Pink Georgia marble, slate base, height c. 9 ft 9 ins (2.97 m). The Metropolitan Museum of Art, New York (Fletcher Fund, 1953 [53.87 a–i]).

Georgia O'Keeffe (1887–1986), an American, proved to be one of the most original artists of our time. Her imagery draws on a diverse repertoire of objects abstracted in a uniquely personal way. She takes for example, an animal skull and transforms it into a form of absolute simplicity and beauty. In *Dark Abstraction* (Fig. **14.7**) an organic form becomes an exquisite landscape which, despite the modest size of the painting, appears monumental. Her lines flow gracefully upward and outward with skillful blending of colors and rhythmic grace. Whatever the subject of the painting, it expresses a mystical reverence for nature. O'Keeffe creates a sense of reality which takes us beyond the surface of our perceptions into something much deeper.

Isamu Noguchi (b. 1904), perhaps less concerned with expressive content than others, has continually experimented with abstract sculptural design since the 1930s. His creations have gone beyond sculpture to provide highly dynamic and suggestive designs for the choreography of Martha Graham, with whom he was associated for a number of years. Noguchi's *Kouros* figures (Fig. **14.8**) contain abstract relationships with archaic Greek sculpture and also exhibit exquisitely finished surfaces and masterly technique.

The original mobiles of Alexander Calder (1898–1976) (Fig. **2.17**) put abstract sculpture into motion. Deceptively simple, these colorful shapes turn at the

whim of subtle breezes or by motors. Here is the discovery that sculpture can be created by movement in undefined space.

Objectivity returns in the unique approaches of Alberto Giacometti (1901–66). He was a surrealist sculptor in the 1930s but continued to explore the reality of the human figure and surface depiction and meaning, as can be seen in Figure **2.14**. Here form is reduced to its essence in a tortured fragmentation that appears to comment on the nature of humankind in the contemporary world.

W. H. Auden

Wystan Hugh Auden (1907–73), was an English poet whose work is an example of abstraction in poetry. His main concerns in the 1930s were for man and society, and he was influenced by Marx and Freud. His writings exhibit a strong desire for pattern and order. This early period represented his tendency toward discursiveness, the dialectic, and abstraction. Overall, Auden's writing has been influenced by numerous factors, including Greek literature, Old English poetry, and the Icelandic sagas. His early poetry is marked by an emphasis on personal problems and social causes, although he appears to have become disenchanted with Marx and Freud in later works, which are marked by skepticism, irony, and a semireligious tone. *Poems* preceded his journey to Spain in 1936 to support the left-wing cause in the Spanish Civil War. From 1948 until the mid-1950s, Auden experimented with symbolic landscape poetry, characterized by a syllabically counted line. He remains one of the major influences in twentieth-century British and American poetry.

Musée des Beaux Arts

About suffering they were never wrong,
The Old Masters: how well they understood
Its human position; how it takes place
While someone else is eating or opening a window or just
walking dully along;
How, when the aged are reverently, passionately waiting
For the miraculous birth, there always must be
Children who did not specially want it to happen, skating
On a pond at the edge of the wood:
They never forgot
That even the dreadful martyrdom must run its course

Anyhow in a corner, some untidy spot
Where the dogs go on with their doggy life and the
torturer's horse
Scratches its innocent behind on a tree.
In Brueghel's *Icarus*, for instance: how everything turns away
Quite leisurely from the disaster; the ploughman may
Have heard the splash, the forsaken cry,
But for him was not an important failure; the sun shone
As it had to on the white legs disappearing into the green
Water; and the expensive delicate ship that must have seen
Something amazing, a boy falling out of the sky,
Had somewhere to get to and sailed calmly on.

In War Time

(For Caroline Newton)

Abruptly mounting her ramshackle wheel,
Fortune has pedalled furiously away;
The sobbing mess is on our hands today.

Those accidental terrors, Famine, Flood,
Were never trained to diagnose or heal
Nightmares that are intentional and real.

Nor lust nor gravity can preach an aim
To minds disordered by a lucid dread
Of seeking peace by going off one's head.

Nor will the living waters whistle; though
Diviners cut their throats to prove their claim,
The desert remains arid all the same.

If augurs take up flying to fulfill
The doom they prophesy, it must be so;
The herons have no modern sign for No.

If nothing can upset but total war
The massive fancy of the heathen will
That solitude is something you can kill,

If we are right to choose our suffering
And be tormented by an Either-Or,
The right to fail is worth dying for,

If so, the sweets of victory are rum:
A pride of earthly cities premising
The Inner life as socially the thing,

Where, even to the lawyers, Law is what,
For better or for worse, our vows become
When no one whom we need is looking, Home

A sort of honour, not a building site,
Wherever we are, when, if we chose, we might
Be somewhere else, yet trust that we have chosen right.

Two's Company

Again in conversations
Speaking of fear
And throwing off reserve
The voice is nearer
But no clearer
Than first love
Than boys' imaginations.

For every news
Means pairing off in twos and twos
Another I, another You
Each knowing what to do
But of no use.

Never stronger
But younger and younger
Saying good-bye but coming back, for fear
Is over there
And the centre of anger
Is out of danger.

The Composer

All the others translate: the painter sketches
A visible world to love or reject;
Rummaging into his living, the poet fetches
The images out that hurt and connect.

From Life to Art by painstaking adaption,
Relying on us to cover the rift;
Only your notes are pure contraption,
Only your song is an absolute gift.

Pour out your presence, O delight, cascading
The falls of the knee and the weirs of the spine.
Our climate of silence and doubt invading;
You alone, alone, O imaginary song,
Are unable to say an existence is wrong,
And pour out your forgiveness like a wine.

Voltaire at Ferney

Almost happy now, he looked at his estate.
An exile making watches glanced up as he passed,
And went on working; where a hospital was rising fast
A joiner touched his cap; an agent came to tell
Some of the trees he'd planned were progressing well.
The white alps glittered. It was summer. He was very great.

Far off in Paris, where his enemies
Whispered that he was wicked, in an upright chair
A blind old woman longed for death and letters. He would write
"Nothing is better than life." But was it? Yes, the fight
Against the false and the unfair
Was always worth it. So was gardening. Civilise.

Cajoling, scolding, scheming, cleverest of them all,
He'd led the other children in a holy war
Against the infamous grown-ups; and, like a child, been sly
And humble when there was occasion for
The two-faced answer or the plain protective lie,
But patient like a pheasant waited for their fall.

And never doubted, like D'Alembert, he would win:
Only Pascal was a great enemy, the rest
Were rats already poisoned; there was much, though, to be done,
And only himself to count upon.
Dear Diderot was dull but did his best;
Rousseau, he'd always known, would blubber and give in.

So, like a sentinel, he could not sleep. The night was full of wrong,
Earthquakes and executions. Soon he would be dead,
And still all over Europe stood the horrible nurses
Itching to boil their children. Only his verses
Perhaps could stop them: He must go on working. Overhead
The uncomplaining stars composed their lucid song.

Journey to Iceland

And the traveller hopes: "Let me be far from any
Physician"; and the ports have names for the sea,
 The citiless, the corroding, the sorrow;
 And North means to all: "Reject."

And the great plains are forever where the cold fish is
 hunted,
And everywhere; the light birds flicker and flaunt;
 In the abnormal day of this world, and a river's
 Fan-like polyp of sand.

Then let the good citizen here find natural marvels:
A horse-shoe ravine, an issue of steam from a cleft
 In the rock, and rocks, and waterfalls brushing the
 Rocks, and among the rocks birds.

And the student of prose and conduct places to visit:
The site of a church where a bishop was put in a bag,
 The bath of a great historian, the fort where
 An outlaw dreaded the dark;

Remember the doomed man thrown by his horse and
 crying,
"Beautiful is the hillside, I will not go,"
 The old woman confessing, "He that I loved the
 Best, to him I was worst."

For Europe is absent: this is an island and therefore
A refuge, where the fast affections of its dead may be
 bought
 By those whose dreams accuse them of being
 Spitefully alive, and the pale

From too much passion of kissing feel pure in its deserts.
Can they? For the world is, and the present, and the lie.
 The narrow bridge over the torrent,
 And the small farm under the crag

Are the natural setting for the jealousies of a province;
And the weak vow of fidelity is formed by the cairn;
 And within the indigenous figure on horseback
 On the bridle path down by the lake

The blood moves also by crooked and furtive inches,
Asks all our questions: "Where is the homage? When
 Shall justice be done? O who is against me?
 Why am I always alone?"

No, our time has no favourite suburb; no local features
Are those of the young for whom all wish to care;
 The promise is only a promise, the fabulous
 Country impartially far.

Tears fall in all the rivers. Again the driver
Pulls on his gloves and in a blinding snowstorm starts
 Upon his deadly journey, and again the writer
 Runs howling to his art.[6]

AFRICAN AND PRIMITIVE INFLUENCES

The direct influence of African art can be seen in the sculptures of Constantin Brancusi (1876–1957), but beyond this, the smooth, precise surfaces of much of his work seem to have an abstract, mechanistic quality. His search for essential form led to very economical presentations, often ovoid and simple, yet animate. Certainly, great psychological complexity exists in *Bird in Space*. Its highly polished surface and upward striving line has a modern sleekness, and yet the primitive essence remains, reminding us of the work of African or Aboriginal tribes. *Mlle. Pogany* (Fig. **14.9**), despite the superbly polished surface and accomplished curves which lead the eye inwards, has the enigmatic character of an African mask.

14.9 Constantine Brancusi, *Mlle. Pogany*, 1931. Marble on limestone base, height 19 ins (48 cm). The Philadelphia Museum of Art (Louise and Walter Arensberg Collection).

SURREALISM

Fascination with the subconscious mind, as popularized by the psychiatrist Sigmund Freud, stimulated explorations in psychic experience. By 1924 a surrealist manifesto had been put forward which tied the subconscious mind to painting. "Pure psychic automatism" described surrealist works. Surrealism was seen by its advocates as a means for discovering the basic reality of psychic life through automatic association. A dream was supposedly capable of transference directly from the unconscious mind to canvas without control or conscious interruption by the artist.

Surrealism is probably more accurately described by the paintings of Salvador Dali. Dali (1904–89) called his works, such as the *Persistence of Memory* (Fig. **1.28**), "hand-colored photographs of the subconscious," and the high verisimilitude of this work, coupled with its nightmarish relationships of objects, makes a forceful impact. The whole idea of time is destroyed in these "wet watches" (as they were called by those who first saw this work) hanging limply and crawling with ants. And yet there is a strange fascination here, perhaps akin to our fascination with the world of our dreams. While the anti-art dadaism of Max Ernst may seem repulsive, the irrationality of de Chirico and Dali can be entrancing. The starkness and graphic clarity of Figures **1.28** and **1.31** speaks of the unpolluted light of another planet, yet nonetheless reflects a world we seem to know.

REALISM

Pictorial objectivity was continued in the realist tradition in the works of Grant Wood (1892–1942) — for example, *American Gothic* (Fig. **1.32**), a wonderful celebration of America's heartland and its simple, hardworking people. There is a lyric spirituality behind the façade of this downhome illustration. The upward movement of the elongated forms is pulled together at the top into a pointed arch which encapsulates the Gothic window of the farmhouse and escapes the frame of the painting through the lightning rod, in the same sense that the Gothic spire released the spirituality of the earth into heaven at its tip. Rural American reverence for home and labor is celebrated here with gentle humor. There is a capricious two-dimensionality to the picture plane. All objects, including the people, line up horizontally across the painting. We can see no linear perspective in the middle ground, and so the buildings appear pressed against the backs of the farmer and his wife.

Film

World War II and its aftermath brought radical change to the form and content of the cinema. A film came out in 1940 that stunned even Hollywood. Darryl Zanuck and John Ford's version of John Steinbeck's *The Grapes of Wrath* artistically visualized the social criticism of Steinbeck's portrayal of the Depression, through superb cinematography and compelling performances. Theme and social commentary burst forth again in 1941 with two outstanding works, *How Green Was My Valley*, which dealt with exploited coal miners in Wales, and *Citizen Kane*, about wealth and power, and thought by some to be the best film ever produced. The cinematic techniques of *Citizen Kane* forged a new trail. Orson Welles, director and star, and Greg Toland, cinematographer, brilliantly combined deep-focus photography, unique lighting effects, rapid cutting, and moving camera sequences.

But as the war ended and Italy revived from the yoke of Fascism, a new concept set the stage for the years ahead. In 1945 Roberto Rossellini's *Rome, Open City* graphically depicted the misery of Rome during the German occupation. It was shot on the streets of Rome using hidden cameras and mostly nonprofessional actors and actresses. Technically, the quality of the work was deficient, but the effectiveness of its objective viewpoint and documentary realism changed the course of cinema and inaugurated a style called *neo-realism*.

Theatre

Realism continued its strong tradition in the theatre throughout the post-war era and owed much of its strength to the works of Tennessee Williams (1912–83) and Arthur Miller (b. 1915). However, realism has expanded from its nineteenth-century definition to include more theatrical approaches and devices such as fragmenting settings. Realism has also become more eclectic in its inclusion of many nonrealistic devices such as symbolism. Undoubtedly the theatre has concluded that stage realism and life's realism are two different concepts entirely. Tennessee Williams skillfully blended the qualities of realism with whatever scenic, structural, or symbolic devices were necessary to meet his goals. His plays such as *The Glass Menagerie* deal sensitively and poignantly with the problems and psychology of everyday people. His character development is thorough and occupies the principal focus in his dramas as he explores the mental and emotional ills of our society. Arthur Miller probed the social and psychological forces that destroy contemporary men and women in plays such as *Death of a Salesman*.

Langston Hughes

Langston Hughes (1902–67) is often referred to as the "poet laureate of Harlem." An Afro-American poet, Hughes' poetry portrayed the life of the ordinary black individual in the United States. He caught with sharp immediacy and intensity the humor, pathos, irony, and humiliation of being black in America. His poetry is particularly meaningful to young people. He speaks of the basic qualities of life, that is, love, hate, aspirations, and despair. Yet, he writes with a faith in humanity in general. He interprets all life as it is experienced in the real world as well as in idealism. At the same time, some of his work comprises militant pieces which carry broad sociopolitical implications. He struggled within himself between what he wanted to write and what his audience expected him to write.

Hughes received considerable attention as a poet as early as 1921 with his poem "The Negro Speaks of Rivers." His poetry and his involvement in social causes are often intertwined. In his novel *Not Without Laughter*, Hughes created a brilliant portrayal of a black youth's passage into manhood. In the short selections that follow, readers can sense the black experience and perception of the universe.

Theme for English B

The instructor said,
 Go home and write
 a page tonight.
 And let that page come out of you—
 Then, it will be true.
I wonder if it's that simple?

I am twenty-two, colored, born in Winston-Salem.
I went to school there, then Durham, then here
to this college on the hill above Harlem.
I am the only colored student in my class.
The steps from the hill lead down into Harlem
through a park, then I cross St. Nicholas.
Eighth Avenue. Seventh, and I come to the Y,
the Harlem Branch Y, where I take the elevator
up to my room, sit down, and write this page:
It's not easy to know what is true for you or me
at twenty-two, my age. But I guess I'm what

I feel and see and hear, Harlem, I hear you:
hear you, here me—we two—you, me, talk on this page.
(I hear New York, too) Me—who?

Well, I like to eat, sleep, drink, and be in love.
I like to work, read, learn, and understand life.
I like a pipe for a Christmas present,
or records—Bessie, bop, or Bach.
I guess being colored doesn't make me not like
the same things other folks like who are other races.
So will my page be colored that I write?
Being me, it will not be white.
But it will be
a part of you, instructor.
You are white—
yet a part of me, as I am a part of you.
that's American.
Sometimes perhaps you don't want to be a part of me,
Nor do I often want to be apart of you.
But we are, that's true!

As I learn from you
I guess you learn from me—
although you're older—and white—
and somewhat more free.

This is my page for English B.

Harlem

What happens to a dream deferred?

Does it dry up
like a raisin in the sun?
Or fester like a sore—
And then run?
Does it stink like rotten meat?
Or crust and sugar over—
like a syrupy sweet?

Maybe it just sags
like a heavy load.

Or does it explode?[7]

ABSURDISM

A product of disillusionment, Luigi Pirandello (1867–1936) had lost faith in religion, realism, science, and humanity itself. Still searching, however, for some meaning or basis for existence, he found only chaos, complexity, grotesque laughter, and perhaps, insanity. His plays were obsessed with the question "What is real?" and he pursued that question with brilliant variations. *Right You Are If You Think You Are* presented a situation in which a wife, living with her husband in a top-floor apartment, is not permitted to see her mother. She converses with her daily—the mother is in the street and the daughter is at a garret window. Soon the neighbor's curiosity demands an explanation from the husband. A satisfactory answer is forthcoming, but the mother has an equally plausible, although radically different explanation. Finally, the wife, who is the only one who can clear up the mystery, is approached. Her response, as the curtain falls, is loud laughter! Pirandello cried bitterly at a world he could not understand, but he did so with mocking laughter directed at those who purported to have the answers or were sure that they soon would.

Pirandello's nonrealistic departures created the mold from which emerged a movement called absurdism. Existentialism, a philosophy which questioned the nature of existence, placing a meaningless present amid a guilt-ridden past and an unknowable future, also contributed to absurdist style. From such antecedents came numerous dramas, probably the best known of which were written by the French philosopher and playwright Jean-Paul Sartre (1905–80). Sartre's existentialism held that there were no absolute or universal moral values and that humankind was part of a world without purpose. Therefore, men and women were responsible only to themselves. His plays attempted to draw logical conclusions from "a consistent atheism." Plays such as *No Exit* (1944) translate Sartre's philosophies and existential viewpoint into dramatic form.

Albert Camus (1913–60) was the first playwright to use the term "absurd," a state which he considered to be a result of the dichotomy between humankind's aspirations and the meaninglessness of the universe in which individuals live. Finding one's way in a chaotic universe, then, became the theme of Camus's plays, such as *Cross-Purposes* (1944).

After these two playwrights came a series of absurdists who differed quite radically from both Sartre and Camus, both of whom strove to bring order out of absurdity. The

plays of Samuel Beckett, Eugene Ionesco, and Jean Genet all tend to point only to the absurdity of existence and to reflect the chaos they saw in the universe. Their plays are chaotic and ambiguous, and the absurd and ambiguous nature of these plays make direct analysis purely a matter of interpretation. *Waiting for Godot* (1958), the most popular work of Samuel Beckett (1906–89), has been interpreted in so many ways to suggest so many different meanings that it has become an eclectic experience in and of itself. Beckett, like the minimalist sculptors, left it to the audience to draw whatever conclusions they wished about the work confronting them. The works of Ionesco (b. 1912) are even more baffling, using nonsense syllables and clichés for dialogue, endless and meaningless repetition, and plots that have no development. He called the *Bald Soprano* (1950) an antiplay. The absurdist movement had influenced other playwrights and production approaches, from Harold Pinter to Edward Albee.

ABSTRACT EXPRESSIONISM

The first fifteen years following the end of World War II were dominated by a style called abstract expressionism. Beginning essentially in New York, abstract expressionism spread rapidly throughout the world. Like most modern styles, which include great variation among individual artists, abstract expressionism is difficult to define in specific terms, although some scholars believe it to be self-explanatory. Two characteristics can be identified. One is a freedom from traditional use of brushwork, and the other is the exclusion of representational subject matter. Complete freedom of individual expression to reflect inner life gave rein to create works of high emotional and dynamic intensity. Absolute individual freedom of expression and freedom from rationality underlie this style. There appeared to be some relationship to the optimistic post-war feeling of individual freedom and conquest over totalitarianism. By the early 1960s when life was less certain and the implications of the nuclear age had sunk in, abstract expressionism had all but ceased to exist.

The most heralded artist of this style was Jackson Pollock (1912–56). A rebellious spirit, Pollock evolved this approach to painting only ten years before his death. Although he insisted that he had absolute control, his compositions consisted of what appeared to be totally unfettered dripping and spilling of paint on to huge canvases placed on the floor. His work (Fig. **14.10**), often called *action painting*, elicits a sense of tremendous energy, actually transmitting the action of paint application to the respondent through a new concept of line and form.

14.10 Jackson Pollock, *Autumn Rhythm*, 1950. Canvas, 105 x 207 ins (267 x 526 cm). The Metropolitan Museum of Art, New York, George A. Hearn Fund.

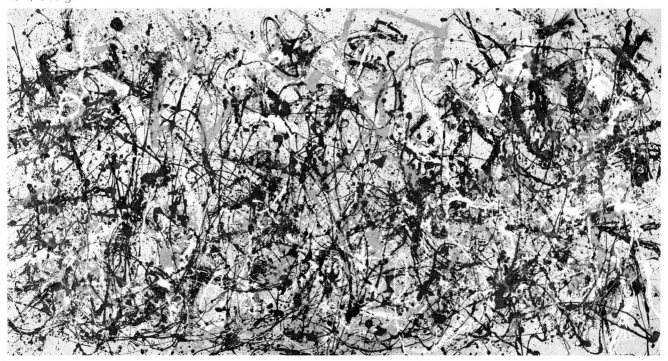

14.11 Helen Frankenthaler, *Buddha*, 1988. Acrylic on canvas, 74 x 81 ins (188 x 206 cm). Private collection. Courtesy of Andre Emmerich Gallery, New York.

The abstract expressionist tradition continues in the work of Helen Frankenthaler (b. 1928). Her *staining technique*, as seen in *Buddha* (Fig. **14.11**), consists of pouring color across an unprimed canvas, creating amorphous shapes which seem to float in space. The image has infinite potential meaning, apart from that suggested by the title. The very freedom of the form symbolizes our freedom to choose its associations. However, we are directed by the sensual quality of the work. Its fluidity, and the nonlinear use of color, give it softness and grace.

Abstract expressionism proved to be a uniquely American movement. Nowhere else did anything even remotely comparable emerge during this time. However, by the early 1960's abstract expressionism seems to have reached its zenith. An entirely new perception of reality, one of consumerism and affluence, began to sweep the world.

After, and in some instances as a reaction against the emotionalism of abstract expressionism came an explosion of styles: pop art, op art, hard edge, minimal art, post-minimal art, environments, body art, earth art, video art, kinetic art, photo realism, and conceptual art. We have space to note only some of these.

POP ART

Pop art evolved in the 1950s, and concerned itself above all with image in a representational sense. Subjects and treatments in this style come from mass culture and commercial design. These sources provided pop artists with what they considered to be essential aspects of today's visual environment. The pop artists traced their heritage to dada, although much of the heritage of the pop tradition continues to be debated. However, pop is essentially an optimistic reflection of the contemporary scene. The term "pop" was coined by the English critic Lawrence Alloway and related to the images found in popular culture that marked this approach. Probably the compelling depictions of Roy Lichtenstein (b. 1923) are the most familiar (Fig. **14.12**). These magnified cartoon-strip details use the Ben-Day screen of dots by which colored ink is applied to cheap newsprint. Using a stencil about the size of a coin, the image is built up into a stark and dynamic, if sometimes violent, portrayal.

Pop objects serve as source materials for Claes Oldenburg (b. 1929). *Dual Hamburgers* (Fig. **14.13**),

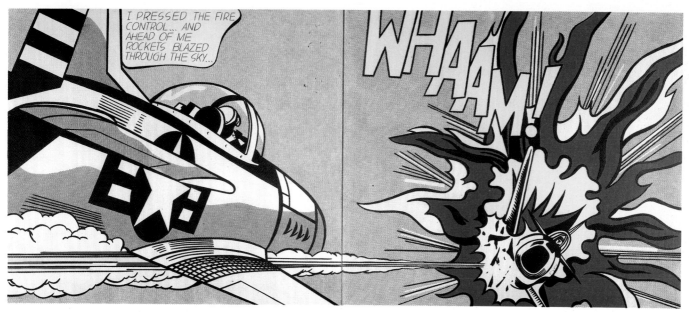

14.12 Roy Lichenstein, *Whaam!*, 1963. Acrylic on canvas, 68 x 160 ins (173 x 405 cm). The Tate Gallery, London.

presents an enigma to the viewer. What are we to make of it? Is it a celebration of the mundane? Or is there a greater comment on our age implicit in these objects? Certainly Oldenburg calls our attention to the qualities of design in ordinary objects by taking them out of their context and changing their scale. The influence of the Pop Movement can also be seen in the plaster figures of George Segal (b. 1924). Working from plaster molds taken from living figures, Segal builds scenes from everyday life with unpainted plaster images. These unpainted ghosts remove the sculptural environment from reality to a different plane altogether. Similar in a way, but in stark contrast are the photo-realistic sculptures of Duane Hanson (b. 1925),

14.13 Claes Oldenburg, *Two Cheeseburgers, with Everything (Dual Hamburgers)*, 1962. Burlap soaked in plaster, painted with enamel, height 7 ins (18 cm). The Museum of Modern Art, New York (Philip Johnson Fund).

whose portrayals, including hair and plastic skin, are often displayed in such circumstances that the respondent does not know for sure at first sight if he or she is viewing a sculpture or a real human. Hanson's portrayals express a tragic quality and are an exposé of crassness and bourgeois tastelessness. They often portray the dregs of American society.

OP ART

Op art concerns itself with optics and perception. Emerging from the 1950s, op art was an intellectually oriented and systematic style, very scientific in its applications. Based on perceptual tricks, the misleading images of these paintings capture our curiosity and pull us into a conscious exploration of what the optical illusion does and why it does it. Victor Vasarély (b. 1908) bends line and form to create a very deceiving sense of three-dimensionality. Complex sets of stimuli proceed from horizontal, vertical, and diagonal arrangements. Using nothing but abstract form, Vasarély creates the illusion of real space.

HARD EDGE

Hard edge or hard edged abstraction also came to its height during the 1950s. In this style, which the work of Ellsworth Kelly (b. 1923) and Frank Stella (b. 1936) best illustrates, flat color areas have hard edges which carefully separate them from each other. Essentially, hard edge is

14.14 Frank Stella, *Tahkt-I-Sulayman I*, 1967. Polymer and fluorescent paint on canvas, 10 ft ¼ in x 20 ft 2¼ ins (3.04 m x 6.15 m). The Pasadena Art Museum, California (gift of Mr. and Mrs. Robert A. Rowan).

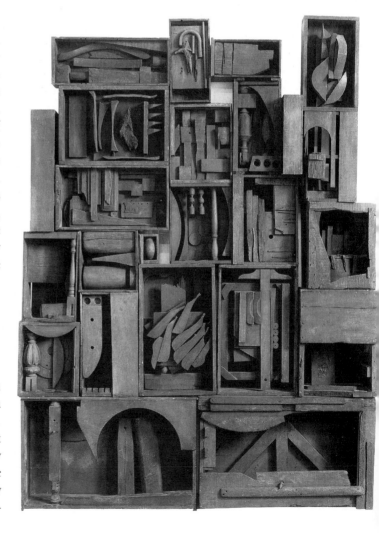

an exploration of design for its own sake. Stella often abandoned the rectangular format in favor of irregular compositions to be sure his paintings had no relationship to windows. The shape of the canvas was part of the design itself, as opposed to being a frame or a formal border within which the design was executed. Some of Stella's paintings have iridescent metal powder mixed into the paint, and the metallic shine further enhances the precision of the composition. *Tahkt-I-Sulayman I* (Fig. **14.14**) stretches 20 ft (6 m) across and intersperses wonderfully surging circles and half-circles of yellow, reds, and blues. The intensity of the surface counters the grace of its form with jarring fluorescence. The simplicity of these forms provides a deceptive counterpoint with the variety of their repetitions.

PHOTO-REALISM AND CONCEPTUALISM

Photo-realism is an offshoot of pop art concerned with photographic images. Using photographic images as a basis, photo-realist works are usually extremely complex.

Conceptual art challenges the relationship between art and life and, in fact, the definition of art itself. Essentially anti-art, like dada, conceptual art attempts to divorce totally the imagination from aesthetics. It insists that only the imagination, not the artwork, is art. Therefore art-

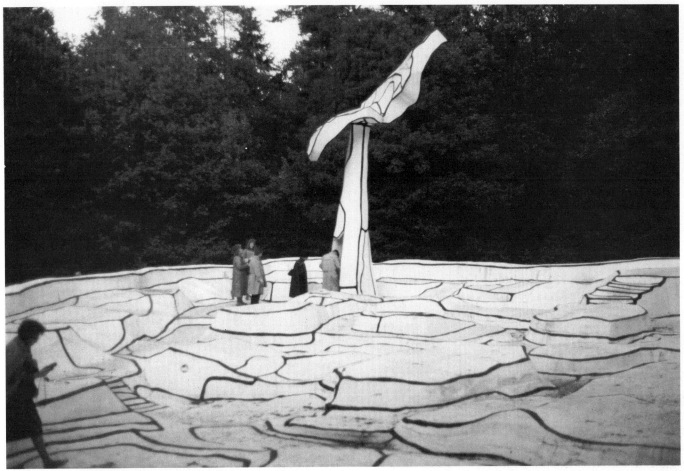

14.16 Jean Dubuffet, *Jardin d'Email*, 1973–74. Concrete, epoxy paint and polyurethane, 66 ft 8 ins x 100 ft (20 x 30 m). State Museum Kröller-Müller, Otterlo, The Netherlands.

works can be done away with. The creative process needs only to be documented by some incidental means such as a verbal description or a simple object like a chair. The paradoxes of conceptual art are many, including its dependence on a physical something to bridge the gap between artist's conception and respondent's imagination.

PRIMARY STRUCTURES

The Primary Structures movement pursues two primary goals: *extreme simplicity of shape* and *a kinship with architecture*. A space–time relationship distinguishes primary structures from other sculpture. The viewer is invited to share an experience in three-dimensional space by walking around and/or through the works. Form and content are abstracted to minimalist qualities.

14.15 Louise Nevelson, *Black Wall*, 1959. Wood, 112 x 85¼ x 25½ ins (264 x 216 x 65 cm). The Tate Gallery, London.

Louise Nevelson (1900–88), perhaps the twentieth century's first major woman sculptor, overcame the perception that sculpture was a man's profession because of the heavy manual labor involved. In the 1950s she began using found pieces of wood to construct her own vision of reality. At first miniature cityscapes, her work grew to larger proportions—for example, *Black Wall* (Fig. **14.15**), a relief-like wall unit painted a monochromatic flat black. These pieces suggest the world of dreams, but their meaning and logic remain a puzzle with intense appeal to the imagination.

ENVIRONMENTAL ART

Environmental art creates an inclusive experience and in Figure **14.16**, *Jardin d'Email* by Jean Dubuffet (b. 1901), we find an area made of concrete, which is painted with white paint and black lines. It is capricious in form and

surrounded by high walls. Inside the sculptural environment we find a tree and two bushes of polyurethane. We might conclude that Dubuffet has pushed the essence and the boundaries of art to their limits. He has consistently opted for chaos, for *art brut*—the art of children, psychotics, and amateurs. The *Jardin d'Email* is one of a small series of recent projects in which he has depicted the chaotic, disorienting, and inexplicable in three-dimensional form.

ART NOUVEAU

The unique characteristic of art nouveau is the lively, serpentine curve known as the "whiplash." The style reflects a fascination with plant and animal life and organic growth. The influence of Japanese art is evident in the undulating curves. Art nouveau incorporates organic and often symbolic motifs, and treats them in a very linear, relieflike manner.

14.17 Antoni Gaudí, Casa Batlló, Barcelona, 1905–7.

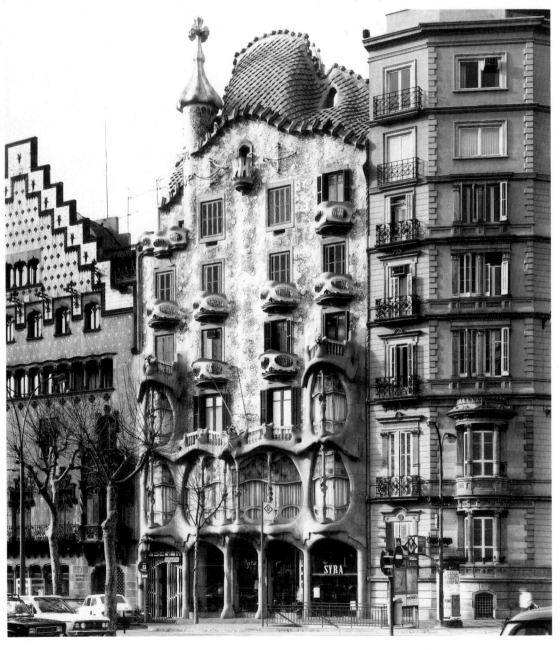

Art nouveau continued into the early years of the twentieth century, with one of its greatest exponents, Antoni Gaudí (1852–1926), designing town houses such as the Casa Batlló (Fig. **14.17**) in Barcelona.

EXPERIMENTATION IN ARCHITECTURE

Structural expression and preoccupation with building materials dominated the early twentieth century, as it had dominated the nineteenth. Of vital importance to the new century and its approaches was reinforced concrete or ferroconcrete. Ferroconcrete had been in use as a material since around 1849, but it had taken nearly fifty years to emerge fully as an important architectural material. Auguste Perret (1874–1954) single-mindedly set about developing formulas for building with ferroconcrete, and his efforts were influential in the works of those who followed. We can grasp some of the implications of this approach in Perret's Garage Ponthieu (Fig. **14.18**). The reinforced concrete structure emerges clearly in the exterior appearance. The open spaces were filled with glass or ceramic panels. The result achieved a certain elegance and logical expression of strength and lightness.

If Perret was single-minded in his approach to problems in structure and materials, his contemporary (and assistant to Louis Sullivan), Frank Lloyd Wright (1867–1959), was one of the most innovative and influential of twentieth-century architects. Perret summarized and continued earlier tradition, but Wright wished to initiate new ones. One manifestation of Wright's pursuits was the prairie style, developed around 1900 and drawing upon the flat landscape of the Midwest for its tone. The prairie houses reflected Japanese influence in their simple horizontal and vertical accents. Wright was also influenced by Sullivan in his pursuit of form and functional relationships. Wright attempted to devise practical arrangements for his interiors and to reflect the interior spaces in the exterior appearance of the building. He also tried to relate the exterior of the building to its context or natural environment and took great pains to suggest an interrelationship of interior and exterior space.

Wright also designed some of the furniture for his houses—comfort, function, and design integration were the chief criteria. Textures and colors in the environment were duplicated in the materials, including large expanses of wood both in the house and its furniture. He made a point of giving his furniture several functions—for example, tables that also served as cabinets. All spaces and objects were precisely designed to present a complete

14.18 Auguste Perret, Garage Ponthieu, Paris, 1905–6.

environment. Wright was convinced that houses profoundly influenced the people who lived in them, and he saw the architect as a "molder of humanity." Wright's works ranged from the simple to the complex, from the serene to the dramatic, and from interpenetration to enclosure of space. He always pursued experimentation, and the exploration of various interrelationships of spaces and geometric forms mark his designs.

Poured concrete and new concepts in design can also be seen in the works of Le Corbusier (1887–1965) in the 1920s and 1930s. The machine concept did not imply a depersonalization, as much machine-related art in the first half of the century did. Rather, it implied efficient construction from standard, mass-produced parts, logically designed for usage as the parts of an efficient house-machine. Le Corbusier had espoused a domino system of design for houses, using a series of slabs supported on slender columns. The resulting building was box-like,

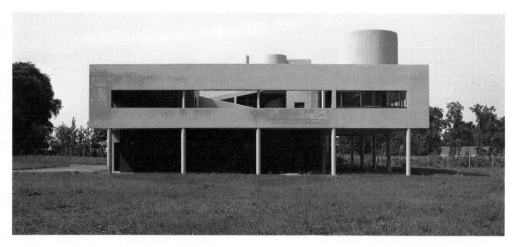

14.19 Le Corbusier, Villa Savoye, Poissy, France, 1928–30.

with a flat roof, which could be used as a terrace. The Villa Savoye (Fig. **14.19**) combines these concepts in a design whose supporting structures freed the interior from the necessity of weight-supporting walls. In many ways the design of the Villa Savoye reveals classical Greek inspiration, from its articulated columns and human scale to its precisely articulated parts and totally coherent and unified whole. The design is crisp, clean, and functional.

MODERNISM

Architecture affords no relief from the problem of trying to sample or overview an era still in the making. In a sense, the task is more difficult here, because the human element of artistic creation has been blurred by architectural corporations, as opposed to individual architects. There is also a tendency for the contemporary observer to see a sameness in the glass and steel boxes of the *international style* that dominate our cities and to miss the truly unique approach to design that may comprise a housing project in an obscure locale.

World War II caused a ten-year break in architectural construction and, to a certain extent, separated what came after from what went before. However, the continuing careers of architects who had achieved significant accomplishment before the war bridged that gap. Geographical focus shifted from Europe to the United States, Japan, and even South America. The overall approach still remained modern or international in flavor, which helps us to select a few examples to illustrate general tendencies.

As a type, the skyscraper saw a resurgence of building in the fifties, in a glass-and-steel box approach that continues today. Illustrative of this type and approach is Lever House in New York City (Fig. **14.20**). A very

14.20 Gordon Bunshaft (Skidmore, Owings and Merrill), Lever House, New York, 1950–52.

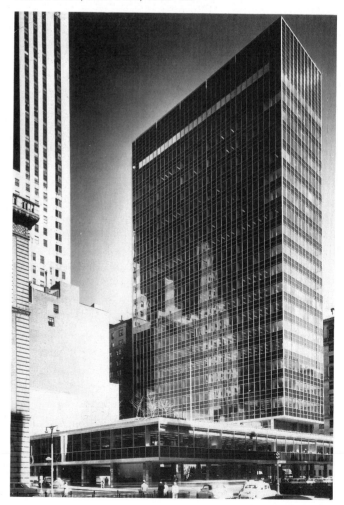

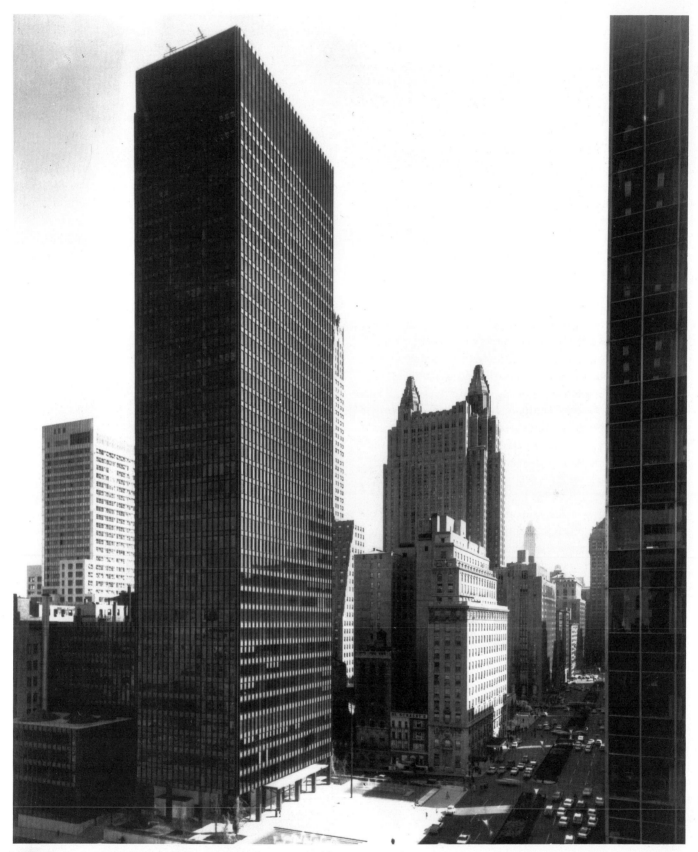

14.21 Mies van der Rohe and Philip Johnson, Seagram Building, New York, 1958.

important consideration in this design is the open space surrounding the tower. Created by setting the tower back from the perimeter of the site, the open space around the building creates its own envelope of environment or context. Reactions against the glazed appearance of the Lever Building have occurred throughout the last thirty years, with surfaces such as aluminium pierced by small windows, for example. In the same sense, an intensification of the glazed exterior has occurred, wherein metalized windows, rather than normal glass, have formed the exterior surface. Such an approach has been particularly popular in the Sun Belt, because metalized glass reflects the sun's rays and their heat. In any case, the functional plain rectangle of the international style has continued as a general architectural form regardless of individual variation.

The rectangle, which has so uniformly and in many cases thoughtlessly, become the mark of contemporary architecture leads us to the architect who, before World War II, was among its advocates. Mies van der Rohe insisted that form should not be an end in itself. Rather, the architect should discover and state the function of the building. His pursuit of those goals and his honesty in taking mass-produced materials at face value—that is, bricks, glass, and manufactured metals—and outwardly expressing their shapes was the basis for the rectangularization that is the common ground of twentieth-century architecture. His search for proportional perfection can be traced, perhaps, to the German Pavilion of the Barcelona Exposition in 1929 and was expressed in projects such as New York's Seagram Building (Fig. **14.21**).

The simple straight line and functional structure basic to Mies's unique insights were easily imitated and readily reproduced. However, such commonplace duplication, although overwhelming in numbers, certainly has not overshadowed exploration of other forms. Differing reflections in contemporary design have ultimately pursued the question formulated by Louis I. Kahn, "What form does the space want to become?" In the case of Frank Lloyd Wright's Guggenheim Museum (Fig. **7.38**), space has become a relaxing spiral that reflects the leisurely progress one should make through an art museum.

The simple curvilinearity of the arch and the dome is the mark of two different and noteworthy architects. The unencumbered free space in their projects represents a contrast to the self-contained boxes of the international style. Pier Luigi Nervi's Small Sports Palace (Fig. **14.22**) and R. Buckminster Fuller's Climatron (Fig. **7.20**) illustrate the practical need for free space, but they also suggest the trend toward spansion architecture which stretches engineering to the limits of its materials, and which, in the case of the Kansas City Hyatt Regency Hotel, took design tragically beyond practicality.

Modern dance

Romantic ballet had become conventional and static by the late nineteenth century. In revolution to traditional ballet came the remarkable and unrestrained Isadora Duncan (1878–1927). By 1905 she had gained notoriety for her barefoot and deeply emotional dancing. She was considered controversial among balletomanes and reformers alike.

Although an American, Isadora Duncan achieved her fame in Europe. Her dances were emotional interpretations of moods suggested to her by music or by nature. Her costume was inspired by Greek tunics and draperies and she danced in bare feet, a strictly unconventional and significant fact, which continues to be a basic quality of the modern dance tradition she helped to form.

Isadora Duncan's contemporary Ruth St. Denis, and her husband, Ted Shawn, were to lay more substantial cornerstones for modern dance. St. Denis's dancing began as a

14.22 Pier Luigi Nervi, Small Sports Palace, Rome, 1957.

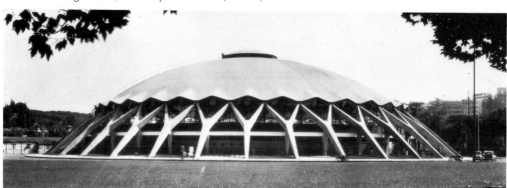

strange combination of exotic, oriental interpretations, and Delsartian poses. (Delsarte is a nineteenth-century system originated by François Delsarte as a scientific examination of the manner in which emotions and ideas were transmitted through gestures and posture. His system came from overzealous disciples who formed his findings into a series of graceful gestures and poses, which supposedly had specific denotative value).

St. Denis's impact on dance was solidified by the formation with her husband of a company and a school to carry on her philosophies and choreography. The Denishawn school and company were headquartered in Los Angeles and took a totally eclectic approach to dance. Any and all traditions were included, from formal ballet to Oriental and American Indian dances.

First to leave Denishawn was Martha Graham, probably the most influential figure in modern dance. Although the term modern dance defies accurate definition and satisfies few, it remains the most appropriate label for the nonballetic tradition Martha Graham has come to symbolize. Graham found Denishawn unsatisfactory as an artistic base, but her point of view, essentially, maintained that artistic individualism is fundamental. "There are no general rules. Each work of art creates its own code." Even modern dance has come to include its own conventions, however, principally because it tried so hard to be different from formal ballet. Ballet movements were largely rounded and symmetrical. Therefore, modern dancers emphasized angularity and asymmetry. Ballet stressed leaps and based its line on toework, while modern dance hugged the floor and dancers went barefoot. As a result, the early works of Graham and others tended to be rather fierce and earthy, as opposed to graceful. But beneath it all was the desire to express emotion first and foremost. The execution of conventional positions and movements, on which ballet is based, was totally disregarded. Martha Graham described her choreography as "a graph of the heart."

After the Depression, when social criticism formed a large part of artistic expression, Graham pursued topical themes (unusual for her) concerning the shaping of America, including her renowned work to the music of Aaron Copland, *Appalachian Spring* (1944). *Appalachian Spring* dealt with the effects of Puritanism and depicted the overcoming of its fire and brimstone by love and common sense.

Martha Graham's troupe produced a radical and controversial choreographer who broke with many of the traditions of modern dance (as flexible as those traditions have been). He incorporated chance or aleatory elements into his choreography and has often been associated with the composer John Cage. Merce Cunningham uses everyday activity as well as dance movements in his works. His concern is to have the audience see the dance in a new light, and, whatever the reaction may be, his choreography is radically different from anyone else's. His works show elegance and coolness, as well as a severely abstract quality. Works such as *Summerspace* and *Winterbranch* illustrate Cunningham's use of chance, or indeterminacy. He thoroughly prepares numerous options and orders for sets, which then (sometimes by flipping a coin) can be varied and intermixed in different order from performance to performance. The same piece may appear different from one night to the next. Cunningham also treats stage space as an integral part of the performance and allows focus to be spread across various areas of the stage, unlike classical ballet which tends to isolate its focus on center stage or downstage center alone. So Cunningham allows the audience member to choose where to focus, as opposed to forcing that focus. Finally, he tends to allow each element of the dance to go its own way. As a result, the direct, beat-for-beat relationship that audiences have come to expect between music and footfalls in ballet and much modern dance simply does not exist.

Since 1954, another graduate of Martha Graham's troupe (and also of Merce Cunningham's) has provided strong direction in modern dance. Paul Taylor's work has a vibrant, energetic, and abstract quality that often suggests primordial actions. Taylor, like Cunningham, often uses strange combinations of music and movement in highly ebullient and unrestrained dances such as *Book of Beasts*. Interestingly, Taylor's music often turns to traditional composers, such as Beethoven, and to specialized works like string quartets. The combination of such a basically esoteric musical form with his wild movements creates unique and challenging works for the viewer.

In a tradition which encourages individual exploration and independence, there have been many accomplished dancer/choreographers. Alwin Nikolais was among these. His works (he designs the scenery, costumes, and lights and composes the music, as well as the choreography) tend to be mixed-media extravaganzas, which celebrate the electronic age. Often the display is so dazzling that the audience loses the dancers in the lighting effects and scenic environment. Another figure of importance is Alvin Ailey, a versatile dancer whose company is known for its unusual repertoire and energetically free movements. Twyla Tharp and Yvonne Ranier have both experimented with space and movement. James Waring has incorporated Bach and 1920s pop songs, florid pantomimes and abstractions, as well as romantic point work.

POST-MODERNISM

Contemporary architecture also has turned in pluralistic directions. Post-modern or revisionist architecture puts new manifestations on past styles. The Spanish architect Ricardo Bofill (b. 1939) and the Italian Aldo Rossi both derive much of their architectural language from the past. As Bofill remarked, his architecture takes "without copying, different themes from the past, but in an eclectic manner, seizing certain moments in history and juxtaposing them, thereby prefiguring a new epoch." We see this eclectic juxtaposition in his public housing development called, with typical grandiosity, Le Palais d'Abraxas (Fig. **14.23**). Here columnar verticality is suggested by glass and by cornice/capitals, which dynamically exhibit the characteristics of classicism. In Japan, post-modern architects such as Arata Isozaki portray in their buildings the restrained elegance and style of traditional Japanese art. In the United States, Michael Graves (b. 1934) has reacted to the repetitive glass, concrete, and steel boxes of the international style, which dominates modern cities, by creating a metaphorical allusion to the keystone of the Roman arch

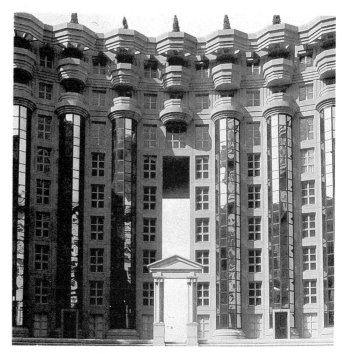

14.23 Ricardo Bofill, The Palace of Abraxas, Marne-la-Vallée, near Paris, 1978–83.

14.24 Renzo Piano and Richard Rogers, Pompidou Center, Paris, 1971–78.

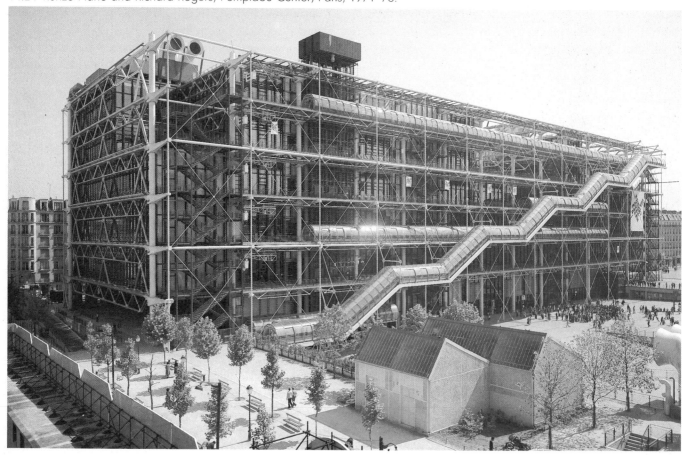

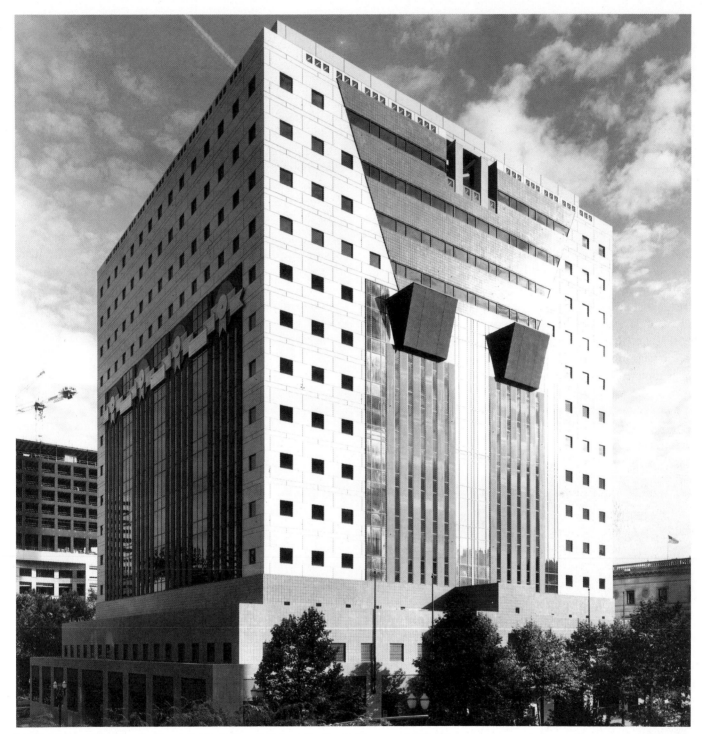

14.25 Michael Graves, Portland Public Office Building, Portland, Oregon, 1979–82.

(Fig. **14.25**). The bright red pilasters suggest fluted columns, and fiberglass garlands recall both art deco and the rococo. Post-modern architecture focuses on meaning and symbolism: The past and ornamentation are acceptable; functionalism no longer controls. The post-modernist seeks to create buildings "in the fuller context of society and the environment." Social identity, cultural continuity, and sense of place become foundations for the art.

In a clear repudiation of the glass and steel box of the international style and other popular forms in mainstream architecture, the design for the Pompidou Center in Paris (Fig. **14.24**) turns the building inside out, externalizing

its network of ducts, pipes, and elevators, while hiding the internal structure, which has no fixed walls; temporary dividers can be arranged in any desired configuration. The bright primary colors of the exterior combine with the serpentine, plexiglass-covered escalators to give a whimsical, lively appearance to a functional building. The Pompidou Center has become a tourist attraction rivaling the Eiffel Tower and, while controversial, has wide popular acceptance.

NON-TRADITIONAL TRANSITIONS

Music took no less radical a path from its nineteenth-century heritage than did painting and sculpture. Nevertheless, contemporary concert programs illustrate for us the unique phenomenon that response to works of art is always in the present tense. Our own experiences with and responses to the meanings in works of art are those of today, whether the artwork was created this morning or 20,000 years ago. So we have the luxury of sharing experiences directly with Michelangelo, Shakespeare, Leonardo da Vinci, J. S. Bach, and the architects of Athens, as well as with those men and women of our own era who illuminate and comment upon the events and circumstances surrounding us. Our contemporaries may and do choose to follow the traditions of the past or invent new ones.

Twentieth-century music took both paths. New directions differed from past essentially in three ways. The first was rhythmic complexity. Prevailing tradition since the Middle Ages emphasized grouping beats together in rhythmic patterns called meter. The characteristic accents of duple and triple meters helped to unify and clarify compositions, as well as to give them certain flavors. The modern composer did away with these patterns and regularity of accents, choosing instead to employ complex, changing rhythms in which it is virtually impossible to determine meter or even the actual beat.

The second change consisted of a focus on dissonant harmonies. Prior to the late nineteenth century, musical convention centered upon consonance as the norm to which all harmonic progressions returned. Dissonance was used to disturb the norm, so as to enable the music to return to consonance. The late nineteenth century witnessed significant tampering with that concept. By the twentieth century composers were using more and more dissonance, focusing on it, and refraining from consonant resolution.

The third major change from the past comprised the rejection of traditional tonality or sense of key altogether.

Traditional thinking held that one note, the *do* or tonic of a scale, was the most important. All music was composed with a specific key in mind. Modulations into distant or related keys occurred, but even then the tonic of the key was the touchstone to which all progression related. Many composers rejected that manner of systematizing musical sound and chose, instead, to pursue two other paths. One was to reject any sense of tonal center and importance of one tone over the other. All twelve tones of the chromatic scale became equal. The systems that resulted from this path were called twelve-tone composition and serialism.

Transition from the nineteenth to the twentieth centuries rode primarily on the works of one major composer, the impressionist Claude Debussy. Several other traditions were current. One, of German–Italian influence, built upon the works of Richard Wagner and was called the *cosmopolitan* style. The principal composer in this group was César Franck. A classically oriented style came into the century in the works of Camille Saint-Säens.

Debussy's style linked him closely with the French composer Maurice Ravel (1875–1937), who began as an impressionist but became more and more classical in orientation as years went by. However, even in his earlier works, Ravel did not adopt Debussy's complex sonorities and modality. Ravel's *Bolero* (1928) exhibits strong primitive influences and the unceasing rhythm of Spanish dance music. More typical works of Ravel—for example, his *Piano Concerto in G*—use Mozart and traditional classicism as their models. As a result of Ravel's tendencies and the similar concerns of other composers, the early twentieth century witnessed a neo-classical direction, which stayed completely within the established conventions of Western music but rejected both romantic and impressionistic developments.

Traditional tendencies continued throughout this period and can be seen in various quarters, one of which is the music of the American William Schuman in the 1930s and 1940s. His symphonies exhibit bright timbres and energetic rhythms and focus on eighteenth- and nineteenth-century American folklore. The eighteenth-century American composer William Billings figures prominently in the works of Schuman in the *William Billings Overture* (1943) and the *New England Triptych* (1956), based on three pieces by Billings. *American Festival Overture* (1939) is perhaps his most famous work. Traditional tonality can also be found in the works of Russia's Prokofiev. Notwithstanding traditional tonality, his *Steel Step* reflected the encroachment of mechanization of the 1920s. The machine as a symbol for

tremendous energy and motion found its way into music, and in the *Steel Step* Prokofiev intentionally dehumanized the subject in order to reflect contemporary life.

Hindemith

Experimentation and departure from traditional tonality marked the compositions of Paul Hindemith (1895–1963). Concerned with problems of musical organization, he systematized his approach to these problems and theorized solutions in the *Craft of Musical Composition*. His work was extremely chromatic, almost atonal. His system of tonality was based on the establishment of tonal centers, but did not include the concepts of major and minor keys. He hoped that his new system would become a universal music language, but it did not. He was, however, extremely influential in twentieth-century music composition, both as a composer and a teacher. His works are broad and varied, encompassing nearly every musical genre, including ten operas, art songs, cantatas, chamber music, requiems, and symphonies.

Bartók

Another nontraditional approach to tonality was the unique style of the Hungarian composer Béla Bartók (1881–1945). He was interested in folk music and is often considered a representative of a nationalistic school of composition. Whether or not that is true, Bartók's interest in Eastern European folk music is significant, because much of that music does not use Western major/minor modality. So Bartók's interest in it and in nontraditional tonality in general went hand in hand. Bartók invented his own type of harmonic structure, which could accommodate folk melodies. As nontraditional as some of his work is, however, he also employed traditional devices and forms. His style was precise and very well structured. He often developed his works from one or two very short motifs. His larger works were unified by repetition of thematic material throughout. He even used sonata-allegro form. Textures in Bartók's works are largely contrapuntal, which gives them a melodic emphasis with little concern for harmony. Dissonances occur freely.

Rhythm was very important to Bartók. His works tended to focus on rhythmic energy, employing many different devices, such as repeated chords and irregular meters (always to generate dynamic rhythms). His use of polyrhythms—that is, various juxtaposed rhythms—created a nonmelodic counterpoint of unique quality. These qualities resulted from the subtleties of rhythms found in folk song and dance. His compositions exhibit a wonderfully spontaneous freshness.

Stravinsky

Nontraditionalism was followed in other quarters, and with *The Firebird* (1910) Igor Stravinsky (1882–1971) came to prominence. *The Rite of Spring* (1912–13) created an even greater impact. Both works were scores for ballets. *The Firebird* was a commission for the Russian impresario Diaghilev, and premièred successfully at the Paris Opéra, while *The Rite of Spring* caused a near riot and a great scandal because of revolutionary orchestrations and driving primitive rhythms. These were Stravinsky's early works. On the whole his works display a variety of styles and forms, but whatever their nature, he was a significant composer who was as prolific as he was diverse.

Schoenberg

The movement which drew the most attention in the first half of the twentieth century grew out of German romanticism and took a radical turn into atonality. The composer at the root of the movement was Arnold Schoenberg (1874–1951). Between 1905 and 1912 Schoenberg turned away from the gigantic post-romantic works he had been composing to a more contained style, in works for small ensembles and in orchestral works, which treated instruments individually. In orchestral works his timbres alternate swiftly, contrasting with large blocks of tone color characteristic of earlier works. They also display rhythmic and polyphonic complexity together with fragmented melodies.

Although the word atonality (without tonality) is used to describe Schoenberg works, he preferred the term pantonality—that is, inclusive of all tonalities. His compositions sought freedom to use any combination of tones without the necessity of having to resolve chordal progressions. He called that concept "the emancipation of dissonance."

At times in their careers Schoenberg, Alban Berg, and Anton Webern represented expressionism in music. Expressionism approached humanity in terms of its psychological relationship to the modern world. Humankind was helpless in a world beyond its control and governed by subconscious forces in rebellion against established order. *Erwartung*, in which Schoenberg utilized complex rhythms, dissonance, strange orchestration, and fragmented melodies, evokes great intensity of feeling. As with many of his works, it sought to portray complex thoughts and emotions relative to his subject matter.

By 1923 Schoenberg was composing in a twelve-tone or dodecaphonic technique, in which a row or series of the

twelve tones in an octave was used in various ways—as melodies and harmonies, with rhythmic considerations, upside down, backward, upside down and backward, that is, in whatever predetermined form the composer desired. The logical structure of this technique is fairly mathematical and somewhat formalized, but it does maintain a balance between emotion, accident, and mechanization. The important thing for a listener to understand about these apparently strange works, or works which stand outside conventional tonal organization, is the fact that they contain specific organization and logical order. When the listener knows the guideposts to look for, Schoenberg's music progresses just as comfortably as does that of traditional tonality.

Berg

Alban Berg (1885–1935) was a close friend and disciple of Schoenberg, and his compositions are based on the serial technique. However, Berg's sense of lyricism means his works do not have the disconnectedness of much serial music. Many of the characteristics of his work can be found in his *Lyric Suite* (1927), a string quartet in six movements with a binary (AA) form. It is based on several different tone rows. Each *tone row* uses the twelve notes of the chromatic scale only once; the composer decides in which order the notes will occur. As a result, the harmonies of the piece are *atonal*.

Ives and Copland

Ives and Copland were both Americans with experimental and highly personal styles. Charles Ives (1874–1954) was so experimental and ahead of his time that many of his compositions were considered unplayable and did not receive public performances until after World War I. Content to remain anonymous, Ives went unrecognized for many years. His melodies spring from folk and popular songs, hymns, and other, often familiar, material, which he treated in most unfamiliar ways. His rhythms are hopelessly irregular and often without measure delineation except for an occasional bar line to indicate an accent beat. Textures involve such dissonant counterpoint that frequently it is impossible to distinguish one melodic line from another. Some of the tone clusters in his piano music are unplayable without using a block of wood to depress all the necessary keys at once. Ives's experiments, such as the *Unanswered Question* (1908), also employ ensembles placed in various locations to create stereophonic effects. For Ives all music related to life's experiences and ideas, some of which were consonant and some dissonant, and his music reflected that philosophy accordingly.

Aaron Copland (b. 1900) integrated national American idioms into his compositions. Jazz, dissonance, Mexican folksongs and Shaker hymns all appear. The latter figure prominently in Copland's most significant work, *Appalachian Spring* (1944). First written as a ballet, later it was reworked as a suite for symphony orchestra. Copland also used a variety of approaches, some reserved and harmonically complex, and some simple. He often used all tones in the diatonic scale, such as in the opening chord of the work. Despite a diversity of influences, he achieved a very personal and individual style, which is traditionally tonal. His unique manipulation of rhythms and chords has been highly influential in twentieth-century American musical composition.

JAZZ

American in its origins, although debatable as to its classical or baroque qualities, is the musical phenomenon called jazz. Undoubtedly the most significant Black contribution to American music, jazz began near the turn of the century and went through many changes and forms. Jazz comprises sophisticated and complicated styles focusing on improvised variations on a theme. One of the earliest forms—blues—went back to the music of the slaves and consisted of two rhythmic lines and repeat of the first line (AAB). Performers at the end of the nineteenth century such as Bessie Smith gave the blues an emotional quality, which the accompanying instruments tried to imitate. At approximately the same time came ragtime, a piano art form with a strict, two-part form. Syncopation played an important role in this style, whose most famous exponent was Scott Joplin. From these early beginnings New Orleans, the cradle of jazz, also produced traditional jazz, which featured improvisational development from a basic, memorized chordal sequence. All this was followed in the thirties and forties by swing, bebop, and cool jazz.

SERIALISM

Post-Webern or post-war serialism reflects a desire to exert more control and to apply a predetermined hierarchy of values to all elements of a composition. Before the war, twelve-tone technique involved the creation of a set or row of twelve pitch classes arranged in a specific order. Although the order could be manipulated in a number of ways, certain relationships between the pitches of the tone-row were constant and provided the underlying structure and much of the flavor of this style.

To a certain extent structural decisions were made before the composer actually began writing the composition itself. The composer was then subject to fairly strict limitations regarding the selection of pitches as the work progressed, since all pitch order was preestablished. Proponents of the technique argued that composers have always worked within limitations of some kind and that the discipline required to do so is an essential part of the creative problem-solving process. Opponents argued that writing music in this fashion was more a matter of mathematical manipulation and less the function of a composer's ear and basic musical instincts.

Three Compositions for piano (1947–48) by the American composer Milton Babbit is one of the earliest examples of serial technique applied to elements other than pitch. In this work, rhythm and dynamics are also predetermined by serial principles.

ALEATORY MUSIC

While some composers were developing techniques and even systems of highly controlled composition in the late 1940s, others went in the opposite direction. John Cage has been a major force in the application of aleatoric or chance procedures to composition with works such as *Imaginary Landscape No. 4* for twelve radios and *The Music of Changes* (1951). Cage relied on the *I Ching* or *Book of Changes* for a random determination of many aspects of his works. The *I Ching* dates from the earliest period of Chinese literature and contains a numerical series of combinations based on the throwing of yarrow sticks (not unlike the throwing of a dice or coins). The ultimate example of chance music is Cage's *4'-33"* (1952) in which the performer makes no sound whatever. The sounds of the hall, audience, traffic outside—that is, whatever occurs—are the content of the composition.

Cage toured Europe in 1954 and 1958 and is thought to have influenced composers such as Boulez and Stockhausen to incorporate aspects of chance and indeterminacy into their music. Examples of this influence are Boulez's *Third Piano Sonata* and Stockhausen's *Klavierstück*, both dating from 1957. These works, however, only go so far as to give options to the performer concerning the overall form of the work or the order of specific musical fragments, which are, for the most part, conventionally notated, and thus controlled. Cage's work suggests a parallel between music and the other arts, a multi-media expression. The elements of chance in painting and sculpture and the "happenings" in the theatre have here their aural counterpart.

IMPROVIZATION

An open, improvizatory tradition was carried on by composers like Lukas Foss with the Improvization Chamber Ensemble of which he was founder. A number of other improvization groups, many funded by granting organizations and universities, sprang up in the United States during the 1960s along with the intense exploration of new sound possibilities from both conventional and electronic instruments.

MAINSTREAM

What is often referred to as a mainstream of musical composition also continued after the war. The source of much of this music is a combination of nineteenth-century romantic tradition, the folk styles of Bartók and Copland, quartet harmonies of Hindemith, the modality of the impressionists Ravel and Debussy, and the neo-classicism of Prokofiev and Stravinsky. To some degree, both serialism and indeterminacy can be found here as well as popular or jazz elements. Many American and European composers belong to the so-called mainstream.

POST-WAR JAZZ

Styles stemming from traditional jazz proliferated after the war. There was a gradual move away from the big bands to smaller groups and a desire for much more improvisation within the context of the compositions. The term *bebop* was coined as a result of the characteristic long-short triplet rhythm which ended many phrases. The prime developers of this style were alto-saxophonist Charlie "Bird" Parker and trumpeter Dizzie Gillespie. The *cool jazz* style developed in the early 1950s with artists like Stan Getz and Miles Davis. Although the technical virtuosity of bebop continued, a certain lyric quality, particularly in the slow ballads, was emphasized and, more importantly, the actual tone quality, particularly of the wind instruments, was a major distinction. *Third Stream*, was a term used by composer Gunther Schuller to describe his own attempt to blend Euro-American art music techniques such as serialism with elements of the bebop and cool jazz styles.

ELECTRONIC MUSIC

The development of the RCA synthesizer and the establishment of the Columbia-Princeton Electronics Music Center provided an opportunity for composers

such as Milton Babbitt to pursue the application and further development of primarily serial techniques. Composers such as John Cage found electronics a logical means to achieve their musical goals of indeterminacy as in *Imaginary Landscape No. 5*. Mainstream and jazz composers were not seriously affected by the electronic medium until the 1960s.

We need to note that electronic production and alteration of sound does not imply, in itself, a specific musical style. However, electronic sound production led to two new approaches during the 1950s. First, *musique concrète*—the use of acoustically produced sounds, and, second, electronically generated sound. In recent times this distinction has become less meaningful due to the major advances in technology since that time.

ULTRARATIONALISM AND BEYOND

The 1960s and early 1970s saw even further extremes in the "ultrarational" and "antirational" directions in addition to an even stronger desire constantly to create something new. At times this desire for newness superseded most other considerations. Stockhausen, for example, became more interested in the total manipulation of sound and the acoustic space in which the performance was to take place. His work *Gruppen* (1957) for three orchestras is an early example. As he became more and more interested in timbre modulation, his work encompassed a greater variety of sound sources both electronic and acoustic in an interesting combination of control and noncontrol. An example of this is *Microphonie I* (1964). Igor Stravinsky, one of the most influential composers of the early part of this century, developed his own serial art form in the late 1950s and early 1960s.

Elliott Carter, although not a serialist, developed a highly organized approach toward rhythm, often called *metric modulation*, in which the mathematical principles of meter, standard rhythmic notation, and other elements are carried to complex ends. The pitch content of Carter's music is highly chromatic and exact, and his music requires virtuoso playing both from the individual and the ensemble. Virtuoso playing produced an important composer–performer relationship in the 1960s, and many composers, such as Luciano Berio, wrote specifically for individual performers, such as trombonist Stewart Dempster. In the same vein percussionist Max Neuhaus was associated with Stockhausen, and pianist David Tudor, with John Cage.

Experimentation with microtones has been of interest to music theorists throughout history and many non-Western cultures employ them routinely. Microtones can be defined as intervals smaller than a half step. Our system divides the octave into twelve equal parts. There seems to be no reason why the octave cannot be divided into 24, 53, 95 or any number of parts. The possibilities are limited only by our ability to hear such intervals and a performer's ability to produce them. Alois Haba experimented in the early part of the century with quarter tones (24 per octave) and sixth tones (36 per octave), as did Charles Ives. A number of instruments were designed to produce microtones, and experimentation and composition has been carried out widely.

In an atmosphere of constant searching and experimentation, composers often questioned the validity of traditional concepts of art in general and specifically the limitations of the traditional concert hall. The earlier work by Cage and others led in a number of directions including theatre pieces, multimedia or mixed media, so-called danger music, biomusic, soundscapes, happenings, and total environments which might include stimulation of all the senses in some way. Thus the definition of a composer as opposed to playwright, filmmaker, visual artist, and so on was often obscured.

Since the early 1960s electronic instruments which could be used in live performance have been highly influential in music composition. Live performance mixed with prerecorded tape occurred in the 1950s, and by the 1960s it became common to alter the sound of live performers by electronic means. Computer technology has been added to the composition and performance of music, and the options available through computer application are now endless.

Theatre music, sometimes referred to as *experimental* music, ranges from relatively subtle examples of performers playing or singing notated music and moving to various points on the stage, as in Berio's *Circles* (1960), to more extreme examples, such as the works of La Monte Young, in which the performer is instructed to "draw a straight line and follow it" or react to the audience just as an audience was to react to the performers, that is, exchange places. A more active example is Nam June Paik's *Homage to John Cage* in which the composer ran down into the audience, cut off Cage's tie, dumped liquid over his head, and ran from the theatre, later to phone and let the audience know the composition had ended. Such compositions contain a high degree of indeterminacy.

Some works were never intended to be performed, but only conceptualized, such as Nam June Paik's *Danger*

Music for Dick Higgins, which instructs the performer to "Creep into the vagina of a living whale," or Robert Moran's *Composition for Piano with Pianist*, which instructs the pianist to climb into the grand piano. There was also a return to minimal materials, exemplified by Stockhausen's *Stimmung (Tuning)*, dating from 1968, for six vocalists singing only six notes. Minimal music generally can be defined as music which uses very little musical material, but often for an extended length of time, such as *One Sound* for string quartet by Harold Budd and the electronic piece *Come Out* (1966) by Steve Reich.

Many mainstream composers continued writing throughout the 1960s and early 1970s. However, a noticeable element of controlled indeterminacy has found its way into the music of many of them. The late 1960s and 1970s brought greater tolerance and acceptance on the part of composers for each other's varying aesthetic viewpoints and musical styles, in a blending of avant-garde techniques with the mainstream.

Just as indeterminacy and aleatoric procedures had been developed during the 1950s by composers of the Western Europe music tradition, freedom from melodic, rhythmic, and formal restraints in jazz led to the free jazz art form of the 1960s. Saxophonist Ornette Colman was one of the earliest proponents of such freedom. Others, such as John Coltrane, developed a rhythmically and melodically free style based on more modal materials, while Cecil Taylor developed materials which were more chromatic. In the mid to late 1960s a mature blend of this freedom, with control and sophistication, was reached in Miles Davis's *Bitches Brew* album of 1967. A number of musicians who originally worked with Miles Davis became leading artists in the 1970s, developing a style called *jazz-rock*, or *fusion*.

Polish composer Krzysztof Penderecki (b. 1933) has striven to produce new sounds from traditional string instruments. He is widely known for both instrumental and choral works, including a major composition, the *Requiem Mass*, written 1985. Penderecki's *Polymorphia* (1961) uses twenty-four violins, eight violas, eight cellos,

and eight double basses. Because of his experimentation with new techniques and sounds for strings, Penderecki had to invent a whole new series of musical markings, listed at the beginning of the score. In actual performance, the timings are measured by a stop watch and there is no clear meter. *Polymorphia* uses a free form with structure achieved from textures, harmonies, and string techniques. The piece is dissonant and remains atonal until the very end. It begins with a low, sustained chord in the bass. The mass of sound grows purposefully, with the entry of the upper strings, and then the middle register. Then comes a section of glissandos, which can be played at any speed between two given pitches or with what amounts to improvization. A climax occurs, after which the sound tapers off. Then a number of pizzicato effects are explored. Fingertips are used to tap the instruments, and the strings are hit with the palms of the hands. A second climax occurs. After another section in which bowed, sustained and sliding sounds are explored, a third climax is reached. After all this atonality, the work ends with a somewhat surprising C major chord.

The post-war period has been one of rapid change due to the constant quest for something new. Whether it be new sounds, the application of new technology, new notation, new formal parameters, entirely new ways of presenting music, or combining music with visual and other stimuli, aesthetic viewpoints and styles have been both numerous and varied. Extremism and intolerance from both the conservative and avant-garde have not been uncommon. An insatiable appetite for something new has affected composers of almost all music styles since World War II. The influence of music composition for film and television has made the era an interesting one, bringing together varying styles for dramatic purpose and proliferating new sounds and applications to a wide audience.

There is no doubt that the extremism beginning after the war and culminating gradually during the 1970s has given way in the 1980s to a reevaluation and acceptance of all styles as containing valid material upon which to draw for a composition.

FOOTNOTES

INTRODUCTION

1 Warren S. Smith in *Perceiving the Arts*, Dennis Sporre, Englewood Cliffs, NJ: Prentice-Hall Inc., 1989.
2 Roger Sperry, *Science and Moral Priority: Merging Mind, Brain and Human Values*, New York: Columbia University Press, 1983.
3 Edwin J. Delatrre, "The Humanities can Irrigate Deserts," *The Chronicle of Higher Education*, October 11, 1977, p. 32.
4 Ibid.

CHAPTER SIX

1 John Martin, *The Dance*, New York: Tudor Publishing Company, 1946, p. 26.

CHAPTER EIGHT

1 K. L. Knickerbocker and W. Willard Reninger, *Interpreting Literature*, New York: Holt, Rinehart and Winston, 1969, p. 218.
2 William Faulkner, "A Rose for Emily," in *American Poetry and Prose*, ed. Norman Foerster, New York: Houghton Mifflin Co., 1970, pp. 1562–67. Copyright © 1930 and renewed 1958 by William Faulkner. Reprinted from *Collected Stories of William Faulkner*, by permission of Random House Inc., and Curtis Brown Ltd.
3 Chaucer, *The Canterbury Tales*, translated by J. Nicolson, New York: The Crown Publishing Group, 1934, pp. 120–23. Used by permission of the publisher.
4 Robert Frost, "Stopping by Woods on a Snowy Evening," from *The Poetry of Robert Frost* edited by Edward Connery Lathem. Copyright 1923, © 1969 by Holt, Rinehart and Winston. Copyright 1951 by Robert Frost. Reprinted by permission of Henry Holt and Company, Inc.
5 W. H. Auden, "Musée des Beaux Arts." Copyright © 1940 and renewed 1968 by W. H. Auden. Reprinted from *W. H. Auden: Collected Poems*, edited by Edward Mendelson, by permission of Random House, Inc., and Faber and Faber Ltd.
6 John Wesley, *God Brought Me Safe*.
7 Oliver Goldsmith, "The Benefits of Luxury, in Making a People more Wise and Happy."

CHAPTER TEN

1 Revised Standard Version Bible.

CHAPTER ELEVEN

1 Hugh Honour and John Fleming, *The Visual Arts: A History*, Englewood Cliffs, NJ: Prentice-Hall Inc., 1982, p. 96.
2 William MacDonald, *Early Christian and Byzantine Architecture*, New York: George Braziller, 1967, p. 32.

CHAPTER TWELVE

1 In each Greek tragic contest a playwright was required to present four plays in succession – three tragedies and a satyr play.
2 Peter D. Arnott, trans, in *An Introduction to the Greek Theatre*, Bloomington, IN: Indiana University Press, 1963, pp. 76–7.
3 The chorus was a distinctive feature of Greek drama, portraying the dual function (in the same play) of narrator and collective character responding to the actors.

4 Virgil, *The Aeneid*, translated by Theodore C. Williams, New York: Houghton Mifflin Co., 1938, p.1.

5 John Garraty and Peter Gay, *A History of the World*, (2 vols), New York: Harper and Row, 1972, p. 209.

6 "Rings around the Pantheon," *Discover*, March 1985, p.12.

7 AOI: these three mysterious letters appear throughout the text. No one has ever adequately explained them, though every reader feels their effect.

8 *The Song of Roland*, translated by Frederick Goldin, New York: W. W. Norton and Co., Inc., 1978.

9 Boccaccio, *The Decameron*, translated by John Payne, New York: Stravon Publishers, 1957, pp. 15–24. Used by permission of the publisher.

10 H. W. Janson, *A Basic History of Art* (2nd edn.), Englewood Cliffs, NJ and New York: Prentice-Hall Inc., and Harry N. Abrams Inc., 1981, p. 452.

11 D. Redig de Campos (ed.), *Art Treasures of the Vatican*, Englewood Cliffs, NJ: Prentice-Hall Inc., 1974, p.7.

12 Lilian Hornstein et al, *World Literature* (2nd edn.), New York: Mentor, 1973, p. 155.

Chapter Thirteen

1 Germain Bazin, *The Baroque*, Greenwich, CN: New York Graphic Society, 1968, p. 30.

2 Frederick Hartt, *Art* (2 vols), Englewood Cliffs, NJ and New York: Prentice-Hall Inc., and Harry N. Abrams Inc., 1981, p. 283.

3 Jonathan Swift, "A Modest Proposal," in *The Norton Anthology of English Literature* (vol. 1, 3rd edn.), New York: W. W. Norton and Co., Inc., 1974, p. 2094.

4 Frederick Hartt, *Art*, op. cit., pp. 292–3.

5 Oliver Goldsmith, "The Deserted Village."

6 Samuel Johnson, "Idler Essays" in *A Johnson Reader*, E. L. McAdams, Jr. and George Milne, eds., New York: Random House Inc., 1964, p. 199.

7 William Wordsworth, "Tintern Abbey," in *The Poetical Works of William Wordsworth*, New York: Houghton Mifflin Co., 1982, pp. 91–3.

8 Helen Gardner, *Art through the Ages*, New York: Harcourt, Brace, Jovanovich, 1980, p. 760.

Chapter Fourteen

1 H. W. Janson, *A Basic History of Art*, op. cit., p. 682.

2 "Harlem Renaissance, Art of Black America," Exhibition book for the traveling exhibition under the auspices of the American Federation of Arts, 1989.

3 Ibid.

4 Ibid.

5 Ibid.

6 W. H. Auden, "Musée des Beaux Arts." Copyright © 1940 and renewed 1968 by W. H. Auden. Reprinted from *W. H. Auden: Collected Poems*, edited by Edward Mendelson, by permission of Random House, Inc. "In War Time," "Two's Company," "The Composer," "Voltaire at Ferney," and "Journey to Iceland" from *The English Auden* edited by Edward Mendelson. Copyright © 1977 by Edward Mendelson, William Meredith and Monroe K. Spears, as Executors of the estate of W. H. Auden. Reprinted by permission of Random House, Inc.

7 Langston Hughes, "Theme for English B," in *Selected Poems*. Reprinted by permission of David Higham Associates Ltd. Copyright © 1951 by Langston Hughes. Copyright renewed 1979 by George Houstan Bass. "Harlem" Copyright © 1951 by Langston Hughes. Reprinted from *The Panther and the Lash*, by permission of Alfred A. Knopf, Inc.

GLOSSARY

ABA. In music, a three-part structure that consists of an opening section, a second section, and a return to the first section.

a cappella. Choral music without instrumental accompaniment.

abacus. The uppermost members of the capital of an architectural column; the slab on which the architrave rests.

absolute music. Music that is free from any reference to nonmusical ideas, such as a text or program.

abstract. Nonrepresentational; the essence of a thing rather than its actual appearance.

abstraction. A thing apart that is removed from real life.

accelerando. In music, a gradual increase in tempo.

accent. In music, a stress that occurs at regular intervals of time. In the visual arts, any device used to highlight or draw attention to a particular area.

adagio. A musical term meaning slow and graceful.

additive. In sculpture, those works that are built. In color, the term refers to the mixing of hues of light.

aerial perspective. The indication of distance in painting through use of light and atmosphere.

aesthetic. Having to do with the pleasurable and beautiful as opposed to the useful.

aesthetics. A branch of philosophy dealing with the nature of beauty and art and their relation to experience.

affective. Relating to feelings or emotions, as opposed to facts.

aleatory. Chance or accidental.

alegretto. A musical term denoting a lively tempo, but one slower than allegro.

allegory. Expression by means of symbols make a more effective generalization or moral commentary about human experience than could be achieved by direct or literal means.

allegro. A musical term meaning brisk.

alliteration. A sound structure in which an initial sound is repeated for effect.

altarplace. A painted or sculptured panel placed above and behind an altar to inspire religious devotion.

alto. In music, the lowest female voice.

ambulatory. A covered passage for walking, found around the apse or choir of a church.

amphora. A two-handled vessel for storing provisions with an opening large enough to admit a ladle and usually fitted with a cover.

andante. A musical term meaning a medium leisurely, walking tempo.

andantino. A musical term meaning a tempo a little faster than andante.

appoggiatura. In music, an ornamental note or series of notes above and below a tone of a chord.

apse. A large niche or niche-like space projecting from and expanding the interior space of an architectural form such as a basilica.

aquatint. An intaglio printmaking process in which the plate is treated with a resin substance to create textured tonal areas.

arabesque. A classical ballet pose in which the body is supported on one leg, and the other leg is extended behind with the knee straight.

arcade. A series of arches placed side by side.

arch. In architecture, a structural system in which space is spanned by a curved member supported by two legs.

architrave. In post-and-lintel architecture, the lintel or lowest part of the entablature, resting directly on the capitals of the columns.

aria. An elaborate solo song found primarily in operas, oratorios, and cantatas.

art song. A vocal musical composition in which the text is the principal focus.

articulation. The connection of the parts of an artwork.

assemblé. In ballet, a leap with one foot brushing the floor at the moment of the leap and both feet coming together in fifth position at the finish.

assonance. A sound structure employing a similarity among vowels but not consonants.

atonality. The avoidance or tendency to avoid tonal centers in musical compositions.

avant-garde. A term used to designate innovators, "the advanced guard," whose experiments in art challenge established values.

balance. In composition, the equilibrium of opposing or interacting forces.

balletomane. A term used by ballet enthusiasts to refer to themselves. A combination of ballet and mania.

balloon construction. Construction of wood using a skeletal framework. See *skeleton frame.*

baroque. A seventeenth- and eighteenth-century style of art, architecture, and music that is highly ornamental.

barre. A wooden railing used by dancers to maintain balance while practicing.

barrel vault (tunnel vault). A series of arches placed back to back to enclose space.

bas-relief. See *relief.*

basilica. In Roman times a term referring to building function, usually a law court, later used by Christians to refer to church buildings and a specific form.

battement jeté. A ballet movement using a small brush kick with the toe sliding on the floor until the foot is fully extended about two inches off the floor.

bearing-wall. Construction in which the wall supports itself, the roof, and floors. See *monolithic construction.*

beats. In music, the equal parts into which a measure is divided.

binary form. In music form consisting of two sections.

biography. A written account of a person's life.

biomorphic. Representing life forms as opposed to geometric forms.

bridge. A musical passage of subordinate importance played between two major themes.

buttress. A support, usually an exterior projection of masonry or wood, for a wall, arch, or vault.

cadence. In music, the specific harmonic arrangement that indicates the closing of a phrase.

cantilever. An architectural structural system in which an overhanging beam is suported only at one end.

capital. The transition between the top of a column and the lintel.

cast. See *sculpture.*

catharsis. The cleansing or purification of the emotions through the experience of art, the result of which is spiritual release and renewal.

cella. The principal enclosed room of a temple; the entire body of a temple as opposed to its external parts.

chaîné. A series of spinning turns in ballet utilizing a half turn of the body on each step.

changement de pied. In ballet, a small jump in which the positions of the feet are reversed.

character Oxfords. Shoes worn by dancers which look like ordinary street shoes but are actually specially constructed for dance.

chiaroscuro. Light and shade. In painting, the use of highlight and shadow to give the appearance of three-dimensionality. In theatre, the use of light to enhance plasticity of human and scenic form.

chord. Three or more musical tones played at the same time.

choreography. The composition of a dance work; the arrangement of patterns of movement in dance.

chromatic scale. A musical scale consisting of half steps.

cinematic motif. In film, a visual image that is repeated either in identical form or in variation.

cinéma verité. Candid camera; a televisionlike technique of recording life and people as they are. The hand-held camera, natural sound, and minimal editing are characteristic.

classic. Specifically referring to Greek art of the fifth century BC.

classical. Adhering to traditional standards. May refer to Greek and Roman art in which simplicity, clarity of structure and appeal to the intellect are fundamental.

coda. A passage added to the end of a musical composition to produce a satisfactory close.

cognitive. Facts and objectivity as opposed to emotions and subjectivity. See *affective*.

collage. An artwork constructed by pasting together various materials, such as newsprint, to create textures or by combining two and three-dimensional media.

collography. A printmaking process utilizing assorted objects glued to a board or plate.

colonnade. A row of columns usually spanned or connected by lintels.

column. A cylindrical post or support which often has three distinct parts: base, shaft and capital.

composition. The arrangement of line, form, mass, color, and so forth in a work of art.

compression. In architecture, stress that results from two forces moving toward each other.

conjunct melody. In music, melody comprising notes close together in the scale.

consonance. The feeling of a comfortable relationship between elements of a composition. Consonance may be both physical and cultural in its ramifications.

contrapposto (counterpoise). In sculpture, the arrangement of body parts so that the weight-bearing leg is apart from the free leg, thereby shifting the hip/shoulder axis.

conventions. The customs or accepted underlying principles of an art.

Corinthian. A specific order of Greek columns employing an elaborate leaf motif in the capital.

cornice. A crowning, projecting architectural feature.

counterpoint. In music, two or more independent melodies played in opposition to each other at the same time.

crescendo. An increase in loudness.

crosscutting. In film, alternation between two independent actions that are related thematically or by plot to give the impression of simultaneous occurrence.

cruciform. Arranged or shaped like a cross.

curvilinear. Formed or characterized by curved line.

cutting. The trimming and joining that occurs during the process of editing film.

cutting within the frame. Changing the viewpoint of the camera within a shot by moving from a long or medium shot to a close-up, without cutting the film.

decrescendo. A decrease in loudness.

demi-hauteur. A ballet pose with the leg positioned at a 45-degree angle to the ground.

demi-plié. In ballet, a halfbend of the knees in any of the five positions.

denouement. The section of a play's structure in which events are brought to a conclusion.

design. A comprehensive scheme, plan or conception.

detachment. Intellectual as opposed to emotional involvement. The opposite of *empathy*.

diatonic minor. The standard musical minor scale achieved by lowering by one half step, the third and sixth of the diatonic or standard major scale.

disjunct melody. In music, melody characterized by skips or jumps in the scale. The opposite of *conjunct melody*.

dissonance. The occurrences of inharmonious elements in music or the other arts. The opposite of *consonance*.

divertissement. A dance, or a portion thereof, intended as a diversion from the idea content of the work.

documentary. In photography or film, the recording of actual events and relationships using real-life subjects as opposed to professional actors.

dome. An architectural form based on the principles of the arch in which space is defined by a hemisphere used as a ceiling.

Doric. A Greek order of column having no base and only a simple slab as a capital.

drypoint. An intaglio process in which the metal plate is scratched with a sharp needlelike tool.

dynamics. The various levels of loudness and softness of sounds: the increase and decrease of intensities.

eclecticism. In design, a combination of examples of several differing styles in a single composition.

editing. The composition of a film from various shots and sound tracks.

elevation. In dance, the height to which a dancer leaps.

empathy. Emotional and/or physical a witness but not a participant.

empirical. Based on experiments, observation, and practical experience, without regard to theory.

engraving. An intaglio process in which sharp, definitive lines are cut into a metal plate.

en pointe. See *on point.*

engaged column. A column, often decorative, which is part of and projects from a wall surface.

entablature. The upper portion of a classical architectural order above the column capital.

entrechat. In ballet, a jump beginning from fifth position in which the dancer reverses the legs front and back one or more times before landing in fifth position. Similar to the *changement de pied.*

ephemeral. Transitory, not lasting.

epic. A long narrative poem in heightened style about the deeds and adventures of a hero.

esprit d'escalier. French, meaning "spirit of the stairs." Remarks, thought of after the fact, that could have been *bon mots* had they been thought of at the right moment; witty remarks.

essay. A short literary composition on a single subject, usually presenting the personal views of the author. Essays can be formal or informal.

etching. An intaglio process in which lines are cut in the metal plate by an acid bath.

façade. The front of a building or the sides if they are emphasized architecturally.

farce. A theatrical genre characterized by broad, slapstick humor and implausible plots.

fenestration. Exterior openings, such as windows and archways, in an architectural façade.

ferroconcrete. Concrete reinforced with rods or webs of steel.

fiction. A literary work created from the author's imagination rather than from fact.

fluting. Vertical ridges in a column.

flying buttress. A semidetached *buttress.*

focal point (focal area). A major or minor area of visual attraction in pictures, sculpture, dance, plays, films, landscape design, or buildings.

foreground. The area of a picture, usually at the bottom, that appears to be closest to the respondent.

form. The shape, structure, configuration, or essence of something.

form cutting. In film, the framing in a successive shot of an object that has a shape similar to an image in the preceding shot.

forte. A musical term meaning loud.

found object. An object taken from life that is presented as an artwork.

fresco. A method of painting in which pigment is mixed with wet plaster and applied as part of the wall surface.

frieze. The central portion of the entablature: any horizontal decorative or sculptural band.

fugue. Originated from a Latin word meaning "flight." A conventional musical composition in which a theme is developed by *counterpoint.*

full-round. See *sculpture.*

genre. A category of artistic composition characterized by a particular style, form or content.

geometric. Based on man-made patterns such as triangles, rectangles, circles, ellipses, and so on. The opposite of *biomorphic.*

Gesamtkunstwerk. A complete totally integrated artwork: associated with the music dramas of Richard Wagner in nineteenth-century Germany.

Gestalt. A whole. The total of all elements in an entity.

glyptic. Sculptural works emphasizing the qualities of the material form which they are created.

Gothic. A style of architecture based on a pointed-arch structure and characterized by simplicity, verticality, elegance, and lightness.

gouache. A watercolor medium in which gum is added to ground opaque colors mixed with water.

grande seconde. Ballet pose with the leg in second position in the air.

grand jeté. In ballet, a leap from one foot to the other, usually with a running start.

grand plié. In ballet, a full bend of the knees with the heels raised and the knees opened wide toward the toes. May be done in any of the five positions.

grave. In music, a tempo marking meaning slow.

Greek cross. A cross in which all arms are the same length.

groin vault. The ceiling formation created by the intersection of two tunnel or barrel vaults.

harmony. The relationship of like elements such as musical notes, colors, and repetitional patterns. See *consonance* and *dissonance.*

Hellenistic. Relating to the time from Alexander the Great to the first century BC.

heroic. Larger than life size.

hierarchy. Any system of persons or things that has higher and lower ranks.

homophony. A musical texture characterized by chordal development supporting one melody. See *monophony* and *polyphony.*

horizon line. A real or implied line across the picture plane which, like the horizon in nature, tends to fix the viewer's vantage point.

hue. The spectrum notation of color; a specific, pure color with a measurable wavelength. There are primary hues, secondary hues, and tertiary hues.

icon. A Greek word meaning "image.'" Used to identify paintings which represent the image of a holy person.

idée fixe. A recurring melodic motif.

identification. See *empathy.*

impasto. The painting technique of applying pigment so as to create a three-dimensional surface.

improvization. Music etc. produced on the spur of the moment, spontaneously.

intaglio. The printmaking process in which ink is transferred from the grooves of a metal plate to paper by extreme pressure.

intensity. The degree of purity of a hue. In music, theatre, and dance, that quality of dynamics denoting the amount of force used to create a sound or movement.

interval. The difference in pitch between two tones.

intrinsic. Belonging to a thing by its nature.

Ionic. A Greek order of column that employs a scroll-like capital with a circular base.

iris. In film and photography, the

adjustable circular control of the aperture of a lens.

isolation shot. In film, the isolation of the subject of interest in the center of the frame.

jamb. The upright piece forming the side of a doorway or window frame.

jeté. In ballet, a small jump from one foot to the other, beginning and ending with one foot raised.

jump cut. In film, the instantaneous cut from one scene to another or from one shot to another; often used for shock effect.

key. A system of tones in music based on and named after a given tone—the tonic.

kouros. An archaic Greek statue of a standing, nude youth.

krater. A bowl for mixing wine and water, the usual Greek beverage.

kylix. A vase turned on a potter's wheel; used as a drinking cup.

Labanotation. A system of writing down dance movements.

largo. In music, a tempo notation meaning large, broad, very slow, and stately movement.

Latin cross. A cross in which the vertical arm is longer than the horizontal arm, through whose midpoint it passes.

legato. In music, a term indicating that passages are to be played with smoothness and without break between the tones.

lekythos. An oil flask with a long, narrow neck adapted for pouring oil slowly; used in funeral rites.

leitmotif. A "leading motif" used in music to identify an individual, idea, object and so on. Associated with Richard Wagner.

lento. A musical term indicating a slow tempo.

libretto. The words, or text, of an opera or musical.

linear perspective. The creation of the illusion of distance in a two-dimensional artwork through the convention of line and foreshortening. That is, the illusion that parallel lines come together in the distance.

linear sculpture. Sculptural works emphasizing two-dimensional materials.

lintel. The horizontal member of a post-and-lintel structure in architecture.

lithography. A printmaking technique, based on the principle that oil and water do not mix, in which ink is applied to a piece of paper from a specially prepared stone.

low relief. See *relief.*

magnitude. The scope or universality of the theme in a play or film.

manipulation. A sculptural technique in which materials such as clay are shaped by skilled use of the hands.

masonry. In architecture, stone or brickwork.

mass. Actual or implied physical bulk, weight, and density. Also, the most solemn rite of the Catholic liturgy.

medium. The process employed by the artist. Also, the binding agent to hold pigments together.

melodrama. A theatrical genre characterized by stereotyped characters, implausible plots, and emphasis on spectacle.

melody. In music, a succession of single tones.

metaphor. A figure of speech by which new implications are given to words.

mime. In dance or theatre, actions that imitate human or animal movements.

mise en scène. The complete visual environment in the theatre, dance, and film, including setting, lighting, costumes, properties, and physical structure of the theatre.

mobile. A constructed structure whose components have been connected by joints to move by force of wind or motor.

mode. A particular form, style, or manner.

modeling. The shaping of three-diminsional forms. Also the suggestion of three-dimensionality in two-dimensional forms.

modern dance. A form of concert dancing relying on emotional use of the body, as opposed to formalized or conventional movement, and stressing human emotion and the human condition.

modulation. A change of key or tonality in music.

monolithic construction. A variation of *bearing-wall* construction in which the wall material is not jointed or pieced together.

monophony. In music, a musical texture employing a single melody line without harmonic support.

montage. The process of making a single composition by combining parts of others. A rapid sequence of film shots bringing together associated ideas or images.

monumental. Works actually or appearing larger than life size.

Moog synthesizer. See *synthesizer.*

motif (motive). In music, a short, recurrent melodic or rhythmic pattern. In the other arts, a recurrent element.

musique concrète. A twentieth-century musical approach in which conventional sounds are altered electronically on tape to produce new sounds.

nave. The great central space in a church.

neo-classicism. Various artistic styles which borrow the devices or objectives of classical art.

nonobjective. Without reference to reality; may be differentiated from "abstract."

nonrepresentational. Without reference to reality; including *abstract* and *nonobjective.*

novel. A prose narrative of considerable length which has a plot that unfolds by the actions, speech, and thoughts of the characters.

objective camera. A camera position based on a third-person viewpoint.

objet d'art. A French term meaning "object of art."

octave. In music, the distance between a specific pitch vibration and its double; for example, concert A equals 440 vibrations per second, one octave above that pitch equals 880, and one octave below equals 220.

on point. In ballet, a specific technique utilizing special shoes in which the dancer dances on the points of the toes. Same as *en pointe.*

opera buffa. A comic opera.

opus. A single work of art.

overtones (overtone series). The sounds

produced by the division of a vibrating body into equal parts. See *sympathetic vibration*.

palette. In the visual arts, the composite use of color, including range and tonality.

pantheon. A Greek work meaning all the gods of a people.

pas. In ballet, a combination of steps forming one dance.

pas de deux. A dance for two dancers.

pathos. The "suffering" aspect of drama usually associated with the evocation of pity.

pavane. A stately court dance in ¾ time; usually follows a galliard.

pediment. The typically triangular roof piece characteristic of classical architecture.

pendentive. A triangular part of the vaulting which allows the stress of the round base of a dome to be transferred to a rectangular wall base.

perspective. The representation of distance and three-dimensionality on a two-dimensional surface. See also *aerial perspective and linear perspective*.

photojournalism. Photography of actual events that have sociological significance.

piano. A musical term meaning soft.

pirouette. In ballet, a full turn on the toe or ball of one foot.

plan. An architectural drawing that reveals in two dimensions the arrangement and distribution of interior spaces and walls, as well as door and window openings, of a building as seen from above.

plasticity. The capability of being molded or altered. In film, the ability to be cut and shaped. In painting, dance, and theatre, the accentuation of dimensionality of form through *chiaroscuro*.

platemark. The ridged or embossed effect created by the pressure used in transferring ink to paper from a metal plate in the intaglio process.

poetry. A literary work designed to convey a vivid and imaginative sense experience through the use of condensed language selected for its sound and suggestive power and meaning, and employing specific technical devices such as meter,

rhyme, and metaphor. There are three major types of poetry: narrative, dramatic, and lyric.

polyphony. See *counterpoint*.

polyrhythm. The use of contrasting rhythms at the same time in music.

port de bras. The technique of moving the arms correctly in dance.

post-and-lintel. An architectural structure in which horizontal pieces (lintels) are held up by vertical columns (posts).

post-tensioned concrete. Concrete using metal rods and wires under stress or tension to cause structural forces to flow in predetermined directions.

precast concrete. Concrete cast in place using wooden forms around a steel framework.

presto. A musical term signifying a rapid tempo.

prestressed concrete. See *post-tensioned concrete*.

proportion. The relation, or ratio, of one part to another and of each part to the whole with regard to size, height, width, length, or depth.

proscenium. A Greek word meaning "before the skene." The plaster arch or "picture frame" stage of traditional theatres.

prototype. The model on which something is based.

pyramidal structure. In film, and dance, the rising of action to a peak, which then tapers to a conclusion.

quadrille. (1) an American square dance; (2) a European ballroom dance of the eighteenth and nineteenth centuries.

realism. A style of painting, sculpture, and theatre based on the theory that the method of presentation should be true to life.

recitative. Sung dialogue, in opera, cantata, and oratorio.

rectilinear. In the visual arts, the formed use of straight lines and angles.

reinforced concrete. See *ferroconcrete*.

relevé. In ballet, the raising of the body to full height or the half height during the execution of a step or movement.

relief. See *sculpture*.

relief printing. The process in printmaking by which the ink is

transferred to the paper from raised areas on a printing block.

representational. Objects which are recognizable from real life.

requiem. A mass for the dead.

rhyme. A sound structure coupling words that sound alike.

rhythm. The relationship, either of time or space, between recurring elements of a composition.

rib. A slender architectural support in a vault system projecting from the surface.

ribbed vault. A structure in which arches are connected by diagonal as well as horizontal members.

ritardando. In music, a decrease in tempo.

rondo. A form of musical composition employing a return to an initial theme after the presentation of each new theme.

ronds de jambe à terre. In ballet, a rapid semicircular movement of the foot in which the toe remains on the floor and the heel brushes the floor in first position as it completes the semicircle.

rubato. A style of musical performance in which liberty is taken by the performer with the rhythm of the piece.

saturation. In color, the purity of a hue in terms of whiteness; the whiter the hue, the less saturated it is.

scale. In music, a graduated series of ascending or descending musical tones. In architecture, the mass of the building in relation to the human body.

sculpture. A three-dimensional art object. Among the types are (1) *cast*: having been created from molten material utilizing a mold, (2) *relief*: attached to a larger background, (3) *full-round*: freestanding.

serial music. A twentieth-century musical style utilizing the tone row and serialization of rhythms, timbres, and dynamics.

serigraphy. A printmaking process in which ink is forced through a piece of stretched fabric, part of which has been blocked out—for example, silk-screening and stencilling.

shape. A two-dimensional area or plane with distinguishable boundaries.

short story. Short fictional works of prose focusing on unity of characterization, theme, and effect.

silhoutte. A form as defined by its outline.

skeleton frame. Construction in which a skeletal framework supports the buildings. See *balloon construction* and *steel cage construction.*

skene. The stage building of the Ancient Greek theatre.

song cycle. A group of art songs combined around a similar text or theme.

sonority. In music, the characteristic of texture resulting from chordal spacing.

staccato. In music, the technique of playing so that individual notes are detached and separated from each other.

static. Devoid of movement or other dynamic qualities.

steel cage construction. Construction using a metal framework. See *skeleton frame.*

stereotype. A standardized concept or image.

strophic form. Vocal music in which all stanzas of the text are sung to the same music.

style. The identifying characteristics of a work of art which identify it with an artist, a group of artists, an era, or a nation.

stylization. Reliance on conventions, distortions, or theatricality; the exaggeration of characteristics that are fundamentally verisimilar.

stylobate. The foundation immediately below a row of columns.

substitution. A sculptural technique utilizing materials transformed from a plastic, molten, or fluid into a solid state.

subtractive. In sculpture, referring to works that are carved. In color, referring to the mixing of pigments as opposed to the mixing of colored light.

symbol. A form, image, or subject standing for something else.

symbolism. The suggestion through imagery of something that is invisible or intangible.

symmetry. The balancing of elements in design by placing physically equal objects on either side of a center line.

sympathetic vibration. The physical phenomenon of one vibrating body being set in motion by a second vibrating body. See also *overtone.*

symphony. A large musical ensemble; a symphony orchestra. Also, a musical composition for orchestra usually consisting of three or four movements.

syncopation. In a musical composition, the displacement of accent from the normally accented beat to the offbeat.

synthesis. The combination of independent factors or entities into a compound that becomes a new, more complex whole.

synthesizer (Moog synthesizer). An electronic instrument that produces and combines musical sounds.

tempera. An opaque watercolor medium, referring to ground pigments and their color binders such as gum, glue, or egg.

tempo. The rate of speed at which a musical composition is performed. In theatre, film, or dance, the rate of speed of the overall performance.

terracotta. An earth-brown clay used in ceramics and sculpture.

tessitura. The general musical range of the voice in a particular composition.

texture. In visual art, the two-dimensional or three-dimensional quality of the surface of a work. In music, the melodic and harmonic characteristics of the composition.

theatricality. Exaggeration and artificiality; the opposite of *verisimilitude.*

theme. The general subject of an artwork, whether melodic or philosophical. that results from the particular source of the sound. The difference between the sound of a violin and the sound of the human voice is a difference in timbre, also called color.

toccata. A composition usually for organ or piano intended to display technique.

tonality. In music, the specific key in which a composition is written. In the visual arts, the characteristics of value.

tondo. A circular painting.

tonic. In music, the root tone (*do*) of a key.

tragédie bourgeois. See *drame bourgeois.*

tragedy. A serious drama or other literary work in which conflict between a protagonist and a superior force (often fate) concludes in disaster for the protagonist.

tragicomedy. A drama combining the qualities of tragedy and comedy.

transept. The crossing arm of a cruciform church, in contrast to the nave.

triad. A chord consisting of three tones.

trompe-l'oeil. "Trick of the eye" or "fool the eye." A two-dimensional artwork so executed as to make the viewer believe that three-dimensional subject matter is being perceived.

tunnel vault. See *barrel vault.*

tutu. A many-layered, stiff short skirt worn by a ballerina.

twelve-tone technique. A twentieth-century atonal form of musical composition associated with Schoenberg.

tympanum. The open space above the door beam and within the arch of a medieval doorway.

value (value scale). On the visual arts, the range of tonalities from white to black.

vanishing point. In linear perspective, the point on the horizon toward which parallel lines appear to converge and at which they seem to vanish.

variation. Repetition of a theme with minor or major changes.

verisimilitude. The appearance of reality in any element of the arts.

vivace. A musical term denoting a vivacious or lively tempo.

virtuoso. Referring to the display of impressive technique or skill by an artist.

waltz. A dance in $\frac{3}{4}$ time

woodcut. A relief printing executed from a design cut in the plank of the grain.

wood engraving. A relief printing made from a design cut in the butt of the grain.

BIBLIOGRAPHY

Abcarian, Richard and Klotz, Marvin (eds.). *Literature, the Human Experience.* New York: St. Martin's Press, 1986.

Anderson, Donald M. *Elements of Design.* New York: Holt, Rinehart, and Winston, 1961.

Anderson, Jack. *Dance.* New York: Newsweek Books, 1974

Andreae, Bernard. *The Art of Rome.* New York: Harry N. Abrams, 1977.

Arnheim, Rudolph. *Art and Visual Perception: A Psychology of the Creative Eye.* Berkeley: University of California Press, 1957.

Arnheim, Rudolph. *Film as Art.* Berkeley: University of California Press, 1967.

Arnott, Peter D. *An Introduction to the Greek Theatre.* Bloomington, IN: Indiana University Press, 1963.

Artz, Frederick. *From the Renaissance to Romanticism.* Chicago: University of Chicago Press, 1962

Bacon, Edmund N. *Design of Cities.* New York: Viking Press, 1967.

Baker, Blanche M. *Theatre and Allied Arts.* New York: H. W. Wilson Company, 1952.

Bataille, Georges. *Lascaux.* Switzerland: Skira, n.d.

Bates, Kenneth F. *Basic Design: Principle and Practice.* New York: Funk and Wagnalls, 1975.

Bawden, Liz-Anne (ed.). *The Oxford Companion to Film.* New York: Oxford University Press, 1976.

Bazin, Germain. *The Baroque.*

Greenwich, CN: New York Graphic Society, 1968.

Beam, P. C. *Language of Art.* New York: John Wiley and Sons, 1958.

Bentley, Eric (ed.). *The Classic Theatre* (four vols.). Garden City, NY: Doubleday Anchor Books, 1959.

Bloom, Eric. *Grove's Dictionary of Music and Musicians* (5th ed.). New York: St. Martin's Press, 1959.

Bloomer, Carolyn M. *Principles of Visual Perception.* New York: Van Nostrand Reinhold Company, 1976.

Bobker Lee R. *Elements of Film.* New York: Harcourt Brace Jovanovich, 1969.

Bohn, T. W., Stromgren, R. L., and Johnson, D. H. *Light and Shadows, A History of Motion Pictures* (2nd edn). Sherman Oaks, CA: Alfred Publishing Co., 1978.

Booth, Michael. *Victorian Spectacular Theatre 1850–1910.* Boston: Routledge and Kegan Paul, 1981.

Bordwell, David and Kristin Thompson. *Film Art: An Introduction.* Reading, Mass.: Addison-Wesley, 1979.

Borroff, Edith. *Music in Europe and the United States: A History.* Englewood Cliffs, NJ: Prentice-Hall, Inc., 1971.

Brandon, S. G. F. *Religion in Ancient History.* New York: Charles Scribner's Sons, 1969.

Brindle, Reginald Smith. *The New Music: The Avant-Garde Since 1945.* London: Oxford University Press, 1975.

Brockett, Oscar G. *History of the Theatre.* Boston: Allyn and Bacon, Inc., 1968.

Brockett, Oscar. *The Theatre* (2d edn). New York: Holt, Rinehart and Winston, 1969.

Campos, D. Redig de (ed.). *Art Treasures of the Vatican.* Englewood Cliffs, NJ: Prentice-Hall, Inc., 1974.

Canaday, John. *What Is Art?* New York: Alfred A. Knopf, 1980.

Cheney, Sheldon. *The Theatre: Three Thousand Years of Drama, Acting and Stagecraft* (rev. edn). New York: Longmans, Green, 1952.

Chujoy, Anatole. *Dance Encyclopedia.* New York: Simon and Schuster, Inc., 1967.

Clarke, Mary and Crisp, Clement. *Ballet.* New York: Universe Books, 1973.

Clough, Shepard B. *et al. A History of the Western World.* Boston: D. C. Heath and Co., 1964.

Coleman, Ronald. *Sculpture: A Basic Handbook for Students.* Dubuque, IA: William C. Brown Company, 1980.

Collier, Graham. *Form, Space, and Vision.* Englewood Cliffs, NJ: Prentice Hall, 1972.

Cook, David A. *A History of Narrative Film.* New York: W. W. Norton and Company, 1981.

Cope, David H. *New Directions in Music.* Dubuque, IA: William C. Brown and Co., 1981.

Corrigan, Robert. "The Search for New Endings: The Theatre in Search of a Fix, Part III," *Theatre Journal,* vol. 36, no. 2, May 1984, pp. 153–63.

Coryell, Julie and Friedman, Laura. *Jazz-*

Rock Fusion. New York: Delacorte Press, 1978.

Crocker, Richard. *A History of Musical Style*. New York: McGraw-Hill, 1966.

Davis, Phil. *Photography*. Dubuque, IA: William C. Brown Company, 1979.

Dean, Alexander and Lawrence Carra. *Fundamentals of Play Directing* (rev. edn). New York: Holt, Rinehart, and Winston, 1965.

Diehl, Charles. *Byzantium*. New Brunswick, NJ: Rutgers University Press, 1957.

Drinkwater, John. *The Outline of Literature*. London: Transatlantic Arts, 1967.

Engel, Carl. *The Music of the Most Ancient Nations*. Freeport, NY: Books for Libraries Press, 1970.

Ernst, David. *The Evolution of Electronic Music*. New York: Schirmer Books. 1977.

Esslin, Martin (ed.). *The Encyclopedia of World Theatre*. New York: Charles Scribner's Sons, 1977.

Faulkner, Ray and Ziegfeld, Edwin. *Art Today* (5th edn). New York: Holt, Rinehart, and Winston, 1969.

Fleming, William. *Arts and Ideas*. New York; Holt, Rinehart, and Winston, 1980.

Frankfort, Henri. *Kingship and the Gods*. Chicago: University of Chicago Press, 1948.

Freedley, George and Reeves, John. *A History of the Theatre* (3rd edn). New York: Crown Publishers, 1968.

Fuller, B. A. G. *A History of Philosophy*. New York: Henry Holt and Company, 1945.

Fulton, Albert R. *Motion Pictures*. Norman, OK: University of Oklahoma Press, 1960.

Gardner, Helen. *Art Through the Ages*. New York: Harcourt, Brace, Jovanovich, 1980.

Garraty, John and Gay, Peter. *A History of the World* (2 vols.). New York: Harper and Row, 1972.

Gassner, John (ed.). *A Treasury of the Theatre*. New York: Holt, Rinehart, and Winston, 1967.

Gessner, Robert. *The Moving Image: A Guide to Cinematic Literacy*. New York: E. P. Dutton, 1970.

Giannetti, Louis. *Understanding Movies* (2nd edn). Englewood Cliffs, NJ: Prentice-Hall, Inc., 1976.

Gilbert, Cecil. *International Folk Dance at a Glance*. Minneapolis, Minn.: Burgess Publishing Company, 1969.

Gilbert, Creighton. *History of Renaissance Art Throughout Europe: Painting, Sculpture, Architecture*. New York: Harry N. Abrams, Inc., 1973.

Glasstone, Victor. *Victorian and Edwardian Theatres*. Cambridge, MA: Harvard University Press, 1975.

Goethe, Johann Wolfgang von. *Faust: Part 1*, trans. Philip Wayne, Baltimore: Penguin Books, 1962.

Grabar, André, *The Art of the Byzantine Empire*. New York: Crown Publishers, Inc., 1966.

Graham, Peter (ed.). *Dictionary of the Cinema*. London: Tantivy Press, 1964.

Graziosi, Paolo. *Paleolithic Art*. New York: McGraw-Hill, 1960.

Griffiths, Paul. *A Concise History of Avante-Garde Music*. New York: Oxford University Press, 1978.

Grimm, Harold. *The Reformation Era*. New York: The MacMillan Co., 1954.

Groenewegen-Frankfort and Ashmole, Bernard. *Art of the Ancient World*. Englewood Cliffs, NJ and New York: Prentice-Hall, Inc. and Harry N. Abrams, Inc. n.d.

Gropius, Walter (ed.) *The Theatre of the Bauhaus*. Middletown, CN: Wesleyan University Press, 1961.

Gropius, Walter. *The New Architecture and the Bauhaus*, Cambridge, MA: M.I.T. Press, 1965.

Grout, Donald Jay. *A History of Western Music* (rev. edn). New York: W. W. Norton and Co., Inc., 1973.

Halliwell, Leslie. *The Filmgoer's Companion*. New York: Avon Books, 1978.

Hamilton, Edith. *Three Greek Plays*. New York: W. W. Norton and Co., 1965.

Hamilton, George Heard. *Nineteenth and Twentieth Century Art: Painting, Sculpture, Architecture*. New York: Harry N. Abrams, Inc. 1970

Hartt, Frederick. *Art* (2 vols.). Englewood Cliffs, NJ and New York: Prentice-Hall, Inc. and Harry N. Abrams, Inc., 1979.

Hartt, Frederick. *Italian Renaissance Art* (3rd edn). Englewood Cliffs. NJ and New York: Prentice-Hall, Inc. and Harry N. Abrams, Inc., 1987.

Hatlen, Theodore. *Orientation to the Theatre* (3rd edn). Englewood Cliffs, NJ: Prentice Hall, 1981.

Hawkes, Jacquetta, and Wooley, Sir Leonard. *History of Mankind: Prehistory and the Beginnings of Civilization*. New York: Harper and Row, 1963.

Heffner, Hubert. *The Nature of Drama*. Boston: Houghton Mifflin Company, 1959.

Held, Julius and Posner, D. *17th and 18th Century Art*. New York: Harry N. Abrams, n.d.

Helm, Ernest. *Music at the Court of Frederick the Great*. Norman, OK: University of Oklahoma Press, 1960.

Henig, Martin (ed.). *A Handbook of Roman Art*. Ithaca, NY: Cornell University Press, 1983.

Hewett, Bernard. *Theatre U.S.A.* New York: McGraw-Hill Book Company, 1959.

Heyer, Paul. *Architects on Architecture: New Directions in America*. New York: Walker and Company, 1966.

Hickok, Robert. *Music Appreciation*. New York: Appleton-Century-Crofts, 1971.

Hitchcock, Henry-Russell. *Architecture: Nineteenth and Twentieth Centuries*. Baltimore: Penguin Books, 1971.

Hofstadter, Albert and Kuhns, Richard. *Philosophies of Art and Beauty*. Chicago: University of Chicago Press, 1976.

Honour, Hugh and Fleming, John. *The Visual Arts: A History* (2nd edn) Englewood Cliffs, NJ: Prentice-Hall, Inc., 1986.

Hoppin, Richard. *Medieval Music*. New York: W. W. Norton and Co., Inc., 1978.

Hornstein, Lillian, Percy, G. D., and Brown, Sterling A. *World Literature* (2nd edn). New York: Mentor, 1973.

Hubatsch, Walther. *Ferderick the Great of Prussia*. London: Thames and Hudson, 1975.

Hubert, J., Porcher, J., and Volbach, W. F. *The Carolingian Renaissance*. New York: George Braziller, 1970.

Jacobs, Lewis. *An Introduction to the Art of the Movies*. New York: Noonday Press, 1967.

Janson, H. W. *A Basic History of Art* (2nd edn). Englewood Cliffs, NJ and New York: Prentice-Hall, Inc. and Harry N. Abrams, Inc., 1981.

Jung, Carl G. *Man and His Symbols*. New York: Doubleday and Co., Inc., 1964.

Karsavina, Tamara. *Theatre Street*. New York: E. P. Dutton, 1961.

Kassler, Elizabeth B. *Modern Gardens and the Landscape*. New York: Museum of Modern Art, 1964.

Kepes, Gyorgy. *Language of Vision*. Chicago: Paul Theobald and Company, 1951.

Kernodle, George R. *Invitation to the Theatre*. New York: Harcourt Brace Jovanovich, 1967.

Keutner, Hubert. *Sculpture: Renaissance to Rococo*. Greenwich, CT: New York Graphic Society, 1969.

Kirby, F. E. *A Short History of Keyboard Music*. New York: Macmillan Company, 1966.

Kjellberg, Ernst and Saflund, Gosta. *Greek and Roman Art*. New York: Thomas Y. Crowell Co., 1968.

Knickerbocker, K. L. and Reninger, H. Willard. *Interpreting Literature*. New York: Holt, Rinehart, and Winston, 1969.

Knight, Arthur. *The Liveliest Art: A Panoramic History of the Movies* (rev. edn). New York: MacMillan, Inc., 1978.

Knobler, Nathan. *The Visual Dialogue*. New York: Holt, Rinehart, and Winston, 1967.

Kratzenstein, Marilou. *Survey of Organ Literature and Editions*. Ames, Iowa: Iowa State University Press, 1980.

Kraus, Richard. *History of the Dance*. Englewood Cliffs, NJ: Prentice-Hall, Inc., 1969.

Lange, Kurt and Hirmer, Max. *Egypt*. London: Phaidon, 1968.

Lawler, Lillian. *The Dance in Ancient Greece*. Middletown, CT: Wesleyan University Press, 1964.

Leish, Kenneth W. *Cinema*. New York: Newsweek Books, 1974.

Lippard, Lucy R. *Pop Art*. New York: Oxford University Press, 1966.

Lloyd, Seton. *The Archaeology of Mesopotomia*. London: Thames and Hudson, 1978.

Lommel, Andreas. *Prehistoric and Primitive Man*. New York: McGraw-Hill, 1966.

Maas, Jeremy. *Victorian Painters*. New York: G. P. Putnam's Sons, 1969.

MacDonald, William. *Early Christian and Byzantine Architecture*. New York: George Braziller, 1967.

Machiavelli, Niccolo. *The Prince*, trans. George Bull. Baltimore: Penguin Books, 1963.

Machlis, Joseph. *The Enjoyment of Music* (3rd edn). New York: W. W. Norton and Company, 1955.

Mango, Cyril. *Byzantium*. New York: Charles Scribner's Sons, 1980.

Marshack, Alexander. *The Roots of Civilization*. New York: McGraw-Hill, 1972.

Martin, John. *The Dance*. New York: Tudor Publishing Company, 1946.

Martin, John. *The Modern Dance*. Brooklyn: Dance Horizons, 1965.

McDermott, Dana Sue. "Creativity in the Theatre: Robert Edmond Jones and C. G. Jung." *Theatre Journal*, May 1984, pp. 212–30.

McDonagh, Don. *The Rise and Fall of Modern Dance*. New York: E. P. Dutton, Inc., 1971.

McGiffert, Arthur. *A History of Christian Thought*. New York: Charles Scribner's Sons, 1961.

McLeish, Kenneth. *The Theatre of Aristophanes*. New York: Taplinger Publishing Co., 1980.

McNeill, William H. *The Shape of European History*. New York: Oxford University Press, 1974.

Miller, Hugh. *Introduction to Music*. New York: Barnes and Noble, 1961.

Montet, Pierre. *Lives of the Pharoahs*. Cleveland: World Publishing Co., 1968.

Moore, Douglas. *Listening to Music*. New York: W. W. Norton and Company, 1963.

Moortgat, Anton. *The Art of Ancient Mesopotamia*. London: Phaidon, 1969.

Munro, Thomas. *The Arts and Their Interrelationships*. New York: Liberal Arts Press. 1949.

Murray, Margaret, *Egyptian Sculpture*.

New York: Charles Scribner's Sons, 1930.

Muthesius, Stefan. *The High Victorian Movement in Architecture 1850–1870*. London: Routledge and Kegan Paul, 1972.

Myers, Bernard S. *Art and Civilization*. New York: McGraw-Hill Book Company, Inc., 1957.

Nadel, Constance and Nadel, Myron. *The Dance Experience*. New York: Praeger Publishers, 1970.

Newman, William S. *Understanding Music* (2nd edn). New York: Harper and Row, 1961.

Nicoll, Allardyce. *The Development of the Theatre* (5th edn). London: Harrap and Co., Ltd., 1966.

Nyman, Michael. *Experimental Music: Cage and Beyond*. New York: Schirmer Books, 1974.

Ocvirk, Otto, Bone, Robert O., Stinson, Robert E. and Wigg, Philip R. *Art Fundamentals* (4th edn). Dubuque, IA: William C. Brown Company, 1981.

Oppenheim, A. Leo. *Ancient Mesopotamia*. Chicago: University of Chicago Press, 1964.

Ostransky, Leroy. *Understanding Jazz*. Englewood Cliffs, NJ: Prentice-Hall, Inc., 1977.

Parker, Oren W. and Smith, Harvey K. *Scene Design and Stage Lighting* (2nd edn). New York: Holt, Rinehart, and Winston, 1968.

Perkins, V. F. *Film as Film: Understanding and Judging Movies*. New York: Penguin Books, 1972.

Pfeiffer, John E., *The Creative Explosion*. New York: Harper and Row, 1982.

Pignatti, Terisio. *The Age of Rococo*. London: Paul Hamlyn, 1969.

Politoske, Daniel T. *Music* (3rd edn). Englewood Cliffs, NJ: Prentice-Hall, 1984.

Powell, T. G. E. *Prehistoric Art*, New York: Frederick Praeger Publishers, 1966.

Preble, Duane. *We Create, Art Creates Us*. New York: Harper and Row, 1976.

Purves, Frederick (ed.). *The Focal Encyclopedia of Photography*. London: Ford Press, 1965.

Raphael, Max. *Prehistoric Cave Paintings*. Washington, DC: Pantheon, 1946.

Rasmussen, Steen Eiler. *Experiencing Architecture*. New York: John Wiley and Sons, 1959.

Read, Benedict. *Victorian Sculpture*. New Haven: Yale University Press, 1982.

Read, Herbert E. *Art and Society* (2nd edn). New York: Pantheon Books, Inc., 1950.

Renner, Paul. *Color, Order, and Harmony*. New York: Van Nostrand Reinhold Company, 1965.

Rice, David Talbot. *The Art of Byzantium*. New York: Harry N. Abrams, n.d.

Richter, Gisela. *Greek Art*. Greenwich, CN: Phaidon, 1960.

Roberts, J. M. *History of the World*. New York: Alfred A. Knopf, Inc., 1976.

Robertson, Martin. *A Shorter History of Greek Art*. Cambridge, MA: Cambridge University Press, 1981.

Robinson, David. *The History of World Cinema*. New York: Stein and Day Publishers, 1973.

Roters, Eberhard. *Painters of the Bauhaus*. New York: Praeger Publishers, 1965.

Rotha, Paul. *The Film Til Now*. London: Spring Books, 1967.

Rowell, George. *The Victorian Theatre* (2nd edn) Cambridge University Press, 1978.

Sachs, Curt. *World History of the Dance*. New York: W. W. Norton and Co., 1937.

Sachs, Curt. *The Rise of Music in the Ancient World*. New York: W. W. Norton Company, 1943.

Salzman, Eric. *Twentieth Century Music: An Introduction*. Englewood Cliffs, NJ: Prentice-Hall, Inc., 1967.

Sandars, N. K. *Prehistoric Art in Europe*. Baltimore: Penguin Books, 1968.

Saylor, Henry H. *Dictionary of Architecture*. New York: John Wiley and Sons, 1963.

Schevill, Ferdinand. *A History of Europe*. New York, Harcourt Brace and Co., Inc., 1938.

Schneider, Elisabeth *et al*. *The Range of Literature*. New York: American Book Company. 1960.

Schonberger, Arno and Soehner, Halldor. *The Rococo Age*. New York: McGraw-Hill, 1960.

Seiberling, Frank. *Looking into Art*. New York: Holt, Rinehart, and Winston, 1959.

Sherrard, Philip. *Byzantium*. New York: Time Inc., 1966.

Sitwell, Sacheverell, *Great Houses of Europe*. London: Spring Books, 1970.

Smith, Hermann. *The World's Earliest Music*, London: W. Reeve, n.d.

Smith, W. Stevenson. *The Art and Architecture of Ancient Egypt*. Baltimore: Penguin Books, 1958.

Sorell, Walter. *Dance in its Time*. Garden City, NY: Doubleday Anchor Press, 1981.

Sorell, Walter. *The Dance Through the Ages*. New York: Grosset and Dunlap, Inc., 1967.

Southern, Richard. *The Seven Ages of the Theatre*. New York: Hill and Wang, 1961.

Sperry, Roger. *Science and Moral Priority: Merging Mind, Brain, and Human Values*. New York: Columbia University Press, 1983.

Spitz, Lewis (ed.). *The Protestant Reformation*. Englewood Cliffs, NJ: Prentice-Hall, Inc., 1966.

Sporre, Dennis J. *The Arts*. Englewood Cliffs, NJ: Prentice-Hall, Inc., 1985.

Sporre, Dennis J. *Perceiving the Arts*. Englewood Cliffs, NJ: Prentice-Hall, Inc., 1981.

Sporre, Dennis and Burroughs, Robert C. *Scene Design in the Theatre*, Englewood Cliffs, NJ: Prentice-Hall Inc., 1989.

Stamp, Kenneth M. and Wright, Esmond (eds.). *Illustrated World History*. New York: McGraw-Hill Book Company, 1964.

Stearns, Marshall and Marshall, Jean. *Jazz Dance*. New York: The Macmillan Company, 1968.

Steinberg, Cobbett. *The Dance Anthology*. New York: Times Mirror, 1980.

Strayer, Joseph and Munro, Dana. *The Middle Ages*. Pacific Palisades: Goodyear Publishing Company, 1970.

Styan, J. L. *The Dramatic Experience*. Cambridge: Cambridge University Press, 1965.

Tierney, Brian and Painter, Sidney. *Western Europe in the Middle Ages*. New York: Alred A. Knopf, 1974.

Tirro, Frank. *Jazz: A History*. New York: W. W. Norton and Co., Inc., 1977.

Trythall, Gilbert. *Principles and Practice of Electronic Music*. New York: Grosset and Dunlap, 1973.

Ucko, Peter J. and Rosenfeld, Andree. *Paleolithic Cave Art*. London: World University Library, 1967.

Ulrich, Homer. *Music: A Design for Listening*. (3rd edn). New York: Harcourt, Brace and World, Inc., 1970.

Van Der Kemp, Gerald, *Versailles*. New York: The Vendome Press, 1977.

Wheeler, Robert Eric Mortimer. *Roman Art and Architecture*. New York: Praeger Publishers Inc., 1964.

Wigman Mary. *The Language of Dance*. Walter Sorrell, trans. Middleton, CN: Wesleyan University Press, 1963.

Wittlich, Gary E. (ed.). *Aspects of Twentieth Century Music*. Englewood Cliffs, NJ: Prentice-Hall, Inc., 1975.

Zarnecki, George. *Art of the Medieval World*. Englewood Cliffs, NJ: Prentice-Hall Inc., 1975.

PICTURE CREDITS

The author, the publishers and John Calmann & King Ltd wish to thank the museums, galleries, collectors and other owners who have kindly allowed their works to be reproduced in this book. In general, museums have supplied their own photographs; other sources are listed below:

INDEX